This Book Belongs To

Your

Beauty

Mark

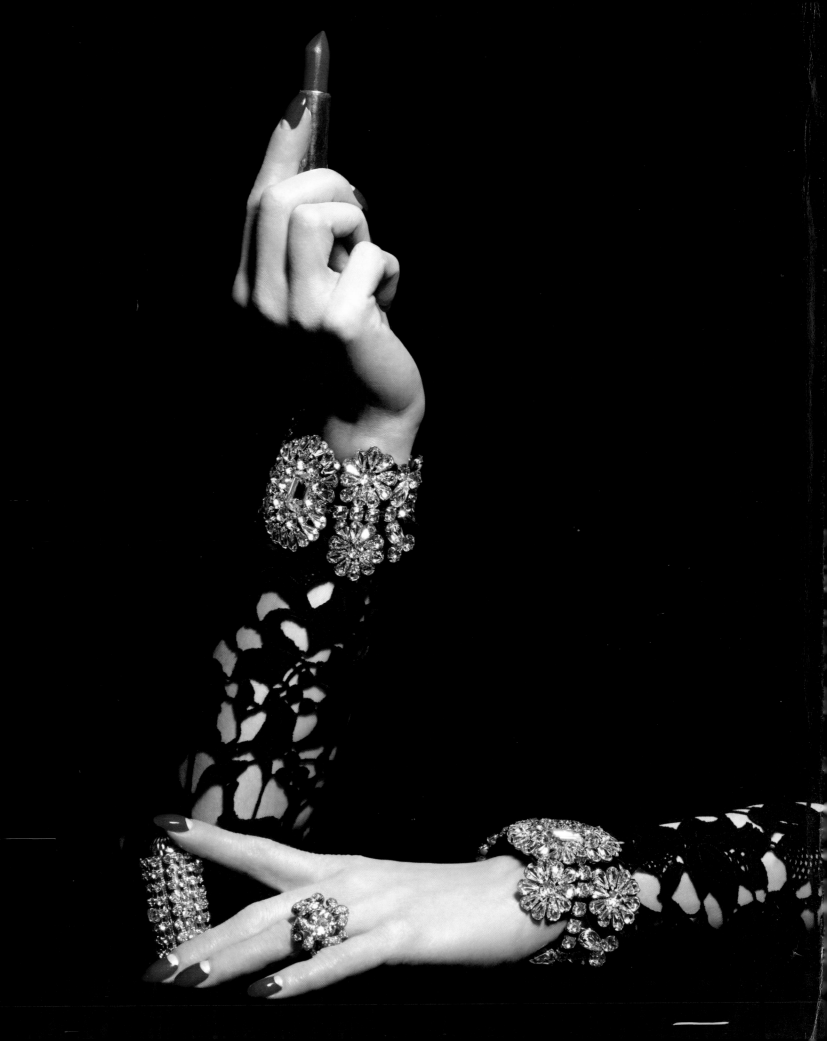

Your Beauty Mark

The Ultimate Guide to Eccentric Glamour

DITA VON TEESE
WITH ROSE APODACA

DEY ST.
AN IMPRINT OF
WILLIAM MORROW *PUBLISHERS*

ALSO BY DITA VON TEESE

Burlesque and the Art of the Teese/Fetish and the Art of the Teese

Dita: Stripteese (with photographer Sheryl Nields)

DEY ST.
AN IMPRINT OF
WILLIAM MORROW PUBLISHERS

HarperCollins books may be purchased for educational, business, or sales promotional use. For information please e-mail the Special Markets Department at SPsales@harpercollins.com.

FIRST EDITION

Designed by Kris Tobiassen of Matchbook Digital
Illustrations by Adele Mildred

Library of Congress Cataloging-in-Publication Data has been applied for.

ISBN 978-0-06-072271-5

16 17 18 19 OV/RRD 10 9 8 7 6 5 4 3

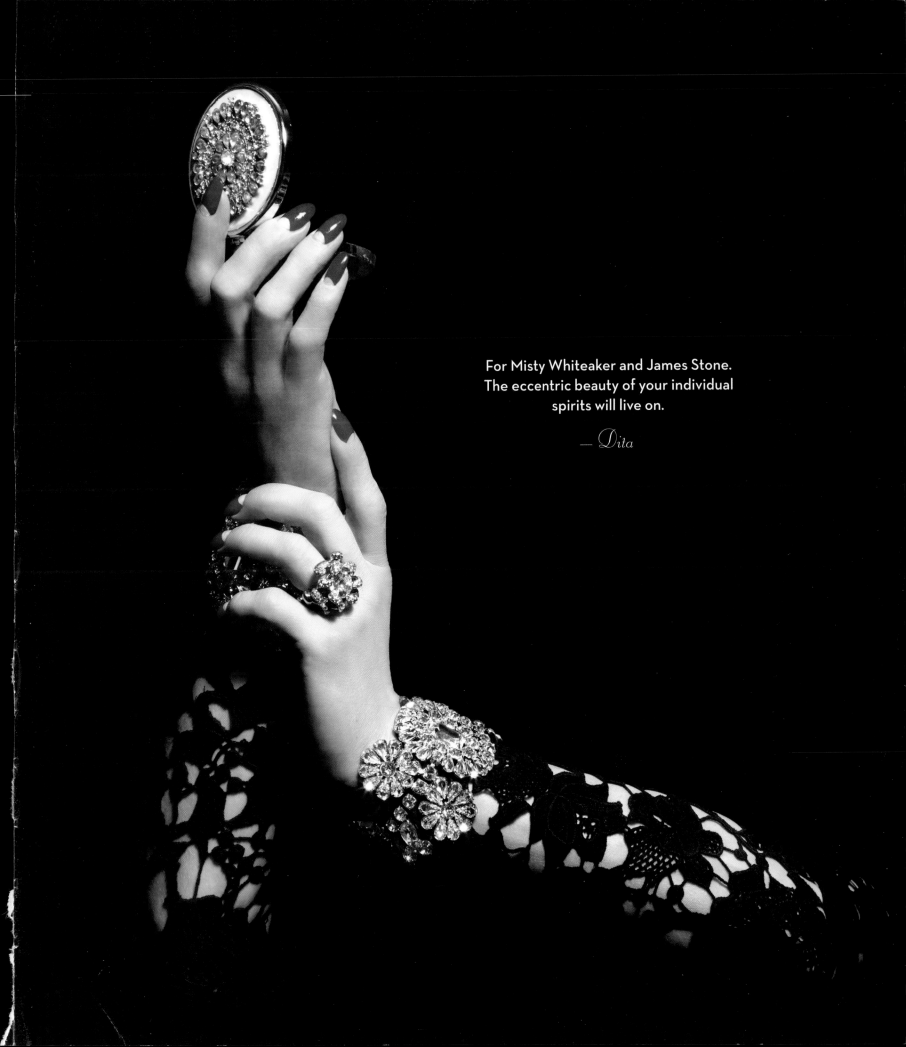

For Misty Whiteaker and James Stone.
The eccentric beauty of your individual
spirits will live on.

— *Dita*

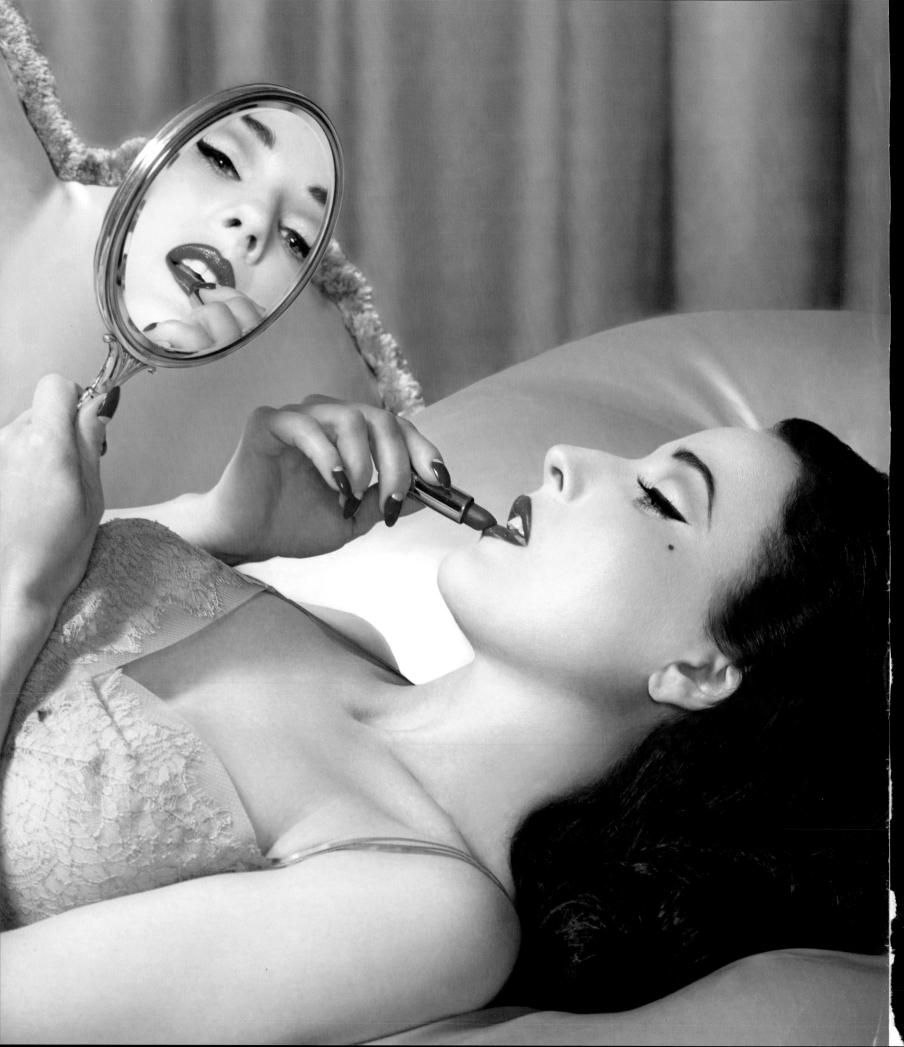

CONTENTS

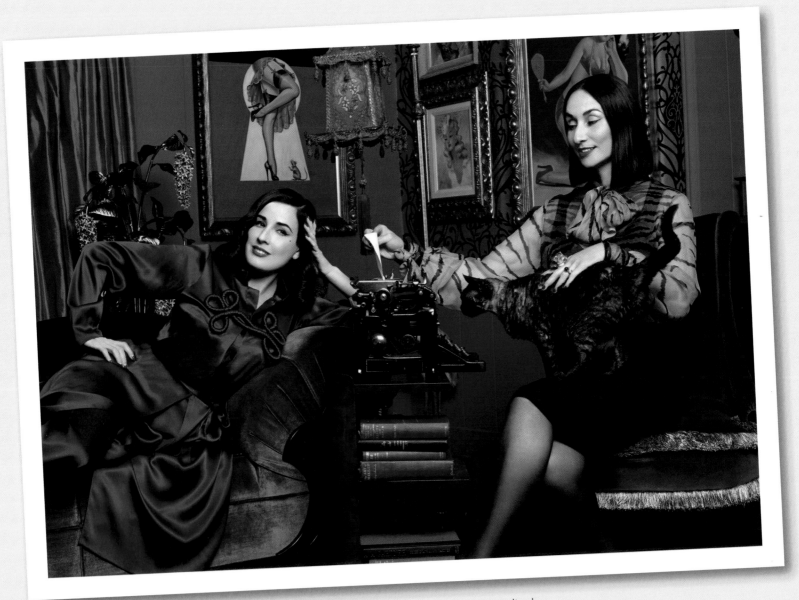

Imagine that: Dita, Aleister and I conjure beauty to live by.

Preface

Is she for real?

I'm nearly always asked this when anyone learns I know Dita Von Teese. Sometimes it comes in a whisper, pregnant with snarky anticipation for something that will confirm their misconceptions; other times, it's voiced at full volume across a dinner table, shushing fellow guests, eager to hear a confidence revealed.

And nearly always, the initial response that pops to mind is the observation O. J. Berman (played by the great character actor Martin Balsam) conveys to leading man Paul Varjak (George Peppard) in the film version of *Breakfast at Tiffany's*:

"She's a real phony. You know why? Because she honestly believes all this phony junk she believes in."

Now, don't misunderstand me. I do not believe for a nanosecond that Dita is a phony by dictionary definition.

In *Breakfast,* when the Hollywood agent tells the lovesick Paul that Holly is a real phony because this once small-town girl *believes* in the crocodile-kitten-heeled life she's conjured in Manhattan as Holly Golightly, there is a wonderfully exhilarating truth to it. In this context, the "phony" is the drag of makeup, hair color, and wardrobe. It's the flair of speech and mannerism. And, of course, the adopted name—be it Holly Golightly or Dita Von Teese or that of her friends RuPaul or Raja (who appears

on page 208) or Catherine Baba (page 182). Or it can be insisting on a single name, like the hair guru featured prominently on these pages, Danilo, who prefers to drop the family-given Dixon altogether.

These individuals each had the courage and determination to cultivate the eccentric beauty within them, to hone it as art form and turn it into a career *and* a lifestyle. They have manifested who they truly imagined themselves to be. And there is nothing fake about that.

Besides, the gal who started life in a Michigan town before conquering the world as the queen of burlesque and a bona fide fashion icon is no Holly Golightly. She is neither naïve nor indecisive. She is no gold digger, having always made her way in this world through grit and grace. Nor is she a woman running from her past; her mother and sisters are every part of her showbiz family. And since I first met the pretty young go-go dancer, then

known as Heather but already transforming into Dita, about a quarter century ago, she has wowed the world and her friends with a relentless work ethic.

Dita is also candid about the kinds of topics most private, let alone public, figures wouldn't even imagine broaching. Yet she also has the good sense and style to know when to keep matters of her private life to herself. She is more real than any reality star.

As for other uncertainties that bring into question her "realness," allow me to set the record straight:

Yes, she really lives the life. Even her "casual" look at home means a pretty garden dress or lacy slip à la Elizabeth Taylor in *Cat on a Hot Tin Roof.* The only time I have ever seen her in jeans in the last quarter century? You'll have to read about it on page 14.

As for brains, boy, has she got them. You cannot reach the height of the neo-burlesque world and maintain that stature, keep a small army employed, and fashion a signature empire without a very good head on those porcelain shoulders.

Yes, she did earn that skin and body. Okay, so some of it is due to genetics (you should see her mother, Bonnie!). And she has always copped to whatever "work" she's undergone—she shares it all again in chapter 19. Otherwise, the work is all perspiration and dedication. When I stayed with her in Paris, after an evening out dining on our favorite cockles and Champagne, she was off the next morning to a local Pilates session before I'd emptied my first cup of tea. She frequents ballet and other classes in cities she travels to the way most visitors do the local landmarks. Oh, she enjoys herself at the dinner table—with moderation and without failing to eat smartly the rest of the time.

Yes, Dita does her own hair and makeup 99 percent of the time—unlike 99 percent of the celebrities out there with their own beauty guidebooks. So she very much deserves to have her name on this one. In the majority of photographs featured in this book, Dita has done her own hair and makeup. And little or no retouching was done on the step-by-step photographs and a few of the glamour shots. As someone who at age thirteen started wearing a cat eye, swiping on red lipstick, and teasing my hair, I deeply appreciate that she brought me on board to collaborate, write, and creative-direct this book. I get her. And I get how real all this "phony" stuff is to those of us who bask in it.

Yes, it was an experience. While this book admittedly took longer than either of us imagined it would, we weren't about to put her name on something that wasn't the best we could make it. That is integrity. And it's an experience I will forever cherish.

As for the other most-frequently-asked query, weighed down most of the time with some skepticism: is she *really* nice?

Yep. Dita is no phony.

—ROSE APODACA
Los Angeles, 2015

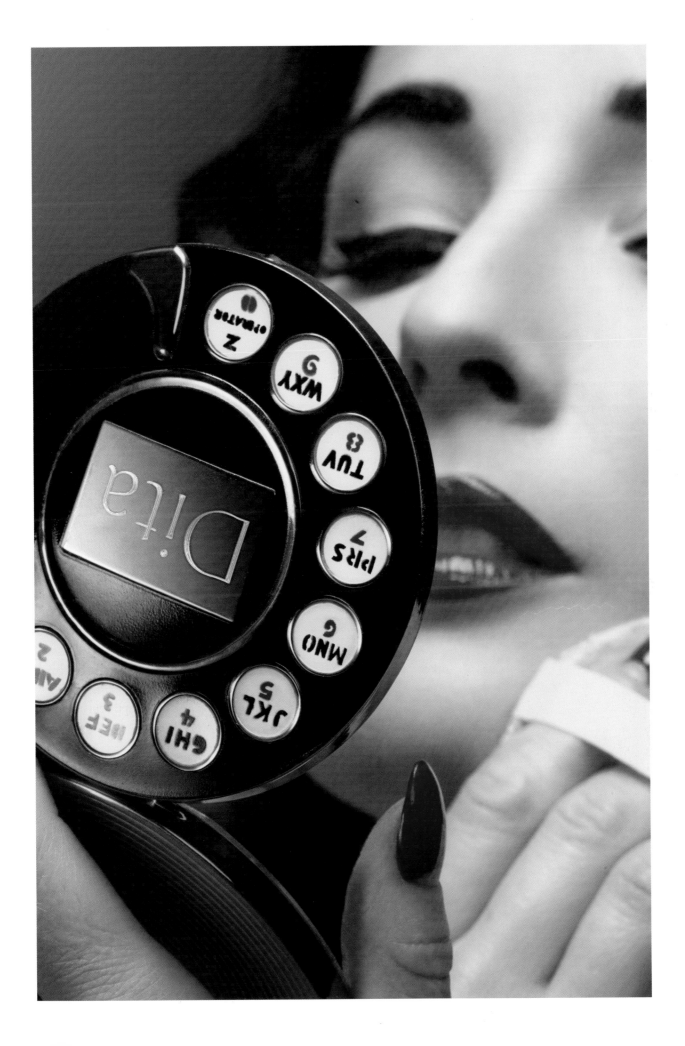

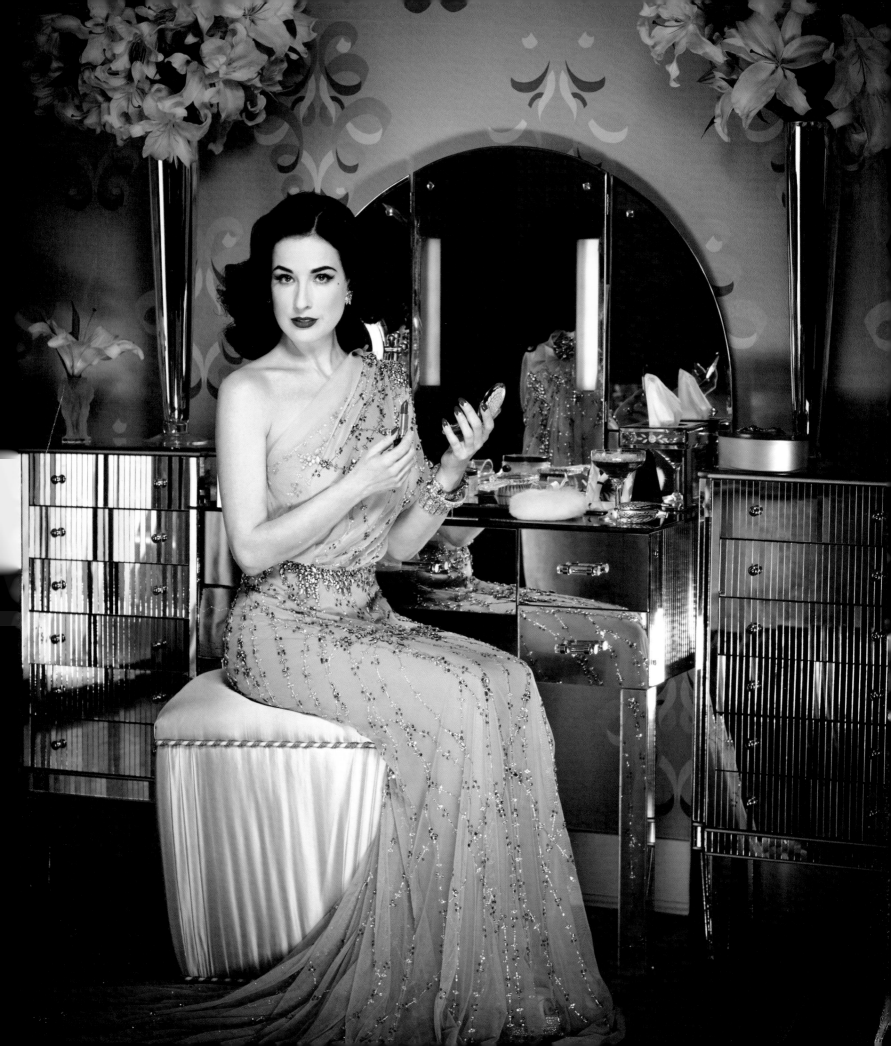

Making Your Mark

You've read and heard it all before:

Downplay the eye makeup if lips are bold and red.

Or play up the eyes and keep the lips nude.

Nude?

As nearly naked as you can catch me in the act onstage, I am not about to pucker up in a lip shade formulated to look *natural*. For me, it's a painted eye, a heavily penciled brow, and a swipe of crimson lipstick. Just as the true laws of nature intended.

Rules? You're going to tell me Marilyn Monroe, Hedy Lamarr, and Rita Hayworth got it wrong?

In my book, they got it very right. Through the magic of beauty, including some tricks outright extreme for their time, these mere mortals transformed themselves from pretty to divine. These glamorous eccentrics remain powerful weapons of mass seduction worldwide more than a half century later, painted pouts and all. If that goes against the rules du jour, then in my book, it's all about breaking the rules!

From burlesque show to fashion runway, magazine cover to music video, I've undergone more strokes of red lipstick, bursts of hair spray, boxes of blue-black hair dye, and pats of powder in a month than most drag queens dream of in a lifetime.

For most, my claim to fame might center on my part in reviving the art of burlesque, epitomized in my hallmark swirl inside a towering martini glass, in barely more than a flash of Swarovski-covered pasties. For others, it's about my dedication to pinup style, from cat eye to seamed stockings, a commitment that has taken me to the red carpets of Cannes and Hollywood in spectacular couture gowns I'm very lucky to have had the chance to shimmy into, as well as onto the pages of *Vogue* and *Vanity Fair* (and on the best-dressed lists, no less!).

Others might have heard of me as the headlining confection at an amfAR fund-raiser for AIDS research in São Paulo or for a fashion house gala on the Champs-Élysées. Or it might be the performances on stages in New Orleans and Moscow, Beijing and Berlin, and points in between and beyond. Then there are those still living under a rock who simply relegate me as that stripper once married to a rock star. Amusing as that is, darlings, no individual should be the sum of her mates in this life!

Every time I find myself before the spotlights, I pinch myself and have a kind of Dorothy-in-Oz moment, marveling how this girl from a small Midwestern town ended up in such an enchanted life.

I like to believe it's because I am a sucker for beauty. It's what gets me up with each sunrise and what gets me through countless leg lifts at the barre, and through the yank and pull of a corset to within a fraction of an 18-inch waist.

Beauty is my art. It's my nourishment, my salvation.

It's what brings me joy. I live to surround myself with everyday things that are beautiful. I serve my home-baked petit fours on porcelain pedestals and sip tea from flowery teacups, charming gems from my flea market treasure hunts. I keep cosmetic brushes in vintage vases cast like the heads of ladies, complete with glamorous dos and makeup. I always carry a pretty compact, maybe one I scored for next to nothing on eBay.

I would never be caught in a tatty robe or sweatpants . . . even by Aleister! (That would be my Devon Rex cat.) A sweeping satin dressing gown can be had for a meow on Etsy or other vintage sources, and it will put you in the mood for a big night . . . or morning.

Beauty, glamour, even luxury need not be determined by one's bank account. True luxury is using the silk robe or teacups every single day. I'll always take a secondhand party dress or a $5 scarlet lipstick over the most coveted jeans (not that I'd ever be caught dead in jeans). A beautiful thing doesn't have to be new or even particularly valuable or precious, as long as it is a thing to behold.

To live a life beautiful is the ultimate *joie de vivre* in my *livre!*

While I have an art deco walnut buffet filled with silver spoons now (pretty ones I picked up at the antiques flea market), I didn't exactly come into the world with one between

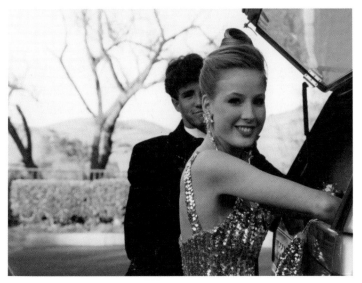

Sweet Sixteen in 1988 in a prom dress my mom made.

these ruby lips. West Branch is a small Midwestern farming town in Michigan named by lumberjacks, and it is where I grew up. It's a universe away from the colored klieg lights of Hollywood and Paris (just ask my fellow Michiganders Sherilyn Fenn and Madonna). But weekend afternoons, my mom and I had a front seat on a rocket ship to those faraway worlds by way of all the old movies starring the most glamorous creatures—Betty Grable, Mae West, Carmen Miranda, Marlene Dietrich . . .

They were our muses, at least in our imaginations. Glued to the set, watching those movies, I was determined to apply myself, one lash at a time. Before I'd hit my teens, before I even understood what it all fully entailed, I had the most perfect and prescient realization:

"Why, I could paint my way to glamour!"

Be it reality or reel life, when it comes to beauty and glamour, I'm an honor student. I study images in yellowed books and magazines. I watch old movies and I watch old ladies. I absolutely love those grandes dames (and I do mean dames as in *Mame*), with their aquamarine eye shadow and coral lip cream, hair piled high on their heads and wrapped in a fine hair net nightly so as to keep those dos intact until their next weekly standing appointment at the hairdresser. That's commitment I can appreciate. That was my great-aunt Opal. I've channeled her many a balmy summer night.

So, in the great American way, I reinvented myself from a freckle-faced strawberry blonde to what you see now. I taught myself to dye my own hair. I still wash that blond right out of my hair with nothing more than a $10 box from the drugstore. I also taught myself to do the cat eyes, the rouged lips, the lacquered talons with shimmering half-moons, and the beauty spot like a punctuation mark.

Writers and other cultural observers, some not always with the purest hearts, have made much ado about my transformations of hair color, body, even the name I was born with— Heather Renée Sweet.

Seriously, I've nothing to hide. This is no illusion. To call it that is to say that all this is something false, make-believe, something of a betrayal. To live looking any other way would be a lie. This *is* me.

"Always be a first-rate version of yourself, instead of a second-rate version of somebody else."

—Judy Garland

I experiment and I fail and try again and again until I get it right. What a sense of accomplishment and empowerment I experience each time I give my hair a final blast of spray and my lips a finishing swipe of red. It would certainly make my life easier if I could simply let someone else do the work. I am grateful for all the generous offers from fashion and beauty houses to send over a glam squad before I attend their runway shows and VIP dinners. But I politely decline.

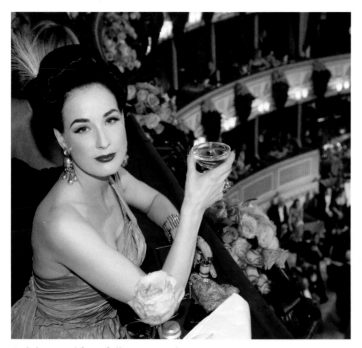

Celebrating life at full coupe at the Vienna Opera House.

Doing it myself is a matter of integrity and pride. I look forward to stepping out into the world and honestly stating, "Yes, I did this." I love the confidence it gives me. I would feel a fraud otherwise. Truth is, it takes less time for me to do it myself. It is also so much more fun! Why would I deny myself such pure pleasure?

Why would *you*? Dear reader, we're in this together. Finding and making your beauty mark is about living as your authentic, empowered self. If this is what the world calls being an eccentric beauty, so be it!

I celebrate these transformations as birthrights, as facets of my art and my love of life. As Christian Dior once said, "Zest is the secret of all beauty. There is no beauty that is attractive without zest."

Call it zest or joie de vivre, over the years I learned that to make my beauty mark on this life I had to learn to do it myself. All this art and artifice doesn't come by accident. Nor does paying lip service to it. Turning reverie into rite is about seeing the glass half full. Life is better when we look better. Making your beauty mark in this great black and blue world means taking matters into your own hands, be it a lip pencil or hairbrush, and doing it yourself: DIY.

Backstage before the curtain rises, or before the twinkling flashes of a gala's press corps, it's just me at my vanity table. There is no makeup artist, no hairstylist at my heels everywhere I go. I can be ready for the world in just under twenty minutes for a day off-camera; about sixty minutes for a full-blown red-carpet close-up. I relish the quiet time alone with just my brushes and powders.

While I nearly always insist on doing my own hair and makeup, I admit that I occasionally surrender to the able hands on a big photo shoot. These masters of makeup, hair, nails, and wardrobe are as integral to a photographer's vision as the lens and lighting. I don't claim to be an authority on everything. That is why friends who are respected experts will be weighing in throughout these pages. What I am is a lifelong student of glamour with an insatiable need to sharpen my knowledge.

Even the virtuosos among these experts freely admit it doesn't happen without hard work. It also takes a certain level of faith to reach where they are in their careers. They have faith in their craft, and like any other craft, artistry and skill come by doing.

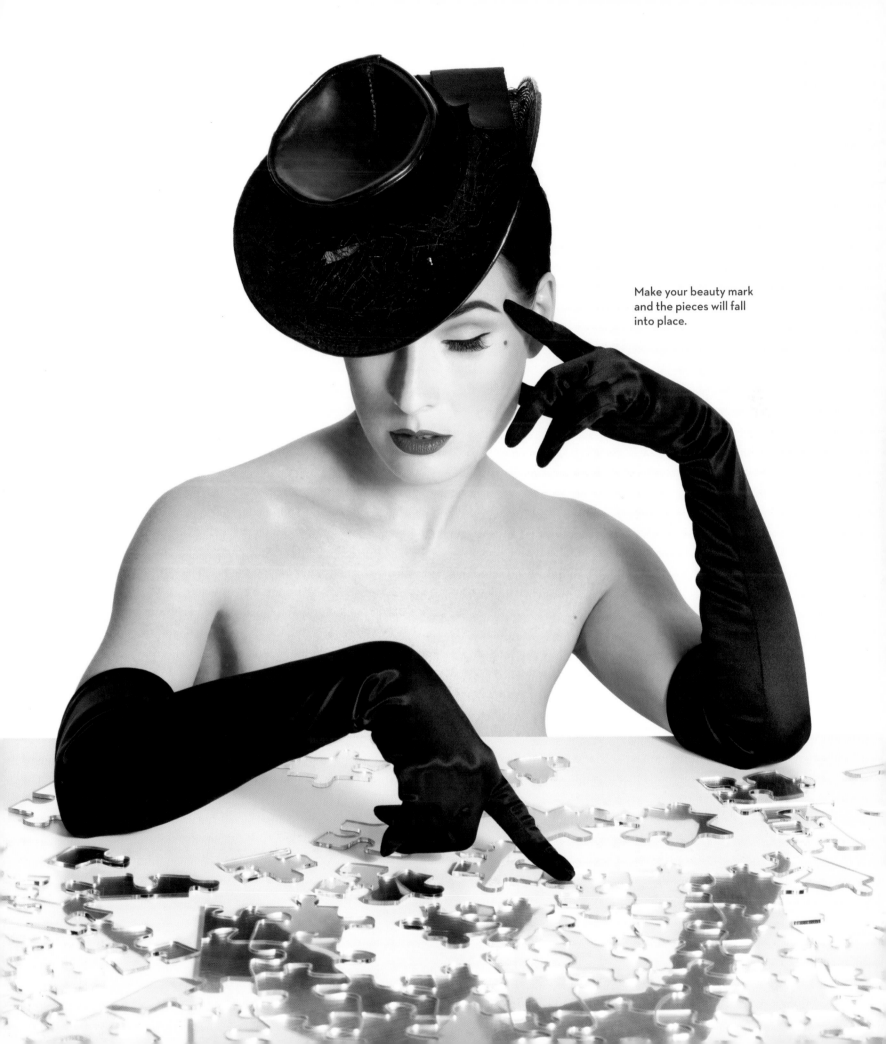

Make your beauty mark
and the pieces will fall
into place.

As one who absolutely adores beauty, I've got the faith. Do you?

I am a bona fide evangelist when it comes to beauty. One of my inspirations as a beauty crusader was the great French milliner Lilly Daché, who summed it up superlatively:

"I think I've been doing this all my life because to me glamour is more important than bread and meat. Perhaps this sounds foolish because as my old cook has pointed out you can't live on glamour. Perhaps, not. But without glamour I would not want to live. Without it there would be no excitement to life. If I talk too much about the thing called glamour, I can't help it. I'm an evangelist who preaches his creed to anyone who will listen and even to some who will not. I am perhaps what you call overboard on this subject. Not everybody gets it, not everyone wants it, and that's what makes us even more powerful and glamorous."

Amen.

For me, the *joie* remains in the doing. Beauty takes practice. And you know what practice makes. So often, a stranger or friend will admire my look, and, in the same breath, hopelessly follow up that she or he can't possibly achieve such "perfection." I am not perfect. Who is? What is perfection, anyway, but *striving* to be the best you can be!

Strive for glamour! Glamour is enchantment, wonder. It is standing out from the crowd, by way of flourish, manners, charm. Glamour is a thing of beauty—but it's not about being born beautiful. Glamour doesn't belong to those naturally stunning, or to the rich or the young. Hollywood has no monopoly on glamour. Nor do women. I know many a glamorous man, with tailored style and beautiful manners.

Glamour is the creation of beauty and allure, and anyone can achieve it. So . . . glamorize!

Beauty is duty!

Everyone has a chance. I have two sisters, and let me tell you, without any carousing at the pity party, that when we were all young girls, I did not outshine them.

Throughout my life, I've certainly heard I am beautiful and not beautiful in equal measures. I wasn't someone who received much attention before I learned how to do all this—and that's a fact.

I say, enhance what others might deem less than wow and make that your beauty mark. There is certainly so much that is lovely in the natural world. I enjoy a sunset or forest as much as the next romantic. But the so-called natural look? Ugh. Give me an emerald-shadowed lid and blue-black hair any day.

What thrill in artifice! It's even one of my favorite words. I love artifice in all its manifestations, especially when lavishly and deftly rendered. I admire the engineering feat of an architectural spectacle such as la Tour Eiffel. I treasure standing before one of Edgar Degas's painted dancers, or studying the exquisite hand-

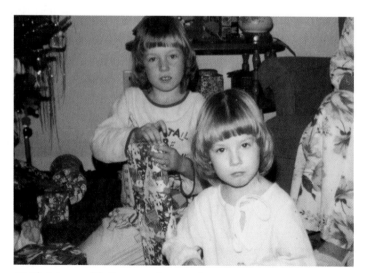

At Christmas a lifetime ago, Jena and me.

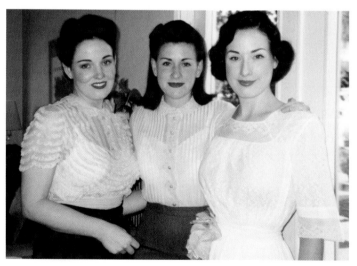

Sisters Forever: Jena, Sarah, and me as adults.

beadwork of a couture gown by my friend Elie Saab. I have deep respect for craftsmanship, for the artistry not only imagined but come to life at the hands of a gifted individual. How fascinating are those who *make* themselves look beautiful, more so than those who pop out of the womb blessed with the features of a supermodel?

I appreciate the time and skill that goes into the art of beauty. I am simply mad for the big makeover moment in a magazine or on TV. Give me a makeover montage in a movie and I just perk up. A make-under? Not so. I remember watching *The Phil Donahue Show* after school as a girl, when guests would be coerced into updating their look. These poor women looked absolutely tortured as their poufy bouffants were de-flated into something loose and "natural," and their colorful face paint wiped away for something more contemporary. The make-under stripped them of what made them feel beautiful, even glamorous, right on national television for those at home to gawk at and mock. I just wanted them to be happy with who they wanted to be.

Does it make us any less beautiful if we *create* the appearance of beauty versus someone who doesn't have to do a thing? Does it make it worth any less? Or is it a worthier form of beauty? Like my great-aunt Opal with her coral lipstick, the beauty icons I have looked up to most happen to be those who have to get up earlier, stay up later, and, in between, work harder than anyone else. To them, it's a game to master and enjoy!

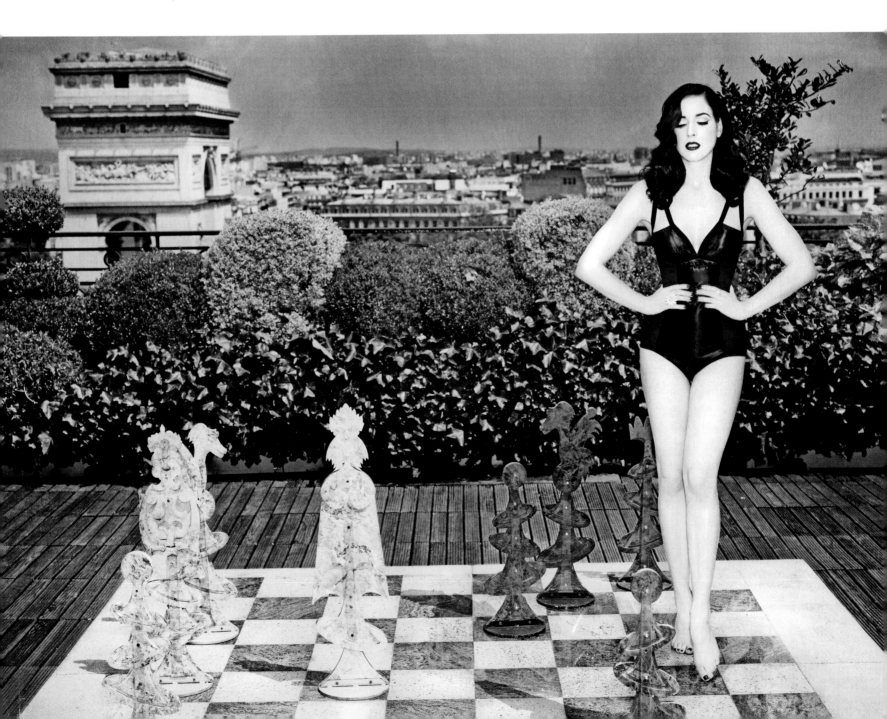

Consider Grable, Lamarr, Hayworth, or Dietrich—even silent-film star Dita Parlo, who never got to shine in American cinema but was a legend in Germany and whom I honor in name. These sirens ruled the screens decades ago. So why even now do they continue to captivate us? It's not because they were born stunners. It was their charm! Their mystique! Their makeup and style! They all took extreme steps in their quests. Without the grand play at cosmetics and coiffures, most of these women would not have stood out among the pretty chorus girls. But work they did, to reinvent themselves. These are women who redefined the very notion of beauty!

As a child, watching their films on Saturday-afternoon television, I, too, recognized that I could transform, reinvent, and in doing so, live the life I always dreamed of living.

"Don't talk to me about rules, dear. Where I stay, I make the goddamn rules."

—Maria Callas

That is why I have always found the greatest inspiration and kinship in those brave shapeshifters, those famously infamous eccentrics, lauded and lambasted for breaking the rules of dress, of behavior, of beauty and glamour, who endure in our imaginations as constant sources of inspiration despite their unconventional looks. I'm guessing, dear reader, that you have, too, if you've read this far!

The roster is like a roll call of eccentrics of the last century: Isabella Blow, Rossy de Palma, Diana Vreeland, Margot Fonteyn, Kiki de Montparnasse, Elsa Schiaparelli, Marchesa Casati, Gala Dalí (whom I had the pleasure of portraying in a little art film called *The Death of Salvador Dalí*) . . .

Carmen Dell'Orefice, as gorgeous as ever in her ninth decade and who, as a young model, shared Gala's role as muse to Salvador Dalí, gave me this advice: "Don't you ever change who you are and what you look like. Don't let anyone tell you to change your makeup or change your hair." She's always retained her "look" and style, and she still makes young men weak and inspires women of all ages (you'll fall in love with her in chapter 19).

These eccentric women, with their strong looks to match strong personalities, were not afraid to look, act, or be different. To each one, every new day offered another opportunity to re-craft herself into the individual she woke up imagining herself to be that very day, always staying true to who she is, who she wanted to be. It's why I've always considered myself a woman who knows that being around other great women is uplifting and inspiring and doesn't detract from her own greatness.

One icon who has irrefutably reached the heights of the transformative arts is Madonna. Naysayers like to go on about how she is not the world's greatest singer. Who cares? She's never made such a claim. On the contrary! From day one she proved she was someone to be reckoned with by focusing the attention on her other assets. She is truly a genius of reinvention, a master student of studying other eras, other genres. Her attention to detail is bar none. That ambition, that desire and willingness to take risks against accepted standards is highly appealing to me because it tells a story. There has to be something, an element of substance, for there to be a story. An individual with a past. An individual writing her own ticket to life. It's the story that makes these beautifully eccentric creatures so hypnotic.

Take the late, great Anna Piaggi, the über-eccentric Italian fashion writer and clotheshorse. Her very presence commanded attention. She was a wonderfully weird thing of beauty because of it. You wanted to *know* who she was. *Why* she was! I wanted to speak to this vision with the madcap hat and wardrobe and even madder makeup. There was something going on there and, spellbound, I wanted to know more.

I prefer to talk to the "weirdos" and hang out with the eccentrics. There is beauty, glamour in them, *and* in each of their stories, in the adventures and risks they have taken. I want to know how they made their mark.

I love something the late Elizabeth Taylor once said: "My personal philosophy of beauty is to always believe something wonderful is about to happen." What a wonderful way to live!

That drive propelled me to the stage at the Crazy Horse Paris—as the first-ever guest star at the legendary theater—even though I hardly fit the strict commandments that have made the

place an institution since flipping on its spotlights in 1951. I'm too old and I'm too short. I'm five foot five, under the minimum five-foot-seven requirement. But as I've learned in life, sometimes not fitting in forces us to work another angle. I think of one of my friends in Paris, Betony Vernon, a Virginia-born freak of nature, all carmine-colored hair and five foot ten and not in the least reluctant to slip into sky-high heels (read more about her in chapter 17).

Don't just work what you have—accentuate and exaggerate.

If perfection is about being free of all flaws, then the only flaws worth fretting over are apathy and self-doubt. Consider how our state of self—self-worth, self-identity—is so tied to how we feel. Then consider how you feel when you do something,

anything—swipe on lipstick, set your hair, spritz on a sensuous scent. You can *feel* the difference between doing something and doing nothing, right? *Feel* beautiful, and you'll *look* it, too.

I adore those who have a sense of fun, a sense of theater. That's what it is, theater. They are living in their own theatrical revue, or perhaps it's their own movie, enjoying every minute of artifice in their starring role.

That is beauty.

It might take just as much effort to fit in as it does to stand out, because you're standing up for yourself. It's those who take a risk and take chances who achieve greatness. Those who play it safe never can.

Only mediocrity is safe from ridicule. Dare to be different!

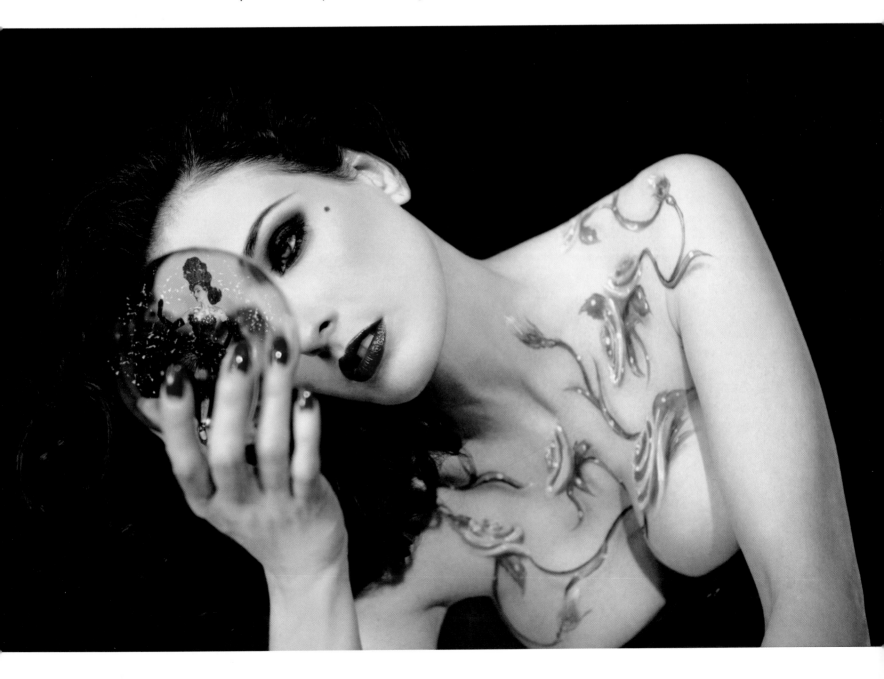

The Sorcerer: Ali Mahdavi

Painter, illustrator, filmmaker, fashion designer, artistic director of the Crazy Horse Paris, and, foremost, photographer, Ali Mahdavi is among my trusted companions and collaborators in Paris. He is a master of lighting. To Ali, the construct of photography and beauty is equally based in the "magic" of transformation. It's a lifelong theme in his life, first as a war refugee at age eight, then, at sixteen, when he inexplicably lost all his hair—even his eyelashes. Throughout it all, he found sanctuary in the beauty around him.

I've been insulted. I've been assaulted, both at school and on the street. When I began to lose my hair, people were afraid. They thought I was sick. It created a real insecurity. I didn't kiss anyone until I was twenty. I imagined I must be a monster. But that was something they were projecting.

For years I thought life was so unfair. But through the work I'm doing, I have learned to accept myself. I will never reach conventional beauty. I realize I was destined to be beautiful this way. I wouldn't change my life now with anyone in the world.

I've learned I can hide and apologize for how I look, or I can put it in your face. This experience has forced me to connect with more complicated, more graphic, more sophisticated beauty. You see, beauty is a wild animal. You have to make peace with it, create a link with it. That is what I have done. It's a long process, but worth it.

People think you need to suffer to be an artist. But you have to be in this life to create. You cannot create if you are always in depression or deep anxiety. Most artists are trying to create a parallel universe of their own vision of the world.

Beauty can be something you construct. I love the saying, "There are no ugly women, only lazy women." Some are born with beauty. It's a gift. But it is ephemeral. Other women run away from their femininity.

I am always fascinated by women who transform themselves through sheer will, particularly those who take their metamorphosis into the sublime, with all its beauty, mystery, and power. The highest level of beauty is not one that is given to you, but the one you achieve. You can use artifice in the most authentic and relevant way. It can reveal who you are.

Consider Marlene Dietrich. Here was a very common woman in 1920s Germany. She was heavy. She had amazing eyes and chin, yet she was not what anyone would call beautiful. But she became an exotic bird of paradise. She is the most striking personification of the will of transformation.

In contemporary times, there are Dita, Betony Vernon, Catherine Baba, the Russian actress Renata Litvinova, Suzanne von Aichinger, and Arielle Dombasle. As muses, I call Dita, Suzanne, and Arielle my trinity. There are the great models such as Erin O'Connor, Hannelore Knuts, Kristen McMenamy. They know they are not conventional. They know how to create movement with their bodies, and that makes them most inspiring for photographers or artists.

All these women embrace their flaws, and they build their personality and character. This makes them more inspiring, more interesting, more beautiful.

This obsession with beauty started as a child, before the revolution and the war in Iran forced us to leave for France. Women in Iran couldn't study; they couldn't develop skills in any way. A woman could only live by her beauty. Beauty was her power. It was her only weapon at this time.

Before the revolution, I would go with my mother to the couture shows twice a year here in Paris, to Chanel and Dior and Yves Saint Laurent. The models held a numbered card as they walked the salon, and the *vendeuses* such as the legendary Simone Noir at Christian Dior would take care of my mom, along with clients such as Elizabeth Taylor. We would have a little book and a tiny pencil to note the number of the clothes we liked. I was always very serious to note in the *carnet de couture* the number of my favorite outfit.

We would visit Van Cleef and Cartier to choose her jewels. My grandmother and mother were beautiful and extremely clever. As a boy, I was obsessed by the way they recreated themselves. It was my way to connect with them, to communicate.

The war made everything so ugly. We left for Paris, and my escape became beauty, glamour, old Hollywood movies. They were the starting points of my developing vision on beauty. Even now, I find I cannot get attached to a film or artwork unless there is a very glamorous, beautiful woman connected in some way!

The Experiment: Playing "Normal"

What would I look like "normal"?

It's a question I am asked relentlessly, and one that always warrants the same reply: what I look like *is* normal.

Oh, I know what they're getting at—how would I look like without all the attributes that make me "me": the powdered and pale complexion, the cat eye and red lipstick, the hair colored black instead of the strawberry blond at the root of it all.

I started to wonder, too, but only to gauge how others would react to me if they saw me in another "skin."

Since I was going to conceal my true self, I chose the year's most popular occasion for make-believe: Halloween. I was going to the party like a "normal" girl, dressed in skinny jeans, heels, gold hoop earrings. I covered any exposed skin in bronzing powder, and glided on plenty of beige lip gloss. I'm not knocking the look, by the way. It's just not me. Even so, a couple of friends who look like this every day were miffed, wondering, "What do you mean calling *me* normal?" Apologetically, I just didn't know how else to describe their look, a style more widely embraced as a beauty standard.

I wore an auburn wig. I even removed my red nail polish. I felt naked. I went all beige, from head to toe. Even my sexy little top was golden beige.

At this grand rave of a party, I showed up looking like the gal who didn't bother with a costume. I was not recognized all night by a soul! I felt totally anonymous. Paparazzi even asked me to step out of a picture with my famous friends, whom I begged not to out me.

That night I found I was a magnet for the type of men I don't usually date. It got me thinking about how we present ourselves to the world and what we attract with our drag. I don't want a guy who doesn't appreciate me for exactly who I've always been. There are guys who prefer the "natural" look. No matter how much of a catch such a guy is to other women, I'm not the girl for him. As they say, like minds think alike. I want a guy who wants me for who I am, who wants me to be at my best in my own way. I want a man who celebrates and encourages my eccentricities!

When someone tells me, "You look so nice scrubbed up, with no makeup. You look so much younger," they're right. I do look younger. I, too, can admire a pretty girl without makeup and say so. But I never once thought, "Oh, I want to look *that kind of pretty.*" I never wanted to look like a girl, to look younger. I wanted to be "pretty" like Marilyn Monroe—not-of-this-world

hair, gravity-defying heels, waist-cinching corset, fake eyelashes, fake name . . . fake everything.

Norma Jeane Mortenson was a very pretty girl. But even she knew she wasn't going to become a star for being naturally pretty. It's because Norma risked living larger than life that her greatest undertaking—becoming Marilyn Monroe—remains an everlasting cultural force. Even decades after her passing, the likes of *Vanity Fair* can't get through the year without a cover of the late supernova. And it was in large part due to the artifice of beauty.

As for yours truly, you could not scrub me clean and put me on the cover of one of today's magazines. Compared with the cover girls I grew up on and continue to see smiling back at me from newsstands, I have never fit conventional standards of American beauty. But, with practice, I mastered playing up what makes me stand apart. In doing so, I also realized that one can either submit to other people's ideals of beauty, or get on with the business of realizing one's own personal greatness!

Whenever someone is trying to change me, I draw strength from what I call the Dietrich rule: Marlene Dietrich was never photographed as anything but Marlene Dietrich. She stuck to her guns, and how lucky we are now.

When it comes to my look, imagine how it is dissected. The fashion press will herald it one year and deem it out of style the next. A fashion editor will push to have me in her magazine, only to insist I have a nude lip. Then there are those ill-mannered strangers who seem to think my appearance gives them permission to freely cast aspersions, even in my presence. Others have claimed that looking so outlandish in their estimation is a kind of armor, a means of intimidation.

"Give me lipstick, give me powder, give me fake lashes and hair curled and sprayed stiff. Give me glamour, and give me life!"

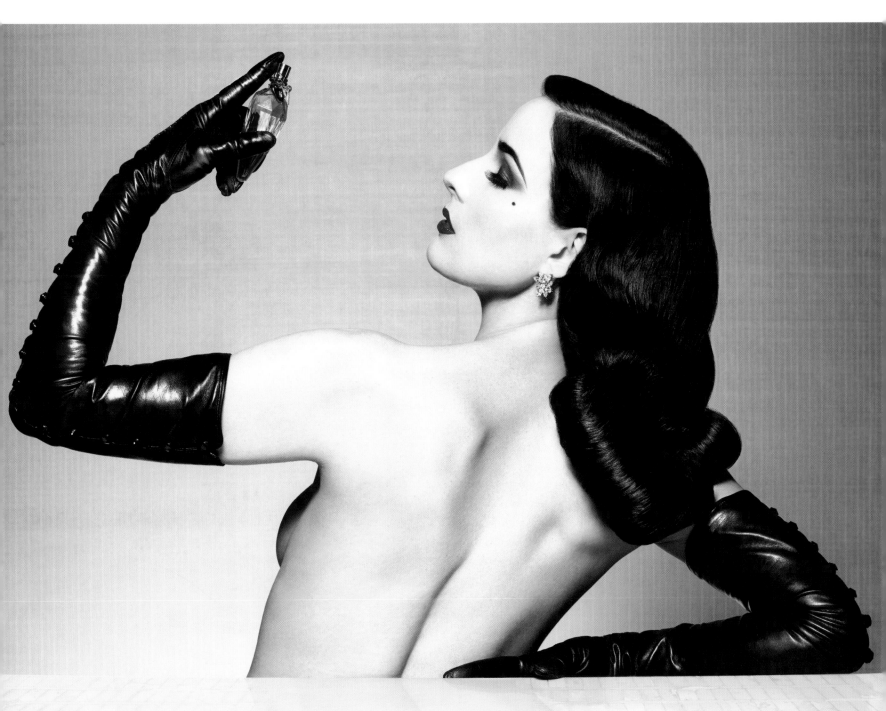

Every movie, every performance needs a sound track, so why not one as you get set for the grand stage that is life? A set playlist can also keep you on schedule, with the coda of each tune a reminder that the final song is approaching— and with it the final steps before heading out! (I also keep clocks everywhere, especially on my vanity.) It's rude to keep anyone waiting, and even if the glamour regimen had nothing to do with it, everyone will assume it's the primping. No need to give glamour a bad rap.

Here are a few of my most cherished tunes to put me in a beauty state of mind and keep me on time:

> *"Powder Your Face with Sunshine" by Kay Starr*
> *"You're My Little Pin-Up Girl" by Betty Grable*
> *"Parisian Women" by Cy Coleman*
> *"Teach Me Tonight" by Jo Stafford*
> *"Aquellos Ojos Verdes" by Nat King Cole*
> *"Déshabillez-Moi" by Juliette Gréco*
> *"Strip-Tease" by Juliette Gréco*
> *"Je Cherche un Homme" by Eartha Kitt*
> *"Quizás, Quizás, Quizás" by Nat King Cole*
> *"Gee, Baby, Ain't I Good to You" by Billie Holiday*

"I don't want to belong to any club that would accept me as one of its members."

—*Groucho Marx*

I have had my share of paramours who wanted me for the way I looked, only to change their minds later, as they grew weary of the attention from others. I soon enough realized in life that this was one way to separate the boys from the men! (My dream man never rushes me when I am readying for an evening out. He loves when I feel good and ready for the world.)

Freud and the like might have something to say about all that. But I'm no exhibitionist.

The reality is that on-trend or not, the way I look is always de rigueur in *my* world. It's what empowers me; it's who I am. I was painfully shy growing up. Yet I realized that if I was going to live fully, I had to live on my own terms. It's not always easy. Sticks and stones and all that, I am not about to compromise just so those sad critics can feel better. Do I want to be a part of their club? *Hell. No.* Come to think about it, it's a compliment if I do *not* fit their ideal of beauty.

I have my signature look and I'm sticking to it, because it's the look that is one hundred percent me, and one hundred percent created by me. I might be a one-trick pony for it. But it's a pretty good trick!

With this guidebook, I am sharing my tricks with those of you who also prefer not to conform to the standards of any club. You might fashion yourself in the spirit of some of the looks on these pages, for a day, or for a lifetime. You might imagine another look altogether, encouraged by and experimenting with the tips and tools suggested in this book. The end goal is the same: it's all about making your mark on the world, your very own beauty mark.

Even on those days when you're feeling the most beautiful, not everyone is going to agree. They may never. It requires a certain courage, a certain craziness, to be able to live life without compromise, to step out the door and risk ridicule. When someone calls another individual ugly, all I see is that the one doing the insulting becomes instantly less beautiful. Consider it a compliment to be mocked for being different.

Energy is never expended on mediocrity.

The best thing, the most important thing is to be true to your *self*. I encourage you to experiment. Only through trial and error can you truly find out what it means for you. It's also a heck of a lot of fun.

Everyone else can go ahead and live in their beige movie. I prefer mine in Technicolor. They might all look at me and they might talk about me and they might think I'm weird.

And you know what? I couldn't possibly disappoint them.

So let's not.

Instead, let's show them how it's done.

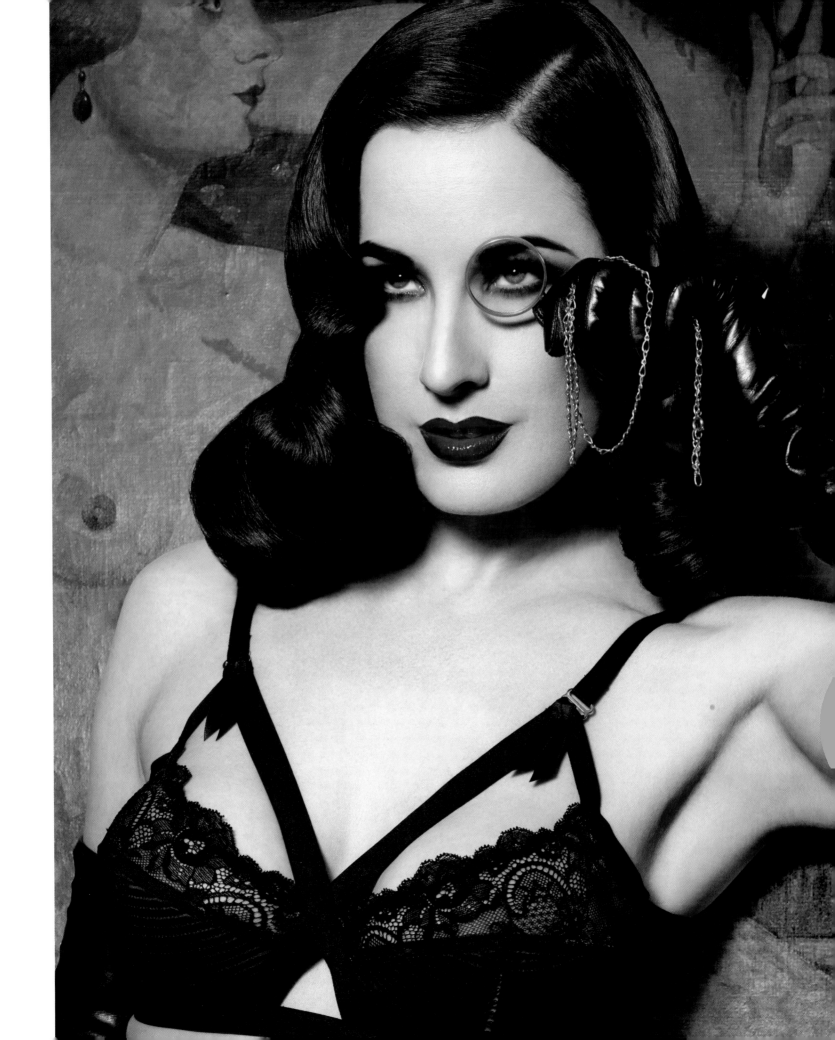

Underneath It All

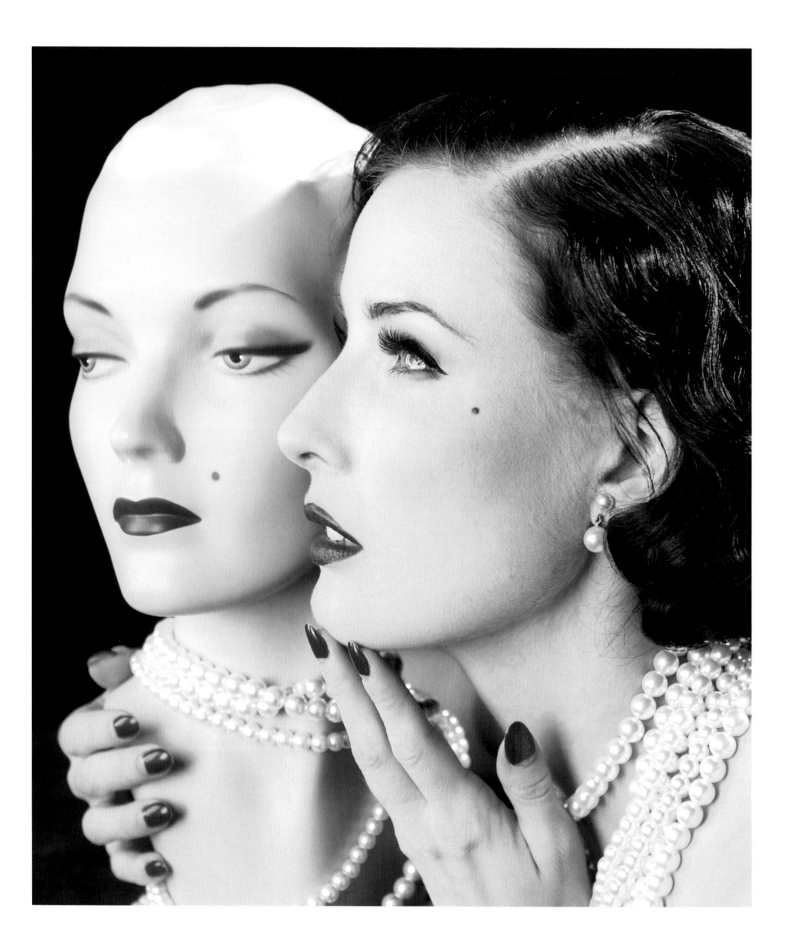

CHAPTER 1

Face Forward

When Sir Thomas Overbury wrote in 1613 that "All the carnall beauty of my wife, Is but skin-deep [*sic*]," he was wielding his lethal pen at the adulterous affair between a certain married countess and his friend. A favorite of the king, this pal was in danger of catastrophically compromising his courtly power. Not to mention both of their nifty lives among the regal splendor.

But blasting the countess's alluring beauty as merely superficial proved fatal. The social-climbing poet was thrown into the Tower of London, exiting a mere six months later for permanent residence at the city graveyard. His words—notably, the notion that beauty is only skin-deep—live on eternally.

Despite all the proverbs on the intrinsically spiritual nature of beauty that came before and after Overbury's brief life (he died young and stayed pretty at age thirty-two), the fact of the matter remains:

Good skin is no trivial pursuit.

Skin care *is* consequential. Giving it the time of day—two times, preferably—is among the most crucial steps toward beauty and health any of us can do for ourselves. Don't, and it most certainly will reflect badly, especially as the calendar leapfrogs into the future. All the shimmering eye shadow and ruby lipstick in the world won't make you dazzle if the complexion underneath it all is dull and damaged. Like style, good skin is not about expensive products.

Face Value

I am always asked what brands I use. But that's the most irrelevant question in the world. My skin is not your skin. It's not going to become the same if we use the same product. If you have skin issues, see a dermatologist. It's more economical than buying fifty face creams in search of a miracle.

I know it's hard to resist all those glossy ads starring airbrushed models. Admittedly, I love the *feel* and scent of an expensive face cream as much as anyone.

While I adore the way those pricey potions feel, there are plenty of affordable options that any good dermatologist, including my own good doctor, will approve of. Proof is in the results. My mother swears by Olay, and Rose's choice is Eucerin Q10, a sensitive-skin formulation complete with sunscreen. These women both have great skin.

As for products based on ingredients that are organic or natural, I long avoided much of the category as something too hippie, lacking the luxurious experience I sought in my beauty ritual, which, let's face it, is part of what we are paying for. No more. My bathroom counter is now heaving with them. While I won't be giving up my retinol or sunscreen, I'm replacing many of the traditional beauty, and all of the household, products in my home with natural and organic formulations. It's all about the balance in life, after all.

I alternate between a trio of products by Éminence Organic: Coconut Age Corrective Moisturizer, Apricot Calendula Nourishing Cream, and Linden Calendula Treatment cream for night (which I also might apply as a treatment mask). I also love Trilogy's Rosehip Oil Antioxidant and Dr. Hauschka Rose Day Cream.

Rose and I also adore the benefits of coconut oil. Antifungal, antioxidizing, and antibacterial, it makes an ideal makeup remover. It's also effective as a scalp and hair conditioner and shaving cream because of its hydrating qualities. Just make sure the grade is organic and virgin. A pint jar can be had for as little as $6 at many grocery stores.

Let me underscore what it comes down to: spending money you don't have on a jar of hope isn't going to change your skin or your life.

Taking care of it daily just might. There are plenty of ways to do so without going into debt. You only get one face, one body, in this life. It can't be enjoyed by ignoring your well-being. That begins with skin.

Skin care should be second nature, a daily habit as routine as brushing your teeth (another vital step in living a good life that should be done no less than twice a day).

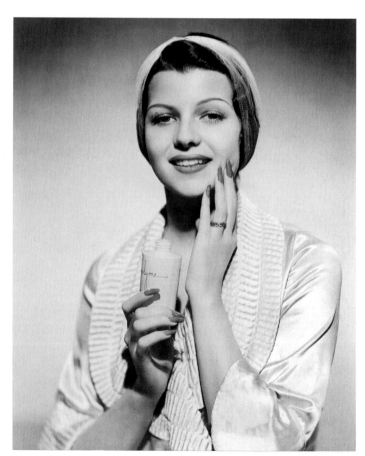

Rita Hayworth was a favorite spokes-starlet for beauty brands, as in this promotional shot, circa 1940.

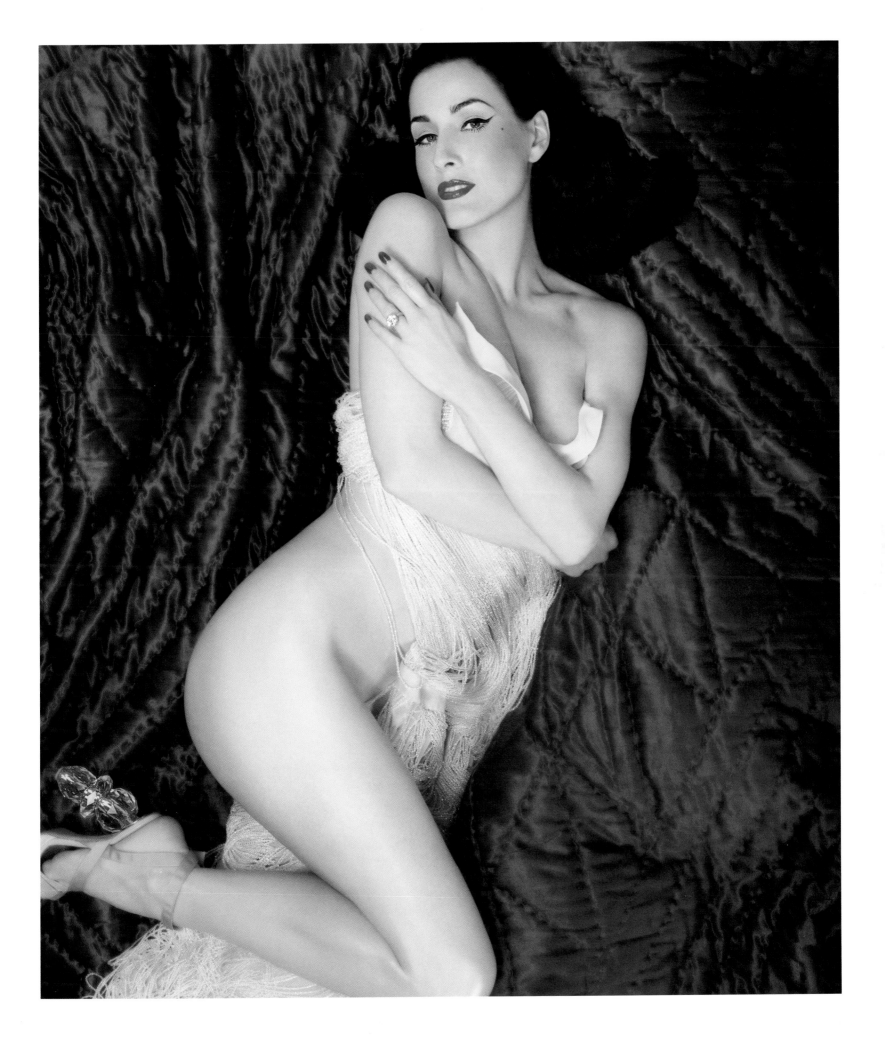

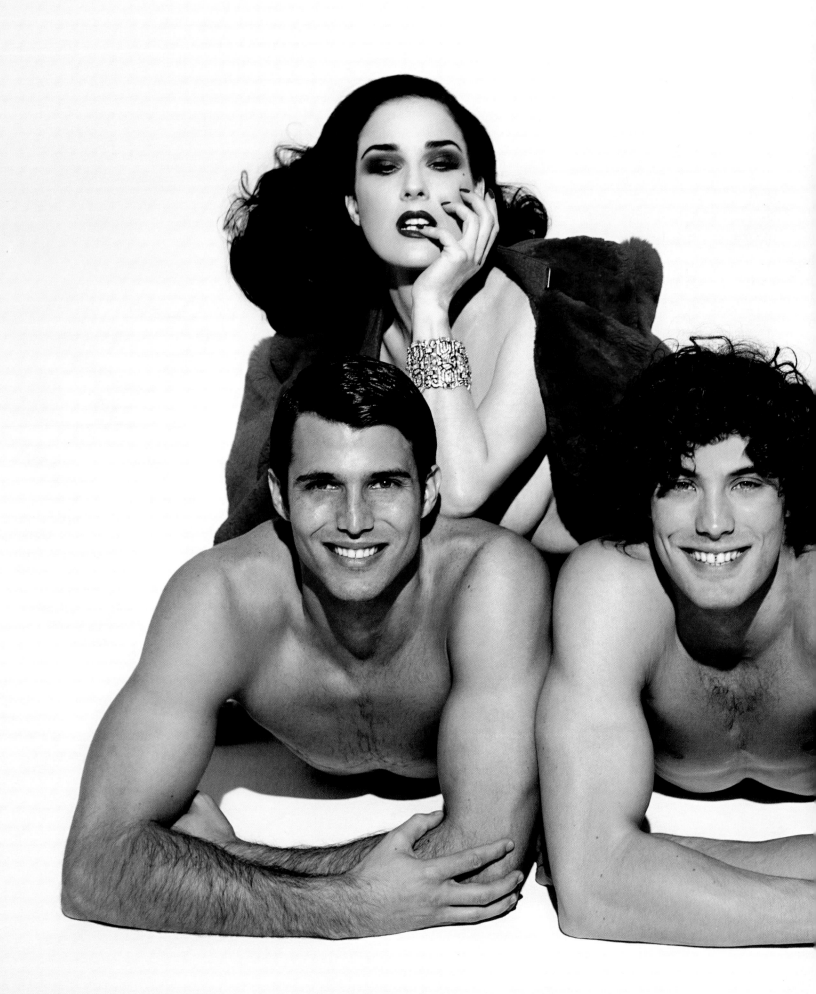

"I need sex for a clear complexion,
but I'd rather do it for love."

—Joan Crawford

What's Your Type?

Here's a tried-and-true test: take cosmetic blot paper (lens-cleaning tissue or rice paper also work well) and press it across a cleansed, dry face. Oily spots will make the paper stick. No sticking means skin is dry.

Skin type is determined by the activity of the sebaceous or oil-producing glands. Gland activity is regulated by diet, medications, stress level, and genes. Establishing skin type enables you to determine what cleansers, moisturizers, and cosmetics are best for your face.

Normal: Neither dry nor oily, skin has a smooth texture and healthy glow.

Dry: Less active glands means less moisture and oil. Skin texture is fine, so is prone to flakes and early lines.

Oily: Overactive glands produce more oil than desired and enlarge pores, resulting in clogged pores and excess blemishes.

Sensitive: Even routine washing can result in itchy, flaky patches, breakouts, and other unwanted reactions. Avoid irritation by applying hypoallergenic, unscented products.

Combination: Comprising some 70 percent of faces, combo skin is a meeting of more than one skin type, with the T-zone across the chin, nose, and forehead typically greasy, while cheeks and the area around eyes are dry.

The Daily Show

Whether I'm home in L.A. or in some faraway place, my morning routine is just that, as fixed as a dance act onstage. In between brushing my teeth and having breakfast (which I never skip), the next step is my face.

Start out with a splash of warm water—never too cold, never too hot, or the shock can break fine capillaries.

Use a pea-size drop of sudsy cleanser. The trick is to use something that is mild, soap-free, and noncomedogenic. As the French like to preach, soap should only come into contact with your skin from the neck down. Too much oil in a face cleanser can clog pores, and too little can dry out skin. So choose something suitable to your skin type.

Beware of skin care products that cause skin to feel too taut. It can be a sign of over-cleansing, or a cleanser that is too harsh—and likely better suited to scrubbing the basin! The aim is dewy skin.

Gentle, circular motions during washing are as critical as anything else. Smooth, upward strokes increase circulation of blood to the face, bringing more nourishment to skin, a healthy glow, and the all-important improvement of skin elasticity. It also contributes to the exfoliation of dead skin cells. Do not rub hard or you risk damaging skin.

Follow up by splashing your face with warm water and rinsing well. Take your time. Residue can clog pores. Pat dry with a clean, soft towel. Rubbing can irritate and damage skin.

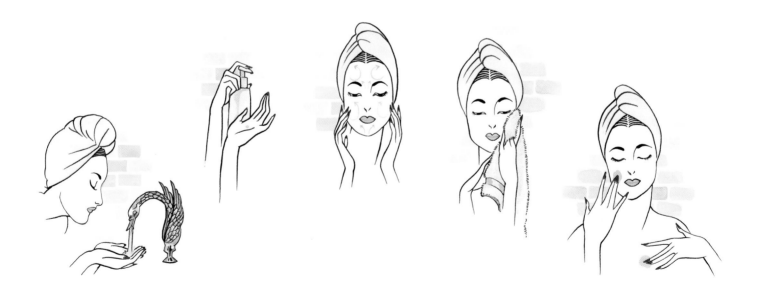

Toner is optional. Alcohol, whether in the form of a cocktail or toner, will dry skin. Make sure the toner is alcohol-free and, preferably, one with glycolic or alpha-hydroxy acids that can minimize pore size and ingrown hairs.

Moisturizer, on the other hand, is *never* optional. Some faces need less lubing up (those with acne or oily skin) than others (such as dry or older skin, which never seem to get enough). Moisturize with an antioxidant-rich cream or serum immediately after cleansing while skin is fresh and damp. Don't forget neck and décolletage!

Before makeup goes on, sunscreen, sunscreen, sunscreen. After moisturizing, I protect my face, ears, neck, arms, and hands with a layer of nothing less than SPF 20. (Please do not skip the section in this chapter on sunscreen!)

Help, Not Hype

Young women and men with skin trouble always ask me, "How is your skin so perfect?"

But my skin is not perfect. I work at it. "Find a good dermatologist," I advise them. Before countering that it's too much money, consider how much you might blow on a pair of shoes or an overpriced jar of magic cream. Those are objects of immediate gratification. Your face is forever.

The only way to change skin is by considering it from a medical point of view and investing in a good dermatologist. Like products, *good* doesn't mean expensive or famous.

For more than a year, I frequented a celebrity dermatologist in Beverly Hills. He wasn't cheap. I have very sensitive skin with a few allergies, and he diagnosed me with rosacea, an inflammation of the skin. He began pushing one expensive potion after another, all of them part of his branded skin care regime. I felt like a laboratory experiment as I continued to shell out for laser treatments and special facials. Nothing worked. But I kept seeing him. At every visit, I would spot yet another famous face in the waiting room. "He must be great," I figured.

My skin worsened, and with it my good sense. This dermatologist was so famous and his clients were so beautiful and his prescribed products for me so expensive, then surely I was the problem. I even bought into the costliest prognosis of all about my inflamed skin when this renowned dermatologist concluded: "This is your life now."

Freaked out by this verdict, I went to the dermatologist I knew from my youth in Orange County. I'd been distracted by the glimmer of this media-savvy doctor, but my wise mother reminded me of my roots just an hour south on the freeway. Ronald W. Cotliar, MD, keeps an office in a suburb there and, incidentally, in Los Angeles, and has the kind of credentials that should make him famous (see our interview with him in this chapter). But he's too into his science and his clients to go chasing celebrity.

Dr. Cotliar determined it was not rosacea, but a milder irritation, exacerbated by the many fancy products dictated by the Hollywood derm. Dr. Cotliar wrote me a prescription. Within a month, my skin problems receded and never returned.

The lesson? Find a doctor who accepts your insurance and cares more about your skin than pushing the trendiest, priciest creams and procedures.

Out with the Dead, in with the New

Exfoliation is the skin's best friend. The process removes dead skin cells and stimulates blood circulation, boosting oxygen to the skin surface and provoking collagen production. It also

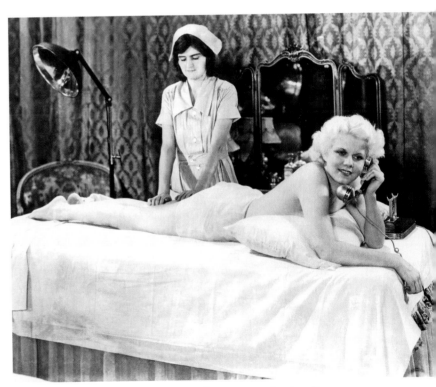

Whether it's your own fingers on your face, or a professional's hands on your body, regular massage stimulates blood flow, increasing cellular oxygenation and improving skin tone. As Jean Harlow affirms, it feels so good, too.

increases the effectiveness of skin care products and minimizes clogging of pores, which can lead to blackheads or other impurities.

Gentle exfoliation is critical, advises my dermatologist. Warm steam or warm water opens pores. After cleansing skin, apply an exfoliation product safe for the face. Or simply use a washcloth. While it's important to slough off dead skin cells all over, resist putting the face under the same vigorous treatment and abrasive exfoliants designed for feet or elbows. That said, thigh tissue can be as delicate as neck tissue. Follow up by rinsing thoroughly, and never forget to moisturize, or you risk drying out your skin.

As for frequency, for normal to oily skin, exfoliate four times a week, and no more than twice weekly for dry to sensitive skin.

Taking It Off After Dark

Dirty martinis, dirty talk, dirty dancing. But a dirty face to bed? Never.

As for those who take pride in boasting about all the times they've awoken to find last night's face on the pillow? For shame! No matter how much an evening runneth over with follies and toasts, I always remove my makeup. I can count on one finger when I've fallen asleep with whatever smudge remained from an evening flurry. I just won't do it. I'll even run a makeup removal wipe across my

IN DOCTORS WE TRUST

Ronald W. Cotliar, MD

My face is under the watchful eye of Dr. Ronald Cotliar, a clinical professor of dermatology and pediatrics at the David Geffen School of Medicine at the University of California, Los Angeles. Dr. Cotliar is no celebrity—but he's a VIP in my book and among the adults and children who rely on his good sense.

Dr. Cotliar loves talking skin. So Rose and I met with him at UCLA for a face-to-face confab.

Dr. Cotliar: What is the secret to good skin? Genetics play a key role. But there are things we should all do. Don't stay in the sun. Don't smoke. Stay moisturized. Regardless of your skin color, whether you're Caucasian, black, brown, or Asian, the rule is the same: hydration and lubrication—wet and schmear.

DVT: Will drinking lots of water help keep skin hydrated?

Dr. C.: No. If that were the case, I'd have you drink olive oil. But it quenches your thirst and feels good. Water reaches the skin on a cellular level. If you were in the tropics, as soon as you walk outdoors you're damp, even wet. Not because of the heat, but because the moisture is so high in the atmosphere.

RA: I love the small bottles of serum my aesthetician hands me on my few and far between visits. But I think what I love is how dewy it makes my skin.

Dr. C.: You can get the same effect for a fraction of the price with the Neutrogena line of serums. I have every serum on the market at my house, and that one provides a nice effect. They also have a night moisturizer eye cream.

DVT: What do you recommend for night repair?

Dr. C.: Apply the antiwrinkle products before going to bed, especially ones with retinol. What it's doing is reorganizing the skin, so it's increasing collagen. Always use sunscreen the following morning.

DVT: We love facials. Who doesn't love being massaged with all kinds of delightful-smelling ointments? But apart from the massaging and moisturizing, I don't know that my skin looks any better . . .

girlfriends' face if they're too pie-eyed to have the good sense to remove their mascara.

Whatever you prefer to use to clean away makeup, ensure that the emollient is slick. Friction is the enemy.

As for a nightcap? I use a night cream (as in something *without* sunscreen) such as Linden Calendula Treatment cream for night by Éminence or a nourishing face oil such as Soin d'Arôme à La Rose from Darphin. Or try a pure vitamin E or coconut oil from a reputable health food supplier. Two or three times a week, I use a prescription retinol. There are plenty over-the-counter versions with effective retinol dosages, too, such as CeraVe (which also has an A.M. version with sunscreen).

Sleeping Beauty

Sleep is never optional. Do without and do damage to your face, your performance, your very health. Besides, all the concealer in the world isn't going to hide those dark circles for long. There is nothing glamorous about subjecting the world to a tired you.

Think of it: simply seven hours to a more beautiful you! A full night's slumber can do wonders for your mood, not to mention your immune system and skin condition. Sleep is one of the best luxuries in life—and it doesn't cost a thing.

Dr. C.: People do feel great after a facial, their skin all plumped up from the massage. There are treatments such as microdermabrasion, some with vitamin C and salicylic acid infusing it. To me, it's all gimmick. I don't push it or not push it. I have patients who get it and love it.

DVT: I remember watching a TV documentary on face-lifts, and it said the best thing to prevent any work is to just keep moisturized.

Dr. C.: *That* is the secret to minimizing wrinkles. Keeping moisturized.

RA: Cosmeceuticals are a multibillion-dollar industry that claims to be rooted in science. What's your take on it?

Dr. C.: When you walk into a department store, what's on the first floor? Cosmetics. Why? Cosmetics earn more per square foot than any designer bag or shoes. You put an attractive woman in a lab coat, classify a product as a cosmeceutical, and market it as "giving the *appearance of* reducing wrinkles" or "*seeming to* make your skin look fresher." And whom do they have shilling the stuff? Youthful models who may not even use the product. The scientific claims are usually completely nonexistent.

DVT: I always encourage people to see a dermatologist for science-based solutions.

Dr. C.: You want a doctor with an office that's not wallpapered with posters for products and treatments or spa tours for skin care. It's not about seeing a dermatologist with his own line or an office filled with laser equipment. A good doctor is going to know where to refer you for those kinds of cosmetic treatments. Always ask, "If I were your wife, your mother, your sister, whom would you send me to?" It's a good idea to find a dermatologist connected to a university. But you can find lousy doctors anywhere, of course.

RA: It's why I keep seeing the same aesthetician, Olga Lorencin-Northrup at Kinara Spa. She has her own line, but never pushes it. She tells me, "You don't need that. Buy whatever feels right and works." I trust her because she says that.

Dr. C.: Good advice. Whatever Dita does, too, she does well, whether it's performing or caring for her skin. She's not swayed by opinions that don't have a real basis to them, which is why I think she should be a role model for a lot of people. She has lovely skin—the best skin in Hollywood!

RA: I think you just made her speechless.

Old Days and Arsenic

Once upon a time, pale skin was a symbol of high society, since only the kept and wealthy could avoid the swarthy skin that resulted from long days toiling under the hot sun.

But avoiding a tan reaped some near-fatal effects:

Romans and Greeks applied chalks and lead paints to look whiter, putting them at risk for lead poisoning.

While the alkaloids and acids in lemon juice and dandelion removed dead cells and, it was believed, bleached skin, another bleaching practice proved deadly. Arsenic and mercury are highly toxic to the blood, bone marrow, and liver. Don't do as Madame Pompadour did. Stick to the sunscreen.

Queen Elizabeth I had it partly right. To give the effect of translucent paleness, the queen and her groupies would draw fine blue lines on their skin to suggest veins. They also began the fashion of carrying parasols. I have quite a collection, and some of my favorites cost a few bucks at the flea market or Chinese tchotchke shop.

Prodigal Sun

Pretty parasols, glamorous hats, and high SPF sunscreens are part of my daily sun protection. Basking in the heat on holiday, especially in an ocean as blue as sapphires and so clear you can see your coral-colored toenails, is a delicious pleasure. It can also be hazardous to skin tone and health.

I never see the light of day—not even a cloudy day—without sunscreen. Whatever the weather report, the damaging rays will inevitably make contact. Choose a sunscreen with either Mexoryl or Helioplex, chemical stabilizers that slow the breakdown of a sunscreen's potency. Likewise, select a sunscreen that blocks both UVA *and* UVB rays.

The higher a sunscreen's sun protection factor, or SPF, the more insurance against ultraviolet rays that cause sunburn. There is a limit, as Dr. Cotliar points out. An SPF of 30 blocks 97 percent of UVB rays, but anything above that SPF rating will not block out 100 percent of UVB rays. During a long day outdoors, reapply any SPF consistently—at least every two hours. And always after swimming, since no sunscreen is fully waterproof.

The one and only time when sunscreen isn't necessary: after the sun goes down. After dark, wash away the sunscreen and use a moisturizer without it. If you're heading out for the night, slather a cream without SPF ingredients under your makeup.

So what's my number? At the very least, a light moisturizer or foundation with SPF 20. For my face, I typically opt for the light, nongreasy texture and tinted formulations of Sarah McNamara Miracle Skin Transformer with SPF 20 or MDSolarSciences Mineral Tinted Crème SPF 30. A drugstore favorite is L'Oréal RevitaLift Miracle Blur with SPF 30; Rose is devoted to Eucerin Daily Protection SPF 30 Moisturizing Face Lotion.

If I'm out all day at a flea market or music festival, I turn up the SPF. For my shoulders, arms, and any other exposed parts below my neck, I love the unscented, silky texture of MD SolarSciences Mineral Screen Lotion SPF 40 and CeraVe Sunscreen Broad Spectrum SPF 50. Many of the water-resistant, nongreasy SPF oils or clear sprays (such as L'Oréal Sublime Sun Advanced Sunscreen Oil Spray and Coppertone ClearlySheer Beach & Pool Spray) are worth considering, particularly among those of you with darker skin tones, because they don't leave the white residue associated with many SPF formulations.

Always apply sunscreen fifteen minutes before going outdoors. And do not forget: if you'll be remaining outdoors, re-apply *throughout* daylight hours. My admonishment is due to excruciating experience . . .

A sunrise trip to a Sunday outdoor antiques market turned into a full day of treasure hunting, and the heavy-duty sunscreen I'd meticulously applied on my arms, décolletage, and legs that morning had long worn off. The next day I was compelled to show up at Dr. Cotliar's office, my skin the shade of a lobster. What a reprimanding I got!

Only months before I had been featured in my friend Marc Jacobs's Protect the Skin You're In skin cancer prevention campaign. It took weeks for the red to fade away. I learned my lesson: keep sunscreen close at hand in the car or purse and reapply it throughout the day. Dr. Cotliar strongly suggests a spray formula to make reapplication easier. Believe me, I won't get burned again.

Not So Hot

In cases of sunburn, it's all about reducing inflammation. The most effective anti-inflammatory is an aspirin, or if added relief is necessary, apply cold compresses.

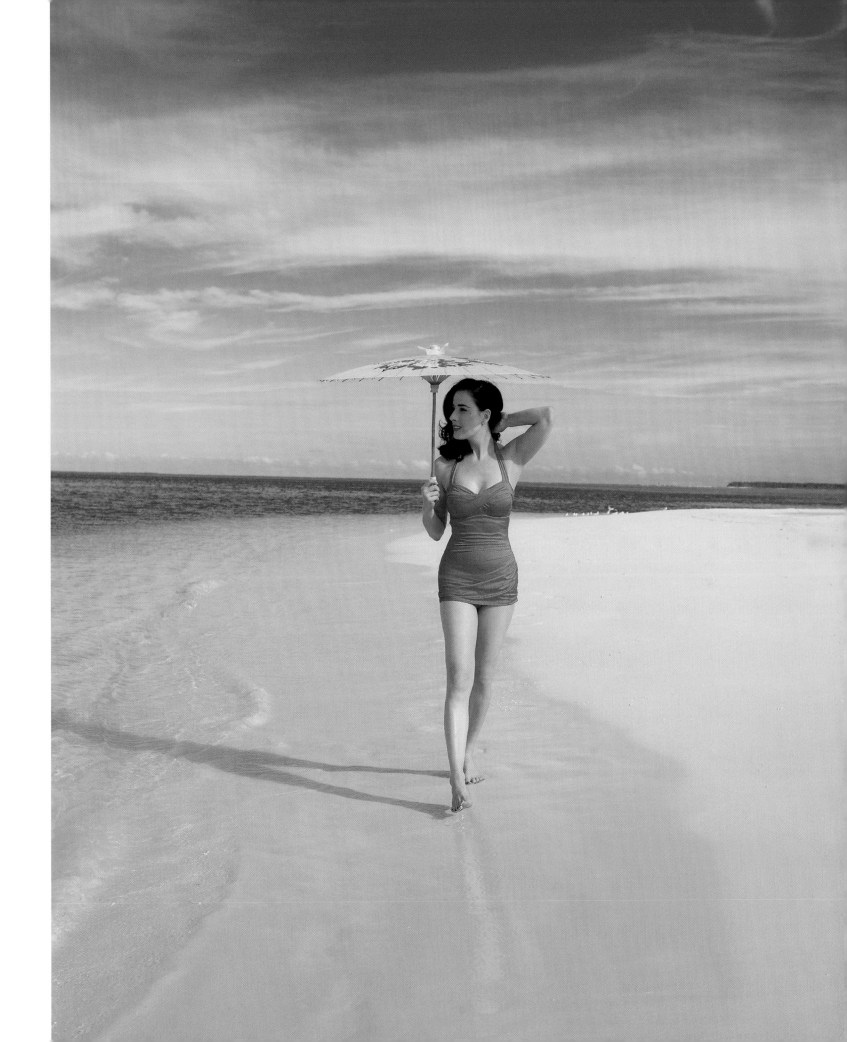

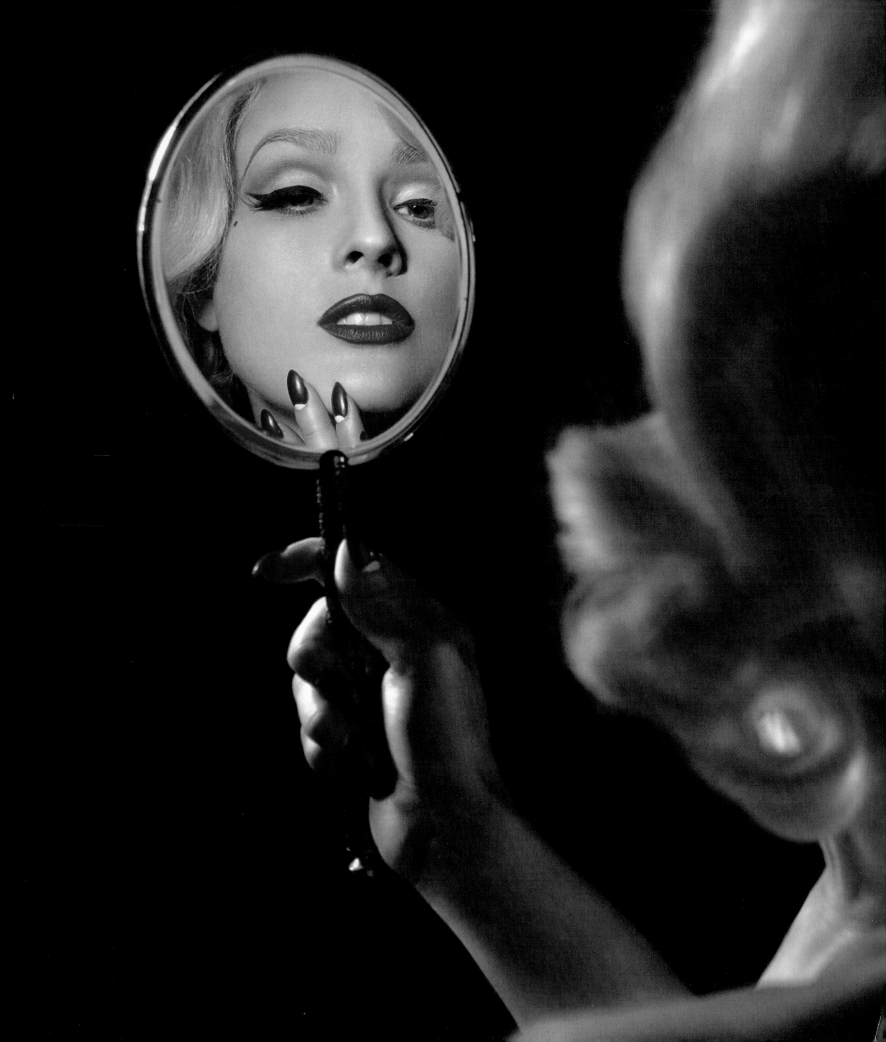

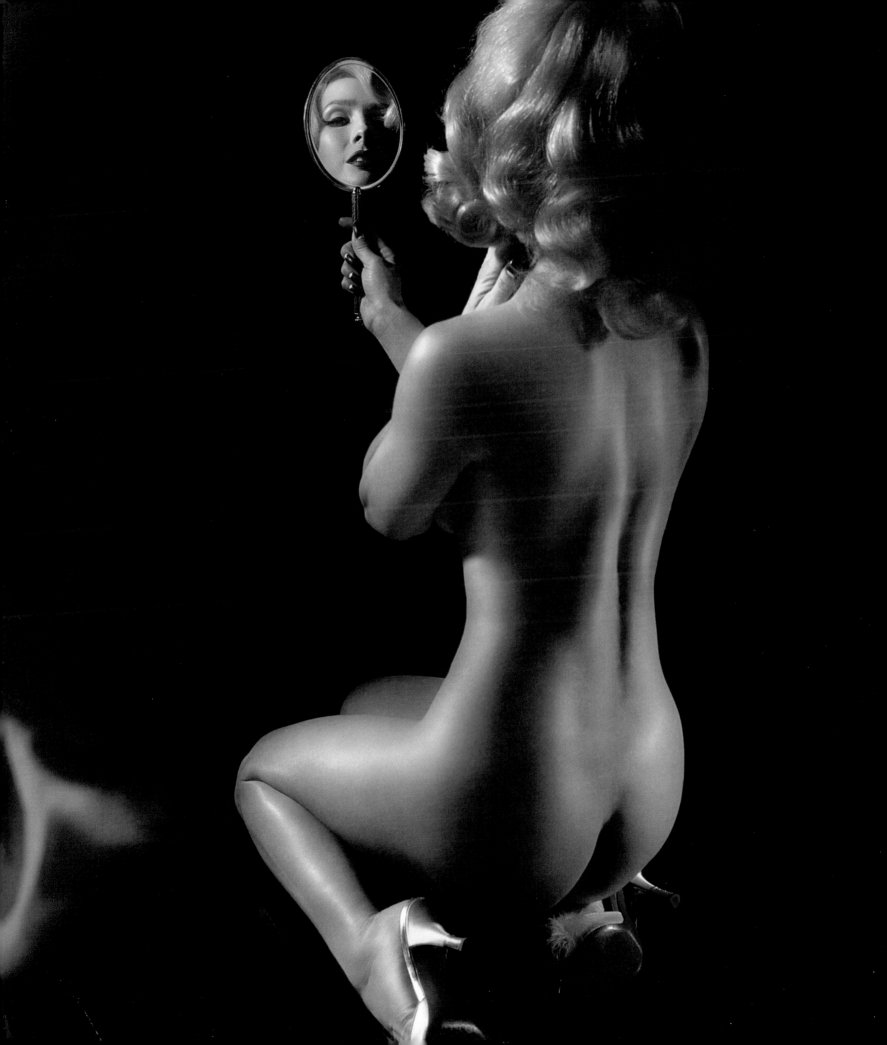

Also helpful are cool baths and emollients, such as Aquaphor, Eucerin, or a high-grade pure aloe vera gel. Beware: not all aloe vera products are formulated equally. As Dr. Cotliar points out, most are far from pure and are loaded with artificial scents and other ingredients that can further irritate skin. If you do not have access to a fresh cutting from an aloe vera plant, hit the health store or a respected source for this relieving natural salve.

Bronze Mettle

A lot is made of my pale coloring as an echo of retro style. I've even bumped heads with those who flippantly remarked that "in the old days no one had tans."

The old days? It was 1923 when Coco Chanel shocked fashionable society on the deck of her yacht on the French Riviera by allowing her milky complexion to bronze. A deep tan has been the height of modernity ever since.

The chic of it all, both the deep tan and the holiday hot spot, continued to be de rigueur some eleven years later, as F. Scott Fitzgerald retold tales of the Beautiful People cavorting seaside there in *Tender Is the Night*.

But it was the advent of color film in Hollywood that same decade that had many stars desiring a golden glow onscreen. Sparking the vogue was Joan Crawford. For that sun-kissed look year-round, however, Crawford relied on more than nature by way of a much darker foundation on her face and body. Coupled with snapshots of the latest matinee idols at their fabulous homes, sunbathing next to an oversize swimming pool, these images forever sealed popular notions of a glamorous California. Movie fans followed their cue. And all this *before* the advent in 1946 of the first home-tanning lamp and the revolutionary bikini.

I'm always amazed at those who assume Bettie Page was pale. This woman loved to be out in the sun, and she was frequently photographed with a deep tan. Just look at the Technicolor images by the talented lenswoman Bunny Yeager.

But that was then. Given all we know now about the damaging effects of the sun, the most glamorous look is embracing the skin you're born in. There are all kinds of retro icons under the rainbow worth admiring and emulating, from the alabaster Anna May Wong to the sable shades of Carmen Miranda, Dolores del Rio, and Dorothy Dandridge.

Please *do not* try to lighten your own skin because of some ill-informed idea that it would look more retro! I don't lighten my skin. I'm asked all the time how I do it, and I definitely do not. I'm dismayed by the very notion.

Certainly we can all benefit from the vitamin D a bit of solar therapy provides. But if it's the sun-kissed effect you're after and not the virtues of vitamin D, then spray tan or apply bronzer. And skip the tanning bed.

When color transformed the silver screen, stars such as Joan Crawford, shown here catching the California sun in April 1933, took to tanning.

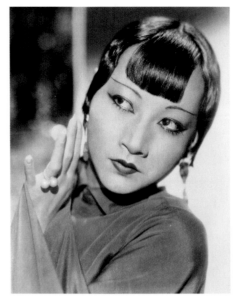

Two of the most beautiful eccentrics, Mexican actress Dolores del Rio (1937) and Chinese American actress Anna May Wong (1932).

All skin tones, from the palest ivory to the richest brown, need serious skin care; sun damage causes dark spots, wrinkles, and worse. It's never too late to start applying sunscreen on your face, ears, neck, décolletage, shoulders, arms, tops of hands—any place exposed to the sun.

On that note, sun protection can also come in more fabulous forms . . .

Going Under Cover

SPF doesn't only have to come in a bottle. It can be a wonderful wide-brimmed hat, a second skin of gloves, or a magnificent pair of sunglasses. While they don't replace the use of sunscreen and should be used as an additional level of protection, they are undeniably a glamorous option, and one in the spirit of beauty wellness.

Secret to Youth?

Don't bitch about how your skin looks like last season's It bag when you won't put down the cigarettes and you can't keep out of the sun. Too many cocktails can take their toll, too. So when it comes to skin, drink from the fountain of common sense.

Sometimes I drive around Los Angeles wearing opera-length gloves because of all the sunlight flooding through the car windows. Okay, so I might be slightly more motivated by style than safety. Yet what a stylish form of sun protection!

Curves, Swerves, and the Pinup Physique

I am not going to lie.

I can think of more pleasurable ways of spending my time than punishing through yet another series of Pilates teasers. I may even be tempted to convince myself that yesterday's grueling session means that today I can forgo working out altogether. . . .

Then I think of Mae West. Yes, she of the super-sized quips and curves, both of which she worked with equal gusto. "Cultivate your curves. They may be dangerous, but they won't be avoided," Mae liked to shrug seductively to her audience, one of many delicious bon mots from a deluxe sweet box full of them.

Another of her humdingers: "I never worry about diets. The only carrots that interest me are the number of carats in a diamond."

As much as Mae West enjoyed piling it on for her act, the truth is that she treasured her diamonds as much as her dumbbells.

The Brooklyn-born bombshell inherited a passion for health and fitness along with a maverick spirit and proclivity for pulling no punches from her daddy Jack, a bare-knuckle prizefighter. For the Wests, daily exercise and lifting weights was something of a religion. "I decided at an early age if I was going to live a long life, I wanted to stay healthy and look good," she told her longtime private secretary and confidant Tim Malachosky, who retold this in his lavish volume on the legend, simply titled *Mae West*, published in 1993 in commemoration of the hundredth anniversary of her birth. Young Mae trained in gymnastics and acrobatics and roller-skated. She claimed later in life that as a teen she could bench-press five hundred pounds! True or not, it certainly puts a spin on another line she apparently favored: "An ounce of performance is worth pounds of promises."

The Broadway star was nearly forty when Paramount Pictures offered her a contract and her first movie. She proceeded to vamp it up as Hollywood's funniest sex symbol on big and small screen, and back to stage, well into the winter of her life.

Tipsy on the Fountain of Youth

Mae West wasn't the only screen goddess who filled time in between scenes on the set with a set of hand weights in her dressing room. Marilyn Monroe and Greta Garbo also flaunted the virtues of daily calisthenics, stretching, and weight lifting.

Garbo was especially dedicated to the Sparta physical fitness regime. She took extensive walks through the forests of France or along the boulevards of Beverly Hills or Manhattan. Her confidant Gayelord Hauser, a pioneering health food nut, inspired her diet.

She also refused to quit dragging on cigarettes, curb her daily shot of vodka, or sunbathe in anything but the buff. But these were the good ol' days when ciggies and suntans were *endorsed* by doctors in advertisements—advice best left in the past. A shot of pure vodka, however, is probably the most healthful of choices a social drinker can make. The distillation process makes it sugar- and yeast-free; if it's organic, even better.

Without good nutrition and habitual exercise, all the beauty products in the world are not going to add up to beans. Keeping fit is central to maintaining a pinup physique—no matter your dress size. It's at the very core of making your beauty mark for life! I see sixty- and seventy-year-old women in my Pilates studio giving it their all, week after week, and I'm in awe of their commitment and stamina. *That* is inspiration.

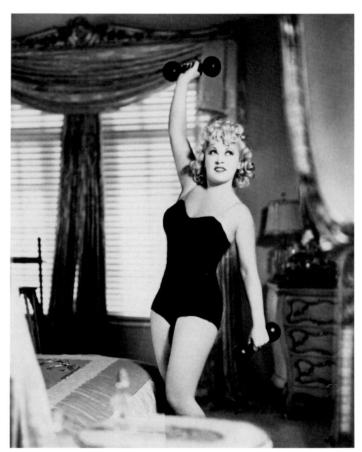

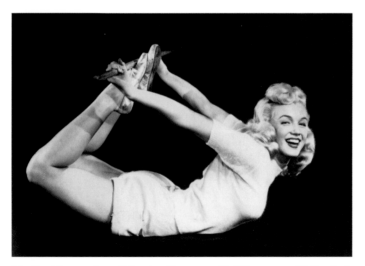

Marilyn Monroe brandishes her flex appeal in this 1950 publicity shot.

Mae West knew the value of weights as far back as 1920.

Don't be blinded by cinematic
notions of smoking.

A common misconception is that exercise detoxifies skin. The task of neutralizing toxins actually belongs mostly to the liver. What exercise does achieve is the critical functions of increasing blood flow, nourishing skin cells with oxygen, and carrying away waste products from the blood, including those nasty free radicals that contribute to the aging process.

I keep two three-pound weights around to strengthen my arms. Traveling with them is not always possible. So imagine my joy during a hotel stay when I discovered I could optimize my morning lunges by clutching in each hand an unopened Champagne bottle by the neck!

I Eat, Therefore I Am

Let's start out with what I don't put in my mouth. I rarely ever eat fast food. I don't swig soda. I never, ever sit down in front of the TV and polish off a bag of potato chips or a carton of ice cream.

I went on a juice cleanse once in the interest of "cleaning out" my system. But I hated how it made me feel. I took that as a sure sign that it wasn't a good idea.

Diets in the name of weight loss or body cleanses can wreak havoc on our system, not unlike the effects of eating fast food. If I chow down on a drive-through burger and fries, I'm asking for trouble with my digestive system. Never mind how terribly disastrous all that greasy fare is to red lips! In the name of slenderizing or supersizing, the body is inevitably going to rebel against such extreme measures.

I tip my hat to the inspiration at the start of this chapter, Mae West. She gained an early taste for fresh foods because of her father, who was always training for the next prizefight. "I was raised on these foods and insisted on them for the rest of my life, nothing canned or preserved," she proselytized. She avoided alcohol; and when a part called for smoking, she insisted on de-nicotined cigarettes and exhaled the smoke immediately.

How you start out your day can also make all the difference. For me, I rise with the sun and take a probiotic (Dr. Ohhira's Probiotics Original Formula has been a favorite, as is Kimberly Snyder's Probiotics+) and a multivitamin (I like Garden of Life Raw One Women's) with a full 12-ounce glass of water. The best thing you can do when you wake up is drink a full glass of water.

Better still, knock it back with a squeeze of fresh lemon. Lemons are high in vitamin C, which is good for skin and bones; they are a natural diuretic, helping in the elimination of toxins and waste; and lemons help the liver produce more bile, which in turn aids in the digestion of food, assisting relief of constipation symptoms, nausea, and heartburn. Water with fresh lemons is mostly how I keep hydrated throughout the day.

After taking my supplements, I fix myself a teacup of hot water and squeeze in the other half of the lemon. A pinch of grated fresh ginger is a natural aid, not unlike lemon, with inherent properties that may reduce inflammation, aiding in the relief of joint and muscle soreness. It's also refreshingly delicious.

From there, it's a glass or two of green smoothie through the first half of the day (see page 44 on my life elixir). Late morning, I enjoy a bowl of steel-cut oats with cardamom, cinnamon, or other spices in lieu of sugar. Or I'll cook it in a flavored infusion of tea, steeping the tea until it's very strong and boiling the oats in the liquid. Some of my favorite teas are perfumed violet-rose black leaf, green matcha, and smoky Lapsang souchong. I get all my teas, when I can, from Mariage Frères, my favorite tea shop in Paris. I am so obsessed with smoky tea that I made Lapsang souchong the basis for my third perfume, Rouge.

There are so many creative ways to flavor oats without adding sugar. On the occasions that I do wake up with a sweet tooth, though, I might sprinkle on a touch of the natural sweetener stevia, some maple syrup, or coconut nectar.

I usually resist eating bread during dinner—unless it's homemade or from an exceptionally good bakery. In Paris, of course, one would have to lack a pulse to resist the corner bakeries there. So I might enjoy a tear of a baguette or croissant. It's part of the joy of traveling. In Ireland, I love the soda bread. How can I resist a freshly baked pretzel roll in Germany? I always sniff and take a nibble to assess whether it's worth eating. I am *very* choosy.

I adore millet bread. My choice is a sliced loaf by Food For Life. One of the most ancient foods, millet is 15 percent protein and is one of the most digestible, nutritional grains available. My nutritionist, Kimberly Snyder, introduced me to it, and one of my go-to snacks is a slice of millet toast with avocado and a pinch of sea salt. I also might add a handful of mixed sprouts or a smear of mustard. I love tarragon mustard, horseradish mustard, truffle mustard . . . I hated all mustards as a kid. Now I collect them, as well as any exotic salts I discover on my adventures.

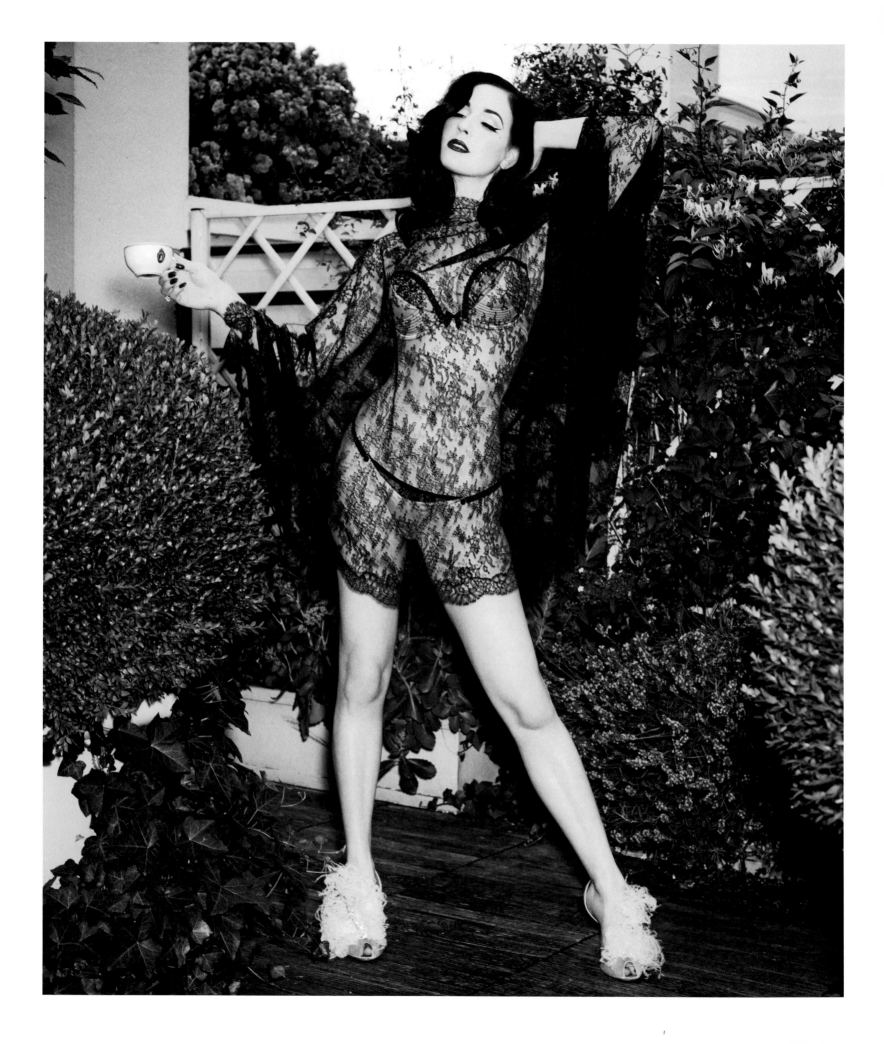

Treat your bread choices as you should red meat or any other creature protein. Be selective of its origin. I love a good steak maybe once or twice monthly, and it better be a choice cut, preferably ethically raised and sourced, and seasoned and cooked beautifully. Poultry is also best served when the chickens, turkeys, or ducks are pasture raised without soy and definitely without lab-based enhancements.

When I do enjoy animal protein, it tends to be on my travels. Far away from my kitchen, I tend to dine out more often, and the lack of good vegetarian offerings in many parts of the world means I'm usually better off ordering the best meat or fish I can find. In contrast, Los Angeles has so many accessible vegan options, be they restaurants, markets, or my kitchen. I started interspersing meatless meals of grilled seasonal vegetables, buckwheat soba noodles, quinoa, and colorful salads in my overall daily diet as a way to balance what I consume.

On regular rotation are favorites such as kabocha squash soup; an omelet or egg salad with truffle sauce (I always keep on hand a jar of Truffle Gatherers Sauce by the funny-titled Fungus Among Us); sweet potato roasted with curry, turmeric, and coconut oil; a green salad with homemade oil-free tahini-and-almond-butter dressing I've premade; or grilled chicken smeared with one of my fancy mustards. When I have friends over for dinner I use it as an excuse to be more indulgent, but always balance it with the best ingredients I can find when I make signature dishes such as coq au vin or my famous saffron absinthe vegetable potpie.

One of the best reasons for cooking at home for myself or for others? The leftovers. I was raised to finish my plate or save whatever was left for later. So when I had a boyfriend who refused to eat any kind of leftovers, I knew there was something awry. What kind of guy won't eat a turkey sandwich the day after Thanksgiving? Red flag!

Some of my everyday favorite beauty-building snacking boosters include crudités with homemade dairy-free dressing such as tahini; raw almonds (in moderation!); homemade guacamole; gluten-free Mary's Gone Crackers; and coconut or almond milk (in lieu of cow's milk). Plain coconut water is good, too, as long as it's not rife with artificial flavorings or sweeteners; also stay away from concentrates, in which the coconut water is heated down to syrup and then reconstituted with water.

In terms of diet (and by this I don't mean *dieting* but overall nutrition), it all comes down to balance and discipline. I take a

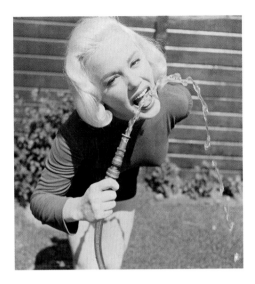

As Dr. Cotliar noted in chapter 1, binging on water won't hydrate skin on a cellular level. But quenching thirst can alter your mood. Mamie Van Doren looks happy here!

page out of my friend RuPaul's book. He's a very sensible eater because, like me, he's big on corsetry. Ru steers clear of overindulging by skipping the dining hour at any big gala or other event. He prepares healthy meals at home instead of loading up on all the fancy, endless courses. He also keeps dining out to a minimum, cooking at home when he can, because so many restaurant meals are prepared without concern for health or corsets.

It's Not All Slim Pickings

In the days leading up to a performance, no matter how mad crazy life is between rehearsals and interviews and meetings, I *never* cut the meals. I enjoy smaller repasts with more salads and steamed vegetables, as well as an additional green smoothie—because, darlings, all those bugle beads and Swarovski crystals weigh something fierce. In between the costumes and the choreography, a gal requires good ol' wholesome energy to make it all look easy. And that's not going to come from a can.

Take this to heart. No matter what your calling in life, better nutrition means a better chance at looking and feeling glamorous all day.

Of course, living is also about enjoying a fabulous meal with friends. I appreciate my share of cockles and Champagne when in Paris. After an especially physically taxing week, I love a medium-rare steak, or, in L.A., I'll indulge in tacos. I love a medium-rare burger, too, as long as it's ground from a good cut of beef and stacked with quality ingredients. I might even order dessert. My vices: crunchy cookies and anything with coconut.

Good to Be Green

Life cannot be all caviar and bubbly. Onstage or off, the best fuel is the most basic food, unprocessed and wholesome.

Few things beat a healthy dose of fresh greens. The rich proteins in green vegetables are easily absorbed, helping build critical muscle mass, revving up metabolism, and detoxifying the body with antioxidants. Daily, along with crunchy salads or cooked veggies, I enjoy smoothies made of 70 percent green vegetables and 30 percent fruit—even during the long weeks when I'm on the road and living out of a suitcase. I rarely leave home without my travel blender. But in countries where the voltage doesn't comply, the hotel kitchen thankfully obliges.

There are many recipes out there, but I live for the one touted by my nutritionist, Kimberly Snyder (see page 48 for

more on this inspiring individual). The riper the fruit, the sweeter—and higher in antioxidants. I cannot live without my Vitamix machine. But decent results can be had with most high-powered blenders designed to pulverize vegetable cells into a creamy consistency. This process allows the body to better absorb the benefits of ingredients going into this healthful cocktail.

Kimberly's recipe makes about 24 ounces, which keeps for about two and a half days in the refrigerator. I knock back at least one serving daily.

Glowing Green Smoothie

1 cup cold filtered water

2 cups spinach or kale, chopped

1 cup romaine lettuce, chopped

1 apple or pear, cored and chopped

½ medium banana, peeled and cut into thirds

1 tablespoon freshly squeezed lemon juice

Optional

Ice cubes (the extra coldness can help newbies with the taste; add during blending or serve smoothie over cubes)

Combine the water and greens in a high-powered blender. Mix on low speed until smooth. Add the fruit and lemon juice at a slightly higher speed and blend until smooth.

It's all about experimenting according to the seasonal bounty, as long as you maintain the 70/30 ratio when it comes to fresh vegetables and fruit. Herbs should always be fresh, too. Some of my own tweaks to Kimberly's original recipe include pineapple, papaya, mango, cilantro, and ginger. Melons are not recommended, as they are digested differently—and not in a fruitful way.

I just don't make those culinary orgies a habit. Most days and most meals, I eat simply and sensibly. Doing so makes maintaining my spark that much easier.

I love a well-made cocktail, too, of course (make mine a dirty vodka martini). But I don't knock them back every night. Besides being high in calories, alcoholic drinks deplete the body of extra fluids, leading to dehydration. That is good for neither your metabolism nor your skin.

Work the one-to-one ratio: for every glass of spirit or wine, enjoy a glass of water. If the night before was a gastronomic bacchanal, opt for something light and nutritional the day after.

Pace yourself not only at the dining table but at the lip-smacking banquet that is life.

I also watch what I keep in the house. I wasn't always able to afford good food and drink, so I love filling my shopping cart with things I can finally afford. But I do so soundly. Who doesn't have a family member or friend who has been trying to lose weight for years, but they keep their pantries and refrigerators stocked with rich treats? The excuses for having them on hand run the gamut, but inevitably, frustratingly, for these loved ones, they mostly end up between their lips and on their hips!

Gorging, binging, and starving are no way to live. Nor is being thin the be-all and end-all.

There are some zaftig lovelies who are much more physically fit and sexier than some of the size 0s scampering around town these days. Beth Ditto and Adele put on seductively high-energy

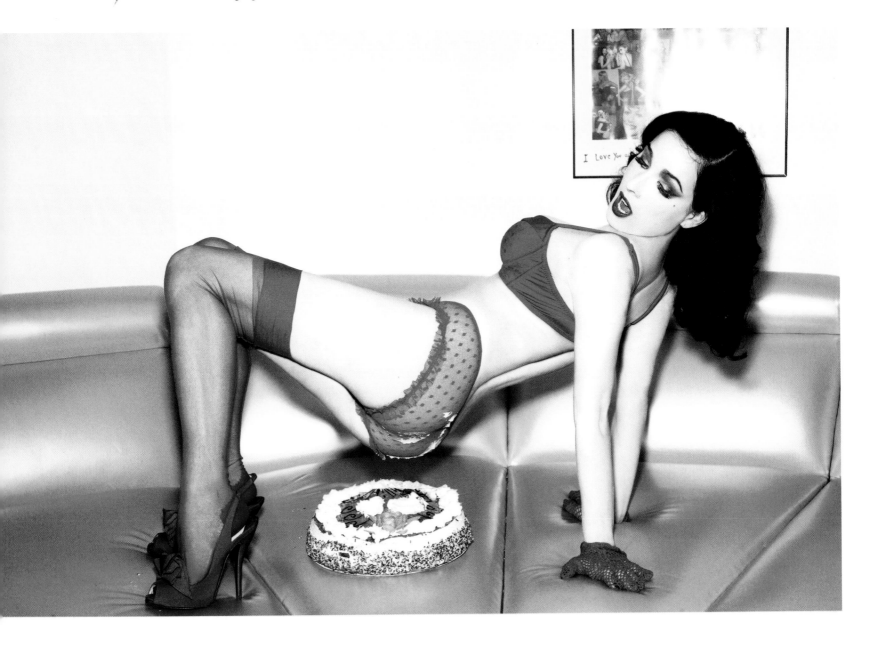

performances. Beth is among the many women of all shapes and sizes that Jean Paul Gaultier selected to open his collections. He is a maverick in the fashion industry for celebrating diverse and eccentric beauty on his runway. He loves the self-made women who dare to be different, and that certainly describes Beth.

Then, of course, there are my fellow burlesque stars Dirty Martini and the World Famous *BOB*. *Magnifique!* When Dirty and *BOB* set their forty-plus-inch hips in motion, the crowd loses it. Audiences worldwide revel in all their ample voluptuousness. And these gals are each physically, beautifully fit. Have no doubt: they exercise. They have to be in spectacular shape to accomplish the feats they do onstage. After all, Dirty *dances en pointe*.

These women have confidence in spades. They do not apologize for their Rubenesque curves. In fact, they celebrate them with brio and allure, and that is why men and women alike cannot get enough of them. I always say, either take the steps to lose the weight you keep threatening to lose, or love the way you are.

Be a woman among the girls and celebrate your strength and curves!

But do it with your well-being in consideration. Yes, keeping in tip-top shape is part of my livelihood. But when I'm in fine fettle, I feel a strength and power that I can walk in these heels wherever—and as confidently—as I want.

Train of Thought

An early vocal champion of the correlation between health and glamour was Elizabeth Arden. There was nothing shameful about working out *and* looking beautiful, the cosmetics entrepreneur believed. Alongside the latest facials and skin care procedures, as far back as the 1940s, Madame Arden's signature Red Door salons offered restorative physical fitness regimens, including yoga. She credited the practice with having saved her from hip surgery.

Like yoga, Pilates and ballet can serve as a low-impact fitness regimen, which is why I prefer them in lieu of other workouts. The exception is my rebounder, a mini trampoline. Twenty minutes of running and dancing on it in my garden gets my heart rate up.

Otherwise, I take to the studio for an hour of Pilates or ballet. Before I started Pilates in 1999, I couldn't manage a single sit-up. Now I have mastered the perfect teaser, an exercise at the very core of this discipline. I'd always studied ballet and I even wanted to be a ballerina when I grew up. One of my many collections is pointe shoes dyed in every color of the rainbow. Such a pretty pile of satin shoes!

When I'm home in L.A., I take a Pilates class three to six times a week. It energizes me. Even when my body aches, stretching and exercise get me through the stiffness to feel human again, both physically and emotionally.

All this low-impact training staves off some of the inevitable risks of aging. That's reason enough to start lifting those legs along with weights.

Besides, much of what's involved in conditioning the body—such as core strength, which straightens posture—is essential to walking in heels. While the stretches in this chapter cannot prevent pain and injury from stilettos, they are one indispensable source of prevention.

Look Good, Feel Good

To me, Elizabeth Arden's belief that beauty and exercise should go hand in hand means also looking one's best during a workout. Look like a slob and it's just not possible to execute a move in an elegant, focused manner.

Minimal attention to clothes and hair even on "off days" can transform one's outlook. At home or in the studio, consider channeling Audrey Hepburn and slip into a black form-fitting T-shirt and capri leggings. I love my Capezio turtleneck leotard and seamed dance tights. Comb your hair back into a neat chignon or ponytail.

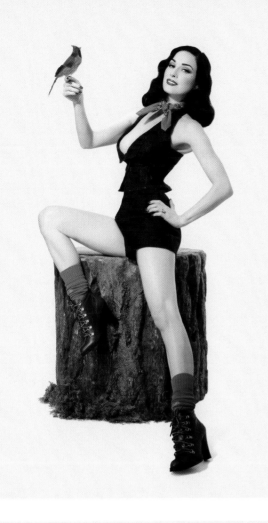

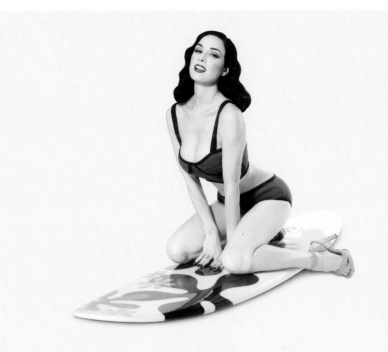

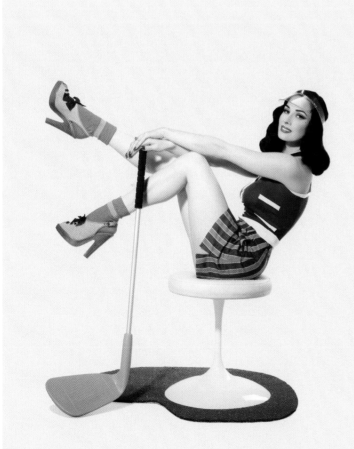

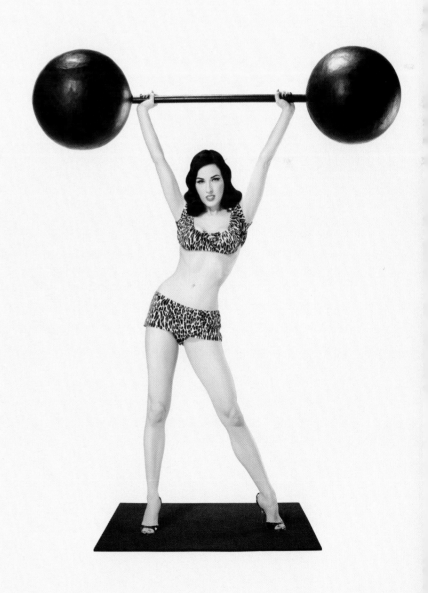

Beauty Nutritionist: Kimberly Snyder

Discovering Kimberly Snyder in 2011 was life-changing. Her signature Glowing Green Smoothies, in all their variations, quickly became an integral part of my daily menu.

But it's not all about nutrition through a straw and I continue to enjoy an indulgence here and there. Beauty is in the balance. With Kimberly's insights, I've rethought my grocery list, and make many meals, snacks, and dressings in advance so they are ready when I'm in no mood to cook.

Kimberly is all about "beauty foods," and through her Beauty Detox *blog and books, the changes I have eased into my life have made the difference for my skin and hair, but best of all in the way I feel. I have more energy throughout the day, less facial skin redness, a flatter stomach, and less bloating. I can maintain my ideal weight. I also haven't had nearly as many bouts of allergies as I once did. I've been allergy-pill-free since 2011.*

Through this evolution, I've come to know Kimberly. She is the real deal, a tireless crusader who believes, as she tells it here, that everyone can make his or her beauty mark with something as essential as food.

What good is it be a size 0 if you look ten years older? You might maintain a thin figure, but starving yourself or living on processed "food" can actually make you look older.

Eating can be beautiful. Energy is beautiful. You can eat in a way that makes your skin look great and promotes a youthful energy, a radiance—that je ne sais quoi that makes you attractive.

My philosophy is that health and beauty are synonymous. The healthier you become, the more beautiful you become. Health cannot be broken down to a series of numbers. Counting carbs, counting calories . . . those are just numbers. They don't give any indication of how foods metabolize in the body. The foods you eat are the building blocks upon which your cells are built, and largely determine how you will age, how your organs function, the health of your skin and hair, and so on.

Eating whole plant foods as close to their natural state as possible will infuse your body with beauty-promoting minerals and vitamins, and provide tons of energy so you don't have to seek it from sugar or caffeine.

When I say "detox," I say it as a verb. It's something we should do every day with the foods we eat. It's about making better choices. At the end of college and in my early twenties, I gained weight. I thought my diet was good. I ate low-fat yogurt and pretzels. But my skin was breaking out and my hair became so coarse I had to keep it in a bun all the time.

I had college science scholarships and always loved biology and nutrition. My first job after college was in Australia, where I began learning about the connection between health, energy, and digestion. This lit the fire to continue learning and experiencing the world beyond Western culture. I traveled and studied in fifty-six countries over a three-year backpacking adventure. I spent eighteen months in Asia, three months in India, seven months in Africa living out of a tent. . . .

When I returned home, I took the best beauty and health secrets I'd collected and became a clinical nutritionist. I backed up my findings with science.

I believe in looking at the body in a much more holistic way. It requires a little more planning, but it is accessible and affordable. Can't buy organic? Spend a little more time soaking and washing vegetables and fruit. An avocado or box of blueberries is nearly the price of a bag of potato chips. Romaine lettuce and celery can be bought in bulk.

It's so easy to find and prepare inexpensive beauty foods! Cabbage is a great source of vitamin C, which repairs collagen and damaged tissue; just shred it and add to salads and soups. Raw sunflower seeds are high in vitamin E, a potent scavenger of free radicals, which contribute to aging. Sprinkle them on salads or snack on a quarter cup. Or there are cucumbers, high in silica, which supports skin and nails and makes hair shiny.

There are foods I don't advocate. Avoid dairy and red meat. Watch your gluten intake. It's not about cutting everything out in life, either. I drink organic red wine occasionally; wine is not as hard on the liver as hard liquor.

You don't have to be perfect. But if you can aim at reaching 80 percent of your targets, you're doing well.

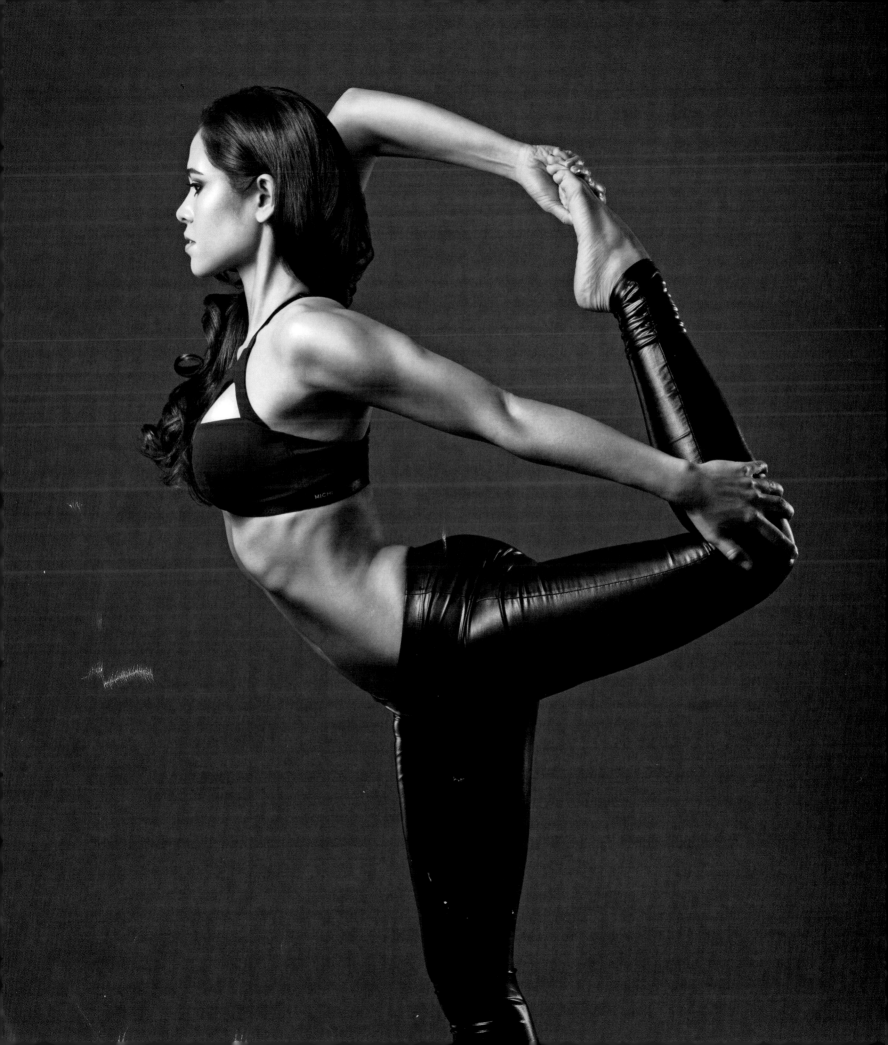

Cute as that get-up might be, it's not enough to walk out the door. When leaving home for a workout, slip into a coat (a light one if it's warm) or a full skirt. Add a scarf and sunglasses and step into demi heels or ballet flats. Sweep on lip gloss and powder. I go for a bold bright lip: matte red orange or a fuschia are lovely and have great staying power. You would be surprised how a little lip color can boost an arduous moment in front of a gym mirror. If I like the way a bright lip makes me feel any other time, then why not when I'm going through my paces?

What's that? You're not being hounded by stalkerazzi, so why bother looking good en route to the gym and back? Because you never know who you might run into.

When Exercise Begins with "S"

"An orgasm a day keeps the doctor away," promised Mae West. In love and writing, Mae was prolific. In *On Sex, Health and ESP,* her 1975 book published about five years before she died at age eighty-seven, there is even a chapter entitled "Sexercises."

No joke. Three decades earlier, gynecologist Dr. Arnold Kegel published his findings on the benefits of exercises involving contraction and relaxation of the pelvic floor muscles. The benefits are more than just sexual, and even now the so-called Kegel exercises are considered another aid in the anti-aging arsenal.

Endorphins released during orgasm stimulate immune system cells that can target wrinkles along with combating illness. Thirty minutes of making whoopee burns 150 to 350 calories, while an hour of kissing can smoke 200 calories. That is the equivalent of a brisk, half-hour stroll. Times that by five every week and it's only a matter of time before that pencil skirt slips right on. Or off.

After all, being sexy isn't about one look any more than it is about one thing. For me, it can be about gorgeous lingerie, stockings, and garters. But it's not because I want men to approve. It's what I like. Ultimately, it's about what makes you personally feel sexy and confident. Plus, a smile is always part of the equation.

After my divorce, I spent nearly a year being celibate. Ironic, I know, considering I flirt with sexual imagery in my work as a burlesque performer, pinup, and lingerie designer. I needed to get the past out of my system. When I did, I was finally emotionally and mentally available for meeting Mr. Right and for that internal chemistry needed for sexual desire.

To the Core: Mari Winsor

After nearly a decade of practicing Pilates at various studios around town and at home with her DVDs, I learned of Mari Winsor's studio in Hollywood. I have been a disciple ever since.

Mari is responsive to my end goal: how I look in a G-string. She understands that I don't want a six-pack and I definitely don't want to do five hundred crunches a day. Here she breaks and takes five from an afternoon workout to talk shop.

Dita is an amazing performer. To performers, movement comes naturally. They are concerned about the way they look because they are onstage and know all eyes in the audience and even those backstage are judging them.

As for those who don't perform, don't feel good about their bodies, they can still go to the same place—because life really is a performance.

When you meet someone for the first or fiftieth time, what's the first thing they look at? Certainly, it's *not* your eyes. They look at the whole package. They look at your presence, how you hold yourself. Then comes the figure. And *then* personality! But first comes the whole package and how you carry it.

I've worked with individuals in every condition, from an American Ballet Theatre dancer to a woman who hadn't worked out in years. I believe a woman needs to get fit for herself.

Pilates gives a body a long, lean line and an inner strength, and it's so good for everyone. Joseph Pilates, who was a former gymnast, bodybuilder, boxer, and circus performer, was actually quite sick as a child. He suffered from rickets, asthma, and rheumatoid fever. Before he was a teenager, he decided to change all that. Later in 1925, he and his wife, Clara, whom he met on a ship from Germany to America, arrived in New York, where they opened their studio and introduced a regimen based on strengthening the core muscles and aligning the spine. It was great for rehabilitating injuries from dancing and sports, and legends such as George Balanchine and Martha Graham flocked to his studio.

I danced professionally for decades and long practiced Pilates. I studied with Romana Kryzanowska, who trained with Joseph Pilates and eventually took over his studio. I still studied with her until her death in 2013—at ninety years old! So when I decided to hang up my dancing shoes, I opened a Pilates studio in 1990.

The exercises I teach don't require fancy equipment. The focus is on the powerhouse, the core muscle group of abdominal, back, and buttock regions. It's about toning and defining muscles, developing a sculpted look, and, most important, increasing flexibility.

It's great for longevity. I'm sixty-five and I'm still at it. Strength is sexy.

It's about how you present yourself, how you carry yourself, your posture. It doesn't matter if you're a bit overweight. Many women just stop exercising. They figure, "What's the use. I don't have time. I don't have energy." What matters is that you take the time, even just fifteen minutes a day for yourself. Jump-start the day with a few stretches and exercises in the morning. Or close the door of your office and take fifteen minutes then. It's better than a disco nap or more coffee. You'll perform better!

It's all about connections. Make the connection from the tip of your toes to the top of your head. The connections between mind and body. The connections between movement and feeling fit, between you and someone else. It's how you perform in everyday life.

I enjoy life's roller coasters, and nowhere does the ride turn wilder than when it comes to love. Dear reader, we might not share the same hair color or lipstick shade, but matters of the heart are universal. Take solace in knowing that Betty Grable, Ava Gardner, and Lana Turner were women with adventurous love affairs and big heartaches. Even *in* love there can be heartache. But just as the road less traveled can be more challenging, it can also be gads more fun. So live and love!

Which leads to another prized quote from Mae West: "I'm single because I was born that way."

Jayne Mansfield assumes the "crab" position, circa 1955.

Bum Rap

Mari Winsor has many cherished maxims, among them: any exercise can tone and tighten the derrière. Even just sitting at a desk or in a car, the gluteal muscles can be activated by simply flexing them.

Every time I walk, even if it's from one room to another, I consciously energize these muscles. The key is extending focus to this part of the body. Along with the stomach, the bum is part of the powerhouse.

Squeeze the cheeks together and you can actually lengthen your waist, notes Mari. "The opposite of this," she points out, "is sinking down—and *that* is not sexy. When you're in high heels and your buttocks are a little tighter from exercise, you feel a little taller. You really are taller, since the core is engaged, the posture is straight, the chest goes out, and the head is held up high. You have presence and that *is* sexy."

Mari also says, "When it comes to exercising the tush, tweeze, don't grip—and by tweeze, I don't mean plucking hairs but the action of your glutes. Gripping can impede breathing and create tension. Consider that when you tense your arm up, you can't do much else. It closes the arm and very likely tenses up every other body part. So if you squeeze your butt, that's it, too. You can't relax, you can't breathe.

"There's no purpose to a grip," she notes. "A slight tweeze is where the glutes come together lightly, as if holding a fifty-cent piece between them. Just a little tweeze lifts the bum. Even as an exercise, it's an elegant move."

The Winning Stretch

Victory? It's yours when you begin moving daily. The prize comes with even fifteen minutes a day of stretching.

There's no contest when it comes to listening carefully to your body and giving it the opportunity to release muscle tension that could be creating aches and stiffness. If you experience any pain during these moves or others, stop immediately. If it's acute, see a doctor.

 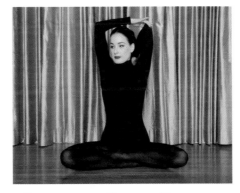 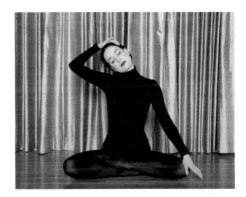

Arm Crossover: To stretch the chest and shoulders.

Sitting on the floor (your legs can be stretched out or crossed), with shoulders down, outstretch your left arm, long, toward the front of the room. Clutching your left elbow with your right hand, cross it over your chest, and gently guide it toward your right shoulder. Hold for 10 to 20 seconds, feeling the stretch in the muscle across the top of your right shoulder blade. Alternate arms.

Overhead Arm Crossover: To stretch the backs of the arms and sides.

Raise your left arm above your head and bend. Reach your right hand up and place on your left elbow. Gently press so your upper arm moves toward the back of your head. Let your left hand dangle against the back of your neck. Hold for 10 to 20 seconds, then alternate arms.

Neck Flex: To stretch the neck.

Place your left hand on the floor and extend your right arm to the ceiling for a drawn-out stretch. Cup your extended right arm over your head and gently pull your head toward your right shoulder. Let your head relax as it drops to the side and deepen the stretch along the left side of your neck. Tilt head slightly forward. Repeat on the opposite side.

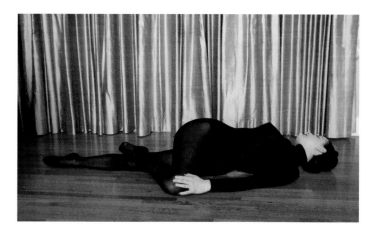

Leg Crossover: To stretch hips, spine and abs.

Lie flat on your back with your arms extended at your sides. Raise your right leg and bend it into a 90-degree position while maintaining your left leg straight and connected to the floor. Slowly cross the bended leg over the extended leg, while keeping your shoulders flat on the floor. Turn your head to the left, looking forward to your extended left hand. Keep your hips relaxed. Hold for 30 seconds. Repeat the sequence with the opposite side.

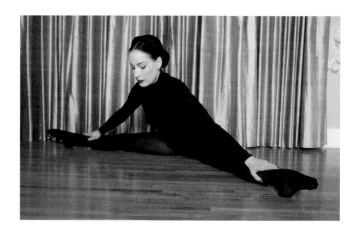 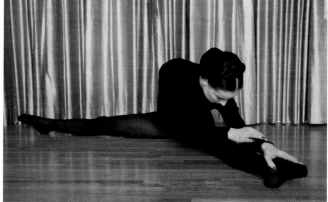

Straddle Split: To stretch your shoulders, back, torso, hamstrings, inner thighs, and feet.

Sit in a straddle position and extended as far as is comfortable and possible to keep your knees outward and connected to the ground and toes pointed.

Bending at the waist and striving to keep your back flat, reach toward your left toes. Hold stretch for 20-plus seconds. Return to an upward neutral position. Alternate on the opposite side. Return upward. Reach toward center and hold. The sequence can be continued with the feet flexed.

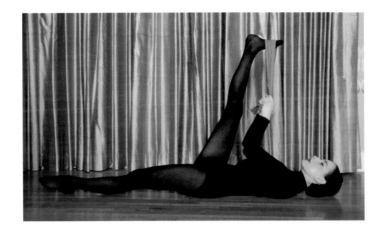

Hard to Resist: To increase the flexibility of your calves and hamstrings and release lower back tension.

Lie on your back, legs extended. Gripping a resistance band or bathrobe tie in both hands, hook the strap around the arch of your right foot. Inhale and steadily raise your right foot, keeping your right leg flexed and your left leg and hip connected to the floor and your toe pointed. Continue to guide your raised leg until you feel the stretch in your hamstrings, while keeping your legs straight. Hold for 5 deep breaths. Repeat with the opposite leg.

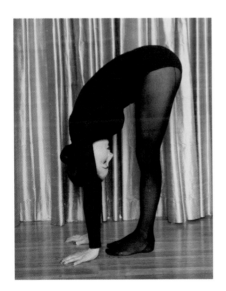 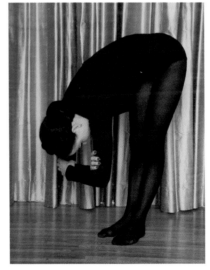

Standing Forward Bend: Stretches your hips, hamstrings, and calves; strengthens thighs and knees while activating abs; relieves tension and aids in the flexibility of the spine, neck, and back.

Exhale and bend forward from the hip joints—not the waist! Lengthen your torso and draw your navel slightly inward as you move fully into position. Press your heels into the floor. Gently reach for the floor with your fingertips or palms.

Another option is to cross your forearms and hold your elbows. Either way, with each exhalation, deepen your forward bend. Let your head hang; gently nod your head from side to side. Hold this position for upward of a minute. With arms released and hanging downward, gently roll up into standing position, pressing your tailbone deep and unfolding your torso one vertebra at a time. Roll shoulders as you gradually come into a standing position.

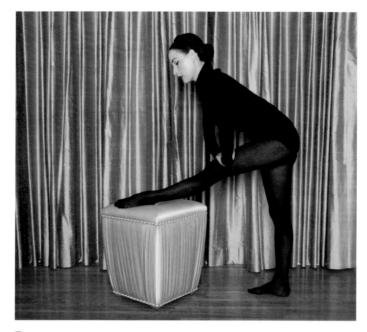

A Leg Up: To stretch your hamstrings, which aid in holding posture.

Use a sturdy surface that is at knee or waist height. Standing balanced and relaxed, raise your left leg and extend, placing the heel on the seat. Square off your hips (this might require shifting your right hip slightly forward). Bending at the hips, gently lean forward, keeping your back straight, until you feel a stretch. For a deeper stretch, lean toward your foot in a controlled motion and reach toward your pointed toes. Switch legs and repeat the sequence.

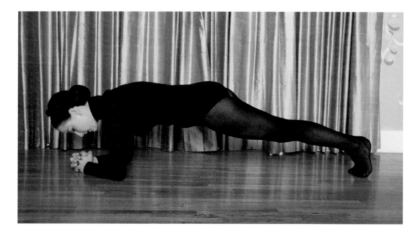

Plank: Use as an overall warm-up, plus to strengthen your wrists, arms, spine, thighs, and core. There are dozens of plank variations; this forearm position will work your abs, plus it is less taxing on your wrists and shoulders.

Start by lying facedown. With your legs hip-width apart, tuck your toes under. Bend your elbows beneath your shoulders and rest on your forearms. According to your comfort level, either relax your palms to the floor or turn them into fists. Contract your abs and glutes, and look down without curving your neck, while lifting your hips and thighs off the floor. You should form a straight line from head to toe as you lengthen your spine. Hold as long as you can.

Five to Fierce

Select five of these exercises to do one day, and follow up the next day with the other five. Keep alternating sets of five over a five-day period. Rest on the weekend. Come Monday, start up again with the same sets or mix up the five for that week! Variety is a motivator.

The proper position for all exercises is abdomen engaged and pulled back in toward the spine, and the back should always be as flat as possible. On the mat, press the bony parts of the buttocks (and we *all* have bony parts!) into the floor.

Start with ten repetitions on each side, unless otherwise noted, and gradually increase to two or three sets of ten repetitions each. You'll experience better results with controlled, steady movements rather than rushing through each sequence.

Accessories

Medium-size towel and resistance band (or a bathrobe strap in a pinch), floor mat (while not pictured here, a mat or a towel is optimal on a hard floor surface for safety and quality of movement).

Note: A band is optional. So no excuses! But the band provides resistance and counter-resistance with each move. A flexed foot can also work the leg further.

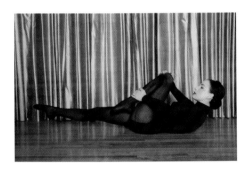 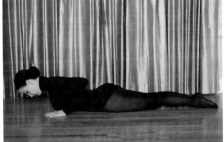 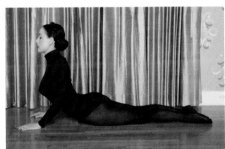
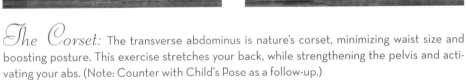

Hold Tight: To stretch your lower back, improve your hip and glute flexibility, and strengthen your abdomen.

Lie flat on your back with your legs straight and your hips relaxed. Inhaling slowly, simultaneously raise your head and shoulders off mat and your chin toward your chest, while bringing your right knee into your chest. During this movement, place your right hand on your right knee and your left at or under your right folded leg for a deeper stretch. Maintaining a strong core, stretch and point your left leg toward end of room. Relax your shoulders and your right ankle. Hold position for two tugs. Alternate your legs. *Repeat alternating sequence 9 times.*

The Corset: The transverse abdominus is nature's corset, minimizing waist size and boosting posture. This exercise stretches your back, while strengthening the pelvis and activating your abs. (Note: Counter with Child's Pose as a follow-up.)

Lie facedown, with your elbows bent yet raised slightly, your palms flat, and your shoulders directly above your hands. Heels reach back and connect.

Push upward on your palms, using your back muscles to assist your arms, and gently raise your head. Pull your shoulders back, keeping your thighs on the mat and chest open. Lift your pelvis and inner thighs and draw in your core.

If you can, give your abs more of a stretch. Hold for 20 seconds, tweezing your buttocks. Release gently, lowering back into your original position, and rest for a few seconds. *Repeat 9 more times.*

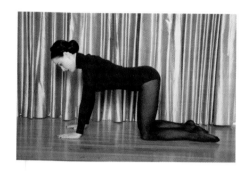 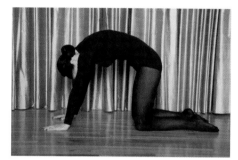 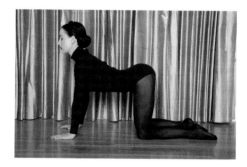

The Cat's Meow: To stretch your back and strengthen your core.

On all fours, start in a neutral position, aiming to keep your arms and thighs at right angles.

Inhale deeply, bring your navel in and arch your back like a cat, feeling a light stretch in your back and abs. Hold for 10 seconds.

Slowly ease back to neutral position, before drawing your navel to the floor and forming your torso into a downward curve. Feel the stretch in your lower back. Hold for 10 seconds. *Repeat up-and-down motions 3 to 5 times.*

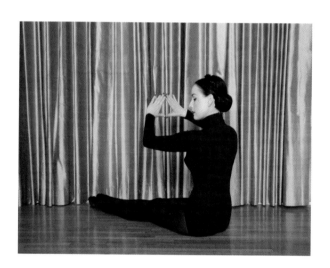 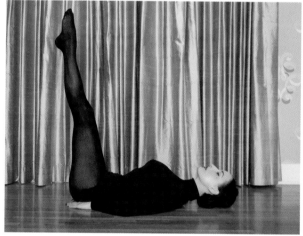

Supine Leg Raise: To tone your lower abs and strengthen your hip flexors.

Precaution: Until you strengthen your core, minimize undue pressure on your back by positioning your hands into a diamond and place them under your tailbone before lifting legs.

Lie flat on your back with your legs stretched out in front of you (at this point, place hands positioned as a diamond under tailbone). If you're not doing a diamond, position hands next to your body, palms down. Contract your core, so you're pulling your navel into your spine. As you exhale, raise your legs skyward—keeping your toes pointed, shins parallel, legs "glued" together and straightened.

Lower legs in a steady and controlled manner, stopping just short of resting on the floor. The first 2 feet off the ground is the most difficult range of motion, so don't skimp on your effort during this part. *Repeat 9 more times.*

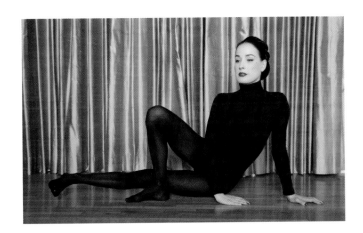

Inner Thigh Lift: To tone and strengthen your inner thighs and aid in stabilizing knees.

Seated with legs extended, cross your right leg over your left and bend, bringing the foot flat against the left knee. Stabilize your core by sitting up straight and pushing down into your left shoulder, palms flat on the floor. Flexing your left foot to activate your leg muscles, lift the leg off the ground with control. Lift it a bit more! Lower your leg to the starting position—without resting it on the floor. Repeat 9 more times. Alternate legs. *Repeat sequence for 2 sets on each leg.*

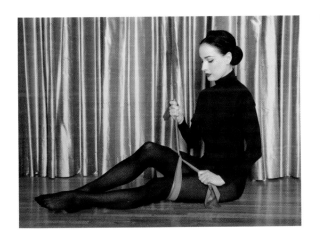
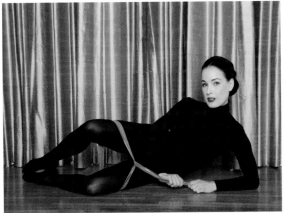

Open Clamshell: A resistance band is optional, yet creates greater tension. If using one, wrap it around both legs just above your knees. Lie on your side with your legs stacked, knees bent forward 45 degrees.

Exhale while lifting up your top knee, keeping your feet together and stacked. Raise as high as you can without moving your pelvis or lifting your lower leg off the floor. This is your open clamshell. Inhale as your legs close. With each repetition, breathe out and in, intensifying movement by squeezing your glutes in the open position. *Repeat 9 more times on same side. Alternate sides and repeat.*

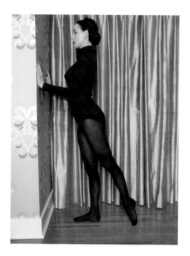 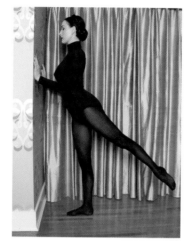

Standing Hip Extension: To strengthen your hips and knees and tone your bum.

Stand facing a wall, with your hands at about chest level, fingertips upward on the wall. Activating your glutes, draw your left leg behind you, toe pointed.

While maintaining a straight line with your right leg and body, raise your left leg behind you. Hold for 15 seconds. Slowly lower your back leg to the starting position. *Repeat 9 more times, then alternate legs.*

 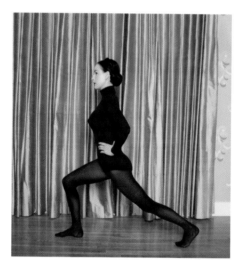 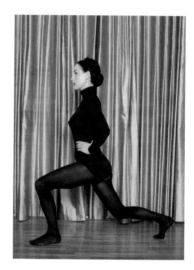

Basic Lunge: To tone and strengthen the lower body and overall alignment.

Stand up tall, with your feet hip-width apart and your hands on your hips. Your shoulders should be pulled back and relaxed. Pick a point on the opposite wall to focus on so your chin remains up. Draw your core in and upward.

Keeping your back straight, step your left foot forward 2 to 3 feet. Slightly lift your right heel up, keeping your toes in contact with the floor.

Lower your hips and bend your knees until both knees are bent at a 90-degree angle. Your left knee should be directly above the ankle. Pause for 5 seconds. Push off of your right heel, maintaining weight in both heels as you return to the start position. Feel pain in your knees? Reduce the range of motion. *Repeat 9 more times, then alternate legs.*

Arms to Hold...
Beaucoup Bangles

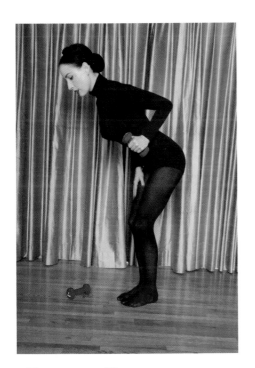
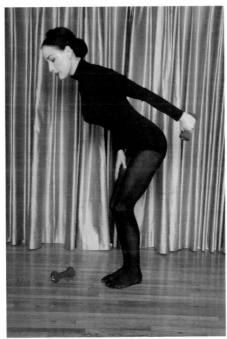
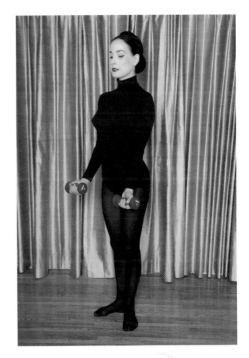

Batwing Begone: Tone and strengthen your triceps.

In standing position with your feet hip-width apart, slightly bend your knees and hinge forward from your hips. Clutching a 2- to 5-pound dumbbell with elbows bent at 90 degrees, raise arm to a comfortable level.

Extend your arm. Raise the straightened arm a bit higher. Bend your elbows and return to starting position. *Do 2 to 3 sets of 10 repetitions with each arm.*

Standing Dumbbell Curls:

To tone and strengthen the biceps.

Stand with your feet hip-width apart, chest up, back straight, and shoulders relaxed. Clasp a dumbbell in each hand, with your arms straight and elbows at your waist. Steadily bend your arms, raising the dumbbells in front of your shoulder. Squeeze your bicep and hold for 2 seconds. Slowly lower with control. *Do 2 to 3 sets of 10 repetitions.*

High on Heels

This combo of stretches and exercises executed on a stable seat will prime your pins and poise for glamorous heights.

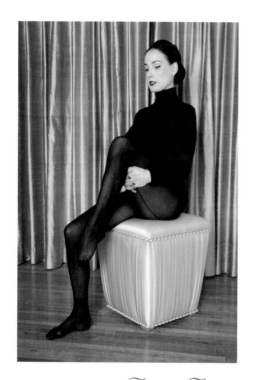 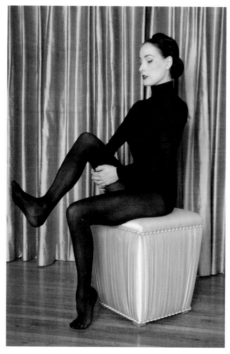 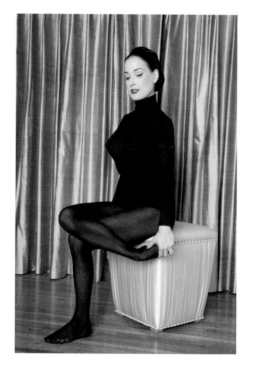

Fancy Footwork: Do before and after wearing stilettos for pain prevention and relief.

Clasp your hands under one knee and lift it slightly toward your chest, keeping your arms bent at about 90 degrees. Flex your foot toward your body, then point and hold for 5 seconds, lengthening it as much as possible to give the foot and knee a stretch. *Repeat 9 more times, and alternate legs.*

Articulate your foot by turning it at the ankle 5 times in one direction, then the other way for another 5. Alternate legs.

Cross your right leg over your left. Clutch your right toes with your left hand and gently stretch the top of your foot toward your thigh. Hold for 10 seconds and release. *Alternate legs.*

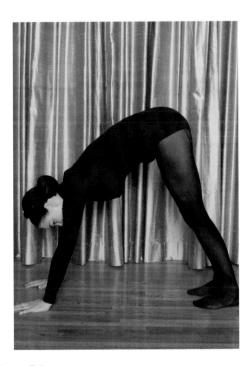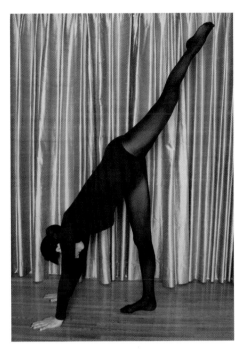

The Tripod: Stretches your hamstrings and hip flexors, and strengthens your arms.

Start by forming a downward-facing dog position. Stand with your feet hip-width apart, toes spread, making sure your balance is evenly distributed between both feet. Press your weight back into your legs, contracting your thighs to lift your kneecaps, shifting pressure off your shoulders. Hinge forward at the waist, keeping your back straight and abs pressed toward your spine. Plant your palms flat on the floor, fingers pointing forward and spread apart. It's not critical for your legs to be straight or for your feet to be flat on the floor, but it's a goal to reach. Step each foot back and lift your hips until your body forms a kind of inverted V.

From downward-facing dog, slowly lift one leg upward with the toe pointed. Resist kicking your leg up off the floor or you could lose alignment, even balance. Gaze at your navel or the top of your thighs. Lower again slowly back into downward-facing dog position. Repeat on the other side.

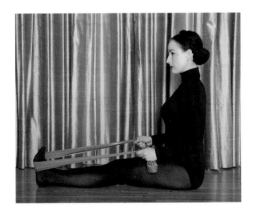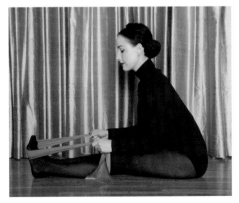

With the Band: To stretch the muscles along the spine, in the lower back, and hamstrings.

Sit on the floor with your legs outstretched in front and together. Clutching a band or bathrobe tie in both hands, loop it around the soles of your feet.

Bend forward at the waist, keeping your back as straight as possible as your torso reaches forward, re-gripping the band until it's taut. Hold position, giving your hamstrings, calves, and lower back a good stretch.

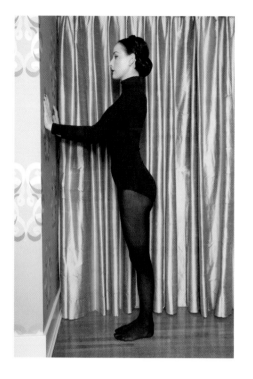

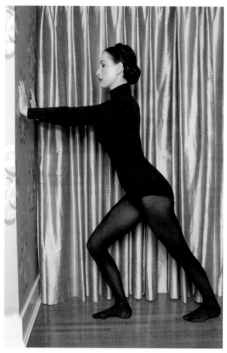

Gam Go-To: To stretch the calves and Achilles tendon and reduce the likelihood of knee injury.

Stand facing the wall at arm's length and place both palms on the wall at eye level. Point your toes and knees toward the wall.

Step your left leg back. Bending at the right knee, lean into the wall while pressing your left heel as close to the ground as possible, straightening the leg. Gently square your hips. Feel the stretch in back of your left calf. Hold for 15 seconds. Alternate with the opposite leg. Expand on this by easing into a bend with the extended leg. Keep both heels flat on the floor as your hips lower for a critical stretch in the Achilles tendon of the extended leg. *Repeat sequences with each leg 2 to 4 times.*

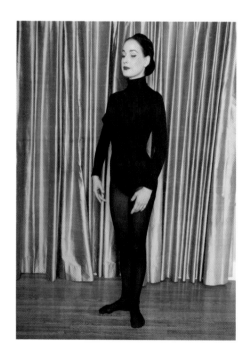

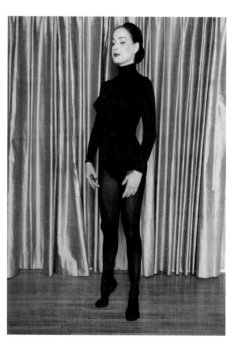

Relevé Is in Sight: Strengthens your ankles and feet, while toning your calves and thighs.

Stand in ballet first position, with your heels connecting, legs straight, and feet making a V. Your arms can sit on your hips or be held in ballet first position. Keep your back straight, bum in line with your body, and abs tucked in.

Tweeze your bum cheeks and lift your body upward, shifting the weight once on your heels to the ball of your foot. This upward motion is the elevé. Hold for 5 seconds and at a controlled, slow pace, ease your heels down to the starting position, feet flat. *Do 9 more times.* Transform this elevé into a relevé by first lowering yourself into a plié formation, bending your knees while keeping your upper body upright. Return to first position, transitioning directly to the balls of your feet. Take care that your weight is distributed properly. *Do 9 more times. Repeat each exercise for 2 to 3 sets.*

Making an Exit

Leave them with a tail to talk about. These exercises are a boon to the bum.
Repeat each modification 10 times a set, maintaining an even, focused pace.

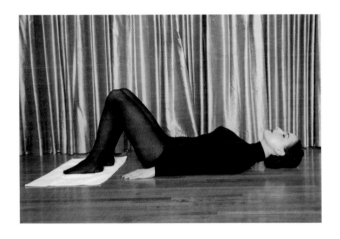
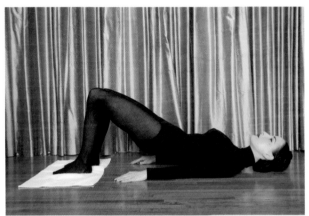
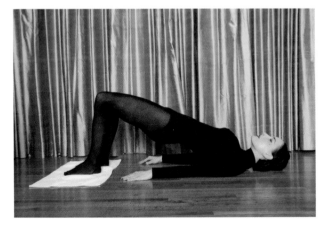

Lifting Bridge: Lie flat on the floor, with your knees at a 45-degree angle and feet parallel, with the soles flat on a towel. Keep your feet and knees hip-width apart. Press your shoulders and upper back into the floor and pull your stomach in tight.

Tweeze your bum, draw your abdomen in, and scoop your hips upward. To avoid arching your back, roll hips and back upward, and keep your upper body relaxed.

Continue tweezing your bum with lift, keeping your knees closed to engage your inner thighs.

If you feel any lower back discomfort, position your hands in a diamond formation, palm side down, underneath your tailbone. *Do 9 more counts.*

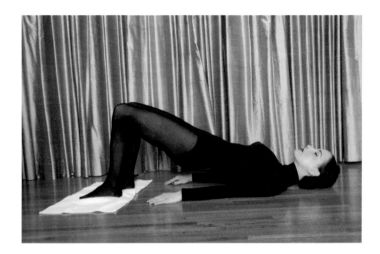
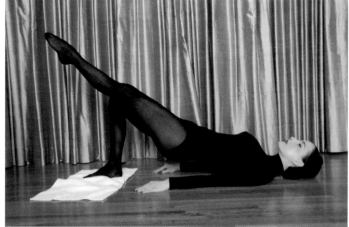

Straight-Leg Lift: Lie faceup, with your knees bent and feet and knees hip-width apart. Extend relaxed arms at your sides with your palms down. Press your heels into the ground (towel optional). Scoop your hips upward, keeping your shoulder blades connected to the floor.

Extend your leg and slowly raise it to a 45-degree angle, keeping the leg straight, hips off the ground, and toes pointed. It's unnecessary to raise the leg higher, as the greatest impact occurs in the first 2 feet off the ground. Hold the raised leg for 5 seconds. Slowly lower your legs and hips, stopping just short of the resting leg on the ground. *Repeat 9 more times, and alternate legs.*

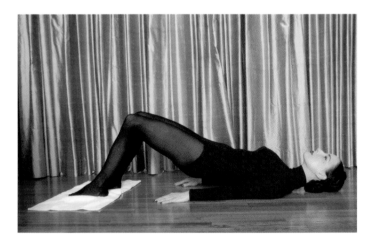
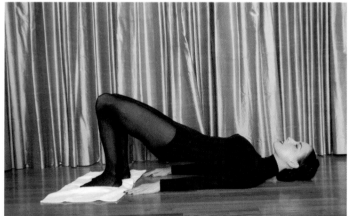

Sliding Hamstring Curl: Lie faceup, with your arms relaxed and extended at your sides with your palms down. With your knees bent, position your feet and knees hip-width apart with your heels pressing into a towel (remove mat for this exercise). Scoop your hips upward, keeping your shoulder blades connected to the ground.

Slowly drag your heels on the towel toward your bum until they form a 90-degree angle. Pause. Slide your legs forward to return to the start position. *Repeat 9 times.*

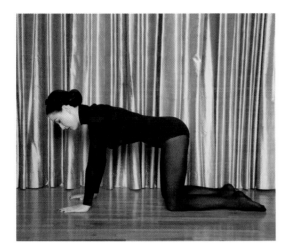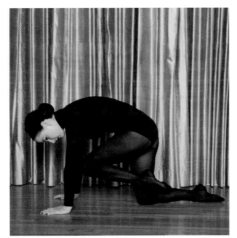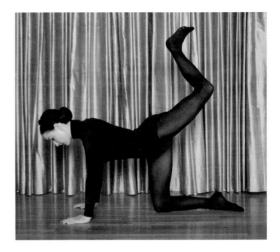

Can-Can Back Kick: A modified Donkey Kick, which the American Council on Exercise calls the number one best butt exercise, my Can-Can can improve hip and hamstring extension.

Start on all fours, with your knees under your hips and bent at a 90-degree angle, and your palms down and below your shoulders. Use a mat or towel, flat or folded, to protect knees.

Draw your abdominal muscles toward the spine (this is your core!) and bring your knee toward your chin with your toes pointed.

Begin a slow and controlled swing of your leg back upward. Keep your leg bent and foot flexed during the lift. Raise the lifted leg higher, until it is in line with your body and your flexed foot is parallel with the ceiling. Pulse the flexed foot upward by squeezing your glutes. *Repeat each leg 9 times.*

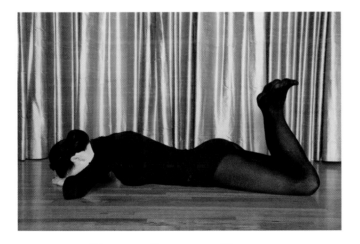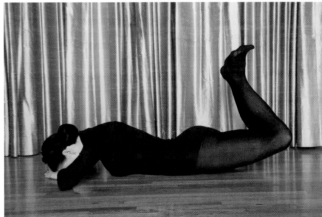

Heel Squeeze Prone: Lie facedown on the floor with your arms bent and crossed over each other. Rest your forehead atop the backs of your hands. Press hips into floor as you draw your abs back into your spine. Maintaining about a foot's width between your legs, bend both legs about 90 degrees and flex your feet. Bring heels together into ballet first position.

Raise both legs together a few inches off the floor, then the hips. Pulse both legs up and down together for 10 counts. Return your thighs to the floor and rest for 10 seconds. Repeat for 2 more sets. Further strengthen your mid-back by connecting your heels together and slightly bending your knees.

Knead to Rest

Following any stretch of exercise, take time to work out and release any tension points.
The following are two of my favorites.

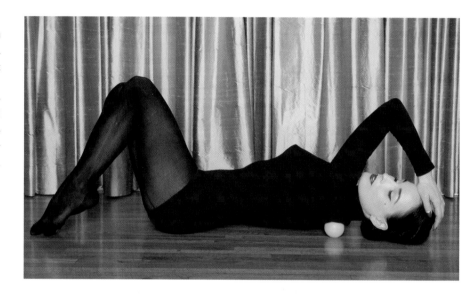

On the Ball: A tennis ball between you and the wall or floor can save the day or a mood. The aim is to relax, not irritate, so judge the amount of pressure you apply accordingly.

Once the ball is at the point of tension, focus on breathing deeply and relaxing your overall body. Continue until the knot releases. This can be repeated on any tension points throughout your body, from a shoulder blade to the arch of the foot.

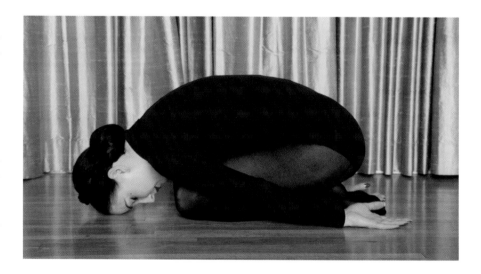

Child's Pose: Relaxes your neck, spine, and shoulders while stretching your lower back, hips, thighs, knees, and ankles.

Kneel on the floor with your knees hip-width apart. Seated on top of your heels, slowly bend at the hips while sliding your arms forward until your forehead gently connects with the ground (a mat or towel is optional). Leave your arms on the floor, reaching forward; or bring them to your sides, as pictured, palms up, as the weight of your shoulders seems to spread the shoulder blades. With your torso folded over your thighs, on each exhale, feel your neck and tailbone lengthen. After several deep breaths, inhale and rise, pressing the tailbone toward the heels.

The Cooldown

After a workout, it's good to spend time just relaxing on the floor,
getting focused and centered. Lie flat and close your eyes.

Take a deep breath for five counts. Exhale. Repeat, upward of a dozen or more times, each time taking inventory of each part of the body starting with the neck and shoulders. Feel the lower back elongating (bring your knees to your chest, if it helps).

With each breath, keep mentally reconnecting with the physical point that is the focus that moment. This both relaxes and reenergizes the mind and body.

It is so important to reconnect with the body, as Mari advises. When we get stressed out, our breath shortens and the body tenses. Taking even a few minutes in the morning or early evening for five minutes of deep, focused breathing can reorient us for the next step in life.

Variety Show

There is no magic piece of equipment that is going to keep you fit. What will is an array of activities that won't bore you to laziness.

I work out an hour a day, three to six days a week. There is no way I could maintain that if I were doing the same routine with the same group, day after day. I also prefer the camaraderie that I get from a classroom setting.

For me, the greatest exercise of all—well, apart from a frisky bout of sex—is dancing. I love being in a supper club, tearing up the boards doing the Collegiate Shag, Lindy Hop, and Smooth Balboa.

Try something new. Try something fun. Try something scary. I started dressage training, a vigorous discipline that not only works out my entire body, but also requires complete mental focus on the moment. Nothing like straddling a brawny Thoroughbred to give you a waft of nature! It's one of the most challenging undertakings I have ever experienced. Oh, and the clothes and boots that go with it . . .

Take beginning ballet or Argentine tango. It doesn't matter if you're a natural or not. Throughout the year, I'll take a few new dance classes here or there just to change things up. I finally started fencing and hula hooping . . . just not at the same time!

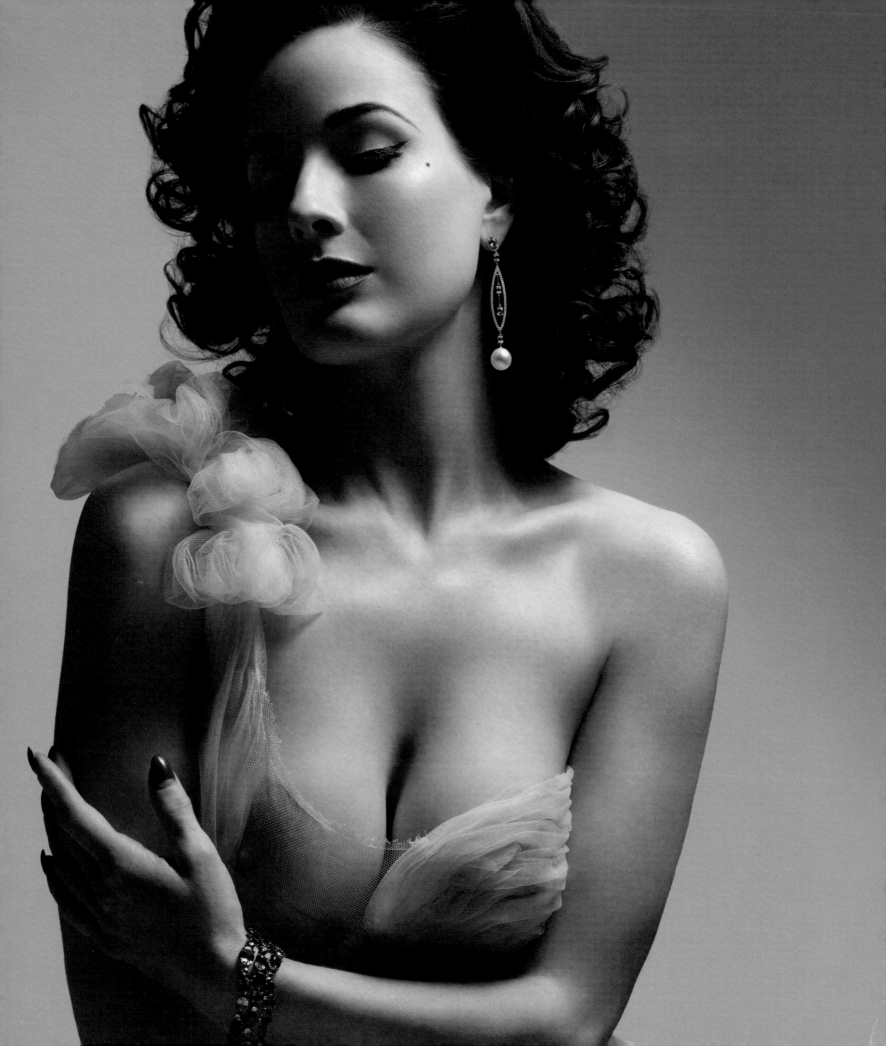

CHAPTER 3

Beautify Your Bosom

With an IQ of 163 and a blond ambition to match, Jayne Mansfield made clever use of her ample assets to notorious effect. Not even the equally voluptuous Sophia Loren could resist darting a dubious glance at what Mansfield's deeply décolleté dress revealed, an instant in time recorded in black-and-white at the legendary Beverly Hills supper club Romanoff's in 1958 that continues to titillate a half century later.

This was no accident. Mansfield was already a master of the publicity stunt, and she intentionally crashed Loren's dinner, to the chagrin of the Italian film star and the delight of awaiting photographers such as Joe Shere, who captured the

now-iconic moment. As Mansfield proved, sexuality is as much a function of the organ between the ears.

Your own bosom deserves such attention. Prizing your treasure chest is a matter of unfaltering care and not expensive shortcuts. No amount of fillers and scalpel to the face can mask the skin and tone of the neck and breasts. The area below the chin can age a woman who has allowed too many sunburns and other unhealthful habits to prematurely and irreparably crease her skin.

But you don't have to burn money on any products marketed specifically for the neck, chest, or breasts. When it comes to beautifying my bosom, my rule is simple: if it's good enough for the face, it's good enough for my décolletage. It should also be a part of the morning and nightly skin care routines. Lather up the face, then keep working those circular motions south and east and west across this equally delicate part of the body.

Shy about handling yourself? Don't be. The body is a wonder of nature, a real humdinger in the grand scheme of the universe. Every part of it deserves our consideration, both in the quest for self-improvement and for maintaining our health. Detecting a lump or freckle or other change before it's too late and seeing a doctor about it can be the difference between life and death. It's only by being truly in touch with ourselves that we can keep in fine fettle.

Titillate the daily moisturizing routine by letting a bosom buddy lend a hand. The more the merrier, I always say, be it a salve or any other affairs of beauty! Use a basic moisturizer or coconut oil. Or swap those for an aromatic massage oil. Massage stimulates blood flow and the lubricant softens skin.

At least weekly in the bath or shower, gently exfoliate. I find Egyptian loofahs to be superior in feel and effect to the rock-hard kind because the loose weave and dense fibers of do not tear at the skin. Other efficacious options are a fine-grained

exfoliator, a hand towel, or scrub gloves. Apply the same, light-handed pressure you would on the face. Being too vigorous can aggravate the delicate skin.

Follow up this daily drill with a dollop of moisturizer. Apply a formulation with sunscreen for day. At night, apply a moisturizer with retinol across the chest, avoiding those twin peaks.

Getting It off Your Chest

There's a blight nobody wants to talk about but nearly everyone incurs. Since it's not as obvious as, say, a female moustache, let's hope it's being seen to behind closed doors . . .

Ladies, I'm talking nipple hairs. There is nothing sexy about them. I'm not referring to the chick fuzz that naturally covers and shields the skin, but those wiry hairs that are usually dark and tend to sprout with more frequency with the natural hormonal changes of life.

So pluck them. Laser and electrolysis are other, more permanent options. There is simply no defense for hirsute hooters.

Overexposed and Undercover

Breasts, no matter the size, are a feature to be celebrated, to bask under the spotlight of admiring eyes. So while I am the first to declare that they not go into hiding under a pup tent masquerading as a dress, I am adamant when it comes to shielding an exposed neckline and cleavage from the harmful effects of excessive sun.

Go bust on the sunscreen. Slather it on daily before getting dressed to ensure it extends below the neckline, where otherwise clothed skin might come into the light, even briefly.

Don't skip or skimp on those seasonal gray days, either. There's plenty of evidence that solar rays zap right through the clouds. Besides, there are many practical reasons to block the décolletage from the sun. There are no tan lines to distract from the pretty neckline of a dress. More significantly, long-term, premature wrinkles and freckles requiring a dermatologist's attention are averted.

A flawless décolletage can be flaunted to great effect. Consider that of Madame Gautreau. The American-born Paris socialite known as Virginie prided herself on a complexion of "uniform lavender or blotting paper colour all over," as described by artist John Singer Sargent. His portrait of the vaunted beauty in a sylphlike dress, with a plunging neckline and flagrantly dropped jeweled shoulder strap, sparked a collective gasp at the Salon of 1884.

The portrait prompted the poor dear to flee to London! And Sargent to repaint the strap over the shoulder. True, there where whispers of indiscretions that also fueled Virginie's departure. On selling the painting to the Metropolitan Museum of Art in New York years later, the painter required anonymity for his subject, only imbuing the already deliciously scandalous image with even greater appeal when he gave his work the title *Madame X*.

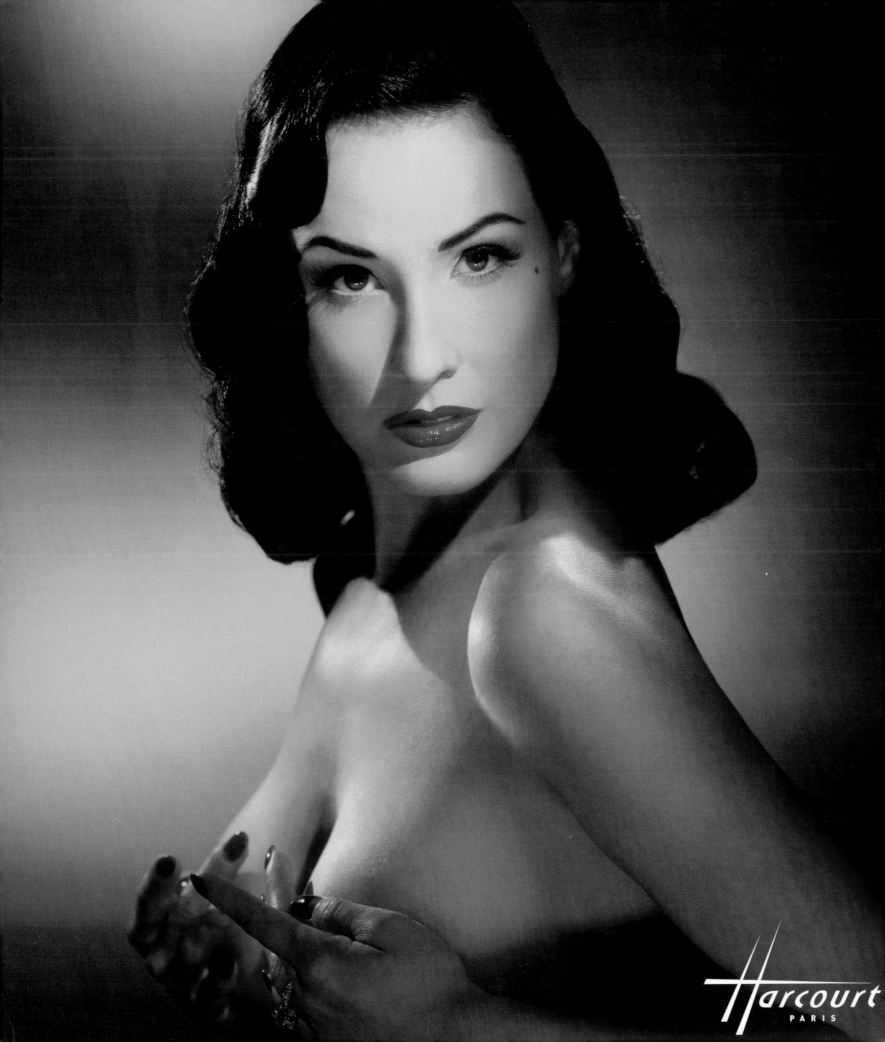

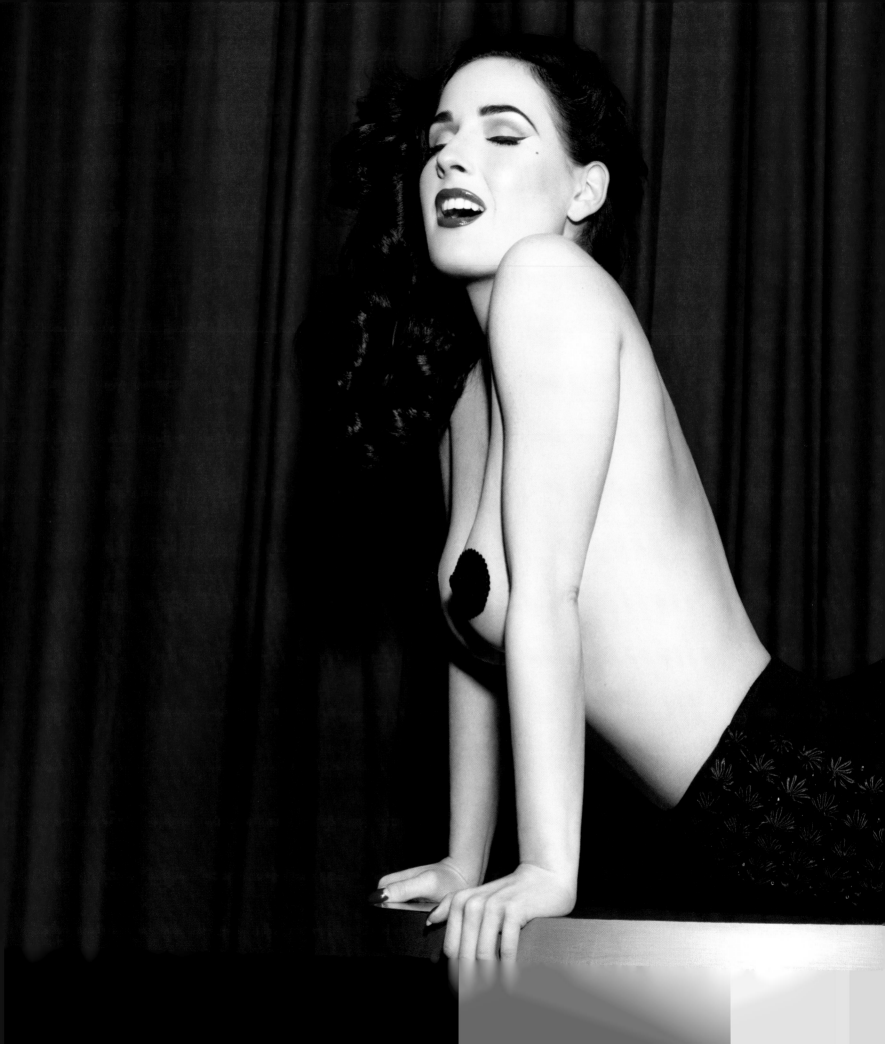

Incidentally, Gautreau apparently dusted herself with lavender powder and routinely sipped a splash of arsenic to maintain her pasty-white appearance. Those wild Edwardians! Some also took to piercing their nipples with tiny gold rings, believing it improved the silhouette while embracing the sensation as it brushed against undergarments.

Stick with the sunscreen.

If the evening is going to be filled with spotlights and camera flashes, consider a light dab of foundation for protection and polish. Sponge away freckles or any redness, then lightly sweep with facial powder. I like powder with a touch of luminosity. With a puff or pad, I pat it across my décolletage, shoulders, and wherever I might want to catch a gentleman's eye.

Tipping Point

For tits and giggles, rouge your nipples. It's a very old-fashioned trick that was the height of fashion in the 1800s and re-emerged a century and a half later among strippers during their stage acts.

I do it onstage at the Crazy Horse Paris, where going topless and pastie-less is simply *comme il faut*.

If it's a striptease you have in mind for an audience of one or more, try a cream or gel blush or a lip tint. A pale pink or peach is pretty, and a fuchsia can pop. At the Crazy Horse, under its robust stage lighting, I loved a true cherry red. With a small brush or the tip of the finger, color the nipple and areola (the pigmented skin ringing the nipple). Keep applying until satisfied . . . with the shade, darlings.

Hollywood or Bust

Following a decade of bandaging breasts into boyish silhouettes, the 1930s heralded their return and the rise of the sex symbol Jean Harlow. Nipples got by censors as costumers designed slinky charmeuse gowns for Harlow, who would ice her tips for exuberant effect.

Marlene Dietrich would have a ten-and-a-half-millimeter pearl sewn into her dresses to ensure a "pointed" silhouette. In the same spirit, Marilyn Monroe would sew buttons into her frocks.

But Hollywood really went bust when Howard Hughes spotted Jane Russell, and the link between aerospace engineers and a pair of pinup-worthy projectiles was not so far-fetched. On signing Russell to a seven-film deal in 1940, beginning with

The Outlaw, Hughes turned his scientific resources to fashioning a bra worthy of his budding starlet's bumper assets. A team went to work on building a better booby trap: it would not only feature an underwire and push-up, but would appear seamless under a silky form-fitting top and emphasize the "two good reasons why men go to see her," chortled Hughes.

A few tissues were carefully placed to smooth out any seams, because the highly engineered version simply didn't fit well. When it came time to go before the cameras, the ravishing brunette ditched it for her own. Apparently, a well-fitting bra isn't rocket science, after all.

Supporting Role

Let the love and beauty in life runneth over.

But tits? No way. How sad to see an otherwise well-dressed woman and catch a glimpse of the bulge over her cup line or at the sides near the armpits, faux pas not even her turtleneck can obscure. It's the bosom's version of panty lines, and it comes from too small a bra pinching and squeezing.

Just as painful, for both observer and, likely, wearer, is the strap that is digging into the shoulder or riding up the back. Even the most Rubenesque rack should never suffer such a beauty faux pas.

A well-fitting bra is crucial to the way clothes fit and, along with good posture, how we overall look and feel. Unfortunately, too many women are living with bras that don't hold up. While a well-fitting bra is the best boost to a beautiful bosom, scientific and medical studies indicate that more than 80 percent of women are wearing bras that are not their true size.

While I don't want to sidetrack too much into garments in this book, a bra that fits is as key to your overall image and sense of beauty as anything else you can slather or spritz on. (Let me add that a lacy-edged camisole can similarly enhance, so it's good to keep ones in white, nude, and black in the boudoir drawer!)

There are those who wear a bra too small because they wish they were smaller or, just the opposite, they believe if their cups brim over it will make them appear bigger. Or they slip into a size too big on the off chance they might really be that size. But this is not the time to let your aspirations run to delusion.

One of my first jobs, while I was still in high school, was in a lingerie store. There I learned the ins and outs of foundation

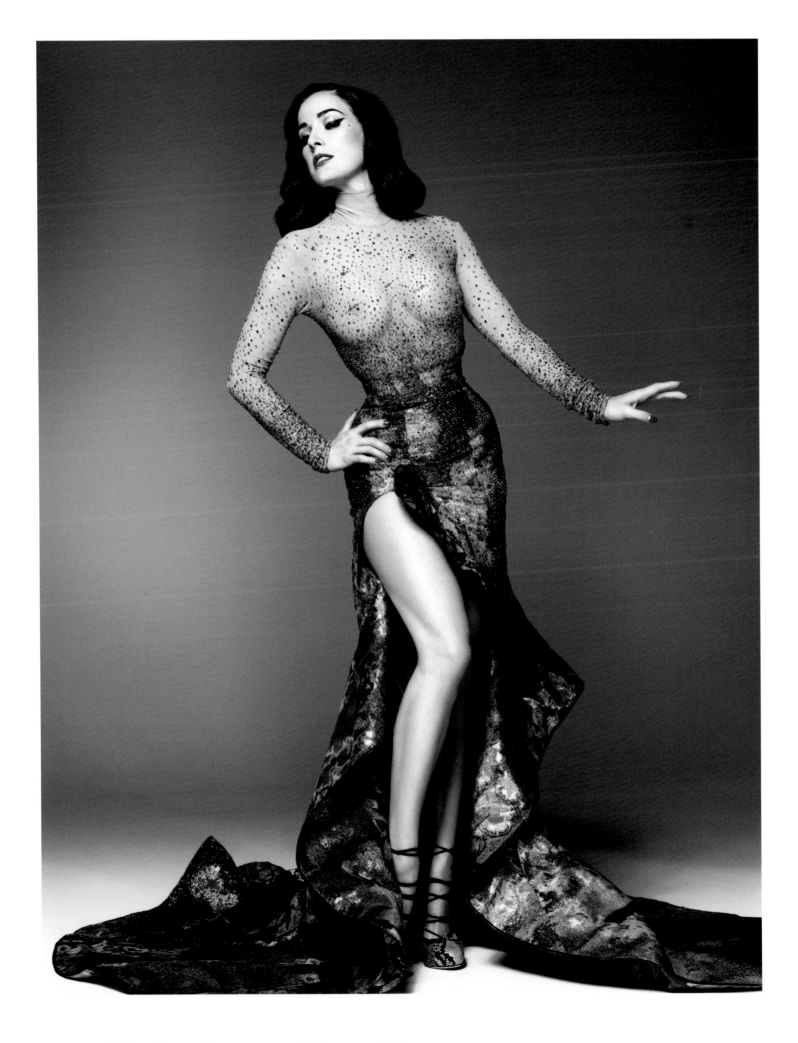

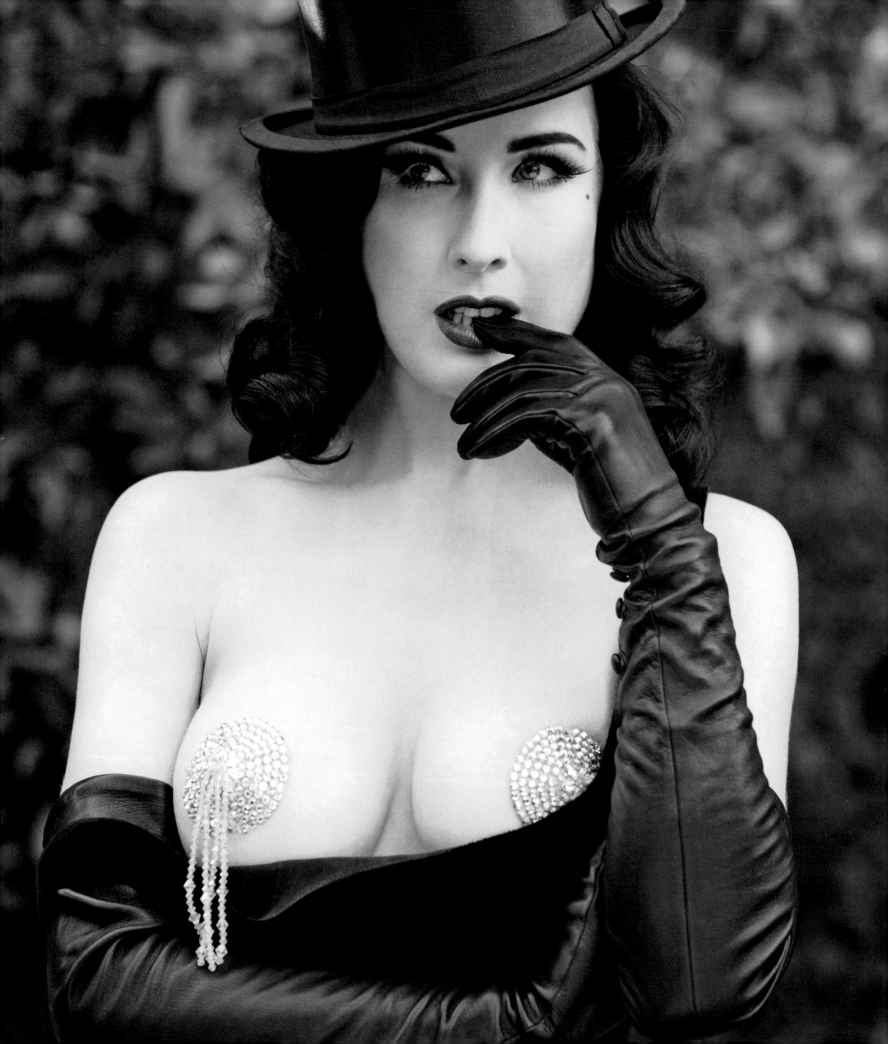

garments. I know when the straps are not right. I recognize when the cup runs too small and flesh is bulging over the sides. And I always bend over to test whether my boobs are spilling out of a bra. They should not.

Be honest with yourself. If *you* can't, after all, who can? Treat your true size neither as shame nor as deficit.

Case in point on a related matter: I wear a medium panty. I am not concerned that someone might take a peek at the tag inside my panties and expect to see size small. A medium size neither fits too tight, nor puts my panties in a bunch.

Likewise, I'm not going to be a sucker for a certain size dress because that's what I think I should be wearing. Take stock of any of my vintage dresses from the 1950s and the label plainly states size 14. Which, by the way, was also Marilyn Monroe's dress size. It's all a numbers game. Through the years, the fashion industry has flirted with sizes, shrinking them down to literally nothing, in order to flatter us that we're a tiny number. The fashion business calls it vanity sizing. Not even manufacturers in the same country can reach a consistent sizing scale. It's irritating and it's a fact of life. But too often, size and not fit becomes the focus.

It's one of the gravest mistakes women make about dresses and bras alike: buying the size they *think* they want to be.

So stop thinking about numbers and start looking, really looking, at how your clothes—including those garments underneath—feel and look. I was committed to fit and form as I worked on my signature lingerie collection. Accessibility became my raison d'être—not only in terms of financial figures, but in designing sexy, beautiful lingerie for all womanly figures. Ultimately, if you can't get past the number on the tag, take a pair of sharp scissors and cut it out!

Survival of the Fittest

If you can't find an expert, measure yourself. Measure yourself even if you do plan on consulting an expert. Even among professionals, the practice isn't perfect. So a second or even third try is advisable since it is essential to find the right bra.

Chest Band Length

Wrap a measuring tape just under your naked breasts, keeping it parallel with the ground. Exhale completely. Round up or down to the closest whole number. If the number is even, add four inches to the figure. If it's odd, add five.

Confirm the result by measuring above the breasts. Wrap the tape under the armpits and above the bust. If even, this is the actual number. If odd, round up or down to the nearest even number.

Cup Size

Take the two measurements—above and below the breasts—for the band size. Subtract. A difference of one inch is an A cup, two inches is a B cup, three is a C, four is a D, and so on.

Finishing Touches

The right bra should have a firm, comfortable band that doesn't ride up the back, runs horizontally, and serves as the primary support for the breasts.

Cups should enclose the breasts, with the nipple in the center (even if it involves the tiniest swatch of fabric). Any underwire must rest flat against the sternum and never dig or rub.

Once you determine your true size, review it every now and then. Our bodies change, and so do our breasts. Don't buy a bra just because it's pretty. Good bras are engineered according to size. I've been pressed why some styles in my signature lingerie collections are not offered in the larger cup sizes. Due to the very mechanics of construction, not all styles are ideal for all cup sizes. Wider straps and back hooks are necessary in a style for a larger cup size. There are loads of stunning options out there that fit well and, crucially, vaunt your shape to its best effect.

I have to accept that many a sexy lace triangle bra is simply not for me. I'm a 32D. Let me tell you, time and again, I'll go into a shop and an untrained clerk will tell me I can also slip into a 34C. Rarely. Out of hundreds, I have four bras sized 34C that fit well. But in most cases the back rises, a sign it's ill fitting. The bra strap should be exactly mid-back. It should not ride up. It should not be loose. There's nothing comfortable about that, and there's nothing sexy.

Embrace your size and shape and (no matter how full) the cup you have in life.

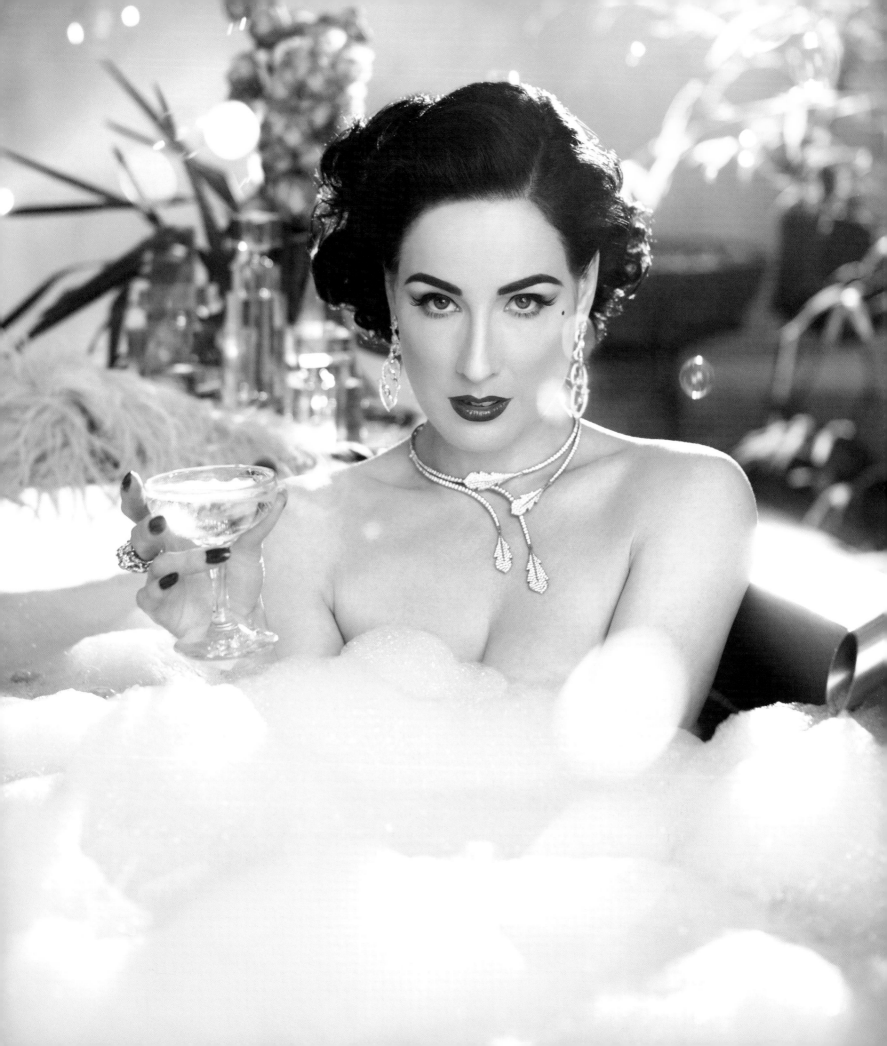

Bathing Beauty

I realize some of you are partial to imagining me bathing at home in a jumbo martini glass, under the rosy glow of a floodlight, rubbing my dirty self clean with a stroke and a squeeze of a sponge resembling a giant olive.

But, seriously, darlings, that is an act!

Bathing is baptism by soap and bubbles, an interlude in life to cleanse the skin and the mind and, most of all, the senses. It's an opportunity to wash away a riotous night or a bad day, a chance to start all over again. A soak, even a quickie, under the spray of a shower, can be a tonic as restorative and revitalizing as a catnap.

Is cleanliness next to godliness? Between the sixteenth and eighteenth centuries, being filthy was equated with being righteous. Dirt symbolized purity of mind and soul. Bathing was considered simply too sensuous a practice by the moral high-minded, who were overly concerned with keeping up appearances in other ways. So born again was another era of the great unwashed. The ravenous plagues also fueled the belief that washing encouraged disease.

Alive now or then, with beliefs like those, I'd rather be called a sinner than a saint!

In general, bathing, as private or public ritual, has long claimed a place in all the great world religions, monotheistic or otherwise.

It's at the altar of art, however, that this simple practice has received the most masterful exaltation, appealing to artists of every stroke, from the anonymously created mosaic in the thermal baths of ancient Greece to the splashing scenes of film director Federico Fellini. One artist who couldn't get enough was the French Impressionist Edgar Degas, who depicted the act in no fewer than one hundred studies. Or was he simply interested in the buxom figures frolicking in and out of the water?

Elisabeth de Feydeau, author of *A Scented Palace,* wrote about how Marie-Antoinette dipped in a tub laced with a confection of blanched sweet almonds, pine nuts, linseed, marshmallow root, and lily bulb. She then exfoliated her body with a sachet of bran.

Champagne baths have become an indispensable part of the bombshell playbook, and in no small part thanks to the biggest bombshells of them all.

Jayne Mansfield adored her Champagne. At her Pink Palace, the Bel-Air mansion she shared with her husband and tots, Jayne boasted of having an outdoor fountain that burbled with bubbly. Inside, she luxuriated in a big tub filled with pink Champagne at least twice a week. She so made champers a part of her shtick that in a twenty-four-page booklet she produced during the 1964 presidential election positing she run for the White House, she appears in a black strapless bra and black

pumps, a magnum of Piper-Heidsieck parked in an ice bucket next to her patio lounge chair. It's a scream.

It's also very likely she took a page out of Marilyn Monroe's manual, down to the brand of bubbly. The queen bee of blondes apparently once bathed in hundreds of bottles of Piper-Heidsieck. She also claimed to go to bed nightly after dabbing Chanel Nº5 behind each ear, then reopening her eyes each morning with a glass of Piper-Heidsieck.

Not to be out of the platinum players club, Mamie Van Doren praised sparkling soaks, too. She indulged her B-movie fans with a Champagne bubble bath for the 1964 Tommy Noonan sexploitation flick *3 Nuts in Search of a Bolt*. It was a gimmick all right, and we love her for it.

"Every bath should be a beauty bath," declares one of my favorite vintage beauty books, the 1955 beauty bible *Lady, Be Lovely*. And you know, in these crazy-busy times, author Edyth Thornton McLeod (even her name is amazing!) is completely on note.

That Sinking Feeling

There are few delights in life more glorious than a bath. If you have a tub, taking a dip is a luxury within reach.

It's all in the prep. Always start with a clean basin. Set out a towel, robe, slippers. As a comforting touch in the tub, fold a medium towel to use as a neck and head pillow. Line up a soft flannel washcloth (preferably the organic kind made for babies); a pumice stone or foot file for heel-to-toe softening; a bathing cap or terry turban; and an Egyptian loofah or brush. Egyptian loofahs are superior to those from Asia and South America because they last longer and are softer, and the loose weave and dense fibers will not scratch delicate skin. I also like that they are a biodegradable alternative to cellulose sponges and artificial fibers: loofahs are a vegetable from the same family as the cucumber.

Next, turn your attention to the lighting. Set the scene with a soft glow. I have dimmer switches in every room of my home, and especially the bathrooms. But I love to indulge in the soothing flicker of candlelight. The sensual component to bathing is part of the experience, even if it's a brief soak.

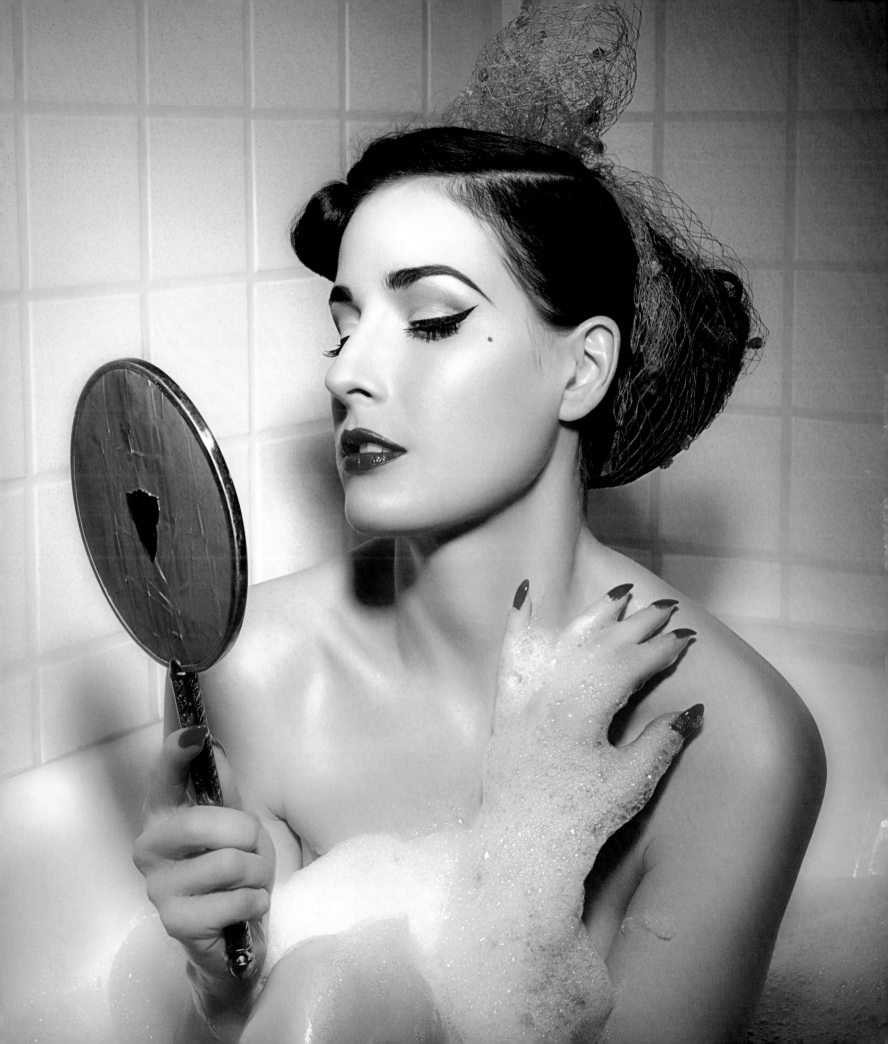

Likewise, scent. Try a cheesecloth pouchette filled with crushed herbs and flowers to stimulate or soothe. I also love a few drops of lavender essential oil. This aromatic tops my list because of its distinct scent and powerful properties. It is a natural antiseptic and contains antibacterial ursolic acid, which fights lipid oxidation and inhibits elastase, a culprit in skin inflammation such as eczema and tissue degeneration. It can also soothe skin (great for insect bites or sunburns, too), relax muscles, stimulate peripheral circulation, lower temperature, benefit digestion, and aid in the relief of migraines or other headaches. A good oil can be found in a health food store or other like source. As for my splurge, it's REN Moroccan Rose Otto Bath Oil.

For their therapeutic benefits, Epsom salts soften water, ease muscle cramps, and aid in the healing of bruising. They're indispensable for flushing toxins, reducing inflammation, and treating any congestion (both mental and nasal). At least once a week, detoxify by adding 2 cups of Epsom salts to the tub. As a bonus, add a few drops of mint, lavender, pine, rose, or eucalyptus oil. Marinate yourself in this concoction for at least ten minutes.

Unlike seasoning salt, Epsom salts contain no sodium and are a naturally occurring pure mineral compound called magnesium sulfate. Always keep a carton on hand—they're cheap and available at any corner drugstore. I also love Batherapy brand, a concoction of Epsom salts and energizing Siberian fir oil.

Coarse sea salt and sugar are other natural ways to exfoliate away the day. (Be careful not to use salts after shaving, since they can sting and trigger redness.) Take a handful in your palm or in a washcloth and rub it into warm, wet skin. Work in a circular motion along your arms, hands, bum, thighs, and feet—really

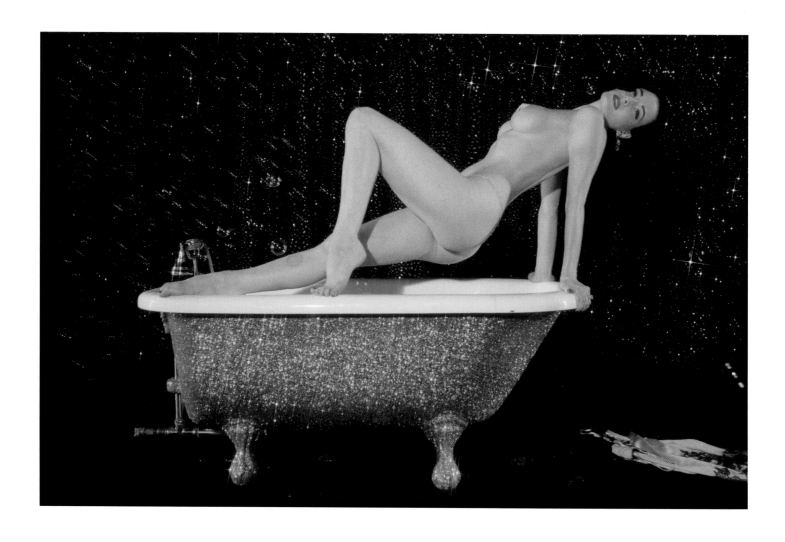

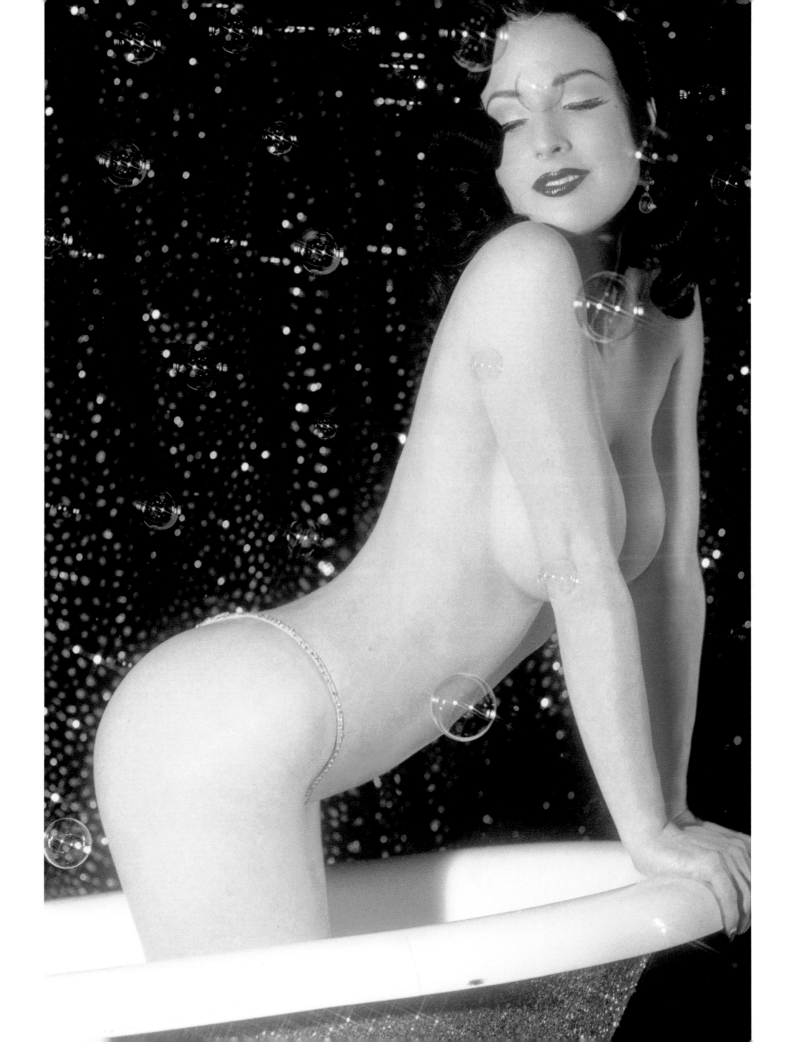

all over except the face—to revitalize dull skin. Rinse thoroughly with warm water.

As for water temperature? A warm 90 to 105 degrees Fahrenheit is best for a comforting dunk (as a reference point, water freezes at 32 degrees Fahrenheit and boils at 212 degrees). Frequent hot baths or showers, along with harsh cleansers, can break down the lipid barriers in skin and cause drying.

Shower Power

Of course, a bath, even a brief one, isn't always in the cards. A shower can be a fast and effective alternative. It has its benefits, too, and not simply the magic jolt to revive a listless body.

The right heat and pressure on sore spots can relieve tension in nerves and muscles like a mini massage. But don't turn up the temperature so high that it will dry out or damage your skin.

If time does allow, take an Egyptian loofah or a fistful of sea salt on a washcloth and exfoliate all over.

In a Lather

In the bath or shower, when it comes time to wash, consider it time to work up a lather. Rinse thoroughly with clear water. So often it's not the soap that proves too drying, but the residue left behind.

At an intimate birthday party for George Michael at Sharon Stone's home one summer night, the hostess stunned me by cornering me and, in a half-cheeky, half-serious tone, demanded

my beauty secrets. I looked straight into those baby blue eyes of Sharon's and replied: "Well, I want to know what *your* beauty secrets are first!"

Sharon radiates stardom. Her presence and beauty demand a room's attention, and in person, it appears she hasn't had any plastic surgery. She is facing age with vigor and poise, embracing any lines around her eyes while ensuring she fills a gown with a body to covet.

"I'll tell you what my secret is," Sharon began. "I never use soap anywhere on my body, except my pits and . . ." Well, you can use your imagination on that second spot (fans of her biggest cinema moment have!).

Astonished as I was at her frankness, I understood. And my dermatologist, Dr. Cotliar, agrees with her soap use, noting that not all soap is created equal. He recommends a fragrance-free, low-pH product such as those by Aveeno or Dove. I use Dr. Bronner's Magic Soaps Pure Castile Soap, a fair-trade, organic liquid, in almond or rose, generously squeezed onto my Egyptian loofah.

Jonesing for a Jimjilbang

After weeks away from Los Angeles, one of the great joys of returning to town is an evening at the Korean spa. L.A. boasts dozens and nowhere more than in Koreatown, which is fortunately just a quick drive from my home.

Spas are havens of health and relaxation around the world, and Koreans prize their ancient calming and cleansing rituals, as do most Asian cultures. Because of this, visits are modestly priced, making it at least a weekly rite for most regulars.

They are known as *jimjil,* which loosely translates to "thermal bath." After stripping down, guests of all ages, shapes, and sizes unabashedly pour into a cavernous room to cleanse and prep for the scrub and massage. The first stop is the shower. Small wooden benches offer respite while lathering up. The communal atmosphere is counter to Westerners' more private bathing habits—usually alone, behind closed doors.

After rinsing, it's off to the many aquatic offerings, from pools of pure water, bubbling hot water, and ice water to a dry sauna and moist steam room. A good steam is believed to rid the body of toxins. Rose and I think it feels delicious.

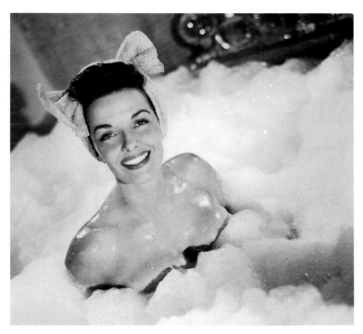

Jane Russell soaks it up in this promotional studio portrait from 1954.

When your number is called, it's into the scrub room and onto a vinyl-covered, padded table. This is where the entire ritual of Korean spas becomes quirky. Whether in New York or L.A., we've always found the staff inside the scrub rooms uniformed in lacy black boy short panties and bras. It's not meant to be sexy, and it isn't. (On the men's side, it's typically stocky male masseurs in white T-shirts and shorts.)

These diminutive women are powerful. They get to work with a gauzy scrub towel or scrub mitt, sloughing off in unflagging circular motions the layers of modern life. Blood flow is revitalized; pores open and are cleared. Gallons of tepid water splash it all away. Then comes the brisk massage with oils, followed by a facial and shampoo rubdown that leaves a girl like putty.

Towel Dry

Once the bathing ritual comes to an end, resist rushing into a drying rubdown. While standing in the shower or tub, use your hand as a squeegee to stroke water off your skin.

Allow any remaining moisture to seep into your pores during the subsequent minutes. They are still open from the heat of the water and better receptive to skin emollients, according to my dermatologist, Dr. Cotliar. Meanwhile, there are a handful of other tasks that need attending to, from towel drying your hair and brushing your teeth to plucking any stray brow hairs. Those few moist moments can do skin a lifetime of good.

By the way, while a towel should be absorbent, consider how many towels leave skin less than dry. Go natural. Cotton, bamboo, beech, or rayon fibers are more absorbent options than synthetic. The longer the loops, the softer the fabric. The denser they are, the greater the absorbency.

Blot your face, neck, and body. Gently and thoroughly dry your crevices and creases—from behind the ears to below the breasts to between the toes—to prevent chafing.

"Dry skin is due to a lack of water," reminds Dr. Cotliar. "Apply cream or oil while your skin is still damp, right after bathing, to trap moisture. Use a product that is fragrance-free and that contains ceramides, such as CeraVe." A quality coconut oil is an effective and accessible option. Or try one of the nourishing dry oils on the market now. As a splurge I love Darphin Nourishing Satin Oil. Or I enjoy NUXE Huile Prodigieuse with its natural ingredients. Once I could only score NUXE at Paris drugstores, but it's now available stateside at the fancier "Super Walgreens."

The good doctor then recommends slipping a damp body into a terry robe to extend the moisturizing benefits while you move on to the next step in grooming.

Strip, Tweeze

Before giving it all in a striptease, a gal needs to get rid of the inessentials, all with a strip and a tweeze.

A bushy brow or stubbly panty line can mar even the most otherwise flawless appearance under the spotlight of the stage or the candlelight of the bedroom. Among my stockpile of beauty books, there is a 1939 tome (and it *is* a tome) entitled *Superfluous Hair and Its Removal* by the equally superfluously titled A. F. Niemoeller, AB, MA, BS. We can't resist giggling over its grave tone:

"*Superfluous hair is one of the most unlawful gifts that nature bestows on the fairer sex. It has been a source of suffering and humiliation since the dawn of civilization.*"

Rather dramatic, right?

Sure, I wish the "laws" of nature would catch up to a gal's desire for a perennially groomed appearance. I also prefer to consider the whole bristly matter of unwanted body hair removal as not so much humiliating as a source of *temporary* discomfort, not to mention slightly vexing if I get caught with a hair out of place.

Hair Apparent

I've done it all. I've waxed. I've plucked and pruned.

Because many of the zones we zero in on for hair removal—brows, above the lip, bikini line—are inherently delicate and thereby sensitive, redness or other irritation can result from some procedures. Best to do any stripping a day or two before a big reveal, whether it's taking place by the pool, onstage, or behind closed doors.

In advance of any visit to a salon or spa, don't hesitate to ask as many questions as you need to about the professional, the procedure, and what measures are in place to ensure your health and safety. It comes down to what is right for you and your budget. So try a new procedure or a new technician well before a special occasion. What works for me and my skin might not be right for you and your skin.

From high-tech to no-tech, there are hair removal options that have served beauties for centuries with the shared objective: revealing our true bloom from those overgrown weeds!

Shaving

When it comes to accessible hair removal, shaving is the cheapest and easiest. I have always shaved my legs (read on to learn what I do at the bikini line and up). The unshakable rules: never shave dry, don't skimp on the razor, and *do* toss it after a few uses. For the best shave, let the heat of the shower or bath soften skin. Gently exfoliate the area to be shaved with a loofah. Slather on hair conditioner to lower the hair's pH and soften the cuticle, minimizing brittleness. Gently run a clean razor upward, starting at the ankle, and rinse the blade between strokes. Light to medium pressure is best.

Besides exfoliating and using a sharp, clean razor, there are a few drugstore products that can stave off bacteria that lead to folliculitis, those nasty red bumps triggered by irritation or infection from any skin tears during shaving. A favorite is Tend Skin Liquid, with the exfoliating powers of acetylsalicylic acid.

Soothe inflammation with calming oils containing aloe vera or chamomile, and apply a hydrocortisone cream to reduce itching. And never, ever share a razor.

Depilatories

Some skin is invariably prone to ingrown hair no matter how much care is taken when shaving. Depilatories dissolve the disulphide bonds in the keratin of the hair, so surface hair becomes so weak it can be washed away. The strong alkaline chemicals in these creams can irritate sensitive skin. I personally don't use them. But for those who can benefit from them, thankfully, there are many depilatory products on the market now without the scent of rotten eggs, like those products our mothers had to endure for their short shorts. Our beauty editor friends recommend Olay Smooth Finish Facial Hair Removal Duo and the sensitive formula of the Veet Fast Acting Gel Cream Hair Remover, which smells of lemons and roses.

Electrolysis and Laser Therapy

There's always the option of zapping those hairs into quasi-permanent oblivion, a particularly effective option among natural brunettes. Be it electric currents or a laser, individual hairs are detached from the follicle and the follicle itself is obliterated. Several monthly sessions in (usually about six), hair growth is reduced or stopped.

Any procedure involving such high-tech tools should only be performed by an experienced dermatologist who is trained to use this equipment. A tab can run into the thousands of dollars and periodic maintenance is normal, which is why splurging on a quality razor or a threading or waxing service might be the way to go.

Threading

Living proof that the desire to come clean of hair dates back thousands of years, and in this case six millennia, threading has been in continual practice in India and, subsequently, among the Asian and Middle Eastern women whom it caught on with. Today, many salons in Los Angeles and other Western cities offer threading services.

A double-filament cotton or polyester thread is twisted open and, as it's rolled over the unwanted hair, twisted closed

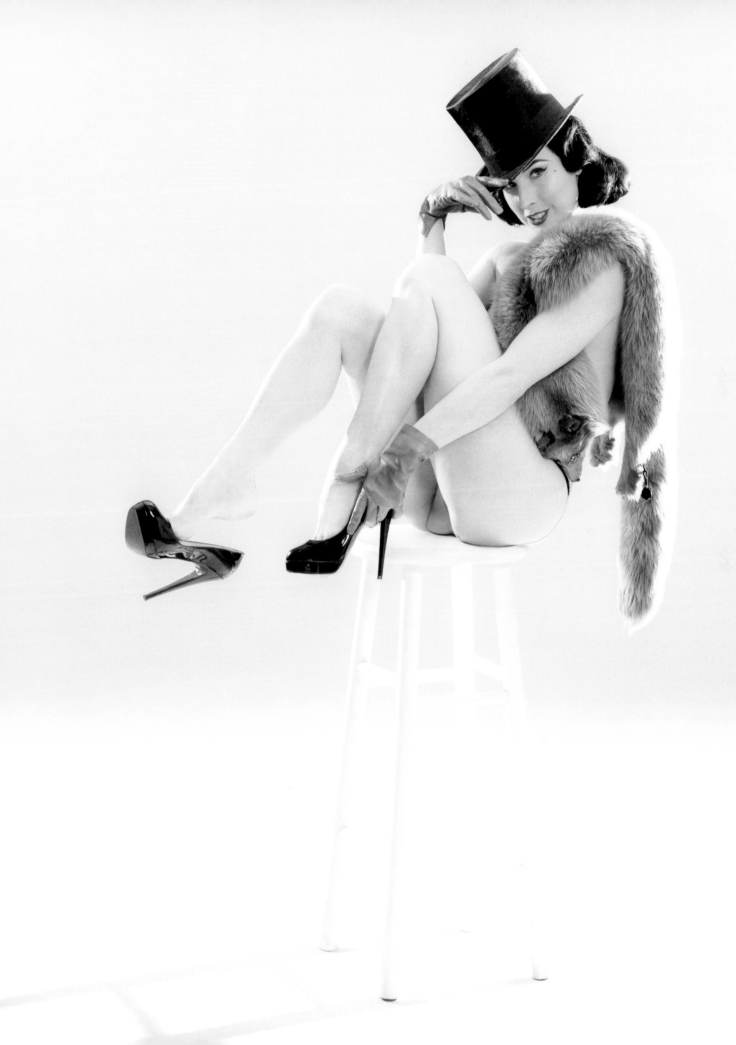

again, removing hair at the follicle, not unlike waxing. For some, this can prove irritating. But it's completely safe and can last up to four to six weeks. And unlike tweezing, it removes several hairs at a time and can allow for more precise shaping, making it ideal for brows, the upper lip, or anywhere on the face.

Waxing

Nearly any area of the body can be waxed, which is likely why this is among the most popular forms of epilation. The heat from the warm, melted wax slightly dilates hair follicles, facilitating hair removal down to the root. Methods dating back to ancient Egypt involved a sticky paste of beeswax and a cloth strip to yank it all off, not unlike modern waxing.

Hard wax, typically applied to the bikini area, can be less painful because it goes on thicker and is peeled off, as opposed to strip wax, which is removed by a slip of fabric. More experienced waxers, including my own, are deft at strip waxing. Bottom line, it's your skin and your prerogative. If you prefer a technician to apply strips to a smaller area at a time, or believe hard wax will be more gentle, insist on it.

The upshot is that with time, the more you wax, hair becomes finer and easier to remove and less pain is experienced.

I'm a do-it-yourselfer in 99 percent of my beauty routine, as you know. So I couldn't pay just anybody to wax me. Then I found a great waxer. Besides, there *are* some things in life worth splurging on. My waxer takes to the task like a clinician, with a bright light over her head and an assiduous eye. She's not the most expensive waxer in town, either, just someone who keeps a clean salon and is truly serious about her craft. Mind you, it's not exactly a pain-free experience. But an experienced waxer can minimize the blow.

I'm monogamous when it comes to my trusted waxer, too. Trying new ones out each time can be a disappointing process that involves sharing my nether regions with a new technician every time. Not my thing.

Waxing, not unlike threading and sugaring, is a craft, a skill involving as much technique as flair, and care and judgment during that brief rip-rip. Trusting the individual applying hot wax is as crucial as gauging the temperature. Practitioners should always use a new stick of wax for each client, or risk spreading bacterial infection.

Resist waxing just before or during your period; the increased hormones during this time make the bikini area more sensitive, magnifying any pain.

Sugaring

The antibacterial, hypoallergenic, and pain-reducing exfoliating properties of sugar make this an ideal alternative among those with especially sensitive skin (that said, this and any practice can prove irritating to some individuals). Just as the generations of women who've relied on it since 1900 BC, when it first surfaced in Persia.

Honey or sugar are mixed with lemon juice and water into a paste. It can be used cold or warm. The paste is dragged against the direction of root growth, and then pulled off in the opposite direction with cloth strips (that can be washed and reused because of the sugar paste). The taffy-like concoction sticks to hair and not skin, making for minimal pain compared with standard waxing. As in waxing, any redness should dissipate within hours and the results should last upward of four weeks or more. It's also easier left to professionals than executed at home (at least not without plenty of practice!).

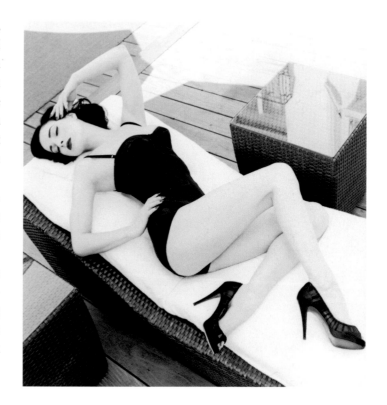

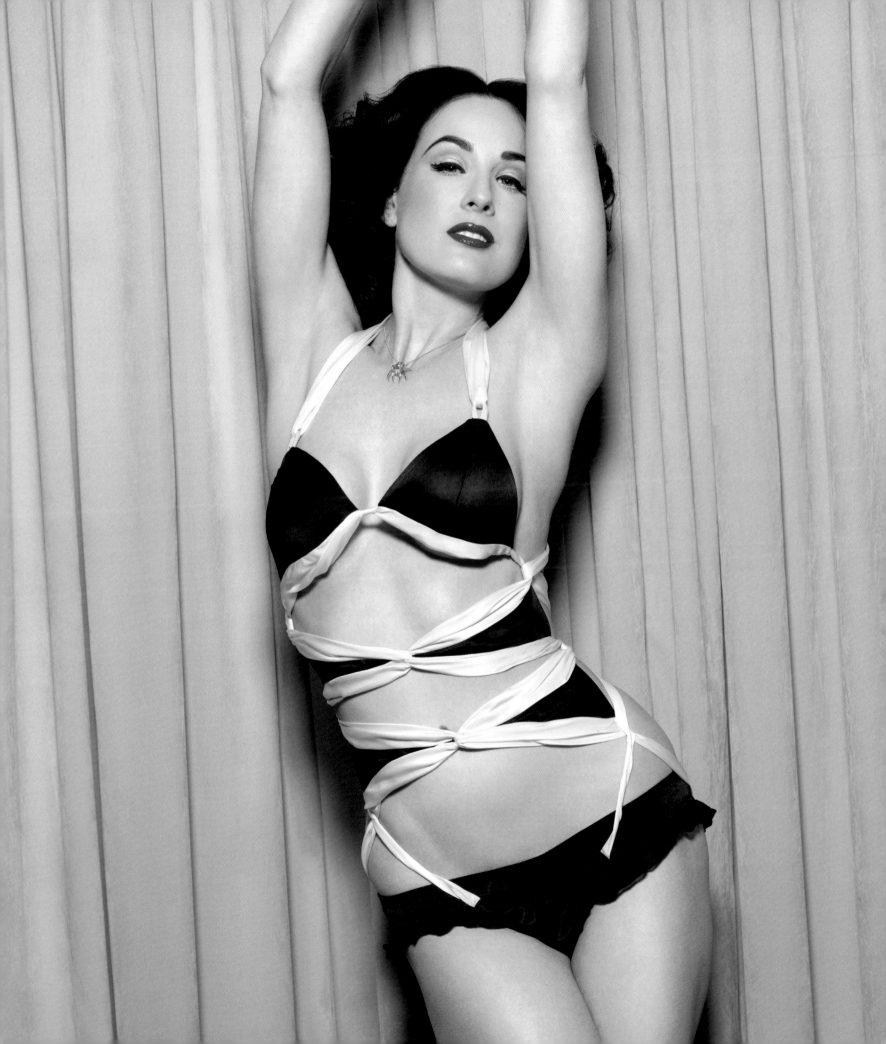

Strip Strip, Hooray!

Whatever the procedure, before stripping it off, a little advance planning can make all the difference.

Schedule thoughtfully. This is no time to pressure a technician into jamming several unplanned services into one. Likewise, arrive at the appointment on time and free of any beauty products. Do not apply lotion or makeup on the area to be treated. Steer clear of products containing isotretinoin or retinol at least a week before any facial waxing.

Before an appointment, gently exfoliate the area undergoing treatment to minimize ingrown hairs. Hair growth should be at least a half inch long if coarse and a quarter inch long if fine. If you'd like, manage the pain by taking an ibuprofen an hour before arrival.

During treatment, focus on something else, whether by going into a meditative state by zeroing in on a decorative element in the room or digging into an engrossing chapter in a book. Personally, I like to catch up on texts or play *Words with Friends* on my iPhone while I'm getting waxed. Or I might go into reflective breathing, inhaling on the application, exhaling on the rip of the strip.

Following the service, the technician should gently pat the area with a warm cloth, then witch hazel or an aloe lotion. If red bumps appear, apply a hydrocortisone cream.

Yes, it hurts—for a lightning instant. And a moment of pain is worth weeks of smoothness.

A Girl Needs a Great Pair

A pair of quality tweezers is essential, be it to tidy up the upper lip or other body spot or, mostly, to groom brows. I keep a pointy-tipped pincer and a slanted-edge pair in my kit. Always keep them clean with a quick rubbing of alcohol.

Pull one hair at a time gently, in the direction of growth. Best to tweeze following a warm bath or shower, or apply a warm washcloth to soften skin and open pores. If pain is a concern, finish off with an ice cube or flannel moistened in cold water.

Pit Stop

When it comes to the axilla (sounds lovelier than armpit, don't you agree?), I know some find a hairy pit sexy. But in the world I come from, a bona fide pinup gal would never be caught dead with an arm raised to reveal a furry pit to the world. Never.

As for the endless babble about the bushy-pitted femmes fatales of France? For all the time I spend there, and it's considerable, I don't see legions of women ambling about with bristly tufts sprouting out from sleeveless dresses. In fact, I've never seen a single one. I'm not simply talking about the beautiful creatures at the Crazy Horse Paris, either. I can't even imagine the sight of the dancers there lifting a synchronized tier of graceful arms marred by wooly patches.

The old chestnut about Frenchwomen going au naturel in that respect is nothing more than pit *bull*.

As for my own armpits, I either shave or have them waxed. As an aside, I also use a natural deodorant. I'm not a fan of the chemicals found in antiperspirants, and combined with other synthetic scents and ingredients, they can be harsh on skin and delicate fabrics. And who wants a vintage gem ruined by deodorant? (See page 118 for more on this topic.)

Lip Service

There are so many marvelous moustaches. John Waters just wouldn't be the same without his signature pencil-thin 'stache, and Salvador Dalí was so enchanted by his own exuberant moustache that he waxed the ends and pointed them upward to keep himself tuned in to the universe! The master surrealist even published a booklet with nothing more than photographs of his moustache pointed this way and that.

The one moustache I am no fan of is the kind that appears on the upper lip of an adult woman. Whether she bears it blindly or boldly, it's as unappealing as, well, a hairy toe jutting out of a strappy satin slipper (more on that in chapter 15).

Like brow grooming, doing away with upper lip hair can open up the appearance of the face. Also like the brows, this is no place for a razor. Plucking the upper lip is a more suitable option for those with light, fine hair than for brunettes. It might

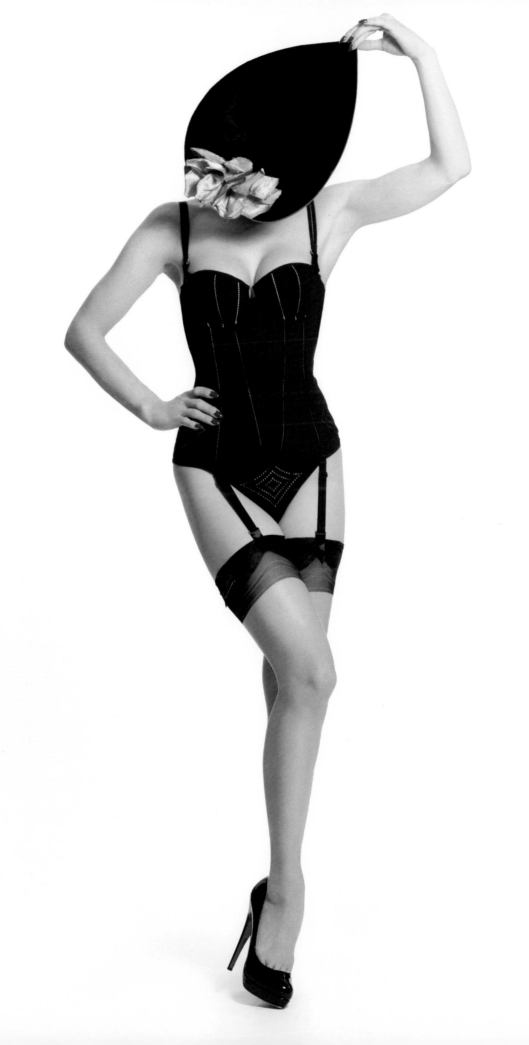

Strip Search

I outsource my brow waxing. Lying back in a professional's chair allows me a brief respite in a harried week.

After years of entrusting my brows to all kinds of celebrity artists in the interest of reporting on them, I became convinced that craft is not a matter of high prices (or having a good publicist).

When meeting an eyebrow professional, examine the pro's own brows. If they look overplucked or overgrown, is this someone you really want to trust with your own brows? Run for the nearest exit. Ditto any professional to whom you're entrusting your hair, nails, and especially your skin.

As with any service, pay attention. The goal is to be able to do it yourself. Ask questions. Why pluck that hair and not this one? What should you avoid? After all, if you find yourself without an appointment or far away from home, being unable to see a professional is no reason to let those brows go shaggy.

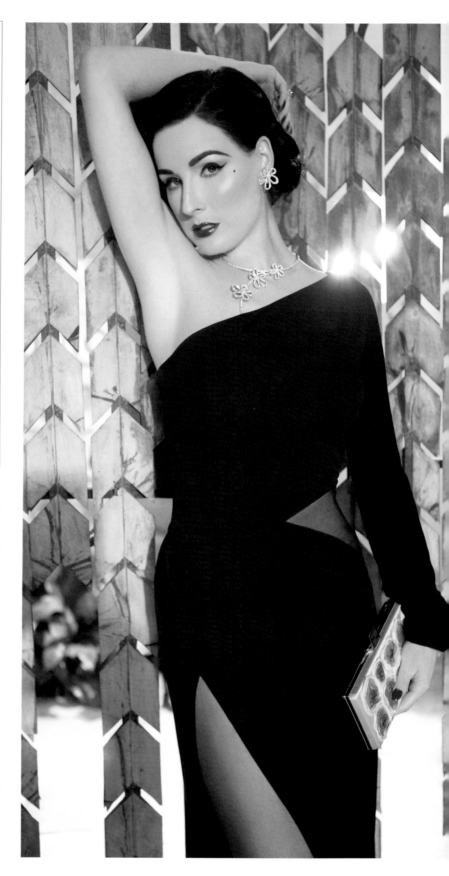

also be the way to go if your skin and pain threshold are averse to the alternatives. The same goes for chin hairs.

Threading and waxing are the most effective ways to strip the upper lip bare of any unwanted hair. In between treatments, closely examine the lip daily in the mirror and pluck away noticeable hairs.

Easy on the Eyebrows

When I was growing up, my mother's eyebrows were beyond plucked, as was the fashion of the day. I also remember her refrain years later: "Don't overpluck your brows. You'll be sorry."

Her admonishment had a point. Follicles can become damaged from frequent plucking and stop growing hair. Overly groomed brows also demand daily attention. While they *might* grow back for most of us, for others who took a razor or pair of tweezers to remove all traces of hair, naked brow bones remain just that. Bald.

Barely there brows can also come off as harsh on all but a very few individuals. I talk about a few of these standouts, as well as the overall making up of brows, in chapter 10. This section on brows is all about grooming.

When it comes to my brows, I've never visited a professional for a tweeze or a wax. Sure, I've let the occasional trusted makeup artist on a photo shoot pluck a stray hair or three. Otherwise, I don't let anyone touch my eyebrows.

Native brunettes like Rose might be better off waxing for a smoother, polished result. After years of checking out one highly publicized celebrity brow queen or another, she now goes under the magnifying mirror with a brow technician unknown to all but her clients. This professional gives more of her time and care, and for a fraction of the price (see sidebar).

In between visits or when a technician is out of town, we tend to our own brows. Keeping brows looking great daily is as critical to feeling beautiful as bathing or lipstick!

Following the fundamental form of the brow is sound advice I received long ago that has become one of my beauty commandments. I believe the face asks for a shape. Bone structure, eyes, even personality are all considerations.

With a hand mirror and bright natural light, study your face. Now your brows. How do they follow the line of your brow bone? Are the hairs growing in one direction or another? Are they thick or thin? Overtweezed or undergroomed? How does the right brow compare with the left? What do your brows seem to suggest?

Some of my favorite eyebrow tweezing happens a mile high when I'm on a plane. With my mirror and my tweezers, I can lean into the good light blasting through the window.

It's imperative to tailor brows under good lighting, and nothing beats natural light. Even if you are not among the clouds, go outside under the light of day. Just don't carry pointed tweezers on the plane; only the kinds with angled tips seem to pass the security checkpoint.

Any brow grooming should begin with a shape in mind. It should be a shape that retains hair rather than removing it entirely. Lightly filling in of the brows with a matching color powder or pencil can provide a better perspective on the desired shape during grooming.

Brows should start where the nose bridge meets the brow bone—not outside of the nostril, a sin too many do-it-yourselfers commit. Try this age-old trick: vertically line up tweezers or a brow brush next to the bridge of your nose. This is where the groomed brow should begin.

Comb brows upward and toward the temples (the left brow hairs brush to the left, and vice versa). If the hairs slant downward naturally, brush in that direction.

Prime the area to tweeze with a cotton ball or washcloth dampened with hot water to open up the hair follicles. Tweeze strays on the brow bone in the direction hair grows. Don't rush it. Tweeze one hair at a time, and never tweeze into the brow. Continue tweezing hairs growing beyond your natural, preferred brow line.

Press your finger gently on the tweezed spot for a moment. The light pressure helps dissipate any shock of pain. If the skin is tender or red, moisten a cotton ball with witch hazel, aloe, or cool water and gently dab.

Bushy brows might require a snip. When grooming is nearly complete, carefully trim any lengthy hairs. But beware not to butcher the brow. You don't want them to resemble stubble on a man's shaved chest.

Whether groomed at home or in a salon, avoid rubbing freshly tweezed or waxed brows or the area just groomed. Skin is more vulnerable at this time and can become aggravated easily. It tells the world you've just been plucked!

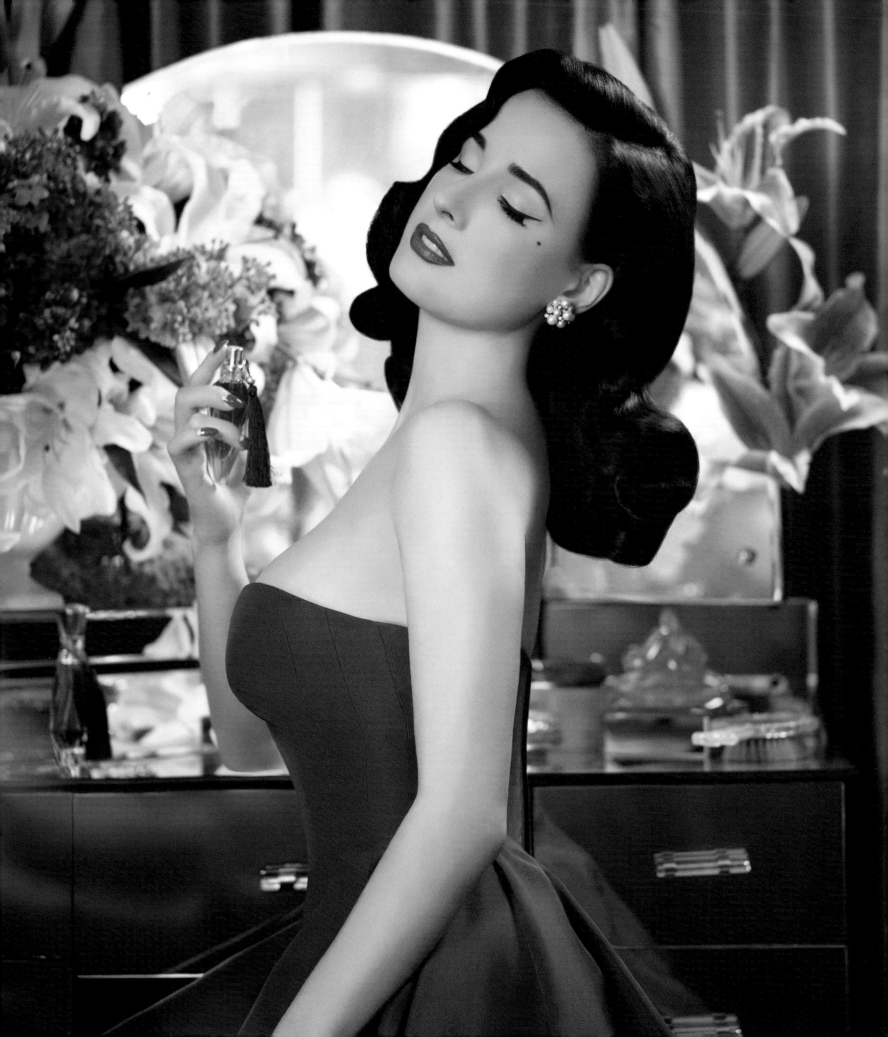

CHAPTER 6

Simply Scentillating

From the mouths of men, I thought I'd heard it all. But nothing could buffer the utter shock when this Frenchman with movie star looks, and dashing style to match, shared something that would rattle my world. I can hardly bear to repeat it now.

"Your perfume," he remarked, with a gentle hesitation befitting his elegant bearing, "I think it's the same as my mother's."

His mother also wore Quelques Fleurs?

Our relationship was still in the getting-to-know-you phase, and he had used the opportunity of a stroll by one of the many charming perfume shops in Paris to broach the topic.

Quelques Fleurs had been my signature scent, well, forever. Created by the legendary nose Robert Bienaimé in 1912 for the House of Houbigant, among the oldest perfumeries in the world, it has also long been one of the most coveted both for its fragrance and legend. Jean-François Houbigant grew up in the perfume paradise of Grasse. He opened his shop in 1775 selling fresh bouquets, handmade gloves, and perfumes he concocted for all of Europe's royals. Marie-Antoinette was a client, as was Madame du Barry, the mistress of Marie-Antoinette's father-in-law, King Louis XV.

The sensually floral Quelques Fleurs eau de parfum is said to require some 250 individual raw materials and more than 15,000 flowers to create one ounce.

What could I do? My friend in Paris and confidant in scent Kilian Hennessy, a perfumer by passion and trade, gave it to me straight: "You either get rid of the man or you get rid of the perfume. But you cannot have both."

I believe in fragrance and its powers. Perfume is the magic potion that transforms a charming woman into an enchanting one. Now the magic of my potion of twenty-two years was under question.

Smelling like his mother, drop-dead chic and eloquent as she is, opened up a box of Oedipal flights of fancy that I just wasn't willing to entertain.

The scent of a woman most profound and primal has to be that of our mothers. Even now a trace of Halston by Halston reminds me of my own mother. Contained in a voluptuous bottle designed by Tiffany jeweler and Studio 54 socialite Elsa Peretti, Halston is a nouveau chypre concoction of herbaceous oakmoss with rose and jasmine. *Chypre* is French for "cypress," and in modern perfumery it refers to notes that are floral, woody, animalic, or fruity, but as a blend convey a warmth with a fresh contrast. Bergamot, vetiver, sandalwood, patchouli, and labdanum most frequently emerge from chypre accords, which is why it makes frequent appearances in so many best-selling perfumes.

The memory of this deep golden juice is so vivid, even though it has been a lifetime since my mother sprayed it on. Such is the potency of fragrance on the senses and mind. So the search for a new fragrance to scent the next phase in my life began. Perfume is the veil of glamour that enhances a woman's beauty. And no way was I going naked.

Nose Around

Because I love an opulent scent, a fast favorite was Dior Passage No.4, in part because of the webbed atomizer ball and curvaceous garnet-colored flacon made of Baccarat crystal. The original Christian Dior fragrances were bottled in such splendid fashion. Modern perfumer François Demachy created it as part of a trio of limited-edition fragrances called La Collection Particulière to celebrate the house's sixtieth birthday in 2007. There is something outré about the rose-heavy No.4, with its blend of musk, orange, amber, and fiery pimiento.

I am never one to do anything watered down in life. I prefer high octane when it comes to my scent and always opt for the pricier *parfum*. As No.4 was a limited-edition scent, it cost me a pretty euro. But I was intoxicated with its effect on my skin. I'm a sucker for appearances, too, when it comes to the objects in my beauty arsenal, and the more exquisite, the better. A crystal bottle of No.4 met my desires inside and out.

So I nearly fainted when I knocked it over during a refill and it spilled on my counter. What's a gal to do in such cases? I grabbed a lacy bra I rarely wear and mopped up every precious drop. I then threw it into my lingerie drawer. Voilà! Instant sachet.

During this flirtatious spell with No.4 and other scents, I was becoming increasingly intimate with the very process of perfumery. I was not finding an alternative to Quelques Fleurs that suited me as well, and that only galvanized my education.

The knowledge and effective use of perfume is the very foundation of glamour. Great history and artistry are involved, and with friends fiercely committed to this art form, such as Kilian Hennessy in Paris and Douglas Little in New York (read about Douglas on page 110), I became ever more eager to realize a dream: my very own signature fragrance. So I got to work.

Making Scents

I lusted after something that would appeal to those of us not reluctant to proclaim we are women. Too many best-selling scents are so fruity and vanilla with a sweetly cloying air that a mere spritz gives me a toothache. Or they smell like cake. I do *not* want to smell like cake!

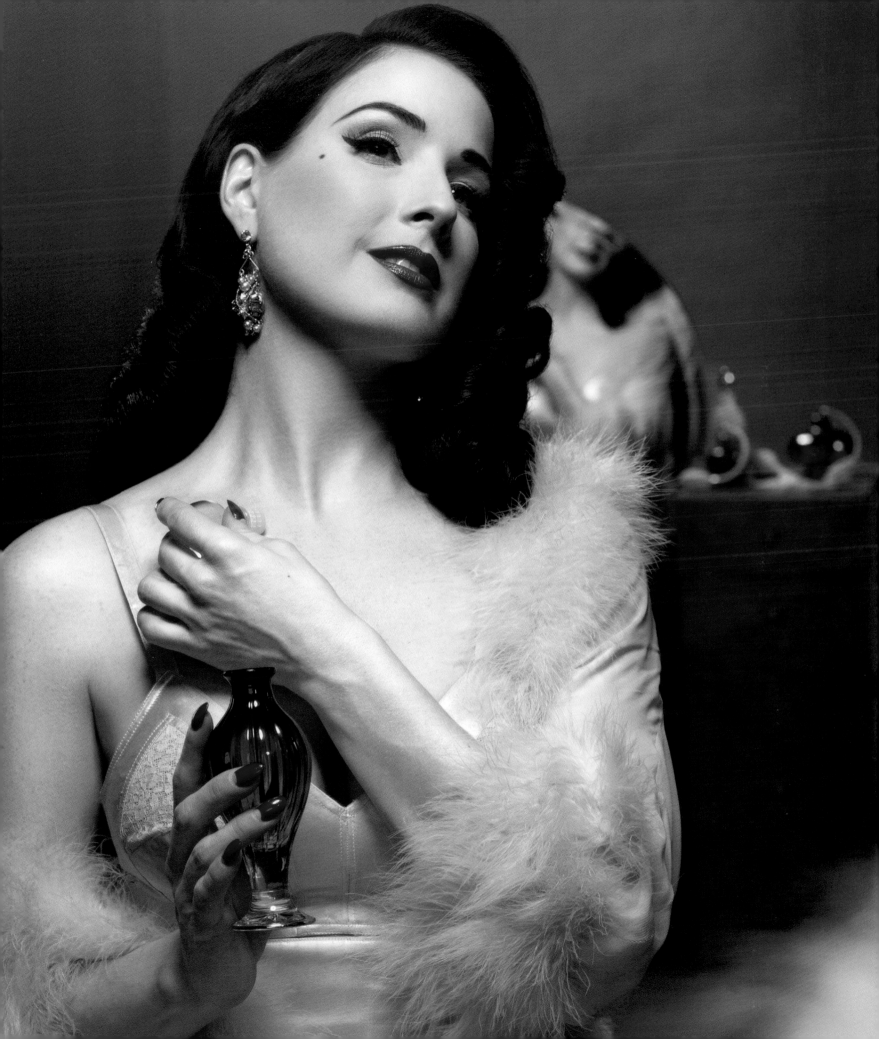

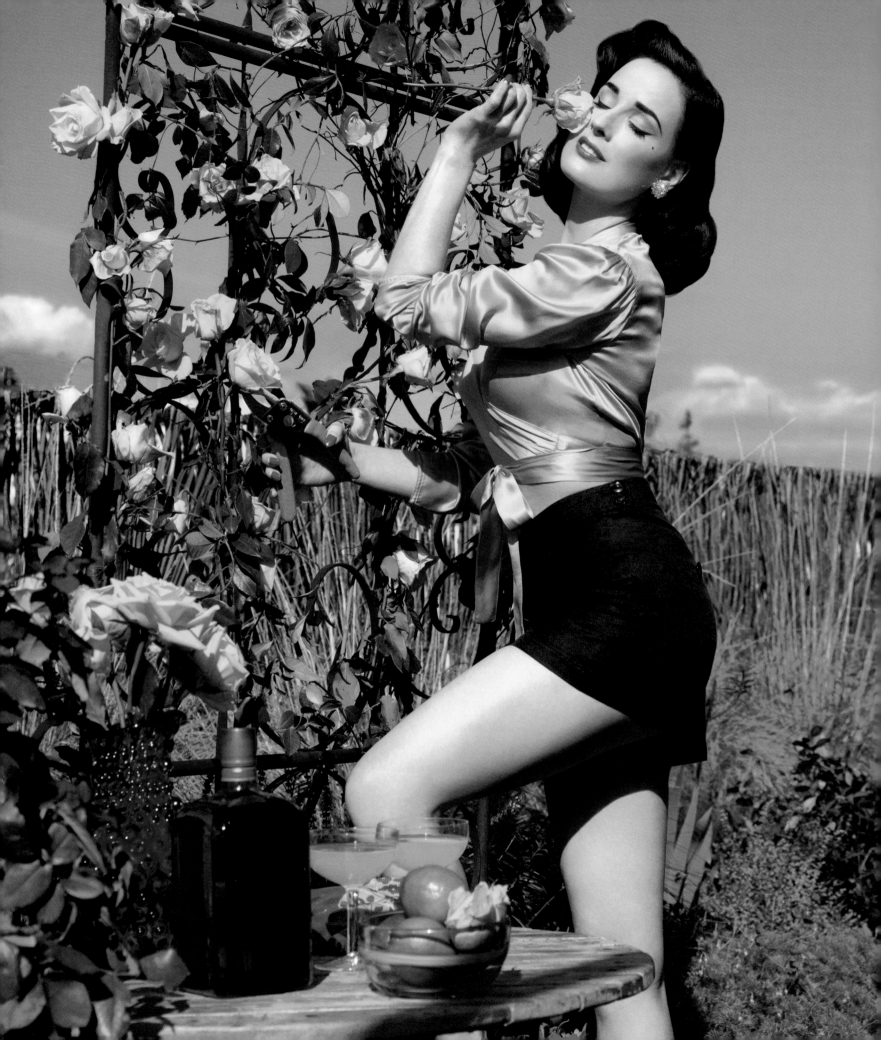

As you can imagine, I am not about to trade in on my hard-earned reputation by slapping my name on something others *think* represents me. I dye my own hair, groom my own brows. Why wouldn't I be nose-deep in the creation of my own perfume?

The German fragrance house Luxess no doubt got more than they bargained for when they signed me on. The process began at the Paris headquarters of Firmenich, one of the top fragrance houses. There I was introduced to a half-dozen premade scents, all promising to be a grand commercial success. None caught my imagination.

As I was living partly in Paris at the time, for the next year, I relentlessly dropped in on the team creating my first fragrance. A "nose" in perfume parlance is the trained individual who creates the blend. There might be thousands of noses around the world, but only some fifty who truly matter. No fewer than six toiled in search of a formulation for my inaugural perfume. I challenged them on every point. I asked questions. Our discussions were intense. We considered my favorite scents, from cut fruit to a single flower. We talked about my olfactory memories, those I enjoyed as a teen and those that had stimulated my emotions since. I inhaled an endless reserve of miniature bottles filled with raw ingredients. I told them which accords I loved and didn't.

The reworking continued until the six noses were down to two semifinalists. This duo continued to refine the juice with my every new recommendation. Make it a little more skin-like. A little less sweet. Bring up the spicy. It should linger longer. It needs a little more sex.

We were close so very many times. But knowing my name would be on the bottle motivated me to press on further. Close was not good enough. I needed to be seduced. Perfume is about seduction, and I wanted my scent to beguile the senses—my senses—before I signed off on it. I shared new blends with friends, with strangers. The team and I spent a weekend at a classic château on a grand estate outside Paris for the single purpose of refining a final scent. A pretty model would spritz various zones of her body and we would take turns sniffing her to gauge how the skin reacted to a particular formula. The winning scent had to be right on the nose.

Ultimately, the victor was Nathalie Lorson of the global fragrance powerhouse Firmenich. Nathalie is a native of Grasse with perfume in her blood. Her father was a chemist with Roure (now Givaudan). Just out of high school in the 1980s, she entered the training program at her father's company, at a time when there were very few female fragrance designers. She has since created remarkable perfumes for Givenchy, Christian Lacroix, and Isabella Rossellini, among many others.

And so with Nathalie's talent, my debut juice was a blend suggesting feminine wiles: a woman who is on the one side sophisticated and elegant, and on the other, dark, sensual, and mysterious. Combined, there is something special, magical, glamorous—the very essence of the femme fatale!

Fatale Attraction

My debut scent, named simply after yours truly, is a nouveau chypre. At the top, there are fresh peonies, fizzy bergamot, and slightly spicy Bourbon pepper. The heart is a full and pure bouquet of Bulgarian rose, Tahitian Tiaré petals, and fresh jasmine. Underscoring the composition is a base of the mystical and warm scents of patchouli, musk, and smoky guaiac wood and sandalwood.

It captures some of what I loved of my original signature scent, yet is more in tune with those tenets of beauty and glamour I live and love by.

The flacon also had to embody these ideas. For me, the *experience* of perfume is also about the vessel, the packaging it comes in, and the narrative evoked visually in the campaign. I admit I'm a sucker for all of it, and as a student of vintage beauty, I find these elements equally fascinating.

As a collector of beauty accoutrements, I have long been inspired by unusual and rare perfume bottles from the 1920s and 1930s. What variety! Flacons of faceted ruby or blue cut glass. Those embellished with hand-painted flowers or pretty ribbons. Figural bottles. Crystal ones! Atomizers with long tassels. There is something so elegant, so luxurious about them. What can I say? A decorative bottle makes me happy.

So imagine my dismay when my nice partners at Luxess presented me with sketches of a powder-pink bottle wrapped up in their sparkly notions of what is burlesque and girly. I didn't want anything sweet in it, and I certainly didn't want this. I fought it. Dear reader, being your authentic self trumps all, including a fast buck.

Part of my obsession with my favorite perfumes is the experience of wrapping my fingers around the flacon they're contained in. Take the Baccarat crystal flask of Dior No.4. The wasp-waisted corset in black Chantilly lace that couturier Marcel Rochas made for Mae West also influenced his bestselling Femme Rochas perfume, a chypre that bowed in 1945.

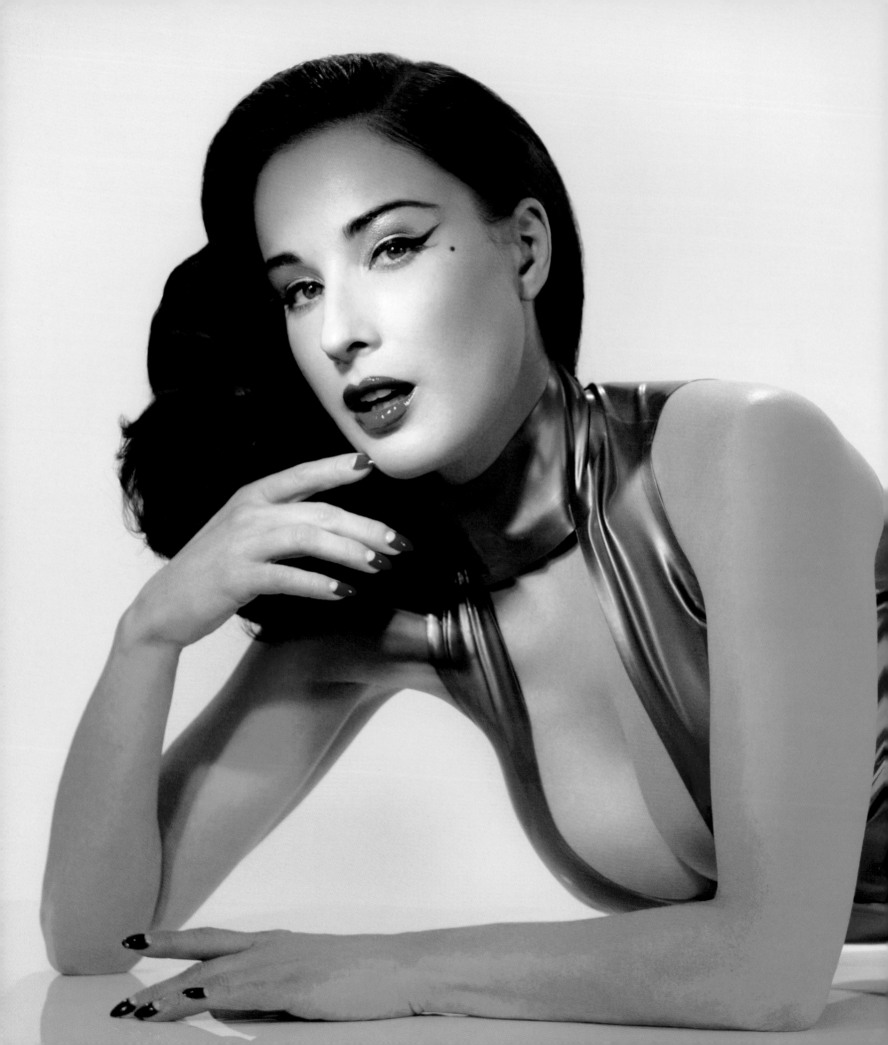

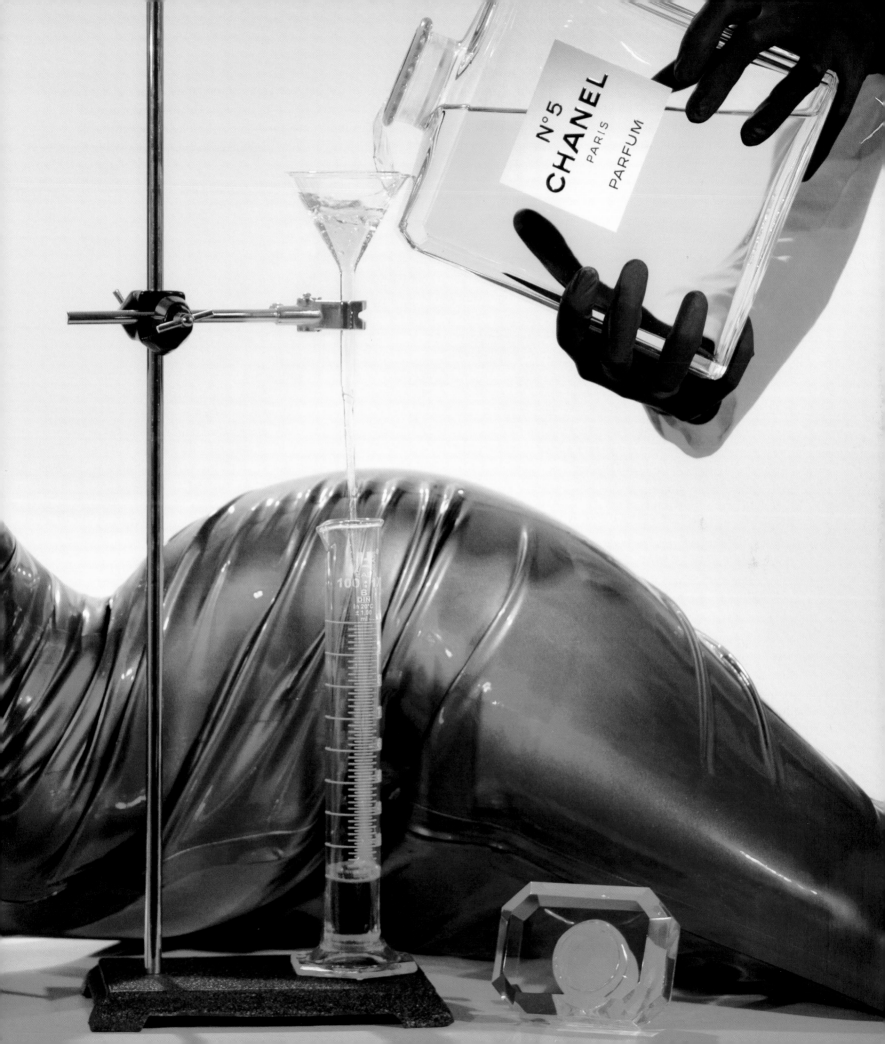

The audacious actress was already a muse to the designer. She inspired his strapless bra-girdle—called the "Waspie," or *guêpière* in French—which greatly cinched in at the waist and accentuated the bust. Rochas loved an hourglass figure, and the original Lalique crystal bottle for Femme resembled the top half of an hourglass.

Despite the homage and friendship, West didn't fancy Femme. She was already a fan of another fragrance, contained in a bottle that was also inspired by her curves, the aptly titled oriental floral Shocking that fashion provocateur Elsa Schiaparelli introduced in 1937. Fellow surrealist and eccentric beauty Leonor Fini designed the bottle, based on the mannequin West's tailor used. The flowers around the bottle's neck came from a painting by Salvador Dalí. (That West was quite the muse to the surrealists: Dalí also painted her and created the iconic red sofa inspired by her lips!)

Schiaparelli always said she never minded when others paid homage to her concepts, and she would no doubt have found pleasure in the corseted hourglass flacon that my darling Jean Paul Gaultier introduced with his line of fragrances. I love these perfumes, too, and still display his shapely bottles on my vanity.

With my own perfume, in the end, I got the scent and the bottle I wanted. I was unwavering in getting my way on every feature. The flacon for my maiden voyage into perfumery pays homage to the vintage flasks I long admired. The cut glass is raven-wing black. There is a webbed atomizer ball and around the neck, a silky cord with a nail polish–red pearl and a drawn-out black tassel.

I am proud of the level of sophistication in my debut perfume, given its accessible price, and I didn't flinch at it brandishing my name. It's not for everyone. But I know it's for me and women like me. That includes those of us who hold the conviction that our fiscal affairs should not be a hurdle in realizing our potential!

A Symphony of Spirits

When it came time to share my first perfume with the world, my creative soul mates rallied. Just as the bottle, the tassel, and the box containing it all mattered in conjuring the narrative of a femme fatale, so did the imagery connected to it.

Among my intimate conspirators was Suzanne von Aichinger. A true influencer behind the scenes at most every

important fashion house, Suzanne brought me to the salon of the grand couturier Hervé L. LeRoux. His place is in Saint-Germain-des-Prés, once the home of the legendary interior designer and arts patron Madeleine Castaing. You can feel her shadow there.

Hervé and I became fast friends, and he created a sublime, one-shouldered gown for the campaign that epitomized everything that went into the black glass flacon. Darling Hervé even selected the black gossamer silk jersey for the *belle* pair of sheer opera-length gloves that Suzanne had made me for the occasion at a glove maker in the city that has been around for generations.

Behind the lens for the campaign was the gifted photographer Ali Mahdavi. He is as masterful at capturing the sensuality of women as he is at the art of lighting.

In a studio in the 14th arrondissement—not too far from the beautiful resting place of Baudelaire, Kiki de Montparnasse, and Serge Gainsbourg—with Suzanne on set and me in Hervé's gown, Ali did his magic. Here, he recalled our session to Rose:

"It goes very fast now, our shoots, because Suzanne and Dita and I have a special relationship. The concept was clear: to go to the DNA of Dita. I don't complicate. I don't intellectualize. I work with emotion and what is essential. I prefer a graphic vision. The height of this is a black dress that embodies the powerful essence and allure of a woman like Dita.

"I set up the lighting the day before with a dancer from the Crazy Horse. Suzanne is more than a stylist and Dita more than a model, so we can collaborate and move through from setup to setup with one mind. I have photographed Dita many times. But this image for the perfume might be my favorite I've done of Dita."

It might be one of my favorite portraits, too. There is a behind-the-scenes video of the shoot making the rounds. But what is really worth watching are the couple of short films Ali created. In them, an animated line pencils in my brows, lips, beauty mark, as if I were a blank canvas, until the scent reveals the true me. Another animated beam draws along where I might wear scent. These brief films superlatively sum up the transformative potential of perfume.

A Whiff of History

The mingling and bottling of fragrant concoctions is as old as time. They have been rubbed and sprinkled for religious cere-

BEAUTY POINT WITH ROSE

Removing a Stuck Stopper

It's heartbreaking when a pretty antique glass flacon fractures. It's all the more of a possibility when a glass stopper becomes lodged into the bottle's neck because of perfume buildup.

Start by running warm water around the neck; be careful that the water does not become too scalding hot or the glass might crack.

If that doesn't effortlessly do the trick, try sticking a couple of sewing needles, point down, into the bottle's neck. Remove the needles and repeat. With a paintbrush, lightly sweep a bit of vegetable oil around the seal. Next, take a cloth in the palm of your hand and carefully grip the stopper. Wiggle gently. When it loosens, twist slowly.

The contents may have spoiled with time. But at least taking the time to remove the stopper means the vintage bottle lives to scent another day.

Do not forget to clean the container with diluted alcohol before refilling it with the same scent or a new one.

monies, healing regimens, and seductive intrigue. The record of scent follows that of the global trade and the very history of civilization.

From trading ports such as India and Persia came exotic herbs mixed into wearable bouquets during the reign of the Queen of Sheba in what is now Yemen and Ethiopia. Ancient Persians and Romans loved splashing themselves with fragrant oils after bathing and massaging. Ancient Greeks attributed the invention of perfume to the gods. A lingering scent, they believed, indicated the presence of a god or goddess.

All these first efforts came from resins gleaned from aromatic plants or, in the case of musk, creatures with four legs and odiferous glands. Then, sometime in the ninth century, the Persian doctor and thinker Ibn Sînâ worked out how to distill oil from flowers, giving rise to the very essence of what we know as perfume.

But the artistry of perfume came from the Italians and French who perfected refining techniques. From the Renaissance and into the next five centuries, the authors of the Romance languages also proved the greatest poets of perfume. While the English and Germans demonstrated a talent, to this day, some of the greatest noses in the world continue to hail from France. As with couture and cuisine, the haute pursuit of these arts is simply a part of the cultural fabric.

The Big Eau

Like lipstick, perfume can change how we feel, and how others perceive us. There is something so primal about it. Scent can arouse memories, emotions, actions, imaginations.

When poets and romantics wax on about the sensory experience the object of their desire summons, scent is foremost in their rhapsodies. It's what puts them in a haze. The very word for such an ephemeral potion derives from the Latin *per fumare*, meaning "through smoke."

The smell of blooming lilac trees and fallen autumn leaves sends me home to Michigan, where I grew up. Our backyard was encircled by hulking lilac hedges speckled in the purples and whites of these fragrant blossoms. The branches would entwine, creating a secret chamber, and, in the spring, I loved sitting under the flowering canopy, becoming intoxicated by the scent and color.

Come October, my sisters and I could be found in the front yard watching my father rake up towering mounds of dried, crispy leaves from the tall trees, waiting until the moment when he'd give us the go-ahead and we'd excitedly leap in. I would bury myself in their comforting earthiness and inhale deeply. The old house had a wood-burning stove to heat the place, too, and that wintry, smoky odor is fixed in my mind.

A whiff of Polo cologne takes me right back, too—to the backseat of my first boyfriend's car! It's such an herbal fragrance redolent of crisp autumn air and pine forests. Maybe that is why, despite turning my nose up at most masculine colognes, I have a soft spot for those smelling of pine.

Because smell can be so tied to memories, we often evoke the past when trying to put words to describe a smell. Like memories, scent is ephemeral. No wonder it seems like we're grasping for air when we try to describe them.

A smell can be effortlessly singled out—night jasmine, cut grass, old leather. And it can be a struggle to define. What doesn't require a master class in education or expertise is knowing what you fundamentally love and don't love. As you embark on your own search for a signature scent, know that your own experience and opinion counts above all else.

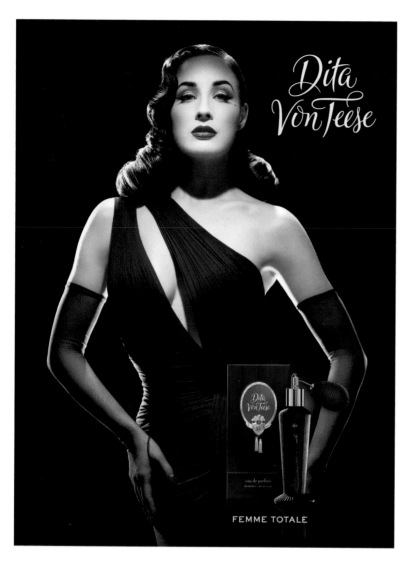

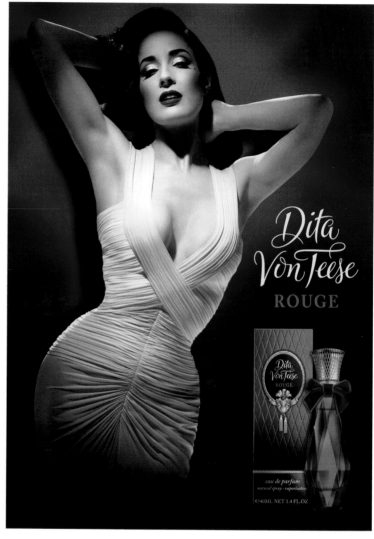

Dita Von Teese

"Perfume sets the mood . . . and I'm in the mood for glamour."

Mood: Conjures the elegant sophistication and mystery of femininity

Release Date: Fall 2011

In the Details: Lavish black glass bottles with ball atomizer

Top Notes: Bourbon pepper, peony, bergamot

Heart: Bulgarian rose, Tahitian Tiaré, jasmine

Base Notes: Guaiac wood, patchouli, sandalwood, musk

Rouge

"Perfume sets the mood . . . and I'm in the mood to seduce."

Mood: For the irresistibly sensual and confident seductress

Release Date: November 2012

In the Details: First fragrance to contain Lapsang souchong tea as a component

Top Notes: Bergamot, Lapsang souchong tea, pink pepper

Heart: Amber, guaiac wood, magnolia

Base Notes: Tonka bean, patchouli, sandalwood

FleurTeese

"Perfume sets the mood . . . and I'm in the mood for romance."

Mood: Summons the flirtatious femininity and sensuality of spring

Release Date: Spring 2013

In the Details: Color evokes lilac, heliotrope, and other favorite purple flowers

Top Notes: Casablanca lily, jasmine sambac, bergamot

Heart: Iris, heliotrope, purple lilac

Base Notes: Sandalwood, cedarwood, musk

Erotique

"Perfume sets the mood . . . and I'm in the mood to be erotic."

Mood: An aphrodisiac inspired by rare and erotic perfumes of the past

Release Date: Fall 2013

In the Details: A gilded heart-shaped lock and key at the neck of the bottle

Top Notes: Rose, pepper, coriander

Heart: Bulgarian rose, leather

Base Notes: Gaiac wood, musk, sandalwood, cedarwood

The Alchemist: Douglas Little

Calling Douglas Little a perfumer doesn't adequately portray what he does. Douglas is an aesthete who approaches everything he creates—scent, installations, sets, curiosities—with equal intensity and inventiveness. No surprise that he serves as a creative director at large for companies as disparate as Van Cleef & Arpels, Bergdorf Goodman, and Dell Computers.

Many know Douglas as the eponymous founder of D.L. & Co., the critically acclaimed haute candle company he founded in 2003 and helmed for seven years as a means of expressing scent. Even packaging matters: he set the bar for wrapping sumptuous candles in Swiss tissue paper and nestling them in elegant silk-covered boxes. They were almost too beautiful to burn. But once lit, the candles filled the room with the most sublime of olfactory experiences.

Here, Douglas, my adviser and friend through my own perfume-making adventures, shares his insight into his obsession.

Perfume is an ephemeral art. Any discussion of perfume is an inevitable struggle for words to accurately describe what cannot be locked down. Dita is a creature like that. When people see her perform or in private, you can see them grapple for the words to adequately describe her. She conjures the ephemeral.

Dita is the very face of the fantasy that is perfume.

As a child growing up in Los Angeles, I always looked for high-concept inspiration. It would come from another era or another world. I grew up in a darkroom, literally. Both my parents are photographers. As a child, I would be strapped to my mother's side as she developed her work. My dad was also a teacher of fine art and photography at UCLA, and as young as eight, I would sit in his classes.

I became obsessed with the obscure, arcane, the supernatural. By eleven, I had a garden of carnivore plants and took classes at the Huntington Botanical Gardens, learning to raise hydrangeas and the art of Japanese painting. By thirteen, I was bottling my own fragrances and selling them to my friends' moms—complete with a bonus tarot card reading!

After studying in Paris, I returned to the States to provide creative direction for a large cosmetic firm. I realized right then I didn't want to develop shampoo and clever ways to sell it to everyone. I wanted to develop the obscure, the beautiful. So I started D.L. & Co. with the intent of creating rarefied fragrances and gifts. I wanted to create the entire experience of opening the box, the sound of the paper.

Sparking the imagination is everything. Because scent is essentially invisible, there is so much that can be conveyed in the packaging, in the bottle. Perfume can transform the mundane into the exquisite. It's the first detail you notice, the last you forget.

My focus is natural fragrance. It's so unstable. Lack of rain in Florida can affect grapefruit oil conditions or prices. It's nearly impossible to get the same product twice. It's very similar to wine that way.

An important factor about scent is it's not always beautiful. Odor can be both good and bad. Often people associate the term *odor* with something bad. But there can be something very sensual in a less-than-pretty smell. We explore this, along with the mythical and botanical histories, in the courses I teach at places such as Kiki de Montparnasse, the Brooklyn Botanic Garden, and my old stomping ground, the Huntington Library.

We also explore the art of sensual application. Perfume should always be applied where you want someone to discover it: behind the ear, the nape of the neck, between the breasts and behind the knees, in the pubic region. It should never be sloshed on, but dabbed strategically to heighten the senses. It should be about creating a landmine of explosions that blow your lover's mind.

The more I study scent, the more I'm fascinated by it. It's so ingrained to a primal part of our brain. It can conjure memories we miss and some we want to forget. Scent is a really magical sense.

Prime Choice

Selecting the fragrance that becomes your signature, even building a signature wardrobe from which to draw from according to whim and occasion, is among the most essential steps in making your beauty mark.

First impressions can be everything, after all. Over a lifetime, we can identify some ten thousand smells, and each one is tied to an association or experience that becomes part of our individual memory banks. The fragrance worn on a first date might end up being the one he looks forward to smelling again and again, happily ever after (or at least while he lasts). So choose wisely.

Patience and persistence are only par for the course. A little personality self-analysis goes a long way, too, and not just your own. The cult of personality does not a good scent necessarily make, and this includes even the biggest stars and the biggest-selling perfumes. Scrutinize who is attached to a perfume. Is this who you want to smell like? Dig deeper. Consider the names on the bottles and their relationship to the fragrance. They may simply be a hired gun, a celebrity or model contracted to sell a scent with little to do with its formulation. They might not even wear it in real life.

Does this name on the bottle epitomize style, or is she known for a wardrobe malfunction? So much of what is cluttering the cosmetic counters are profit-oriented juices, quickly made to cash in on someone famous, all too often for nothing more than simply being famous. Too often, these personalities are making "style" statements informed by a hired glam squad. I was repeatedly advised to go with an existing standard with proven sales that would be rebranded in my likeness. But I resisted. My perfumes have never been runaway sellers, and I take that as a sign that I'm doing something true to myself.

If you want a rare perfume, look for a rare individual who is possibly not the most famous but is faithful to creating something with integrity, artistry, flair. An unwavering original with impeccable, influential taste, such as Frédéric Malle, Serge Lutens, or Tom Ford, is invested in the very art *and* craft of perfume. These individuals live every day dedicated to creating beauty; they strive to reveal the exquisite over the commercial.

Chasing down the perfume du jour simply because everyone is wearing it can make for disastrous effects. By its very nature, scent reacts with skin chemistry and body temperature.

The same bottle of juice will not smell precisely the same on two different people. The contrast can run the gamut—from so slight it's imperceptible to so extreme it smells like an entirely different perfume. I remember enjoying Clinique Elixir on one friend and finding it repulsive on another.

Skin texture and chemistry also changes with hormones and as we get older, so it goes to reason that our affinity for a specific perfume will also shift.

Then there are those reasons that have nothing to do with biochemistry and everything to do with the heart, as in "the great perfume incident," the story that opens this chapter involving my scent and a certain gentleman's mother.

So deep-rooted is scent that it can not only bind lovers—it can turn strangers into friends.

Scented Storylines

Against Nature by Joris-Karl Huysmans
Bitch by Roald Dahl
Perfume: The Story of a Murderer by Patrick Süskind
Jitterbug Perfume by Tom Robbins
A Scented Palace: The Secret History of Marie Antoinette's Perfumer by Elisabeth de Feydeau
Perfumes: The A-Z Guide by Luca Turin and Tania Sanchez
Scent and Subversion: Decoding a Century of Provocative Perfume by Barbara Herman
The Essence of Perfume by Roja Dove

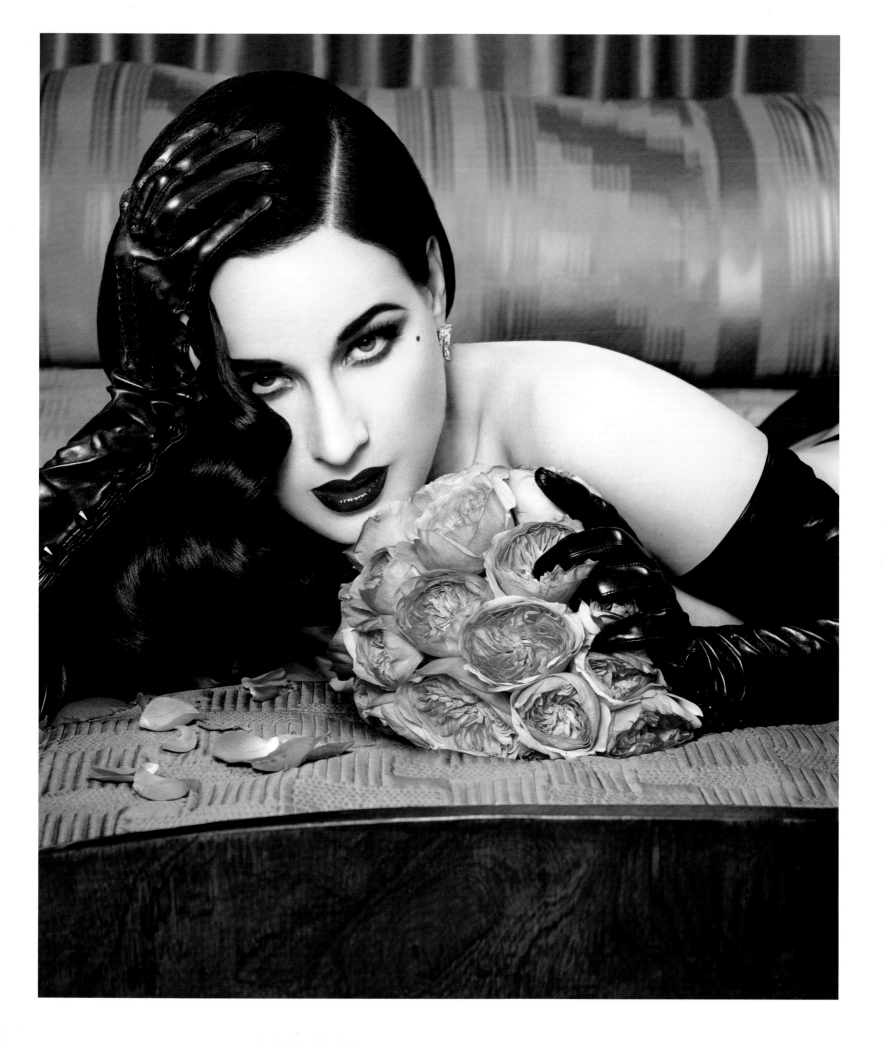

I discovered Féminité du Bois when I worked the Shiseido counter in my early twenties. The dark and honey-scented pink-colored juice is considered a milestone in modern perfumery. First released by Shiseido in 1992, it was developed by perfumers Pierre Bourdon and Christopher Sheldrake under the direction of Serge Lutens, who took it under his own house in 2009.

The richly elegant cocktail of plum, violet, and cedar, with a touch of cinnamon and cardamom, quickly became my scent at the time.

A lifetime later, I caught a whiff of it on a young woman named Misty Whiteaker. Like those who knew and loved her, I knew Misty all too briefly because of a dreadful illness that claimed her too soon during the fall of 2011.

Misty adored Féminité du Bois. At Misty's request, her mother, Karen, sent me her bottle to remember her by. I cherish it, along with her memory and, in return, have dedicated this book to her enduringly beautiful spirit.

Never feel married to a single scent, however, regardless of your love for it.

Even when I was my happiest with Quelques Fleurs, I was eager to stimulate my senses with new perfumes, occasionally trying one or another for a spell. Like clothes, scent has a remarkable power to reveal identity, and I have always loved cultivating a fragrance wardrobe that I can tap when the mood, season, day, or lover fits.

Choosing the perfect perfume isn't always easy, but it can be fun. A misfortune greater than someone soaked in too much fragrance is reeking of a badly chosen one.

Spray the wrist or inside of the elbow and, if possible, cover the area with a sleeve so it doesn't evaporate before it settles on

An Elixir by Any Other Name

Accord: The composition of three to four notes that lose their unique identity when they are blended into a new, balanced odor impression.

Animalic: Though usually synthetic now, these animal-derived substances such as musk or civet can give a fragrance a sensual depth.

Atomizer: A bottle, usually petite, for spritzing a fine mist; handy for filling with perfume from a larger bottle.

Perfume: A blend of oils and aromas. As a rule, it is 15 to 50 percent perfume oils with the remaining solution alcohol; those concentrations between 20 and 50 percent are the longest lasting.

Eau de Parfum: A solution of 10 to 15 percent perfume with alcohol.

Eau de Toilette: A solution of 3 to 8 percent perfume with alcohol/water.

Juice/Jus: The concentration of oils in a fragrance extracted from flowers and other sources or synthetically manufactured; also refers to the alcoholic solution of a perfume concentrate, and as such is ubiquitously used in the beauty industry.

Fragrance: While it's interchanged with *perfume*, it better applies to the more ephemeral part—the smell—than the total product.

Nose: The highly trained individual who mixes components into fragrance.

Top Notes: The head of a perfume, these notes are typically sharp and volatile, lasting maybe twenty minutes before evaporating.

Middle Notes: Known as the "heart," these softer, rounded notes (such as floral, spicy, or woody) appear as the top notes fade, and last from three to six hours. These and the base notes provide the character.

Base Notes: Also known as the dry-down, these slowly evaporating notes are the rich, deeper ingredients that emerge after the first half hour and last up to a full day or more.

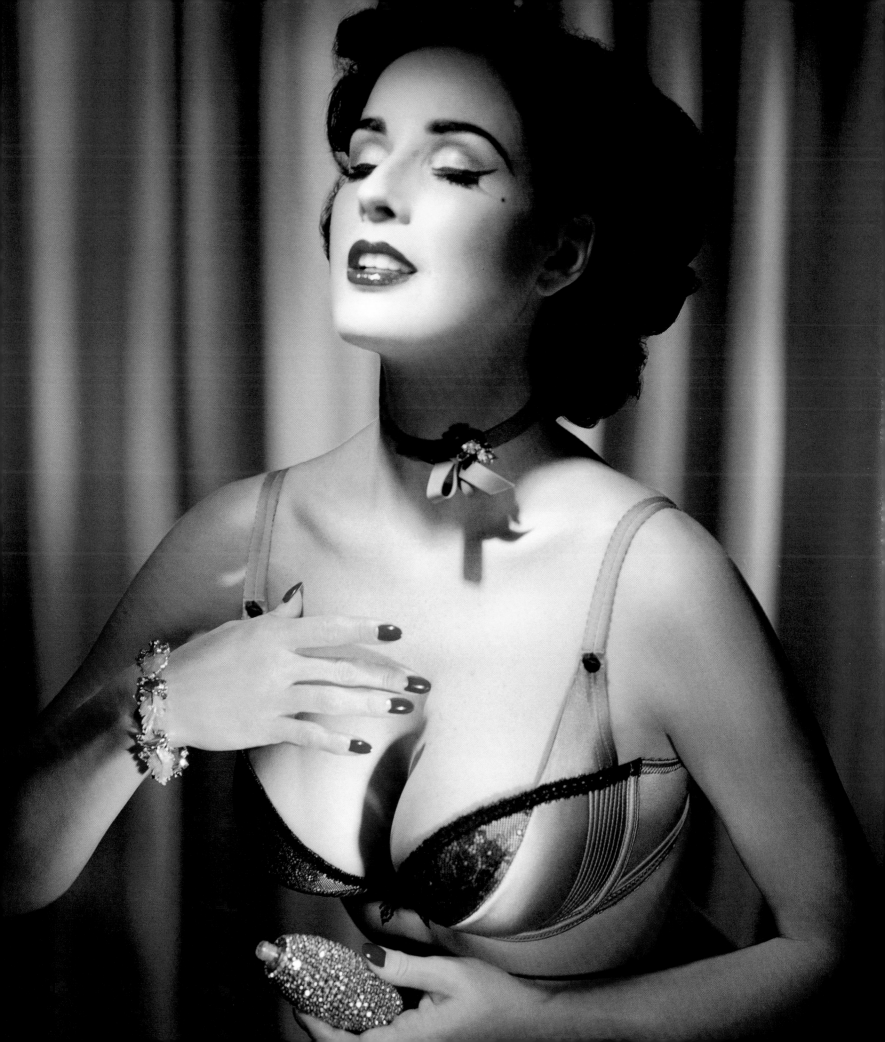

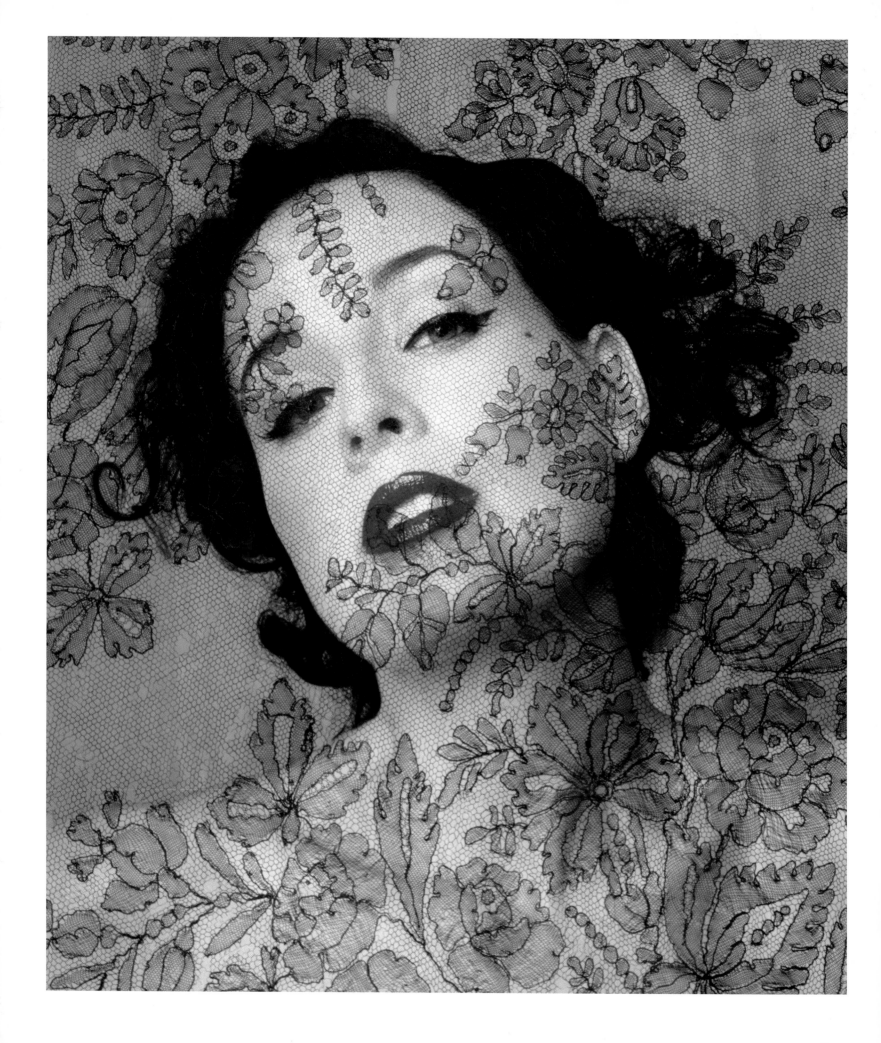

the skin. As the initial alcohol hit evaporates, the top notes will emerge. Spray a test strip, too, and do not forget to write down what is on the strip.

Spritz and leave. (Unless it's one of mine . . . then you know you simply cannot leave the shop counter without it!)

The dizzying haze of smells inside a shop is no place to get the true effect. Besides, a test is best undertaken with time enough for the accord to fully develop. If there are any samples, take advantage of them, too. Never feel pressured to buy any perfume on the spot. This is about you, not the salesclerk. As with all beauty products, before handing over your hard-earned cash, check the retailer's return policy.

Now out and about scented with this possible new potion, gauge response, and not only from friends. Strangers of the opposite and same sex and sexual orientation can prove very telling, particularly if the compliments come unsolicited.

Wear It Well

How to wear perfume? Irresistibly.

There's a fine line, certainly, between being lavish with perfume and drowning in the stuff. Or swimming in it, literally, as the outrageous Gabor sisters Eva and Zsa Zsa did. The pair claimed they would have their pool boys pour Florence Gunnarson No. 67 into their swimming pools by the gallon, despite its big-ticket price.

I like people to be able to smell me. I wear good perfume, and I like to wear it lavishly. So I like it when I walk by and they tell me I smell good, or when someone leans in to greet me with a kiss and commends me on my scent. I like smelling other people, too.

The trick is balance. It should not be about a cloud, but an aura. Others should smell you within a foot of approaching . . . never down the hall. Once it emanates a couple of feet outside your personal space, then you've really crossed the line. The aim is not to overpower but to create a veil of a signature scent.

Where to drop a hint? As Coco Chanel so quotably put it: "Wherever one wants to be kissed." So true. I start at the wrists and dab from there to the nape of the neck, behind the ears, cleavage, base of the spine, behind the knees . . . the inner thighs and ankles (especially if he's a foot fetishist). I always spray my ankles before heading out onstage to give my audience a sense of scent-o-vision! A few other places worth a spritz are a hairbrush to freshen up a do, a cloth fan or handkerchief, or a love letter (*before* writing on it!).

I love that moment when I'm readying for the day or night and the time comes for selection and application of a perfume. To be honest, I don't have a hard-and-fast rule in my ritual as to when I apply it. Sometimes it's immediately when I exit the shower or bath and my skin is still dewy. Or before getting dressed, I spray the air and walk through it naked or in my bra and stockings.

Be willing to layer perfumes, too. Layer a couple of perfumes, or layer a perfume and a scented body lotion.

Always carry a purse-size atomizer or solid form to refresh throughout the day or night.

There are certainly times to refrain from wearing a scent if at all possible,

such as in a doctor's office, at a wine tasting, or at the gym or workout studio. It's a matter of courtesy and respect. Being rude always stinks.

Scent and Scentsibility

One way to get the most bang from a fragrance is with ancillary lotions and oils tied to a perfume. From deluxe to drugstore, many popular perfumes have these extras. When I set out to create my own signature perfume, I made sure to have body lotion, shower gel, and even a deodorant spray as part of the collection.

Mixing up your own scented lotion is a snap. In a bowl, blend about 2 ounces (¼ cup) perfume with 16 ounces (2 cups) unscented lotion. Pour it into a jar with a cap, preferably something pretty.

"Perfume sets the mood . . . and I'm in the mood for glamour!"

Also consider the scent in shampoos and soaps. I choose what cleanses and conditions well *and* has a nice fragrance. Most shampoos on the market are similar in formulation, so it may simply come down to choosing one with a desired scent. Take into account when you've been complimented on the scent of your hair.

Do not confuse my love of perfume, along with scented soaps, lotions, deodorants, and even face powder, with an aversion to corporal miasma.

There's nothing like the whiff of primal attraction, no matter where the individual of interest hails from. I have found, however, that it's true what they say: body odor as aphrodisiac is not so embraced among American or Asian men or women as it is among those from other nations. I've found that European men, on the other hand, always take delight in a little body smell. And I love them for it.

Personally, I like deodorant. Concerned about the potential toxicity of conventional deodorants, I switched to natural formulations. I tried many until I found ones that work with my skin chemistry, Weleda Wild Rose Deodorant, Soapwalla Deodorant Cream and Green Tidings All Natural Deodorant in lavender (all on Amazon). They don't contain aluminum zirconium, a common ingredient that curbs perspiration by causing skin cells to swell, thereby closing sweat glands. So while these deodorize, they are not an antiperspirant.

When Good Scents Go Bad

Perfume, like any other beauty product, can spoil. The moment it's opened, exposure to air and temperature begins to compromise the juice, even its color.

Protect your investment for as long as possible by avoiding extremes. Keep bottles out of the bathroom or other places where there are swings in temperature because of humidity from bathing. This includes the warming sunlight from a window. Minimize evaporation by always replacing the cap after each use.

You never know when that well-cared-for bottle can, in fact, pay off. There's an entire marketplace online and at antiques fairs rife with collectors vying for a flask of an iconic, rare, or little-known perfume. Not all formulations remain the same, and others do not survive the trends of time, commerce, or governmental regulations. But nostalgia and novelty for vintage scents is a highly intense trade.

Still Scentillating After All These Years

If you can score a vintage formulation!

Jicky by Guerlain (1889)
My Sin by Lanvin (1924)
Cuir de Russie by Chanel (1924)
Shalimar by Guerlain (1925)
Jungle Gardenia by Tuvaché (1932)
Angélique Encens by Creed (1933)
Bandit by Robert Piguet (1944)
Baghari by Robert Piguet (1950)

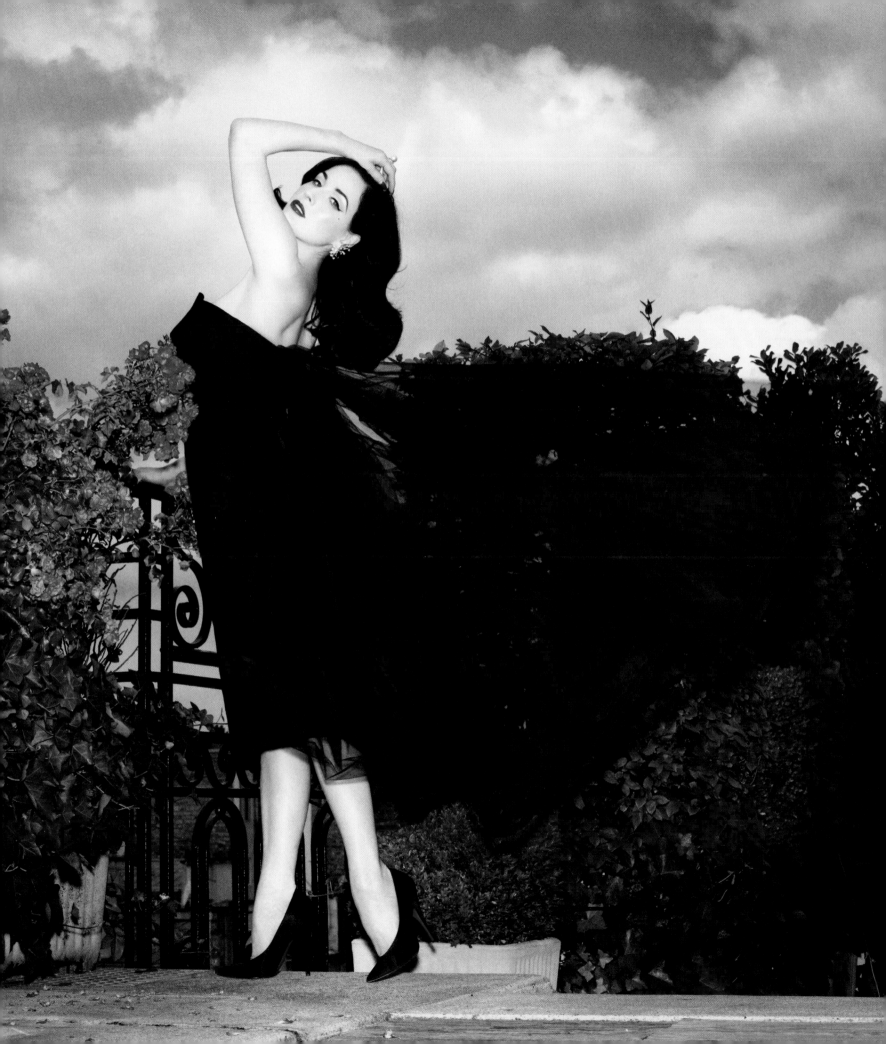

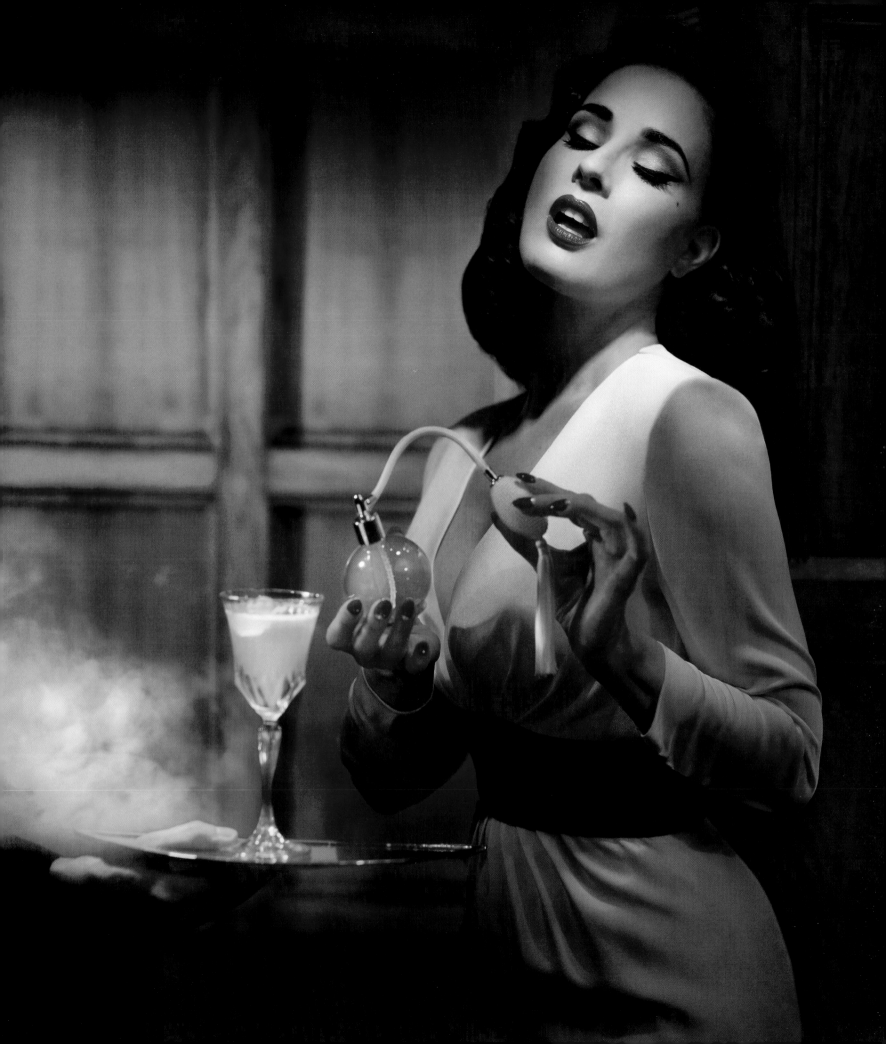

Evoking the Past

The fashion of fragrance is not immune to the pendulum of trends, and as of this writing, perfume makers were responding to a reviving interest in the kind of headier juices that personified the glamour goddesses of the 1920s through the 1950s.

And as is always the case when contemporary whims flash backward, an interest in the forerunners—in this case, the actual vintage perfumes—has also piqued collectors. And no one loves collecting more than me! One voice I've come to trust is Barbara Herman. Her blog, *Yesterday's Perfume,* is a favorite source, as is her book, *Scent & Subversion: Decoding a Century of Provocative Perfume.* Barbara's aptitude for vintage perfumery proved an invaluable guide as I developed my fourth fragrance, Erotique. That this scent immediately garnered praise from passionate perfume bloggers with nothing to gain from advertisers only validated my own conviction to go with what I love, even if it went against the commercial wisdom of "celebrity scents."

What's key when collecting vintage juices is that they must be from as close to their original release date as possible. All too often, formulations alter even slightly as prices for the ingredients fluctuate or governmental policies deem them no longer fit for public consumption (even though it might take hundreds of gallons of an individual substance to actually do any damage). The fact that they might no longer be, well, "street legal," to steal a phrase from perfume critic Chandler Burr, possibly makes them all the more covetable in their original formulation.

Among my favorite vintage perfumes is Bandit. I love everything about it, from the original ads to its formulation. It has been described as among the most daring of scents from the last century, made for the most daring of women. Count its creator among them. The beautiful, towering Germaine Cellier was among the first women considered a master nose, and fashion houses sought her for her expertise in original, bold scents. When former Paul Poiret designer Robert Piguet set out on his own, he engaged Cellier, and by 1944, her efforts came to fruition in Bandit.

With the distinction of containing one of the first leather chypres in perfumery, the original formulation included 1% isobutyl quinoline to imbue it with a powerfully sexy, leathery character. This, combined with sharp galbanum, blunted the sweetness of heart notes of rose, carnation, and jasmine. Inspired by the romance of the sea and pirates, the scent had its first public release on the runway, with models draped in couture Piguet along with villainous masks, toy revolvers, and knives. It's also been described as the scent of a dominatrix. Is it any wonder it was Marlene Dietrich's signature scent?

The original ads exploit its inspirational cues, specifically one of a surreal black-and-white photograph by Pierre Jahan from 1947 showing the bottle being broken open by way of a dagger.

Although Bandit relaunched in 1999, with a new formulation by Delphine Lebeau of Givaudan, like so many replications in life, it pales in comparison to the original. Some of the original juice formulations can still be found online with a bit of perseverance and luck.

PART TWO

Cosmetically Yours

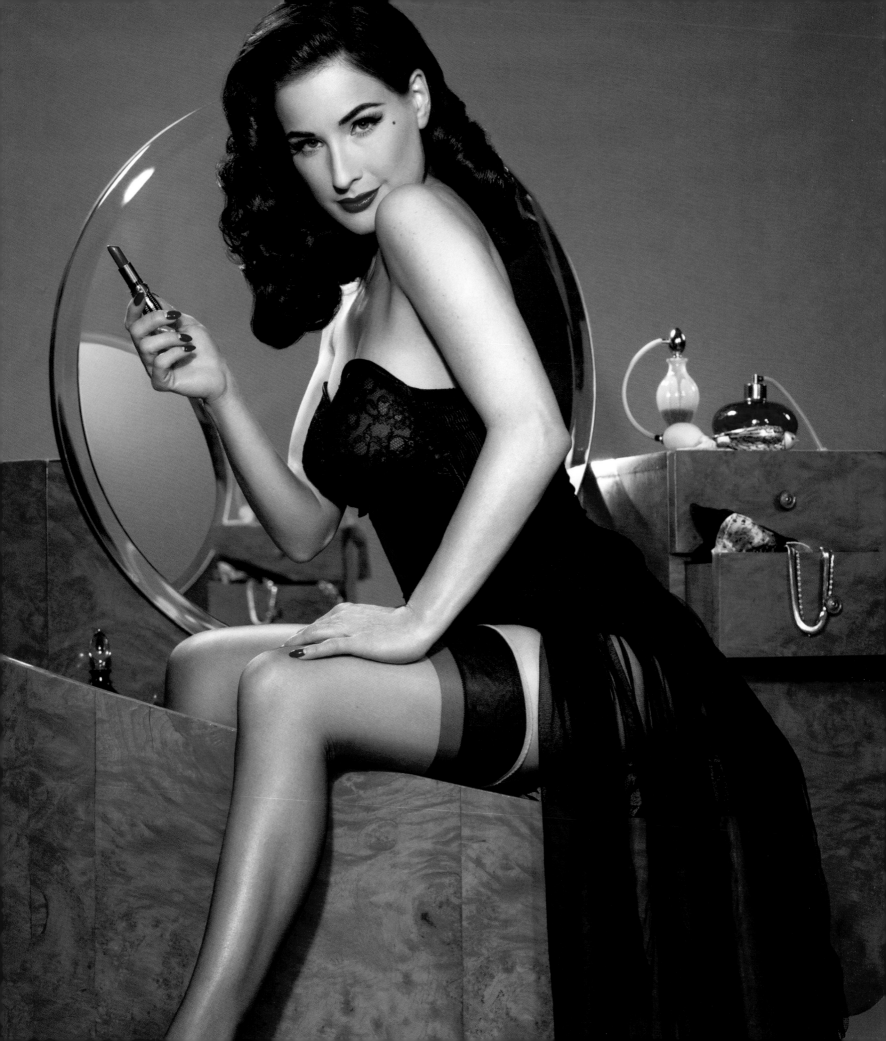

Kiss and Makeup

"To be beautiful is the birthright of every woman," declared Elizabeth Arden, the trailblazing cosmetics entrepreneur.

I couldn't agree more.

To a new century of women who weren't going to abide by the old rules of gender, class, or beauty, Arden introduced the very notion of a makeover, notably the "Total Look." Applying makeup, painting fingernails, setting hair into a do—all the facets in the beauty ritual—came together in what she called "exterior decorating."

Much as an interior decorator transforms a blank space by highlighting its assets to create a room that is truly extraordinary, exterior decorating is about an

individual considering her best features and what colors, textures, lines, and, ultimately, unique (dare we add, eccentric!) flair will transform a naked face into something appealing, engaging, possibly even extraordinary . . .

Think of it: even so-called "natural" makeup still involves a few tricks courtesy of cosmetics to really amp a gal's best attributes.

When it comes to making our beauty mark in this world, the kind of "interior decorating" that counts is having a generous attitude and a generous smile to match—and the latter will make all the more of an impression with a swath of bright lip color from a well-stocked cosmetics kit.

Makeup is not a privilege. It is not a luxury. Sure, there are store counters packed with premium products and brands that even sneaking a peek at will cost you. But, really, no one is the wiser whether that lipstick on your face set you back five dollars or fifty.

Makeup is as essential as shelter and bread. Don't just take my word for it: The U.S. government, in all its infinite wisdom, recognized during World War II that women considered lipstick not only a necessity, but representative of the very definition of freedom and democracy. So while seamed stockings made the list of rationed items, lipstick did not.

In matters of beauty and struggle, whether it was the Great Depression of the 1930s or the Great Recession of recent memory, studies show that when the economy drags its feet, women manage to look at life face-forward with whatever cosmetics they can score.

Is It All Just Hope in a Jar?

Yes. So what's wrong with a little dream, an aspiring desire in the form of a pot of rouge or a flask of perfume with their promise of a better day?

The promise of a better, more beautiful desire came in the form of an endearing proclamation by one of my French beaus. The love letter read, "*Tu es ma crème de beauté . . .*" and went on about how our affair rejuvenated him. It was tantamount to that expression "You make me want to be a better person," and certainly charged the romance . . .

Translation? "You are my beauty cream." Darlings, if I could bottle the sensation of brand-new love, I'd be the next Estée Lauder!

I'm also reminded of an afternoon a lifetime ago during my shift behind the counter at Shiseido. A gentleman appeared, his poise in selecting colors and products immediately piquing my curiosity. As I helped him with his shopping, he shared with me that his wife was ill from cancer. It had become increasingly taxing for her to do her own makeup. He understood this, so he learned how to apply her eye shadow and cheek blush. His wife's body might have been failing her, but her desire to feel beautiful was not. That remains one of the most romantic stories I have ever heard.

I am also crazy for those women belonging to the Grandes Dames Club. This is not a real club. Its constituents are women of a certain age whom my friends and I have "collected" in memory, ladies like our great-aunts who are still wearing their makeup and hair the same way they always have, since their glorious days of wine and roses and valentines sent by admirers. Or at least that's what we like to imagine.

I was at the Long Beach Antique Market at Veterans Stadium when I spotted a lady who was undeniably a card-carrying member of the Grandes Dames Club. She was on a lounge chair positioned like a throne on a wheeled platform. Pushing the four-wheeled sight was her much younger paramour. He was probably in his late sixties. He was also clearly still smitten with his queen after all these years.

In my mind, I could imagine her resolve: "I may be old, but there's no way in hell I will ever be in a wheelchair. I will sit in this chaise longue and *let* you push me."

So here was this grande dame, seated on her platform, clad in a lavender pantsuit and matching lavender gardening gloves to protect her hands from the sun, a huge hat atop a platinum wig styled in marcel waves. Her face was colored with a fearless amount of coral lipstick, aqua-blue eye shadow, and black eyeliner dragged out into a cat outline. The Mister had on a matching lavender pantsuit, too.

After lifting my jaw off the ground (because, as you can imagine, it free-fell at such an inspired sight), I started following them. *Who is that? I need to talk to her*, I thought, along with the truly impossible, *How am I ever going to get a picture?*

At one of the stalls, I acted as if we were inspecting the same item. "I really love your makeup," I told her. She responded in kind, and with one of those transatlantic accents that seem to exist only in vintage movies.

I admired her eyeliner. "Oh, it's not as easy as it used to be, my hands are a little shaky now," she confided.

"You know, you look so beautiful and amazing," I continued, fingering my phone with its camera, tucked inside my pocket. I

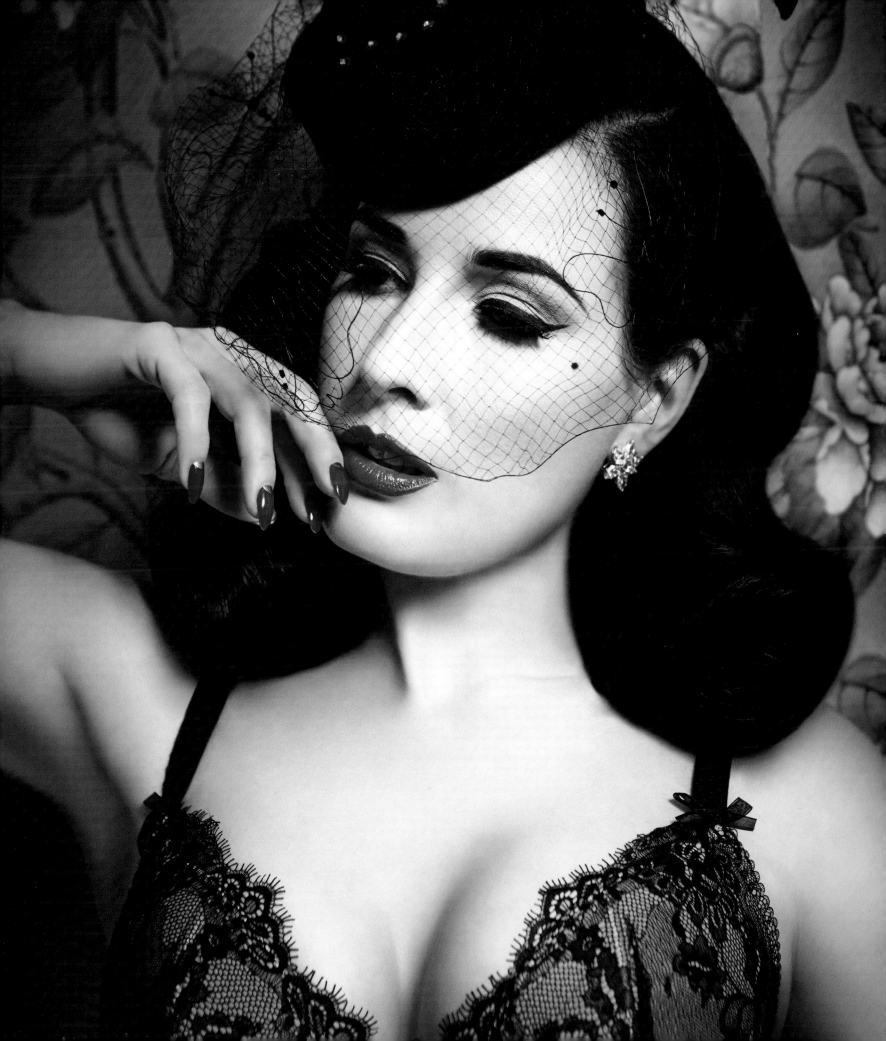

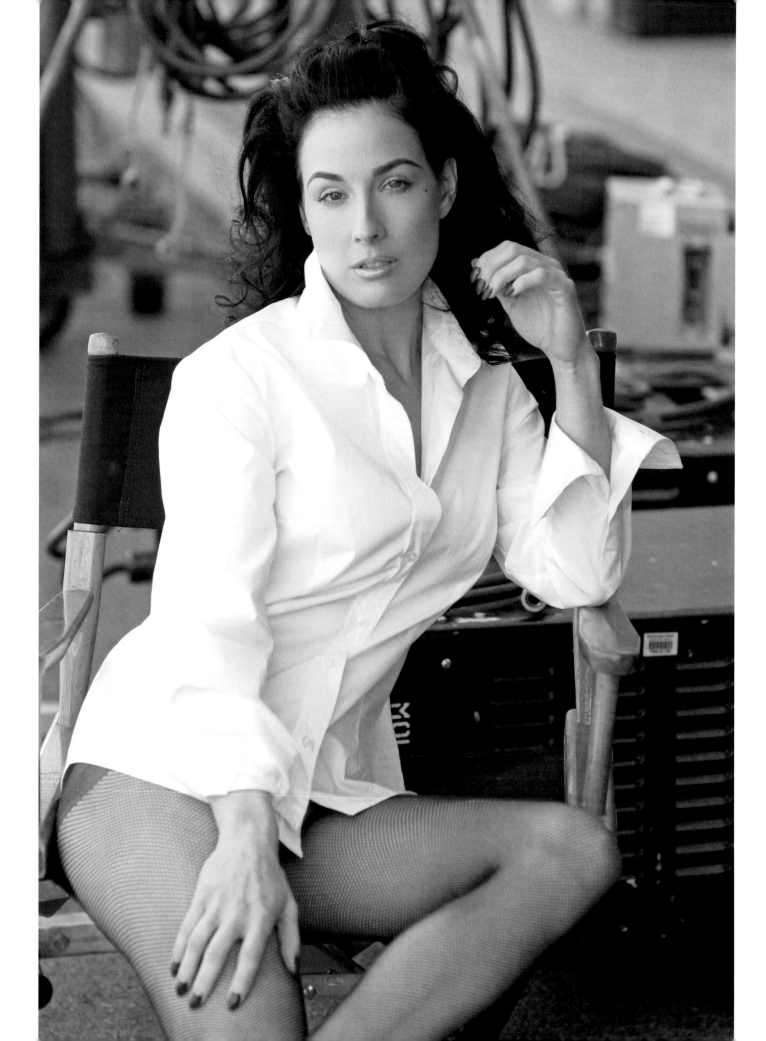

was reluctant to ask for a photograph. For starters, I can be terribly shy about approaching a stranger. But I also know what it's like to be out and about on my off time when someone takes a photograph of me. I especially don't appreciate it when it's done without asking me first. Even then, if I'm under the weather or not feeling my best, I might politely decline. So I spoke to this glamorous eccentric with trepidation: "I'm doing a beauty book and, well, I was wondering if can I take a picture of you?"

"Oh, no . . . remember me as I am, *dahling*," she responded kindly, in a moment of elegant, high stagecraft under the blazing sun. "But thank you for asking first."

I had the feeling I wasn't the first to request a photograph. I also got the feeling she had long ago been used to having her picture snapped, possibly as some kind of showgirl, maybe a B-movie star. One does not have such an intimate relationship with that much makeup and end up with a "younger" guy pushing her around by only clocking in the hours behind a coat check counter.

It took courage on my end to ask her for a snapshot. But I was not about to disrespect this rare bird by ruffling her feathers for my own gratification. That's no way to treat a lady.

I remember marveling to myself, *Someday, I am going to be with a man who will push me around on a platform . . . and we will both be wearing matching pastel pantsuits.*

Visiting this antiques market is part of my routine when I'm home in L.A. And on each visit, I look for her.

Everyone, no matter her or his stage in life, has the right to *feel* beautiful.

While the heroes of both these stories (the ailing wife of the man at the Shiseido counter; the grande dame at the antiques market) were driven by their desire for beauty, likely the one VIP they were each most interested in charming was the very individual who appeared to be at their call: their husbands. I do not believe there is anything old-fashioned or meek in making oneself beautiful for a love interest. This reminds me of one of my favorite phrases: "gilding the lily." Why not gild the lily—that is, use makeup and perfume and anything else you like—to make you more attractive to a lover?

Young Priscilla Presley, with that mountain of coal-black hair and even blacker eyeliner, had an amazing look. I can only imagine Amy Winehouse, may she rest in peace, thought so, too. Elvis (no stranger to a bit of eyeshadow and eyeliner himself) never saw his teen bride without it, or so goes the legend. Priscilla would slip out of bed early and put her glam on before he laid eyes on her. I'm not going to judge whether that is right or wrong or even weird. This was Planet Elvis, after all. Young Priscilla did it for love, and Elvis certainly worshiped her for it (at least while it lasted).

And I am a sucker for stories like that.

More Is Fabulously More

Personally—and let me make this perfectly clear—I am not embarrassed to be seen without makeup by the men or close friends or family in my life. I am not about to go to bed with a full face of makeup, and I am certainly not going to rise before a lover in order to get my drag on.

I wear makeup *not* because I am embarrassed about how I look without it. I'm not trying to hide anything. I just really, really enjoy it. I love what it does for me, how I feel with it on. What's wrong with that?

When I have my beauty on, I feel like I can rule the world. I like the sense of transformation, not just physically but inside. No one can say "no" to the girl with the black hair and the red lips. Or at least I like to believe so . . .

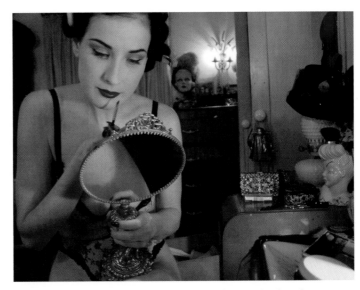

A memory in snapshot form, taken by my former husband.

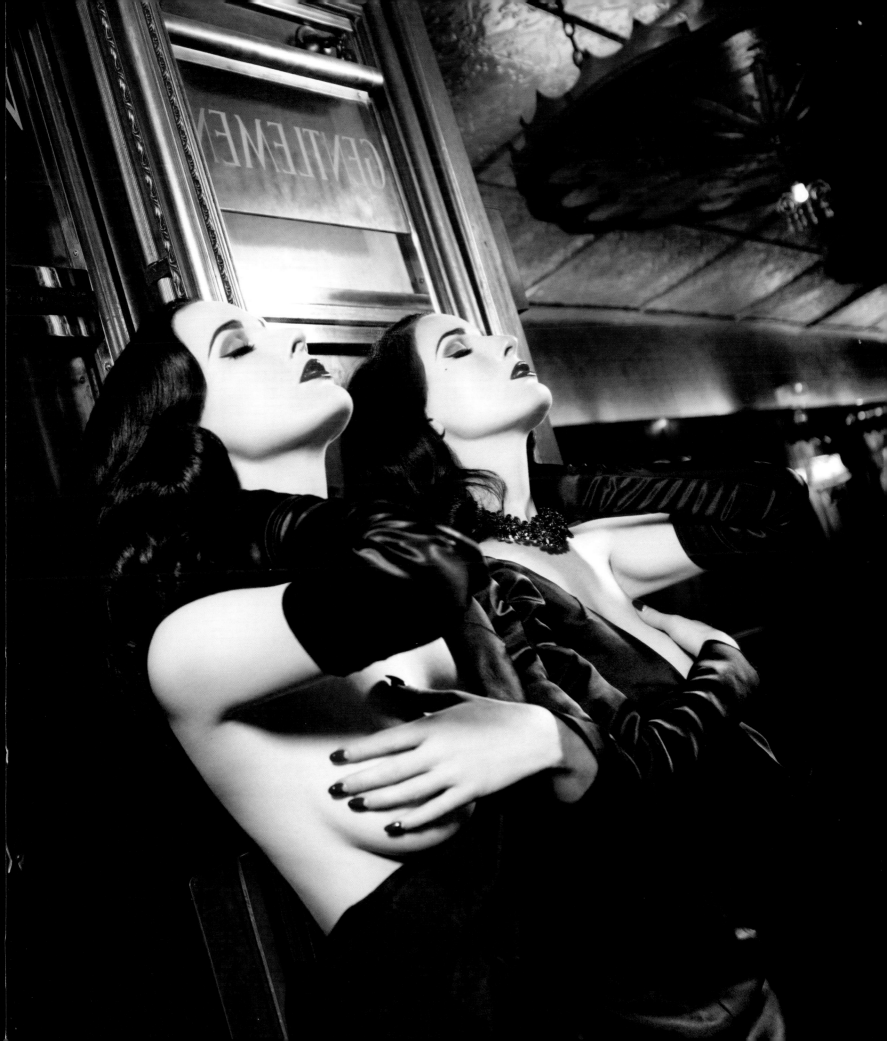

Call it a sense of confidence. But don't call it superficial. It might all come off before I hit the pillow at night, but it's as second nature as breathing. Consider this: it takes just as much time for a gal to brush her hair and pull it into a smooth bun, apply lip color, and throw on a dress and a pair of ballet flats as it does for another gal to slather on bronzer, strategically muss up bleached hair, and throw on jeans and a hat. So much effort to appear too cool to care, when it can actually take more time than looking polished.

I love it when people compliment me on my makeup. There are those who insist makeup should not be visibly noticeable. But I actually appreciate it when it is.

Ellen von Unwerth once told me: "I love photographing you because you love makeup." What a marvelous thing to be told!

The Prima Donnas of Powder: Elizabeth Arden and Helena Rubinstein

Makeup is as much about reinvention as anything, and two individuals who epitomized this through their trailblazing entrepreneurship and imagination, self-made personas, and wealth are the legendary Elizabeth Arden and Helena Rubinstein.

They are the subject of a worth-watching 2009 PBS documentary called *The Powder & the Glory* by Ann Carol Grossman and Arnie Reisman. The ephemera scattered throughout the program alone is worth making it part of your library.

These women were not born into affluence. Neither of them was particularly handsome. But a DIY spirit and championing of aesthetics beyond their businesses—Arden was an avid collector of horses, Rubinstein of modernist art—made them the wealthiest women in the world and the unrivaled queens of a beauty industry they helped create.

Chaya Rubinstein couldn't even speak English when she left her native Poland for Australia in 1902. But her experiments with herbs and lanolin quickly changed her life. She opened a salon, became Helena, and a thriving business took her to London, then New York in 1914, where her empire really flourished.

New York was also the re-birthplace during this period for the Canadian-born Florence Nightingale Graham. Whipping up new creams and other skin care concoctions of her own, she adopted her new hometown along with a new name by borrowing the first from a former beauty business partner and the surname from the Tennyson poem "Enoch Arden."

While the two couldn't be more extreme in their appearances—Arden was tall, while Rubinstein was about four foot ten—their lives mirrored each other, and likely fueled their rivalry: revolutionary innovations in formulations, marketing, and package design; dozens of signature salons worldwide; celebrity clientele and endorsements; and receiving (or taking?) credit for recognizing the benefits of science in cosmetics and touting that to great sales effect.

In fact, Arden and Rubinstein espoused another business rule that remains as valid as ever: their financial success lay in *creating desire*. Both entrepreneurs went to great effort early on to ensure their brands were associated with the exclusive classes. Arden and Rubinstein recognized that the higher the price for something, the more women wanted it. (A high price is usually just that—a high price.)

They were fiercely independent, married more than twice, and died within eighteen months of each other in the mid-1960s. Sadly, their rivalry kept them from ever speaking to each other, something they didn't boast about, but certainly were not shy in offering when pressed during interviews. Since their deaths, the brands these women built have changed hands many, many times, and in recent years, the powers that be at both companies have recognized the strength in paying tribute to their visionary founders.

After all, it takes an original to make her own beauty mark on the world.

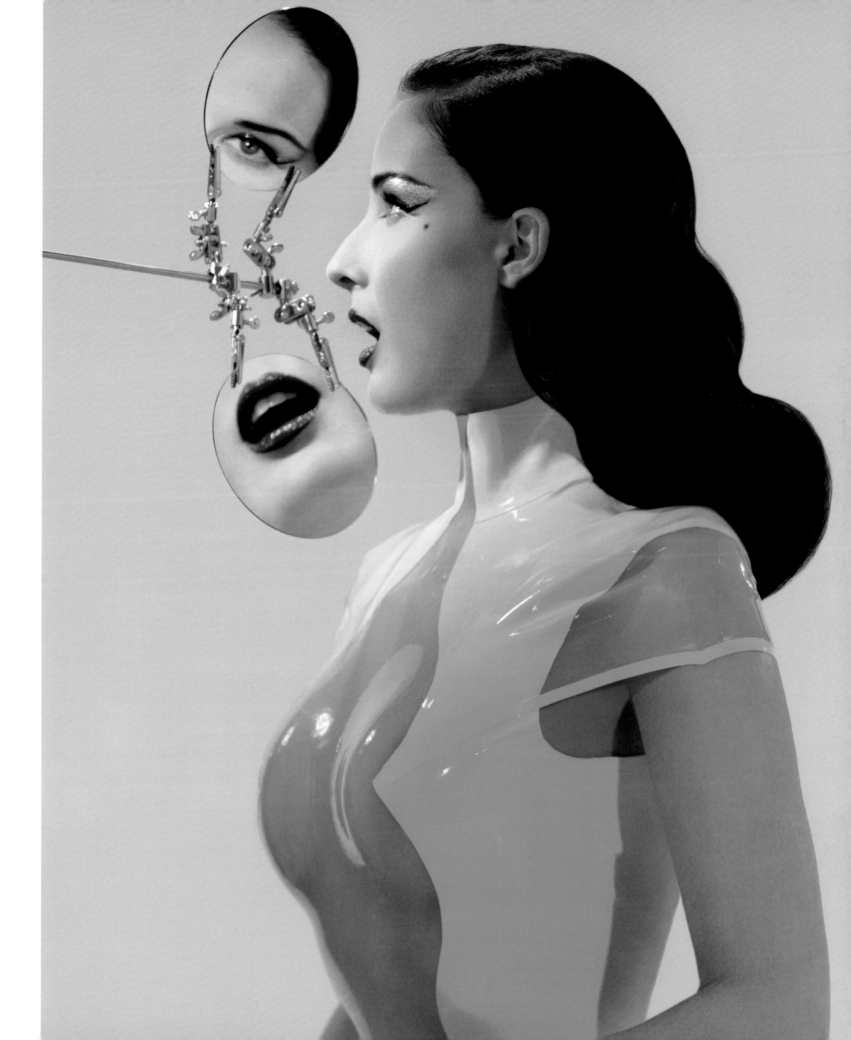

Ellen and I got along famously over our love of makeup. When I first met her on set in Paris, I was overjoyed when she found me in the chair and asked the makeup artist working on my face: "Can we do *more* lash, *bigger* cat eye . . . ?" She just kept demanding "more, more, more." I was so happy. My biggest risk is sitting in the chair before a shoot and not getting enough!

The beauty ritual is integral to who I am. It's what makes me a showgirl. Can you imagine any burlesque star in the history of showgirls venturing onstage with no makeup and no hairdo?

There isn't one legendary showgirl or sex symbol in history who didn't do it up to the hilt. Look at Blaze Starr, Lili St. Cyr, or Sally Rand. Likewise, no one can argue the maximum appeal of Marilyn Monroe, Jane Russell, Sophia Loren, or Brigitte Bardot.

A showgirl is about glamour. I firmly believe every gal, even a Plain Jane, fantasizes about those special days in her otherwise "normal" life when the beauty ritual is not an option. Think of that scene in *Gypsy* in which Natalie Wood as Gypsy Rose Lee looks in the mirror, lipstick and all, and marvels, "I'm a pretty

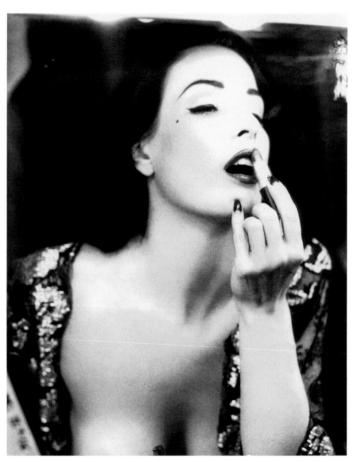

More is more in the world of photographer Ellen von Unwerth.

girl." Everyone desires that moment. Everyone *deserves* that moment!

Mind you, I don't wear a full face of makeup every time I step out the door. It doesn't make sense if I'm heading into Pilates or a scrub and steam at the Korean spa. I also keep it simple when I hit the antiques flea markets. It's usually ninety degrees, or at least it feels that way on the black pavement. I wear a hat, sunscreen, sunglasses, and lipstick. Always lipstick.

I remember the time I was in London for my first book launch. I was dead-to-the-world asleep in my hotel room thanks to a heavy touring schedule around Europe and the inevitable jet lag, when the phone let out one of those harsh, jangly rings. "Are you ready yet?" my former manager trumpeted, sounding more stressed than usual. I was already late, and here I was at zero in terms of prep. I hate being late.

"Give me half an hour!" I pleaded with all the optimism I could muster. In what I recall was more like thirty-four minutes tops, I was inside an open-air carriage that was saturated in Harrods's signature green and gold. Between bed and carriage, I had managed to pin my hair into Victory Rolls, paint on the most minimal of glamour essentials—red lip, cat eye, defined brows—and slip into a tissue-thin, bias-cut midnight blue gown by Moschino and matching satin Louboutin slippers.

Inside the carriage, I felt like the queen as I waved to the crowd of *thousands* of screaming Londoners who had gathered in front of Harrods for who . . . *me*? I had done Jonathan Ross's TV show the night before, but had no idea that would mean so many more people were going to show up. Harrods had planned for maybe four hundred guests. My head was still spinning from the speed dressing, let alone the turnout. I became so emotional at it all and almost began to cry, because I couldn't believe they were all there for me. Of course, I held it together and smiled through that glorious day. There was no time for touching up smeared makeup!

Would I have preferred hours of leisurely preparation? Definitely. But life rarely turns out according to plan. Had I arrived in that carriage looking as if I didn't have time . . . had I arrived hours late . . . well, it would have been an ill-mannered way to treat all the wonderful admirers who had taken the time to share in the festivities. Take this to heart even if your day doesn't

One of life's greatest luxuries? Time.

Whether you have three minutes or three hours, it is all about being organized. Book a slice of time monthly to take inventory of all your cosmetics and make a list of what needs to be replaced or introduced into the mix. (During my go-go dancing days, my friend and I would get together with our respective kits—and Caboodles!—and use it as an excuse to catch up on bad TV and good gossip.)

Make a list and restock everything that is missing. Now make a clean sweep. You wouldn't want to brush your floor with a filthy broom. So why apply makeup with a dirty brush?

At least weekly, run all the brushes you used during the week under warm water. With a drop of shampoo (preferably one formulated for babies), lather up the bristles. Rinse until the water runs clear. Squeeze out excess moisture, reshape, and leave to air-dry, laying them flat on a clean towel. Since brushes are out of commission until thoroughly dry, it's best to leave this chore until right before bedtime or after a morning face application. Product can also carry its share of bacterial nasties. Keep containers clean and, when not in use, closed. Replace, at minimum, annually. Mascara should be changed more frequently, monthly, if possible.

Monthly, break the pattern and schedule a decent block of time, most advisably before a special affair, to experiment. Knowing you have all the time in the world to really savor each moment and each beauty ritual can be a boon to your mind, body, and soul.

I often start with a twenty-minute dance party. Yes, by myself, or, if I'm lucky, with a friend or three present. Then I bathe, set my hair, apply makeup. All the while, candles are burning, the tunes are blasting (see page 16 for my beauty makeover sound track), the bubbly is popping, and the outside world remains out there. All that matters is the here and now.

Of course, time *is* ticking. Among the perfume bottles and vintage vases packed with cosmetic brushes on my vanity sits a *working* clock. A more realistic time frame for getting my drag on daily is thirty

involve a horse-drawn carriage: it is a matter of decency toward our fellow friends and strangers to look our best. Anything less is just rude.

You should have seen the women that day, too! Hundreds of them, beautifully dolled up, from the Victory rolls on top of their heads to the red toenails visible from peekaboo heels.

It takes me back to another cherished stop on memory lane, also with Moschino. In 2006, the Italian house's runway show paid tribute by sending out a dozen models before me, fashioned in makeup and hairdos inspired by my look. It wasn't the fact that they resembled me, however, that gave me goose bumps (okay, maybe it did a bit). It was seeing all these women, some of them well-known queens of the catwalk, styled in my *ideal* beauty look. After all, I wasn't the first to brandish red lipstick and cat eyeliner and a beauty mark. And I won't be the last.

They looked stunning, glamorous. I only hoped some of them would see themselves in the mirror and think so, too, and, just possibly, try a little red lipstick in real life.

minutes. I can also do it in ten minutes flat. No matter the time, success without stress lies in prioritizing and being organized.

Stellar Effect in Retrograde

What is it about the beauty looks of the 1920s, 1930s, 1940s, and especially the 1950s that more than a half century later inspire so many women, including yours truly, to regard them as the foundation for our everyday beauty?

Be aware, dear reader, that for me and so many of these women, more often than not, the look isn't bound by a single decade (as the following chapters will detail). My makeup echoes the cat eye and red lip of the 1950s. My hair references the stylized sets of the 1940s. My nails are an updated take on what was all the rage during the 1920s and 1930s. There's something timeless, dare I say, modern, about the mix, since the aim is to take what's most flattering and make it your own.

Those decades embody glamour. The first part of the twentieth century experienced an unrivaled alignment of forces that took cosmetics out of the realms of the morally questionable classes of actors, coquettes, and prostitutes and upgraded the artifice of beauty as something of a gloriously appealing statement of self-determination. Over the previous centuries, "glamour" was considered a kind of spell, a mysticism of exotic charms cast to impel someone into devotion.

Motion and still photography shifted the concept to the magic of film and lighting, trickling notions of glamour across fandom like so much fairy dust. Likewise, the suffragette movement empowered legions of women to rock the vote—and the world. Planes, telephones, and automobiles heightened a free exchange of aesthetic influences. A rising middle class put all these revolutions within the grasp of the average gal.

Both women and men revealed their aspirations for a better life in the way they looked. Think about vintage snapshots from that time. Not one family member is hanging out in sweatpants. Even the poorest folks put on their finest, day after day, out of respect for themselves and others. I know I feel life is a little better when I look my best.

Why This Face?

There is an Irving Penn photograph I'll never forget because it motivated me to try black cat eye liner on myself. I must have been eighteen. In the image, the eye is reflected in the mirror of an open powder compact. I saw something striking, something feline, unnatural, in that eyeliner that made me obsessed with the look.

I thought, *I don't have eyes like that, but I can certainly change the shape with makeup.*

Another life changer was Erwin Blumenfeld's iconic photograph of model Jean Patchett. Actually, the image, which appeared as a *Vogue* cover in 1950, features only her crimson lips, arched brow, flawlessly lined eye, and beauty spot. Collectively, at least to me, these features are the very essence of glamour, and why I have also made them my hallmarks.

Blumenfeld, Penn, Richard Avedon, and Lillian Bassman and their model collaborators, such as Patchett, Lisa Fonssagrives, Suzy Parker, and Dovima, continue to hold our collective awe and admiration because they conveyed beauty and glamour in a nearly effortless, instinctual way. These women were the supermodels of their day, and they were super for reasons beyond their looks. In those days, there were no beauty or wardrobe

Glam by the Minute

In 5 minutes: Sweep face powder over face and eyelids, apply red lipstick, pull hair back into a simple chignon. Slide on sunglasses!

In 10 minutes: To the above, add a touch of concealer under eyes or on blemishes, eyelashes curled, and mascara.

In 15 minutes: Add a single shade of eye shadow, a (less-than-flawless) cat eye, blush, and brows.

In 20 minutes: The 10-minute makeup, plus a quickie roller set.

It's all about prioritizing. In advance of an actual rush, try timing each step; then decide which beauty steps are most doable. Practice and focus make it possible. Don't become distracted by phone calls or text messaging, and definitely not by experimenting.

Must-Have Makeup Brushes

While fingers can serve as great tools in makeup application, a great set of tools is integral to making up. The brushes that come enclosed with many cosmetics are not always the best in terms of design or quality. So investing in a quality set, even just a pretty good one, is advisable.

There are many kinds of brushes to apply makeup. The smaller the brush, the more concentrated the application. Brushes with wider areas, be they the full figures of a dome brush or the flat fine blade of a fan, are essential in blending.

Always shake away excess makeup before sweeping onto the skin. Brushes can be used dry or wet, depending on the makeup and intention.

Start a collection with these eight:

- **Camouflage/concealer brush:** A flat, soft-bristled brush with a pointed tip and wider base for applying concealer and precisely dabbing problem spots such as pimples, broken capillaries, or other discolored spots.

- **Contour brush:** Bristles are short, rounded, and beveled for a smooth application of eye shadow, including highlighter. Ideal for "dragging" shadows.

- **Dome brush:** The full, rounded collection of bristles suits picking up face and blush powder and distributing it perfectly on skin. Just don't use a single brush for both types of powder without cleaning it first.

- **Fan brush:** The fine bristles lightly dust loose powder for a soft, velvety effect. Also great for removing excess powder, such as eyeshadow on a cheek.

- **Fine-point eyeliner brush:** The tip is extra fine for liquid and gel liner application on eyelids or anywhere a beauty mark is desired.

- **Flat eyebrow brush:** Stiff, angled bristles allow for precise control of powder or liquid brow makeup, whether for filling sparse areas or defining shape.

- **Brow brush:** For grooming brows into place.

- **Lip brush:** A short, firm tip for a controlled, flawless line.

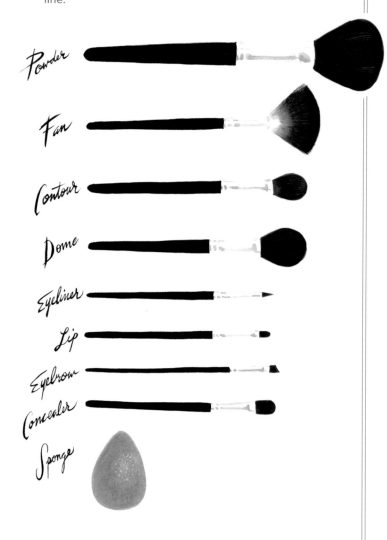

Powder

Fan

Contour

Dome

Eyeliner

Lip

Eyebrow

Concealer

Sponge

stylists on set. There was a photographer and assistant, a fashion editor, and a model. That's it. A model had to be as skilled at applying makeup as striking a pose.

These women had a do-it-yourself ethos that we all can take inspiration from.

Character Study

A bad day always goes better with a bold lipstick. I find comfort in feeling glamorous.

I recall an encounter with my ex-husband at a party in West Hollywood. It was a cordial face-to-face, certainly far more cordial than our previous meeting at his manager's home a few years before, to discuss the details of our divorce. Do you know what he said to me at the party? What he remembered most about our last visit was the way I looked. "You really turned on the Dita Von Teese that day," he remarked. "I won't ever forget how incredible you looked when you walked out that door."

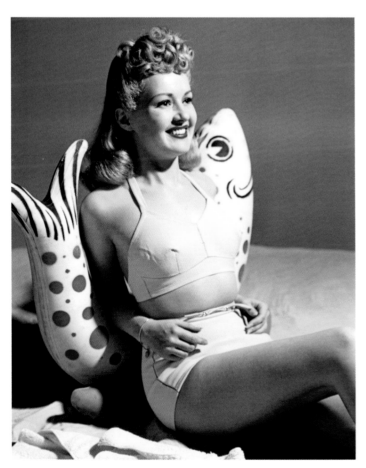

Betty Grable was a gal always at ease, even with a fish in this 1940 glamour portrait.

As he spoke those words, I also recalled the day. I was snug in my favorite black Roland Mouret dress. I had on a pair of my highest heels. I had on my diamonds. Taking the time that day to set my hair and overall appearance just right empowered me to face an otherwise challenging situation. I wanted to feel that way and I wanted him to know it. And here it was, years later, and I received my confirmation.

Some time later I was in my attorney's office. My accountant was there, too, along with a notary. As part of getting my house in order (because, darlings, you must!), I was signing my will. Dire? Doesn't have to be. That morning, as I dressed for the appointment, I asked myself, *How would Joan Crawford appear at such an engagement?* For the occasion, I donned a white turban and red lips. It made an otherwise cheerless affair more fun, more theatrical, more of a moment.

Besides, for me, it's not simply perfume that evokes memories. My look on any given day has always served as a way to look back.

What Would Betty Do?

Of all the icons who inspire and influence me at the vanity table, when I'm in a squeeze—for time, élan, or comic relief—I think: *What would Betty Grable do?*

I know everything there is to know about Betty Grable. I have seen all her movies countless times, and I read everything I can get my hands on about her. I even own a petal-pink silk chiffon dance blouse from the 1951 musical *Call Me Mister* and one of the corsets she hooked into for the 1953 remake of *The Farmer Takes a Wife*. Her name is written on the inside, complete with the number from the scene, which involved her splashing in the water. The hooks still show the rust. She tops my icons list.

Women enjoyed being around Betty Grable, and men appreciated that she could swear, drink, and gamble like the best of them. I've watched a clip of her rehearsing, and she seemed such a laugh to be around. She was engaging and talented and so unpretentious. As far as I've been able to tell from all the biographical material I've consumed about her, no one has ever uttered a bad word about Betty Grable. What you saw on the screen is apparently what you got with Grable in the flesh. (Well, except for the swearing, of course!)

These, too, are beauty lessons to practice in life.

Make-Believe: Gregory Arlt

Gregory and I first met in 2006 on a shoot for a French magazine. We had so many friends in common that it was odd we hadn't crossed paths before. Now we're thick as thieves. That is, of course, when we're not both traveling. He spends much of his days around the world, making up celebrities and models for editorial shoots and runway shows, mostly as director of makeup artistry for MAC Cosmetics.

Throughout my career, I very rarely meet an artist who impresses me. I get excited about working with some famous makeup artists, and either they take hours to do what I could have done in ten minutes or insist on silly rules (such as "a bold eye must have a nude lip"). Then I met Gregory, and he immediately became someone I implicitly trusted because he is so well versed in the history of beauty—and what works for my face.

Gregory will chime in from time to time throughout this section on makeup with invaluable insight and tips. But first, a few words about how his love of beauty led him to a career in it.

When did I start playing with makeup? The short answer is that I had no choice, with two older sisters and a mother, plus a dad who is a visual artist. Aesthetics mattered in my house.

I loved playing with makeup as a child. I was in dance class, and even the boys had to wear makeup onstage. I couldn't wait for that moment leading up to the performance, when we were backstage, applying what came out of our mothers' makeup bags. I loved the smell of cosmetics. I loved the idea of it: the transformative and creative aspects.

There were two defining moments that led me to a career as an artist. When I was eight, my mom came home from having a makeover at the Broadway department store. Shades of blues and purples brought her face to life in a way that just captivated me. I couldn't believe it was my mother. She was so confident and beautiful. It was then that I realized the magic of makeup.

About 1982, when I was in junior high, my dad brought home the book *Women*, featuring the photography of Francesco Scavullo. "Look at these before and afters," my father pointed out. I remember the picture of Patti Hansen freckled and with no makeup on and no lashes. She looked erased. Then there was the after picture with makeup. Whoa!

My dad agreed. He had a great eye for recognizing when a darker shade of lipstick or a different eye shadow altogether could improve the look of some stranger we would spot across the way at, say, the mall.

That day with the heavy Scavullo book, my dad presciently said to me, "Can you believe what makeup can do?"

Dita and I met on the first day of a two-day shoot, and by the end we were fast friends. I was so excited to work with her because here was someone who loved a fierce cat eye and a fiercer red lip. I love pinup makeup. As a child, I would endlessly sketch composites of a cat eye with a beauty mark and a red lip on my school folders. For me, it was a trifecta that epitomized glamour. That's why I believe that red lipstick and black eyeliner are your two most powerful tools.

The 1940s and the 1980s are my two favorite eras. The makeup was heavy and colorful, and women were daring and different. Joan Crawford was always my style icon. Not the *Mommie Dearest* Joan, mind you, but the Joan who was willing to change her look so radically from whim to whim. She was the Madonna of her time, and Madonna, of course, is a great beauty chameleon.

CHAPTER 8

A Good Foundation

What is more essential to a polished face than foundation? Powder.

In this chapter, foundation and powder, those indispensable components to the beauty ritual, will be spotlighted because more often than not, one doesn't go on without the other.

A key part of presenting the public a fabulously flawless face is healthy skin, or at least something close to it. As discussed in the first chapter, healthy skin comes with care: keeping it clean and sunscreened, hydrated and rested.

Mind you, perfect skin does not exist. Nearly perfect? Possibly. But it's not on the cover of a magazine, where pores or bumps or any other signs of life are brushed away by a very talented retouching artist. Darlings, even those on the auspicious side of "nearly perfect" benefit from the tricks of illusion.

You and I reside in the real world, with all the inevitable effects of weather, pollution, hormones, genetics, and living *la vie en rose*. Yet that's no excuse to accept the ramifications passively!

Think of foundation (and its accomplice, concealer) and powder in terms of those fundamental helpers below the neck. Without the right bra or slimming underpinnings, the curviest figure will not optimally fill out the most femme fatale of frocks. Tissue-thin panties can cancel out any VPLs (that's visible panty lines) on the backside of a beautiful dress, just as facial lines can be minimized with a deft dab of concealer and foundation. A highlighting powder can serve like an underwire bustier, giving skin a boost.

It's all a matter of taking what nature gave us and making the best of it with a little creativity and help from science and technology. Now, that's what I call haute tech!

Powder is so essential that I regard it as integral to the idea of a good foundation.

So after foundation, powder. Bring it back for an encore before leaving the vanity spotlights, a final dusting to finish off the face. Return with repeat dustings throughout the day or night, hopefully with a glamorous compact.

Be smart about it, too. The sleight of hand from foundation, concealer, and powder is designed to even out complexion, and, ultimately, give good face. It's not about creating a cakey mask.

Prime Time

The first step to anything is starting with a clean surface.

A morning face deserves a splash of tepid water and a gentle wash. If it's evening, and you're putting on your face for the second time in a day, a way of refreshing both your face and overall attitude is to wipe away the foundation and any sunscreen. It's one of my secrets to looking fresh during the long glamathon of fashion week. Use a makeup cleanser or toner on a cotton pad or washcloth. Optimize these few minutes as an opportunity to clean the slate, literally, by unwinding and refocusing.

Follow up any cleansing with a generous dollop of moisturizer, gently working it into your skin. Cover the entire face for a smooth, hydrated base. If it's still daylight outside, use a moisturizer containing an SPF—no matter if your skin is as pale as mine or at the opposite end of the skin color spectrum.

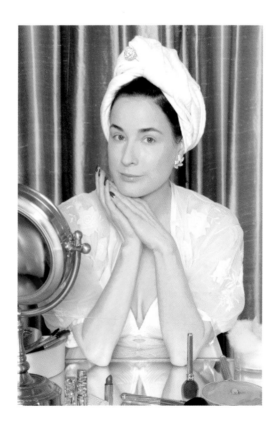

Gregory Arlt and other makeup artist friends swear by primers in lieu of moisturizer. With a similar concept in mind when priming a wall before painting, a skin primer promises to even out skin tone, fill in pores and fine wrinkles, hold makeup under even balmy conditions, and soak up oil with salicylic acid while staving off absorption of pigment and talc from foundation. Most contain botanicals to soothe the skin. There are primers for just about every skin type and with an SPF.

As to whether to prime or not to prime, I have just as many makeup artist pals who believe moisturizer does the trick just fine. Personally, I don't notice a major distinction with or without priming.

But during the summer months, I might apply a mattifier as an additional reinforcement to face powder in my fight against shine. I like a matte face. What works best for you depends on your individual skin type and what feels best.

Apply Yourself

In makeup application—and especially concealer and foundation—the pick of tools can seem as diverse as the formulations and shades available (see the essentials on page 138). Is it best to use a sponge? A brush? Fingers?

It comes down to what is most comfortable for you. When applying foundation, I love the Beauty Blender, a teardrop-shaped sponge created by makeup artist Rea Ann Silva.

I also like using a foundation brush to apply and blend foundation or MAC Studio Fix Powder Plus Foundation (I love this product because it is completely matte, long wearing, and provides full coverage). I use a small flat brush to dab Studio Fix to the corners of my nose and on any blemishes or anywhere else I need extra matte full coverage.

A small or fine-point brush is great for the precise touching up of spots with foundation. It can also serve as the perfect tool for applying eyeliner or cleaning up the lip edge.

A wider, fluffier brush, at least two fingers thick, is great for powder and blush. I also love a powder puff and sometimes use it to lightly press in the finishing powder.

From face to face, day to day, the choice of tools can be a matter of preference, time, and desired effect.

First Base

Needless to say, my favorite makeup looks draw from an era when women aimed for skin that looked flawless and matte. Okay, so maybe it was more like cinematic verisimilitude. I get so much inspiration from movies that were out of the theaters some three decades before I was born. Then, like now, it's about giving one's best shot.

It's also no surprise, then, that so many beauty innovations were fueled by the Hollywood dream factory. We have the King of Cosmetics, Maksymilian Faktorowicz, to thank for so much of what we take for granted today, including foundation. Who knows? We might still be slapping on lead paste like the beauties of ancient times, or some concoction of lard, zinc, and pigment, as women did in more recent centuries.

Foundation is not spackle. A good foundation can aid in smoothing out discolorations in the skin's surface. It might even minimize a minor scar, along with covering blemishes and patchy redness. But it's not going to change the skin's texture or eliminate wrinkles.

Foundation works best when it is used judiciously.

Just Your Type

Not all foundations are formulated equal, because not all skin is the same. It really can make the difference to go with a formula that works for your skin type, whether it falls under oily, dry, combination, or sensitive. (Review skin types and how to determine what type you are on page 26.) The cues are right there, spelled out on the bottle label. So read.

As for coverage, select the sheerest formulation you can get away with for your skin tone and texture. A bit of luminosity can do wonders for brightening up skin. So don't fear it.

Combination skin loves a liquid foundation. There are also formulations specific to dry skin, with satin finish and matte options for oilier faces. But while a lighter consistency can even out skin tone, don't expect it to cover freckles or blemishes. For that, see the section on concealer (page 149).

A medium viscosity that is nearly opaque is great for most faces and can conceal freckles, pimples, and blotchiness.

Mineral powder foundations cover the gamut, from light to full coverage, and can be great for controlling oil.

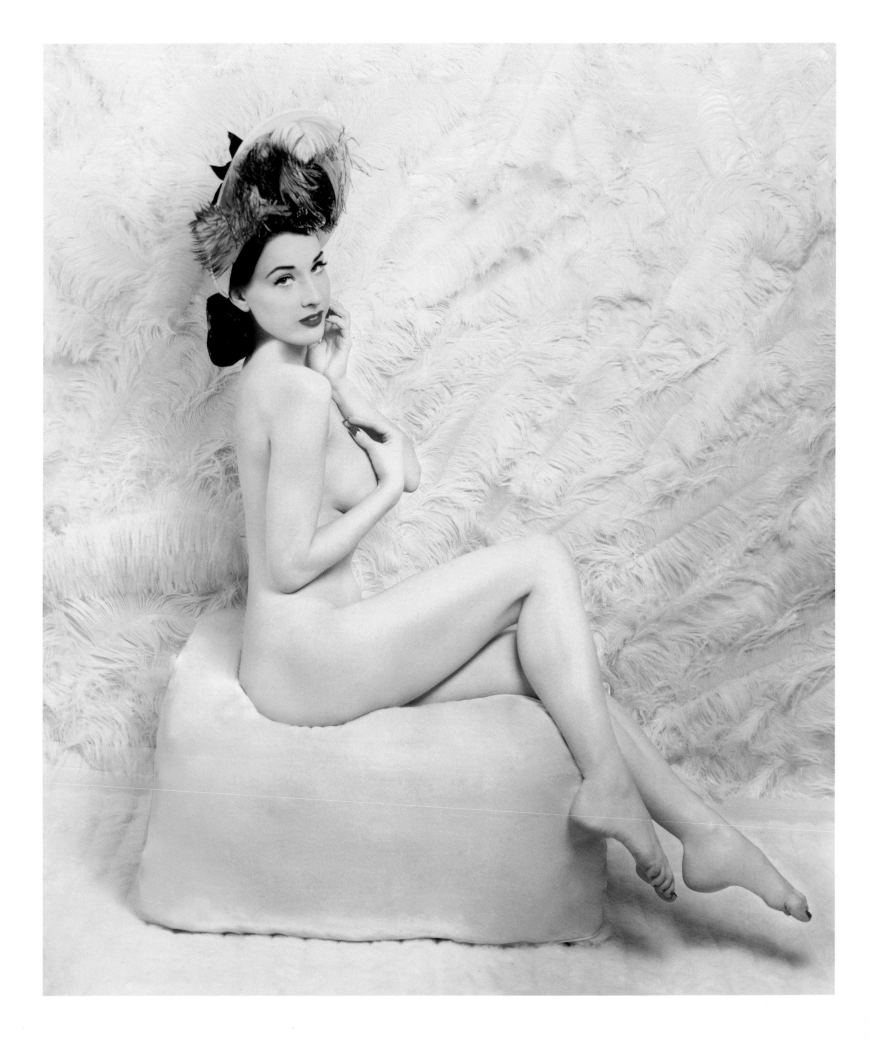

Brains and Beauty: Max Factor

From Clara Bow's heart-shaped pucker to Jean Harlow's platinum coif, a constellation of Hollywood's most influentially stylish stars owe much of their glamour to Max Factor. We fans owe him for helping legitimize the very beauty of artifice!

Maksymilian Faktorowicz escaped anti-Semitic czarist Russia for St. Louis with the dual talents that made him a wealthy man in the old country: custom-making wigs and stage cosmetics. Stateside, the newly minted Mr. Factor got wind of the sun and fledgling entertainment industry in Los Angeles, and in 1908 he set up shop downtown. He quickly observed the reality of this fantasy business:

> Some [actors] were using stage makeup, while others wore concoctions they had made themselves: odd mixtures of Vaseline and flour, lard and cornstarch, or cold cream and paprika. The more adventurous had even tried ground brick dust mixed with Vaseline or lard to get a flesh-colored look.

The industrious visionary got to work and changed all of that—and the way audiences perceived their screen idols.

Factor invented a finer greasepaint for the screen in 1914 and expanded the available palette of face powder shades in 1918. By 1927, having risen to become the most famous of secret weapons in Hollywood, his formulations became available to women everywhere.

The advent of the "talkies" brought about a revolution in both cinema and cinema makeup that cycled as quickly as the studios churned out films. Early klieg lights used on set were noisy and replaced by the quieter and softer tungstens. That alone had Factor reworking the way makeup appeared on film. Soon after came panchromatic celluloid, which was faster and more sensitive—and visibly altered skin tones.

To save face—that is, the faces of the many A-list actors now practically betting their careers on his talents—in 1937, Factor patented his greatest invention, Pan-Cake. This new founda-

tion offered a transparent matte finish, concealed small blemishes and flaws, and was porous enough for skin to breathe.

While Max Factor insisted it was only for the movies, his son Frank realized the possibilities. So did the many actresses on set who started helping themselves to this state-of-the-art face paint when no one was looking. They wouldn't have to much longer. Within three years, a third of American women were wearing Pan-Cake, and it was outselling the sixty-five copycats on the market also using the word *cake* in their own products.

The following year, the Great Max died in his sleep at age sixty-one. His sons Davis and Frank (who changed his name to Max to carry on the legacy) carried on in Hollywood, supplying the green makeup for the Munchkins in 1939's *The Wizard of Oz*, and six hundred gallons of tawny-bronze body paint for 1959's *Ben-Hur*.

Cinema's leading ladies and men continued to line up at the Max Factor Makeup Studio, a grand art deco building complete with labs for research and salons for beautifying. Fortunately, the building and some of the memorabilia inside survived the wrecking ball and now exists as one of my favorite local stops, the Hollywood Museum.

A foundation in compact or stick form tends to be denser, providing more coverage. Dry skin is better off with a cream foundation, which should be avoided on combination or oily faces. Use any heavier coverage sparingly or risk too cakey an effect.

To block out scars, birthmarks, or even out pigmentation unevenness due to leukoderma or other conditions, try a foundation for corrective or stage use.

Finally, do not drive yourself mad trying to cover every blemish. Like the wife in Nathaniel Hawthorne's tale (which I reference on page 202, on beauty marks) some "imperfections" are not as hideous as we might believe. They are, in fact, what make us perfectly who we are.

Pale by Comparison

A question women frequently ask me is where on earth I find foundation pale enough for my skin tone. Since a number of these questions come via email or Twitter and without my seeing how pale these gals are, I can only figure they must be considerably paler than I am, because I can readily find foundation that is right for me.

Maybe it's a *perception* that they need an even lighter foundation than what is already available?

Personally, I strive not to appear chalky. On my vanity are several options, including Chanel Vitalumière 001, Guerlain

Lingerie de Peau, Dior Beauty Capture Totale 0101, and Suqqu Frame Fix Cream Foundation N 102. They all are formulated with an SPF between 15 and 25. One of my favorites came on a tip from Gregory Arlt, who learned it from the incomparable Cher, which makes me love it even more: L'Oréal True Match Soft Ivory N1 is a great light shade, and it can be found in any drugstore. Cosmetic companies are finally realizing how many shades of beauty there are and thankfully responding with plenty of foundation offerings at all price points.

Which brings me to the second most regularly asked question I get: does my look translate on a face of color? Seriously? From Dorothy Dandridge and Dolores del Rio to my friend Fatima Robinson and a legion of Mexican American rockabillies around Southern California, I reply with a resounding "yes!"

Cat eyes and red lips look beautiful on every ethnicity, whether skin is brown, black, yellow, olive, white, or a combination of any and all of the above. It's still about finding the right foundation. A wrong shade is more conspicuous than whatever is being covered. More than one shade, thoroughly mixed, might be necessary, too, according to the season.

Short of hitting the cosmetic counter with you personally, I urge you to take these tips when shopping for foundation:

Don't judge a color by the bottle, nor evaluate it against artificial indoor light. Color is best assessed in natural daylight and on skin. Give it a minute to oxidize. If shopping a department store or other resource where testing is possible, it's always useful to bring an empty makeup pot (available at drugstores and beauty shops for less than a dollar). Take the sample home and test it outside. Test it with a sweep of powder, too. Otherwise, if you must buy the bottle then and there, first check the store's return policy.

If there's an opportunity to sample, hit the store with bare skin. It's okay to arrive with a bit of blusher and eyes and lips made up, but neither skin nor a new product can be evaluated with an existing coat of foundation. Common sense? Yes. But I can recall more than a few women coming to me during my days behind the cosmetics counter expecting me to able to see through their mask of peachy cream.

Don't become too mesmerized by snazzy names used by cosmetic brands to describe their colors. Most skin tones match up to a yellow base—*no matter the ethnicity*. Black, Latina,

Asian, Southeast Asian, Caucasian, and every combination skin tone among them typically look best with a yellow-based foundation. Fairer tones can play with cooler pinks, as long as they don't come off too pink; significantly darker skin can try a shade with warmer red/orange undertones. Keep in mind that foundation can become a shade darker once it blends with the skin's natural oils. While this might not be of much concern for drier or combination skin, it should be taken into account if skin is oily.

Natural pigmentation can also vary from face to neck to chest, appearing darker or lighter than the face. The aim is to apply a color that is most uniform to overall skin tone. Because coloring can also vary according to the seasons, I also like to have a few shades on hand to choose from.

Forget the inner wrist, the back of the hand, or even the cheeks and neck to accurately judge a shade. Test a foundation along the jawline. "Always!" emphasizes Gregory. The jawline, he notes, is "ultimately where foundation will end, and most women are more pale under their necks due to lack of sun exposure." He recommends this: "Swatch a line going from just below the cheekbone down to the jawline. Wait about thirty seconds for it to oxidize. If the foundation edge blends into the skin, it's probably the correct shade." Even when it does, don't forget to blend it fully into the surrounding skin.

Last, during the day, go with a foundation with sunscreen. Although it is still wise to wear a moisturizer underneath with a minimum SPF of 15 (or more), a face cannot go wrong with the extra protection.

On Contouring

Contouring is a skill that requires a masterful hand if it's going to look good. So it's not something I typically do as I go about my daily or evening business.

Gregory Arlt is such a master, as his mother's friend the saturnine British actress Barbara Steele attested in her sweeping fashion when she praised him with: "Oh my God, you know how to contour like the Italians!" (And as the muse of director Federico Fellini, she would know!)

Gregory followed up this story with a sound tip: "The best advice I can give on any attempts to 'correct' a feature with contouring is live with it or do something about it. Just don't try to fake it. The minute you start shading the nose, any issues you had get worse. Contouring is not for that. Just look at Barbra Streisand in *Funny Girl*.

"What I do recommend is taking a powder that is two shades lighter than your face and hitting the cheekbones and other higher planes."

Something to Conceal

Concealer is your friend. A good concealer can be your best friend.

Treat concealer like skin care. The thinner, moisture-centric formulation of a liquid concealer is best on drier skin. Oilier skin can benefit from the thicker consistency of stick and compact concealers. I don't have oily skin, but I do like the control and coverage a stick concealer provides me.

Choose a shade that matches your skin tone. Your skin should look like *your* skin. While a light-reflective formulation can do wonders under the eyes and around laugh lines, a shade too light is no laughing matter. Others *will* notice it.

Dark eye circles tend to be bluish in tone, so a concealer on the peachier side can do the trick. It's not about lightening, as Gregory points out, but correcting. He has used a shade with more orange to correct the under-eye circles of East Indian women. Beware, too, of smearing anything heavy under the eye, or risk that unsightly creasing and cracking effect. A pindrop of foundation can give concealer more slip, making it easier to blend.

To tone down blemishes, moisturize the blemish lightly. An eye gel or skin serum works well. Let it absorb for a few seconds. Next, dip a small, pointed brush into a corrective foundation or primer with calming ingredients such as chamomile and lightly blot the aggravated spots. Gently feather the foundation or primer into the surrounding area.

Keep the layers thin as you build on them to even out tone. Blend by dabbing lightly with the ring finger. Avoid the surrounding skin. The goal is to neutralize redness and create the illusion of a smooth surface. If areas of the face are inflamed because of rosacea, acne, or other conditions, resist too much foundation and see a dermatologist.

A bit of concealer on a fine brush can also help in correcting the lip line or eye edge.

The Renegade: Angelique Noire

When it comes to race, gender, or any other factors that define identity, a cat eye knows no boundaries. Be it the flourish of eyeliner or wardrobe, beauty is in the eye of the beholder—namely, the individual truly doing her own thing who is staring back at you in the looking glass.

Thanks to Instagram and other social media phenomena, the rest of the world can hold eccentric beauty in the palms of their collective hands.

That is how I came to admire the modern-day pinup Angelique Noire (and unbelievably, given her fitness and youthful looks, mother to a daughter, thirteen, and son, ten). When fashion magazines were passing over the Pasadena-born model for retro-colored shoots because of her skin tone, she took matters into her own hands with a side project into vintage beauty worthy of its ever-growing following.

What got me interested in modeling is seeing the old classic movies and fashion photography of the 1940s through the 1960s. I loved watching Rita Hayworth, Dorothy Dandridge, Eartha Kitt, Betty Grable, and Lena Horne. Even if I didn't care for the storyline, I wanted to watch their movies for the hair, makeup, and clothes. The beautiful images of that time period made me dream.

I started to focus on retro makeup and hair four years ago. The fashion world was, too, but *Vogue* and other magazines tended not to feature any black models in vintage-inspired editorials—unless it was a Josephine Baker style, of course. I thought, *If I wait for a client to realize I could do this look, too, I'll be waiting a long time. So I better show them I can do this myself.*

Once I started posting photos on social media, the response was overwhelming—so many encouraging words . . .

even that I'm an inspiration. I really appreciate it all. But I also love that I can live my passion.

I wasn't allowed to wear makeup until I was seventeen. So I would practice at home and wash my face before my mom could find out! When I was finally allowed to wear makeup, I would try a simple cat eye and very simple retro hairstyles. I wasn't too much into experimenting with eye shadow, and I wasn't brave enough to try intricate waves. Plus, my hair texture can be challenging. But I don't want to chemically straighten my hair. Over the years, I've picked up tips from modeling and by teaching myself from photos.

Both my kids love when I dress up in retro style. My son will even request a certain dress on his school open house day. Or if he knows I have a shoot, he'll insist I come onto campus that day to pick him up and then tell everyone, "This is my momma," while holding my hand. My daughter enjoys it, too, but she cares less about dressing up herself. She's more athletic, a tomboy. I won't allow her to wear makeup till she's fifteen or sixteen. . . .

I'm for anyone trying any kind of look. The only barrier is yourself. Do not worry about what other people think.

When I started out playing with retro style, I didn't have many role models of color to derive inspiration from—only Lena, Eartha, and Dorothy. Not a bad trio. But their skin is much lighter than mine, and they never showcased their natural, textured hair. I have dark skin and love many hairstyling options. I choose to incorporate my interpretation of 1940s and 1950s hairstyles with my textured hair into my "pinup look."

Because I couldn't find many photographs of other black women doing these vintage looks, that also motivated me to start sharing this style. I'm proof that vintage beauty is also for modern dark-skinned women and women with naturally curly hair.

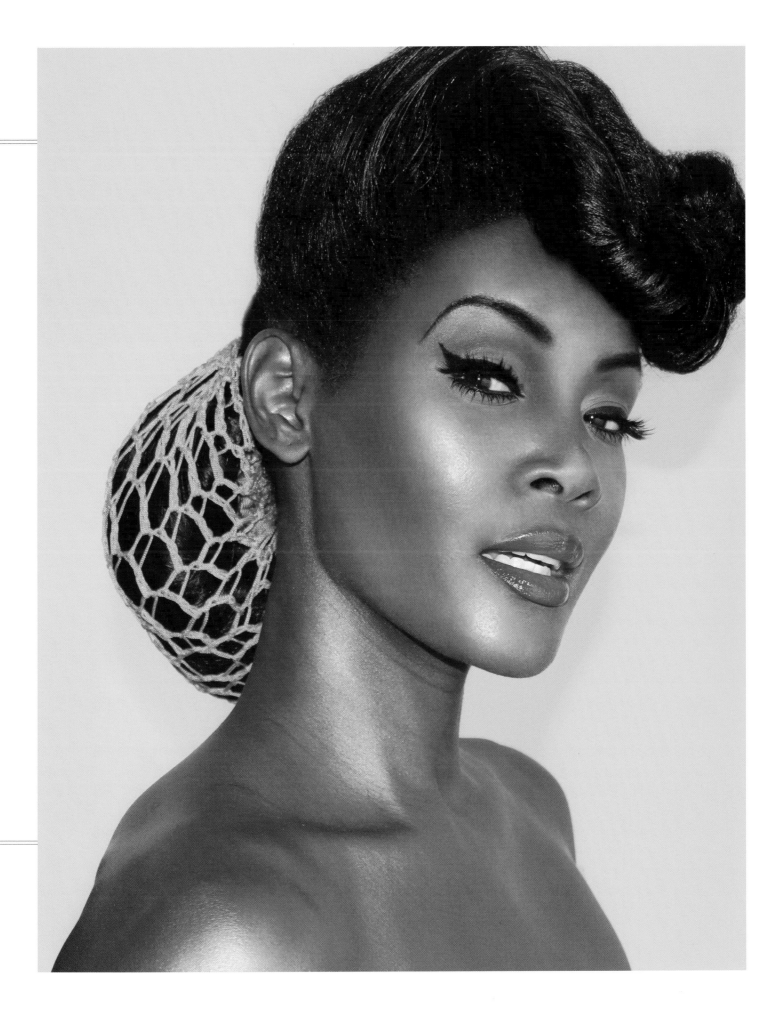

Concealer should be used before applying foundation. While the foundation should even it out, it's critical to blend the edges into the surrounding skin. Apply, blend, and step back to review. Reapply if necessary. This is where a fine-point brush can come in handy. If time allows or if it is going to be a photo-heavy day, touch up spots across the décolletage, neck, shoulders, or anywhere that might be exposed. Just use a light hand with the concealer, and don't forget to blend!

As Gregory points out: "Your skin is your canvas. Make it look good. Blend your skin tone. Cover those blemishes. It really only takes a minute. Otherwise, it doesn't matter if you have a ten-thousand-dollar eye shadow on."

Taking a Powder

I'm all for a shining personality. I love a shining review. I am especially mad about jewelry that shines and a city shiny with the magic of midnight.

But skin that shines? Never. For me, it all hinges on the shine.

If I ever find myself marooned on a desert island with little more than the man of my dreams and a couple of belongings, pray tell that those two worldly possessions are a matte red lipstick and face powder.

A powdery matte finish diffuses the focus on any parts of my face I am not comfortable highlighting on film or in person. It's like moonlit soft focus.

It's also a look gleaned from Hollywood's cinematic past. The matte appearance resulted from all the powder dusted on movie stars' faces to set their makeup and to minimize reflection under the bright lights.

Those pioneering feminist beauties, the flappers of the 1920s, wielded their powder puff as much as an emblem of a newly embraced independence and sexuality. Those roaring years also brought the wider emergence of vanity dressing tables for similar reasons. It was the height of modern style to have a vanity at home. Likewise, it was common for those jazz babes heading out to the clubs to keep a powder puff tucked into the thigh edge of stockings.

But don't go considering powder a throwback. It is every bit as relevant on modern faces, and desperately so by the growing number of excessively shiny mugs I'm seeing around every town

thanks to the popularity of derma peels. It's distracting looking at such glazed faces. Some look even waxy. *As if the wax were melting.* More than a few of my straight male friends have also wondered why so many women mistake this as attractive.

Thanks to all the ultra-fine powders now on the market, anyone, any age, can wear powder. It's for all ages, all skin colors.

So *powder.*

A Sprinkling of Options

Just as I have a sampling of foundations, some with shimmer and of varying shades, I also dip into a selection of powders depending on the final look.

For an overall powder, I like MAC Mineralize Skinfinish Powder, Shiseido Translucent Pressed Powder, Guerlain Les Voilettes, or Dior Capture Totale loose powder in Rose Lumière 001 (it contains a smidgen of sparkle). Caron loose facial mineral powder delightfully scented with Bulgarian rose is another favorite.

A touch of reflective shimmer isn't bad, either, across facial areas with fine lines. Lines or not, I like to sweep MAC Mineralize Natural Skinfinish Powder Foundation all over my face. A bit of sheen gives skin a glow and helps matte makeup appear less flat.

To snuff out any redness around the nose or anywhere else that needs a bit more coverage, I love MAC Studio Fix (which, you will learn soon enough, pops up frequently in my beauty routine). Under my eyes, Laura Mercier Secret Brightening Powder is indispensable.

For a bit of brightening, I twirl my brush in a mattifying powder with a hint of shimmer and dust everything—my eyelids, under the eyes, even my décolletage.

Don't forget to care for your powder puff or pads! During those weekly dips for makeup brushes, include them. They're

just as susceptible to dirty bacteria. As with all brushes and applicators, simply wash with warm water and a pea-size drop of gentle shampoo or liquid soap. Rinse until clear of soap. Gently squeeze out the excess water and leave to air-dry.

Compact Deal

A woman cannot be expected to wear red lipstick and eat with joie de vivre *and* not check her makeup.

A powder compact with a mirror is one of my most accessible beauty secrets. There are so many sources for them, from eBay to flea markets and vintage shops to your grandmother's vanity drawer. (Always ask first, of course! There's nothing pretty about unsolicited borrowing.)

Trawling for them online is, I must admit, a guilty pleasure of mine. I've lost track, in fact, of how many I've amassed. The upshot is that I can usually find one forgotten in the pocket of one of countless handbags.

New or not, Estée Lauder continues to offer an array of compacts with shells that are crystallized, enameled, jeweled, and engraved. There are even unusual shapes, such as a ladybug, a castle, or a train. Some collectibles can cost a pretty penny, so keep that in mind if money *is* an object.

Replacing the pressed powder inside is a snap, because of the standardized pan in Lauder compacts. They even fit many of the non-Lauder compacts I have scored in my travels. If finding one that fits is proving a challenge, simply follow the easy recipe on page 154.

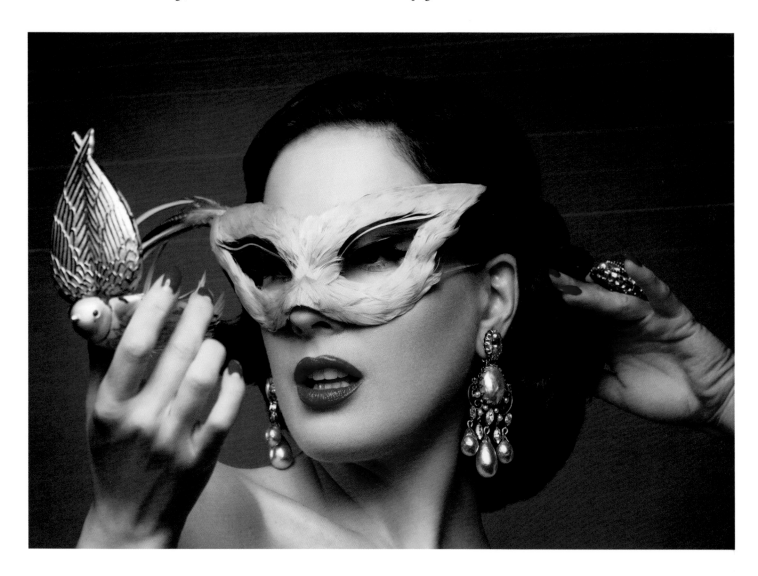

Recipe for Powder Cake

Dita makes delicious powdery baked bars. But that edible treat is for the next book. Refilling a vintage compact is a piece of cake, however, with this simple recipe. Or rescue and refresh a crumbled cake from a newer pressed powder pod (this recipe works for colored eye shadows and blushes, too).

Gather a toothpick, rubbing alcohol, a cotton ball or scrap cloth, loose face powder, a bowl, a small spoon to stir, a small butter knife, and a smooth-bottomed glass.

- Start by removing the old powder from the compact. Use the toothpick for the hard-to-clean cracks.

- Clean the entire compact with rubbing alcohol and the cotton ball or cloth.

- Mix the loose powder in a bowl with a few drops of rubbing alcohol until it becomes a paste. The paste should be smooth but not too liquidy.

- Fill the compact base, packing it with the back of a clean spoon and smoothing it flat with the knife.

- Pat the mixture with the flat bottom of the glass (or apply a swatch of net or cloth for a pretty imprint).

- Allow to dry fully.

A Sweep at Etiquette

Whether to powder and refresh lipstick at the dining table is a conundrum that is vehemently split between those who do and those who regard it as an affront to human decency. As one who really does prize manners as much as a powdered nose, I have dug deep into this duel between etiquette experts.

Those who sanction a powder and lipstick swipe at the table do so with sound sense: do so unceremoniously, swiftly, and not too frequently.

To that I add that it should only be done with a presentable-looking compact in hand. Even the grumpiest guest cannot help but be intrigued by a beautiful compact, or at least that's what I have found over the years.

In my two-plus decades of touching up at the table, never have I drawn a raised eyebrow from a fellow diner. Quite the contrary! Perform your beauty rites with effortless polish and poise. (That said, it is *never* suitable to groom your hair at the table. Keep the comb in the bag until the visit to the powder room!)

This is also the more reason to have beautiful fingernails. Once the eye focuses in on the shiny object, the natural progression is to the fingers clutching it—and the nails at the end of them.

The Five-Minute Face-Lift

Tired makeup is a sure way of aging even the prettiest of faces. As the hours pass by and powder is reapplied, it can start caking under eyes and emphasizing lines all over. You can't just keep packing the makeup on.

But more often than not, there just isn't the luxury of time to wipe the slate completely and start over for the evening run. In those instances, like during fashion week, when a twelve-hour day of dashing from show to show to party is the norm, I take a shortcut that revives my face without having to redo my carefully painted eye makeup.

The first step is plugging in hot rollers—I also use this time to double up on the overall sprucing.

With a gentle cleanser and washcloth, from under the eyes down, wipe away all foundation, blush, and lipstick. Apply moisturizer, especially under the eyes, and leave to penetrate. Brush your teeth and roll your hair where necessary.

Cleansed and hydrated, it's time to reapply concealer, foundation, powder, and blush. Touch up the eyeliner and brows. Finally, paint in the lips. Finish off your hair, spritz perfume, and, just like that, a new you.

Ready, Set, Apply

With a foundation, concealer, powder, and the necessary tools in place, the first step in making up a face can begin. I also like to use a lit magnifying mirror and a hand mirror to review my progress from every angle.

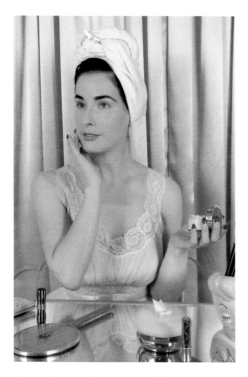 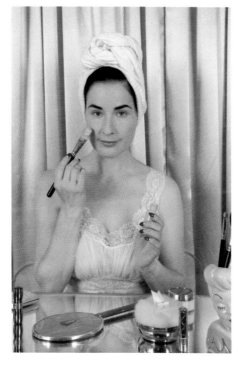 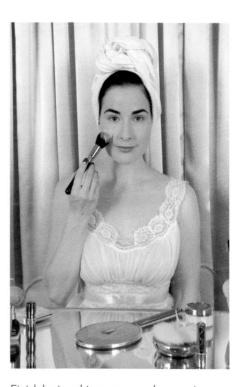

On a clean and moisturized face, start by applying concealer to any blemishes or redness using a finger, brush, sponge, or all three. Blend by lightly tapping or blending the edges.

Apply a tiny drop of foundation, spreading and blending outward. Repeat on the other side and across the forehead and chin zones. The eyelids and the area around them, along with the edges of the face, should be covered with the thinnest layer possible.

Spread the color very lightly beyond the chin and jawline until it blends in and there is no discernible border between skin that is bare and skin that is layered with foundation. Lightly touch up the neck and décolletage. Address any redness or spots (see Gregory's tips on page 149). Don't forget to feather in any camouflaging with a touch of concealer using the tip of a small brush, or, as I like to use, the fingertips.

Once the foundation step is completed, immediately set it all with powder, including eyelids. A dusting of powder aids in bonding the eye shadow and blush to the skin.

Finish by touching up any redness not already concealed; for a bit of brightening, twirl a brush in a mattifying powder with a hint of shimmer and dust your eyelids, under the eyes, even your décolletage.

Don't forget: this is only the first powder set, to be followed by a second, even third or fourth hit during making up—including the all-important final dusting.

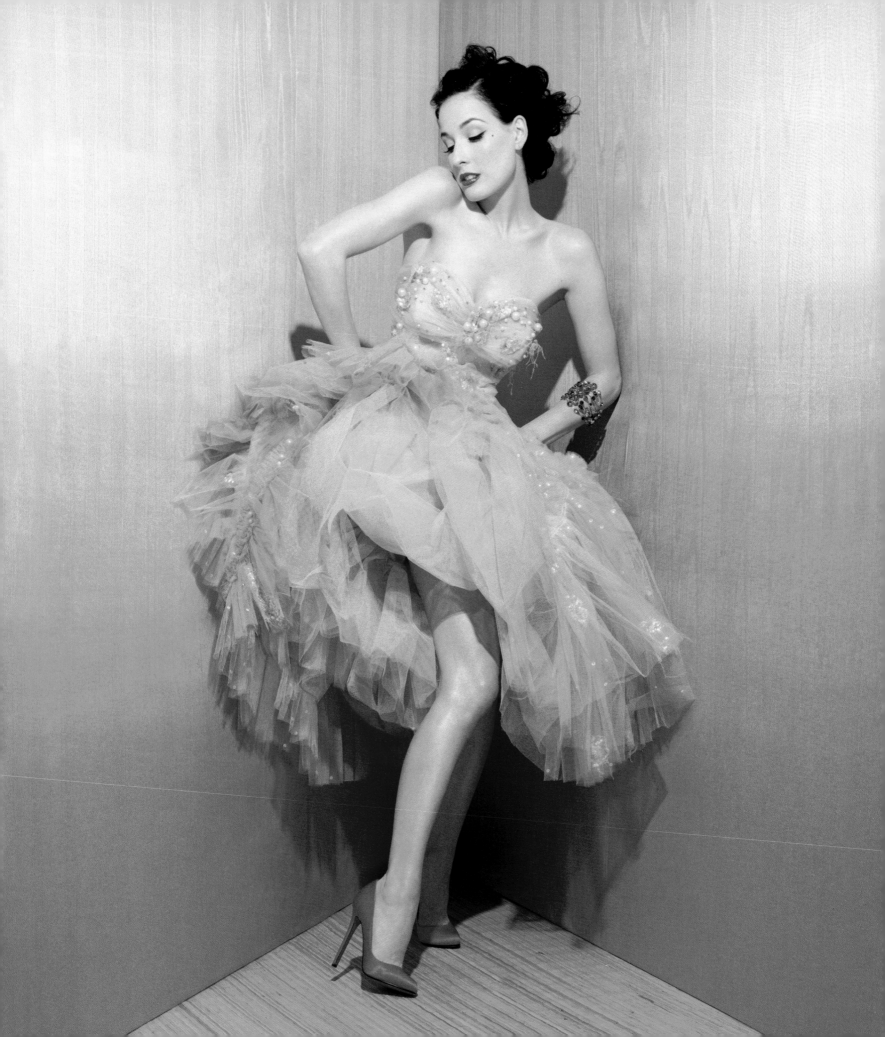

Making a Sifter for Vintage Compacts

While vintage compacts are readily accessible thanks to online resources and vintage fairs, all too often the original sifter—the gauzy sieve that would hold loose powder in place—is long gone. Before starting, assemble your materials: card stock, PVA glue, scissors, fine netting, pins, a narrow bit of ribbon (no more than a couple of inches long), and a needle and thread.

- Strengthen the card stock by having it laminated or fixing two layers together with pH-neutral PVA glue.

- Once fully dry, cut the card into a shape that fits within the compact. Any gap between the edge of the card and the edge of the compact should be minimal.

- Cut out the center, leaving about 1 centimeter between the center hole and the ring edge. The cuts don't have to be flawless as the edges will eventually be sewn.

- Take a small swatch of fine netting and pin it to the card ring.

- Fold the ribbon into what will become the loop to remove the sifter from the compact. Pin it in place onto the excess netting on the outside edge of the ring, with the loop inside the ring.

- Take a needle and pink thread and blanket stitch the card, taking care to make your stitches as even as possible. Stitch over the ribbon loop on the card. Stitch the edges. Overlap the first round of stitches with a second for extra stiffness and to completely hide any peeking cardboard.

- Cut away the excess ribbon and netting around the outside of the ring. A slight edge of netting is fine, as it will help secure your new sifter in that old compact.

- Fill the compact with powder and top with the sifter. Now it's ready for a puff!

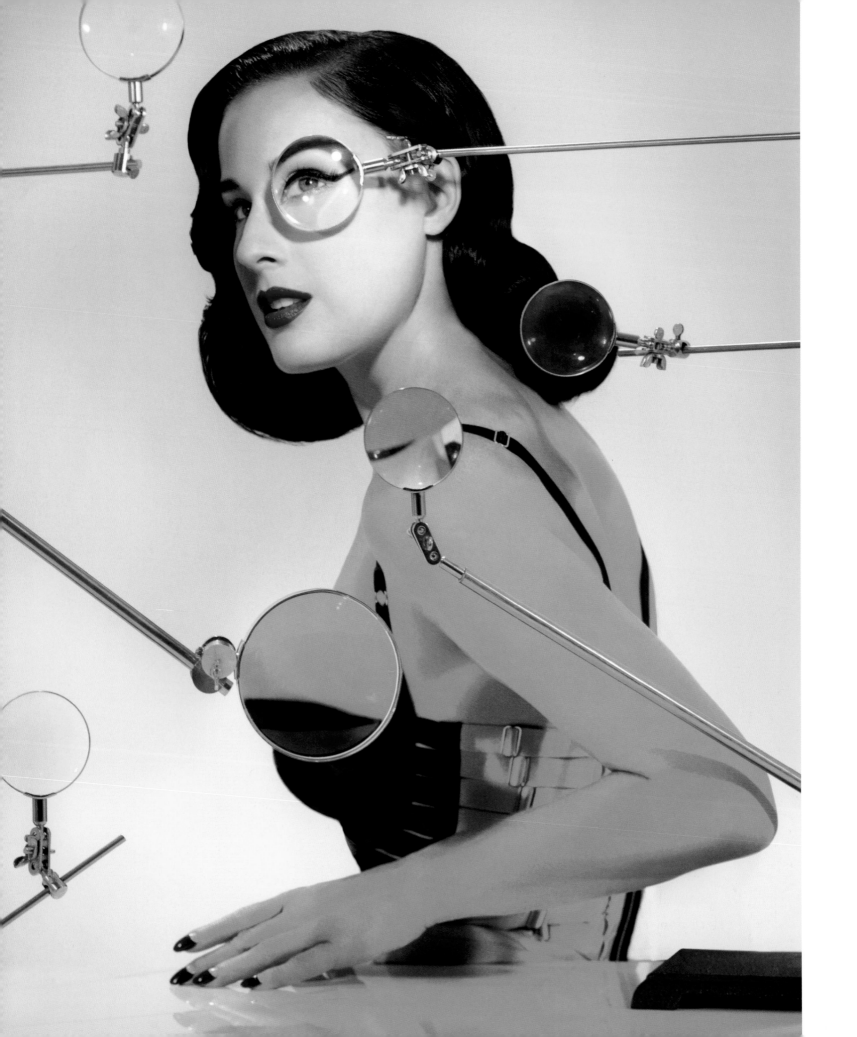

Making
Eyes

When it comes to visualizing a beautiful look, the eyes are where I draw the line.

Eyes can express volumes. Think of silent films or silent glances. For me, no other makeup effect better showcases these great communicators than that instantly glamorizing, sleek effect of a defined, divine cat eye. It conveys a precarious combination of strength and softness, fierceness and femininity.

That swoop can be so effortless and yet so elusive at times. See, a cat eye, my darlings, has so many more than nine incarnations. It can be cute kitten or wild jaguar. A fine line can stay fine or quickly grow broad. A tail can curve upward or straight out or both to divine dramatic flair. The enhancement from liner or pencil can accentuate the shape of an eye, even lifting those with a downward tilt. It can convey a haughty bearing, a flirtatious sophistication, or a cool sex appeal. It can be all or none of the above.

The form follows fancy or fashion, ending up in random design according to chance.

What is always certain is that a cat eye is the height of style. And the more highly stylized, the better.

Bird's-Eye View

Dear Amy Winehouse relished a drawn-out inky outline resembling not so much a tail but a wing. Or as style critic Guy Trebay aptly memorialized: "Her basic eyeliner became an ornate volute, a swath of clown makeup, a cat mask." In song and beauty, Amy echoed Ronnie Spector of the legendary Ronettes. And both women channeled Elizabeth Taylor as Cleopatra, whose exaggeratedly winged profile was only rivaled by an ample swath of blue eye shadow and those signature arched brows of hers.

The whole lot of them can bow to the ancient Egyptians on this cool kohl distinction, specifically the god Horus, represented in hieroglyphics with the head of the peregrine falcon. This feathered creature of prey has an outlined eye and markings on the cheek suggesting a winged eye. The optical delineation came to be known as the eye of Horus, further embodied in the goddess Wadjet and a parade of subsequent goddesses and rulers from Egypt to Hollywood forever after. The markings serve as an emblem of protection, majesty, power, and healing. (That's why the symbol was later distilled as the medical shorthand Rx!)

Of course, it's the feral sensuality of this look that forever enshrines it as a cat eye. Guess the pussy got the better of the beak. Meow.

Jeepers Peepers

I'll let you in on a secret. Sometimes when I am out flashing a prominently thickset cat eye, it can mean, just possibly, that I messed up.

I likely started with the liquid liner wand between my fingers and the best intentions for a fine line. But on occasion, the hand has a will of its own. So instead of wiping the slate clean and starting over (because, really, who has the time?), I build on it.

Just like the brows, consider the eyes sisters and not twins. While practice toward mastery of a quiver-free line is certainly encouraged, *strive* to make them look as alike as possible. Do not beat yourself up if it doesn't come off perfectly. I think Maria Callas is a perfect example. The soprano diva always brandished a cat eye, and it was not always perfect. But she never looked anything less than chic.

Imperfect is not the same as intentionally "messy," just-rolled-out-of-bed, smudged eye makeup. Maria Callas never looked like she just rolled out of bed. Her cat eyes might have been more flawless some days than others. But smudged? Not a look I strive for.

The key is to accept the outcome on the first eye, because it will serve as the template for making up the second eye. Step away from the mirror and return minutes later for a fresh view. This small step can make a big difference. Otherwise, the focus becomes so intense on making a match that the entire process can drive a gal mad.

Reviewing lashes, brows—the entire face—from several angles using a hand mirror can make all the difference. *Always* keep a hand mirror handy. Think of it: no one person is going to exclusively look you straight on. So always assess yourself from every angle.

Finally, recognize when it's time to put down the wand and the mirror and walk away. If the liner is a hair off? Or a tail is a millimeter higher on one side than the other? No one has ever nitpicked my less-than-perfect cat eye.

Feast for the Eyes

A cat eye is much more than just black liner. A rainbow of colors and glimmers can bring it fresh definition. It also longs for a sweep of shadow on the lid, maybe beyond, even if it is a barely there shade of shimmer.

"Aggressively unreal" is how beauty culture writer Kate de Castelbajac describes such an extravagant combination of shadow, eyeliner, boosted lashes (by mascara or other applied means), and brow pencil in her book, *The Face of the Century*. (It is an essential for every beauty enthusiast's library.) The look, she notes, burst on the cultural radar in 1949 courtesy of cosmetologist Étienne Aubrey, who dubbed it the *oeil de biche*, or "doe-eyed look." That's right, what we think of as inspired by a cat, the French relate to a female deer.

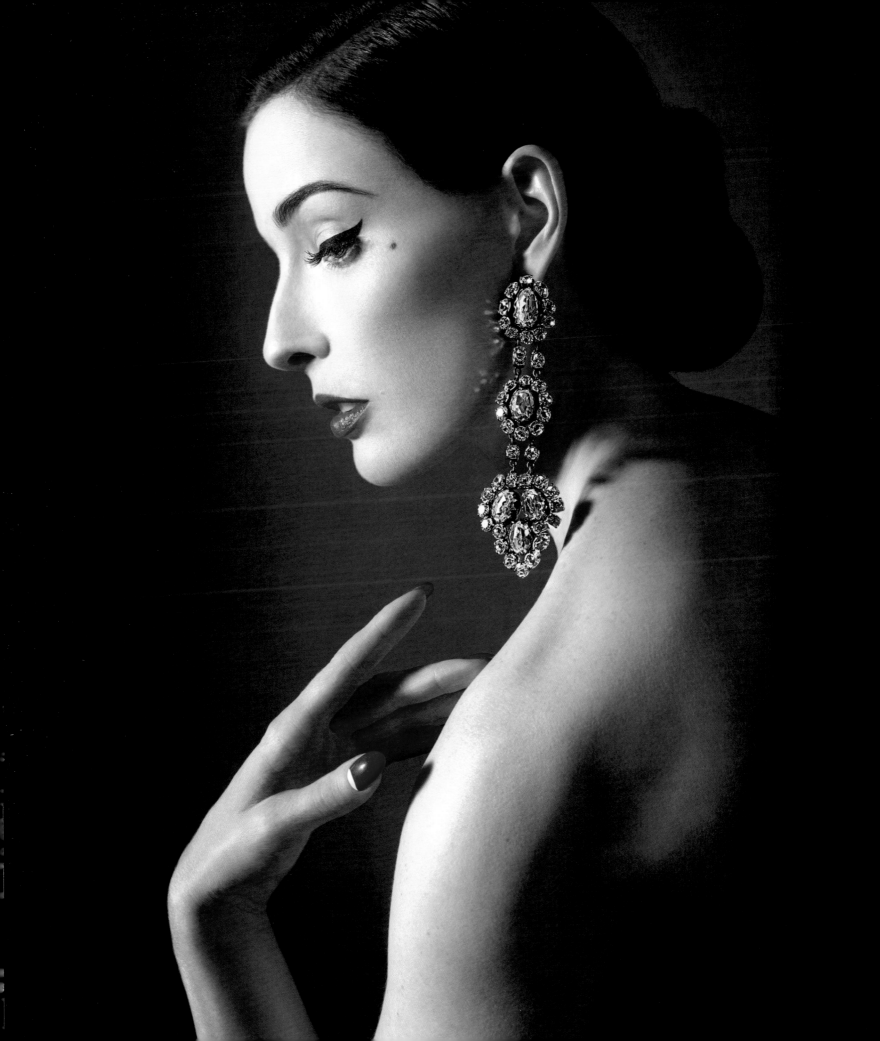

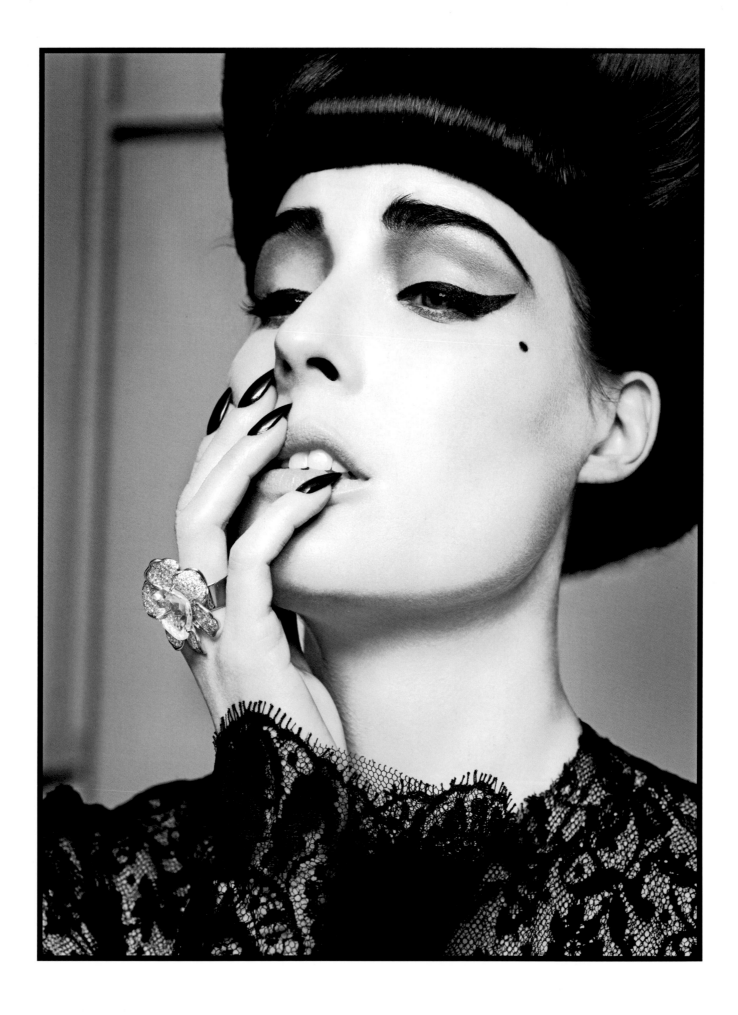

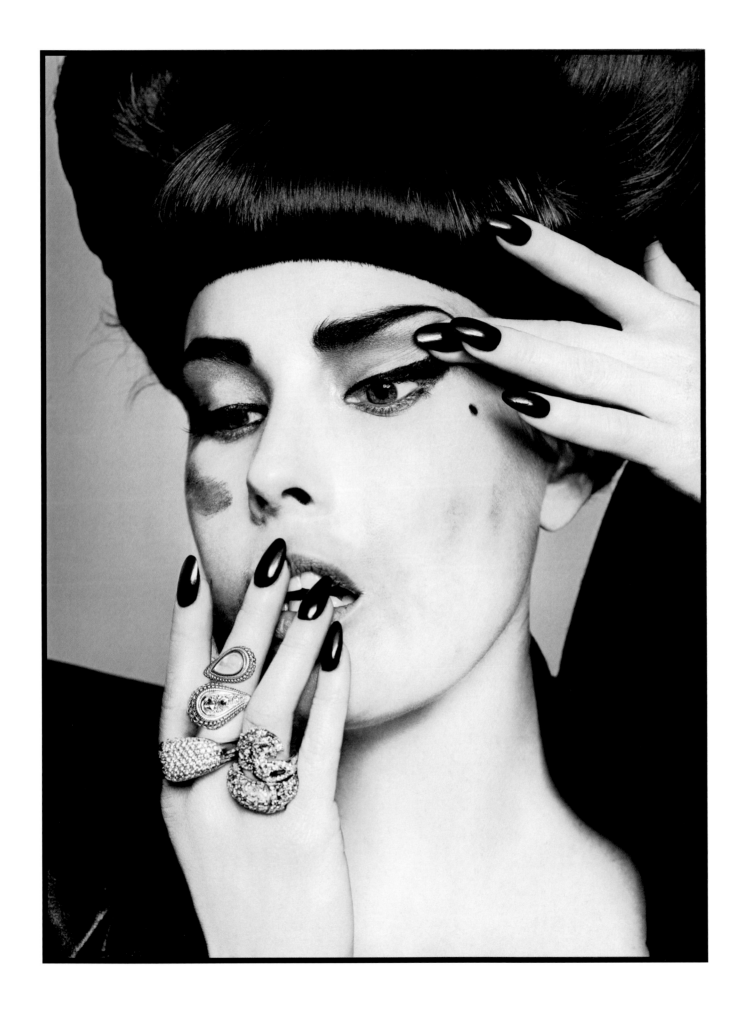

"There is no eye that can't support a cat eye," notes our makeup artist confidant Gregory Arlt. "The line might be thinner or thicker depending on the shape of the eye. Don't think you have to be limited by ethnic traits. On my travels through the Americas, Asia, and Europe, I've lined every shape and size of eye. A cat eye works on *everyone*. The only limitation is imagination!

"Personality is also a big factor," he continues. "A 'pinup face' is an exaggeration of beauty features. It's all in how far you want to take it, and that includes how far the cat eye tail extends. A lined eye without mascara is like Champagne without the bubbles."

Stroke of Color

As beauty products became more widely fashionable and accessible during the 1950s, the concept of matching cosmetics to clothes spread among designers and their clients and fans like a run in a silk stocking.

Fashion editors and advertisers began touting green eye shadow with an emerald eye pencil, or a powder violet lid lined in peacock blue. It might have not always translated delicately

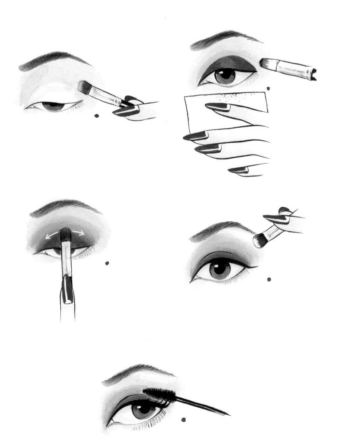

among the throng of beauty adventurers on the street. But these gals who dared had a vibrant time experimenting!

Medium and darker violets are particularly flattering against all eye colorings, brown included. So experiment. The marvelous thing about makeup is that it can be easily wiped away until another play.

Casting a Shadow

Even more than eyeliners, shadows come in an infinite array of colors, textures, finishes, and formulas. What color is right for blue eyes? For brown eyes? In my book, any color within comfort level and mood. After all, a contrasting color can actually intensify the eye.

Take an electric blue. For years, it has gotten a bad rap. But a gal who is fearless can own it. Don't think a swath of peacock blue on the lids of olive-brown eyes can work? Rose (also an enthusiast of Yves Klein blue and malachite-green eyeliners) proves otherwise.

I have a weak spot for those hyper-color advertisements from the 1950s picturing models with swaths across their lids of the most vibrant, most matte pigments of aqua, emerald, and robin's-egg blue, bordered by a cat eye streak of black liner. What a fabulously bold way to brandish color!

On the other end of the color spectrum, a sweep of barely there vanilla, peach, lilac, or other neutral across the lid and upward to the brow gives a flattering, polished finish. I like a matte shadow with the tiniest hint of sparkle to give eyes a twinkle, day or night. It can also provide a "sticky" base for any layers of darker or textured shades applied on top. Another trick is to use a sweep of face powder across the lid as a shadow base. This base layer keeps natural skin oils from creasing eye shadow.

Lighter shades emphasize eye features (such as a stroke of highlighting shimmer across the brow bone) and darker shades de-emphasize.

The best application tools can seemingly run the gamut, too, from a finger to a small brush or cotton swab. Use what works. Just blend, blend, blend.

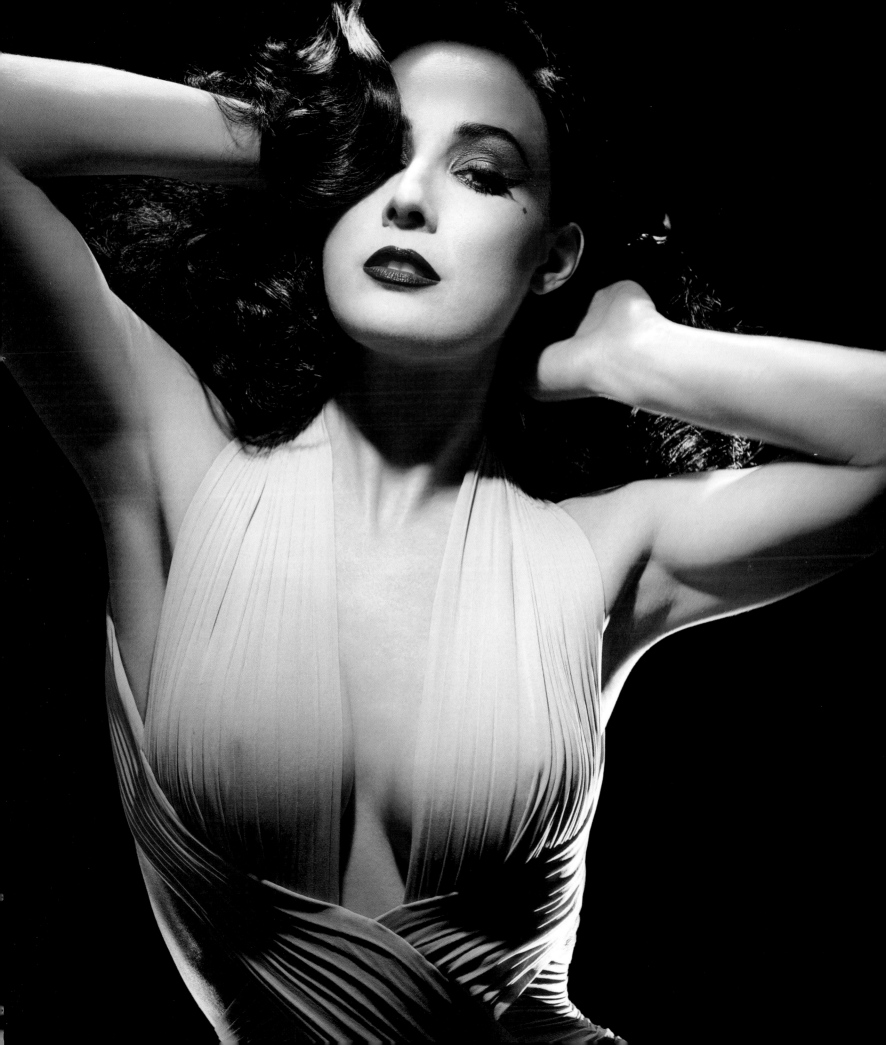

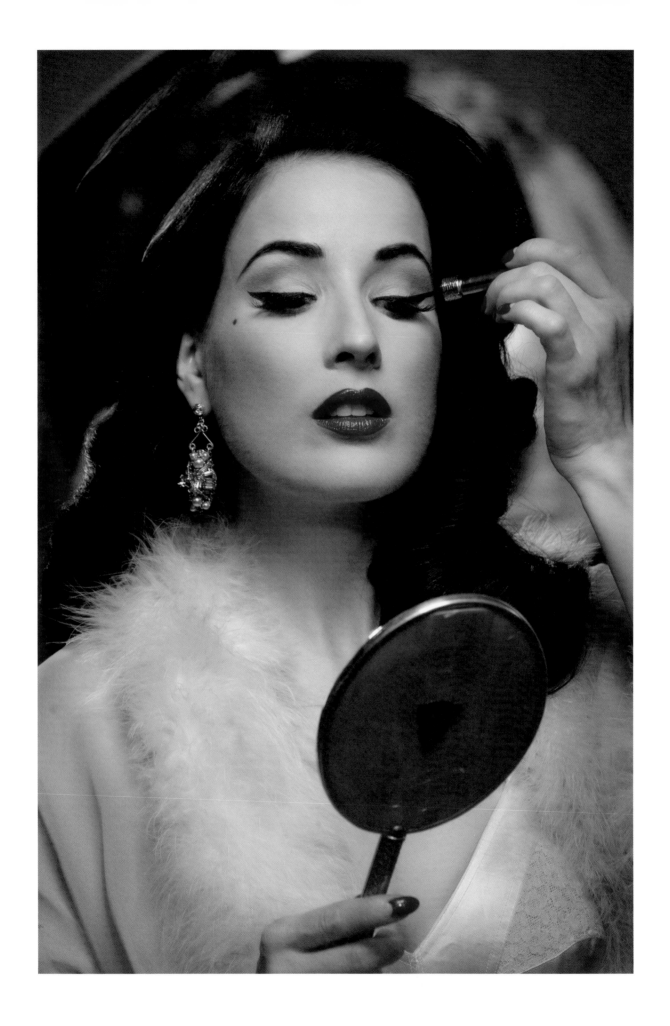

On the Line

A cat eye is not a cat eye without the liner. Whether the medium is liquid in a tube, a solid in a pot, or a crayon pencil, the choice is as much a matter of preference as convenience. And what a bounty of choices, from fine to fat point, have appeared of late. I might use more than one type to achieve the desired result. My go-to tends to be MAC Fluidline Blacktrack, a pot of silky jet-black cream.

In any form, a fine brush or pencil point is crucial to achieve a (near) flawless line.

So is patience. This is the one eye makeup step, above all others, where it's best not to rush. If necessary, complete one eye and step away for a moment before returning and completing the other. Personally, I go back and forth between both eyes from start to finish. *The best way is the most comfortable way for you.*

Begin the outline by pointing your chin up, with your eyes looking down.

From there, it's a matter of what feels natural. I begin on the inside corner and work outward; Rose begins in the middle. In the long run, being patient with this step will actually save minutes and potential aggravation.

While it might be necessary to close a lid partially or all the way during application, do open them in between lining and shadowing. It's crucial to keep inspecting your work throughout the process.

Resist squinting. It won't do you any favors. Tilt your chin, look down into the mirror, and apply. As Gregory likes to quip, unless you're sleeping through the day, your eyes *will* be open, and that's how the world will see you.

Choose the most complementary, darkest color liner. Some blondes find black can appear too harsh. If that's you, a deep chestnut is a flattering option. Personally, whatever the shade of mop on top, the inkier color across the lids, the better.

On trend or not, Rose has long played with colored pencils in matte grape or frosted moss or liquid liner in metallic blue or lustrous gold, making such special-effect cat eyes a signature of sorts. I remember an African American dancer who could beautifully flaunt a winter white cat eye and white mascara. (All good reasons to keep sharpeners clean of residue, so they don't taint pencils of other colors.)

In recent seasons, Dior and other brands have offered multiuse adhesive patches to get a cat eye look. The effect isn't exactly like drawing it on. But worked right, these patches can look striking. For me, though, they take all the fun out of the ritual!

Chalking a Tightline

To give the illusion of brighter, bigger eyes, carefully run an eyeliner pencil along the roots of the lashes and inside rim. This stippling, or tightlining (as makeup artists prefer to call it), really opens the eye, and done in tandem with lining the eye, it's a kind of invisible trick.

Go with a waterproof formula. A mechanical pencil is preferable to a wood-based pencil, too, because it tends to be creamier. As for color, it depends on the effect. A chalky bright white pencil is a great opener. But black or another color (the same one used above the lash line, of course) can intensify a look.

Accentuate the outer corners both at the top and bottom (with the bottom, you could either do the inside or, instead, only the area under the lashes). Avoid drawing into the inner corners or eyes can appear beady. Only use a white pencil on the inside rim, and even this is optional and not something I do daily, but tend to reserve for a special evening or onstage. Finally, do any cleanup with a fine cotton swab, curl your lashes, and apply mascara.

Lashes of Fun

Mascara

The teasing art of batting an eye involves attitude, conviction, and plenty of mascara.

Choose a formula with qualities that suit your needs at any moment. There are countless options these days. Waterproof mascara can be just the thing during the hot summer months of swimming invitations and uninvited allergies.

Can't decide between a mascara with strengthening formula or one promising to thicken? Get both. Professional makeup artists often layer two kinds of mascara to get the desired effect. Gregory suggests letting the first coat nearly dry before applying the second. "Think of it like painting a wall," he says. "If a coat is not fully dry, it could create clumps when another coat is prematurely applied."

A few mascaras I love include Diorshow New Look Mascara and Diorshow Iconic Overcurl Mascara; Voluminous False Fiber Lashes Mascara by L'Oréal Paris; and False Lashes Extreme Black by MAC.

Colored mascaras can be as fun as colored eyeliners, and there are so many gorgeous ones to select, from eggplant to electric blue.

The illusion of lash length comes from mascara coating the roots. So drag the wand from roots to tips. This will also help separate lashes.

A lash comb is also a useful way to separate lashes and clear away any clumps. There are a variety of wands now on the market, including smaller, round-tipped brushes well suited for bottom lashes. Wiping the wand with a tissue before coating it again can keep it clump-free. *Never* pump the wand in the tube—it forces air in, drying the contents out. Instead, gently run the wand around the inner sides of the container to collect mascara.

Don't forget to hit the inner lashes. Work the wand toward the bridge of your nose to reach them, using a root-to-tip dragging motion.

I also like when lower lashes are coated. The trick is to touch the wand lightly along the bottom tier. Of course, this isn't for everyone. Some women loathe it; some women love it (whether they need it or not). A makeup artist once told me he always asks in advance whether the woman in his chair likes this or not, so strong are the views on it.

If any mascara gets on your skin, wait for it to dry and then flake it off with a dry cotton swab.

Watching Out

The eyes are delicate. Treat them with an extra dose of TLC. Death and blindness by a lash dye called Lash Lure finally forced safety standards for beauty products in 1938. Nearly two decades later, in 1957, Helena Rubinstein upended the application of mascara when she replaced the hard cake with a new cream in a tube.

Mascara has an expiration date. Not one literally stamped on the tube. But a mascara's days are numbered from the first moment the wand slips out of the container. Exactly how numbered? Any used mascara should be tossed after four months. If the texture changes or it suddenly smells, definitely trash it. Most likely the bad kind of bacteria has festered. Anything used during a bout of pinkeye or other eye ailment should definitely be discarded immediately. Why play roulette with eyes over a few bucks?

If a new mascara isn't doing the job, then take it back. Most department stores and drugstore chains have state-mandated return policies for cosmetics.

In terms of removal, the nonprofit Lashologist Council of America (yes, there is such a group) recommends using a lint-free applicator or cotton buds to remove makeup with a non-oily, scent-free eye makeup remover.

Admittedly, I prefer an oily makeup remover applied with a finger, followed up with a washcloth and clean rinse. Or use a cotton swab moistened with remover and gently run it across the lash line of the lid. Whatever your approach, repeat until *all* traces of makeup are gone and rinse with clear water.

Eye care is also a matter of specs appeal. Sunglasses with combination UVA/UVB filters ward off sun damage, and they prevent squinting, a cause of dreaded crow's-feet. They can also save a face following a long night with little shut-eye or if time only allows for powder and lipstick. Your public won't be the wiser about the naked eyes behind the mask.

There are so many iconic moments in cinema and fashion featuring women and men brandishing dark shades. What comes to mind most is the sight of Rita Hayworth disembarking from an airplane, showing the world her great big pair.

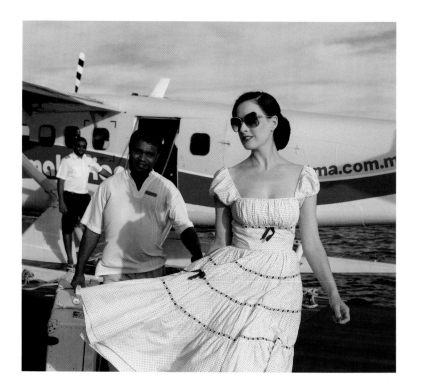

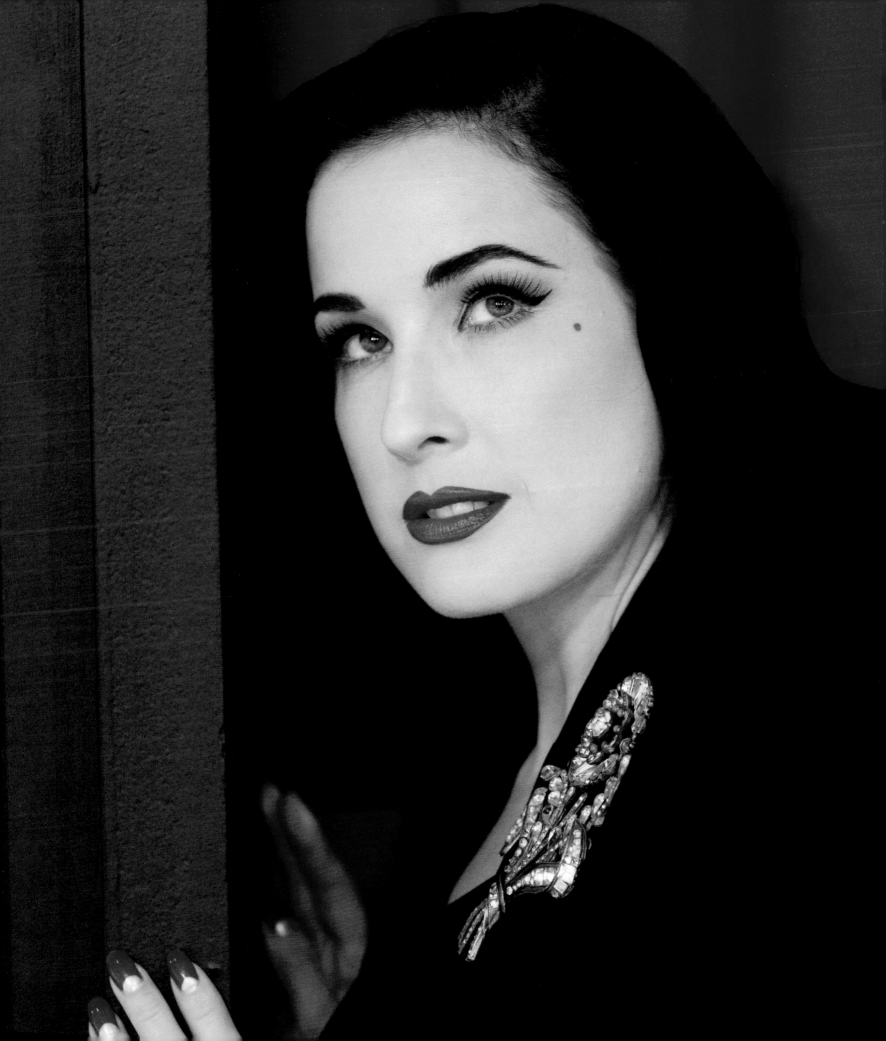

Squinting is also a confederate to poor eyesight, proving the right accessory can make or break a look. I realize modern life is all about contact lenses, and they do have their place. But unless there's some medical reason for opting out, why would anyone deprive herself of something with so many charming options?

Boys *do* make passes at girls who wear glasses. I've heard as many wolf calls directed at gals in glasses as those without, yours truly included. Besides, there's a secret power among the vision-challenged. Remove the glasses and all unsightly nuisances go out of focus. Talk about turning a blind eye on someone.

The Curl

To curl the lashes before or after applying mascara? While I won't say I never go back after my lashes are good and coated and (gently) re-curl, I know better. The damage to natural lashes from doing this regularly isn't worth the risk. While it's best to curl before liner or mascara, I curl after lining because I find it's easier to line with relaxed lashes. But do it when the liner is dry.

There are exceptions: if the mascara formula isn't particularly sticky, Gregory suggests warming up the curling tool with a hair dryer for a few seconds. Make sure it's not too hot, and very gently squeeze mascara-coated lashes.

As for the quality of a curling tool? A drugstore version works as well as an expensive one. As with mascara, there are plenty of cheapie models that can do the job. Proof is inside most any professional makeup artist's kit.

Faux Real

Lash enhancement has come a long way. In the pursuit of volume, thickness, and curvature, advances run from safer, longer-lasting tinting to water-resistant extensions, individually and painstakingly applied.

The first time I had lash extensions was in Bangkok in 2009. Mind you, I'm not into exaggeratedly long lashes. I prefer them natural length, unnaturally dark and thick. I immediately became obsessed. I now wear extensions every once in a while on holiday or on a romantic weekend.

Prescription treatments such as Latisse actually grow lashes. But as with many prescription supplemental enhance-ments, there are potential side effects during the treatments, and careful application is essential.

Despite all the new technologies, for me, false lashes remain a girl's best friend. They are an instant way to make eyes alluringly pop. There are so many styles of falsies to choose from, from natural to fantasy, ones that provide an illusionary frame of a rounder eye or an almond shape.

Lashes with a gradation look more natural, more appealing. Never cut the lash hair, but do cut the strip to fit your eye width. They should begin just slightly in from the inside corner and end at the other end—not beyond the eye line. I also like to use half a falsie to really play with the shape and emphasis of the eye.

Clear adhesive works well on an eye without liner, but when it comes to a cat eye, a black adhesive gives a seamless appearance. There are also adhesives that function like a liner, the tube tipped with a tiny brush for easy application.

I always keep a couple of tubes of adhesive in my beauty case. But there was one night when I was backstage for the Macy's Passport extravaganza, the annual fashion show that raises millions for AIDS/HIV causes, and I realized I forgot my lash glue. I was performing my act inside a supersized mirrored Champagne glass for an audience that included Dame Elizabeth Taylor! Obviously, I needed my lashes.

Crisis averted when a makeup artist nearby came to the rescue. I paid in kind when he asked me to sign probably the trickiest item I ever had to autograph: the very glue tube I squeezed!

Gregory points out that since falsies are already black, already curled, and already long, it's possible to skip the mascara step. Because my natural lashes are pale, I need a light coat before applying falsies. So experiment.

A set of falsies can be reused if cared for properly. Remove gently, starting from the outside and working inward. Some makeup pros recommend washing them in clear, warm water or a lash-cleaning liquid, then patting dry with a tissue. I never wash them for fear that they might lose their shape. Instead, I carefully pick off the dried glue.

Always replace the cap on the lash glue. I once stepped in my new cherry-red suede Louboutins on top of an open tube of black lash glue. Oh, the tears! Thankfully I was wearing waterproof mascara!

Framing a False Impression

I favor faux lashes for the dramatic volume and uniformity they give the made-up eye.

Curl the natural lashes and, if the lash is light colored, sparingly apply mascara. This can also help them serve as a kind of "shelf" or base for the faux strip.

Lift the false lashes carefully and slowly from the package using tweezers. Hold them up to your eye to gauge positioning. The lash strip should never extend into the inside corners of the eye. If necessary, trim the outside corners of the lash strip to fit.

Hold the lash upright, slightly bending it to create an arch. Holding the adhesive tube in the other hand, gently squeeze so only a drop peeks out. Guide the tube tip with adhesive along the edge of the lash strip. Continue to slightly bend the strip and wait 10 seconds for the glue to set—not dry. Avoid bacterial taint by *not* blowing on it!

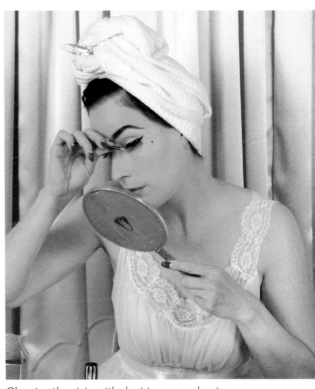

Clasping the strip with slant tweezers, begin application from the inside corner out and by tilting your head back just enough to still see into the mirror. Steadily merge the falsie with the natural lash line, carefully pressing it into place as close to the lash line as possible or risk distorting the line of the cat eye.

Gently press your natural and fake lashes together with the end of the tweezers until set. If a corner of the lash lifts, start over. The lash strip might be too long, or the application requires more patience. Repeat with the other eye.

Eye of the Tiger

In life, there are fundamental skills a gal must master: Walk in heels. Poach an egg.
Pen a thank-you note. And, most absolutely, without a doubt, create a cat eye.

After quickly studying the brow line to remove any stray hairs, brush a neutral shadow (I like a shimmering or matte peachy pink, powder blue, lilac, ivory, or winter white) over the entire lid from the lash line to the brow bone with a flat brush. If you're planning to contour, brush lid and brow bone only.

For added depth, consider a sweep of a neutral taupe shadow (Gregory recommends a grayish taupe, while I like a pinky almond shade) in the crease of the lid. If the mood hits, layer on a shimmering highlight at the arch (now and repeat at the end).

Taking the fine liquid liner brush or a sharpened soft-textured pencil, slowly outline the top lash line into a cat eye shape. Begin where it feels natural for you, be it on the inside, middle, or outside. The line can be thickened and shaped once the base line is drawn.

Repeat on the opposite eye. Keep pointed, moistened cotton swabs on hand to correct any flaws. Review each eye from different angles with a hand mirror and match up lined shapes as best as possible.

Once the desired cat eye is achieved, wait a few seconds for your work to fully dry. I like to spur drying with a pretty hand fan.

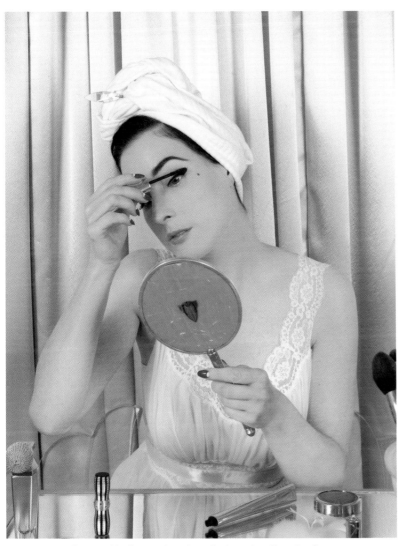

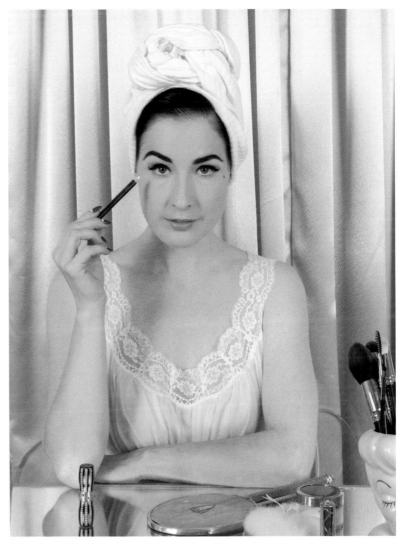

Curl natural lashes with a clean lash curler. If you're forgoing falsies, don't skimp on the mascara. Drag the wand comb from root to tip and repeat. I also like a lighter coat along the bottom row, emphasizing the outer corners.

Survey your work from every angle with a hand mirror. Reapply finishing touches, be it an extra sweep of highlighter powder across the brow bone or lightest part of the lid, or tightlining with a white pencil (see page 167). Spot-clean and repair with a pointed swab. If those cat eyes look good enough for Maria Callas to sing your praises, they are, indeed, purr-fect.

Night Vision

These steps show how I quickly take a day look into evening (note: I'm already made up).
However, they are the same even when you have the luxury of time.

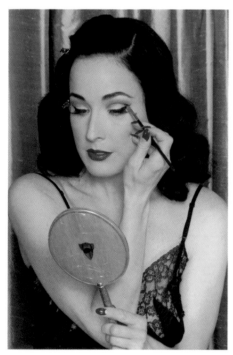

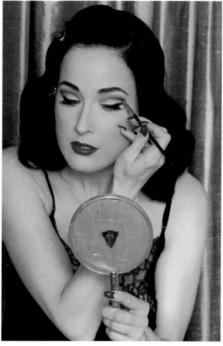

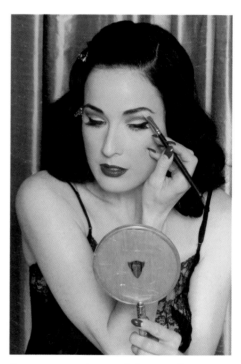

Sweep neutral shadow from the lash line to the brow bone with a flat brush, minimizing or avoiding coverage over the crease area. Drag a pointed, denser powder brush with a darker neutral of taupe, burgundy, brown, or navy shadow over the crease. (Remember: only one side of the brush should tap the eye shadow to curb fallout from the other side on your cheek; consider using a tissue under the eye to catch fallout, too.)

Alternate between the flat brush dusted with the lighter shade and the denser brush with the darker contour shade, blending well. Once both eyes are complete, review. Consider turning up the drama by further defining the crease from midway out with a shadow in a deeper tone. Don't be afraid to apply black shadow.

For an evening boost of glamour glimmer, give the brow bone and pale part of the lid a graze of sparkling white, or shimmer of pale gold or silver.

A dust of eyeshadow on the cat eye? Blacken it with a fresh stroke of liner.

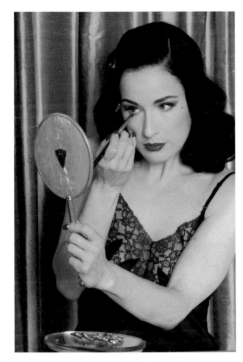

With a small, flat brush, lightly sweep a touch of the neutral shadow underneath the bottom lash rims to really heighten the after-hour allure.

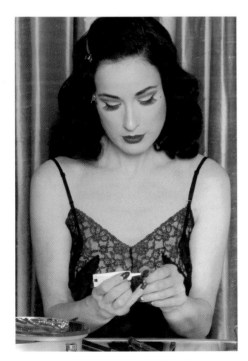

As detailed in the section in this chapter on applying false lashes, trim and trace false lashes with lash glue. Apply, carefully positioning them along the lash line with tweezers. Finish with a lavish brush of mascara.

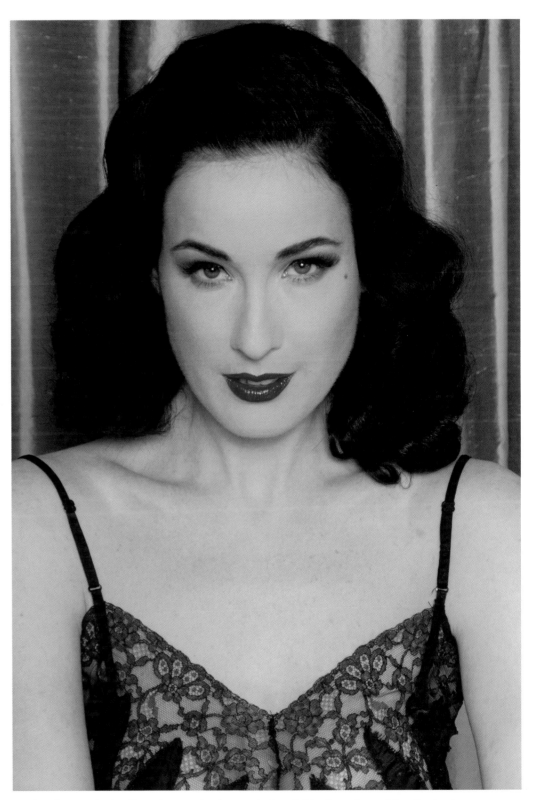

Apply a deeper shade of lip color, one that honors the bewitching hour. As explained in chapter 13, layering shades can give a richer effect, a particularly good way to go for evening. Cheeks can go bolder, too. Forgo the softer pinks for a light touch of heightened reds. Ready for cocktails and candlelight.

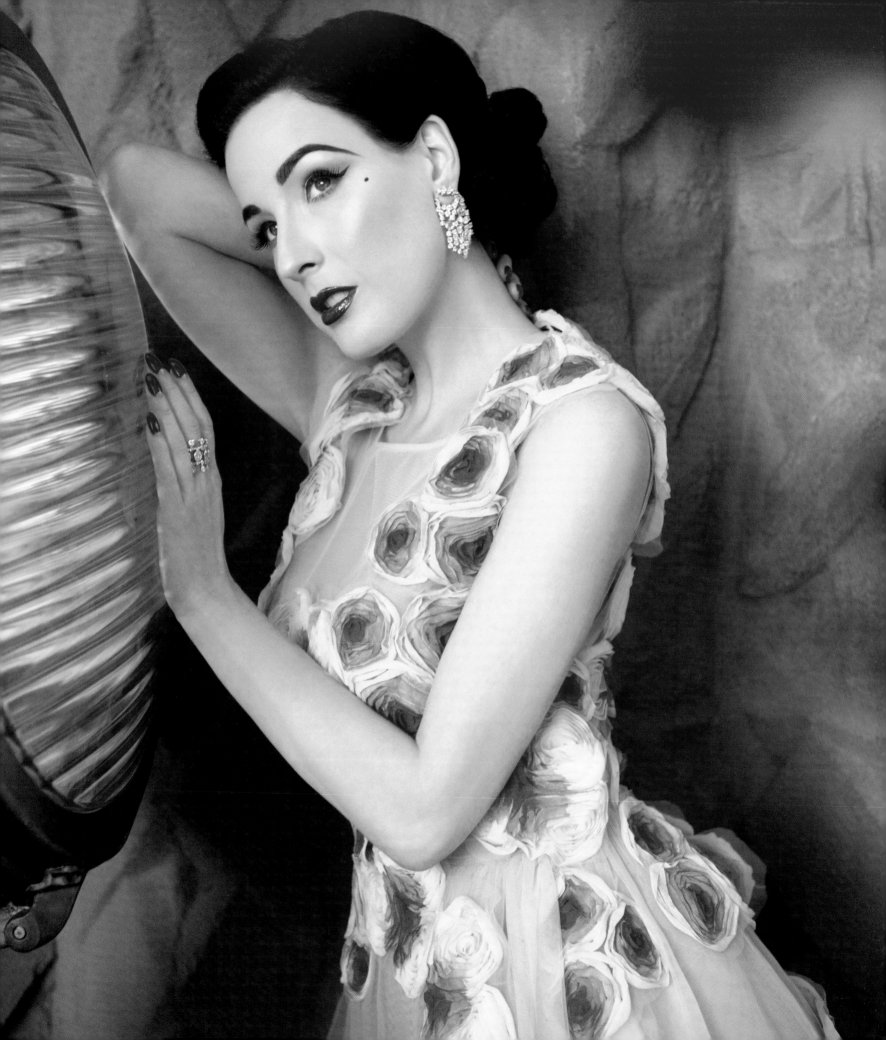

CHAPTER 10

Arch de Triomphe!

This might come as a real eye-opener, but despite all the time spent in my teens mastering a red lip and cat eye, my eyebrows were the last of the makeup flourishes I gave my attention.

It was an afterthought, really. Once I started dyeing my hair black, I also took to darkening my blond brows. It was then that I began scrutinizing the significance of an eye-catching brow.

The arc of the brow is not unlike the arc of a story. All it took was one lift of those perfectly shaped arches of Marilyn Monroe and Jane Russell in *Gentlemen Prefer Blondes* or Julie Newmar as Catwoman and you knew they meant business.

The ancient Egyptians believed in the power of kohl-crayoned brows, as did my favorite Cleopatra of all, Elizabeth Taylor.

Arcs might peak at the midpoint, or curve like a bow. They might be lush or feathered. Or they might not exist at all. Straight and angular, they might resemble two slashes. However they appear, thanks to nature or nurture or even neglect, eyebrows can set the tone. They can speak louder than words, signaling astonishment, anger, glee, or mystery.

Do they give off a flinty glare? Do they evoke the all-American girl, or something more exotic? Do they suggest a Ziegfield gal or femme fatale? Or do they unwittingly make you look sad or mad or anxious?

What statement are you making with yours?

A Temple to Worship

A great set of brows is a thing to behold. I'm convinced it's among the features we are most impressed by, more than lip or hair color. The goal is to cultivate a pair that does not overwhelm the face. Brows are a key factor in the expressions we make, but they don't have to dominate communication.

This chapter concerns itself with the cosmetic enhancement and fashion of the brow *after* it has been primed, a first step outlined in chapter 5 on body hair grooming. I try to maintain mine according to the natural line of the brow and contour of the eye. That is, of course, except when I'm laying it on thick, painting them in a fashion more exaggerated than what nature provided!

The Bold and the Beautiful

Brow aficionados, be they professionals or civilians, will resist fads for what is the most attractive for an individual. Consider the brows of a modern icon such as Brooke Shields or starlets such as Camilla Belle. Most faces look better with more brow than not enough.

While I flirted with thin brows in my twenties, for my face now, I prefer them more robust. There's always a bit of drawing, of shading in, even with my gal-about-town arches.

Strong brows convey power, presence. But as history has shown, attainment has occasionally been blinded by desire. Eighteenth-century French and British society considered it haute when they slapped on falsie brows made of mouse hide. Centuries earlier, Roman women applied swatches of fur to brows and perfumed them with bergamot and mink oil. While I appreciate the dedication to feminine allure and even like the idea of a brow brush dipped in perfumed water, I can't help but be grateful that I live in a time when facial artifice doesn't involve rodent parts!

Then there is the monobrow.

Deemed a mark of beauty and even intelligence among many ancient civilizations, Greek and Roman women not blessed with a single strip of a brow would connect the left and right with kohl, a pigment made of soot or lead. Aside from Frida Kahlo and Helena Bonham Carter, this is one antediluvian accent that should remain in the distant past.

Of the women I always admired—postwar beauties such as Elizabeth Taylor and Marilyn Monroe and Jane Russell, along with the original supermodel Suzy Parker, diva Maria Callas, and, not in the least, Audrey Hepburn—all of them have big, bold, beautiful brows in common.

Certainly, too much of anything can be simply a drag. Bushy brows can draw such a focus that they take away from the harmony of the rest of the face. A scrubbed, makeup-free face still holds up beautifully with a polished brow.

The transformation to belle of the brow doesn't come overnight. And, like many of my other approaches to do-it-yourself beautification, my own education involved study, practice, and, crucially, patience.

I know what I want my eyebrows to look like. So I've always pruned them myself. If you are completely at a loss over what shape your brow should be for the shape of your face, then by all means see a professional aesthetician or brow artist for a consultation.

As I noted in chapter 5, if you like their basic shape, don't give in to the intimidation of any brow bully, even if she is a star plucker. Skill always trumps a good publicity machine.

Line of Sight

Thick and thin, I've seen all kinds of brows manipulated to great effect. Pencil-thin brows on a face that can pull it off is a look I can admire. Hello, Marlene Dietrich, Clara Bow, and Mina!

The Italian pop superstar Mina Mazzini ruled it during the 1960s and 1970s, when completely stripping away the brows became de rigueur. Think Angie and David Bowie during those glam rock years. Like them, Mina endlessly scandalized prim society through her heyday, and to the tune of sales of some 76 million records! I'm obsessed with her old videos on YouTube. It's like there's a whole different ticker tape going on in her head. I adore the way she looks, browless and all.

Mina's eccentric flair reminds me of my friend Catherine Baba in Paris. She also presents a striking image, in part because she long ago did away with her brows. Instead of arches, she might color her entire forehead gold. She can pull it off, too.

A good part of that is attitude, naturally. I've met young women at my appearances and on my travels who can pull off the most razor-sharp line-drawn brows. But it's not a look for everyone.

The life changes everyone inevitably undergoes might also spur hair loss on all parts of the body, including the face. Whether the changes are a result of rages in fashion or hormone levels, an eyebrow can be rendered best with powder and brush and a very light hand of a brow pencil.

Ali Mahdavi, who lost the hair all over his body as a teen (as he so eloquently discussed on page 12), put Gregory Arlt to the test once when he dared him to paint perfect brows on his hairless brow. At the time, he and Ali were strangers, and Ali only likes to use his own crew. I wanted Gregory there because he knows pinup makeup like few others. Gregory accepted the challenge and expertly drew in über-brows. Ali was impressed, and the pair became arch friends!

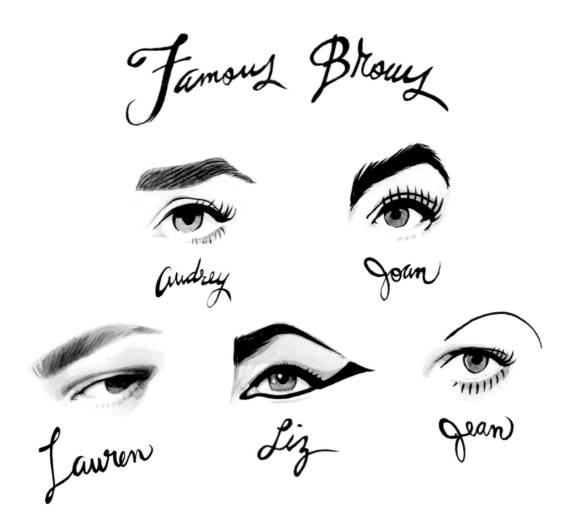

Famous Brows

Audrey

Joan

Lauren

Liz

Jean

The Enchantress: Catherine Baba

Catherine Baba is a marvel, as audacious about her jewelry and cigarettes as she is about her heavy layers of lipstick and strikingly stripped and penciled-in brow bones. Catherine is a stylist living in Paris, who, since leaving Sydney in 1994, has made her mark collaborating with Chanel, Givenchy, and Balmain, as well as a host of fashion magazines.

When I first spotted her, I thought, This creature is beyond. What an eccentric! She's taking her self-invention way further than I have. What follow-through! She neither dresses for men nor for society—but for herself. I adore Catherine and those like her, who do not try to be sexy . . . yet still very much are.

The amazing Baba also speaks in dramatic form, stretching out French-inflected words like honeyed taffy. She describes even the mundane in the most vivid of phrases. When she sees something she likes she declares without an ounce of irony, "Oh, that's devotion!"

There are loads of wild anecdotes—all true, mind you—about Catherine. Of how she was hiking through the desert in heels and a ball gown and bright lipstick; of swimming in Sicily wearing piles of sparkling jewelry and a turban and carrying a parasol; of removing a chandelier from a ceiling and wearing it as a hat during a stint behind the turntables; of getting around Paris on a bicycle, in nose-bleed stilettos and a vintage fur coat.

Those lucky to have come into contact with Catherine prize their tales about her. I am fortunate to have collaborated with her on shoots, and she's become a friend and lipstick confidante. During an interlude of work and pleasure in London, she riffed about making a beauty mark in this world.

To me, it's about expressing the beauty within externally. We are all multilayered and completely individual. We don't have to say everything in one sentence or in one look.

We are born who we are and we just evolve from there. I am number seven among eight children. My siblings and I might come from the same parents, but we are all completely different. I expressed myself in more visual terms. I was always out of the norm. Among such a large family, you had to exist, darling. You had to exist!

Sydney is a young city, open and eclectic and exciting. But history is important to move forward, and Paris was always a dream for me. My mother was a couturier and my brother worked with fabrics as a cutter. I grew up among sewing machines and everything to do with the industry. But Paris! It is synonymous with style and beauty, and I don't necessarily mean the women. Frenchwomen are beautiful and stylish, yes. But beneath the city there is a magnetism that draws creative minds from all over the world—the poets, the painters, the writers, the designers. Paris is open to anyone and anything that is aesthetically expressionistic.

I didn't set out to create a look. I did what felt comfortable. When I arrived in Paris, I discovered the flea markets and beauty I never imagined—it was about silhouettes, proportions, fabrics, details. *J'adore* accessorizing. More is never enough. I've always loved to experiment with makeup. In beauty, an important aspect is to play, to arrive to that point where it's all second skin.

By the way, did I tell you about how much *j'adore* bathing in sake? The rice-based wine has real benefits for the skin. I read somewhere that geishas back in the heyday bathed in sake, and since then I have done so, too, pouring in a bottle with my warm water. It depends where I am in the world, of course. Sometimes it's not so easy to locate a bottle. It's a divine experience. It illuminates the skin. You can get a bit high on it, too. Anything that makes us feel good, *pourquoi pas*? Why not?

While I don't think we should dress for others, it is so true that everything is ultimately about seduction. Anywhere in the world, it's about seduction! Of course, I adapt depending on the scenario. But I adapt according to my rules. You take me how I am or do not. If you don't *feel* divine, if you don't feel like yourself, you won't *be* divine. We all want to be divine in life, *n'est-ce pas*?

I would love to grow old, elegantly, embracing my lines. They reveal my experiences, my life lived. It's about celebrating yourself with a raised shot of vodka, darling! How divine!

Lasting Impression?

When it comes to brows, tattooing is another option. But it requires research and commitment. In advance, work out a shape and live with it—*before* going under the needle. Then find an artist by way of finished work you admire. Be sure their talent deserves your face.

Likewise, when it comes to the new field of semipermanent eyebrow tattoos, still limited to a handful of salons around the world. Like tattooing, the small incisions are filled with ink, in this case natural vegetable dye. The process can cost nearly $1,000 and lasts for two years.

While I've flirted with the idea of tattooing my brows, after considerable thought I opted to keep painting them in myself. After all, what if I wanted to go blond or ginger or silver fox gray one day? Unlike my beauty mark, my brows are a feature I like to change up from time to time, even if the difference is ever so slight.

Fending Off Arch Enemies

Science is also responding to anemic brows with products such as Rogaine and Latisse, which spur hair growth. Of course, before experimenting with any chemicals, especially when it comes to the area around the eyes, see a doctor before use.

Brows that are blatantly uneven can also prove distracting. But don't go driving yourself crazy trying to make them mirror images of each other. "They're sisters, not twins," makeup artist Gregory Arlt likes to say. Provide a semblance of balance by applying colored brow powder with a small stiff brush. The beauty of makeup is that it can always be removed on the spot and reapplied.

Choosing Your Brow Shade

Rules are made to be broken, of course, but the rule of thumb if you choose to synchronize:

Blondes: Go a shade or two darker

Brunettes: Chestnut to charcoal to jet-black

Ginger: Blond or auburn

Gray: Blond or taupe, depending on skin tone

Can't decide? Go taupe, regarded as the most flattering on the most faces.

That said, we thrill at the sight of a graphic brow! There are those brave souls who color their brows in a bold blue, purple, or other shade. And we're mad for a dark, dark brow on a blonde, à la circa-1980s Madonna.

While Rose tends toward shades in a deep mahogany or off black, I prefer as close to black as black itself! I dye the hair on my head blue-black, so it goes that my brows complement accordingly.

Experiment with brow powder or eye shadows. I have a discontinued black eye shadow with a speckle of sparkling gold that is my go-to brow powder.

Coloring in the Frames

I dye. There, I said it. But this falls under the probably-shouldn't-try-this-at-home category. See a professional. And definitely don't try it if you haven't mastered your brows by way of colored powder.

I use what is left from coloring my hair, which usually isn't much, but I don't need more than a few drops. I also never leave it on for more than five to eight minutes.

Another option is Just for Men Brush-In Color Gel for Mustache, Beard & Sideburns, which comes in two tubes and can be easily mixed in small amounts as needed. There are also tints designated for brows and available in tube form.

Using a sharp, angled brush, carefully apply the dye in a precise shape as if it were brow powder.

Unless you're adept at this, it's best not to tempt the fate of stained skin by dyeing your brows before a big event, especially one during the afternoon when daylight might not be as forgiving and makeup might be less heavy-handed. After dark? A superstrong, just-dyed brow looks best with whatever your drag.

I love another result: dyed brows cut down on makeup time. There they are, ready to go.

In the Toolbox

- Quality flat-slanted stainless-steel tweezers (Splurge a little. They can last for years and are also essential for applying fake eyelashes. Size depends on individual handling comfort.)

- Magnifying mirror: handheld or one that illuminates (or both!)

- Brow brush or mascara wand (clean or new toothbrush, in a pinch)

- Small straight-edged scissors

- Eyebrow powder: matching base shade of hair

- Small angled brow brush: flat bristled for brow powder

- Eye shadow: a pearly and/or matte shade paler than skin tone to highlight the arc

- Brow pencil (though Rose and I prefer an angled brush)

- Brow fixer, gel or hair spray

How to Get the Brow Factor

*Once the brows are groomed, as described in chapter 5,
it's time to build up those arches.*

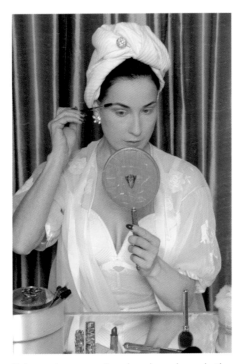

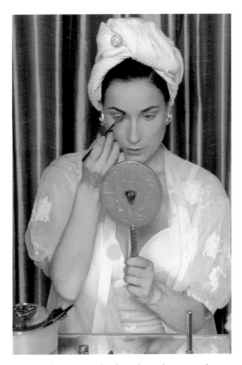

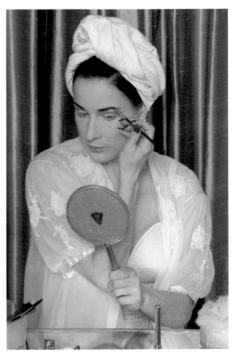

Take a clean wand or brush and comb the brow hairs upward at an angle and into place.

With a sharp angular brush and a matte brow or eye shadow, lightly brush color onto the brow with clipped, feathery strokes, starting on the inside. I always first test the brush on the back of my hand to ensure it's not overloaded with powder. If it is, tap the brush to free any excess that might otherwise end up on your cheek. Continue to brush outward into the intended shape, maintaining a steady hand.

Take your time when shaping the brow with makeup. Stop every few strokes to examine your face and brows in the mirror, up close and at arm's distance. Fill in, but not so much that it masks any sign of hair. It takes practice and patience to achieve brows that look bold but not overworked.

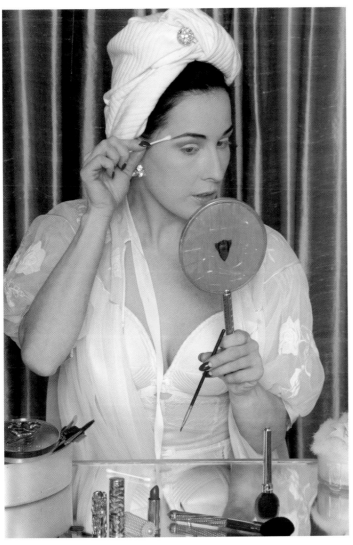

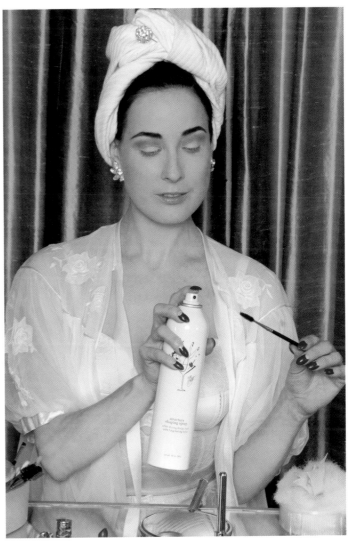

Clean up any smudges with a clean cotton swab. Next, highlight the brow bone with a light stroke of matte white, ivory, or pearly pale shadow.

Take another look. Further define the arch or fill in any spot with the angled brush. Don't forget to use the hand mirror to inspect your handiwork from every angle.

Fix those made-up brows in place with a brow gel or clear mascara, or simply spritz hair spray on a brow brush and sweep it across each brow. Triumph!

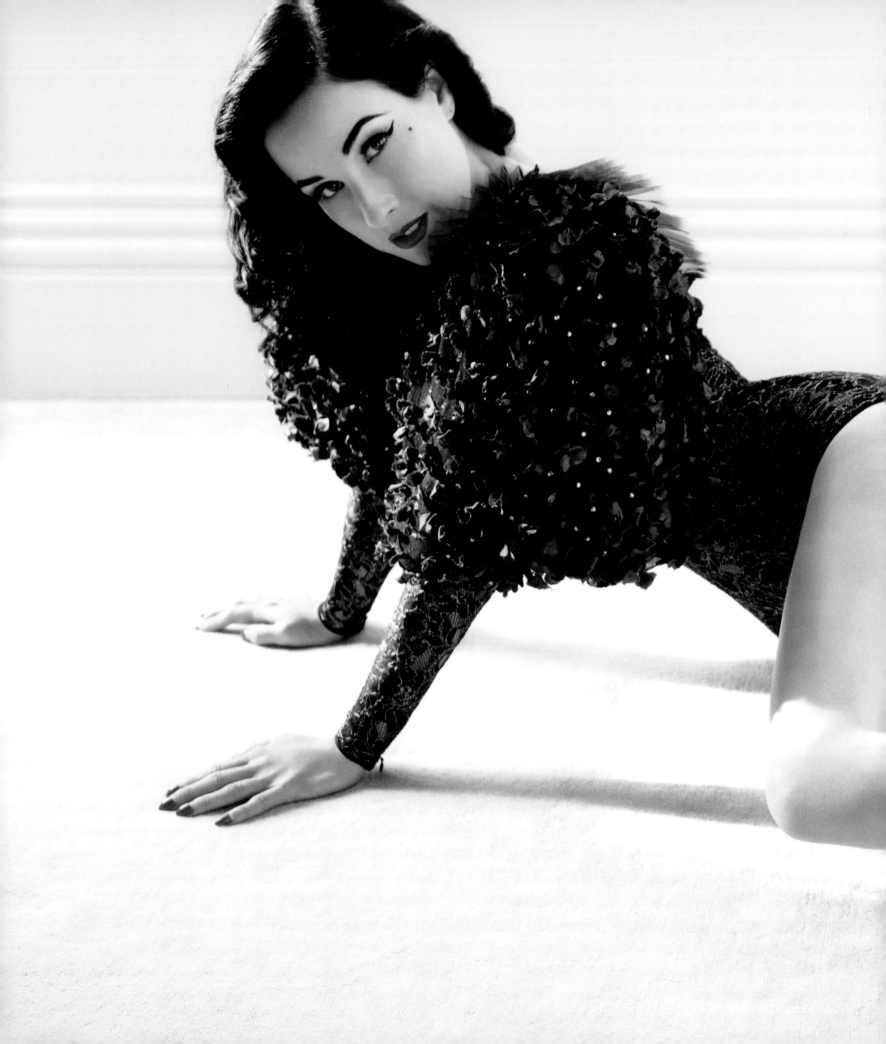

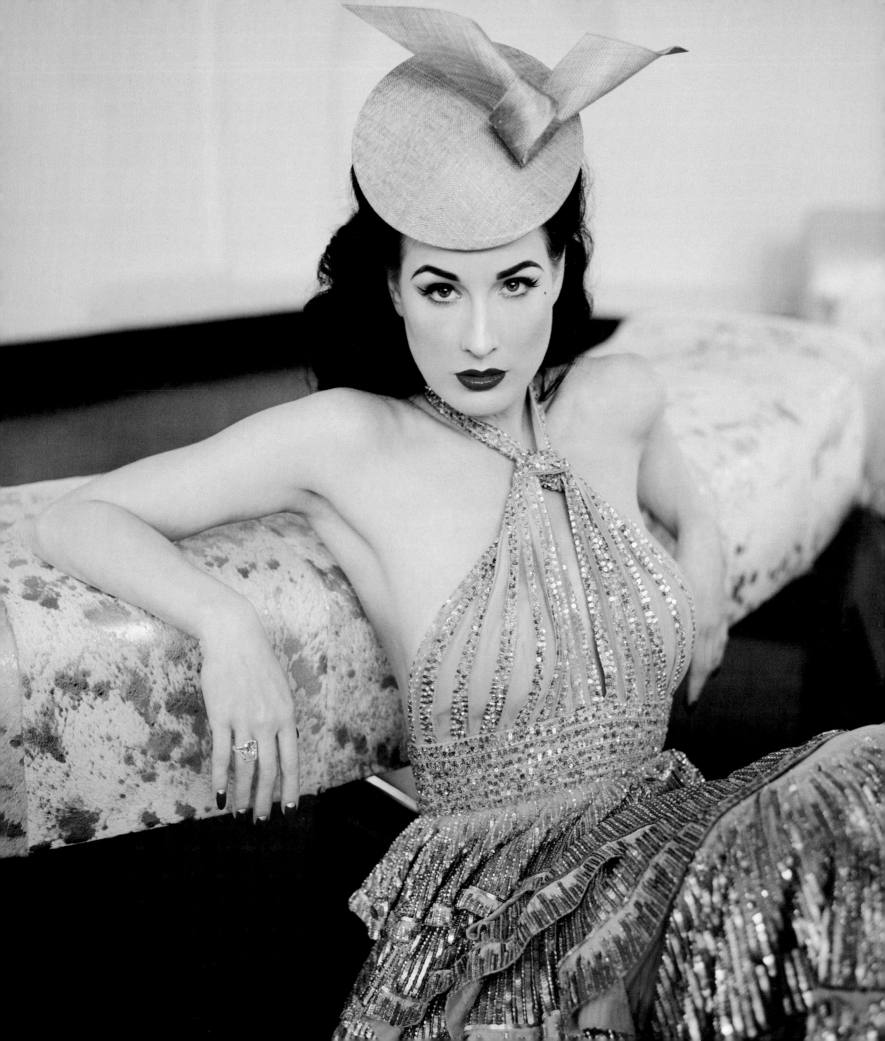

CHAPTER 11

Cheek to Chic

Never underestimate the allure of a rouged cheek.

One can spend all the time in the world contouring the consummate cat eye and intensifying a deep ruby lip. Even punctuate it all with a beauty mark.

But without a flush of blush, not only is the face incomplete, but the entire state of mind and body can come into question, giving off the impression of a girl who's got no vim. No vigor. No va-va-voom.

While I treasure my pale skin and go to great pains to keep it that way, there is a difference between pale and pallid. Miscalculating the power of rouge sweeps both ways. No blush at all is a drag. But there is also the risk of looking like bad drag if there's too much of the stuff in all the wrong places. The same goes if the shade neither flatters skin tone or a pairing lipstick.

Turn the Other Cheek

In the beginning, there was rouge.

Seriously, it was probably the very first cosmetic. It was dabbed on cheeks and it was dabbed on lips. Those ancients knew blush, with or without lip color, could be a quick pick-me-up. Flush cheeks also evoked a postcoital glow that was simply irresistible.

Classical Grecian beauties used seaweed colored with root of polderos, while Romans used a brown algae called *focus*, along with red ocher and wine dregs.

During the fourteenth century, rouge was also smudged on nipples. Such rosebuds readily peeked from décolletages that parted and plunged to the navel of the most fashionable women throughout Europe, a fad owed to Isabella of Bavaria, queen consort of Charles VI of France, a politician in her own right and great patron of the decorative arts. Queen Izzy delighted in coloring her "little apples of paradise" carmine and decorating them with pierced diamonds or other jewels, or linking them with strands of gold chains or bright pearls.

Marie-Antoinette's trendsetting rule more than three centuries later sparked the craze for a youthfully radiant face, even among little boys and girls, who received a healthy flush of coloring on each cheek.

Throughout the ages, anything that could stain a rosy wash on skin was squashed and smeared on: mulberries, strawberries, beet juice, henna, hollyhock root. A most exotic option was the dried and crushed bodies of the female scale insect from Mexico

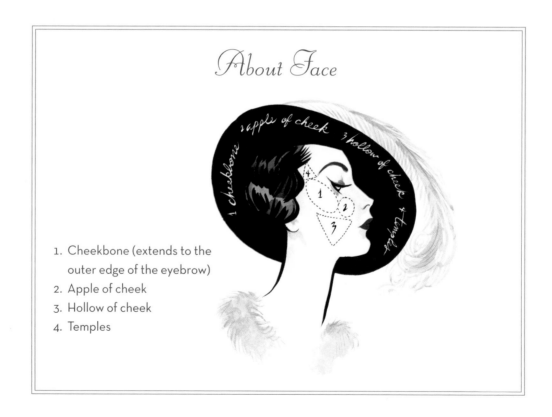

About Face

1. Cheekbone (extends to the outer edge of the eyebrow)
2. Apple of cheek
3. Hollow of cheek
4. Temples

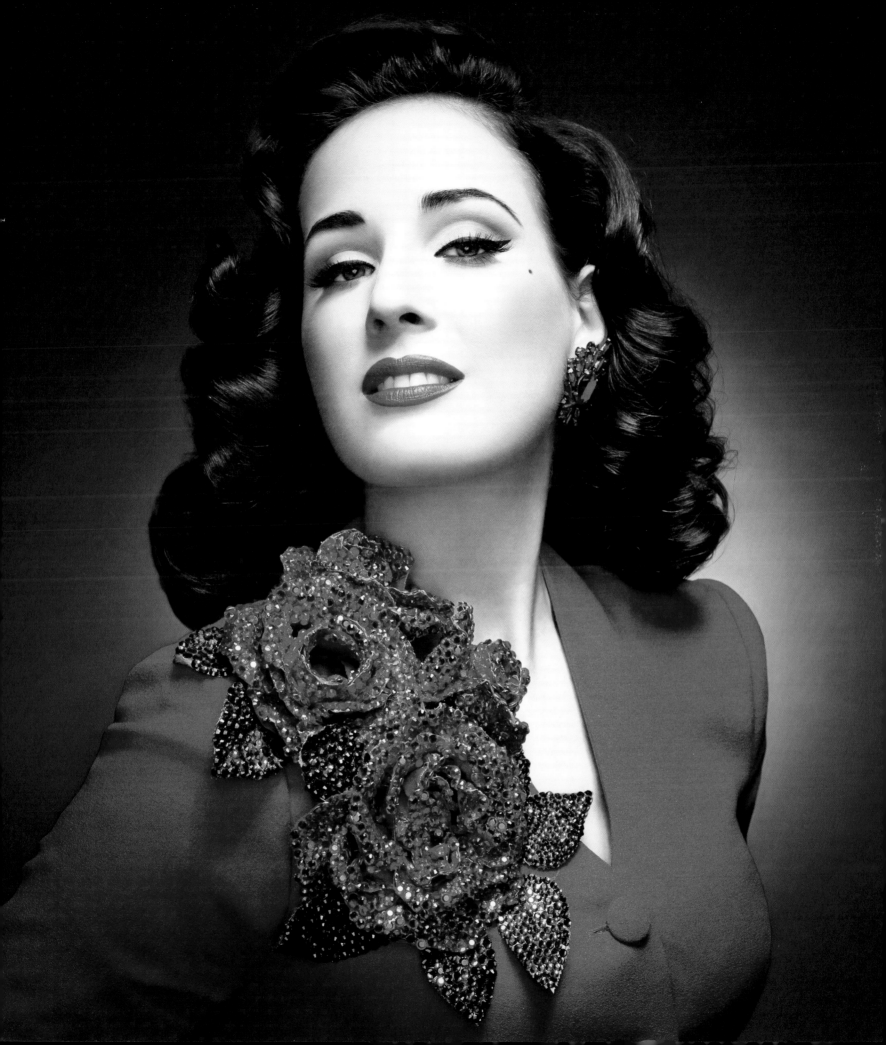

and Central America called cochineal. These bugs, with their shieldlike covering, resemble tiny berries. Their flesh and fertile eggs are a bright red, and when macerated they make a scarlet dye used in cosmetics and food.

Aspiring beauties would mix any and all natural ingredients in a liquor or ammonia along with rose water, or with talcum powders or pomades.

Among the beautiful people of Regency England, rouged cheeks were the rage, and both sexes slapped it on with gusto. King George IV loved his brightly colored fashions with corseted waists as much as his cosmetics.

At the extravagant coronation that Georgie threw himself in 1821, the *Times* of London reported that he looked "a fat Adonis of loveliness." Backhanded compliment? Possibly, since his good chum Beau Brummell, the ruling arbiter of men's style, had a far more restrained sense of luxury, opting for flawless, fitted tailoring and full-length trousers. So blush on men's cheeks went the way of man tights.

That is, at least until the marvelous Stuart Leslie Goddard, a.k.a. Adam Ant, came along more than a century and a half later . . .

I pale by comparison! Together at London Fashion Week in 2005.

Victorians, in all their conflicted glory, tried to achieve flush cheeks while staving off cosmetics—deemed immoral by pious pale faces—by vigorously squeezing them. Not an advisable practice, since broken capillaries and blemish breakouts are not pretty. (Admittedly, if I'm looking wan and no blush is within reach, in such a pinch I will give my cheeks a gentle squeeze! But the emphasis is on *gentle*.)

Like hair and clothes, the fashion of rouge itself changed. Add science driven by entrepreneurs in the mix, and *le chic* of cheeks was forever impressed on women everywhere.

With the invention of a synthetic form of cochineal with a wax and oil base, rouge on cheeks and lips became de rigueur in the 1920s. The palette of choices widened, too, from pinks and berries to corals and peach, worn unblended in disks of color on the apples of cheeks. It's an effect worn boldly in recent memory by the likes of the late brilliant eccentric Anna Piaggi.

Signora Piaggi was the original when it came to being spot-on with rouge. The style icon, fashion enthusiast, and *Vogue Italia* editor readily allowed that blush was essential to her look, and she blotted it high up on her cheeks without reservations.

Sometimes the cheeks would appear plum; other times, red. She was always such a riot of electric, glamorous eccentricity and color, from the top of her Stephen Jones hats to her Manolo Blahnik–shod toes. She was as fearless with her makeup as she was with her fashion.

Piaggi channeled it all as an expression of frivolity. She embraced this ideal audaciously, and I worshiped her for it. Even during her final months, before she died at eighty-one, she gave us all the awe-inspiring hope for what it could mean to make a distinguishing beauty mark at any age.

The Big Apple

Rouge is about giving cheeks a rosy glow. That's cheeks—not the area below the cheekbone or anywhere else the sun wouldn't kiss.

Contrary to beauty lore, placement has nothing to do with the shape of the face. The spot to focus on is the "apple" of the cheek. Smile in the mirror. The cheesier the smile, the better. Those fleshy, pinchable pads on either side of your face, around the center below the eyes are the apples.

With any formulation, the radiance that comes from blush is only as effective as its application. It should never come off as a garish stripe, yet the amount depends on the desired effect. For example, a smaller smudge may better define the "apples."

A Blushing Array

Achieving a rosy glow, the application involved, and when to apply it during making up all comes down to the type of rouge: powder, cream, or liquid.

What kind is best for your face depends on your skin type (see page 26 for more details). While I tend to go with powder blushes, about 5 percent of the time I like a cream blush because to apply it, I only need my fingers and not the extra tool of a blush brush (especially practical with the limited space of a carry-on case when I'm flying). A cream or tint is also lovely on cheeks and lips when I'm going for a more natural effect . . . say, during a romantic rendezvous *chez moi*!

Powder

To apply: Dry blush is ideal for all skin types, notably oily skin. For a smooth finish, apply to *powdered* foundation. This type of blush should be the next-to-final step in makeup application, just before yet another last dusting of face powder. Powder blends best atop a powder. Swirl a dome brush into the blush. Tap off any excess before applying. Sweep the brush across the apples of your cheeks, toward the hairline (but not into it!), in short, vertical, circular motions, lifting with a flick of the wrist. Blend away any edges.

Cream

To apply: The sheer, dewy effect makes cream perfect for younger or drier skin. It's an especially good option during the minimal makeup months of summer. Cream can clump on powdered faces, so apply on skin with or without foundation and keep any powdering for the final step. Glean a bit of cream blush by tapping the ring and middle fingers or a (clean!) damp makeup sponge into the cream. Dab color on your cheeks from the apples to the top of your cheekbones, starting in the middle and stroking in quick, short motions upward and outward. The concentration should be on the apple, fading outward. Blend softly with your fingers or a sponge. To fix it further, or amp up the color, after powdering, brush on another layer of blush in powder form.

Liquid or Gel

To apply: Ideal for a sheer, smooth, flush appearance—which is why I love it on lips or cheeks for a glow before a lover drops by. Trickier for the novice is a liquid tint, which is intensely pigmented and requires quick blending. That's also why it's best on oily skin. Liquid can dry too fast on dry skin, and is definitely not a good choice for spotty complexions because it can magnify any blemishes. Start with an easy touch and reapply, layering it until the target shade is realized. Gels tend to contain silicone, making them easier to blend in with most skin types. These, too, tend to be high in pigment.

Simply Cheek!

While application can happen before most makeup, as I mostly rely on the powdered kind, I tend to apply blush *after* doing my eyes. Swirl a dome brush in blush. Tap off any excess before applying. You can always add more as you continue to blend.

Application is all in the feathering by upward strokes. Start with a small amount of blush and gently sweep upward. Be careful not to apply the blush too close to the eye edge or nose, or in the hollows of the cheeks. Never apply on the chin or forehead or temples. I do a cheesy smile to mark the spot.

Blush is not for contouring. It's not for sculpting. Properly applied and blended, it might give the illusion of cheekbones. But any attempt at creating higher cheekbones or hollow cheeks simply doesn't work.

Use a hand mirror to inspect your face from all angles. Don't be shy about giving your cheeks a touch more. Applied too much? A clean, dry sponge can clean up excess color. The aim is to give the flush of a rosy glow to the face.

Brushing Up

That might be the perfect shade. But don't expect it to come with the perfect application brush.

That bitty bunch of bristles barely big enough to hold between your thumb and fingers simply won't do the job, at least not during prep. (For touch-ups after leaving the house? Maybe.)

A full, rounded brush is best. It's also good to have a fan brush for powder or cream, as the fine hairs blend color seamlessly. Choose a brush according to the desired look: the broader the surface of the brush, the more diffused the color; the smaller, the more focused, for an "apple" bloom. I have brushes in a variety of sizes in my kit to choose from according to the effect I desire.

Investing in quality bristles and caring for them can mean a lifetime of use. And don't forget to keep the blush brushes separate from those for face powder.

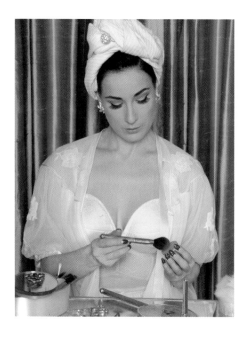

Color Field

A little rouge can go a long way. Zeroing in on the right color, however, might take some trial and error.

So how to choose the right shade for your face?

Color should enhance. Cheek color should at least mimic the flush of a schoolgirl crush. That au naturel glow is a good place to start.

A neutral shade of rose flatters most faces. But if your lips will be coral or other orangey shades, the combination might not suit. I recommend working within the same hue family, whether based in orange, red, or blue-based berry tones.

For the best results, blush after the foundation step, when any reds or other discolorations in the face are canceled out.

While there's always some room for tweaking the rules, as a guide:

- If skin tone is yellowish or olive, go with warmer pinks or plums for a pop that still looks pretty. Apricot and corals also look lovely on olive skin.

- Darker skin can work wine, berry, and orange shades. The darker the skin tone, in fact, the more beautiful the bolder options. Fuchsia, cranberry, orange, and even gold glow stunningly on black skin. As gold can come off a bit too disco, consider using it sparingly as an upper cheekbone highlighter.

- If complexion is too acned, blemished, or scarred, consider a matte shade to minimize imperfections.

- Regardless of shade, going a bit heavier handed for evening or photos is all good and well. During the day? Don't fret about applying frosts or shimmers. Technological advancements in formulations have brought about blushes with a luminosity that can convey a more youthful appearance. Hitting the planes of the cheekbones with a face powder containing a hint of shimmer can mean alluring highlights, no matter the time of day.

It's also perfectly reasonable, even fun, to choose a color to achieve a specific mood or look, even if it doesn't come off as a natural glow. It's just makeup, after all!

I'll say it until the end of days: experimenting is an indispensable part of the beauty process. Just don't experiment right before going out into the world. Use a night or afternoon off to test shades and skill.

Don't forget: lighting matters! Always review color and application under natural light or the brightest light available. Step away from the mirror and review your work from every angle with a hand mirror.

Ignore any of these tips, and that face is just asking for a stroke of bad flush.

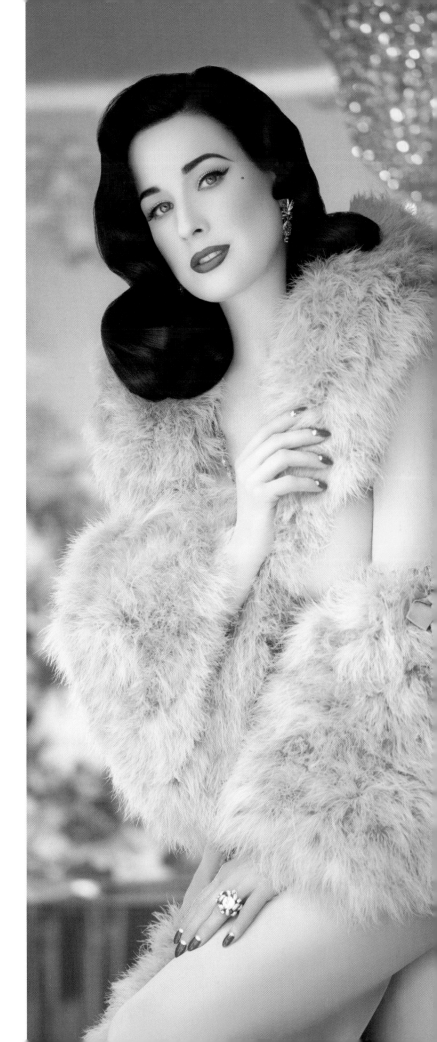

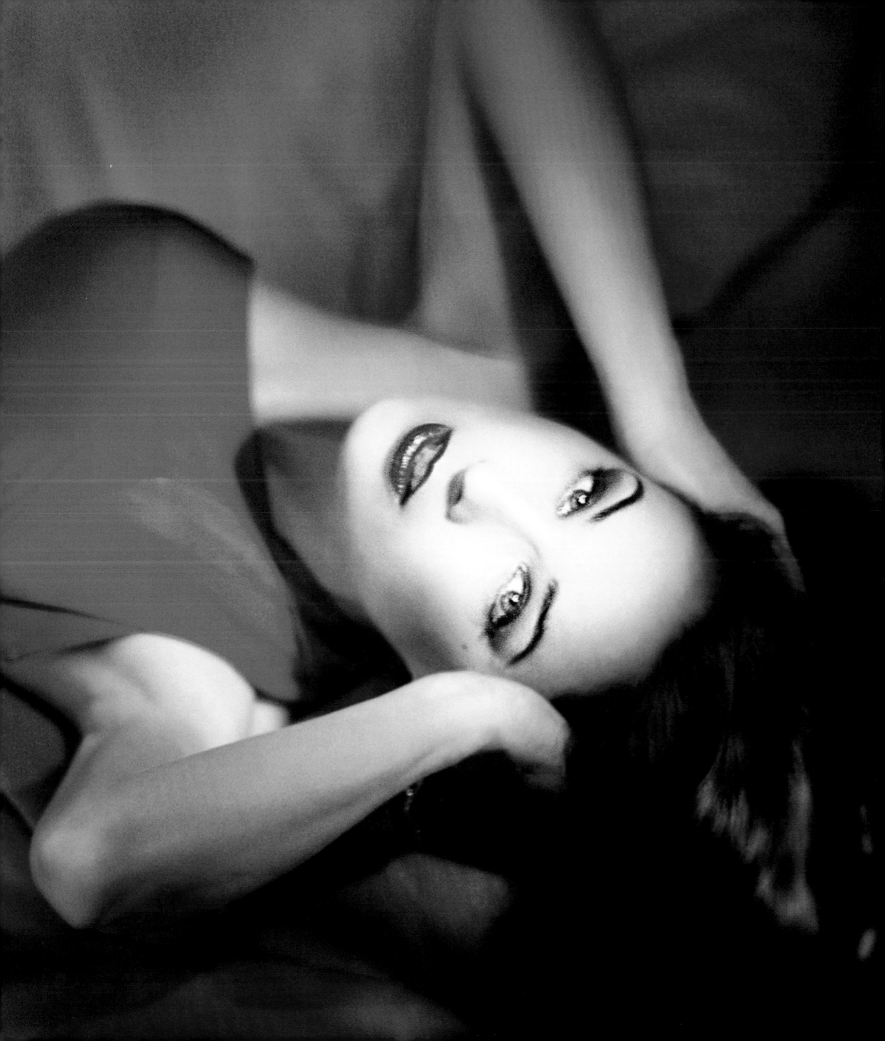

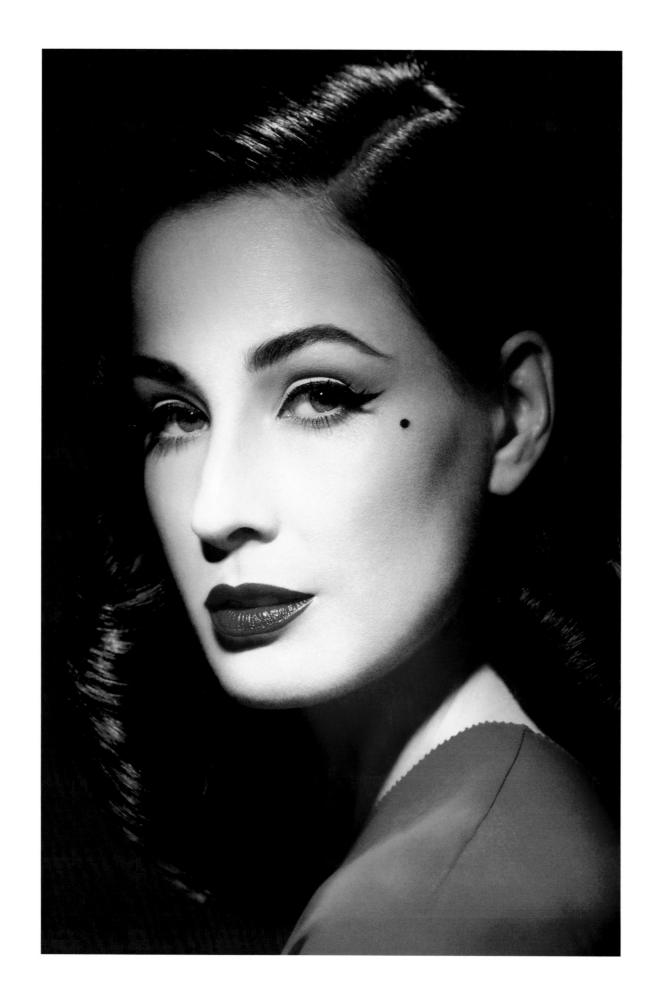

Mark the Spot!

If any further proof is necessary that making your beauty mark is only limited by imagination and resourcefulness, consider the one tweak I made that has, probably more than anything else I've done, become my signature—and it's just slightly larger than a pen prick: my beauty mark.

I originally reached for a star. I loved how during the height of her "It" girl craze of the 1920s, Clara Bow flirted with a star-shaped beauty mark, as well as a heart and a simple dot. I was always drawing in hearts and stars right below my left eye. Why my left eye? I wish I had some fascinating secret to reveal! In all honesty, I instinctually considered it my "good" side. Still do.

So at eighteen, I was determined to have a five-point beauty mark permanently inked in. I marched into Classic Tattoo Parlor in the North Orange County town of Fullerton, California. The studio is near a favorite vintage clothing boutique, and it's a favorite among punks and rockabillies—so I figured they would be willing to indulge me on this request.

The artist, clearly an aficionado of his trade given how heavily pierced and tattooed he was, looked at me and squarely replied, "We're *not* putting a star on your face." Rejected!

At that time, no one was going into tattoo joints asking to be inked with a beauty mark, let alone a teenage girl requesting a beauty mark shaped like a star. While I didn't want to hear what he had to say at that very moment, it turns out this artist was the voice of reason. He was so right to steer me to a no-frills dot. For me, at least, the round beauty mark he gave me that day is something I can age into elegantly.

Of course, if I'm feeling it, I can simply use it as a starting point for a star or any other shape or embellishment (like an adhesive-backed crystal) that fits the mood!

Spot On

While a beauty mark shouldn't demand all the attention, the most effectual ones act as a kind of pointer, a beacon to the best parts.

That's why it's all about location, location, location.

Think about childhood fairy tales. The evil witch is defined by an unsightly mole on her nose or chin. But why shouldn't these be perfectly seductive spots for beauty marks?

Consider the spot hovering at the right above Marilyn Monroe's top lip. The sexual appeal of a beauty mark directs the eye to a feature ripe with possibilities.

The spot to the left of Elizabeth Taylor's knowing smile is as iconic as her violet eyes. When Sherilyn Fenn channeled the grande dame for a made-for-TV bio years ago, a beauty mark like Elizabeth Taylor's was as key to her look for the role as anything—and Sherilyn Fenn's own famous beauty mark, just below the ending tip of her right eyebrow, was blocked out.

I was so taken by Sherilyn's beauty mark when David Lynch's mad crazy *Twin Peaks* series first aired in 1990. It popped like an exclamation point. She wasn't the only one who caught my eye, either.

During those years before I had my own, it seemed like all my favorite modern-day goddesses, from Madonna to Cindy Crawford—brandished beauty marks like a badge of empowering seductiveness.

I had to have one.

Fabulously Flawed

It's happened more times than I want to remember: on a magazine shoot, someone will have the grand plan to conceal my beauty mark. It usually goes hand in hand with the bright idea to change out my red lipstick for something boringly beige.

If they didn't want Dita Von Teese, then what am I doing in front of their lens?

Conceal it, and I may very well go the way of the wife in Nathaniel Hawthorne's story "The Birth-Mark." While the small hand-shaped mark on the wife's face is admired by friends and strangers as something charming, her scientist husband grows increasingly repulsed by it, since he views the mark as a defect on an otherwise "perfect" face. Desiring to please him, she succumbs to a tonic he invents to make it vanish. On application, however, it not only fades away the mark—it also makes a disappearing act of the poor dear.

You see, a beauty mark is a naturally occurring imperfection. A mole, a skin lesion. A benign tumor of damaged tissue. Yes, dear reader, a flaw.

Medieval churchgoers considered moles something akin to black holes, an entrance for demons looking for access to the body and soul. They might have been onto something. Not all moles are beauty marks, after all.

One out of every ten of us has an asymmetrical mole that can be a symptom of melanoma or other skin problems, according to the National Institutes of Health. If you find a mole changes or feels or looks different from the rest, get it checked out by a doctor. If it is nothing more than a mark, a flaw of nature? Embrace it!

The NIH also points out that most of us have between ten and forty moles on our bodies. Actress Dorothy Dandridge had a bewitching trio on her face. Rose always loved the chocolate spot on the back of her left calf, and I've spied some sexy beauty marks appearing on a bare shoulder, an earlobe, and exposed cleavage. I know a TV executive lucky enough to be born with a beauty mark in the exact place where I had mine tattooed.

Moles can be pink, tan, even blue-black in nature. But most are brown or brownish black. A perfectly normal mole can be oval or round, appear solo or grouped, be hairless or hairy, raised or flat.

Why they occur is not known. But what we do know is that this speck of otherwise imperfect pigment can emphasize one's looks like a well-placed punctuation mark!

On the Move

There is no law, earthly or otherwise, that deems a beauty mark is set in stone . . . or on a face.

Clara Bow freely altered the already faux dot under her left eye into a heart and star, and on a whim she would shift it near her Cupid's bow mouth.

Jean Harlow is likely the greatest enthusiast of the migrating beauty mark, having moved her spot no less than eighteen times during her short career (due to her untimely death at age twenty-six).

It was on again, off again for Liz Renay, the notorious bombshell whom the *Saturday Evening Post* described in a three-page profile in 1965 as one who could "claim the prize as the girl who looks most like Marilyn Monroe."

The buxom blonde seemed to change her mind about emphasizing the mole she was born with the way she did careers

during her storied life, which included recurring turns as a stripper, mob moll, painter, B-movie actress, mother, and streaker (she was arrested running down Hollywood Boulevard during the height of the streaking fad in the early 1970s). She appears with a beauty mark on the cover of the first of her two best-selling memoirs, 1971's *My Face for the World to See,* and without it in her starring role in John Waters's 1977 film, *Desperate Living.* (I also adore her second book, an autobiography entitled *My First 2,000 Men.* What a hoot!)

Reading Between the Dots

Forget tea leaves. The magical hold of moles throughout human history has run the gamut, with one ancient seer after another contending all manner of revelations based on shape and placement and whether it appeared on a man or woman.

The legendary healer and scribe Melampous of Greek mythology believed the future could be foretold in moles. The nose, already considered a sizing up of what was underneath a toga, was further scrutinized as an indication of sexual prowess: a birthmark on the nose signaled an avid lover.

The ancient Chinese culture had moleomancy, where a mole's location and size determined one's fate. I can't say I mind their prophecy that a spot on the cheek is a sign of great future wealth. Surely a tattooed beauty mark is just as worthy.

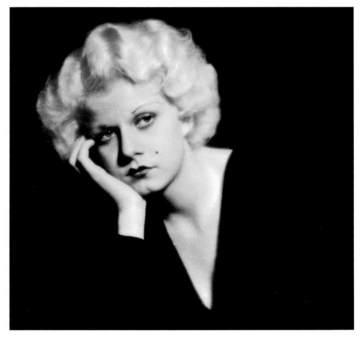

In this 1931 portrait, Jean Harlow made her mark just north of her Cupid's bow lips.

majestic

thief

passionate

coquette

open to propositions

playful

can keep a secret

generous

Renaissance doc Richard Sanders created his own methodology in which birthmarks could determine character traits, and centuries later the Victorians did the same with a most unscientific system that they labeled with a scientific-sounding name, moleoscopy.

Paint It Black—or Not

Since I am no wallflower to extremes, I prefer to emphasize my tattooed beauty mark by darkening it with a black pencil.

Natural beauty marks can be darkly pigmented, though they tend to lean on the black side of brown, and most faces look best with a color that matches other moles on the body. Auburn-haired lovelies might consider a burnt sienna color, while blondes can opt for a medium brown.

Or break the rules altogether and draw in a beauty mark that is purple, electric blue, or hot pink!

Amuse-Mouche

The rage for beauty marks over the centuries has inspired some expressive alternatives to makeup, which can smear when one least wants it to.

As early as the 1600s, English citizenry of all ages, genders, and classes pasted "patches" of suns, stars, fish, and other designs on their cheeks. This didn't go over well with the stiff upper English Parliament, which introduced a bill for the trend's suppression in 1650. The proposed law failed.

A half century later, in fact, the side on which a beauty patch was worn revealed political allegiance: Whigs on the right, Tories on the left. That's one way to rock the vote.

Tiny patches cut from silk, taffeta, and velvet called *mouches* (French for "flies") adorned the rouged and powdered faces of eighteenth-century ladies and gents. To match the wildly extravagant one-upmanship among many of the most fashionable, there were *mouches* shaped as a three-masted ship, a tree with lovebirds, or a coach drawn by four horses.

Since then, ornamental marks applied with coquettish aplomb have undergone all sorts of material manifestations, from a single Swarovski crystal to a geometric bindi to a patent leather dot.

The San Francisco French-inspired curiosity shop Bell'occhio offers a twenty-pack of velvet *mouches* in circles, hearts, clubs, diamonds, and spades based on the archaic codes that each shape signified. At the corner of the mouth, a *mouche* suggests playfulness; at the corner of the eye, it's the sign of a come-hither vamp.

A Swarovski crystal in a variety of sizes and colors can also provide a twinkle of glamour. Stick on skin, as with any *mouche*, by way of eyelash glue or spirit gum . . . and luck!

Then there's Miki Lanese, a suburban cosmetics entrepreneur based in Orange, California, who after decades of beauty experiments came up with her own peel-and-stick *mouches* at an accessible price, which she calls Hottiedots! Proof that even the real housewives of the OC can make their beauty mark!

Making an Indelible Point

Tattooing requires commitment, since it means always having a mark—and going under the needle for it. Not only is it advisable to see a specialist in permanent cosmetics or medical cosmetic tattooing because of his or her ability, but my dermatologist insists on it for health reasons.

For others, getting needled means a piercing with a metal or jeweled stud serving as a kind of extreme *mouche*. This type of piercing just above the lip has even earned the nickname "the Monroe" after the icon who inspired it, Marilyn Monroe.

Marking the Spot

*When it comes to the face, the sexiest spots tend to be the outside edges of the
eye or around an eyebrow, on the cheek, or around the lip or jawline. In other words,
next to what you want to draw attention to and inspire a stir.*

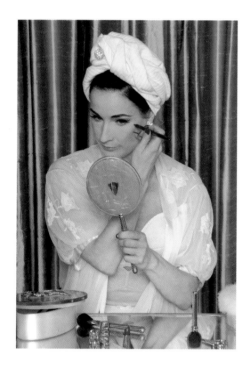 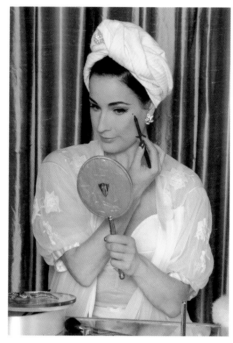 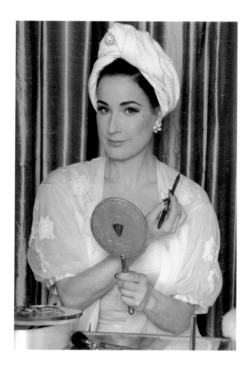

It should not be the focus of the face. It's a signal. An indicator. A metaphorical X—well, more like an O—marking a beautiful feature.

For the best control, I like a waterproof eye or brow pencil that is soft enough to leave a mark, yet sharp enough to execute it cleanly.

Press and twist gently and swiftly to achieve a small, round mark. Twist until it's dark enough—but not too big.

A waterproof liquid eyeliner or paint pot cream is also a great option, especially if the pencil is not resulting in a pigment intense enough for your eccentric aims. But this is for master beauty markers only. Novices shouldn't attempt this just before a big date. Lip Ink offers a liquid eyeliner that is smudgeproof and waterproof. It only comes off with the Lip Ink remover, so there's no need to fear a comet smudge. Another lasting alternative is my old standby MAC Liquidlast Liner. Or apply a clear makeup sealant over the pencil point for a smudge- and water-resistant finish.

In front of a magnifying mirror, with a stiff brush and steady hand, start in the center and dab lightly to create the shape.

After it dries, set the mark with powder or a sealant as an extra precaution against smudging. Now watch your vamp stock soar!

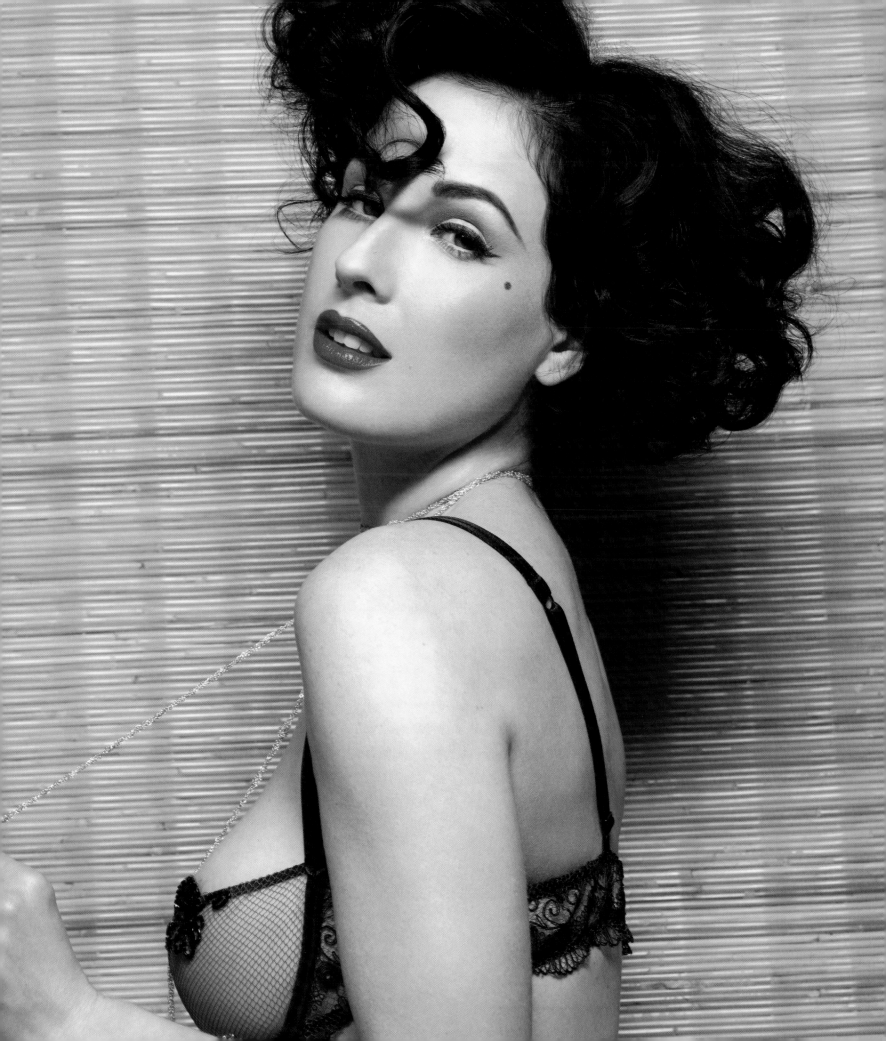

Drag Net: Sutan Amrull, a.k.a. Raja

Among the beautiful eccentrics I see eye to eye with is one of the fairest of them all in looks and friendship, Sutan Amrull.

You might have caught Sutan channeling his equally enchanting alter ego, Raja, on RuPaul's Drag Race. Or perhaps it was performing at one of my variety shows.

Sutan as Raja; Raja as Sutan. Who is each one but a manifestation of the same individual? How I can absolutely relate! Raja never abandoned Sutan, and vice versa. By enabling Raja to thrive, however, Sutan realized his authentic true self as he makes his beauty mark in this life. I'll let him tell you for himself.

I never blended in. I was always well aware that people looked at me as if I were something strange. I was aware of how everyone would comment on my looks. I was this pretty little boy in between two sisters. I was born in the States, but spent much of my childhood in Jakarta and Bali—my mother is half Dutch and half Indonesian. There, every person dances or carves wood or smiths silver or plays music. Everyone has an artistic role that is also tied to spirituality.

My interest in beauty started at a very young age. I remember being three and wrapping bedsheets around myself and feeling how the fabric felt on my legs. I still have a fetish for skirts and collect them. I was mesmerized with the covers of my mother's romance novels and *Cosmopolitan* magazines. I didn't want to hang out with the kids. The world I created was much more interesting than playing ball.

By the time puberty arrived, I lived in a California town rife with gangs and cholas, and boys were supposed to look and act like boys. I felt awkward and strange looking. So I began dressing myself up and playing with styles to cover up my insecurities. Despite what others called me or said, I still needed to surround myself with beauty, to feel beautiful.

My best friend's little sister, Eva, a fourteen-year-old gangster on house arrest with an ankle bracelet, taught me about makeup. I would watch her freeze her chola bangs with superstrength hair spray and apply liquid liner to her eyes and dark purple liner on her lips.

Makeup became the fastest way to surround myself in beauty and to share my point of view. Makeup is not only an embellishment. It's transformative. It's a prescription, something that defines you. With makeup, you can cover yourself up, you can enhance, hide. Makeup has a lot of power.

At nineteen, in the early 1990s, I began working for MAC Cosmetics when it was a very new company. In my late twenties I went freelance, working on TV, music videos, advertising, editorial. I lived the life of a makeup artist, bouncing between Los Angeles and New York. I loved it.

I've been Raja longer than I've been a makeup artist. To me, it's a *celebration* of femininity. My intention is not sexual. I just love the beauty of femininity. That's my art form. I grew up in a religious household, but my family members were cool Christians. We had gay people around us. My own fears were informed by the church, so I didn't officially come out to my family until I was thirty. But they knew. One day, I finally showed them my portfolio. My mom couldn't believe it: she proudly said I looked like a 1940s film star.

Now just over the forty mark, I find I can be the androgyne in a tailored suit and high heels, or a silk blouse with combat boots. If I feel like growing a beard, I do it. I never leave the house without wearing something special. I spend a lot of my money collecting handcrafted items indigenous to older cultures and traditions. Every day is a special occasion.

I have my vices, of course. But I love skin care. I know consuming the right nutrients and oils is important. I do Pilates and yoga and that contributes to overall beauty. Some mornings I may want to put on a full face—but I also know my limits. Daytime drag on someone at forty can be rough! I can spend 90 to 120 minutes on makeup, hair, and clothing—but it can take longer if I want. I live in an enchanted apartment. I play dress-up and wait for evening to come and get ready to go.

There are still a lot of people who try to knock me down. But my mission in life is to be a renaissance man. I don't want to be perfect, but I want to be good. And I want an audience!

I respect the Native American tradition of individuals with two spirits, female and male. These people were revered as holy people. They had their own language, their own clothes, and they weren't looked down on. I always felt that is who I am. Maybe it's because I'm a Gemini, but I do believe there is a duality within us and it's up to us to embrace it.

Look at other species, too, such as male peacocks, flaunting their brightly colored feathers. What makes us the exception? Why do we have to suppress nature?

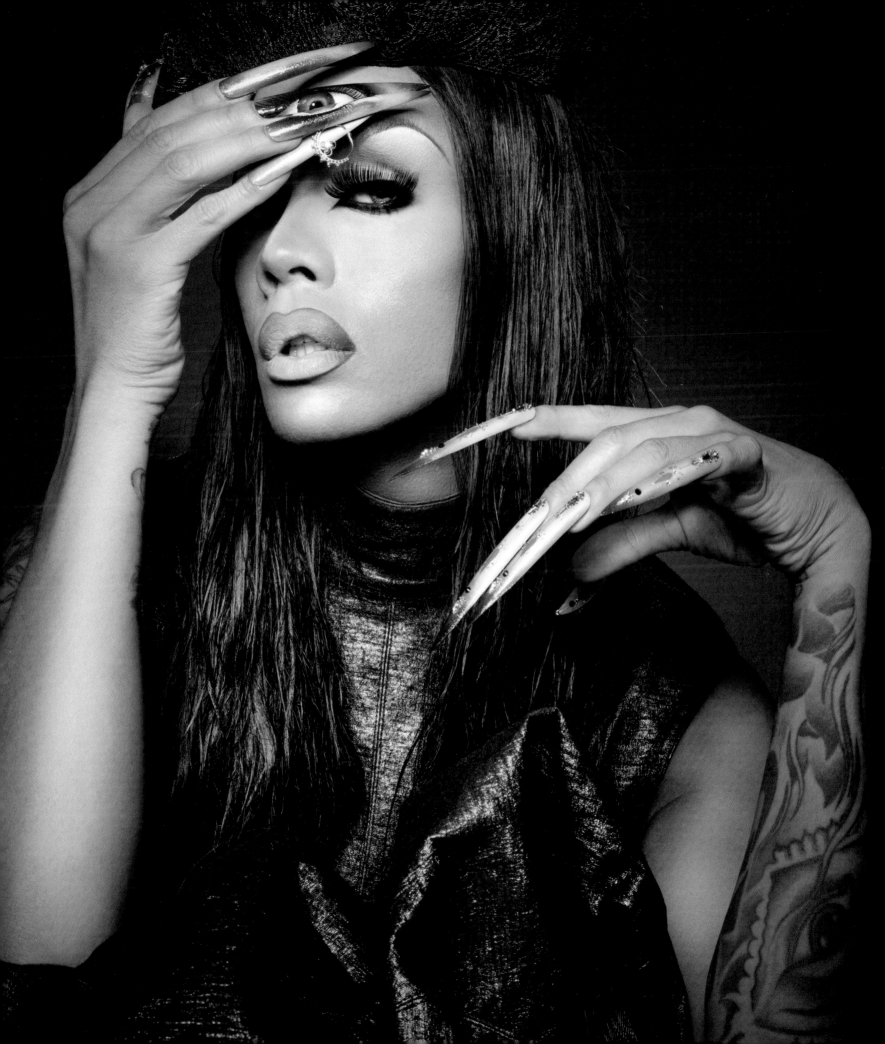

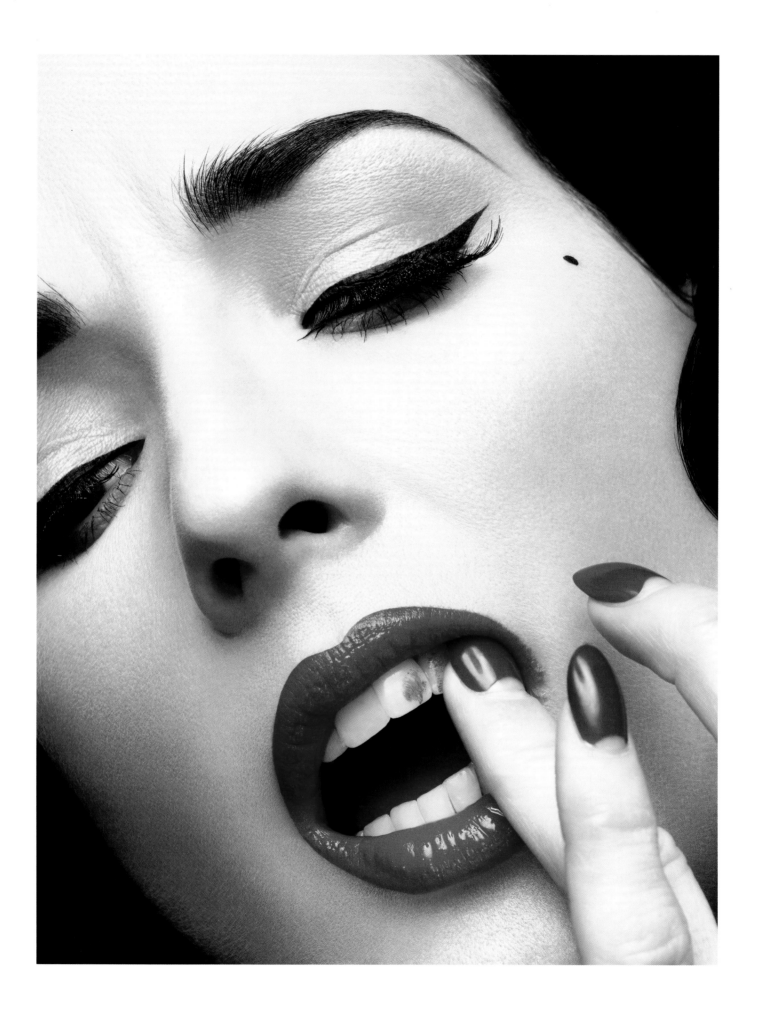

Lipstick Traces

I will never forget my first time. It's not something a gal ever forgets.

I was standing in front of an antique buffet with a mirror that my parents had in the living room in our home in Irvine, California, pretending it was a grand vanity like those in the many old movies that were my obsession. My long blond hair was tightly wrapped around more than a dozen hot rollers, as I had decided to test out a new do. Staring at my pale reflection, I removed the plastic seal from the tube of Revlon lipstick I had bought that morning. My friends and I were all mad for Revlon at the time. But their choice, as was the trend in the mid-1980s, was a shade that was a peachy pearl.

On this day, alone in my home, I held between my fingers the perfectly named Cherries in the Snow. I carefully glided the tip of this grown-up crayon across my lips.

So much took place at that moment. Fireworks went off in my very being. *Wow,* I remember thinking, a terrific sunlight reflecting in the mirror from the light beaming through the side windows. For the first time in my thirteen years on this earth, I felt I could be pretty. Not just pretty, actually. It was the first time I knew what it meant to be glamorous.

I always felt like the ordinary one between my two sisters. There is the cute youngest, Sarah; the popular and stylish eldest, Jennifer (now married with children, yet what a boy magnet she was!); and me in the middle. I could never claim any stand-out striking features. No full lips. No big eyes. There are many "ideal" traits I wasn't born with.

But in that moment with my lips painted Cherries in the Snow red, I felt like a million bucks. The simple stroke of this little scented stick of colored wax did that. It was as if an atomic bomb had gone off inside me, and the world would never be the same thanks to that little red bullet.

The siren call was loud and clear: I knew then that this was who I wanted to be.

That day in my parents' home I was totally transformed. Today, each and every time I swipe lipstick on, that transformation continues.

I love a red lip because I love Technicolor. I love watching movies in all the magnified vibrancy promised by that marvel of cinematic technology. Take Betty Grable, who simply shined with that powder-blue eye shadow, that beautiful pink cheek, the golden hair, and that coral-red lip. All those colors slay me. I love color on the face. If somebody tries to swipe pale lipstick on me, I feel dead, like there's nothing there. I like the drama and the joy of color.

I want to *live* in Technicolor!

At age 12, I saw my future with that first kiss of red.

One of the best places in Los Angeles is the Max Factor Building inside the Hollywood Museum for exactly this reason. There, the walls inside a trio of rooms are colored in shades Mr. Factor deemed flattering for blondes, brunettes, and redheads. These rooms allowed clients to experiment with color, and it was stocked only with shades of lipsticks the cosmetics king believed worked best with a corresponding hair color. What an inspiring concept! Lavender and blush are beautiful backdrops for nearly everyone. When I decorated my home, I considered what would be the most flattering colors to surround myself in when my lips are red and, believe me, both those pretty shades make an appearance throughout the place.

Even in black and white, Max Factor knew how to work lipstick. As part of Joan Crawford's transformation from thin-lipped girl to voluptuous screen goddess, he dragged lip paint beyond her natural lip contours. Factor called this optical illusion "the smear." Others referred to it as "hunter's bow lips" because it suggested the shape of a hunter's bow versus that of Cupid, the height of fashion during Crawford's first years in Hollywood. With Factor's help, she could now reinvent herself in the movies.

Jean
Mae
Joan
Hedy
Greta
Lana
Marlene
Clara

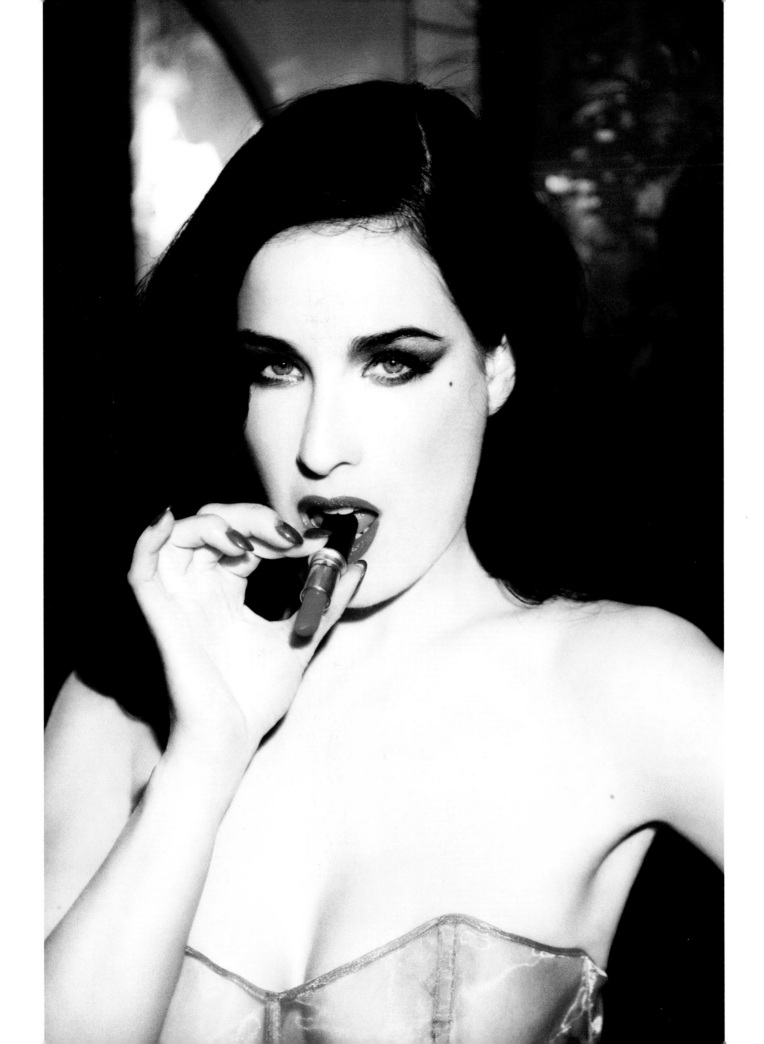

Other actresses sought their own signature lips as their stars rose—and usually with the artistry of Factor or rival George Westmore. Jean Harlow favored a Cupid's bow. Greta Garbo penciled in a severely flawless slash of a mouth. Mae West emphasized a beestung pucker. Lana Turner played down her broad jawline with a hunter's bow. Hedy Lamarr drew the corners of her mouth downward to suggest a pout.

These women understood the power of lipstick in establishing their beauty mark on screen and in the imaginations of their fans.

The Great Liberator: Red Lipstick

No other cosmetic can claim the history and lore of lipstick, with endless articles, studies, and books dedicated to its cultural, social, psychological, and even economic implications. Is it any surprise that many of those ruminations and pages have been devoted to the best hue of them all?

Red.

The first lip paints were red. The five-thousand-year-old tomb of Queen Shub-Ad at Ur contained one made of crushed red rocks. Ancient Egyptian women and men were equally as obsessed with rouging lips and cheeks before—and after—life and used a mixture of pulverized beetles, ants, and henna in small pots. Hindus reddened their lips and teeth with the betel leaf, a mild stimulant when chewed. Which really sounds a heck of a lot better than the mercuric sulfide used by Elizabethans to redden their pouts; not only was it poisonous, but it led to hair loss, sickness, and, finally, early death.

So are the powers of a red lip that the color is unequal to any other shade of lipstick.

In traffic, red might mean stop. Yet everywhere else in life, it connotes action. Ancient civilizations applied red face paint for fertility rituals. Artists color passion, lust, and anger in red. Witches claim it is the most potent of colors in a spell. And for Snow White and Sleeping Beauty, a kiss on their red lips by each of their Prince Charmings awoke them to a lifetime of happily ever after.

Scientists have established that seeing red increases heart rate, blood pressure, and hunger. Appetite of a sexual kind was behind a study by two researchers (a male and a female) in 2008 that demonstrated what they call the "red-sex link." They found that whether the forces are societal or biological, the color red acts as an aphrodisiac for men: they find women in red more attractive, more sexually desirable.

Red Lipstick Divas

Rita Hayworth

Marilyn Monroe

Elizabeth Taylor

Lucille Ball

Paloma Picasso

Diana Vreeland

Isabella Blow

Chantal Thomass

Madonna

Lulu Guinness

Gwen Stefani

Scarlett Johansson

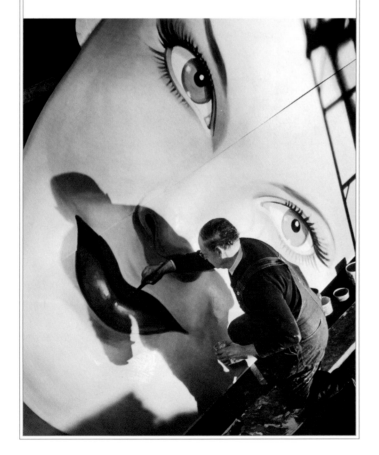

Such intoxicating powers over lip paint were already of concern to the British Parliament in 1770, which outlawed it on the basis that it was a supernatural trick of the ol' black magic kind, luring unsuspecting men into marriage. In the end, anarchy in the U.K. prevailed with both women *and* men painting the town—that is, their pouts and cheeks—red.

One of my favorite beauty tales is that The Cure's Robert Smith keeps a tube of red lipstick on a string, flailing in the air, next to his front door for a convenient swipe before heading out. When I finally met him for the first time, I was too starstruck to ask him about it. Some years later, we were deep in conversation one evening when I decided to raise the rumor. It *was* true! (Though a rite of the past.)

Sticks and Tones

The first stick of lip rouge appeared on the market in 1884, produced by French perfumers Guerlain, a luxury cosmetics house with decades of success with its lip pomades. By 1897, the egalitarian retailer Sears Roebuck was hawking rouge for cheeks and lips.

Cosmetics were no longer for the rich or famous or disreputable, as the rising tide of Hollywood and commercial manufacturing lead to a democratization of beauty. Any working gal could afford to buy a lipstick, and in 1912, red lipstick rose as the symbol of the suffragists during a march in New York.

The modern concept of a lipstick finally turned up in October 1915, when Maurice Levy, the owner of an American company that imported French cosmetics, created a metal dispensing case. And not a moment too soon! Gibson Girls, as the fashionable young of the day were known, were nibbling on their lips and hot cinnamon drops to realize that rosebud bloom. Ah, the pain of beauty . . .

The golden era of lipstick truly made its mark in 1923. A patent appeared that year for an invention that allowed a shaft of cosmetic product to be swiveled out of its case by a screw part at the base. For all its phallic form, the bullet-styled lipstick seems to have developed unsullied by any naughty thoughts!

No matter. That the form and function of the twist-up tube is rife with erotic symbolism has only contributed to its sexually charged metaphorical allure—and more power to it in red.

The most marvelous offshoot of this innovation was the packaging. In their quest to distinguish themselves in the marketplace, cosmetic companies rushed to design tubes according to the fashions in art and architecture of the day. Over the next decades, tubes were scrolled, jeweled, ribbed, patterned, or polished to mirror perfection.

Red lipstick served as a symbol of life and liberty once again with the endorsement of the American government during World War II. Being beautiful was a morale boost for women and the men admiring them alike. In the name of the war effort, metal lipstick casings were temporarily replaced with paper holders, and under the image of Rosie the Riveter in full red lipstick, the Office of Economic Stabilization urged factories to stock red lipstick in women's powder rooms. It was a matter of patriotism and productivity, after all.

Today, lipstick continues to raise the flag of liberation, this time in the fight against AIDS and HIV-related illnesses. A deep red launched MAC Cosmetics' first Viva Glam lipstick in 1994, a campaign that made an indelible impact on me for so many reasons. Oh, the teasers! The slow reveal of parts of the mystery celebrity model featured in the campaign. It was a stroke of marketing genius that made as much a social as a beauty statement. The surprise, as history now knows, is that the model was RuPaul, in full, fabulous drag.

Once again, red lipstick was shaking up the establishment. Here was a drag queen being showcased in a high-profile way by a corporate behemoth (Estée Lauder bought a controlling interest in MAC that very year), stepping up to do something about a health crisis that our own government at the time had been dragging its insensible heels on.

I was making minimum wage back then behind another makeup counter. Yet here was an opportunity to make a difference, and for the price of a lipstick I loved. The MAC AIDS Fund gives 100 percent of sales of every Viva Glam product to research causes and communities living with HIV/AIDS. Beauty saves!

Cut to 2006, and my contribution to the cause really blew up when MAC asked me to be one of that season's Viva Glam spokespeople. We wanted to come up with a show to help promote this worthy program, so MAC and I collaborated on a massive lipstick that bucks like a mechanical bronco. What a dazzling, defying way to call attention to the invaluable power of this little lipstick! I rode that motorized, Swarovski-swathed

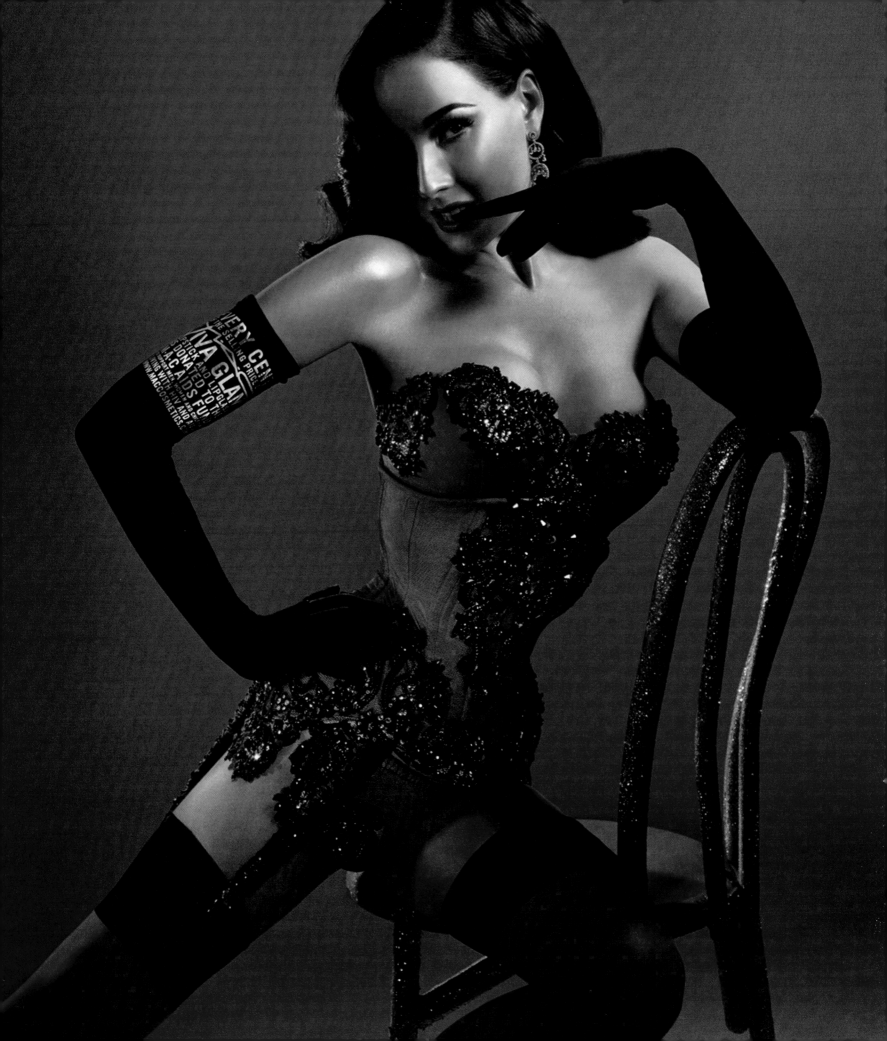

mega-lipstick like a cowgirl—well, one shod in high-heeled cowboy boots custom-made by my dear friend and collaborator Christian Louboutin. We christened them Lou-bootins. How very Paris . . . Texas!

Several writers and fans tried to read into my riding such a monumental lipstick, hopelessly digging through Freudian clichés for the sake of commentary. And that, my dears, is even funnier than the spectacle I made riding it. Sometimes a lipstick is just a lipstick.

Once I became a Viva Glam spokesperson, well, what an experience! The commitment by every salesperson, every MAC employee involved, is so deeply inspiring. There is nothing more beautiful in this life than when we help those in need! I traveled all over the place spreading the gospel, a mantra I came up with: Safe sex is sexy. You know what? It is!

At one event, one of the MAC artists came up to me with a tattoo of my image from the campaign, which I humbly signed. I also signed a tattooed tube of Viva Glam that had been inked in over another artist's heart; he then went and had the tattooist make my scrawl a permanent part of his chest. What a way to share about the fund whenever someone asks him about his tattoo.

My commitment to AIDS research continues, be it contributing to something as high-profile as the annual amFAR benefits in Cannes or during a casual conversation with a friend or fan on how safe sex is always nonnegotiable. When it came time to pass the Viva Glam torch, I encouraged MAC to go with Lady Gaga, who was just making a splash. I advised my friend John Demsey, who, as group president for the Estée Lauder Companies, has overseen MAC since 1998, that Gaga's equally audacious personality and following could be a boon for the cause. She helped the fund by pairing up with eccentric original Cyndi Lauper and by promoting a secondary color under her solo banner.

I believe in lipstick, and expressly the punch of this particular lipstick. Since 1994, MAC Viva Glam Lipstick and Lipglass have raised some $375 million and counting at press time. The

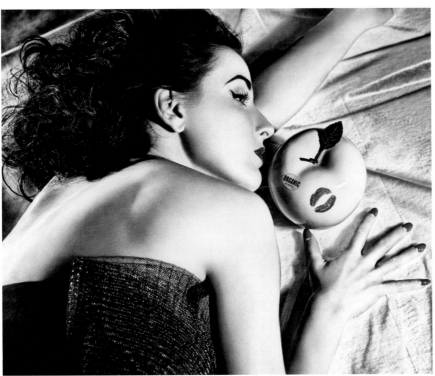

Red Lipsticks to Kiss and Die By

Von Teese by MAC
Diva Louboutin
 by Christian Louboutin
Diorific *Roulette Red* by Dior
Ruby Woo by MAC
Lady Danger by MAC
Excès de Rouge *KissKiss*
 by Guerlain
Devil by Make Up Store
Rouge Pur Couture *01 Le Rouge*
 by Yves Saint Laurent
Rouge Pur Couture Vernis à Lèvres
 Glossy Stain 9 Rouge Laque
 by Yves Saint Laurent
Stoplight Red #911D by Wet & Wild
Red Velvet #910D by Wet & Wild
Red Revival by Maybelline
On Fire Red by Maybelline

company underwrites all production costs, so every cent of what customers pay goes to research and services to the underserved populations of this epidemic. That's power. I still endorse it every chance I get, even though my contract has long since ended. My payoff is that this little token of beauty is saving lives.

"When you're feeling blue, wear red," urged the legendary American designer Pauline Trigère.

Besides the MAC Viva Glam campaign, this last year I gave my kiss of approval to Lipstick Angels, a nonprofit founded by Hollywood makeup artist Renata Helfman to provide patients in hospitals with a beauty boost by skilled professional artists. Whether it's this group or another like it in your town, make the time to make someone feel beautiful. Beauty is duty, and few duties in life are more fulfilling and important than helping others.

Read My (Red) Lipstick

How essential is red to a wardrobe? As my makeup artist friend Gregory Arlt likes to quip: "Red is the little black dress of makeup."

Most women think there's only one shade of red and it's not for them, he notes, having gleaned this misled consensus from his many beauty lectures worldwide. That red, he adds, is likely the shade worn by their mother.

The reality is that there are dozens of reds to choose from, some with blue undertones, others with orange undertones, and many more in between. I have so many shades and brands of lipsticks piled in drawers and boxes, never mind the multiples of the ones I cannot live without, that I'm in constant risk of an intervention!

I can't think of anyone who doesn't look good in red.

Gregory, who has applied lipstick to a legion of lips, agrees. "Dita and I joke that red lip stains are for wimps. But for some women, a lip stain is like training wheels. So start with a stain and then move on to a red lip."

Never trust a makeup artist or other pundit who insists that red lipstick is not for redheads. Jessica Chastain, Shirley Manson, Nicole Kidman, Christina Hendricks, and my dear Catherine D'Lish wear it, all no doubt inspired by the red diva of them all, Rita Hayworth.

When choosing a shade that's right, follow Gregory's sage advice: "Consider your skin tone. Consider what you're wearing. Consider the texture. And don't overlook your personality!"

I know some "experts" will insist the clothes do not dictate the red, or that the best red for any and all outfits is the one that looks best paired with one's skin tone. As a rule, blue reds tend to be more flattering on pinker complexions, while orangey reds or burgundy reds glow on olive skin.

There's logic in such rules. I get it. But I say, be ready to experiment.

One red might fit a look or mood or time of the year and be utterly wrong with another. I like a reddish-coral or tomato lip in summer, and shades infused with deep berry tones in the winter. A candy-apple red or hot fuchsia might suit my mood during the day, while for evening it's the hot red of a race car or a Bordeaux-tinged option.

Reds with blue tones tend to make teeth look whiter, while corals and other orange- or yellow-based colors might have the opposite effect (and by the way, this doesn't get you out of seeing a dentist regularly!). So test it out for yourself and get a second opinion from someone you trust.

When do you know you've happened on the right red? Magic happens. Everything seems to brighten. The face lights up. The overall look—clothes, face, hair—comes together. The mood lifts. *That* is what I love about red lipstick!

The Bold and the Beautiful

The beauty of lipstick? It's one life-changer that doesn't require much of an investment or commitment. All the more reason to experiment with the endless rainbow of colors.

Think of the savage shades of rich plum, hot pink, and tangy orange on the women in the highly stylized photographs of Guy Bourdin. At near-iconic status is Yves Saint Laurent's No. 19, a fuchsia once banned because of the ingredients required for its singular tone. It's now back with a "dermatologist-tested" endorsement.

An absolutely thrilling sight was the neon orange and bright pink lip shades on the girls walking the runway during one Paris Fashion Week—and regardless of skin tone and ethnicity. I went backstage at a few shows to investigate and learned that the makeup artists had mixed hot brights and neon powder pigments to create the variety of electrifying shades. In one case, it was rich pigments of oranges and pinks with an orange lip liner base. A great tip, indeed. If it doesn't exist, do it yourself!

Lipstick Jungle

With so many options to choose from, the topic of lipstick can be a tangle of terms.

Lipstick is a simple concoction of an oil wax base, coloring agents (pigments), and fragrances/flavorings. Other contents can run the gamut from fish scales and mica particles (for frosted formulations) to collagen and sunscreen. The ingredients and production process are not unlike that of a crayon or candle. This is also why it's good to store lipsticks and lip liners in a cool place. My freezer is full of lipsticks.

If a lipstick starts to smell or taste like a crayon or worse? Throw it out.

Pigment is the priciest element in a lipstick. It's also what keeps color from easily coming off, smudging, or feathering. A lipstick that strokes on with a full, true color contains a rich, quality pigment. To test this, glide it across the back of your hand.

The most pigmented lipsticks are matte reds, pinks, plums, and oranges. The coverage is full, intense. While it might have a satin sheen, there is nothing sheer or shiny about a full-pigment color.

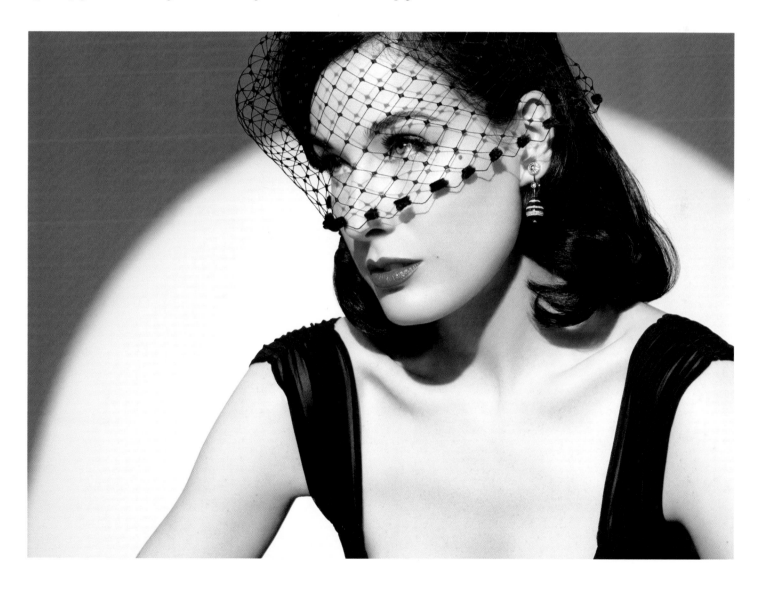

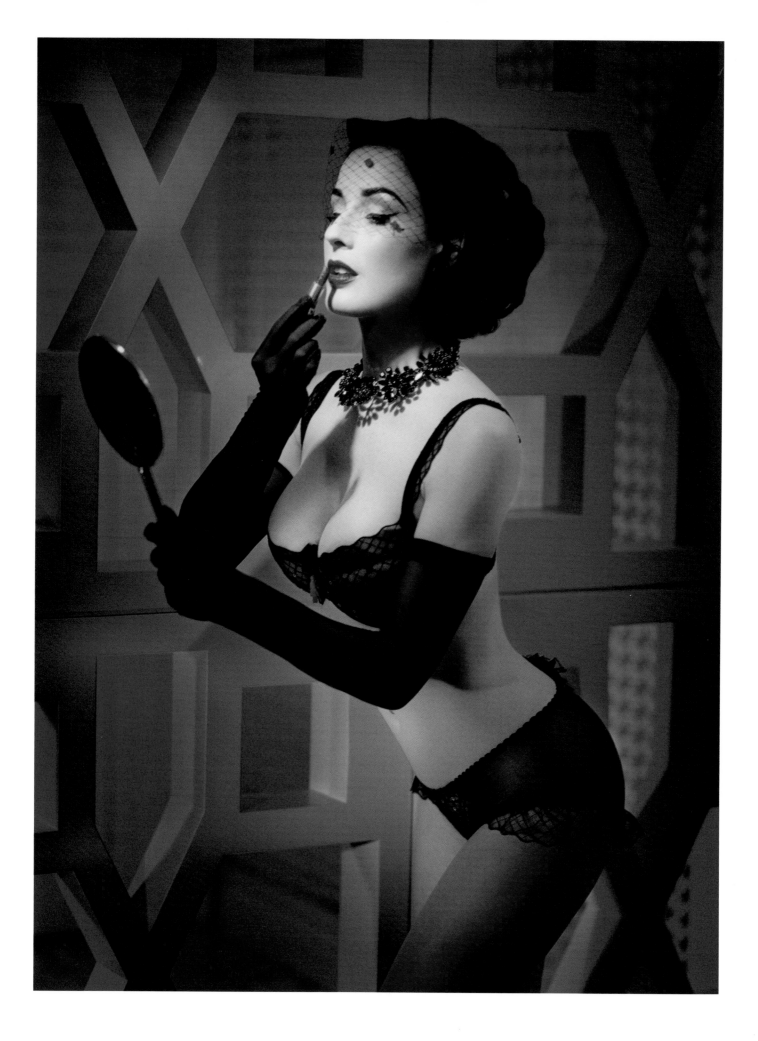

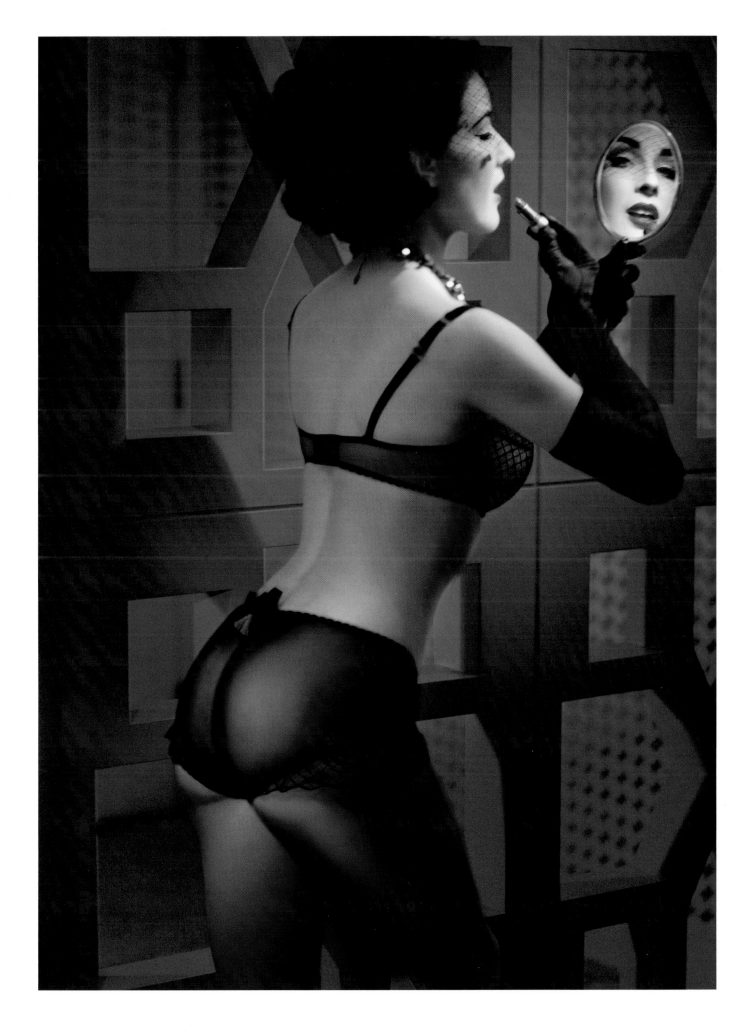

Tips for Refilling Vintage Tubes

Dita loves finding beautiful old metal lipstick tubes on eBay and at the flea market, so she was thrilled when I passed along this tip I learned years ago from my mother during my teenage rockabilly years.

To pair a new lipstick with a vintage canister, first ensure the width of the cosmetic stick is the same as the platform it will sit on in the canister. Freeze the tube of new lipstick. Once firm, carefully slip it out of the holder or slice it off. Relocate it to the vintage platform.

Voilà! A lipstick color you can wear, rising up from a lipstick container you can take pride in showing off.

Coverage is everything. Make the most of the lipsticks you have by combining them. Try a matte lip with gloss; or dab highlights into a lip with a pearlized stick.

Matte: Our daily go-to because of its opaque, flat, and long-lasting qualities. An intense matte tends to have greater staying power and feather and bleed less. Because mattes can be drying, consider applying a second layer of a more moisturizing formula in a similar shade. Keep an eye on a superflat matte lip throughout the day, and regularly freshen it up either with another swipe or by wiping the slate clean and reapplying lipstick. Thankfully, there are increasingly more moisturizing matte options on the market, too.

Semi-matte/Crème: With more emollients than a matte, this formulation provides more texture and shine, and frequently a satiny finish.

Gloss: The glossier the patina, the more the emollient—and, typically, the less the staying power. It also means less color and a softer wax formulation. Since I'm all about a deeply pigmented lip, gloss serves as a finishing layer, a highlighter. I love a pinky gloss over red. A glossy lip that suggests the shiniest patent leather is very sexy. I usually just apply a touch in the center of lips, avoiding the edges, where it can bleed. Great effect, but high maintenance!

Sheer/Stain/Tint: An effective way to rosy lips, these formulations forgo the oil or wax emollients in lipsticks for an alcohol base that dries quickly. While this makes them generally less moisturizing than a lipstick, it also means they require less re-application throughout the day. They provide a lovely flush on lips before a make-out session, or a bloom of color on cheeks or nipples.

Lip Liner

That tip beauty guides like to parade out every other season about skipping the lip liner or pencil altogether? Skip the seasonal advice altogether.

Look at a picture of Dietrich. The lip is perfect. Monroe? Perfect. Liner provides definition. It can also contribute to the staying power of a bolder lip color. I like the perfection of it. Even the bold severity a perfectly outlined lip conveys can be alluring. When I read in beauty magazines that a red lip shouldn't be perfect? My response is look at a red carpet snapshot of a modern star channeling old Hollywood. Her lipstick is perfect, too—thanks to liner.

Lip liners contain less oil and more wax in order to serve as a barrier, curbing feathering and bleeding.

If you are new to lip liners, start slow and steady. Follow the natural lip line and master that before attempting an overdrawn, prominent lip. I can draw a nonstop line from center to corner. A steady hand comes with practice, so no need to rush or to get frustrated. Lip liner can be removed easily if you need to start again.

For those new to liner, Gregory suggests outlining with a nude or other tone close to your skin coloring. Then trace over it with the red or other colored liner that matches the lipstick.

While a liner in a hue similar to a lipstick is recommended, I also frequently apply liner *slightly* darker than my lipstick for both visual effect and staying power. This technique adds to the depth and richness of the look and the viscosity maintains lip color longer, too. The key is blending the darker lip outline into the body of the lip.

In my exhaustive and ongoing examination of lip cosmetics, when it comes to lip liners I have found the best have a bit of drag. I don't care for a lip liner that glides on too easily because the result is less viscosity, less coverage, less staying power.

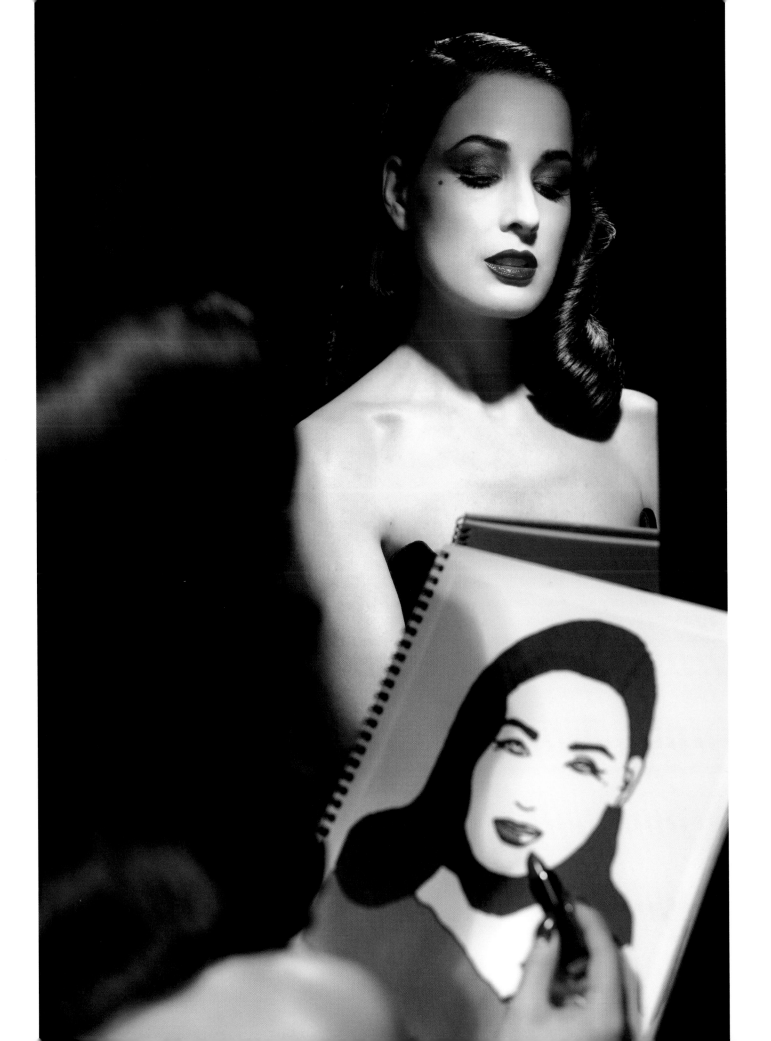

Painting Those Lips

When starting with a fresh application of foundation and makeup, don't forget to conceal any blemishes around the mouth. Powdering clean lips can also boost a lipstick's look and longevity. Just as you would slather on moisturizer before foundation, always brush your teeth before applying that first coat of lipstick.

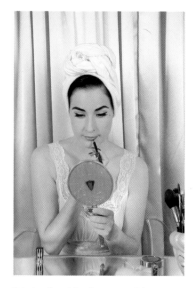 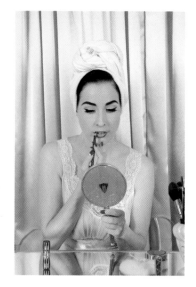 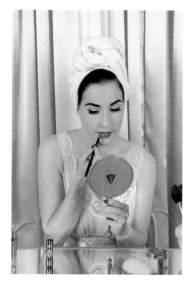 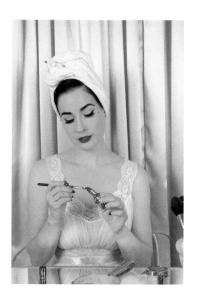

With a freshly sharpened lip pencil, outline the top of the lip, outlining each curve and following the line along the bottom of the lip to the corners of the mouth.

Continue reinforcing the lip line, according to the desired shape, whether it follows the natural lip contour or not (within reason and attractiveness, of course!). How much you overdraw will depend on the desired size and shape of the mouth. Support the pencil by gently planting a finger against your chin.

Using the angled side of the pencil, sparingly fill in the lip. Color in the area extending from the corners of the mouth, the curves of the lip downward, and the middle of the bottom lip upward and outward. Lip liner does not necessarily have to completely fill in the lips. Yet some filling in will provide visual texture and richness, as well as keeping lipstick in place longer. Glide lipstick on smoothly and generously.

A lip brush can also provide greater definition, painting layer upon layer of color.

Bring back the lip pencil for an encore to the perfect lip outline. A lip brush can work just as well, but I prefer the precision of a sharpened lip pencil. Use a hand mirror or magnifying mirror to check your lips from every angle.

Reapply lipstick, minimally blotting in the center of the lips to avoid streaking your teeth with any excess, but letting your lips shine with this fresh coat.

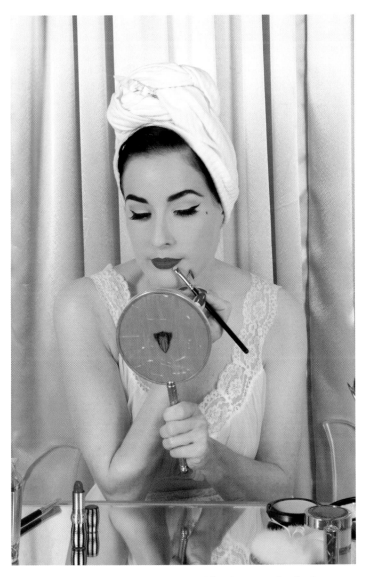

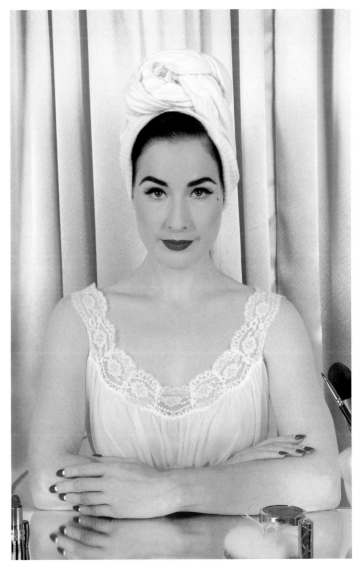

Review again, cleaning up any potential feathering. I also find it useful to take a clean, small, flat brush and lightly dab it in MAC Studio Fix or other heavy powder foundation.

Just as sparingly, outline the lip on the non-lipstick side of the lip line. Hit the corners of the mouth to steer clear of potential color bleeding out.

Blot again with a tissue between your lips or stick your finger in your mouth, wrap your lips around it, and release. Now give 'em your best Mona Lisa.

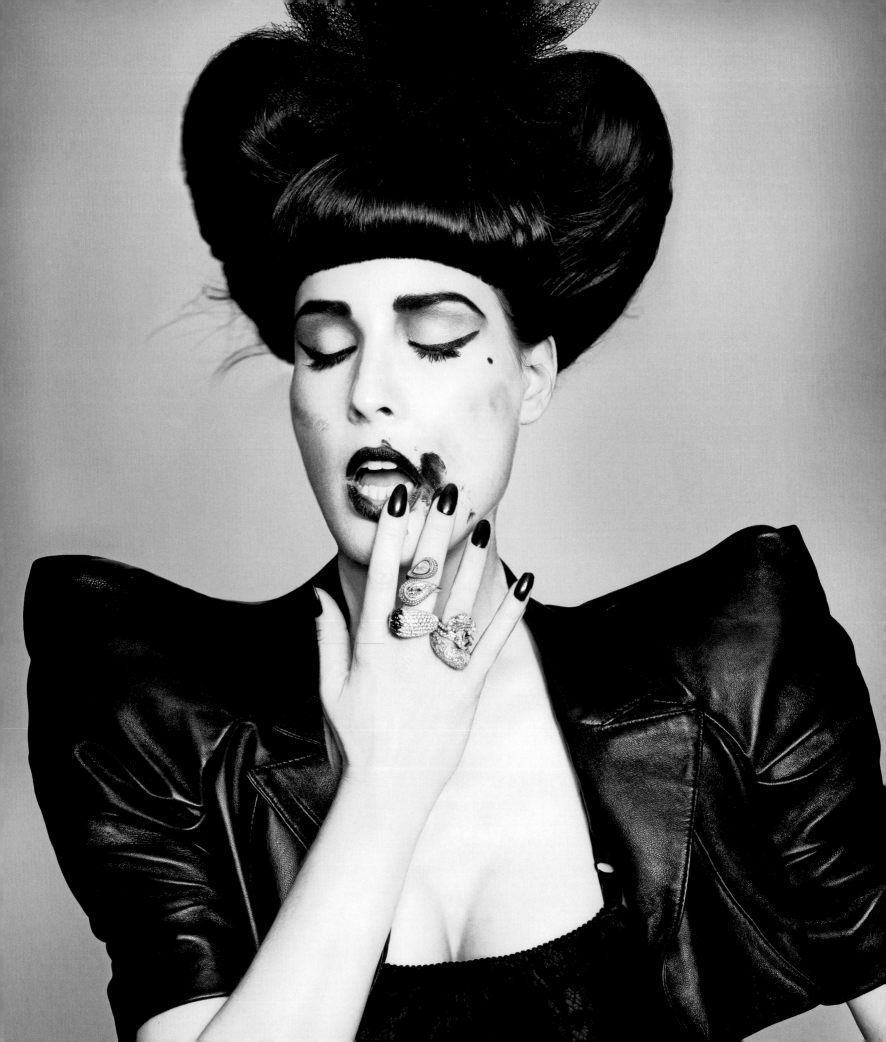

As I noted earlier, the promise of something better can fuel the quest for the ultimate beauty product. There's nothing more frustrating than when a perfect color comes on the market, only to be dropped until the next time beauty editors in their ivory tower dictate it's "back in fashion."

The search for the ultimate liner has vexed me almost as much as the search for the ultimate lip color. For years, I coped with the vanishing act of my favorite, Shiseido No. 7 Wine Haze, by hoarding about thirty pencils of it. I felt as if I could not have red lips without it. It was the secret to my red lip success. It's a deep, rich red bordering on burgundy. I can apply it with a light or heavy hand, and it always does the trick.

When I happen on the right product, I buy in bulk, knowing and fearing full well that it will be discontinued.

Coloring Outside the Lines

I overdraw my lips more often than not. As with a topographical map, there are outlines within and beyond the natural lip line, from a bitsy Betty Boop *bouche* to the brazen lips of Lucille Ball or Joan Crawford.

I recall a photo shoot in Paris where I politely sat for the makeup artist hired for the day. When I appeared in front of the camera, the photographer, my friend Ali Mahdavi, demanded, "Where are your lips?" I had to agree with Ali. For most of our shoots, I either do my own makeup or only submit to Gregory Arlt or another great talent, Lloyd Simmonds, creative director for Yves Saint Laurent Beauty—neither of whom were on set that day.

So before Ali could take a single photograph—and with apologies to the makeup artist who was there—I redid them my way. To which my darling Ali enthusiastically responded, "That's it! From now on, you will always do your own lips!"

"I simply can't look at you without lipstick."
—Isabella Blow

Cracking Up

It happens to even the most well-kept mouths: dreaded cracks at the corners, where lipstick buildup has been repeatedly wiped away. It can also happen to those who never use the stuff.

Called, among other names, perlèche, this problem isn't eradicated by moisturizing like crazy, something I learned the hard way. So I finally turned to my dermatologist.

This temporary, yet unwelcome, condition starts as an inflammation of the skin, the result of repeatedly wiping the corners of the mouth with fingers that have been touching the world. Bacterial and fungal traces are a fact of life, which is why regularly washing hands with soapy water also needs to be a habit in life. Cracks are less likely to appear with clean fingers.

Perlèche can also be due to nutritional deficiencies, drug side effects, or habitual lip licking, so keep that in mind when it comes to this all-too-common irritant.

The doctor prescribed me with an antibacterial hydrocortisone to speed up the healing. At the first hint of perlèche, Rose swabs a dot of Neosporin on the spot. If washing your hands is not possible, then use the corner tip of a handkerchief or tissue to wipe your lips to prevent bacterial taint.

Starting Over

Lipstick, or really any makeup, layered on throughout the day can end up looking and feeling nasty. When it comes to lipstick, no one desires a cakey, cracked pucker.

Remove all traces of it at least twice daily, if not more often. If possible, exfoliate with a damp washcloth and brush your teeth (I keep a dark red washcloth on hand just for this). Reapply fresh lipstick. It's like being reborn.

Likewise, before bed, exfoliate your lips with a washcloth. Follow up with a smear of heavy lip moisturizer. Any drugstore is well stocked with all kinds of inexpensive lip moisturizers.

I usually keep a small container of emollient lip balm in my nightstand drawer in case I forget to apply before slipping in between the sheets, or want to reapply before turning out the light.

The Once-Over Twice

Lipstick takes commitment. It is not for the lackadaisical. From supper to sex and everything in between, it takes an intuitive consciousness to maintain a flawless kisser. You cannot have too many cocktails and simply forget about your lipstick.

Wearing lipstick is much like donning corsetry. It involves decorum, restrictions, limitations, and without either, I'm naked. Like lingerie for the lips, lipstick is filled with suggestion, desire. It provides the mark of the femme fatale.

Lasting Rites

Keeping lipstick flawless cannot happen on intuition alone. To keep it looking good, a mirror is inevitably involved.

The gesture of digging into a purse and retrieving a lipstick tube and powder compact, then putting them to beautiful use is as controversial now as it was more than a century ago when the glorious Sarah Bernhardt took the private public.

The grand star of stage of the 1880s created a scandal of the decade when, according to a reporter of the day, in the midst of conversation on the street, she took out a pot of carmine dye from her bag and applied the cosmetic to her lips. Not only was this just not done, but makeup was absolutely taboo among the decent class. Well, at least that is what they insisted. That high and haughty bunch simply found innovative ways to convey the look of a rosy cheek and tinted lip. Oh, the pretense!

Carmine was made of cochineal, pulverized pregnant insects from Mexico, an expensive cosmetic for lips and cheeks—and a product only a highly successful theater star such as Bernhardt could afford.

These days, take a tip from award show–bound beauties: when that bijou evening bag cannot contain a lipstick and compact *and* mobile phone, instead keep a retractable lip brush

"Since we broke up, I'm using lipstick again . . ."
— Björk, from "Possibly Maybe"

coated in lipstick and a mini flat puff dusted with powder folded in the liner pocket for touch-ups through the night.

Check up on that pout periodically throughout the day, the evening, and particularly following any activity that might compromise a defined lip. Do it with flair. Do it with decorum. Just do it.

When Dining in Company . . .

If an oily remover can wipe away makeup, then it goes to reason that an oily morsel will wreak havoc on a painted pucker. A cheeseburger or pizza can be equally bad for hips and lips. Stick to meals involving a fork and not dripping in butter or oil.

As I noted in chapter 9, it's acceptable to repair lipstick at the table—as long as you hold a beautiful compact in hand and the hand comes finished off by beautifully manicured nails. With a lovely compact, the act of lipstick renewal becomes a conversation piece. It's divine anytime table talk can turn to glamour!

Besides, there are only so many times a gal can excuse herself for the powder room for a lipstick check before the talk turns on her.

I typically limit my tableside lipstick check with a compact to twice during dinner. When there are more courses and more than a couple of dishes require a recheck, I might pretend to be digging for something inside my purse, but am actually sneaking a peak in the mirror. I may even catch a quick glance in the knife just to make sure. It's better than a date having to make you aware of an errant smudge on your face.

I also think it's sexy to leave a single mark of red lipstick on a glass. That's single as in *one*. Resist turning the glass and marking it with a ring of lipstick traces. Nor is the red streak that might inadvertently result from the marked glass edge on your face.

Likewise, rein in reddening up a napkin. I always blot carefully, not wipe. Take care to press lips into the napkin just enough. This is one instance when a waxier, matte liner can extend a colored lip.

This reminds me of the time following a late supper at a favorite Paris bistro, when a busboy chased after me outside, requesting an autograph next to my kiss mark on a white cotton napkin. "But dear boy," I told him, "that mark *is* my signature."

It's one of my favorite qualities of red lipstick: leaving a trace of it where I've been.

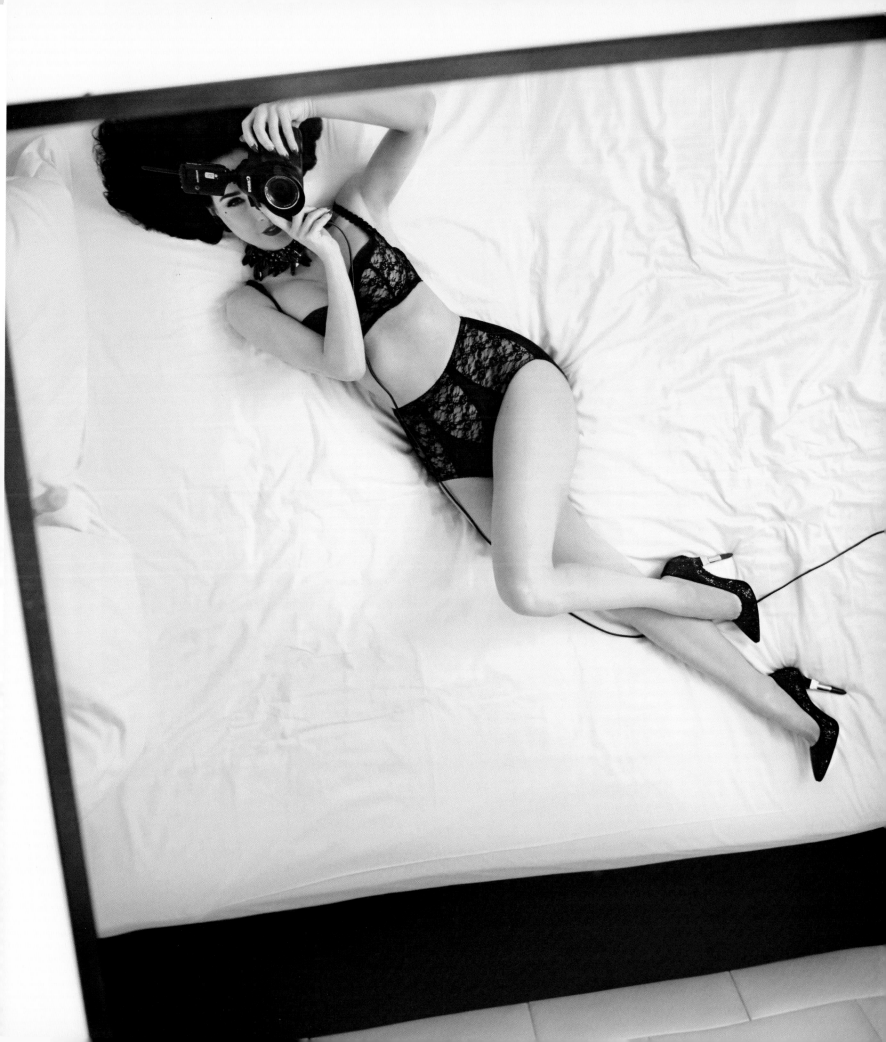

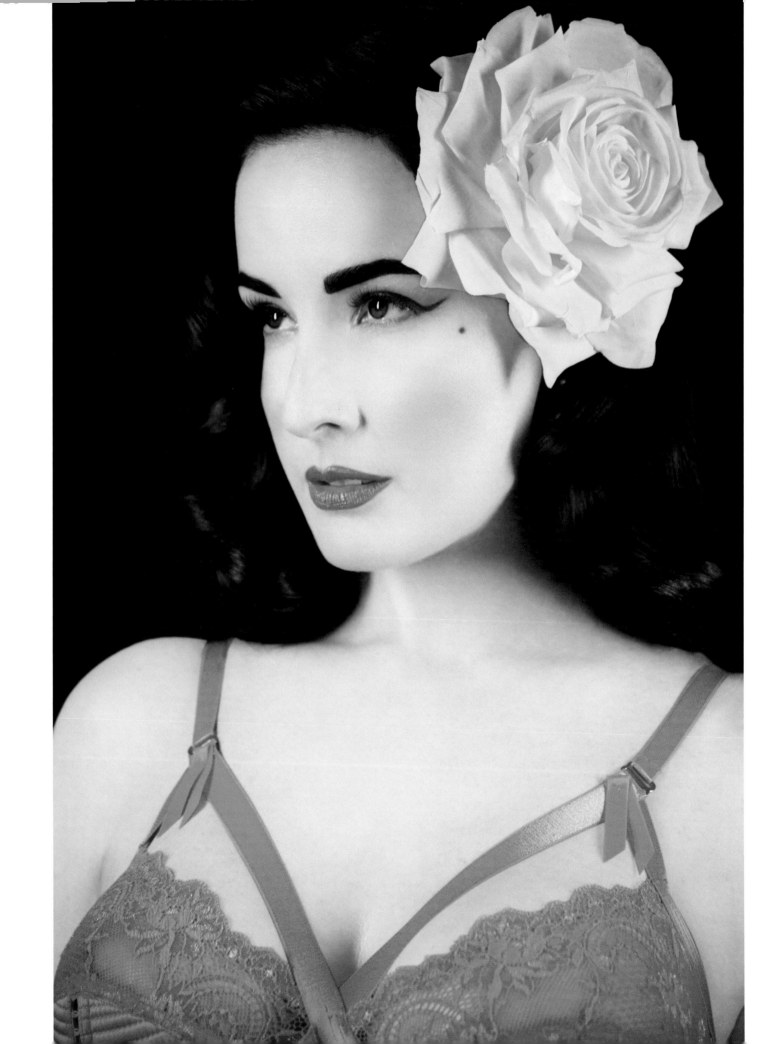

In the Case of Desire . . .

It's a complicated conundrum, the coupling of canoodling and lipstick.

For all their griping about it getting on their face or clothes, men love a woman in lipstick. They love watching a woman apply her lipstick. Maybe there's something Oedipal about it all, evoking a time when they spied their mothers seated at their vanities, but I have always caught the men in my life—lovers, friends, straight or gay—attentively watching me apply my lipstick.

As the study earlier in this chapter and so much anecdotal evidence has shown, men will find the same woman plain without it and worth noticing with it on.

So a woman cannot be expected to go on a hot date without the very red lips that attracted the lover in the first place. Leaving kiss smears all over his skin is the least of the problems. Traces of the stuff on a white collar can mean a whopper of a dry-cleaning bill.

If a serious kissing session is in the cards, I might excuse myself to the powder room and wipe some of the excess off, leaving just enough for rosy lips. The sight of clown face on him or you is not a very amusing way to interrupt a heated session. A lip stain can provide the flush of a rosy lip without the smudging of a lipstick.

There is always Lip Ink. Like its eye-lining counterpart, which I cite in chapter 12 as a solution to streaking beauty mark

"comets," this original, indelible lip cosmetic requires the accompanying removal solution. Lips remain red wherever they land and under *any* activity . . . and nary a mark is imprinted on a lover. Many friends, female and not, have appreciated this tip.

To wit, I shared this insight with one of my friends, a guy who loves a bit of makeup on himself and looks beautiful with it. He soon after followed up with a handwritten thank-you note. My friend reported that neither he nor his boyfriend could believe something like this existed and that it changed their lives.

As for the men in my own life who have been on the receiving end of one of life's delectable pleasures, a similar reaction inevitably transpires when not a bit of lip color leaves a trace. "How do you do that?" I am asked. As I'm not one to kiss and tell, let's just leave it at the power of magic. Glamour is magic, after all, and glamour should reign even behind closed doors . . .

While I keep Lip Ink as part of my extensive options, I don't want to live in it all the time. For me, at least, it takes all the fun out of the ritual of taking out a slender tube, twisting the base, and swiping on a swath of color.

Besides, as one wise man once said: lipstick is another form of coverage like clothes. When it comes off, revealing a naked lip, it's like an act of undressing that only a woman's lover experiences.

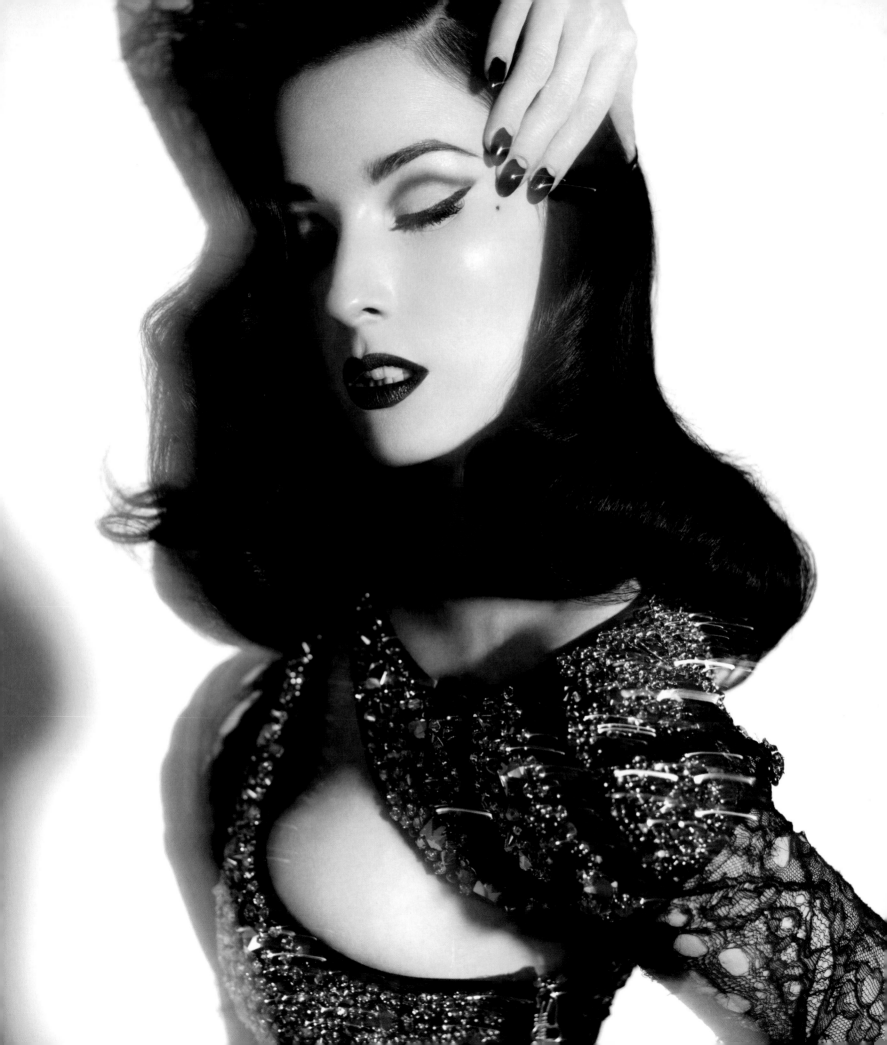

CHAPTER 14

Hand over Moon

When it comes to starlets in those glorious portraits by the kings of glamour photography such as George Hurrell, Edwin Bower Hesser, Will Connell, and Ted Allan, and in the captivating motion pictures of Hollywood's Golden Age, what is it that grabs my attention first?

It's the same now as it was when I was a little girl, cozying up with my mother on a Saturday morning to watch old movies on TV. Was it the gowns? The jewels? The je ne sais quoi of those flawless creatures? Well, of course, it was all that . . . and more. Yet there was a singular trait that gripped my studious eye: the hands.

I watched intently the way these gorgeous women would gesture, as essential to the moment as the lift of a bold brow or the parting of well-drawn lips. My eyes would follow the direction of a hand, framed in a silky bell sleeve, as it would sweep across the screen. Or I would observe how the left and right would be positioned, fingers delicately fanned out just so, near the cheekbone and chin, the entire image forever fixed in black and white.

When I threw myself into studying vintage style in the early 1990s, moon manicures were nearly a lost art. No one was painting their fingernails this way—at least no one under sixty years old. So I learned to do moons—to do just about anything relating to my nails—from the best: Bonnie Lindsey. My mother is a manicurist by profession, and she was the first one to pretty my nails. She worked out the technique, and what I learned from her I passed on to the manicurists who have created my nails since then. (Her steps in executing a healthy manicure are on page 238 and to do a moon manicure are on page 239.)

Well practiced as I am at a self-manicure, I admit it's one beauty ritual I now outsource to professionals. But I don't bother with fancy salons. There are some very skillful technicians around town who don't charge an arm and a leg to do nails. Since I moved to L.A. in 2001, I've been seeing Linh Ho at Diamond Nail on Hollywood Boulevard. I've been singing Linh's praises for such a while now that I more often than not find a line of gals waiting for her to give them my signature manicure—which Linh tells me they ask for by name, "the Dita!"

There is always someone keen to change the color and length of my nails onset on too many magazine shoots. But I nearly always decline (and sometimes, not so politely). I like the shape and length and I definitely love my moons. They are all important facets of my signature style, and I'm not going to submit so easily to someone else's momentary whim!

Paint It Black and Then Some

Those silver screen sirens my mom and I swooned over may be remembered on monochromatic celluloid, but more often than not, their talons were in full color. These were not only the rosy tints that dominated the 1920s, either, when nail polishes first appeared in the marketplace thanks to that other marvelous innovation, the automobile.

Sure, women since the Empress Lü Zhi and Queen Nefertiti have colored their nails with beeswax, egg whites, crushed flora,

and whatever else would do the trick. But what started it all happened centuries later in the 1800s, when the development of nitrocellulose, a cocktail of wood pulp bathed in nitric acid, sped up the dry time of paint. Nitrocellulose production escalated with the nascent auto industry at the start of the twentieth century, and the faster-drying paint lead to new applications—including the first patent for nail polish in 1919.

This was the height of America's ownership of Henry Ford's Model T, which, as Mr. Ford himself touted, "came in any color . . . so long as it is black." Some nail historians point to this as why a noir nail was the height of chic in 1932. Considering this is a full five years after Model T production stopped, we speculate the trend for black and darker fingernails might have another source: on grand screens inside the emerging movie palaces, stunning cinema stars in black and white conveyed a dramatic flair that likely filtered into the theater of life.

Red was already fashionable among Paris trendsetters, among them the Princess Jean-Louis "Baba" de Faucigny-Lucinge. She colored her long claws a deep crimson during the Jazz Age years of the 1920s, a splendid contrast against the deep-bronzed skin already made de rigueur among the leisure set by fellow scenester Coco Chanel.

Within a couple of years, nails were colored emerald green, Prussian blue, mother of pearl, lilac, gold, and silver. The Great Depression was no reason to wash one's hands of even a little pizzazz.

By the 1940s, coordinating was in. Clothes, shoes, and nails had to match, setting off a color wheel of yellow, navy, purple, green, mauve, and marvelous reds with undertones of blues and browns and orange.

While I'll flirt with fuchsias and corals during the summer and burgundies and berries in winter, more often than not I'd rather be caught red or dead. A (very) few of my go-to red varnishes include Fishnet Stockings by Essie, Rouge Louboutin by Christian Louboutin, Passion by Leighton Denny and The Spy Who Loved Me by OPI.

I love a candy-apple finish like that of a slick paint job on a vintage hot rod car. One way to achieve this is by sweeping a true red over a metallic ruby or shimmering burgundy. Mom Von Teese lays down a silver or gold over the entire nail,

then freehands red polish above the crescent to the nail tip. The metallic undercoat glints through the red topcoat.

When London nail guru Leighton Denny was promoting his own line of eponymous products in 2009, he offered a "Louboutin manicure": red moons, black nail, and red *underneath* the tip to mimic the soles of the eponymous slippers by our mutual darling Christian Louboutin (who has gone on to launch his own inspired polishes and open the most spectacular showcase in Paris). I'm not really fond of black nails on me, but it was a novel notion then, and has since taken off as a trend in manicures.

The Moons and the Stars

During the wartime years of the 1940s, the rage was for a nail's tip and lunula to be free of polish and left exposed. The lunula is the whitish crescent shape at the base of the nail. The fad was partly out of necessity. Since polish didn't last as long and nail growth is inevitable, women could save on wartime resources, be it budgeting for polish or a manicure. A prime example of turning necessity on its head and making it work stylishly!

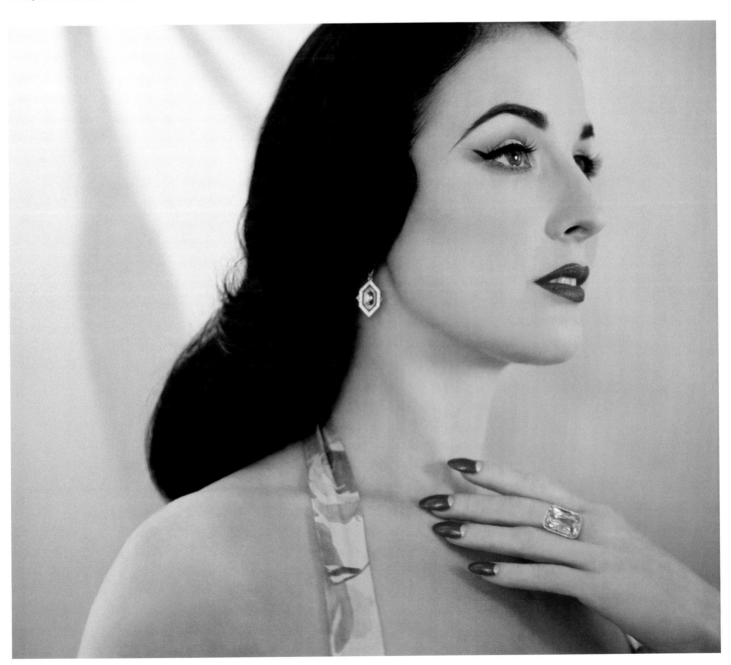

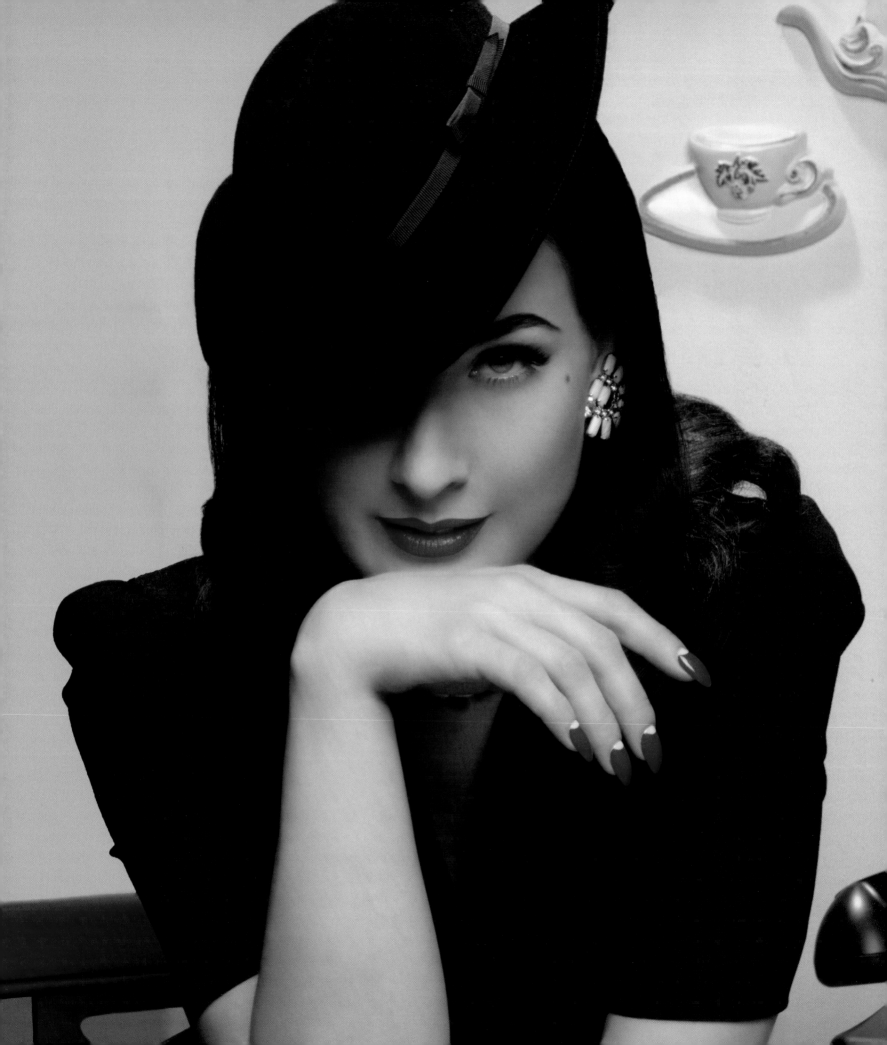

Resources—of time and money—were another reason for the look. As Diana Vreeland, the legendary editor of *Harper's Bazaar* and *Vogue,* retold in her memoirs, a manicure was a prolonged afternoon event. A manicurist would visit her house, and the varnish would take hours to dry.

Those years weren't the first time moons soared in popularity, making them a revival trend of sorts. Unvarnished moons and tips first came into vogue during the mid-1920s thanks to those Paris "It" gals who only stained the center of the nail.

It was a decade later and all the way in Hollywood at Metro-Goldwyn-Mayer Studios where credit for officially christening the look of leaving the crescents unvarnished as a "moon manicure" went to the on-set manicurist Beatrice Kaye.

MGM founder Louis B. Mayer commanded that actors be "coordinated right down to the fingertips," said Ila Hirsch, Mrs. Kaye's only daughter and a second-generation Hollywood studio manicurist. Mayer's request wasn't so crazy. As Ila's mother once observed: "I can tell everything about people by their nails: the state of their health, their lifestyle, their sexuality."

One screen legend who certainly oozed health, life, and sexuality was Carmen Miranda, who brandished very long nails with glaringly noticeable moons, even now when her classic films are on the smallest of screens.

The three-decade moon phase faded to black in the 1950s—at least for the next half a century—when nails were fully coated, cuticle to tip, with at least two coats, preferably in reds, pinks, and corals, to match fully drawn lips.

When it comes to moons, my mom is that rare talent who can freehand the crescent shape flawlessly. It took considerable practice on my part, particularly when it came to rendering moons on my left hand—I'm right-handed. But I can finally freehand a moon . . . sort of.

For the last couple of decades, bystanders would point out the naked spots on my nails, suggesting I needed a fill of polish. It became a kind of litmus test for me, distinguishing between those who cherish the beauty ways of another era because of their love of old movies and other vintage culture—and those who don't. That happens less now, as my moons have received so much attention and admirers have followed suit, that this nail art is no longer a thing of the past.

I love a natural moon, but I also love experimenting with colors and embellishments. I've long trimmed my moons with glitters, foils, even a tiny Swarovski crystal.

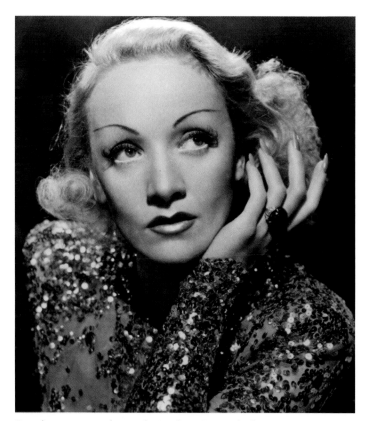

Be it her career or her nails, Marlene Dietrich always went to great lengths.

The recent revival of an endless nail palette has fueled wild experimentation in colors and combinations not seen since, well, the 1920s. The modern twist of coloring the crescent space with a contrasting color or pattern is pure delight.

A sheer ivory moon or a pearlescent moon is lovely. Around the holidays, I tend toward moons in a shimmering shade of silver, gold, or sparkling champagne paired with a ravishing red. Favorite metallic paints are Happy Anniversary! by OPI, Screaming Bright by MAC, Soiree by MAC, Carousel by Ciaté, and Ladylike Luxe by Ciaté.

In the summer, when I wear more orange, fuchsia, and tomato hues, I usually stick with sheer white or something a bit more natural.

There is also a press-on option on the market that (self-promotion alert!) I collaborated on with professional nail product company Kiss. These oval-shaped nails in two shades of red with white moons make it easy to get to the look without the threat of chipping polish.

Nailing It with Mom Von Teese

Basic Manicure

Gather: Polish remover, emery file, bowl of tepid water, orange wood stick, hand cream, clean tissue and cotton pads, alcohol, base coat, color polish, clear topcoat. Optional: creamy cuticle remover, fine brush.

- Remove all traces of polish with remover. Use an emery board to file nails into the desired shape.

My gorgeous mother, Bonnie Lindsey.

- Soak your hands in a bowl of tepid water or in the bath to soften the skin and especially the cuticles.

- A creamy cuticle remover can be applied to help in the next step, but is optional.

- Using a clean orange wood stick, in small motions around the base of the nail, push the cuticle back from the nail bed. This promotes nail growth and can help prevent hangnails. Overgrown cuticles should *never* be cut with scissors. Think of cuticles as barriers against bacteria and fungus. Like any barrier, it needs care to remain in shipshape. If necessary, trim slightly and evenly with a sharp cuticle nipper.

- Generously apply hand cream, baby oil, or petroleum jelly to the hands and rub it in well. Wipe the nail beds clean with a tissue dampened with alcohol.

- Prep the nail by applying a clear base coat. Allow to dry. A base helps prevent darker colors from staining the nail bed.

- Proceed with the color polish. Wait a couple of minutes and apply a second coat of varnish.

- Finish off with a topcoat of clear polish. This will aid in hardening and protecting the colored layer.

- Clean up any excess paint on nails and surrounding skin with either a fine brush or the orange wood stick wrapped in a scrap of cotton or tissue dipped in remover.

- Relax. Even with accelerating polishes and devices, it can take upward of fifteen minutes before hands are ready for minimal tasks and an hour before any major action.

Polish Off: Acetone vs. Non-Acetone Removers

Acetone is a colorless organic solvent that not only breaks down polish, but also strips the natural oils from the nail plate. While this lets a base coat adhere better, it also dries the nail and makes it brittle. (It's also a primary ingredient in nail polish thinner. Just resist adding too much.)

As for products branded as non-acetone?

Well, the fact is that all removers have acetone. So-called non-acetone removers are diluted with water and conditioners, making them the best option for artificial or natural nails. This also means it doesn't work as quickly or as effectively on darker or glittery polishes. So, if you must, alternate. Just use non-acetone when possible.

Tip to the (Half) Moon

Gather: polish, a fine-point curved brush like those used for nail art, acetone remover, a small container, and cotton pad or tissue.

- Examine your nail. There is a natural moon there, and one that changes in size from nail to nail. Let that natural feature be the marker. Follow the first five steps of the basic pedicure. If moons are going to remain naked, brush the base coat can above the curve to make clean up easier in the half moon area.

- Dip the fine-point brush in polish and freehand the crescent, above the curve of the natural moon. Take your time, and remember that any mistakes can be cleaned up.

- Polish the nail bed above the curve up to the tip.

- Pour acetone into the small container. Moisten the fine-point brush with polish remover, taking care that it's not dripping, and carefully swipe away any nail polish in the moon area to the cuticles. Clean the brush in acetone, using the cotton pad or tissue if necessary, before moving on to the next nail or spot to remove polish. For an earlier vintage effect, swipe the brush across the nail tips. (Also use the fine brush, clean and moistened with polish remover, to erase excess paint on the nail and skin.)

- Let varnish dry.

- If half moons are going to be colored, dip the fine brush in the polish and freehand apply color to the base of the nail.

- Once all polish is fully dry, apply a final clear coat. If the color is still wet, you can risk bleeding it into the moon space, creating a fuzzy effect. Some clear polishes don't "grab" darker colors as much. (Two Dita recommends are Super Shiney High-Gloss Top Coat by CND and Airshield Top Coat by NSI.)

Half moons take practice. Once mastered, consider painting the moon a bold color or metallic and the nail center another highly contrasting hue. Say, a chocolate bed and a copper lunula and tip? A peacock blue between jade green edges? The only limits are your imagination.

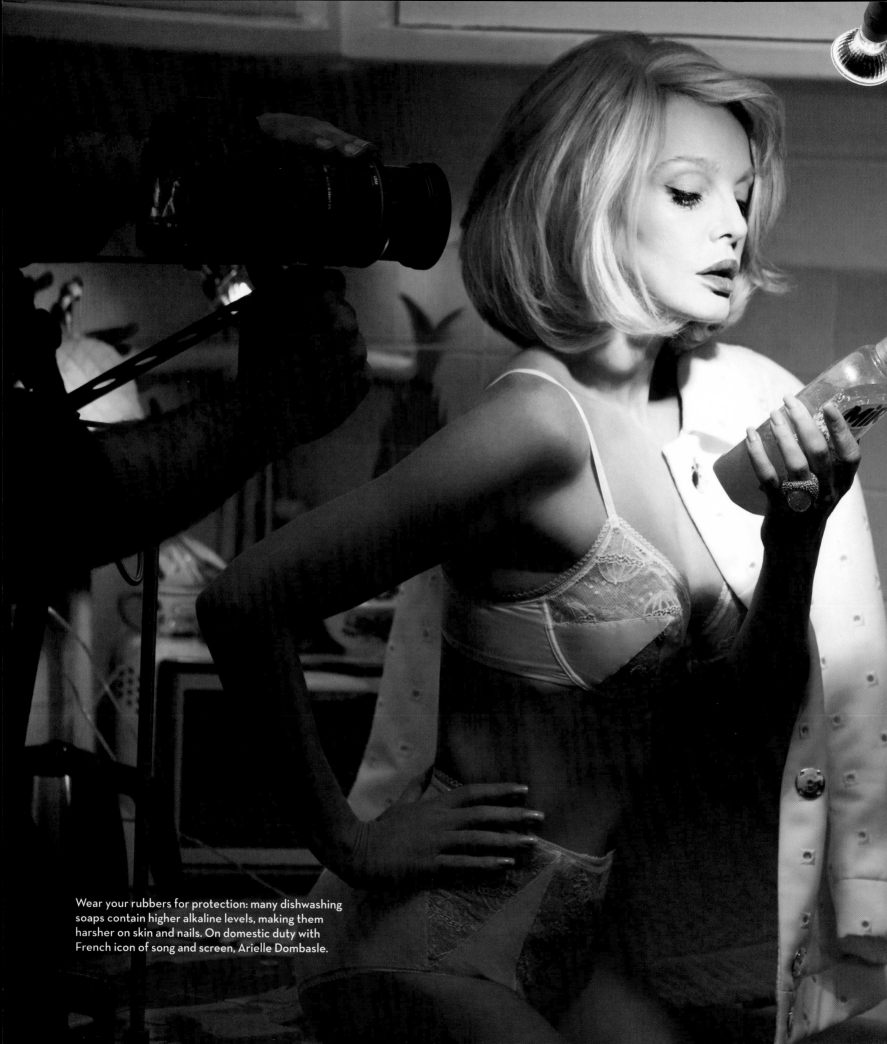

Wear your rubbers for protection: many dishwashing soaps contain higher alkaline levels, making them harsher on skin and nails. On domestic duty with French icon of song and screen, Arielle Dombasle.

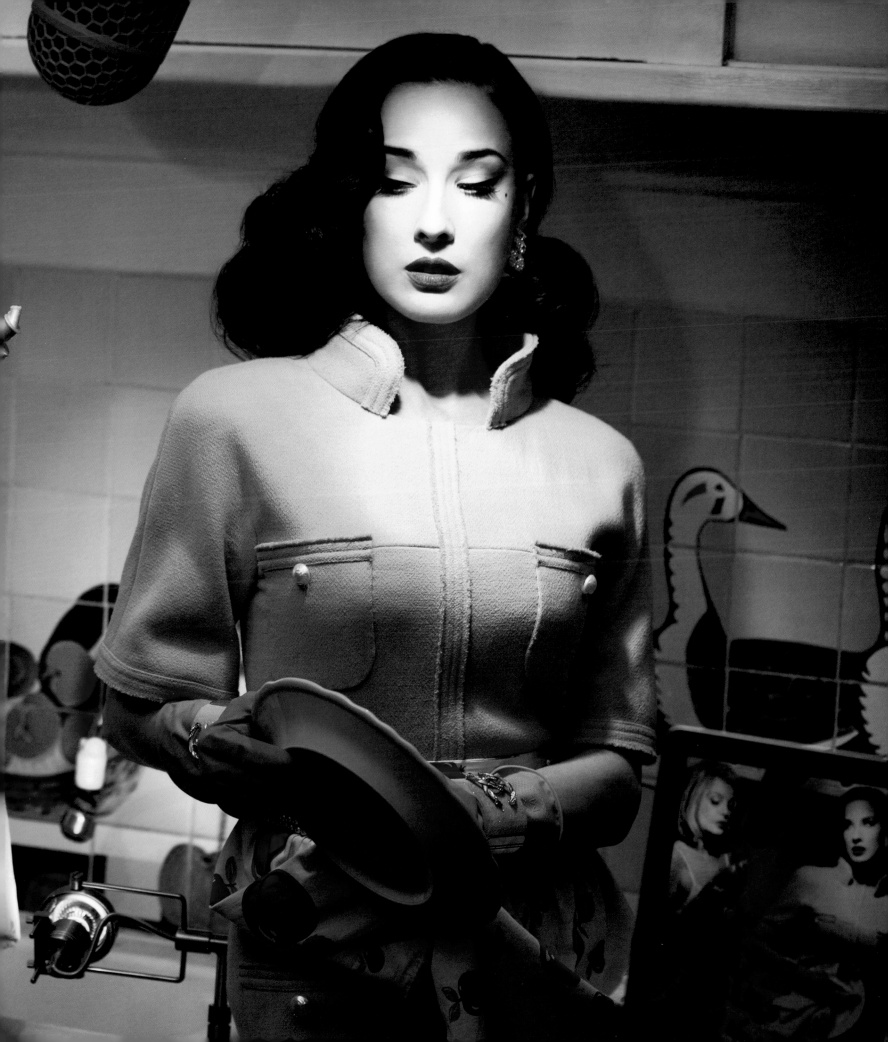

Nail Shapes

Round Short Pointed Square

Going to Great Lengths

Rita Hayworth "probably has the longest fingernails of any actress," panted gossip columnist Sidney Skolsky at the 1944 release of what became one of the starlet's best-known films, *Cover Girl.* Only a decade earlier, when she was brunette Rita Cansino—instead of the flame-haired femme fatale she would become—she was already filing her drawn-out nails into a point and painting the sharpened tips as a contrasting triangle of color.

I love long, sharply pointed nails. But let's face it, dragon-lady claws are hard to maintain. What pain it is, literally, when an acrylic claw accidentally tears off! They also mean another pair of handy hands might be required to lace up (or lace off!) a corset. Given that corsets are a mainstay in my stage wardrobe, this is not a practical consideration.

So it is that my nail length fluctuates from time to time, but generally skews to a more moderate length. This is especially the case during those weeks when I'm stockpiling the frequent-flier miles and don't have time for repairs or too much upkeep.

Because a moon manicure looks best with some length, it's necessary to have even a moderate rise above the fingertip.

If short nails are more fitting for your hand or lifestyle, as they are for Rose, then keep them simple. Forgo moons or any other flourishes for a tidy cuticle, tidy shape, and wash of polish. Short nails always look chic with strong dark colors such as a classic red or deep burgundy. Come to think of it, dark colors always look best on short nails.

The X File

Not all files are interchangeable. Emery boards are flexible and cheap but need periodic replacing. Some metal files are fine, but many can create a ragged edge and even rip nails. They also must be thoroughly sterilized before being used on another pair of hands or feet. The way to go with natural or artificial nails is a fine-grade wood file or the smoother surface of a glass file. Both yield a clean edge and promote stronger growth and can be easily cleaned with hot water.

(Maids in Marie-Antoinette's service would thoroughly hand-wash the *lime à ongles*—a pumice stone file—that the dauphine of France used to diligently shape her nails. When word got out, her admirers followed the habit with a spotless *lime à ongles* of their own.)

Always file in quick, even strokes and in the same direction. Begin on the outside of the nail and lightly file toward the center and into the desired shape.

An emery file should *never* be used to buff the surface of a naked nail. A natural nail requires a fine-grained buffer to smooth away surface ridges. If, for whatever reason, you're going without polish, follow this step with a buffer with an even finer grit or skinned in chamois, coupled with a buffing cream, to leave nails with a glossy patina. It's a low-maintenance option; just don't overdo it. Buffing too rigorously or too long at one sitting or too frequently in a month can damage the surface.

Faux Real

How much do I love acrylic nails? I've probably removed my acrylics once in the last three years—and I have worn them since I was seventeen. I love the way they feel. I especially love how long my polish remains pristine because they seem to hold nail polish better than natural nails.

While it was a couple of brothers in the dental trade who patented and started the first fake nail business, the desire for long nails as far back as the fourteenth century prompted Ming dynasty–era ladies of the court to slip on extensions made of hammered gold, bronze, and silver.

Artificial fingernails are made of a polymer powder and liquid glue. They are usually removed with acetone. There is a long menu of preparations to get the look. If acrylics are not for your nails, another option is a silk wrap. Just like it sounds, the process involves a real strip of silk fabric as a layer safeguarding the nail plate from additional damage. Yet, like everything applied to nails, no one method comes risk-free.

I know how to apply acrylics myself, though without regular practice, I can't say I'm an expert. Besides, some things are worth paying a professional to do.

Put Up Your Dukes

The eyes might reveal the soul. But the hands are the telltale signs of age—be it measured in actual years or mishandling. Consider all the abuse they undergo during everyday activities, from sun exposure while driving around to abrasive solvents while cleaning up. For all the care and cost devoted to the face, the same commitment isn't always extended to the hands.

The primary cause of premature aging is the UVA rays from the sun, which trigger wrinkles and brown spots.

Wicked Mother Nature doesn't cease there, of course. After our thirtieth birthdays, dropping estrogen levels affect tone and texture as skin becomes drier, while diminishing collagen levels thin skin. It's a part of life. The skin on our hands is already thin to begin with because there is nearly no fat under it. The minimal fat that is there also decreases with age.

How to fight it? Emollients. This is one ally that can never be too rich, either, and a rich formulation doesn't have to cost much.

A mild, moisturizing pH soap is best when washing hands. A higher pH means a greater, more caustic alkali level.

Once a week or more, exfoliate the skin to remove dead skin cells and improve penetration of moisturizer. I use a facial scrub, as well as a loofah in the shower. Rose also recommends a scrub made from lemon juice and sea salt. While you're at it, scrub your arms and elbows.

I always have a sunscreen-formulated hand crème in my car. There is usually a tube in my purse, too—and I use it. It's absolutely vital to moisturize your hands throughout the day.

Before bed, smear a serum or other rich emollient on the backs of your hands. Rub the excess moisturizer up your arms and into your elbows and shoulders.

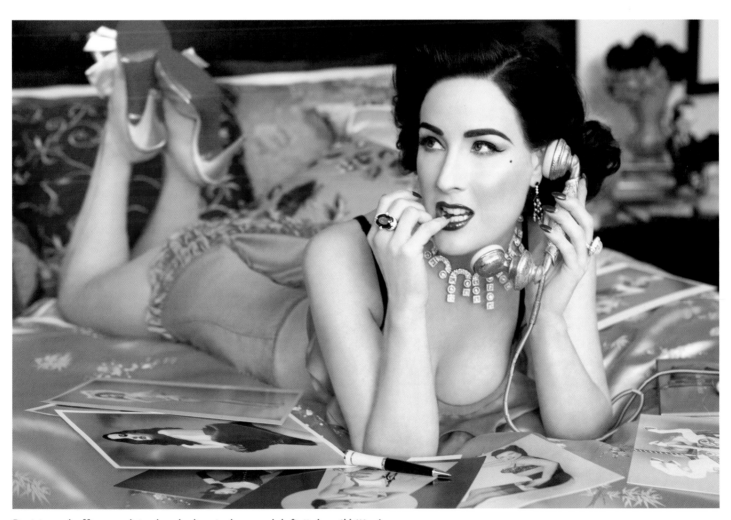

Resist overbuffing, applying harsh chemicals . . . and definitely nail biting!

A collagen-rebuilding cream can aid in repair, especially a retinol cream. Start with a nonprescription formula. There are many great ones at the local drugstore. Look for formulas with 0.1 percent retinol, packaged in aluminum (to protect it from light and air).

There are other options by way of a dermatologist or other professional. Chemical peels and microdermabrasion can strip away the top layer of skin and minimize the appearance of wrinkles for one to three years. Brown spots can be lasered away, with effects lasting from six months to five years. Just be careful who is administering these services, and carefully follow the post-care instructions.

Stress and other emotions can also unconsciously affect hands. If I catch mine subconsciously forming a fist, I take a deep breath and tell myself to relax.

Nails Rx

Her claws always crimson, Diana Vreeland included in her "Why Don't You . . ." series of insider tips sometime in 1937: "Why don't you remember that if you never scrub across the ends of your nails with a nail brush, your varnish will remain twice as long." Sage advice, even now.

Even though I now see a manicurist, whether I need it or not, before an important appointment I like to refresh the tips with a coat of colored polish, followed by a coat of clear polish. It renews the surface with a fresh gloss.

In the case of hangnails, cover with a bandage, either a strip or a liquid alternative, to stave off infection until it heals.

Nail strength is genetic. But using good-quality cuticle and nail oil can moisturize and preserve flexibility of the nail plate by pumping up the nail plate cells. To that end, be careful not to overuse a nail strengthener, because it can have the opposite effect and actually make your nails brittle.

The B vitamin biotin can help promote nail and hair growth, according to the Mayo Clinic and other leading medical sources. Some of our favorite biotin-rich foods are walnuts and sunflower seeds, sweet potatoes, lentils, fish, green peas, and cabbage.

Two of the easiest and best habits toward nail health? Don't use nails as "tools," as the abuse will inevitably end up in breakage. Keep a to-go kit in your car or, if permitted, at the salon. Bacteria exist in even the cleanest corners, so don't risk your health over the convenience of tools used daily on dozens of other clients.

Throwing Down the Gauntlet

I wish I could do everything with gloves on. But they need to come off sometime. A fan sent me a long leather pair with removable thumb sleeves. Whatever for? To better text, without removing the gloves completely. Hilarious. I've since come up with my own signature line of gloves, including an opera-length style with touchscreen conductivity.

But it's no laughing matter what exposure to the elements will wreak on your hands. Make gloves a habit.

During domestic duties at the sink or at other chores, always sport rubber gloves lined in cotton. It's not only the harsh cleansers that warrant concern. Even that lemon-scented dishwashing liquid contains alkaline, which is tough on skin and nails. For this reason, I've been replacing my conventional cleaners with naturally based, nontoxic alternatives. I also always use a thick moisturizer before slipping on my pink rubbers. The warmth from the water boosts activation of the lotion.

Outdoors, I never attend to my flower beds without first putting on a sturdy pair of gardening gloves along with a wide-brimmed hat and plenty of sunscreen.

Driving requires (yes, *requires*) its own pair of mitts, and this can certainly be an excuse to slip on the glamour in the name of skin health! I for one think it's as good a place as any to wear my opera-length gloves. Where better place to store a pair . . . than in the glove compartment!

In places like California where sunshine is as much a birthright as driving, the incidence of skin cancer on the left hand is proportionately high. No matter where you drive in this world, if gloves are not within reach or within reason for your lifestyle,

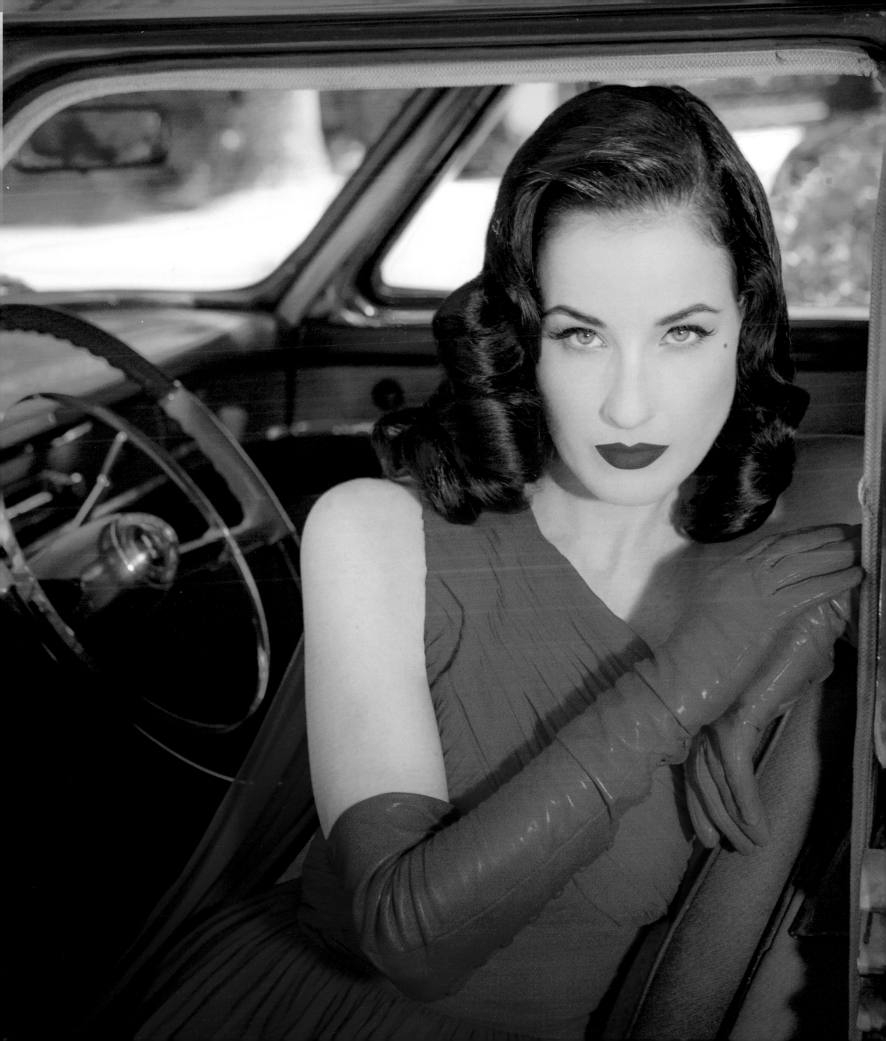

wear a high SPF block on hands and arms when getting behind the wheel. Yet another reason to always keep an extra tube stashed in your purse and in your car.

Close at Hand

Style pundits tend to side with the less-is-best conceit when it comes to jewelry and hands: too many rings and bracelets are not advisable, they insist, lest they bring too much focus on what time and experience have wrought on the hands.

Personally, I like an individual who is not trying to hide all her flaws, who is openly unruffled in her flamboyant embrace of life and accessories.

I tend toward fewer pieces of jewelry in my daily look—a watch, a treasured ring or two, my vintage charm bracelet. But I know women, and some men, who can pile it on to great effect, in the spirit of the intellectual and style provocateur Nancy Cunard, who would ring her arms in bone and Bakelite bangles to the elbow. The wrists of my friend, the stylist Catherine Baba, serve as racks for the sculptural bands she heaps on. And left-handed Rose keeps memories of her travels within reach, stacking her right arm with a dozen alligator-skinned bangles from Nicaragua, along with silver from Mexico and Morocco.

If you're going to go over the top, the key is having a good sense of self and jewelry. If your jewelry comes with stories, all the better.

Like treasured jewelry, nails can dazzle the eye in shades of ruby, emerald, gold, and pearl. Likewise, cultures around the world have developed other ways of expressing their most expressive of features, the hands, be it by henna or tattooing or stacks of rings. Each creative outlet serves to pretty the hands and captivate admirers, like the mesmerizing motioning of a sorcerer.

It's a sign language that every disciple of beauty ought to speak fluently, dear reader. Don't you agree?

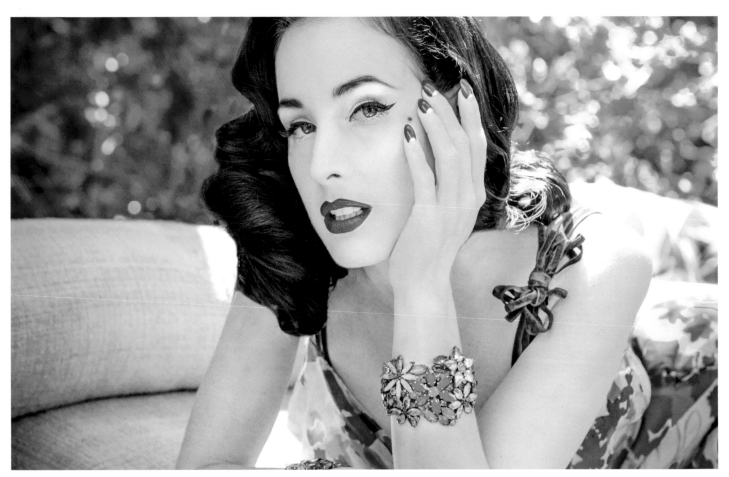

Captivate them with manicured tips and jewelry to set them off.

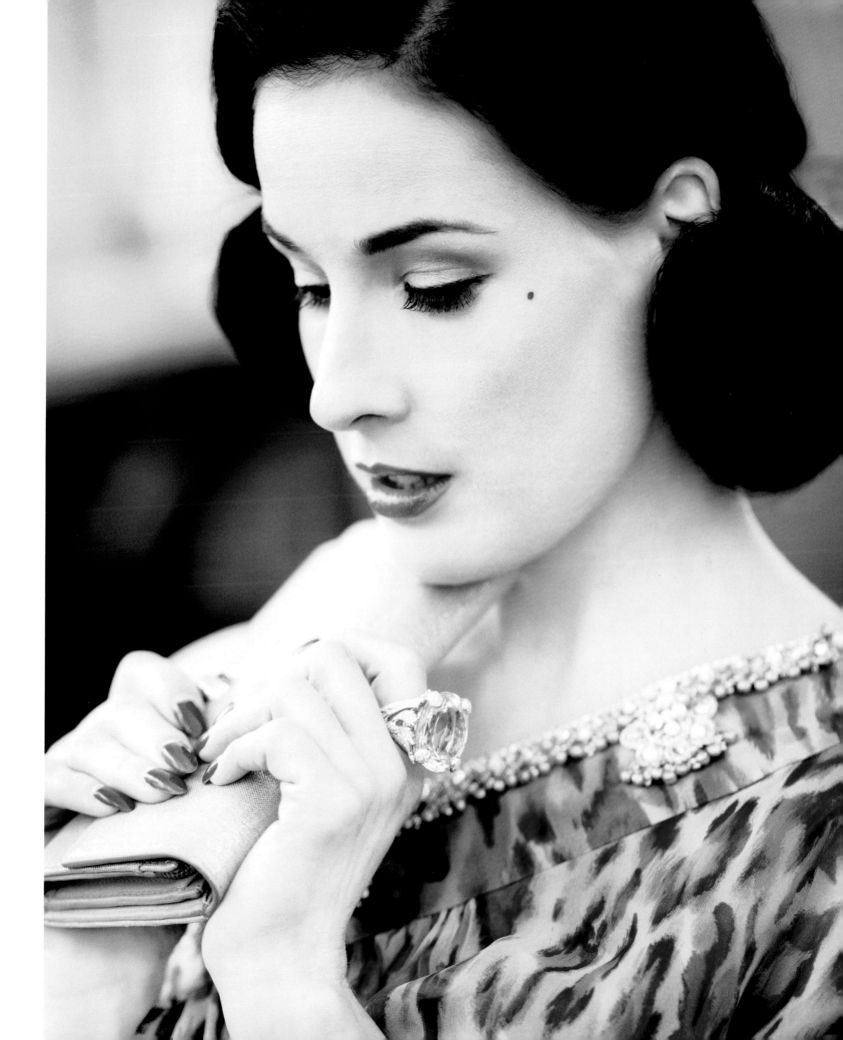

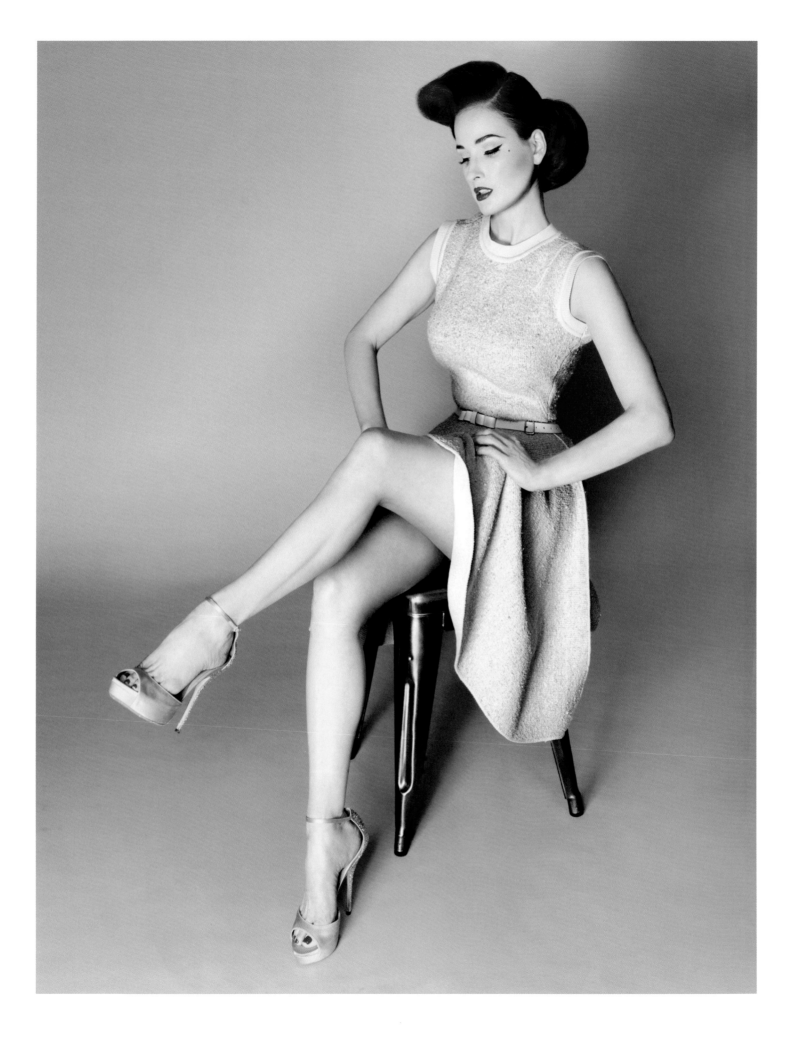

CHAPTER 15

Striking Below the Waist

"There are two reasons why I am successful in show business and I am standing on both of them," Betty Grable liked to crack, whenever asked about her secret to starring in twenty-five musicals and comedies in just thirteen years.

Grable had it all—an effervescent smile, a pretty voice, and, according to her movie costumers, nearly perfect proportions for her five-foot-four figure, with each thigh sizing up at eighteen and a half inches, each calf at twelve inches, and each ankle seven and a half inches. Lloyd's of London insured her legs for an unheard-of sum, earning her the made-in-Hollywood distinction of "the Girl with the Million-Dollar Legs."

But the star really kicked up the numbers when she slipped into a pair of satin heels and a white one-piece bathing suit, piled those platinum curls high on her head, and flashed a megawatt smile over a bare right shoulder at Frank Powolny, a photographer at 20th Century Fox Pictures. It was a snap ogled around the world. The pinup pic ended up in the pockets and lockers of one out of every five servicemen during World War II, and Hugh Hefner cites it as the catalyst to starting *Playboy*. Funnily, the star and lensman carefully struck the pose, according to lore, to put Grable's pregnant belly out of sight!

The rest of us may not be gifted with Grable's gams. (By the way, the slang word *gams* is an Americanization of the French word for legs, *jambes*.) There are traits about my own legs I'm not crazy about. But why dwell on them? Why should you about any flaws you might have? People generally don't notice such details until they're pointed out. So prize the pins you were born with! I've got my tricks and so will you! Spend time on your hair and makeup—but don't forget to strike below the waist.

Waist Not? Want Not

Waistlines, like hems, undergo more reappraisals in the name of fashion than all the stars in the universe. One season they are cinched beyond a gasp; the next, they're set free under a voluminous smock.

Through it all, the one shape that bears out the test of trends and time and is always the height of femme fatale fabulous is the hourglass. Be it biological or bent, mankind has long found the detectable waistline too alluring to resist.

It's no secret I prefer a womanly shape, what books and experts call a "natural" waist. In my case, that means unnaturally pronounced with the tug of a belt or corset.

My hourglass silhouette has spawned some wild tales, too: that I take extreme and exotic measures to cinch it so small, from *sleeping* in my corset to *removing* my ribs. Why all this twisted obsession with my waist is beyond me, but, dear reader, permit me to tell you the simple truth behind these widely spread rumors . . .

At the risk of sounding like a broken record, it comes down to keeping fit, ge-

netics, and clothes and accessories that emphasize my curves. My naked waist measures in at twenty-three inches. This isn't extraordinary for a woman of my height (five foot five).

It's true the kind of commitment I have to corsetry (including a collection of three-hundred-and-counting beautifully constructed foundations) is a form of body modification. I never made a conscious effort, however, to modify my body in the way that, say, my exquisite friend Mr. Pearl corset trains. The five-foot-eight gentleman only interrupts his corsetry training during the day and night for a bath. Otherwise, he lives in his beautifully tailored corsets and suits 24/7, cinching in at his personal best at eighteen inches at the waist!

When it comes to women, I love the exaggeration of the feminine form. I've laced up for upward of eight hours a day. I don't engage in tightlacing that compresses the ribs; it's not a feeling I relish. For me, I love the extreme sight trick of a cinched waist and flared hips.

You know what I tell my dear Mr. Pearl when he tries to talk me into full-time corset training? "Darling, I leave you to all the fun!"

Lips to Hips

Let's be real. Only some 8 percent of women have a true hourglass figure. An overwhelming 46 percent have a rectangular frame (which basically means the waistline is less than nine inches smaller than the hips or bust).

Whatever your shape and size, there is still a waist. It deserves to be emphasized. That includes even the *illusion* of a waist. You might be a rail. You might be zaftig. But darlings, you *do* have a waist!

It's a biological fact that women have greater levels of body fat in the lower parts of their body, because of sexual hormones and other factors (for men, it's the upper half). Instead of fighting nature, embrace this fact and manage it by being in tune with yourself.

I don't put anything in my mouth that I do not absolutely lust after. Counteracting cravings by balancing my overall nutritional intake is how I keep that lust in check. Abuse food, abuse your body. A healthy relationship with food means a healthier body.

Needless to say, a body is not kept trim by diet alone. Exercise is a key ingredient. Consult chapter 2 for nutritional insight and exercises.

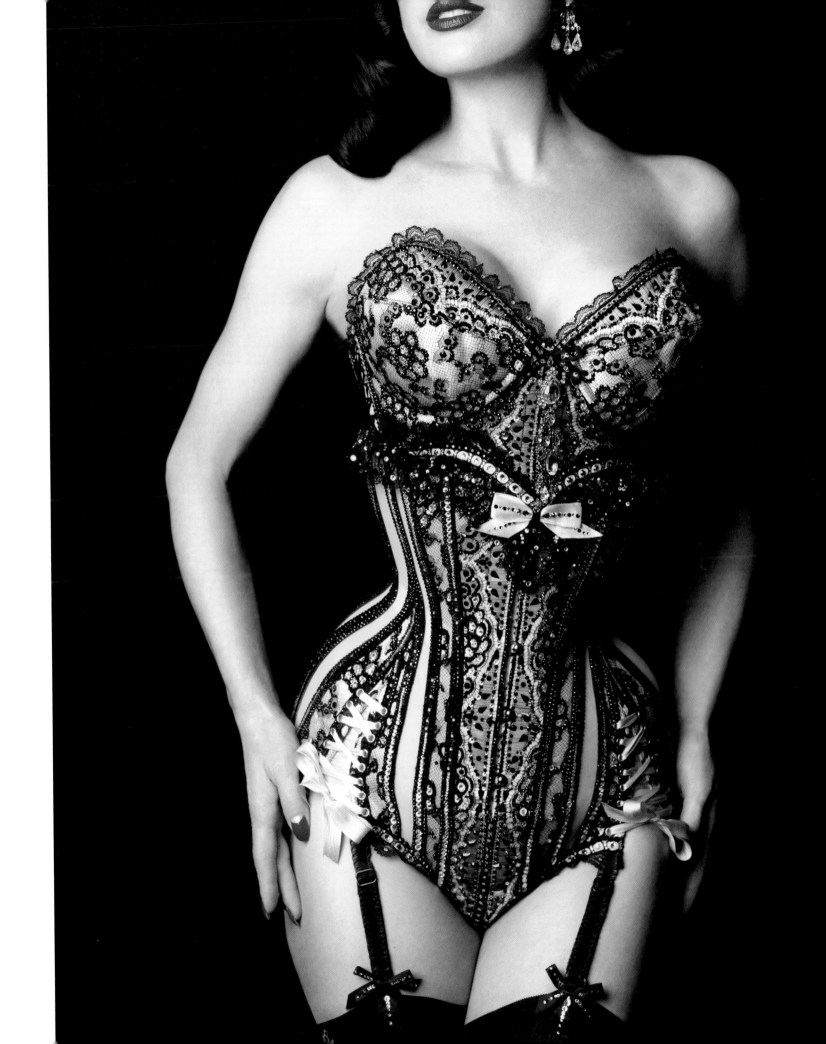

It's All Simply Sauce

God may have plucked a rib from Adam to create Eve, but tales of ribs surgically extracted from the body to shrink the waist are a myth, according to the American Society of Plastic Surgeons. It's all down to diet, exercise, and genetics.

I grew up hearing tales that my glamorous aunt Marilyn, an aspiring actress in the 1950s, removed hers. But Auntie Marilyn likely maintained her über-wasp waist as a result of eating disorders that sadly took her life too soon.

The sublime shape-shifting queen Amanda Lepore also shared with me some years ago in the wee hours of a late-night soiree that she was on her way the next morning to Argentina to have her lower ribs removed. She later offered in interviews that the expensive process actually involved breaking the ribs and pushing them in. Now that's one way, albeit extreme, to make your beauty mark.

Bottoms Up

Lunges and lifts can lead to a shapely rear and lean gams. But the attention shouldn't end there.

From bum to toe, give this area a robust buff while bathing with an exfoliating scrub (an inexpensive homemade concoction such as olive oil and kosher salt is perfect) or an Egyptian loofah to slough off dry skin, clean pores, and promote circulation.

Any acne activity that appears on a person's backside, specifically the bum, has nothing to do with hygiene, points out my dermatologist, Dr. Ronald Cotliar. "The area is like a rain forest." To treat, he recommends taking a cup of bleach to about forty gallons of water. That's about a full bathtub. Bathe in the solution once a week until it clears. "It's not irritating and it's the best thing for the bum and back," he says, noting a chlorinated swimming pool is even stronger. It's also recommended for skin suffering from allergic reactions.

For best shaving practices, follow the tips outlined in chapter 6. Day or night, moisturize with abandon.

The crème de la crème care for legs, advises Dr. Cotliar, is to elevate them for thirty minutes a day. With life comes swelling, whether it's visible or not. Elevating your legs above heart level and slightly flexing them takes some pressure off the blood vessels. Close your eyes, read a book, or tap at your tablet—just keep those pins raised!

As for that great pain in the bum and thighs, cellulite—well, true science confirms there is no magic remedy to complete eradication. It, too, comes down to exercise, diet, and, mostly, genetics. Who hasn't spotted a svelte amazon beauty poolside or on the street who is nevertheless revealing cellulite? So quit thinking it's the bane of everyone but those born beautiful. Even *they* have it.

Cellulite creams are nothing more than delusional hope in a jar. As Dr. Cotliar admonishes, "That technology doesn't work. Everything has been tried: microwave, heat, lasers. But the results are simply not long term. Not yet, at least."

Technological advancements keep coming, and there have been some significant ones such as Cellulaze, a minimally invasive procedure promoted to zap away cellulite. Yet no non-invasive procedure as of yet has proven profoundly effective.

Besides nutrition, fitness, and genes, I also depend on striking a good pose and the miracle of lighting to minimize any signs of dimpling.

We all have our flaws. The best course of action is accepting them—and knowing how to deftly disguise them!

The Cover-Up

If those limbs look best with a bit of sunshine, avoid damaging rays in lieu of a tan in a can (or other container). Just beware of going too orange.

On the occasions when I go barelegged, I like to use leg makeup—especially if my knees are rosier than I would like. But why waste good dosh on the pricey stuff marketed for body use? I use the same $12 foundation for my face and my legs. After all, they should match or at least come close. For more effective coverage, mix foundation with body lotion, even one with a slight shimmer. A drugstore brand will do.

Or use a concealer to erase any razor nicks or bruises. A transfer-resistant foundation or concealer is best. Don't forget to set any makeup with powder. Studio Fix from MAC works like a charm for spots; for body, try any inexpensive loose powder.

It's all very 1940s-inspired, yet preferable to bronzing legs with the walnut juice or gravy browning used by women during those years when stockings went the way of the war effort.

Seams Natural

During World War II, when all nylon production had to go toward tents, parachutes, and other soldier rig, industrious gals didn't do without the look of seamed stockings. After all, they and their boyfriends on shore leave knew that few things are sexier.

Even then, seamed stockings were a matter of preference over production limitations. Their prevalence during the first half of the twentieth century was not due to a lack of technology: as far back as the 1870s, American ingenuity had come up with an invention for manufacturing seamless silk hosiery. It was simply a red-blooded American public who opted to ignore this new advancement for nearly a century. So, too, did the French

when Christian Dior deemed it part of the overall feminine "New Look" in 1947.

Nylon hosiery launched in 1940, and the word reportedly comes from a compromise between the chemists based in New York and London working to develop the DuPont Company–sponsored product. When this miracle material went toward the war effort, women found another use for their eyebrow pencils, drawing a line from point A (as in ankle) to point B (as in bum!).

There was a hitch, however: cross the left over the right on a sultry evening and the seams smeared.

In the early 1990s, I considered tattooing seams up the back of my legs. I'm so glad I didn't take this indelible step. I love the look and feel of fully fashioned nylon-stocking-covered legs

suspended at mid-thigh. I even love the sound when I cross my legs and the silky netting rubs together. Imagine the difficulty in matching up the inked seams with stocking seams.

Instead, I had seams henna-tattooed, a temporary fix that provided the same effect—and made me realize the potential headache if I'd gone permanent. But a word of caution: never use black henna on skin. It contains para-phenylenediamine to stain skin, an ingredient that can cause severe allergic reactions and permanent scarring. When it comes to henna, natural red-brown henna is the only option.

Or really go temporary and toe the line with a waterproof pencil or liquid liner.

Footnote

A beauty arsenal should include hosiery and garters, and thankfully, sourcing seamed stockings is no longer implausible, especially online. Among my go-to sites is Secrets in Lace, which also happens to stock my signature collection. These stockings are made to my exacting standards, down to every vintage detail, even produced on vintage looming machines.

When wearing any seamed stockings, make certain those highways are running straight from heel to thigh.

As for garters, don't settle for plastic clips and hooks when you can have metal. These hold better, look better, and feel better. Accessibly priced as my Von Follies and my signature Dita Von Teese lingerie collections are, I insisted on high-quality metal clips and hooks for all my garters.

Fasten the garter belt around your waist. I prefer a wide belt with six straps for stability and to ensure seams keep straight. Adjust the back straps 1 to 2 inches longer than the front straps so they comfortably stretch over the curve of your bum. If there are side straps, these should be about an inch or so longer than the front straps; whatever it takes to ensure all the straps are similarly taut. Carefully glide on the stockings up to the thigh and clip into place.

Then slip on your knickers over the garter belt.

I rarely go out without stockings and suspenders, as garters are also known. I certainly don't leave my boudoir without them when seduction is in the cards. Too many of the men I have dated have never experienced a woman wearing completely seamed stockings and garters. Once they do, well, let's just say it's worth the wait. Talk about a suspension of disbelief!

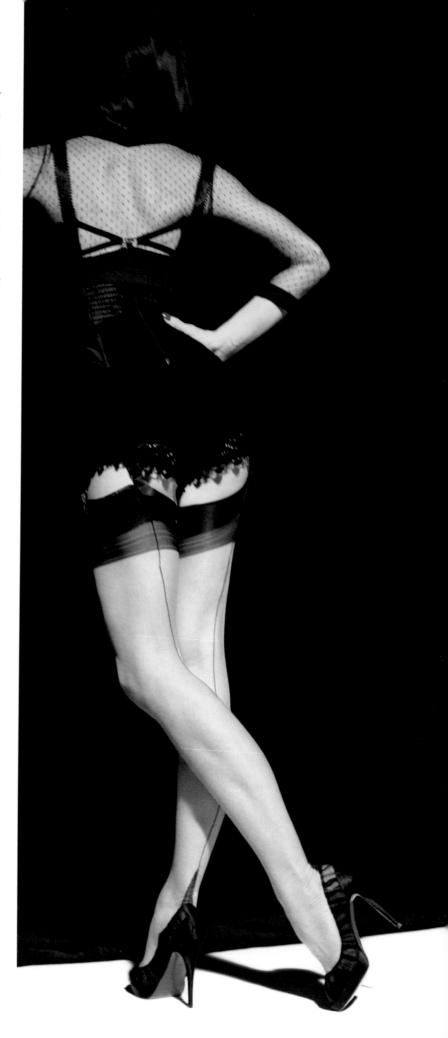

Baring the Sole

Among the gravest disservices committed by fashion magazines is writing off pedicures and other ankle-deep beauty treatments as something only to be relegated to the summer months. What a crazy notion that there is a sandal season versus the winter limbo, when feet are stuffed into thick stockings and boots and therefore consigned to neglect.

Seriously? Of course, there's a time and place to keep the boots on (especially if they're a sexy pair!). For example, the boudoir might be such a place. But inevitably, even behind closed doors, everything comes off.

What if the only one benefiting from pumiced, soothed, and painted paws is the individual connected to them? Luxury is in the details, and what a glorious indulgence to be lying in bed with a book and look down to spot ten glossy rouged tips.

Pedicure

I always use my own clippers, file, pumice, cream, and polish in my pedicure appointments. My kit lives in a box labeled with my name at the salon; Rose carts her own during her visits. As with sex, one can never exercise too many precautionary measures. A salon should look clean (the bathroom is a great indicator of how much cleanliness matters to a business). Ensure technicians are using sterilized tools. Yelp and other user-supported online review services are one way to find a good, clean salon.

I have become a big fan of gel pedicures. They beautifully survive even the most grueling week of back-to-back performances. For shows, in fact, I tend to have a double coat of gel—the first in ruby glitter, followed by a red polish—for an effect that suggests candy-apple red car paint. Gels also don't require

Basic Pedicure

Gather: polish remover, cotton pads, Epsom salts, essential oil, moisturizing oil (vitamin E, olive, or coconut), clean towel, pumice stone, clipper, emery file, rich moisturizer, orangewood stick, toe separator, polish. I also like to light a candle scented with amber or lavender or something spicy for a bit of ambience.

Strip: Swab away old polish with remover and a cotton pad.

Steep: Keep a container reserved for a footbath. Fill with warm water, a handful of Epsom salts, and a few drops of essential oil, such as lavender or mint. Tea tree oil can soothe itchy skin and fight infections. Toss in rose petals. Soak for ten minutes or more.

Buff: With a clean towel, completely dry your feet. Exfoliate your heels and soles with a pumice stone or pad. Never rub the top of the feet with a stone, and never scrub too hard. Calluses do not have to be wiped out, since they are there to protect those parts of the feet subject to friction. Buff away dry skin from the feet and legs with a scrub (make one instantly with olive oil and either kosher salt or sugar). Rinse in the footbath.

Prune: Use a toenail clipper to trim nails. Nails should be level with the top of the toe at their longest. As a dancer, I keep them even shorter, yet with still enough surface area to look pretty and painted. File to a squared shape. This prevents ingrown toenails and looks best.

Revive: Apply a rich cream to your feet and legs, taking the time to really massage it along the arch, into the heels, and up the legs. Don't skimp! Apply an oil (vitamin E, olive, or coconut) to nail beds and cuticles to revitalize.

Press: Push cuticles back with a beveled cuticle pusher. I prefer a simple orangewood stick. Leave any cuticle trimming to the professionals, and even then be very careful. Cuticles are there to prevent bacteria from entering the nail bed.

Lacquer: Separate your toes with a foam separator (or simply twist up a paper towel and insert it between your toes). After wiping the nail beds with an alcohol-soaked cotton ball, apply a base coat. Follow with two light coats of polish. Finish with a topcoat. Despite the inclination to immediately get up and go, simply take five more minutes to let the polish set. Use the time to moisturize your knees, elbows, or any other forsaken spots.

drying time, so pedicured feet can slip right into shoes without a smudge.

As nail salons have proliferated on every shopping block, certified podiatrists are stepping into the field by offering "medical pedicures" in their offices. The procedure involves medical-grade antiseptic and all metal implements are sealed in sterile pouches and sterilized in an autoclave or thrown out after each procedure. This usually includes razor-edged tools to remove calluses. Just beware: in states such as California and New York, licensed manicurists are not permitted to use razor-edged tools, let alone pierce the skin. In the case of a medical pedicure, only the podiatrist should be wielding any knives.

Or stay home and give yourself a basic pedicure, an alternative that can be as relaxing as any salon experience, and no appointment is necessary.

Venus with Fur

If I've urged it once, I've urged it endlessly: in matters below the waist, do not let anything pop out from the sides of that G-string.

No amount of sparkling crystals and no length of tassels will detract from the unsightly sight of a wiry hair peeking from a panty edge. They simply won't.

As a dancer, my philosophy is always be well groomed. But as one who embraces all signs of womanhood, however fleecy they can be, I'm an advocate that well groomed does not have to mean stripped bare. I am not a big fan of the overly landscaped landing strip. Refer to chapter 6 for the menu of options for stripping the bikini line and maintaining those borders.

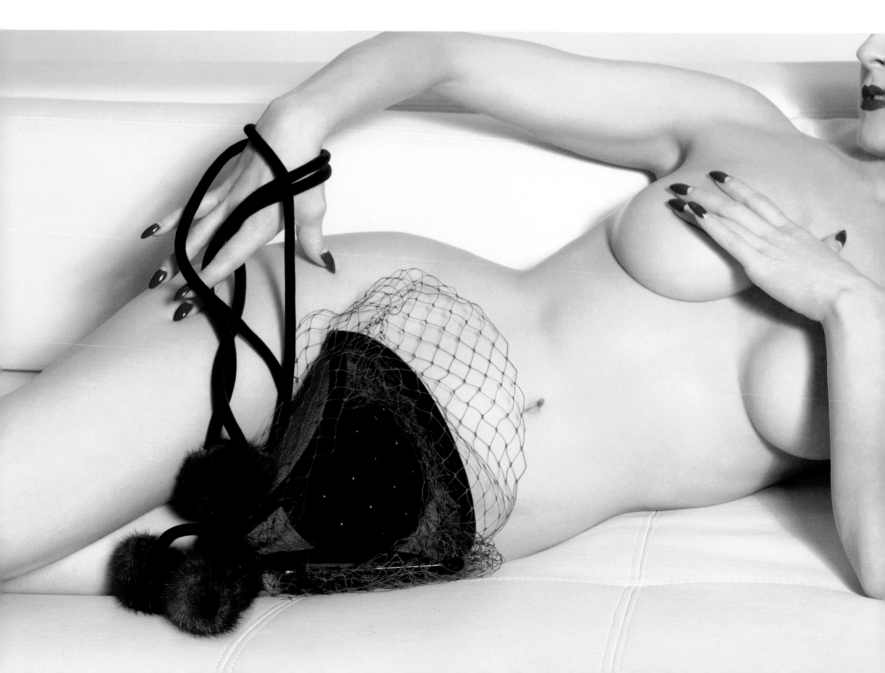

A bit of fur can be sexy. Simply prune the zone with a clean pair of scissors and a fine-tooth comb. Be careful not to snip any skin!

Her Adoring Pubic

The latest revival in pubic preening reflects a very healthy embrace of the body. But let's not beat around the bush: anything done down under can be detrimental to your health if the right products or precautions are not applied. For most, leave the dyeing, bleaching, crystallizing (a.k.a. vajazzling), and even plain ol' waxing to the professionals.

Consider the tale of Marilyn Monroe's brush with a bleach-soaked toothbrush. According to legend, her maid walked in on the platinum goddess squatting over the toilet. "With my white dresses and all," the star apparently explained, "it just wouldn't look nice to be dark down there." But the reaction from the bleach sent her to bed all day with an ice pack between her legs. That certainly goes down as suffering for beauty.

I used to dye my pubic hair to match my head hair. I'm naturally blond, so when I went ginger from the neck up for a few months at age twenty, I also went red from the waist down. Likewise when I decided to go brunette.

These days, I go au naturel. That said, it was a kick sampling the Betty brand line of ammonia- and paraben-free dye specially formulated for the pubic region (making them safe for brows or, for men, other facial hair). Besides vibrant hues of natural hair shades, the collection includes shocking shades of pink, blue, orange, and green. Hilarious.

A Modest Proposal

The mania for crazy coiffing of the nether regions for reasons of self-expression, pleasure, comfort, or simply fun is not a modern trend.

The pubic wig, known as a merkin, dates back to 1450. Good women would shave—with a straight razor blade, no less!—to avoid crab lice. They would then conceal the spot with a merkin to shield their modesty; "bad" women wore them to mask the effects of a career that came with the inevitable transmittable nuisances.

Merkins are still in use today. In Hollywood, they are how actors get around the full frontal exposure that would warrant an NC-17 rating. Ironic, right? A merkin resembling the real thing is allowed, but the real thing could get the more restrictive rating!

In burlesque through the 1930s, some of the bawdier, bolder performers would give their audience a hair-raising good show by teasing them with the suggestion of too much by way of a pubic wig. This was one way to skirt the morality police, just as in modern-day Hollywood.

Those patches decorated with sequins, crystals, or other dazzle worn onstage are also known as merkins. For my performances at the Crazy Horse Paris, I affixed my Swarovski-covered merkins with spirit gum. It's a dazzlingly risqué effect onstage, but between application, drying time, and removal before the next act costume change, it is not the easiest trick during the quick changes involved in a performance. Even a dance sequence must be adjusted to perform in a merkin without revealing too much more than is already possible!

Mane Attraction

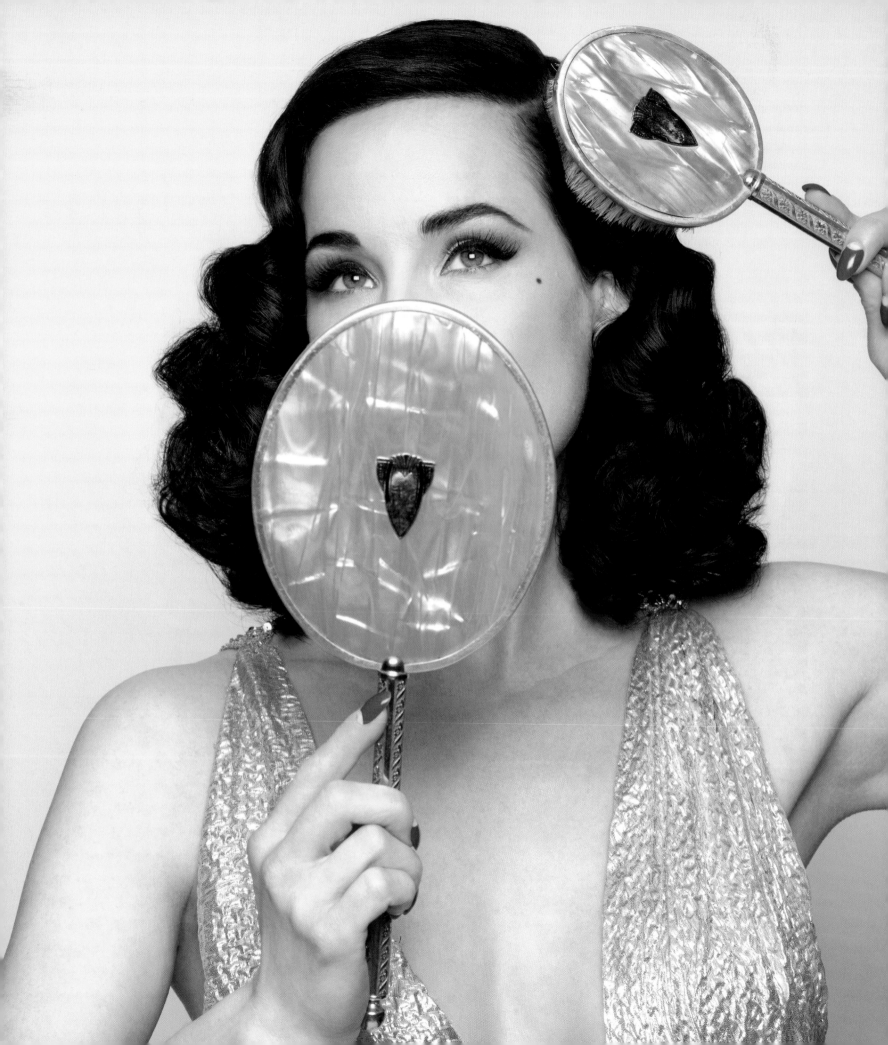

CHAPTER 16

Head Over Heels

Given the choice between a bad makeup day or a bad hair day, I'll always take the makeup. A wonky cat eye can be swiftly fine-tuned with a Q-tip or more liner. But bad hair? Little more can be done with dull or listless or frizzy locks than wrapping up the entire mess in a turban.

When I spot a woman looking like a wet hankie because she stepped out of the shower and into the world with little consideration for her hair, well, I'm just sad. "You deserve better!" I want to implore her. I would never dream of going out in public with wet hair. Ever. Combing it back into a neat bun, concealing it all under a stunning cloche . . . there are so many better options than neglected hair.

With apologies to my dear Christian Louboutin, not even the most extraordinary heels in the world can deflect enough attention from un-loved hair. I am nothing short of flummoxed when I spot a pretty gal who has spent so much money on glorious soles and so little time on her crowning glory. Shoes and clothes come in second to what the world sees first: your face and your hair.

Never underestimate the role grooming plays in our human interactions and responses. Scientists believe that among the young in both the animal and human kingdoms, grooming plays a significant role in biological development. Toy manufacturers have not only heeded this piece of science—they've also helped prove it. They know that dolls do not sell as well unless children can lose themselves in "hair play." The best-selling Barbie doll ever is the Totally Hair model that came out in 1992 and boasted hair extending to the doll's toes.

Like skin, hair is a testament to everything going on in an individual. Good skin and good hair reflect vitality and health. Cleanliness, condition, and texture play as much a part as the color and set. Grooming can speak volumes about one's sense of style *and* state of mind. In this chapter, the emphasis is on the very basics of hair care before the set and style, as well as the tools and products you'll need.

Did you know we have some 90,000 to 140,000 individual strands of hair on our head? How we care for them can make all the difference.

Just Your Type

Like snowflakes and fingerprints, our hair is all our own. But most heads fall into one of three categories, sometimes shifting with the seasons and life; other times becoming a combination of two types. Recognizing your type and applying products and tools specific to it is half the solution in ensuring a good hair day, every day.

Dry Hair

External factors generally trigger dry, thirsty hair. Top of the list is abuse, caused by overdoing it with an inferior brush or too many harsh hair products or chemical treatments. Poor nutrition and something as seemingly benign as a pillowcase can be offenders.

To remedy dry locks, stay away from products with drying ingredients such as sodium chloride. Alcohol, too, is best served up in a martini glass; make sure it's not in shampoo or other hair products.

Condition regularly. Up the ante twice weekly with a cream or oil-based leave-in conditioning mask. For deeper penetration, apply generously, cover with a shower cap, and hit it with a blow-dryer. The heat opens up the cuticle, allowing the formulation to really rehydrate the hair shaft. Multitasker that I am, I also like to leave it in, capped, for a few hours while I do housework or overnight while I sleep (it *is* called beauty rest, after all!).

A final cool water rinse closes the hair cuticle, staving off damage.

After bathing, work into damp hair a drop of shine-enhancing serum or leave-in conditioner for further hydration. Any one of the countless styling products promising to tame frizz, lift roots, and provide overall protection from the heat of blow-dryers, rollers, and irons can do the trick. Use them.

Thirsty ends can also benefit from working in twice weekly a couple of pure and organic drops of one of the many natural oils touted for hair rehydration, nourishment, and shine: olive, coconut, or argan—also known as Moroccan. They are all marvelous additions to any cooking cabinet, too! Once applied, cover hair in a terry turban and let the oil soak in for fifteen minutes.

Dry hair also benefits from brushes made with boar and natural hair bristles, which distribute oils better down the hair shaft than synthetic bristles (more on these brushes later). Of course, what goes inside a body matters as much as any product. Omega-3s maintain scalp health, so include dark green vegetables, salmon, and sesame seeds in your menu.

Oily

A good amount of natural oil can give hair a lustrous shine. Too much can come off greasy. Internal forces such as hormones, genetics, and hair texture can contribute to an oily condition. Straight and fine hair tends to be oilier than thicker or curlier locks.

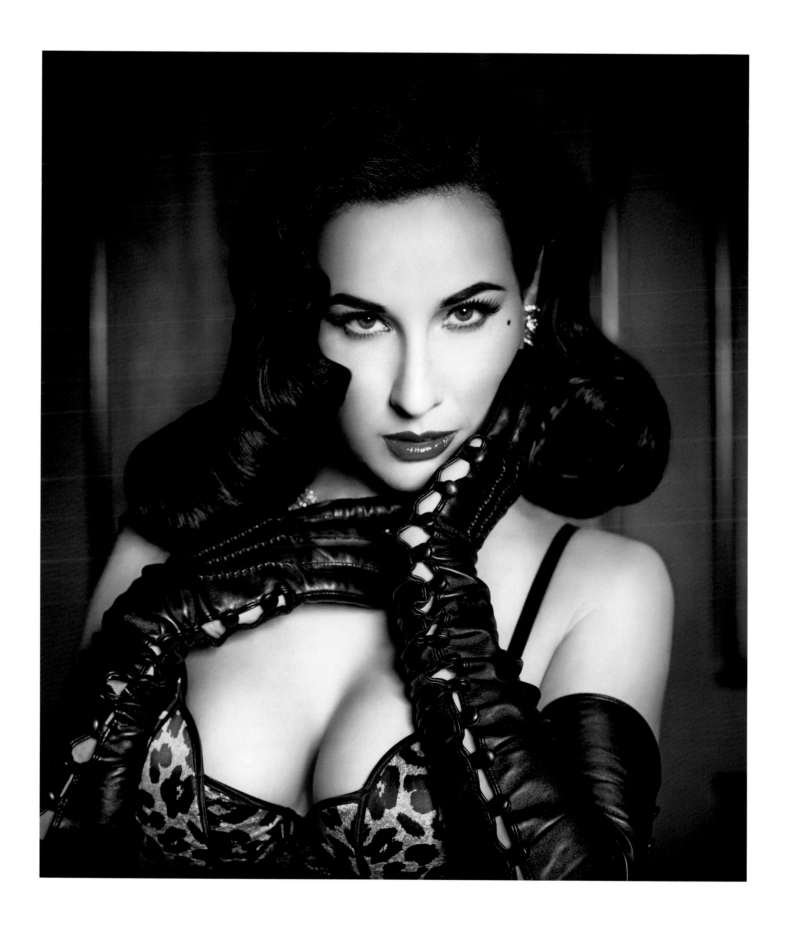

If your hair is oily, don't resist shampooing it! Lather in a mild shampoo, working it gently onto the scalp. Rinse thoroughly so oil doesn't trap in its own residue. Condition ends only once or twice a week, avoiding the scalp. Steer far and clear from products with mineral oils and lanolin.

Home remedies include lemon juice, vinegar, black tea, and even vodka, all highly diluted with water. Just be sure to shampoo and rinse thoroughly with warm water so the scent of these soaks does not cling to hair. A dry shampoo can also get unwashed hair through a busy week, particularly for brunettes. Blondes can get away with tried-and-tested baby powder brushed through hair to absorb oils.

Normal

This is one area where being "normal" is an asset worth protecting. If all or any part of your mane is normal, don't take it for granted. Look after it.

Normal hair has just the right level of natural oil to keep it lustrous, elastic, and healthy. With normal hair, it's all about maintenance—specifically, the "end" results. Focus conditioner applications on dryer ends. Keep ends regularly trimmed to avoid splits and breaks. Resist treatments and products that are too harsh. Internal culprits such as poor nutrition and stress can also ruin perfectly normal hair. One more reason to eat, exercise, and live sensibly!

Root for Vitality

Beautiful hair is healthy hair, and it doesn't happen accidentally. Poor nutrition, smoking, excess stress, and too little exercise and sleep can result in lackluster hair and an irritated scalp. It can also obstruct hair growth and trigger abnormal hair loss.

Hair is made of a tough, fibrous protein called keratin. It's the same substance that produces horns, feathers, and claws. The keratin root is embedded in a follicle in the skin's dermal layer. As new hair cells are produced in the follicle, old cells push upward toward the skin's surface. The thread protruding from the surface is the shaft, and in this state the cells have hardened and died—what's known as keratinized. It's the same with fingernails and toenails, which is why it doesn't hurt when nails are snipped.

The health of your hair can be boosted with foods high in the protein needed for keratin development, such as walnuts, almonds, and crab. What a delightful way to do a do good.

Pores cover the head, as they do the rest of the body, and they need to breathe and perspire. Daily brushing, even a scalp massage, is great for circulation and distributing natural oils—and oh, how divine it feels . . .

Coming Clean

Step one to lovely hair is care. While cleansing your face morning and night is essential, washing hair daily is not. It can strip hair of natural oils, which keep it from becoming dry and brittle. Besides, I love the way my hair sets a day or two after washing.

Regular shampooing and conditioning with products that are right for your hair type can make all the difference. Pollutants and dust already cling to hair because of natural oils. Add to the airborne pileup the dust sucked in and out by hair dryers and the residue from styling products, and hair is robbed of its natural shine and bounce.

As I have noted elsewhere in the book, I'm a champion of drugstore offerings. Pantene is one readily available option, and another favorite at a drugstore price is my signature brand shampoo, available via my website. Beauty product junkie that I am, I enjoy trying products—especially any hair treatment designed to repair the damage from coloring and other inevitable assaults in the beauty regime.

One such magical elixir is made from the hippophae oil in sea buckthorn berry, a fruit found in the Himalayas and Siberia and called obliphica. Hairkop has its own branded Obliphica collection, which I became a fan of after my hairstylist friend John Blaine turned me on to it. Somewhere in between a crammed schedule of coloring and styling hair for editorial work and ad campaigns, including creating wigs and other hairpieces, John served as creative director during the launch of the brand. (As we work on this book, John is working on his own organic line. Stay tuned . . .)

Year-round, it's best to select products with UV filters. Even during winter, harmful ultraviolet rays can damage hair.

If hair is colored, highlighted, or otherwise treated, do it a favor and wash and rinse with specifically formulated products. They further promote shine, preserve color, and reduce yellow in a way that nonspecific shampoos and conditioners cannot.

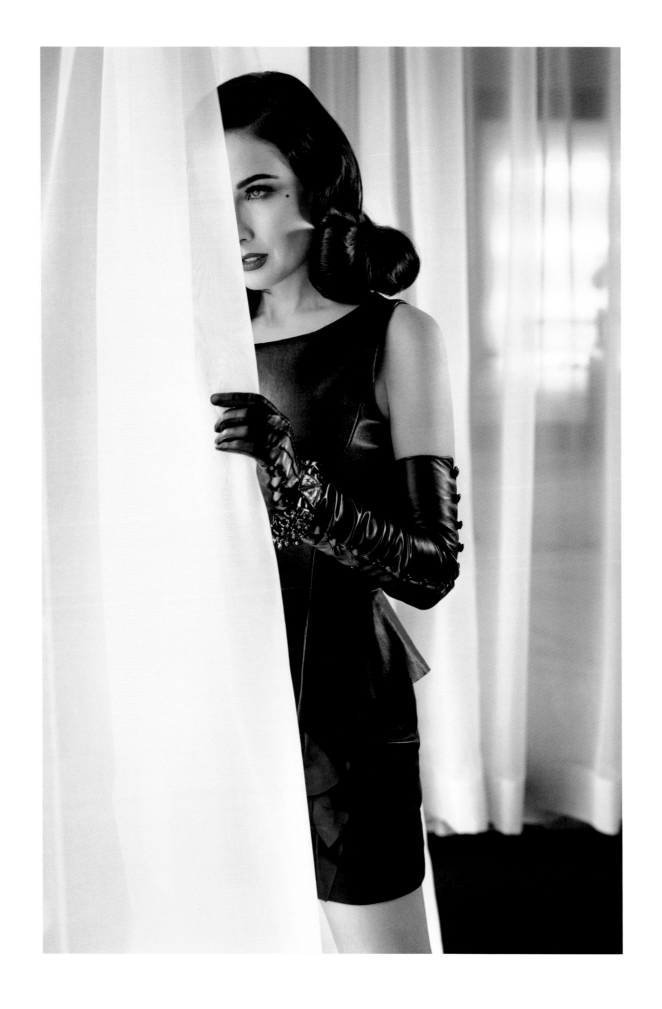

Be Sexy with B₆

A deficiency of vitamin B₆ can result in dry or brittle hair, lips, and even fatigue.

High stress levels and hormonal imbalances, including those caused by oral and other hormonal contraception, can make it hard for the body to absorb what it needs. High-protein diets and too much fat, sugar, or alcohol can also lead to a B₆ shortage.

So load up on B₆-rich whole foods such as fish, lentils, raw pistachios, and sesame and sunflower seeds. Many herbs and spices, including chili powder, paprika, garlic, tarragon, basil, and spearmint, are also a delicious way to get more B₆ into your system and give your hair a fighting chance at luster.

Wash That World Right Out of Your Hair

There is a better way to do anything worth doing in life, and hair is better off when it's cleansed and conditioned.

Warm to cool water is best. Higher temperatures can dry and irritate the scalp. Start by dousing your hair thoroughly for a surface rinse of hair products and other dirt.

Apply shampoo and gently work from the scalp outward. Depending on your hair type, too much lathering can stimulate the oil glands, triggering more oil than what is normal. Hair is also most vulnerable to breakage when wet, so handle it with care.

Rinse out all traces of shampoo. Hair can actually appear dull if it's not rinsed well.

Like moisturizer on skin, a hair conditioner can hydrate, add shine, reduce static, and provide protection. Apply about an inch from the scalp, as oil-rich roots do not need the extra boost. Spread evenly. Leave in for a few minutes before rinsing. I usually take this time to shave my legs or rasp my heels.

Gently squeeze the excess water from your hair before stepping out of the tub or shower. Just as gently, pat your hair dry with a thick, clean towel. Never rub. Toweling too energetically can break tresses. Do this before starting any combing or drying.

Such a Flake

Everyone experiences a flake or more at one point. If it's like snowfall attended by an itchy scalp, it's very likely dandruff.

Dandruff is dead skin shedding from the scalp at an accelerated rate. Overactive oil glands, harsh hair products, stress, allergies, excessive perspiration, and seasonal changes can be triggers.

While the cold, dry air of fall seems to touch off a bout for some individuals, a scalp that's too dry is not to blame. Do not avoid shampooing because of some old wives' tale. It's more likely the alcohol in styling products and hair dyes, so limit use whenever possible.

Clarifying shampoos are designed to reduce product buildup and can help clear the scalp of flakes. Tea tree oil is also a great antiseptic. Resist using fingernails on that itch, too; instead gently use the pads of fingers. If the condition persists or is chronic, see a doctor.

Cut to the Chase

Did you know that hair tends to grow faster in warmer climates? A marvelous excuse, if ever, to take a holiday near the equator!

A haircut is never optional. Snipping off split ends before the split compromises the entire hair shaft is crucial for keeping hair healthy overall. It also prevents evil frizz, which is basically split ends moving up the shaft.

There's no excuse for forgoing a regular trim, especially when one can be had for the price of a couple lattes. For years, I went to Supercuts or to local beauty schools because I liked how I could drop in and get a basic blunt cut for $10 (it must be a bit pricier now).

I'm also not a fan of fancy beauty salons. I don't like sitting anywhere for hours. I could always count on a stylist at a beauty school to keep the conversation and service simple. These days, by the time my ends are in need of a snip, I'm usually on set with a trusted hairstylist. Or my pal John Blaine will make a house call.

My go-to styles basically require a blunt haircut, an inch or so trimmed off the bottom. If only I could snip it myself! I also keep any layering to the front.

As for those age-old theories on haircuts or hair parts corresponding to facial shapes, I favor the opinion of another of my hairstyling confidants, Danilo (he will appear throughout this section on hair): *do not worry*. These concepts are as arcane as the systems set up for skin tones and cosmetics. If you like the way it looks, own it.

Brushing Up

One hundred strokes. In the movies, that always seemed the magic number of brush- strokes to lovely hair, as one starlet or another sat there glamorously at her vanity, draped in some filmy robe and satin slippers, readying for bedtime.

I may have a vanity and negligees worthy of the silver screen. But I am not going to fib and claim I count up to one hundred nightly. I do, however, believe in the powers of a good brushing. It stimulates the scalp with a nourishing circulation to hair roots and evenly distributes natural oils. A good brushing does away with dearly departed, loose hair. I also love the meditative, massaging moment it provides. Most of all, a good brushing is critical to achieving lustrous hair.

Since I always set my hair, my dos also benefit from two-way brushing—that is, brushing hair in the opposite direction it's worn. Then I brush it back into place, until the sections are smooth. This loosens curls and infuses hair with body.

But not all brushes or combs are comparable. Plastic brushes and combs can create static electricity, tear fine hair, scratch the scalp, and split ends. Fine hair responds better to baby-soft bristles, and thicker hair likes coarse bristles.

Natural animal hairs such as boar are best for any brush. Inherently softer and more flexible, they cause less damage. This is why I am fanatical about my Mason Pearson brush (in pink, naturally!). It is one tool in my beauty box worth the investment. I don't leave home without it. Good-quality brushes can last for years. But if a Mason Pearson brush is out of your budget, rest assured that there are other options on the market with natural boar bristles.

There are some of you who wouldn't dream of using anything but a vegan alternative. For you, there are good-quality synthetic bristles, and these are always better than a cheap plastic brush.

Ceramic brushes simultaneously hold heat from the blow-dryer while protecting hair from potential heat damage. If your hair texture is prone to electric charges, ceramic brushes can also reduce static. Don't forget to wash brushes and combs regularly. A drop of shampoo in warm sudsy water is all it takes.

Paddle Brush

As its name implies, this brush resembles a paddle. The platform can be square or oval with bristles shooting from either the base or a cushioned pad.

The wide-set bristles stimulate the scalp and make the cuticle lie flat, which is great for detangling and smoothing hair and boosting sleekness and luster. Besides routine bedtime (or anytime) grooming, a paddle can generate volume during blow-drying. Tip your head forward or sideways, brushing from hairline to ends, and hit the shaft of hair with heat.

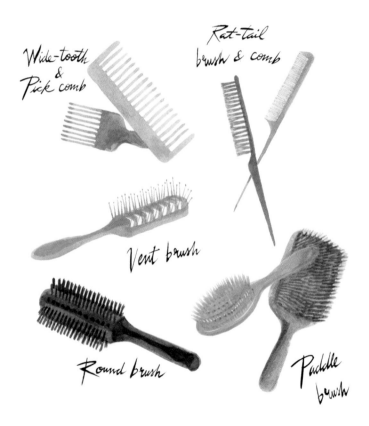

Wide-tooth & Pick comb

Rat-tail brush & comb

Vent brush

Round brush

Paddle brush

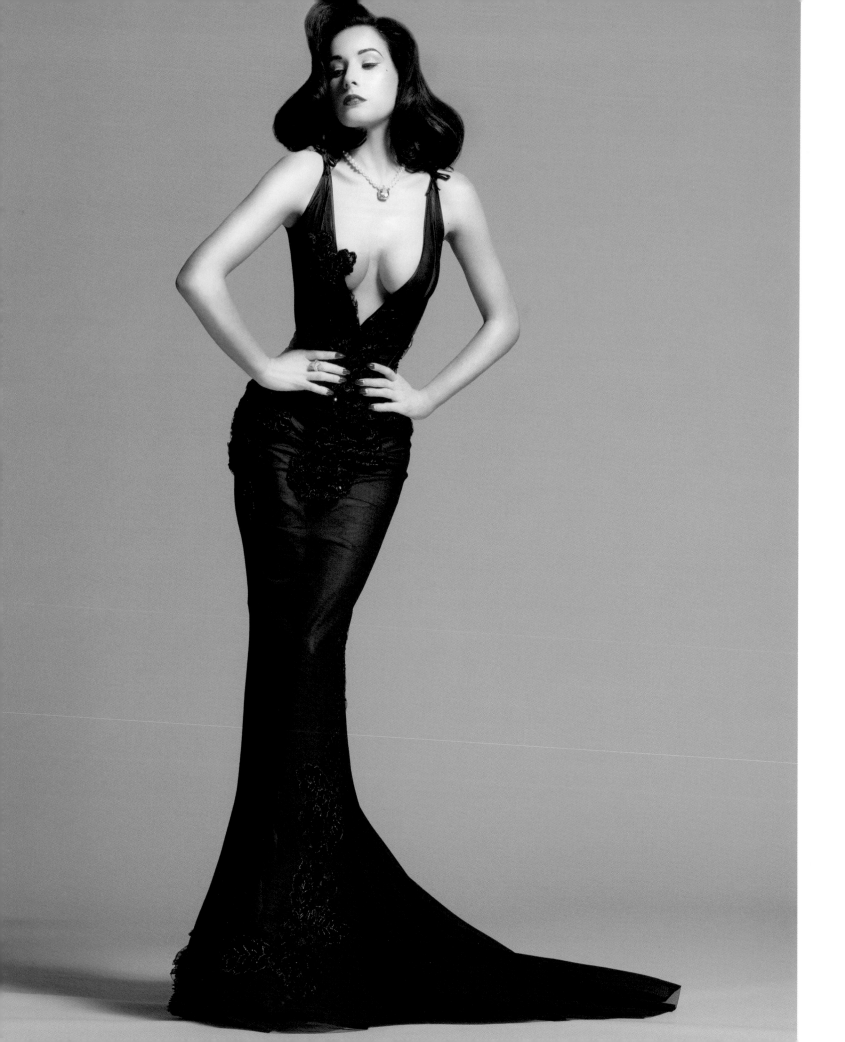

Radial Brush

A radial, or round, brush has a cylindrical head covered with short bristles. It's essential for blow-drying hair into curls, creating waves and flips, encouraging volume and texture, and smoothing curly locks.

Half-radial brushes can do the job of a flip inward or outward. Personally, I go full radial, since it can do this and more. The smaller the round of the brush, the tighter the curl. A medium radial is what I keep at hand for my preferred sets.

Begin the blowout at the root, gently bending hair inward while drying. Then wrap the ends of damp hair around the brush, roll them with a turn of the wrist, and apply heat. Take care not to roll long hair completely inward, or to pull the brush out without rolling it out first—or hair *will* become tangled. Before unrolling the section, blast it with a shot of cool air to set the curl.

Vent Brush

The platform is dotted with holes, or air vents, making drying faster under the heat. Available in all shapes and sizes, and as both radials and paddles, vent brushes are great pre- and post-set. Use one when detangling the hair, and to boost volume during the blow-drying step. A vent brush is also good for grooming dry hair into shape.

Rat-Tail Brush and Comb

The rat-tail is an essential tool in hairstyling. Retro hair is all about a flawless part, and a rat-tail styling tool is perfect to part and section hair for sets and styling. Some stylists swear by a metal tail for precision parting.

When rolling hair, the pointed end of a rat-tail tool can be used to define sections. It is also a handy tool for tucking in loose strands or lifting a teased part at the base of the hair shaft.

Teasing is all in the bristles and teeth, and the more compact the uneven bristles on a rat-tail brush or the teeth on a comb, the greater tension they provide during the downward teasing action that makes for a more textured, fuller lift. A word of caution, however: excessive or poor teasing can damage hair. More on this technique (and other hairstyles) in chapter 18.

The fine, closely placed bristles on these tools are optimal for smoothing out a section, whether on the sides and top when creating a chignon, or taming flyaways on a pumped-up set.

While I'm not often given to bouffant styling, when it comes to sectioning and smoothing out panels of a set, a rat-tail comb is an essential tool in my kit. I use the comb tail to section, lift, and, once hair is sprayed, smooth hair out to (near) perfection.

Wide-Tooth Comb

As handy as a comb can be in detangling hair, it can also tear wet strands, which is when hair is most fragile. After shampooing, rake tresses using a wide-tooth comb with smooth tips to avoid damaging the hair and scalp. If your hair is thick and frizzy, the best tool—brush or comb—is a pick comb.

In the Heat of the Moment

Darlings, there *is* such a thing as being too hot.

Heat from hair dryers and irons can be damaging over time, sometimes sooner than later, depending on hair texture. The finer the hair, the lower the temperature you should use. But that doesn't mean thick hair can undergo the hottest setting available.

Heat cooks the hydration out of the shaft, damaging the outer layer, known as the cortex. Keep the intensity focused on one spot for more than a few seconds, and the entire shaft can be scorched to the core. This is why even the fanciest hair dryer in the world needs to be handled with care. During blow-drying when hair is hot, take care to continue brushing with gentle strokes and, if possible, use a boar-bristle brush.

While there's no need to burn money when it comes to buying any styling tools, hair can pay dearly when a tool comes with a single setting. Get a blow-dryer and irons with a variety of settings. Know your limits, too. Leave those modern irons that dial up to 400 to the pros.

I also give it a rest. I might limit the blow-dryer to the roots for a volumizing boost, and let the rest air-dry. I prefer to air- and towel-dry hair as much as time will allow. True, when it comes to all things beauty, no pain is no gain. But subjecting hair to all that's involved in styling it and never giving it some time off is no way to care for it.

Humidity can also wreak havoc on some hair types. A tiny drop of frizz-control oil or gel, sprayed on or emulsified in palms and combed through just-washed, damp hair before drying can make all the difference.

Hair Apparent: Danilo Dixon

If there's one part of me off limits to 99 percent of men, it's my hair. One man who can most certainly run his fingers and combs through it is Danilo. When it comes to hairstyling, he is a living legend of fashion, film, and fantasy.

His storied career (and believe me, this guy's got stories!) reaches back to the supermodel era of the 1980s and continues to reign today, as he masterminds looks on-screen (for Frozen, he masterminded the style and animation of Elsa's hair, and for Girl with the Dragon Tattoo, he was behind lopping off actress Rooney Mara's hair and bleaching her brows); on the runway for Jean Paul Gaultier, John Galliano, and Thierry Mugler; and on- and offstage for Gwen Stefani, Pink, and so many others. His high hair art has transcended the head, in fact. He divined the hair bra and hair dress for Gaultier, and the hair bow and hair telephone for Lady Gaga.

Danilo splits his time between New York, Los Angeles, and the world at large, stashing kits packed with tools and products in several countries. We managed to catch up with him in between gigs and this is what he had to say.

If all I can see is your hair, something is wrong.

Of course, I look at the hair. But even subconsciously, I want to see the whole package first. It's about the image: heel to head. That's why on set, I always consider what I do a collaboration. I always want to know the wardrobe, the makeup. It's out of respect for my fellow stylists, sure. But it's also about the communication of the total look.

Of course, hair can convey so much. Just as in the animal kingdom (such as birds and their feathers), our hair can appeal or repel.

I didn't aspire to be a hairdresser as a kid growing up in San Francisco. I have always been really inspired by architecture and art, and there is so much of both in that city. Hairdressing can be considered a kind of architectural art. But I have always been excited by all aspects of vanity, from nutrition to skin care, makeup to hairstyling. I especially love the technical aspects, the instruments, the practices. For me, it's always a hybrid of what inevitably leads to the end image.

My desire has always been to make women look seamlessly chic. Maybe it comes from all those old movies! I honor the inspiration of the retro. I always loved seeing a woman in rollers, getting ready for Saturday night. Growing up in California, I also loved the cholas. I grew up with girls who kept razor blades in their hair, always ready to bitch down and cut you if necessary!

So the vehicle for my expression and career became coiffure. My animated proportions, the drama I present . . . that is what people enjoy the most from me. I also have very strong opinions and experience in hair color. I still specialize in it and continue to color Gwen Stefani's hair because of this expertise.

I learned from the great teachers at Vidal Sassoon. I also taught myself—especially when it came to big sets! I moved to New York City in 1980 and spent the next six years developing my craft. I was at clubs such as Area every night. But it was the legendary Oribe who pushed me to go into editorial and runway. It was the birth of supermodels, and I was at the right place at the right time. Supermodels meant super hair. I also was challenged by the likes of Dianne Brill and the gals from the B-52s. They all wanted big hair. In 1980, Kate Pierson and Cindy Wilson from the B-52s came to me to create the biggest, most colorful beehives.

Before I knew it, I found myself working upward of seventeen shows in New York and another dozen or more in Milan. I started working with Jean Paul Gaultier and Azzedine Alaïa. In Paris, I signed a ten-year exclusive contract with Thierry Mugler. It was through Mugler that I knew Abel Villarreal, a Los Angeles designer who specialized in leather corsetry, and it was through him and his photographer partner, Tim Palen, that I met Dita.

I admire women who can throw their hair up and put their makeup on in fifteen minutes, yet look so glamorous that it looks like it took longer. I think of women such as Dita, Gwen, and Debi Mazar. I'll tell you what their secrets are . . . what my secrets are, too: desire, imagination, and practice. Practice is a key element to refining your beauty. Choose images you like and aspire to do them. Get to know your curl patterns and curl sizes through play. Don't be afraid to play.

In terms of products? Look, prestige is lovely on your vanity—that exquisite powder puff or perfume bottle. But today, "masstige"—that intersection of the quality of prestige products made accessible both by price tag and retail source,

as in mass *plus* prestige—is state of the art. I've always been driven by accessibility for all.

When it comes to hair, I've always suggested masstige products. I love Sonia Kashuk's mixed bristle paddle brush for Target, a fabulous alternative to the Mason Pearson paddles and at a fraction of the price.

I have also long been a fan of Pantene. When the company asked me to be global ambassador and to be involved on a technical level, I signed on. I had my reasons, too. For all of my settings going back years, I always used Pantene fine hair spray. Then it was discontinued. But guess what? Now it's back!

These days, there's so much access to knowledge, tools, and products. Go to a hairdresser, pay attention, ask questions. Then go home and practice. It really is all about play and practice. There's no excuse not to do your hair.

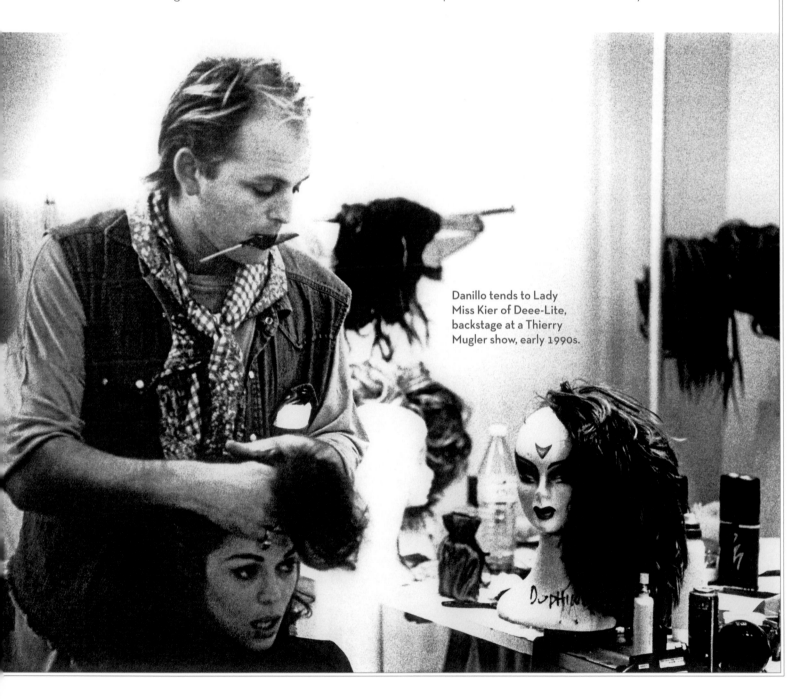

Danillo tends to Lady Miss Kier of Deee-Lite, backstage at a Thierry Mugler show, early 1990s.

Thermal Protector

Prevent damage from the heat of blow-dryers, hot rollers, and curling irons, while moisturizing the hair cuticle and reducing frizz and breakage, with a serum, gel, spray, or other product formulated for heat styling protection.

The kind of heat-protectant solution you need depends on hair texture. The thinner the hair, the lighter the weight and consistency.

For fine hair, go with a mousse. Medium manes can gain from regular gels, liquids, and creams. A protecting spritz during a roller set can make all the difference. Thicker hair needs heavier formulations, whether a cream or a wax, although an extra-strength mousse or gel can also work.

Since these solutions are designed to serve and protect, using a product that specifically caters to your hair type and styling expectations is essential. Read the packaging and experiment.

Shine/Gloss Serums

A boon to curly or thick textures and dry or damaged hair follicles, serums smooth out hair and add shine. Apply sparingly, adding only as necessary, or hair can end up looking greasy.

There are serums in liquid or gel form that can be applied to wet or dry hair. There are also finishing spray serums as a final step (not to be confused with finishing hair sprays).

I like a pump or aerosol spray of shine serum once my do is done. For extra polish, I might spritz a clean dome-shaped powder brush and lightly drag it over a set; or emulsify a drop between my palms and gently smooth the set with my open hands. Either technique yields a beautiful finish.

Divide and Conquer

Once hair is cleansed and patted dry with a clean towel and the tangles are loosened and locks smoothed out with a wide-tooth comb, it's time to dry. Unless it's by air, this is no step to go at mindlessly. Speed drying can mean frizz or worse; an attentive blowout can play a key part in a successful set.

Prep by applying a heat-protecting styling product and any volumizer or leave-in conditioner and combing it all evenly through the hair.

Section hair into manageable two- to four-inch segments, clipping segments up and out of the way with a twist, and moving remaining hair out of the way until it's time to get to it.

With a brush in one hand (preferably a vented radial or paddle brush), hold the dryer with the other hand, pointing the nozzle some six inches from your hair. Sit or stand, it's really up to you, but a comfortable position can go a long way toward remaining vigilant and keeping airflow directed down the shaft. Ultimately, the only way to achieve that elegant balance with a brush in one hand and a blow-dryer in the other is *practice*.

Target the airflow with nozzle attachments such as a diffuser, which can help distribute heat more evenly. Dryers with more airflow mean less time drying. What doesn't work is madly waving a hair dryer back and forth. To avoid letting a spot get too hot, keep the setting at medium and move on to another section of hair after a few seconds.

During drying, I also like two-way brushing, working from the back of the head to the front, and each side, boosting volume from the roots out. Seated, I'll bend at the waist, letting my hair fall forward, gently brushing the hair so the heat hits it evenly.

If there are areas of your hair that are more time consuming to dry than others, focus on those first.

Once it all feels completely dry, stop! Or the cooking begins. To assess if your hair is actually dry, either give it a blast of air on the dryer's cool setting, or move on to another step in the beauty routine, such as brushing your teeth or moisturizing your face, leaving your hair to cool off.

Whenever possible timewise, I blow-dry the crown at the roots for volume and let the rest of my hair dry au naturel to minimize the overall blitz of heat.

Tie One On: Le Turban

Some days, the only antidote to a diabolical do is a turban. I have several constructed turbans for an especially glam eve. Among my most treasured is a hot pink panne velvet turban from the house of Christian Dior, circa the early 1960s. But my everyday go-to turban tends to come from wrapping my head in one of the zillions of square or rectangular scarves stuffed in my drawers and hatboxes. The success of a turban is all in the size of the fabric piece, in the wrap around, and in the tucking in of the ends:

- Use a rectangle of a lightweight material, at least a yard long.

- Making sure the center of the scarf is lined up with the nose, wrap the scarf around the head from front to back. Tie it tightly at the base of the back of the head (if all your hair is going under the turban, twist it into a chignon first and use this as a kind of anchor, tying the knot below and under the bun).

- With the excess scarf on either side of the knot, twist or fold according to your preference, bringing each side toward the temples. Keep wrapping around your head, back around opposite sides.

- Pulling tightly, knot the scarf at the base of the back of the head. Tuck in the tips.

- Review and adjust the wrapped sides so they're even and flattering to the headpiece and your face (for example, tucking in any loose hairs, raising or lowering the front accordingly). Voilà—instant glamarama.

- Allow to dry fully.

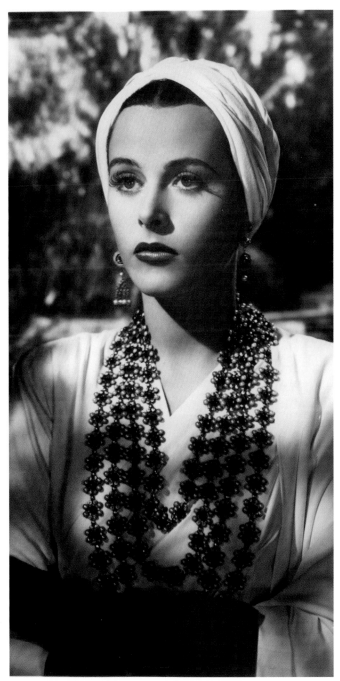

A turban frames Hedy Lamarr's beauty in 1939's *Lady of the Tropics*.

Final Words

Am I a hopeless romantic for falling for a gift of poetry from a paramour? So be it. A lover once presented me with a framed page of this poem by Charles Baudelaire, published posthu-mously in 1869 as one of fifty-one works in *Le Spleen de Paris*.

I still keep it on my vanity as a reminder of those stolen moments together.

"A Hemisphere in Your Hair"

BY CHARLES BAUDELAIRE

Long, long let me breathe the fragrance of your hair.

Let me plunge my face into it like a thirsty man into the water of a spring, and let me wave it like a scented handkerchief to stir memories in the air.

If you only knew all that I see! all that I feel! all that I hear in your hair! My soul voyages on its perfume as other men's souls on music.

Your hair holds a whole dream of masts and sails; it holds seas whose monsoons waft me toward lovely climes where space is bluer and more profound, where fruits and leaves and human skin perfume the air.

In the ocean of your hair I see a harbor teeming with melancholic songs, with lusty men of every nation, and ships of every shape, whose elegant and intricate structures stand out against the enormous sky, home of eternal heat.

In the caresses of your hair I know again the languors of long hours lying on a couch in a fair ship's cabin, cradled by the harbor's imperceptible swell, between pots of flowers and cooling water jars.

On the burning hearth of your hair I breathe in the fragrance of tobacco tinged with opium and sugar; in the night of your hair I see the sheen of the tropic's blue infinity; on the shores of your hair I get drunk with the smell of musk and tar and the oil of coconuts.

Long, long let me bite your black and heavy tresses.

When I gnaw your elastic and rebellious hair I seem to be eating memories.

CHAPTER 17

Your True Colors

Do blondes really have more fun? Do redheads? As a brunette now for more than half of my life, I can honestly share that life is a ball with black hair.

I can also attest to the rip-roaring delight in having hair the color of a fire engine. Being platinum is positively a pleasure, too!

I even know what I look like with snow-white hair. Some years back, an artist came from Germany to beautiful downtown Burbank for a statue he was bronzing in my likeness. To create a master mold of me, he fully laser-scanned me, from head to toe, including a 360-degree scan of my head. I sat there, with my usual makeup

At twenty, I tried my first corset and made my first try at being a redhead.

ered the irrepressible Bettie Page, she of the sable-black mane and razor-sharp bangs. Except for the occasional platinum or scarlet wig—once I went black, I *rarely* went back.

At the Root of It All

Hair color is pigmentation in the form of two types of melanin, designated according to shade: eumelanin and pheomelanin. Just as melanin pigments protect skin from UV damage, so hair also benefits from it.

Eumelanin levels can determine whether hair will run blond or brunette. The higher the levels, the darker the hair. A lower concentration can mean blond hair. Scientists have established that the genetic mutation for blond hair first appeared some eleven thousand years ago.

Yet it's all in the balance, and those blondes with a greater degree of eumelanin tend to have ashier tones. No eumelanin results in white or gray hair.

Pheomelanin gives rise to yellow and red shades, and there is some level of it in everyone's hair. Those of you who have bleached your hair, no matter how dark it is, might have gone through that phase of redness before hitting blond. That's the pheomelanin. Blondes with naturally golden tones have more pheomelanin, and redheads have the most. Scarcely 2 percent of the world's population has naturally red hair.

By sun or peroxide, pigments that are oxidized mean very blond hair and a pigment state called oxymelanin.

Blond Ambitions

The very art of lightening hair with hydrogen peroxide came about only around 1860. It took an endless number of burned scalps and charred tresses before colorists reached where they are today.

It was Jean Harlow who sparked the craze for platinum blondes, and even the descriptor came thanks to her 1931 film *Platinum Blonde.* Hollywood has never since tired of the formula on-screen with each new starlet in town—*Blonde Crazy, Blonde Venus, Blonde Trouble, Blonde Fever, Gentlemen Prefer Blondes,* and so on.

This is a far cry from 35 BC, when Roman prostitutes were forced to dye their hair blond. From whore to virgin, cultures have long imposed their own judgments and ideas about what is actually a very rare naturally occurring hair shade.

and clothes, as the artist requested. Every step was photographed for his studies. The only difference in my appearance was that the black of my hair had been totally sprayed white for the process so greater detail of my hair could be surveyed.

I looked in the mirror. For me, my look—the makeup, the hairstyle—works regardless of whether I am blond or brunette or powder white. I've found what works for me, and it just so happens to be a look that's ageless. I intend on staying true to it. Whether the time comes that I naturally lose all color from this head or I decide it's time to go lighter, I yearn to one day transform into a silver fox!

Of course, long before my inner Von Teese materialized and I hit the bottle of jet black, I was a sandy blonde.

But when I hit eighteen, as many teens do, I started experimenting. First it was as a platinum blonde, then a redhead, before transitioning to a deep burgundy. The pale skin and contrasting hair had me eager to delve darker. I had also just discov-

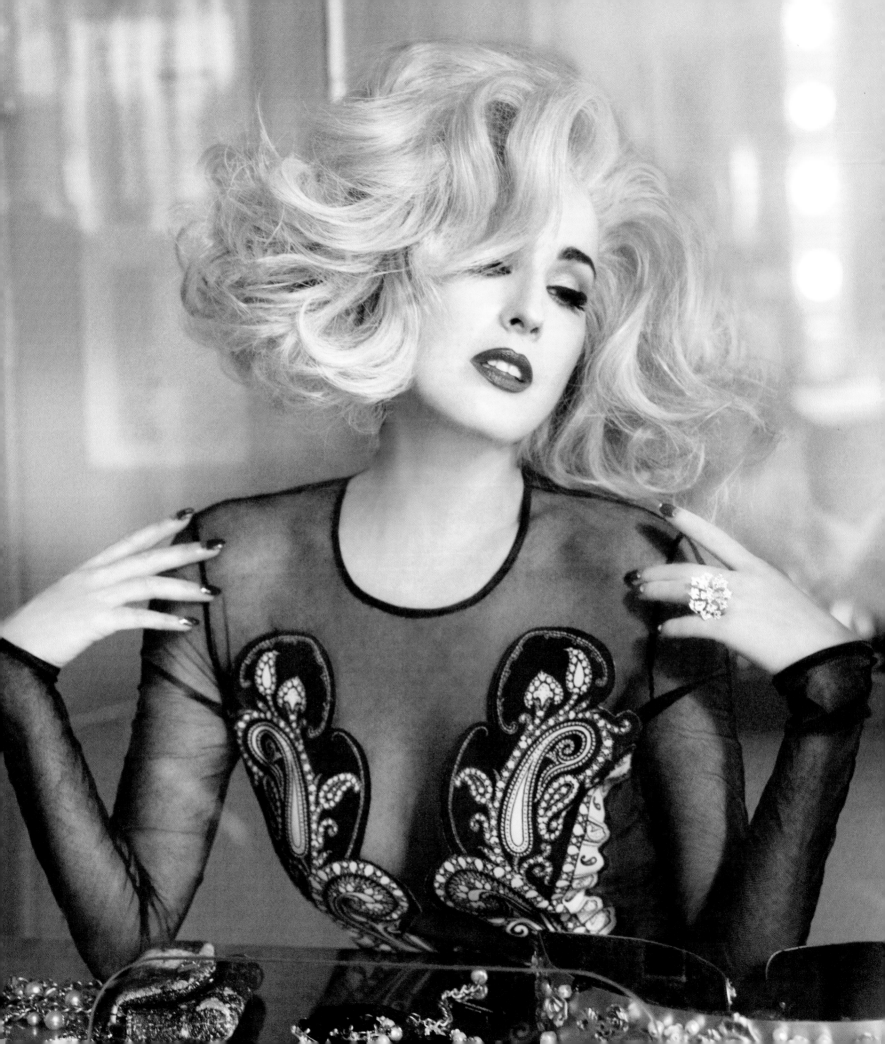

The Sensualist: Betony Vernon

Few embody eccentric beauty in looks and actions like the fiery red-maned Betony Vernon. She is a master goldsmith and a sexual anthropologist. She walked the Paris runways and has a master's degree in industrial design from Domus in Milan. She's served as design director for Fornasetti, and collaborated with Gianfranco Ferré, Alexander Wang, and Karl Lagerfeld.

The Virginia-born Betony grew up in a home with three sisters and under the guidance of a British mother active in civil rights and an American father who was a pilot and inventor. After graduating (cum laude, no less, set on becoming an art historian like her mother) she moved to Florence. She's since split her years between Paris and Milan, as a fashion consultant, designer of her signature B.V. Atelier collection, erotica activist. and author (those of you of age, pick up her Boudoir Bible *for your library). As she explains here, growing is a lifelong experience.*

As a girl, I wanted desperately to fit in . . . to be a size 4 and be flat chested. But by the time I was fourteen, I was a fully formed woman. As much as I would've loved to lie on the beach, I couldn't do it. It was something that was not good for my skin, so I always battled it. As it turns out, I was always a night owl.

By the time I "fit in" among my classmates, I was no longer interested in being among them. I wanted to be with the outcasts, the punks, a much older crowd. I was given this height, these curves, this skin—and I finally realized I had to own "it." It was a realization that came within me that my looks are my responsibility. This is who I am and I need to realize me.

Of course, at the end of the day, no one is truly on the "outside." Birds of a feather flock together, right? It might be a tiny tribe—even now my own friends are few and far between—but it's a universal family.

Beauty and aesthetics were always a part of my life. My grandmother was this extremely elegant lady with beautiful, flaming-red hair. I always looked for inspiration to Marlene Dietrich and Mae West, and to Eartha Kitt, with her beautiful legs and beautiful skin. I respected their beauty and how they evolved and grew into their time and assumed it. And they continued to be beautiful and sexy even as they aged.

Also among my earliest influences was the post-punk icon Nina Hagen. She wore so much makeup and had this bright, big hair. From the age of fourteen, maybe earlier, I was sneaking the look, flirting with lipstick and nail polish.

I continued to experiment until I was twenty, shaving my once thick eyebrows, applying Japanese-style white makeup, changing the entire line of my face. I don't shave my brows anymore. The truth is that being a redhead means little body hair, and I'm not complaining. It also means that there are certain reds I can't wear in terms of clothes and lipstick. I look best in lipstick that has not got too much orange.

Over the years, working in fashion certainly helped. As a model, my attributes were assets. I realized I couldn't care what the rest of the world thought of me, because that wouldn't get me anywhere. Besides, designers such as Jean Paul Gaultier understood me.

I will let you in on one of my beauty secrets, however: I believe in love. I believe in the power of love.

It's so important to continue to reinvent oneself. Don't get stuck into a moment. I still like to push the limits. But less has become more as I've become a woman. Streamlining has become more interesting. I've always appreciated the possibility behind the transition; the transformation is important to testing our boundaries.

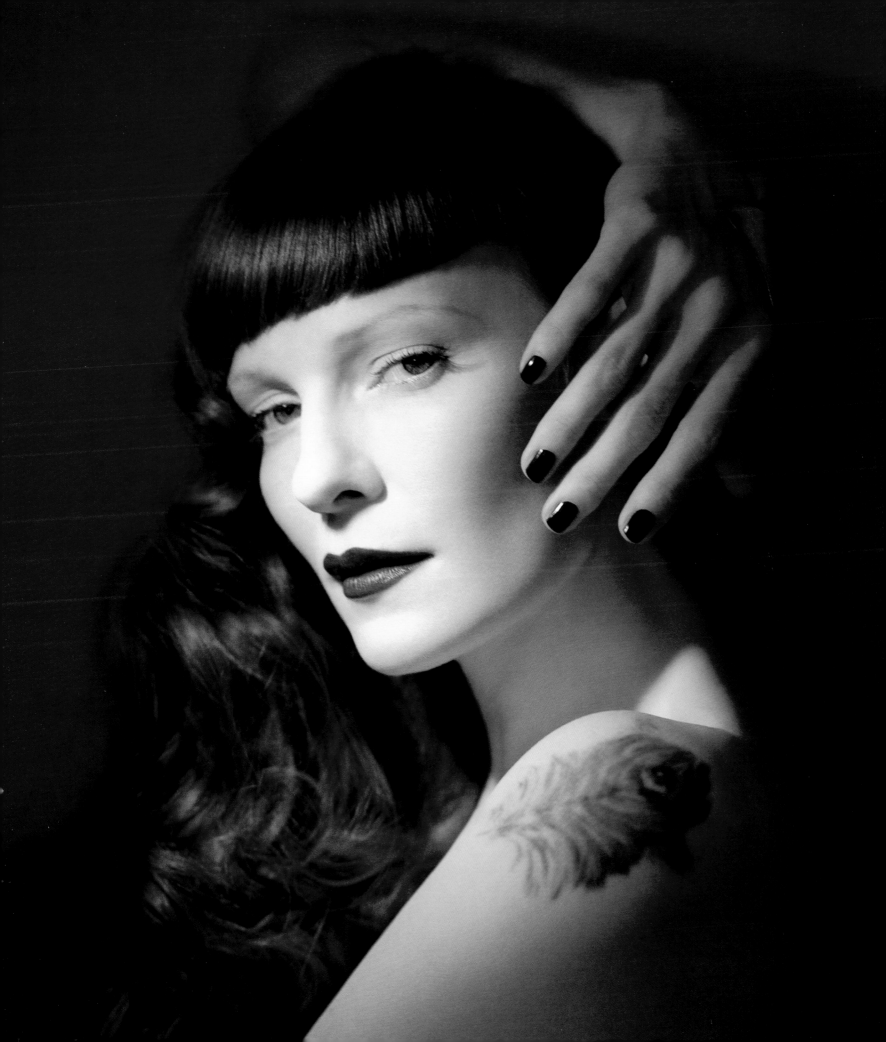

Today, by some estimates, there are five hundred shades of blond available by bottle. Nearly half of American women, some 40 percent, add some blond to their hair!

While I live and dye by DIY, there are some steps in the beauty ritual best done by professionals. Going blond (particularly platinum), lightening roots, or highlighting stripes are just a few occasions when treatment experience does matter. Bleaching raises the cuticle, making it more porous. Whether your hair is healthy, processed, permed, or damaged, seek out a colorist specializing in blondes who comes recommended.

Gray Matter

The very art of coloring hair stems from the desire to wash that gray right out of hair. The earliest known attempts date back, not surprisingly, to the ancient Egyptians. Around 3400 BC, they began applying henna to camouflage aging roots. Some even followed up with a sprinkle of gold powder and a fresh flower. A bit of sparkle and a bright bloom always make for perfect distractions . . .

Hair doesn't *turn* gray, by the way. It loses color. The lack of pigment results in what is termed "colorless" hair. The gray or white is actually light reflecting off individual hairs.

Aside from the natural loss of pigment with age, premature graying can also signal deficiencies in the thyroid hormone or B_{12} in the body. So if you're too young to go gray, get checked out. There are no magic pills, supplements, or diets that can restore pigment loss. Either embrace it or dye it.

Low Mane-tenance

The first recipes for dyeing hair black appeared in AD 100, when Claudius Galen, the most famous doctor in all the Roman Empire, wrote about a mixture of lead oxide and slaked lime, along with boiled walnuts and leeks.

Personally, I prefer to eat my walnuts and leeks (both are divine sources of antioxidants and great for the skin). History has shown all too well how many gals dating from as recently as the Victorian era suffered for beauty because of lead poisoning.

Thankfully, by 1907, the first safe commercial hair colorant was introduced. The clever French chemist named Eugène Schueller called it Auréale. With time, the brand became known as L'Oréal. Is it purely a coincidence that for years I used Garnier, a L'Oréal product? Yes. I guess it's because I'm worth it! (A slogan, by the way, written by a woman, Ilon Specht, when she was a young copywriter, all of twenty-three.)

Sadly, my go-to Garnier 100% Color No. 210 Blue Black, a permanent formulation, was discontinued at this writing and my search is under way for a new favorite. I began flirting with blue-black offerings by a range of brands, ultimately going with another Garnier iteration, Nutrisse Ultra-Color Blue Black.

When I'm really feeling blue, I add a dollop of professional-grade pure blue. My mane man John Blaine gave me Vivitone Permanent Cream Hair Color and advised I mix a portion that equals about one-third or so of the dye and developer amount.

All this dyeing means a regular assault of chemicals, so I've been sampling plant-based hair colors. Admittedly, they're not as blue black as I'd like. But I've found some success with Naturtint. The vegan-friendly, hyper colors of indie culture mainstay Manic Panic are also worth a tease, and I've tapped the array of blues in their Amplified collection.

I normally do my own coloring, frequently with a product from a local drugstore or beauty supplier, no matter where in the world I am. I never go to the beauty salon to have my hair colored. There are those who do it every two weeks, and if that's their thing, I respect it. Some of my best friends are colorists. But, as I shared in the previous chapter, I would rather do it myself than sit captive in a salon chair for an hour or more.

Because of those blond roots, I color my hair every two weeks. Can you even imagine what an expenditure of money and time that would be if I had to hit the salon every time? I also keep close at hand at any vanity around the world a can of Bumble and Bumble Black Hair Powder spray. It comes in a range of colors. I use it when I haven't had time to touch up my roots.

Truth be told, I get an empowering lift when I plunk down twelve bucks for a box of hair dye. That shiny, fresh coat of black I can make happen in my home, without an appointment, can instantly give a girl a whole new outlook on life. Now, *that* is satisfying.

What's more, my hair responds better to curling and other settings just after the conditioning finish of a fresh coloring. My hair color also fades quickly because it is a naturally light shade, turning a kind of reddish brunette. I prefer a deep, glossy blue black.

Hair professionals advise saturating the roots first, then dousing mid-shaft to the ends during the last third of the processing time. It's especially true if hair is fine like mine. On subsequent washings, I occasionally skip the shampoo step and simply rinse and condition hair to stave off fading.

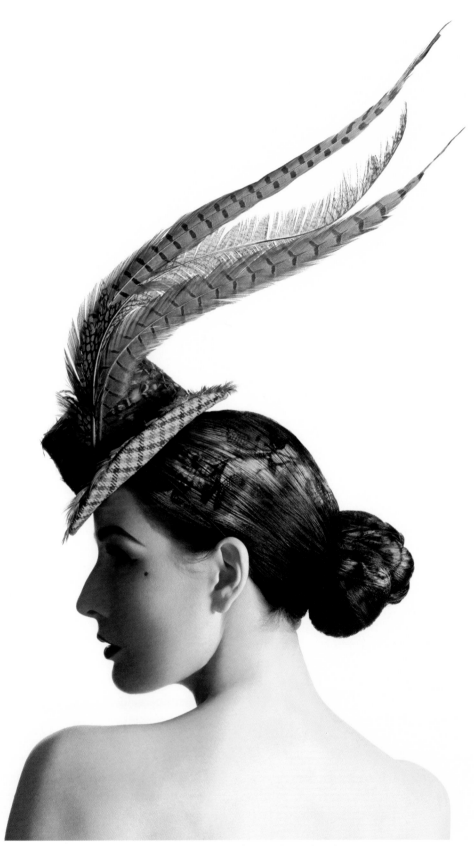

Gone gray, courtesy of a lace stencil and spray and the inspired mind of hairstylist John Blaine.

Making a Commitment

As in matters of love, some rites of beauty require more of a commitment than others.

When it comes to color, the process can be as instant as a wig or engaging as the bleaching and coloring of a brunette going blond. Before coloring your hair, either at home or professionally, it's good to establish the desired results according to expectations and, most important, the state hair is in.

Natural hair color and texture, as well as overall health and quality, can impact the color. What's more, the color on the box along with the poetic name attached to it can be deceiving. A better guide is looking for the actual description of the color (black, brown, red, or blond), the shade (dark, medium, light), and the tone (ashy, golden, brassy).

If a blond, red, or brunette bottle shade ends up too dark on your hair, get thyself to the beauty supply shop fast for a clarifying shampoo. It contains a higher concentration of color-stripping surfactants, the detergents that put normal shampoo and soaps in a lather. Dishwashing liquid contains a higher degree of detergents than shampoo, making it an effective home alternative. If you can't get to the beauty supply store or don't do dishes, wash hair several times with a shampoo not formulated for color-treated hair. Either way, follow up with a rich conditioning treatment under a bathing cap for fifteen minutes.

Temporary Color

Because temporary colors coat the hair shaft instead of penetrating it, they are comparatively easy to rinse out. They also tend to be easy to apply and available in a wide range of formulations: shampoo, rinses, foams, gels, or sprays.

Keep in mind that hair that is dry or damaged is prone to penetration of the shaft. So color may remain beyond multiple washings.

This is why shocking brights, from bright pink to bold blue, tend to linger. While these formulations are supposed to be temporary, the hair is usually so porous from stripping the natural color out first that these vivid colors tend to fade into pastels or murkier shades.

What was once the bleeding edge of a punk ethos is now available in temporary and semipermanent options at drugstores in suburbia. How times have changed.

But that doesn't make it all any less fun. If you have always wanted a blue bob or hot pink highlights, what's stopping you? The same aim here applies as it does with any hair color: healthy, lustrous hair, always styled. A friend of mine used to wear her own hair in the most flawless Marilyn Monroe style, saturated in the palest shade of pink! So chic.

A wig might be the way to go with more delicate tresses, given that the way these bold brights take to hair is by stripping away all the natural color for maximum saturation. For some, the results can mean scorched strands. Just aim for something nicer than the glossy nylon bobs in neon pinks and blues resembling the mane of a My Little Pony. I know because I found myself among a gaggle of Playmates during Mardi Gras many moons ago in little more than a rainbow of bobs and sequin pasties. Silly fun? Yes. Chic, not so much.

Semi-Permanent Color

This is less damaging than permanent dye because it contains lower concentrations of peroxide or ammonia—the developing ingredient in hair color.

But the presence of these developers doesn't mean that semiperm colors lighten hair. While the smaller molecules allow the color to penetrate the hair shaft in a way that temporary colors cannot, the process is minimal. Because of this, semi-perm colors are right for deepening hair color or adding a layer of tone for texture.

They are also a great option for many individuals because the formulations last only six to twelve shampoos, very likely washing out before visible roots appear.

Demi-Permanent

Like semi-permanent colors, demi-permanent formulations can intensify natural hair color. But don't expect any lightening, since these are ammonia-free and the hydrogen peroxide level in the developer is low.

This makes them a less damaging option, and one that can appear more natural since there is no lifting of the shaft's original color. Personally, I prefer a formula that saturates every shaft and gives my hair a uniform shade of blue black.

So demi-perm is not for me. But it can certainly be the right choice for others.

This is why salons tend to apply demi-permanent color as a refresher for existing color or to blend away the gray. Unlike semi-perms, these last through twice as many washes, up to twenty-six times, depending on formulation and hair texture.

Permanent Color

The best option for a complete hair color makeover is permanent dye, which usually comes in an easy-to-use cream or foam formulation and can transform hair by two or more shades lighter or darker. That's why it's my choice.

A blend of peroxide and ammonia removes pigment from hair and deposits the new color into the cortex, where the melanin lives. The permanent color merges with the natural pigments and forms a super molecule that remains in the cortex. It's why permanent color doesn't wash out. Fade, it might, though by then it usually requires another application because of visible roots.

Because of this deep hold on hair, permanent color is an ideal option for covering light or gray hair. It can also be risky if you're not absolutely confident about becoming a brunette, especially one on the darker side of midnight. With this in mind, I went from blond to red first, then black to blue black, with plenty of flirting with wigs in between.

As for removing any dark permanent color, leave it to the professionals. While there are products available at beauty supply stores, the process is complicated and the risk of damage to hair and scalp is serious.

Throwing in the Towel

I dread staining my pretty monogrammed towels. So I keep a few "special" towels—that is, old ones no longer fit for hanging out in any bathroom—to use on my hair during the dyeing process and whenever I shampoo. Even a week or two after coloring, just-washed wet hair can continue to stain towels.

I always wrap wet hair in these "special" towels. Just store them somewhere where they cannot be tapped by another bather in the house, so they're always available when you need them. Keep a towel big enough to wrap into a turban and one or two washcloths for cleanup duty during the coloring process.

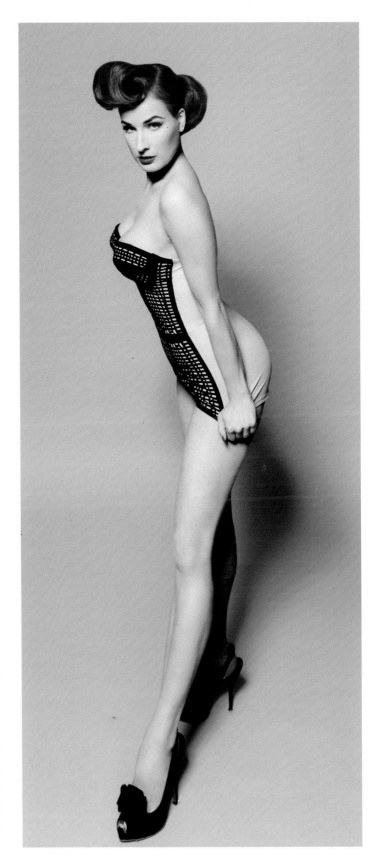

Dye Dye My Darling

It's an exciting day when I color my hair. That's probably why I do it so often. Whether you try it once or become a serial home colorist, how you do it can make all the difference to both the outcome of the process and any surface within splattering distance.

- Prep the space. Remove good towels and bath rugs. If you're new to coloring or just plain messy, cover the counter and floor with old towels or plastic sheeting (take scissors to two sides of a trash bag to make an instant drop cloth). Keep within reach a roll of paper towels, Wet Ones wipes, or old washcloths to help with cleanups on skin or surfaces, and a plastic bag in which to stuff the discarded coloring applicator and other packaging and any soiled disposable towels. Lay out any long clips that might be used, as well as anything to keep you amused during the activating phase.

- This is no time to wear a favorite robe. I always dye in the buff or in an old black slip so as not to ruin any clothes. Rose drapes herself in a reusable plastic cape that Velcros at the neck, which she picked up at a local beauty supply shop.

- Prep your skin. Before mixing dye, apply a stain protectant on your skin along the hairline, edge of ears, and, really, any exposed skin that could come into contact with dye. Rose recommends a smear of petroleum jelly as a protectant.

- Gently comb your hair and create a part where you most likely will wear it in the immediate future. Clip back larger sections to better hit every layer of hair with dye.

- Follow the package instructions for store-bought dye—including wearing the plastic gloves. At the local beauty supply store, we picked up better fitting, reusable gloves.

- Once the hair is saturated according to the directions, inspect from every angle. Use a rat-tail comb to catch any fine hairs, especially those around the front, by gently combing through an inch or two. I also use a flat-head eyebrow brush with a dab of dye to "sculpt" a precise hairline with dye (revisit after the following step).

- Continue surveying your handiwork from every angle, this time looking for any splotches on skin. With darker dyes, it might take a few minutes until marks actually appear. So keep checking. Wipe any emerging residue on ears, neck, or any other skin area immediately with a damp washcloth or paper towel. Reapply jelly or another protectant on the spot.

- During the ten to forty minutes a process might take to develop, attend to other activities that don't require leaving the powder room or much movement: bag any rubbish from the coloring process, moisturize your elbows and heels, cleanse and lay out your makeup brushes, read a magazine. At intervals, check the mirror again for any emerging smudges on your skin and wipe them away. Likewise, check the floor, walls, and any other surfaces for errant splatter. You wouldn't want to step in a drop and track it around the house.

- When the time is up, get in the shower and wash away the color with gloved hands, according to the package instructions. Condition generously.

- Once out of the shower, wrap your hair in a towel (we like an old one so it doesn't ruin the good towels). Remove the towel, comb with a wide-tooth comb, and get set to set. Remove any remaining residue on skin, gently rubbing with an old terry cloth washcloth.

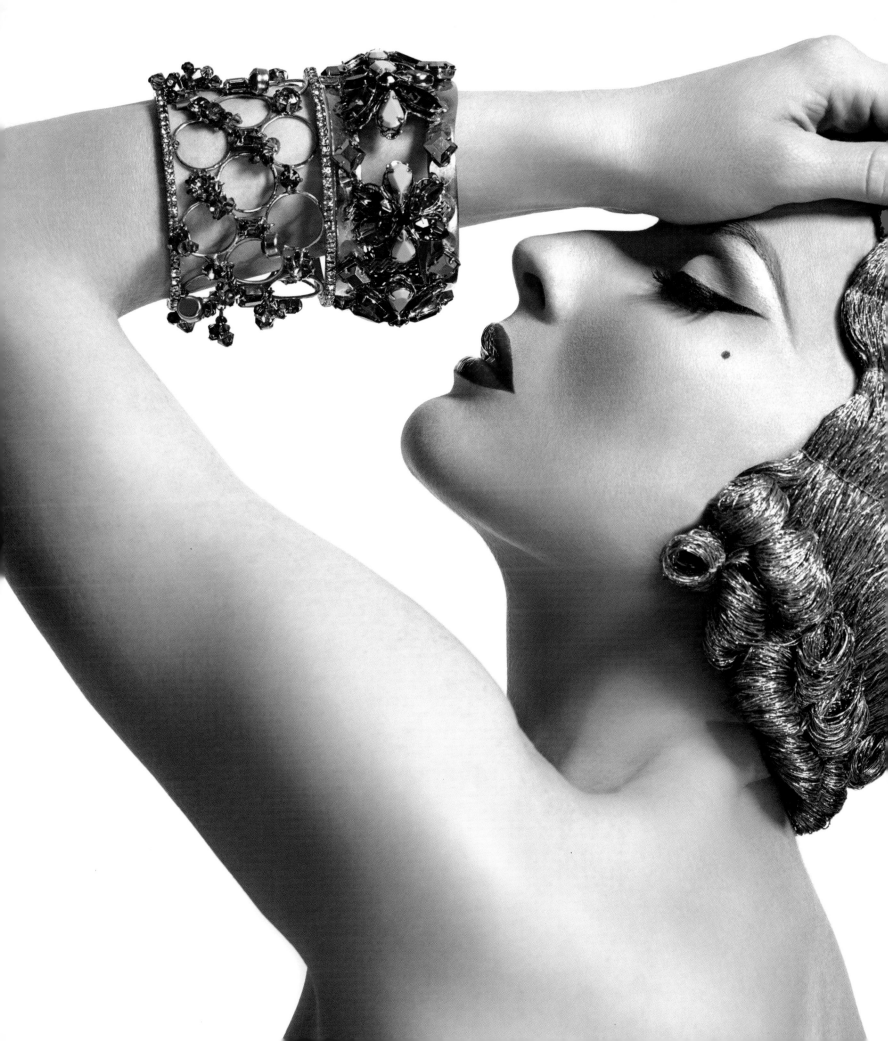

Wigging Out

In a snap, a wig can reveal whether a new hair color or style works. Along with extensions and hairpieces (which I discuss at some length in the following chapter), wigs are one of my favorite forms of instant gratification.

Wigs have a long and lavish history, as they were the way the most fashionable in society—from the gilded plaits of ancient Egyptians to the talc-caked poufs of the pre-Revolutionary French—could parade head and shoulders above the proles with whatever outrageous trends were decreed by the haut monde.

I have a splendid vintage bob woven of gold metallic thread, as well as a powdered froth of a wig that Marie-Antoinette would have approved of (although truth be told, unlike the men, women during her reign did not wear wigs but hairpieces with their natural hair). For a spell, before I actually let someone take scissors to my long hair and lop it all off à la Louise Brooks—before I even went brunette—I tested the length in an inexpensive brunette wig bobbed and fringed in the style of the silver screen star, until I finally decided to cut and color my own hair.

A woman can't go wrong with a bobbed wig. Even a moderately priced one can pass, in large part because it is such a classic style that fits all faces and, most important, the bangs conceal the hairline—always a giveaway with a wig. It is also one of the very few wigs that look truly chic on just about anyone.

More than a dozen years into my signature brunette look, an opportunity came knocking that called for me to be the live manifestation of the pinup illustration for Camel cigarettes. She happened to be a blonde, and that's exactly what Camel insisted on.

Instead of stripping my jet-black hair and bleaching it blond, I turned to John Blaine, a grand illusionist when it comes to creating hair-raising coiffures. John custom-made me a breathtaking blond style that doesn't remotely look like a wig.

Acquiring such a work of art doesn't come cheap. The tab alone on that hairpiece came in at five Gs. But these custom-made wigs for stage by John and my other mane man, Ken Pavés, look so incredibly real because they are measured to order, constructed from the best available materials, and colored and styled to flawless perfection. This particular wig was certainly worth every platinum, curled strand on the tailor-made skullcap.

As truly blond as I looked—and as much as I love a beautiful wig—being obliged to present myself to the world as, well, someone who wasn't of my own making didn't feel right. When I'm onstage, it's immensely important for me to feel like my true self. My physical manifestation as Dita Von Teese is who I am inside, and onstage, and I want my personality to shine as brightly as the Swarovski crystals on my costumes.

Don't go getting all armchair psychiatrist on me. It's not that seeing myself blond is suddenly taking me back to my childhood. I don't think it had anything to do with that. I simply felt like a misrepresentation of who I truly am. For one thing, I had just had my first cover of *Playboy*, and there were those in the audience who would point to me onstage and confidently declare: "That's *not* Dita Von Teese!" There in my martini glass, even I felt like a blond imposter of myself . . .

Oh, I know a lot of showgirls wear wigs, among them some of the biggest "show gals" of all, Mae West, Cher, Dolly Parton, Lady Bunny, and my darling RuPaul. These delightful eccentrics have made no bones throughout their careers that it's *all* showbiz, down to the very last synthetic follicle on a wig.

And I do enjoy a wig that looks like a wig! But I like wearing my own hair onstage. At least, I like to think that *most* of the hair is my own—hairpieces and extensions notwithstanding. Occasionally, I still don the blond wig for a shoot or if I'm simply in the mood. That is the eccentric glamour gal's right to choose.

I have had a ball at parties where the wig is the frill of honor, as in the legendary wig parties thrown by my friend and one of my favorite photographers Ellen von Unwerth. At Ellen's annual wig parties, everyone does his or her damnedest to outdo one another. It becomes a game trying to recognize even old friends in their new transforming hairdos. As the Champagne bottles pile up, there is much switching of wigs, too, which is always good fun. How I love a wig party.

One fall, I had just landed in Paris and just landed a ticket to her party, and without even a clip-on braid in my luggage and thousands of miles from my trunk of wigs at home there, I wasn't going to disappoint Ellen by showing up at her fete sans wig. But where was a gal going to find a wig store at nearly midnight in Paris?

So I did the next best thing: I made my hair *look* like a wig.

No one was the wiser! Okay, so I eventually got caught when someone tried to try my hair on for size. But who can blame a gal for trying?

There are those who do and those who don't. When it comes to making your beauty mark, there's no two ways around it. *Do* you must!

Darlings, there is nothing glamorous about neglected, undone hair. No matter how brief the time in the morning or before an appointment, my hair needs to be cared for and coiffed off the face. It's naturally straight and I don't find glamour in that. A done do empowers me to face the world with a bring-it-on attitude. If I don't do anything, I *will* have an off day.

As with any craft, mastery comes with doing. This includes learning from experts and practicing regularly. None of my hair guru pals would ever claim to have just woken up one morning with the superpower to style. It took study and practice.

One reality I learned early on is that the hairstyles I coveted—marcel waves! Victory rolls! Betty Grable's heap of curls piled high up top!—definitely involves consideration in the set and style to get it right.

I would spend so much of my free time researching, experimenting, and practicing vintage hairstyles. I even consider location an integral element. A room with lavish light is important to truly see what you are doing. As a brunette, I never set or style my hair against a dark wall. If I were a blonde, I might.

This book, in fact, prompted my dear friend Eddie DeBarr to recall how during our club kid days he would ask, "Hey, do you want to go out tonight?" and I'd reply, "No, I'm practicing my hair." He still teases me about that line.

Fixing up your hair doesn't have to take an entire evening. Have a go-to quick hairstyle that leaves you looking and *feeling* beautiful. It can be as simple as a twisted chignon or high ponytail. It should take as little as ten minutes. As Danilo aptly points out: "Women used to live and style like this every single day." You might even still know a great-auntie who hasn't let a week go by in half a century without a salon-style set.

Doing your own hair can be one of the most satisfactory and creative steps in the beauty ritual. I find there is something meditative and relaxing about styling my hair. Maybe that's partly why I won't leave home without doing something.

Of course, it can also be the most vexing. Sometimes I have a look in mind; other times, my hair has a mind of its own and I have to let it be what it wants.

Hair is a fundamental expression. Just as its luster and texture reveal an individual's health and other factors, the style can also communicate so much. Think about it: when we size up a stranger, their choice of hairstyle holds weight in our instant assessment. It's a fact of life.

I love how Sophia Loren still wears that marvelously heavy makeup and mass of teased curls, and is still stunning and sultry as ever as she enters her ninth decade. She resisted getting a short hair makeover or an "old lady" makeover. As far as she's concerned, it is still 1960 and she is still the same sexy Sophia Loren she ever was. She's still sex, sex, sex. And it totally works. I admire when individuals like Sophia Loren don't listen to others who admonish, "You shouldn't wear that look anymore . . . it's not age appropriate." *Age appropriate?*

Mind you, I have my limits. I believe women should revel in being women. I have no interest in looking like a little girl, so I style my hair accordingly. It is also why I cannot hold my tongue when friends who are grown women insist on a pair of girlish *Bad Seed* braids or ponytails. I've heard the arguments for the schoolgirl look, of how some men think it's sexy . . . Hmmm . . .

In my experience, I've come to find that what men ultimately respond to is how a woman *feels* in terms of her emotional and mental state over any trappings of appearance. It all comes down to composure. There are few qualities sexier than confidence. Let's face natural laws of being human: we all, women and men, feel most confident when we look our best, from hair to toe. So it goes to reason, if a woman feels empowered because she looks her best, that empowered sense of self and mind is fundamentally attractive to the object of her desire.

I feel sexiest looking like a woman.

Can you imagine Veronica Lake going for such childish styles? She was scarcely nineteen when her breakthrough film, *I Wanted Wings,* struck box-office gold. Yet there was nothing wet behind the ears about the way she presented herself to the world.

She or any of the starlets during Hollywood's Golden Age were always models of sophistication and glamour, in large part because of the hair. Old movies are an invaluable source for getting a full picture of hairstyles, since they can be seen from all angles. As for those gorgeously lit photographs, the technology of retouching was not what it is today. So having a coiffure that was set to lacquered perfection and the most flattering effect was crucial.

I love glamorous hair.

To wit, I could write an entire book on hairstyles. But, dear friends, until that next book, we will both have to be satisfied with my go-to favorites featured in this chapter.

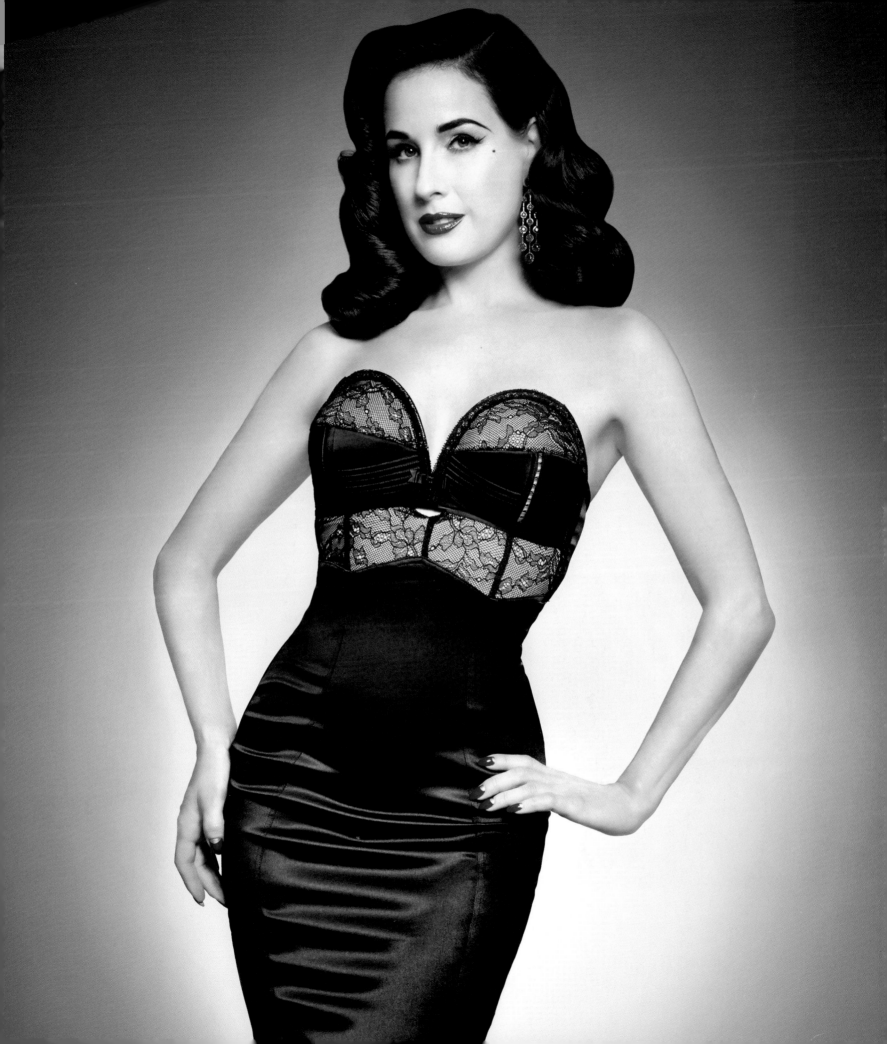

Cinematic Coiffures

While I applaud any gal committed to vintage hair sets, sadly there are those who go out brandishing mistakes that many a starlet of Hollywood's Golden Age would never be caught in.

Movies, in fact, are such an invaluable source for not only fashion and manners but remarkable hairdos, too. Here are a few of my favorites for great hair:

Pandora's Box

Gentlemen Prefer Blondes

Gilda

Pin Up Girl

The Dolly Sisters

Top Hat

How to Marry a Millionaire

Ziegfeld Girl

In the Mood for Love

Funny Girl

Barbarella

Dinner at Eight

The VIPs

Cover Girl

Belle of the Nineties

Cabaret

The Harvey Girls

An American in Paris

The Gang's All Here

Marie Antoinette
(1938 version)

Lauren Bacall, Betty Grable, and Marilyn Monroe, behind the scenes of the 1953 classic *How to Marry a Millionaire*, loved their beauty kit on and off set.

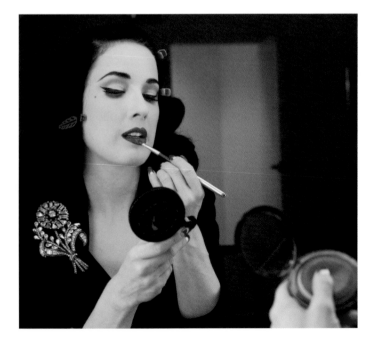

Left to Your Own Devices

I collect all kinds of ephemera related to beauty, and hair tools are part of my expanding research archive. Among my trove of vintage reading sources are old catalogs like those Sears, Roebuck & Co. published before World War II. I love studying the beauty sections for all the neat styling tools. What a variety of accessories and contraptions!

One essential tool to keep close at hand always, in makeup or hairstyling, is a hand mirror. You simply must look at yourself from all angles. The world will.

Fasten-ators

Some of the least expensive tools in your hair kit will also prove the most indispensable when it comes to setting and keeping even the most complicated hairstyles.

Clips come in plastic or metal. But beware: metal heats up quickly at the other end of a blow-dryer, and can harm the hair and scalp.

Duckbill Clips

These clips can be curved or flat, short or long in length, and come clear of teeth. They keep sectioned hair back during drying, rolling, or styling, making the process easier and faster. Flat double-prong clips can fix thicker or larger pin curls; the single-prong clip can hold all other curls in place while cooling. Keep a variety on hand.

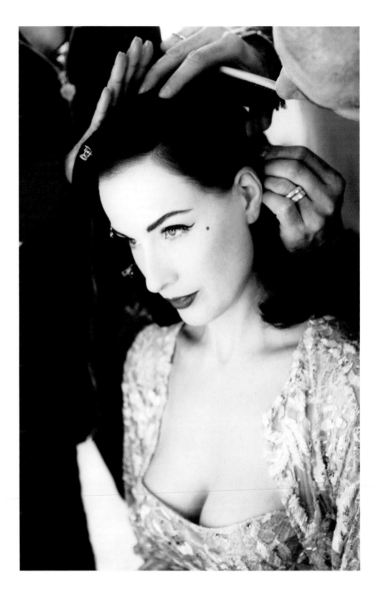

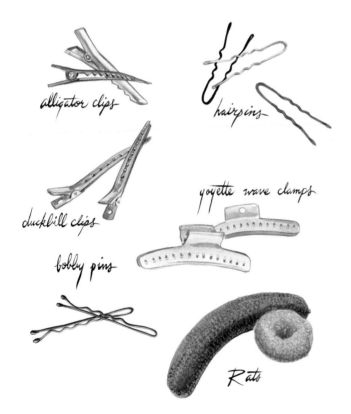

alligator clips

hairpins

duckbill clips

yoyette wave clamps

bobby pins

Rats

Yoyette Wave Clamps

These aluminum clips are my go-to for creating marcel waves. They are curved to closely fit the surface of the head, and can run from two to six inches long. The holes on the side allow for air circulation as the pinched ridges of hair dry into a set.

There are two ways of waving hair with these clamps. There is a wet set, kept wet by both water and styling lotion (a combination can be mixed in a spray bottle). Set, let dry, remove the clips, and comb out.

The other is my favored option, forming waves of set and curled dry hair (as described in this chapter), and clamping the waves until set. Remove the clamps and go.

Hairpins

The U-shaped hairpin is an unsung marvel of design and dates back to the ancient Egyptians.

In contrast to a bobby pin, the standard hairpin is an open-prong form. It comes in an array of sizes. I keep dozens on hand, from one to five inches long. Use them to hold pin curls, buns, hairpieces, and French twists in place (finer hair might be better off with the tighter bobby pin). When carefully inserted, they should disappear.

Bobby Pins

Bobby pins come either flat or alternating flat and waved prongs.

So just who is Bobby? Originally it was a "what." The rage for the bob haircut during the 1920s shot up sales for these pins among the many trend followers who wanted the look without lopping off their hair. So they "bobbed" their hair by tucking it under and pinning it into a bob style.

During this time, a fella named Bob Lépine of Buffalo, New York, filed a US patent on this cheap, ubiquitous grip. Across the pond in the industrial British city of Birmingham, Kirby, Beard & Co. trademarked the Kirbigrip in the 1920s, giving rise forever after in the UK to the widespread term *kirby grip,* no matter the brand. Stateside, Lépine tried for decades to hold his claim on the humble pin, even taking giant Procter & Gamble to court during the 1950s—and winning his case and a princely sum from P&G and anyone else borrowing his design.

Like men named Bob or otherwise, bobby pins also come in a profusion of sizes and skins, from polished shine to velvety matte. While it is necessary to have the basic kind in a color closely resembling your individual hair shade, it is also nice to have a few jeweled, pearl-tipped, or enameled ones on hand to give a hairstyle a finishing spark.

No-Crease Clips

Long and thin or in the shape of leaves or bows, these clips do just as they're billed: keep away flyaway hairs without creating waves or wrinkles. But the decorative options make them a more attractive alternative to all other double-prong clips. Weight and tension are equally distributed, and the flat form keeps hair from creasing.

Combs

Sometimes thicker sections of hair can be fastened into place in one fell swoop better with a simple comb than with pins. Different than the decorative kind that come in endless possibilities and materials, a few basic unembellished plastic or metal combs in a shade close to your hair color are indispensable.

Coated Elastic Band

Hopefully, I am not the first to implore you never to wrap a raw rubber band around your hair. Always make sure the elastic is coated. There are great seamless bands on the market now that can closely match your hair. Or conceal it by wrapping a half-inch section of hair around a band and affix the end with a single bobby pin.

Hairnet

A fine hairnet cast over a chignon or other mass of hair, can help contain loose ends and flyaways and give a finished appearance. Choose a net matching your hair color, because it should be barely visible when worn. The larger the weave, the less visible it is, too.

In Heat

To me, a do isn't a style without a curl. Be it a flirty pin curl above the brow or the sultry stand-up wave of a "bombshell" hairstyle or even the rolled-under ends on a sleek bob, hair simply looks lovelier, livelier with a curl.

I recall those pink sponge rollers my sisters and I would cover our heads in as children before bedtime. What an early introduction to the concept of no pain, no gain in beauty! I have a pile of updated ones covered in black satin that I occasionally tap.

Yet for all the cool ways to curl, nothing beats heat. "It takes heat to realize volume and high-performance curl," notes Danilo. "In an ideal world, I would always put someone under a hood dryer." The hotter a roller or iron during the set, coupled with the longer hair has to cool off, the better.

Thankfully, heating rods over open flames, or in smoldering ashes, are things of the ancient Roman and Egyptian past.

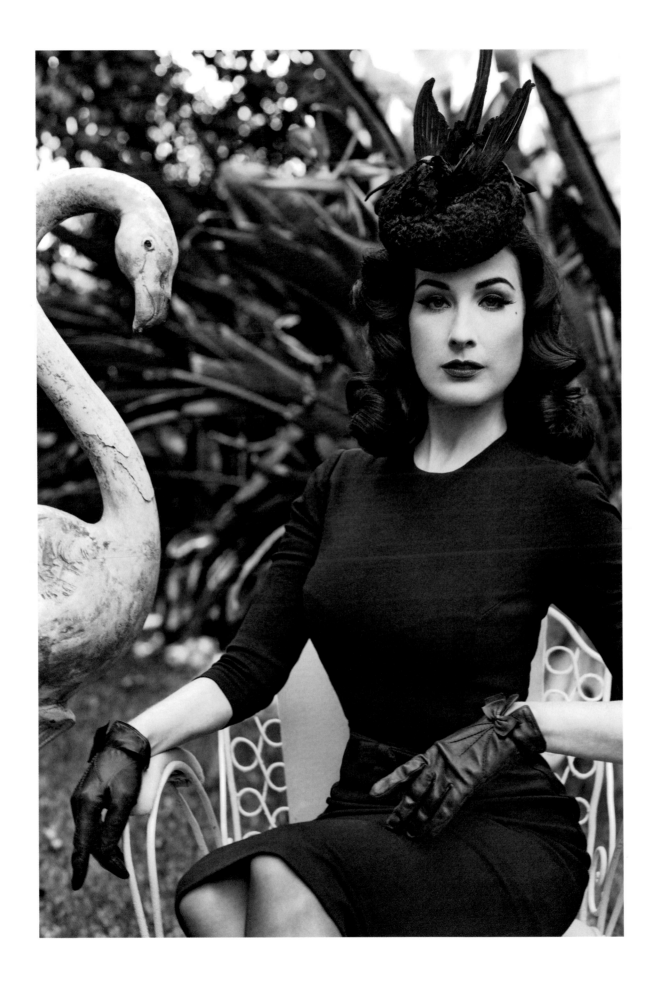

We've also moved beyond the inventions by pioneers of the electric age, such as Charles Nessler. The German hairdresser spent nearly nine years perfecting a technique involving a dozen two-pound brass rods linked to an electric heating machine. His patient wife, however, is the great heroine in this tale. It was she who underwent the six-hour procedure countless times until it was perfected, enduring scalp burns and seared hair.

Since progress cannot be stopped—particularly when it comes to beauty aspirations—the subsequent decades witnessed a barrage of rejiggered devices promising beautiful semi-permanent curls and too often delivering scorched hair. Finally, the revolution hit home in 1966, when Panasonic entered the market with the first hot rollers powered by electricity.

Much as I love collecting vintage hot tools, the electrical connectors and sizzling temperatures are no match for contemporary models, with their wonderful heat controls and coated surfaces. State-of-the-art styling tools and products lead to easier-to-achieve, longer-lasting finishes and healthier hair.

No modern advancement can do away with two commandments: heat styling should always be done with a spritz of thermal protectant product; and all rollers and curling irons should be regularly cleaned of any product residue that accumulates through styling. Moisten an old washcloth and wipe them as you go.

When traveling abroad, take care to use a voltage converter (also known as a transformer). For example, a device rated for, say, 110 volts will need both a converter and an adapter plug if the power supply at your destination is 220 volts. I rack up so many frequent-flier miles throughout the year, and have blown up so many devices, that I now have several country-specific roller sets and irons. I always leave my own blow-dryer at home, instead relying on the guest dryers supplied by the hotel.

Heated Rollers

I cannot imagine a life of glamour without my hot rollers. While I occasionally use a curling iron and metal clips to hold a curl, I prefer rollers, bar none, the hotter the better.

I use a mix of medium and small rollers, culled from three sets. I keep a few more heating up than I can use just in case. In all, my head

requires some thirty-two rollers because my hair is naturally straight and fine. Your hair might require more or less.

Section hair about half the width of a roller. At the very least, it should never be thicker than the roller is wide. The less hair per roller, the stronger the curl.

After spritzing the sectioned hair with thermal setting lotion and winding it up, fix it in place with a metal or plastic clip.

(On my things-to-design wish list is my very own line of rollers in black and other hair shades with the most minimal roller clips possible so a gal doesn't look like a complete alien creature going about the house. Then again, there is a practical trade-off to having rollers in another color: being able to detect whether the ends of hair are wrapped around the roller.)

Hot Sticks

My secret weapon for executing softer marcel waves, these long, flexible rubber rollers introduced in the 1980s interlock at the end so they do not require clips. The sticks are heated up in a powered box that is convenient for traveling.

From sectioned tip to scalp, wind hair around the hot sticks. Then loop and lock. The greatest challenge with this tool is properly winding and tucking the hair ends in place. Hair must be smoothly wrapped around the stick. I first found a working set at a Goodwill in Texas during the early 1990s. Conair and other manufacturers now remake them.

Curling Iron

Roll out the barrel to instantly transform flagging hair into exciting hair. Use it before clipping a pin curl in place, or to quickly repair a weak curl after a rushed set.

Today, there are rods made of ceramic, Teflon, titanium, and even tourmaline. Stick to those that are electrically powered, unless you are, say, glamping (as in glamour camping). The cordless kind that run on butane never get hot enough, but they are better than nothing if you find yourself in the boondocks. In such cases, before I start a road trip, I do a tight set on freshly washed hair. The curl can last for days and loosens nicely as the days go by.

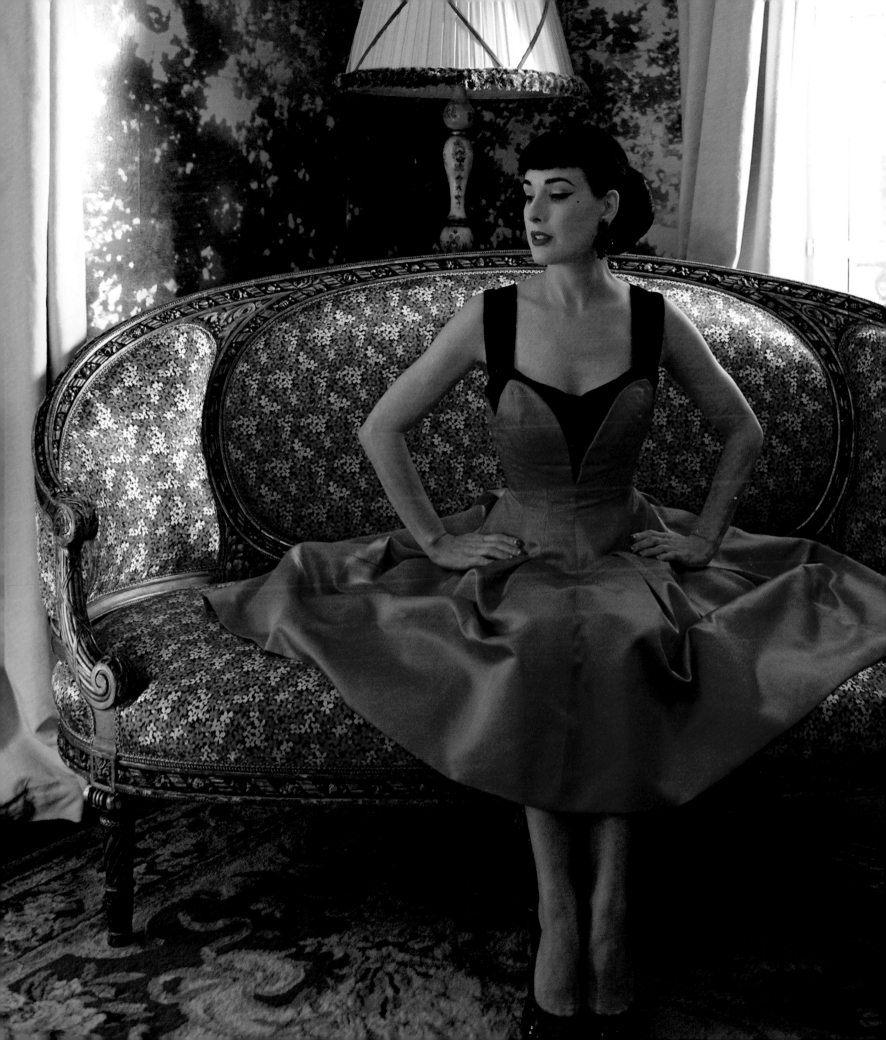

Admittedly, an iron alone is not as long lasting as a roller set—unless the curl is pinned in place and allowed to fully cool before styling hair. Hot rollers give me a better bounce. Every hair type responds differently, however, so experiment.

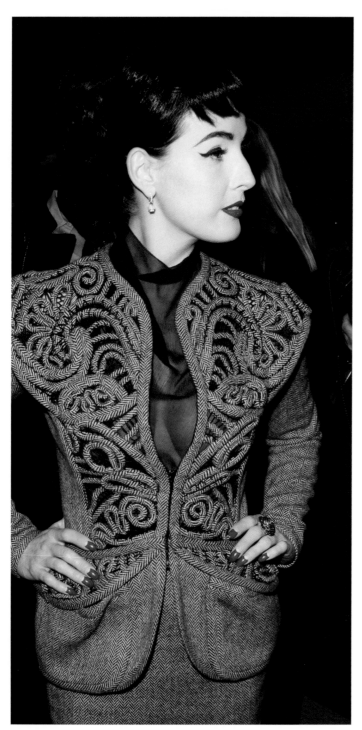
Hairpieces can come in endless forms, including a fringe of bangs.

Pin Curls

Do not underestimate the lowly bobby pin or mini flat clip. When it comes to many ornate and complicated retro hairstyles, the simple combination of a comb, curling iron, and pin or clip is often all that is needed. When and if I pin curl, it's a heated pin curl set that I do dry, twirling a combed section of hair, about a half inch or so, with a hot iron before pinning it into place.

For finer hair texture, where the heat of an iron or blow-dryer can be damaging, a wet set is the way to go. It's also better for shorter hair. I personally never do this myself because it takes me and my hair too long to set. For this reason, my hair has undergone a wet set only at the hands of an old-school master at a beauty school (see page 303 on marcel waves).

If you have the desire, hair texture, and time to try this method, spritz a section of hair with setting lotion and water until moistened and comb smooth. Hold the section straight, bend the end, and begin coiling. If you're new or out of practice, wrap your hair around your forefinger, just not so tight that the finger can't be slipped out. If the strand is sufficiently damp and it is still difficult controlling the ends into a neat curl, consider using an end wrap (though, admittedly, these can be fussy to use).

Continue rolling it in a direction that is somewhat parallel with the head—instead of on end at a 90-degree angle—toward the scalp. Hold the curl against the scalp with thumb and finger, just off the base of the root. Fix it into place with the hairpin or duckbill clip.

Repeat, each time curling and pinning the hair exactly like the previous pin curls. A rat-tail comb is useful here to section strands and keep them smooth for pinning. Uniformity is essential. Dry by air, heated bonnet, or dryer. Only once the hair is fully dry is the entire process complete and ready for a brush-out.

Styling Potions

Styling without product is like an unbuttoned frolic without a condom: potentially harmful, indisputably unsustainable, and plain foolish.

Just as with sex, alcohol can result in undesirable results. In the case of styling products, alcohol can dry hair. Yet it's the alcohol that provides a stiff finish, which is why I can't say my counter is alcohol-free. So use it wisely.

Keep products off the scalp, too, to avoid clogging pores. Never forget to follow up any step involving styling products by lathering up and rinsing off your hands and nails. Finish up with a rich moisturizer on your hands.

Styling Gel

Because the alcohol base in gels is what gives styled hair stiffness, reserve it for styles requiring a medium to strong hold.

Styling/Setting Lotion

By tube or spray, these creamier or liquid-like solutions tend to be alcohol-free and contain nourishing oils that dry into a soft hold. They can fix the curl from hot rollers or curling irons and often help protect hair from heat.

While it is necessary to spritz each sectioned-off piece of hair with setting lotion before rolling it, beware of dousing it with too much product.

Pomades

Also known now as a wax, putty, or paste, these are all essentially made of a sticky, dense substance made of petroleum jelly, beeswax, or mineral oils. Pomades offer control, shape, shine, and slickness.

Only a small amount is usually needed. Emulsify by rubbing it in palms and work it into the hair.

H_2O

Plain water is one essential styling "product" that will not require washing away.

Buy an inexpensive pump bottle from the beauty supply store and fill it with either tap or filtered water, depending on your hair sensitivity. Chlorine in tap water can lead to frizz and dullness. I have a filter on my showerhead, to neutralize the chlorine.

Wet hair will assume any kink or curl when set and dried, and, depending on individual hair texture, can last longer than heat or dry sets (that said, as I stated above, I tend to go with a dry set). The entire shaft should be damp enough to make hair pliable so it will take shape and remain that way once it is dry.

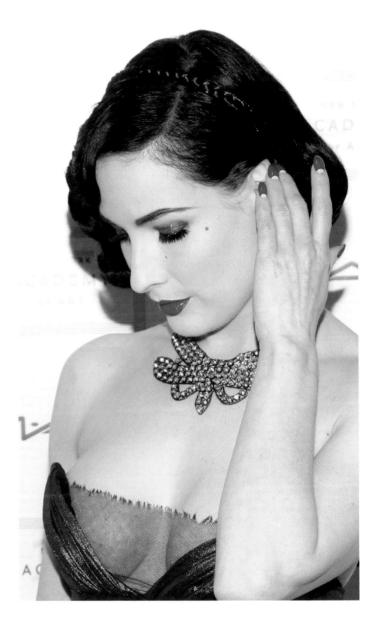

Rats, Switches, and Other Enhancements

In this era of instant gratification, the desire for a complete new look is only a faux piece away.

I enjoy fake hair and padding, as I shared on page 288 regarding the transformational effects of wearing wigs. Whether they're made of natural or synthetic materials, I like the freedom of playing with components that are not naturally mine. The change can be transforming, an immediate way to realize a new look.

As Danilo points out: "With falls and wigs, even rats, you *can* be that person . . . even for the evening!" With wigs already previously covered, here are a few more hairs to raise the glamour stakes.

You Flirty Rats

An easy and effective way to add height or fullness, a rat serves as padding and boosts the appearance of volume.

Throughout history, rats have been made from everything from raw wool to old socks. But they've primarily been fashioned from loose hair left in brushes. Every complete vanity set between the Victorian era through the 1940s even had a pot known as a "hair saver" where women would squirrel away loose hair. Once enough hair was collected, the mass would be matted and rolled into a compact shape like a sausage or ball.

There are synthetic rats readily available now, made of foam or nylon mesh (as I prefer) and available in colors that blend right into hair. Yes, they do resemble something you would scrub pans with, but are they ever an amazing little invention. I keep a variety on hand, and regularly use a doughnut- or ball-shaped pad for a fuller bun and various sizes of tubes for liberty rolls, bumper bangs, or a French twist.

Rats provide a more solid foundation than simply teasing. Without the padding, even the most backcombed and lacquered natural hair can split and deflate. It also minimizes the harsh assault in teasing and backcombing.

Take care to cover and secure the padding with hairpins, and do not resist trimming or tailoring it with needle and thread to better fit a desired style. When not in use, wash and air-dry, and store it in a ventilated drawer or other place.

The Beautiful Fall

Switching up a look can be as simple as a switch of hair. Think Barbarella ponytails, Bettie Page bangs, vibrantly colored streaks—generous falls and other hairpieces should be a part of any glamorous eccentric's beauty kit.

I absolutely love hairpieces and find making them a creatively meditative outlet. It doesn't have to be a costly hobby. Inexpensive pieces can be scored on sale online or at the local beauty shop. A hairpiece in the twelve-inch or longer range is a marvelously versatile option to have. It can serve as a ponytail or braided and wrapped like a headband halo.

I buy falls and braids and have a wig head at home to pin and style them into something I can wear at a future date. Among my favorites is a massive coil I pop on when I am in the mood for a chignon mightier than my natural hair can provide. One of my go-to pieces is a thick and long two-strand twist, and I wrap it around my head in a halo style inspired by Ginger Rogers in *Top Hat*.

It's good to have a variety of pieces ready to wear for those days when one is in a pinch for time. Glamour-to-go. Just pop it on and go.

Marlene Dietrich signaled a new wave in the beauty archetype, countering androgynous fashion with the softest of waves.

With my ex-husband, Marilyn Manson, in 2002. We—and my hair—certainly made waves!

By Extension

For something a bit more lasting than an evening frolic, consider extensions. Like hairpieces, these can be readily sourced in a range of quality, prices, and options online and in stores, and they are available in synthetic and real hair.

Take care that they are of a reasonably good quality, Danilo cautions. Unless it's pink or some other candy color, a hairpiece is supposed to pass off as your own. At the very least, it shouldn't look like it might go up in flames at the mere hint of heat.

Given that extensions have become so readily available in recent years, there are deals to be had. So invest in a good set and care for it.

As early as the 1990s, after a long stint of maintaining my hair in a Louise Brooks bob, I woke up one morning deciding I wanted longer hair. I bought clip-on extensions and wore them until my hair grew out.

I continue to wear them when the hair length and mood fit. Although now I do the long-wearing temporary kind and wear them at the back of my head for a boost of weight and breadth, ideal for greater styling power and grander buns.

Even the best-quality extensions require extra time to dry. They also have to be removed after an inch of natural hair growth because of inevitable breakage to natural strands and roots. They're among my most lavish beauty splurges, and a ritual I undergo every two months or so.

Extensions can become a bit of a beauty addiction. Removing them is not unlike that physical unease that happens when roller skates come off and there's a sense of feeling short. In this case, the lack of extra hair from the extensions only gives me the *impression* I have less hair.

Making Waves

I've collected several antique marcel waving irons, and most of them can become as searing as a hot tin roof. According to lore, the waves and irons are nicknamed after François Marcel Grateau, who introduced the process of waving hair with heating tongs in 1872 out of his tiny salon in Montmarte. After he waved the hair of beloved actress Jane Hading in 1884, all of fashionable Paris was at his doorstep. L. Pelleray of Paris created the tongs, which were heated over a rectangular gas burner. Imagine the inconsistencies in temperature. By 1924, there were irons on the market that could be temperature regulated . . . somewhat.

What distinguishes these tools from other irons is the contrasting levers that clamp down on a section of hair and push it into a big S curve. I once took my collection of old irons to an electrician to have them recalibrated. He refused. I still flirted with them, which wasn't really a good idea. Suffice it to say, there is a very good reason my hairdresser friends call these discontinued devices "hair burners."

While most of us freely interchange the terms *marcel waves* and *finger waves,* there are some experts who insist the former only refers to those waves executed by heated tool. Where's the poetry in that?!

Name-calling aside, when it comes to waves, I've dedicated time and practice to the skill. As I've shared, I am an advocate

of frequenting beauty schools. Students always need to try new techniques, and when I myself was learning to perfect my look in the early 1990s, my hair became of service. As a "client," I closely watched every step, and no more intently than when I wanted to scrutinize the mystery of pin curls and finger waves.

Sadly, not many beauty schools these days are getting requests for finger waves. Yet this technique requires skill, and skill comes with practice. Without it, too many beauty school graduates lack the facility to wave.

I always made a point of visiting schools specializing in Afro-textured hair because the instructors there still consider finger waving worth knowing, and well. It's truly mesmerizing watching able fingers move a wet set into a wave pattern, with or without the help of clips and pins.

There was a beauty college in Orange County, not far from where I lived, that I would frequent. An elderly gentleman helmed this school, and he was a master of marcel. With me in the seat, he would wow his students with a flurry of fingers and clips and setting lotion, forming amazing waves before stationing me under the dryer.

There are countless ways to finger wave hair. No matter the method, the aim is to create an S pattern of soft ridges with hair. Yoyette clamps, setting lotion, a rat-tail comb, and fingers are all that's needed in most instances. A setting lotion or gel, along with a spritz of water if hair dries quickly during the waving, will keep the shape after the clips come out.

To do a full head of bona fide finger waves in the technique of my old beauty school master requires time, craft, and skill. This is why I tend to limit the finger-waving effect to around my face. To that end, I've also developed my own shortcuts over the years:

Start by sectioning hair at the front of the face and spraying it with setting lotion. Set with small rollers and let fully cool. After removing rollers and brushing hair smooth, *use the comb and fingers to form the marcel waves.* Use thumb and forefinger in an action that sends the fingered hair ever so slightly in one direction and the bit pressed down on the scalp by the thumb in the opposite. As each S wave forms, hold and clamp.

Give it a blast of hot air and allow the hair to cool. Leave the set in as long as possible. Remove the clamps and give it a blast of hair spray.

As for a magic tool? I have yet to come across a modern incarnation that can truly marcel waves. Yet another line item on my to-do list, as I'm intent on one of these days devising my own signature model.

Hey, Curl, Talk to Me

Friends and strangers alike will share with me: "I don't understand why I cannot do my hair the right way every time."

What is right?

Experimentation is the only way to really get a true read on what works and what doesn't for your own hair, face, and lifestyle. I have slept in sponge rollers and wet sets, and I now know I don't like to sleep in anything. I use curling irons, but mostly as second fiddle to the symphony of movement, body, and curl I get from hot rollers and hot sticks—the more the better. For me, they're the easiest and fastest, and require the least effort.

Yet for all the power tools, styling products, and hope and prayers that go into styling, hair is not going to turn out the same way every time. It takes practice to understand how your very own hair performs. Making sense of it might be a matter of zeroing in on the best styling lotion for your hair type, or knowing how it reacts according to the weather. Maybe it's about too much, too little, or the wrong product. Sometimes it just comes down to a bad set.

Mostly, it is about not fighting the set you've got.

In the process of brushing it out, working it, and playing with it, I let the style unfold. It might be what I planned. It might turn into something fantastic and absolutely new. Sometimes I start brushing and an amazing wave bounces around my face and I yell out, to no one in particular, a triumphant "yes!" Then I clip that great curl into place until I'm nearly ready to walk out the door.

The outcome might even be an incredible moment in time never to be repeated. Or it might never happen, in which case, it's okay to start over. Once on a shoot, Danilo set my hair perfectly, but on brushing it out, he felt otherwise: "I don't like this set. I'm going to set it again." My response: "Set it again, Sam!"

If time allows and a roller set is not cooperating, I *will* set it again. Sometimes the second time around is best. Sometimes only a chignon or turban can save the day.

When all is said and done, I always follow Danilo's suggestion: Let the hair talk to you . . .

Set for Seduction

As I noted in chapter 13, men love watching a woman applying her makeup and fixing her hair. At some point in a new relationship, if an occasion demands I get ready in front of a new beau, I do my "Liz"—so named after Elizabeth Taylor's turn as Maggie Pollitt in the 1958 screen adaptation of Tennessee Williams's glorious *Cat on a Hot Tin Roof.*

Every reveal calls for restraint. A gal has to keep some of her cards close. So when it is too soon to share myself with a full head of hot rollers, I set my hair instead with a curling iron and clips. I do this clad in a silky vintage slip, paired with a pretty bra underneath, just as Liz-as-Maggie does.

While he has you within view, start by gliding on lipstick. When it comes to bright lipstick and applying it, men become

as focused as babies during this simple act. I once had to get ready for Cannes in front of a young French actor I was dating. So I slinked into the slip, hot-barreled my hair and set it in clips, then applied makeup. He was enchanted by it all!

Of course, once a relationship becomes more serious, certainly after marriage, don't ditch the slip and lipstick. But do get back to those hot rollers. They set a curl the best. Besides, there is nothing wrong with eventually letting Mr. Right (well, even if he's simply Mr. Right Then) in on the process. No doubt Dick caught Liz in on the magic more than once—and those jumbo jewels still kept coming . . .

The Perfect Wind-Up: It's How I Roll

Dear Beauty Enthusiast, if there is anything you take away from this three-chapter section on hair, let it be the proper technique for curling!

A successful retro style calls for a successful curl. Straight hair is an alluring feature of many highly glamorous eccentrics, from Bettie Page to Betony Vernon. For me, though, glamorously S-waved hair is an inexplicable personal obsession. Maybe it's because I have naturally straight hair. Maybe it's all those vintage films. One fact is certain: I have a lifelong obsession with waves and curls.

While heat is crucial to volume, the very success of a curl depends on technique, from winding to positioning.

Get to know your curl patterns and curl sizes through play, advises Danilo. "A tighter, small to medium set leaves a tighter pattern," he says, while "larger pinned curls and rollers mean more voluptuous waves and larger curls."

Never begin winding hair around a roller or rod midway on a section of hair. Always start at or near the ends. The biggest mistake made when rolling hair is not taking care that the ends of a section are wrapped around a hot stick or roller and completely tucked in as it's rolled in *toward* the scalp. It's all in the wrist: a synchronous hand movement of tuck and wind, tuck and wind.

What's more, the better a heated roll is fixed on top of the root—instead of loosely below it—the greater the bend and lift of the hair shaft and the more volume is created.

When hair is rolled right, everything else seems to fall into place. If not? I have been known to reset my hair in rollers without a second thought, which is why I never unplug my rollers until I'm ready to walk out the door. With a bit of practice, rolling hair should take fifteen minutes tops, likely less. But the results can last beyond an evening.

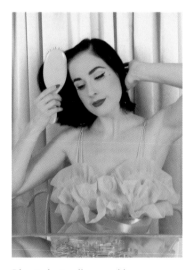 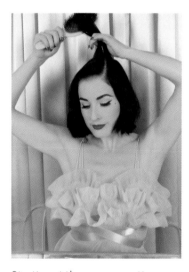 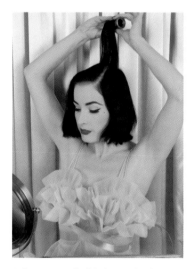 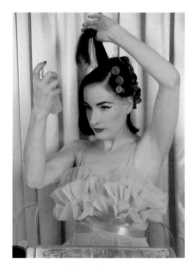

Plug in hot rollers and/or hot sticks (I often use both simultaneously) and as they heat up, comb and smooth your dry hair, carefully disentangling and parting your hair in the direction of the brush-out. Rollers should be good and hot before you start using them.

Starting at the crown, section your hair about one-third to half the width of a roller, maximizing the number of rollers for the optimum curl. Hold a section of hair straight up (as you work down the sides and back, sections will be held outward). Spritz evenly with a light misting of heat protectant setting lotion.

Take care to hold the ends down on the roller surface in a tucking motion as you wind the roller inward toward the scalp. Feel free to use a finger or the end of a rat-tail comb to help hold ends in place during the tuck and wind. Wind the roller in toward the roots so it ends up atop the root base. This bends the shaft for optimum volume. Clip securely against the scalp.

Repeat, working from the crown outward, until your entire head is rolled.

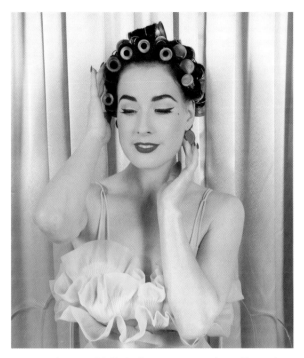

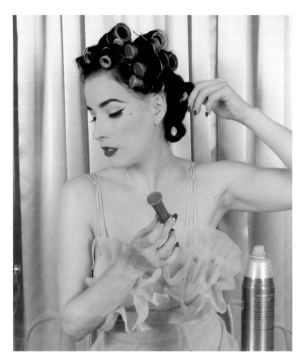

Let your hair cool fully before removing the rollers. This is why I always set my hair before applying makeup or doing any other beauty task, so hair has the maximum time to "cook" and cool.

Remove the rollers only once hair is cool to the touch. As each curl is unfurled, return the rollers to their place on the heat base. This way they're good to go for the next day, and there isn't a sink full of rollers to tend to after a long day or night. Lightly spritz each roll as it is released for added hold.

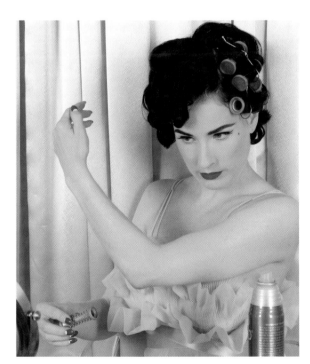

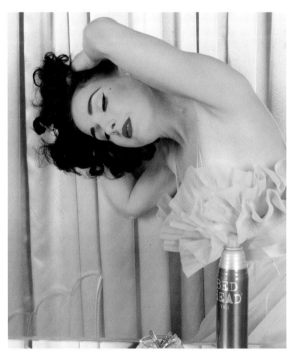

As the rollers are removed, review for any signs of a weak curl and reset for a few minutes if necessary.

With paddle brush in hand, begin brushing out those curls, back to front.

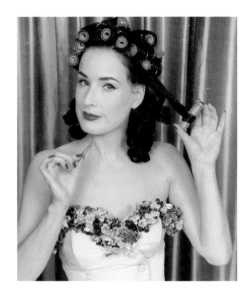

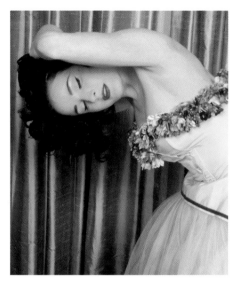

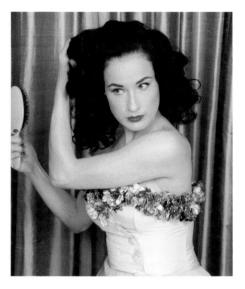

Once a set is cooled and rollers removed, next comes the brush-out. Brushing your hair is no superfluous step, but it doesn't have to be involved or extensive. Nor will it flatten the curl. Regardless of the style, a roller set *must* be brushed out.

Start with your head down, brushing from back to front. I use either my mixed bristle or full-bristle Mason Pearson brush. I might also hit it all with a light aerosol spray for volume before flipping my head back up.

Begin brushing the top layer into the desired style.

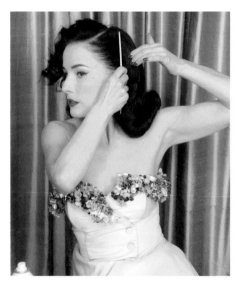

A rat-tail brush or rat-tail comb is also useful, as the long "tail" can help you adjust, tuck, and lift areas as you realize your do.

Continue brushing through the sides and back. As definition and shape get under way, I might fix a wave in place with a clip.

As you brush out your hair and continue blending from top to back and on all sides, only then can you begin determining the style. While this is likely based on whatever style you have planned, be open to how curls are responding and any waves that could be flattering.

Gussy Up Before Grooming

In most cases, as I'm getting ready, I don't have a handsome party of one within eyesight. So for my daily ritual, I almost always dress before finishing my hairstyle—especially when I need to slip a dress over my head.

I tend to remove my rollers, throw on the dress, and *then* brush my hair out. Otherwise, in the interest of keeping the rollers in as long as time allows, I will do everything else first in the beauty ritual and then finally remove the rollers, brush out, and set and spray my hair before walking out the door.

I might even slip my stockings on and wrap up most of my look for the day, handbag included, before removing a single roller. Once my hair is lacquered to perfection, I don't want to muss it up looking for a bag. I just want to apply a finishing spray and go.

The Best Part

An essential part of any retro-inspired hairstyle is the part. It should always be sharp and neat. Whether a part runs down a side or the center, the best part comes down to your comfort level and what you believe fits your face best.

It's usually a matter of which way the hair grows. This can be why center parts can prove the least favorable for many. Root growth can also mean rethinking a part for a day or two to tide a gal over until there's time to color.

Where you part your hair during the roller stage does not have to be the same as where it's parted for styling. In fact, a hairstyle can get a boost of fullness by creating a new part in the reverse direction after the brush-out.

A side part can give glamour an edge. The deeper the side part, the more glamorous: think of Ginger Rogers, Bette Davis, or Jessica Rabbit. Diagonal parts can also be glam, as long as they are sharp and neat, and can work beautifully on heads with thinner hair.

The Tease

Teasing, ratting, or backcombing. Whatever you call it, the process leads to the same end: bigger hair.

Backcombing with a rat-tail brush or comb roughly frizzles and tangles hair, giving rise to a wooly texture and a poufy voluminous mass. The movement toward the scalp, in the opposite direction of its natural growth pattern, repeatedly rubs against the cuticle of the strand, creating this effect.

Necessary evil as it is to achieve some hairstyles—including a bouffant or beehive—be aware that ongoing, excessive teasing can eventually weaken strands and break hair. Whenever possible, minimize the practice by adding height with hairpieces or rats. Always approach the process with a gentle hand. The aim is for hair to be fluffed—not matted.

Hair a second or third day after washing typically responds the best to teasing. According to Brigitte Bardot's hairdresser Jean-Pierre Berroyer, teasing as little as possible keeps hair from actually looking like a rat's nest. Instead, he advised, wash hair only a couple of times a week, use dry shampoo in between, brush lavishly, and trim the ends every couple of weeks.

As Dorothea Zack Hanle cautioned in her 1964 guide, *The Hairdo Handbook*: "Teasing is only an aid to a style—not an excuse for one."

- Holding a one- or two-inch-thick segment away from the head, comb through to smooth it out.

- Continue holding the section upward and, taking the rat-tail comb or brush in the other hand, run it about an inch from the scalp in downward strokes. Repeat an inch higher until the end is reached.

- Let go and repeat on the next small section, backcombing downward each time throughout the length of the segment.

- Once the entire section requiring the lift is teased, gently brush the surface smooth, beginning with the least and last teased portions. Keep smoothing over with the brush and hand, reviewing with a hand mirror and wall mirror, until it's uniform.

Finishing Freeze

Happiness is a dizzying, stifling cloud of hair spray. Soft, touchable hair is not my thing. I do not want to see through a set that's splitting. I strive for a uniform, lush-looking curtain of hair.

Lovers and friends make fun of my obsession with hair spray. They know that when the "shhhhh" starts, only then are we close to leaving the house. On the odd occasion that I work with hairstylists, I tell them, "When it starts looking like a wig, you've got it right." It's one topic Beth Ditto and I bonded on immediately. We agreed that being asked, "Is that a wig?" is the finest compliment one can bestow on our hair.

There are exceptions, no doubt. I might be a little more forgiving if it is a date. (This is not the same as adapting your look to please a beau. That, my darlings, is a cardinal sin!)

A can of hair spray should never be too far out of reach. In my bag or car, there are travel-size cans—because I really hate having a bad hair day.

I have my go-to hair sprays, and I usually go to them during the same styling session: Tigi Bed Head Masterpiece Massive Shine in the blue can, which provides super hold and super shine; the European formulation of L'Oréal Elnett Satin hair spray, as much for the softer, brushable hold as the gold can with the vintage doodle of the coiffed woman; and, of course, my own signature hairspray in the white can with my caricatured image on it. When it comes to beauty tools, it's not only the inside that counts, but the packaging, too!

Shoot from ten to twelve inches away from the hair. If a deflated spot in the hairstyle transpires before walking out the door, spray the heck out of it again. Give it a spray of serum for shine and you're set to go.

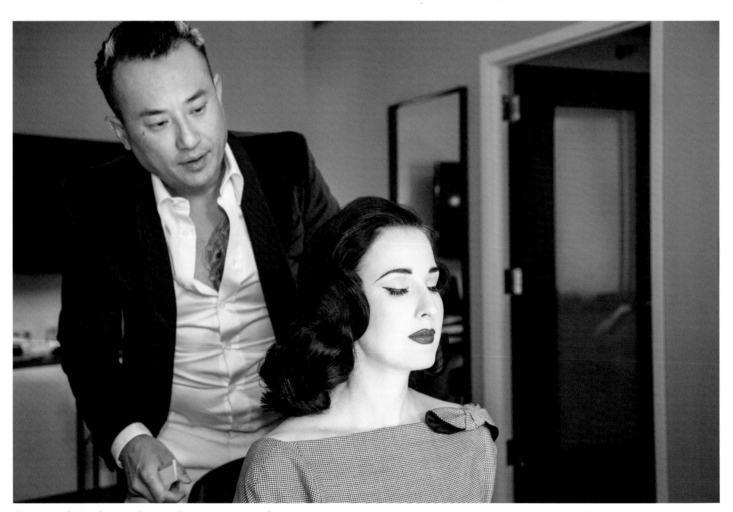

On some photo shoots when I'm home in Los Angeles, my mane man for realizing my signature waves to my standards is John Blaine.

Crowning Memories of a Grande Dame

Rose: Elizabeth Taylor's hair had long ago gone from jet black to a softer tone of blond gray when I saw her onstage at a 2001 benefit concert for the Elton John AIDS Foundation and AIDS Project Los Angeles (APLA). I was a guest of John Demsey, group president of the Estée Lauder Companies; among his longtime responsibilities is MAC Cosmetics, and our seats inside the Universal Amphitheater seemed like the best in the house.

After a few words, Dame Taylor left the stage and Elton took to the piano with the first of many guest artists that night. When I returned from the bar, I took my seat again, only to find that my perfect, unencumbered view was now obstructed by a big mop of hair . . . Elizabeth Taylor's hair! The heck if I cared if I could only hear and not see the music that night. I was within sniffing distance of all that hair spray exuding from the legend herself!

Dita: Now, that was a woman who loved her hair spray. . . . Christian Louboutin shared with me the time he was helping her get ready in her Cannes hotel suite for one of her legendary amfAR fund-raisers during the film festival there. She was spraying and spraying until it seemed she emptied the entire can of hair spray.

Laughing hysterically, she declared to Christian: "I'm helping to save the lives of people with HIV . . . but I'm sure killing the ozone layer!"

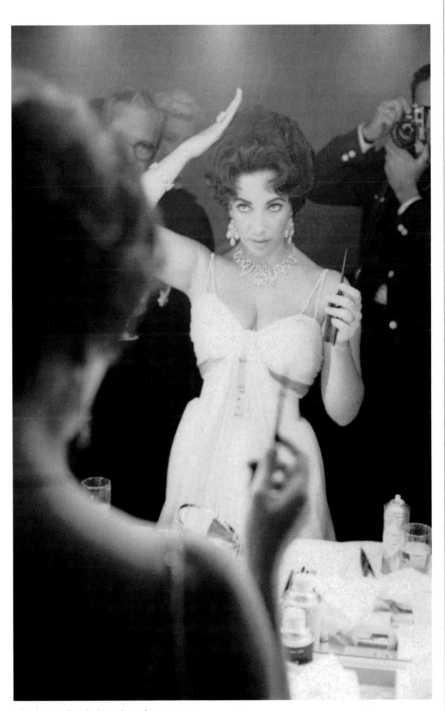

The legend polishing her do in 1959.

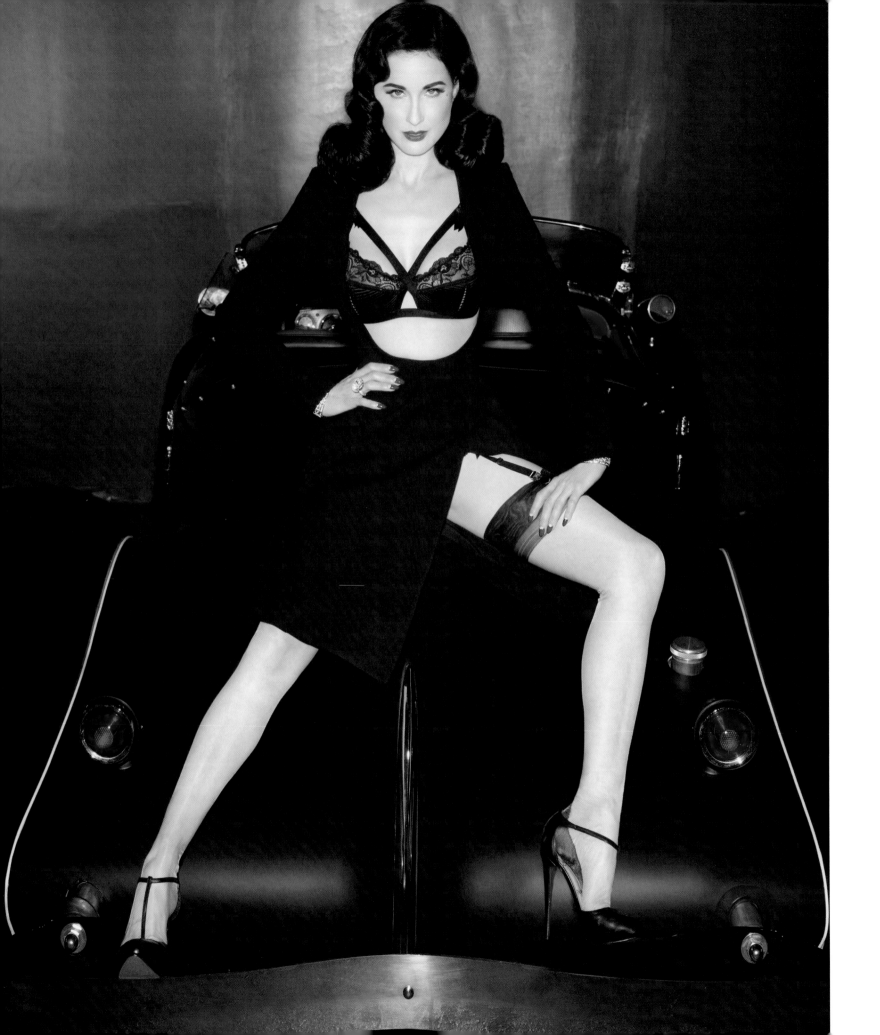

Taming Flyaways

One of the gifts of being able to subject myself to the able hands of the professionals on set is sharing our tried-and-tested tricks, such as these finishing steps to any style:

I learned from a hairstylist in Japan to take a cropped, flat-pile powder brush (a dome powder brush works as well, just reserve it for hair and not the face!) and spritz it with hair spray. Quickly run the moistened brush over any baby hairs on the top, sides, back, and hairline.

From Danilo, I learned to use the actual hair spray can to "iron" out any wisps in the back where it's tough to reach. First spray hair, then immediately use the barrel of the can to smooth the body and ends. Keep spraying and smoothing, moving swiftly through the step.

Of course, another surefire trick that also gives hair shine is a couple of drops of serum in spray or drop form emulsified in the palms. Gently run open hands over hair. A mist of an aerosol shine spray—such as Bed Head Headrush by Tigi—adds gloss while not disturbing the do.

Don't forget to suds any product off your hands and nails. In a pinch, another remedy that requires no hand washing at all is a drop of hand lotion. Emulsify in palms and gently smooth away errant baby hairs with the moisture and weight of the lotion.

Too Pressed to "Do" a Thing?

My chignon didn't become a signature by accident. Sure, I like to play up my Spanish heritage, and will go so far as adding a couple of silk roses or ornate tortoiseshell combs.

But there is a more practical reason: a bun is the most levelheaded option I can muster as I navigate life in overdrive without looking harried.

With a fine-toothed comb, a dab of gel, and a couple of coated bands (to minimize stress on roots and tension on hair overall), I can fix a slick chignon into place in a snap.

Comb a smidgen of gel from the hairline through to where the base of the ponytail will meet with the coated band. Once smooth all around, fasten the hair into a ponytail with the band. Twist and coil the ponytail into a bun. Affix with hairpins or another hair band. An inside tip, courtesy of Dita, on observing flyaways from my bun, is wrapping the twisted coil with a fine hair net.

Or pump up the volume on a basic ballerina bun with a round rat of any size (a rat tube can also be formed into a doughnut shape).

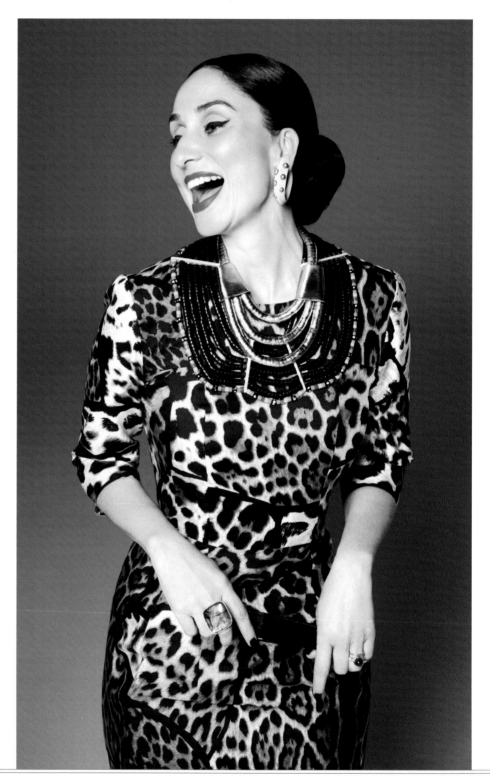

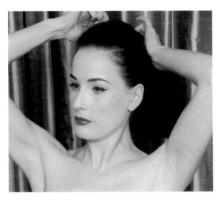

Pull hair back into a ponytail wherever you would like the bun to be positioned, be it the crown, the nape of the neck, or, in this case, somewhere in between, yet just above the center of the rat. (If you want or need more hair or length than you naturally have, consider a thick switch!)

Flop the ponytail over the top of the head and position the rat where you want the bun to ultimately sit. If it sits just above the ponytail it will cover it.

Affix the rat foundation securely with hairpins.

Fold the loose hair from the ponytail over the rat and brush it smoothly over the rat to cover it.

Tuck the loose ends under the rat and pin. Intermittently, interrupt the pinning to comb smooth any strays or bumps, and to survey the emerging do with a hand mirror and wall mirror. Ensure the rat is completely covered.

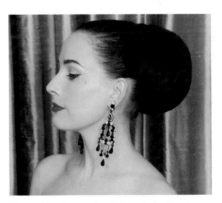

The added oomph of this six-inch rat results in a sculptural form that looks like a million bucks—but really just comes down to an inexpensive rat and a handful of hairpins . . . and fancy earrings.

Let the Good Styles Roll

There are hairstyles so entangled with a moment in history that they require little else in terms of makeup or clothes to strike a chord. The bob is a hallmark of the Jazz Age, just as Victory rolls herald the 1940s and not simply a World War II fighter plane maneuver.

Throughout the 1940s and 1950s, it seems hair was rolled from every direction: top forward rolls, side reverse rolls, half-wave pompadours, forward-rolled bangs, and pin-curled modifications going this way or that. The front section of hair could be rolled into a single sausage-like form or curled into a mass of smaller coils and piled on top of the head in the spirit of Betty Grable.

When it comes to rolling hair, some of the best shows of variety are among the gals attending the rockabilly weekenders or vintage car festivals. What marvelous feats of coiffure! Bravo, ladies!

My own repertoire of rolls is similarly endless. Learn the following and experiment from there. Keep in mind: rolls do not have to be over the top. Bigger isn't necessarily pretty or even practical; nor are rolls that are rigid and straight. Aim for a size and shape that fits your face and personality.

Have on hand a brush, thermal-protecting setting lotion, hot rollers, a curling iron, hairpins, a mesh tube, a rat-tail comb, and hair spray.

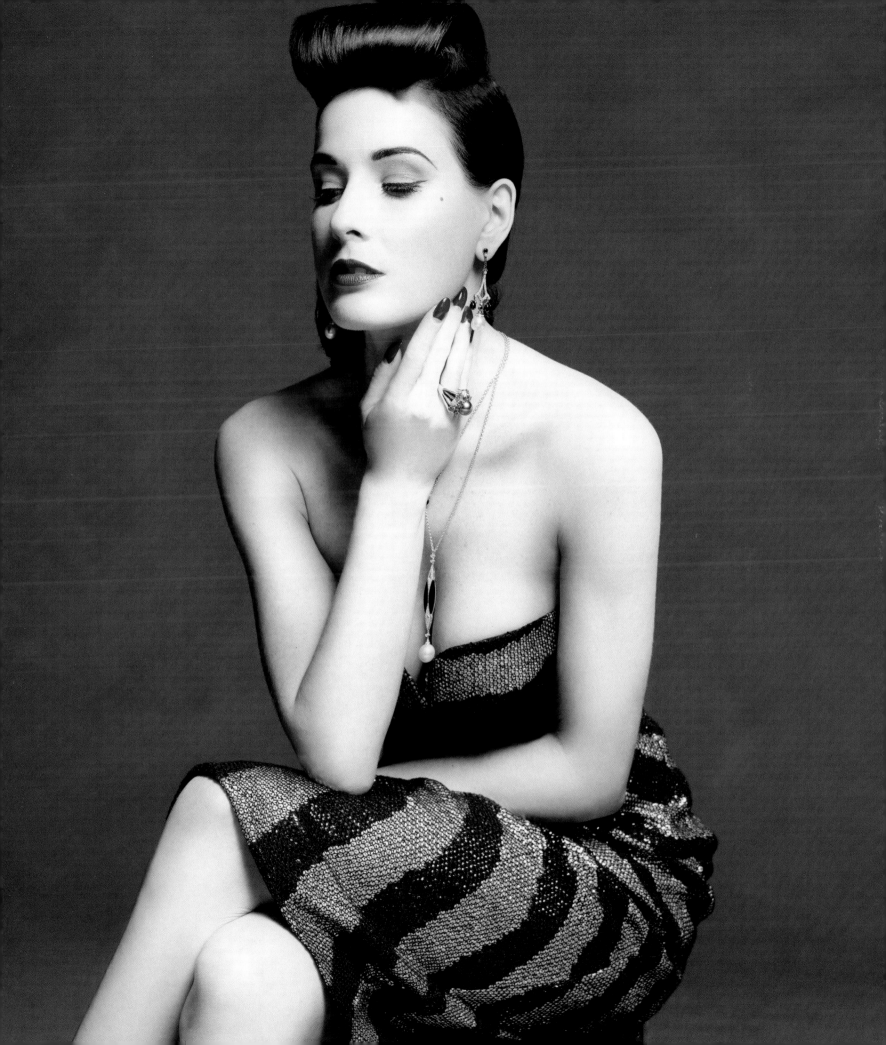

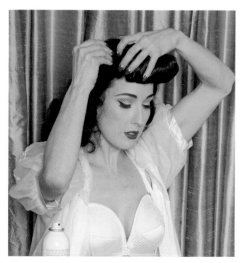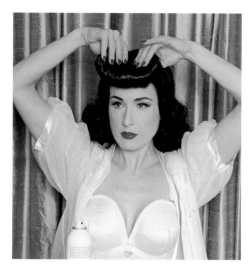

Forward Roll Bangs (a.k.a. Bumper Bangs) This hairstyle creates bangs even without bangs. Some books on vintage hairstyles insist hair for bangs be no more than five inches long. But I manage to achieve the effect with no bangs at all—an option I prefer because bangs can be limiting when it comes to all the hairstyles I like to play with.

After a roller set and brush-out, start at the front hairline, sectioning hair with a rectangular parting between the hairline and the middle of the top of your head. How thick the section should be will depend on hair texture and will become apparent with practice. Need a bit of volume? Tease at the root and underneath the length.

Comb smooth and spritz with hair spray. Wrapping the ends of the sectioned hair over a mesh tube, tuck the hair evenly around the rat as you wind it toward the scalp.

Gently work the formation to curve upward on the ends while pinning it securely into place.

The formation should not resemble a rigid rod. My ideal bumper bang has a slight curve like a sausage, and can be more easily achieved by keeping ends relatively smaller than the center. Test it out by fanning hair at the ends of the roll to ensure it's secured into place and no part of the tube is visible. Review from every angle again with the aid of a hand mirror. With practice, the number of pins should become fewer. The goal is not about minimizing pins but maximizing the hold of a perfect style—and, always, ensuring hairpins are hidden.

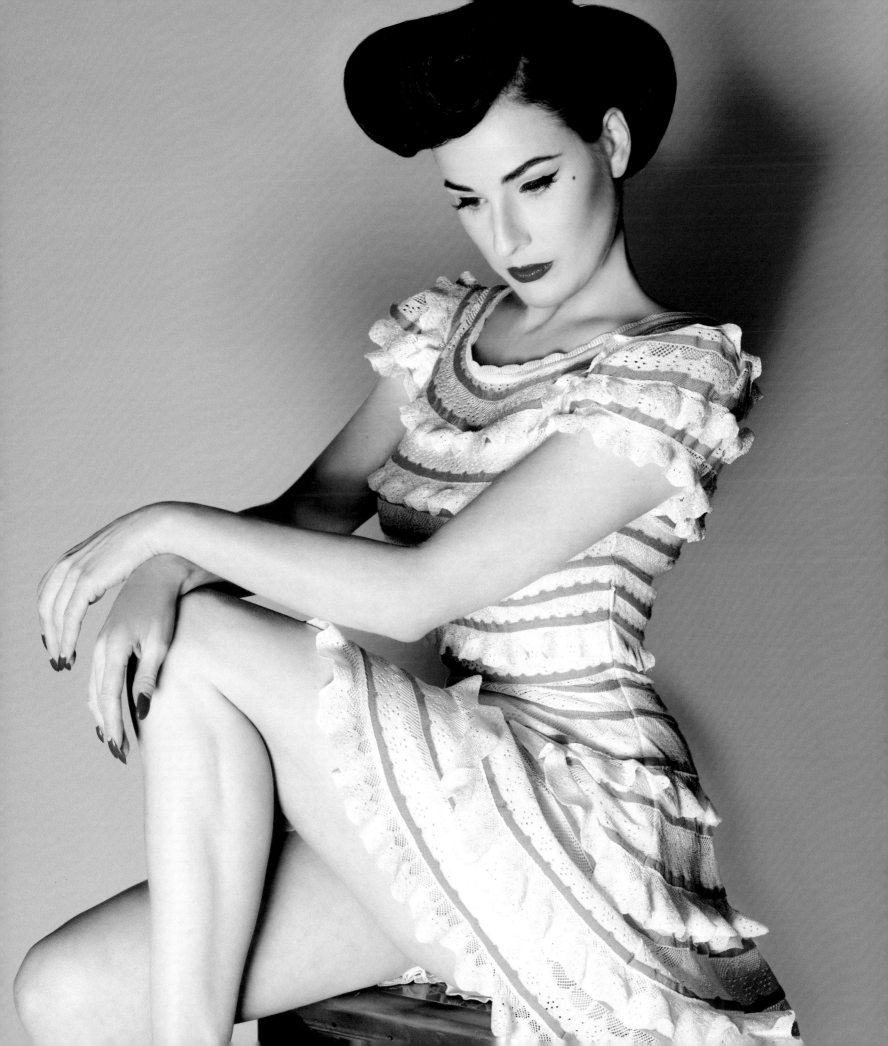

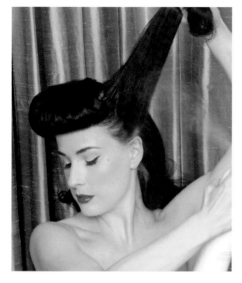 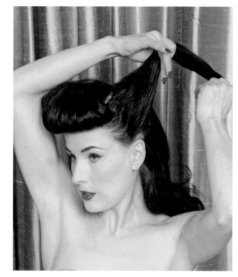 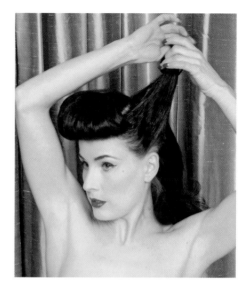

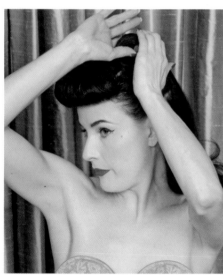 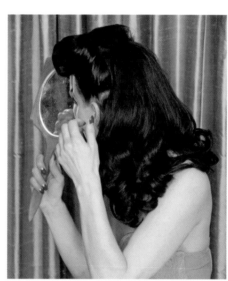 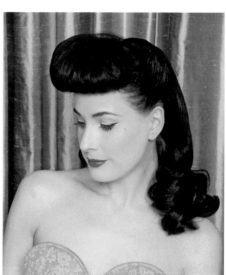

Side Victory Rolls with Bumper Bangs Rolls can be worn according to where you part your hair: equal-size rolls on either side of a center part; one larger and another smaller with a side part; or a duo of rolls at the sides of bumper bangs—which is what I will illustrate here.

Once bumper bangs are completed, take a section of hair at the side, above the ear, about a couple of inches wide. Length is actually an asset. A rat-tail comb is useful for sectioning. Spray and tease a bit at the root for lift. Stretch out the section and comb or brush the length smooth again. Spritz lightly with hair spray.

Begin winding the hair with your thumb and forefinger.

Roll toward the scalp. This coil of hair should be smooth and pretty. Pin into place, taking care that the pins are pushed straight through, perpendicular to the length of the roll, to conceal them.

Review from all angles with a hand mirror, taking care that the pins are not visible anywhere. (Keep a couple of hairpins in the purse you'll be carrying just in case any part of the roll or style needs taming.)

Smooth any loose or flyaway hairs into place by carefully running a cropped or dome brush spritzed with hair spray over the surface. Finish with a generous gush of hair spray.

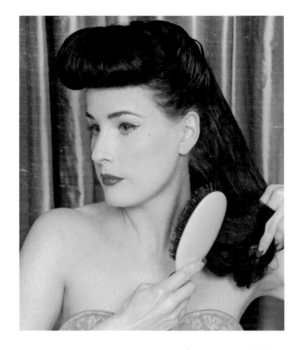
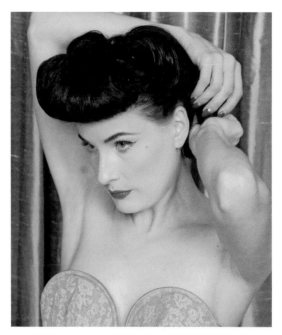
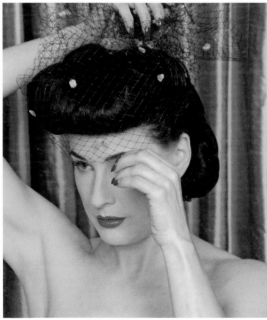
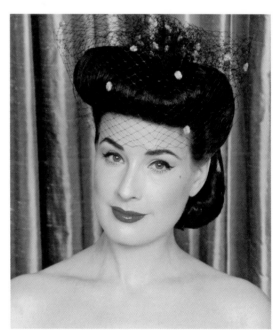

Bonus! Bob and Birdcage Sides and front pinned, so why stop now? You're on a roll! Cup long locks into a bob, and add a birdcage veil to pretty effect.

Brush smooth loose hair.

Section your hair and, using both hands, wind it with your forefingers and thumbs. Pin it into place at the nape of the neck, or use a hairnet. Survey with a hand mirror to ensure all the hair is pinned up neatly.

Position netting into place and fix with two or three pins.

Review the do from all angles and finish off with a final mist of hair spray.

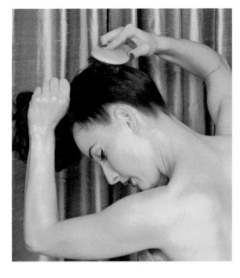 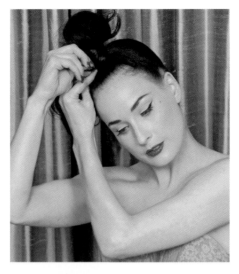 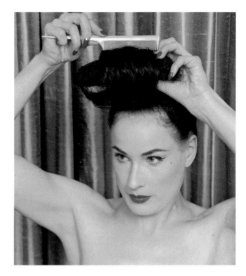

Betty Grable,
circa 1942.

Peekaboo Do This is an updated variation on the curl pileup Gypsy Rose Lee favored and Betty Grable made famous, and which is frequently referred to as a "peekaboo" in a nod to her famous cheesecake pose by Frank Powolny (see chapter 15).

Once the roller set is brushed out, gather hair into a ponytail on top of the head. Brush the sides and back smooth and taut and fasten the ponytail with a coated band. A rat-tail comb can also provide a smoother finish. (An alternative to hair that is pre-set with rollers: once your hair is in the ponytail, create curls from the loose hair by either setting it with hot rollers, or using a small-barrel curling iron and fixing the curls with duckbill clips until they cool and are ready for the next step.)

Take a lock of hair, about a half inch or so, and wrap it around the hair band. This gives the overall look a more polished finish. With the brush or comb, start shaping the do by sectioning and smoothing loose curls.

Take a small section off the side at the hairline. Tease it a bit at the root from the back. Smoothly comb the curl backward in a lifted roll. Pin it close to the hair band.

Gently pull a center section forward, sculpt it into a curl, and fix into place by inserting the pin at a perpendicular angle near the hairline. Continue working other smaller loose sections into pin curls of varying sizes.

The final effect is a combination of a handful of pinned "loose" curls crossing over and under one another. Don't forget to hide any hairpins . . . and to spray the heck out of it all!

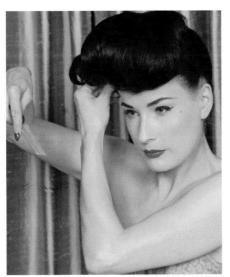

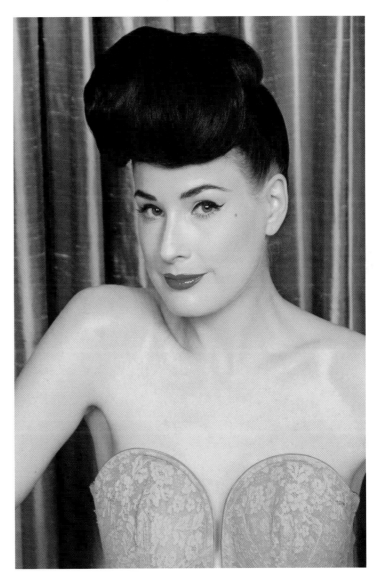

Madame Pompadour This isn't a pompadour in the traditional sense of a combed-back quiff. Instead, it's a voluminous puff of hair that lends a similar profile—yet it's one the Marquise herself would likely have loved.

Smoothly fasten your hair into a ponytail at the top edge of the crown. Wrap a strand of hair, about a half an inch or less, around the ponytail holder or create a small curlicue and pin it to conceal the band (yes, even if it's the same color as your hair); or, once the do is complete, cover the spot with a jeweled brooch, a bow, or other pretty distraction. Affix a large doughnut rat in front of it. Make sure the hair overall is smooth before starting the next step.

Fold the ponytail over the rat and begin pinning it at the hairline. Ensure each section of hair is combed smooth as you pin it under and the form takes shape. Don't forget the sides! A spritz of hair spray as you go along will help to bind coverage over the rat.

Once all loose hairs are pinned, survey from all angles to finesse the desired shape and form. Blast it with hair spray. In the revamped words of Jeanne Antoinette Poisson, it's a piece of cake!

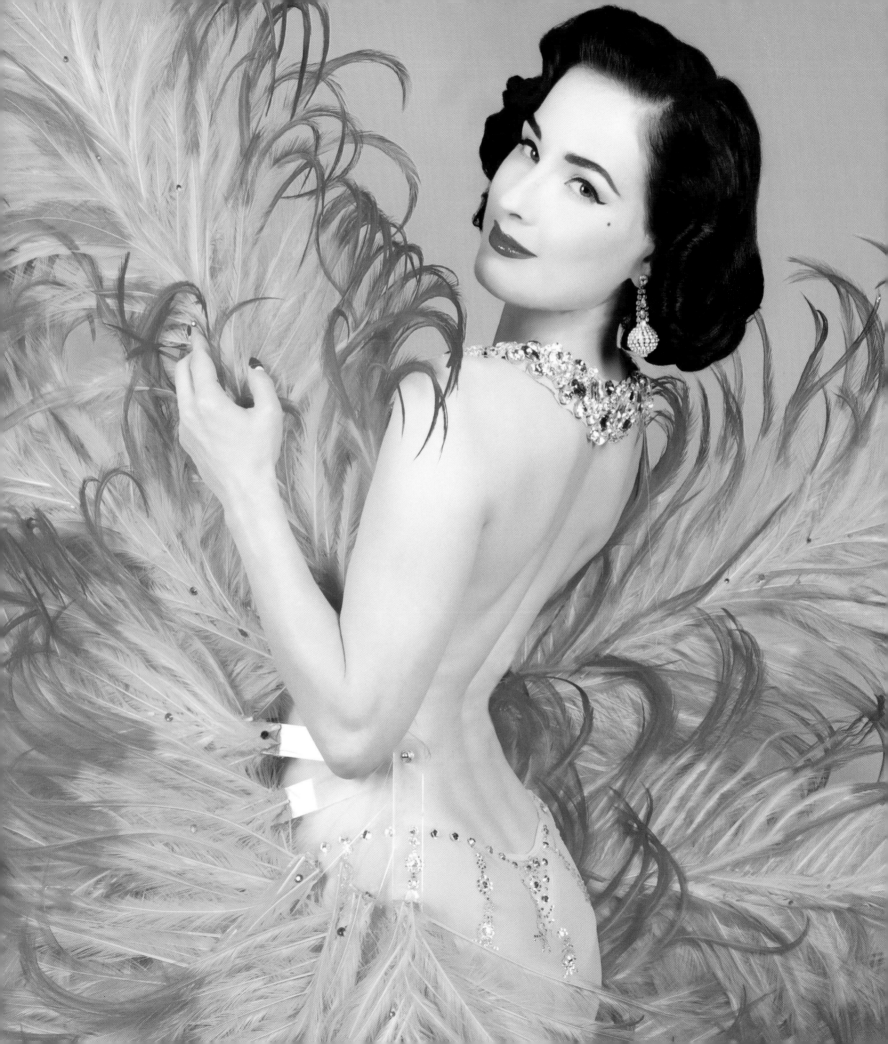

The Pageboy

I have seen this hairstyle and its slight variations on Marilyn Monroe,
Ingrid Bergman, Lauren Bacall, among others referred to as a pageboy.

 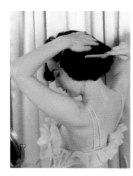 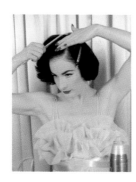 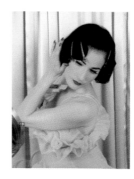 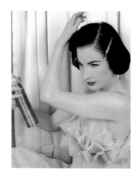

While I've managed to pull off this do (and others) without any layers, with my fine hair, what works best is subtle layering around my face. Friends with thicker hair seem to pull it off with or without layers. Try what works best for your hair type: try a blunt cut first; if it begs for layers, venture steadily. And by all means, let the curl determine the resulting shape.

As favorable outcomes appear with each curl or section, spritz with hair spray. Clip a particularly great wave or curl and leave it in until the very last second. If your hair is long and it's a shorter length you desire, à la Marilyn, begin section by section pinning upward into a kind of bob length, using hairpins to hold it in place.

Use both the rat-tail comb and fingers to form waves.

Where hair scallops inward, clip it. Use your finger to realize a curl inward around the hair- and jawline.

With each step, reach for the hair spray to fix a wave or curl.

Leave it to set while you attend to makeup, dressing, or anything else to fill the time before it's time to set out. Carefully remove clips and tend to any flyaways. Finish off with hair spray.

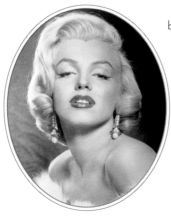

As this 1953 portrait of Marilyn Monroe proves, despite its name the hairstyle is all woman.

The Signature

Channel femmes fatales Rita Hayworth, Ava Gardner, and Jayne Mansfield with this seductive style. It's one I do often because it can be modified according to hair length, part, and how hair is responding on a particular day. Despite what some vintage hair books insist, I've found that layered lengths are optional and any length hair—including a bob—works. The deeper the side part, the sexier the wave of hair draping over an eye. Or part it down the center in the spirit of Hedy Lamarr. I call it the Signature, because this smoothly curled, slightly wavy coif has been my go-to signature style for more than two decades and counting.

After a roller set and brush-out, use a brush, comb, and fingers to smooth out hair, form curls, and shape the ends.

Comb flat above ear and fix it with a duckbill clip and a shot of hair spray.

Continue combing the body of your hair, using the palm of your hand to smooth out the surface.

Intermittently, use the comb to "tuck" edges under. As each section is reached, do not forget to spray.

Patiently work the front and opposite side, with comb, brush, open palm, and thumb. Use fingers to create shape.

Use the end of the rat-tail comb to direct and lift waves around face.

Clip waves in place both at the dip and rise. Generously spray. Leave clips in as long as possible to further set.

Remove clips, spray once more, and go knock 'em dead.

Just don't overdo it on the extras. As with any accessories below the neck, cluttering up a hairdo is a crime against taste and style. Choose one ("one" as in one kind, which can actually mean a couple of small flowers, of course), and let it be.

Don't Tousle the Do

I don't mind Mr. Right running his fingers down my spine or even giving me a swift tap on the bum. A caress to the face is rather nice, too.

But do not tousle my hairdo. At least not until we're behind closed doors . . .

I could just kick Tall, Dark, and Handsome when he makes a play for my perfect coif at a party. A pat on the head? What am I, ten?

Of course, there is a place and time for everything. And, as I cracked one afternoon after a particularly lively coupling—in private, mind you—"Darling, you consumed me—including the curl out of my hair!"

It's not just the straight ones who can prove dangerous to a do, either. One evening, a dear friend of mine, a bit too intoxicated on life and bottomless libations, was so up in my ear, telling me tales, that I could swear the humidity from his breath was flattening my hair.

"Whoa!" I interrupted him. "Your stories are squashing my set!"

Neither Hair nor There

Hair is unpredictable. I have conjured brilliant hairdos and have no idea where they came from or how to later resurrect them.

As Danilo notes, "Don't be afraid to play. Just make sure you are wearing the hair—that it's not wearing you. Beware of any theatrical style that ends up looking like wedding hair. You don't want wedding hair—even on your wedding day! A good hairstyle considers the total package, from head to toe."

I know that no matter what one does—and I know many professionals who will never admit to this—it's impossible to know for sure how a do will ultimately end up. Be open to variation and to creation. Be inventive. The end goal is not a specific hairstyle. The end goal is looking beautiful.

Besides, as I like to remind myself at the most challenging moments, not every day can be a good hair day, or one cannot possibly appreciate the good days when the happy accidents do happen . . .

Exterior Decorating

Half the pleasure of doing hair is all the beautiful embellishments that can complete a look.

Just as a vase of flowers or a gilded frame can provide a room with a punctuation of interest, decorating a hairdo with the glint of a fancy hairpin or zing of a headscarf fastened by a pretty brooch can make a singular statement.

I frequently comb my jewelry trove for something sparkly or unexpected for my hair. A necklace can serve as a dramatic band. Lost the partner of a favorite earring or shoe clip? Give it another life by gluing it onto a barrette. A visit to the local craft or fabric shop can turn up all kinds of creative options, as can trolling the flea markets or Etsy.

This is how I amassed many of my decorative fan combs. Even the odd jeweled or enameled hatpin can do the trick if threaded through a chignon.

Stuff a hatbox or boudoir drawer with silk flowers, jeweled netting, satin ribbons, gleaming barrettes, colored snoods . . . anything and everything that catches your fancy. Rose and I used to decorate our beehives with bitty bees and butterflies from the craft store. A small faux-feathered bird can also be an amusing touch.

Patterned or solid-colored scarves are another wonderful accessory, especially in a pinch.

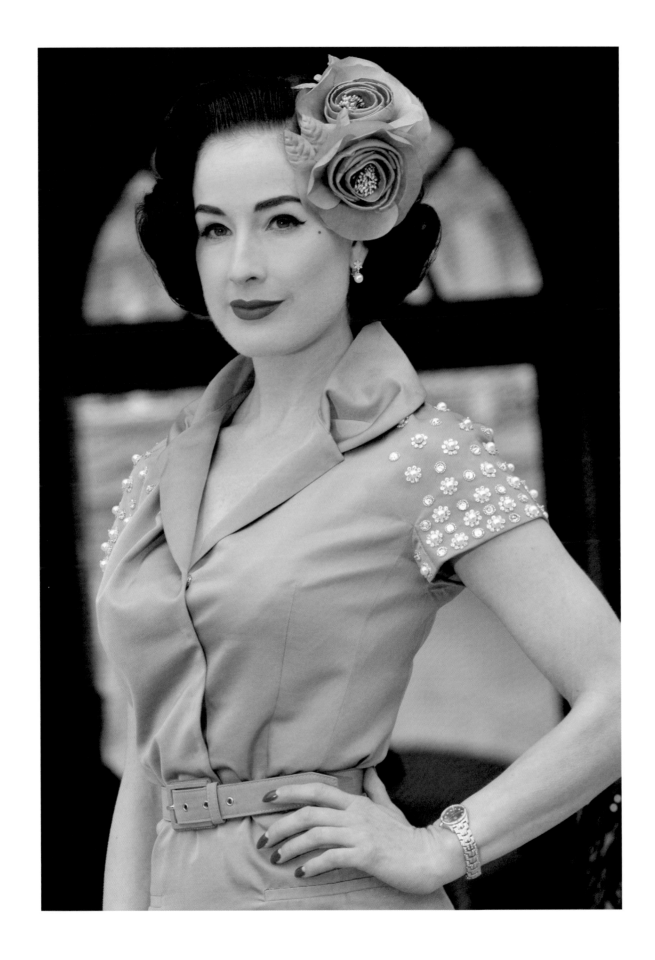

Stages of Beauty

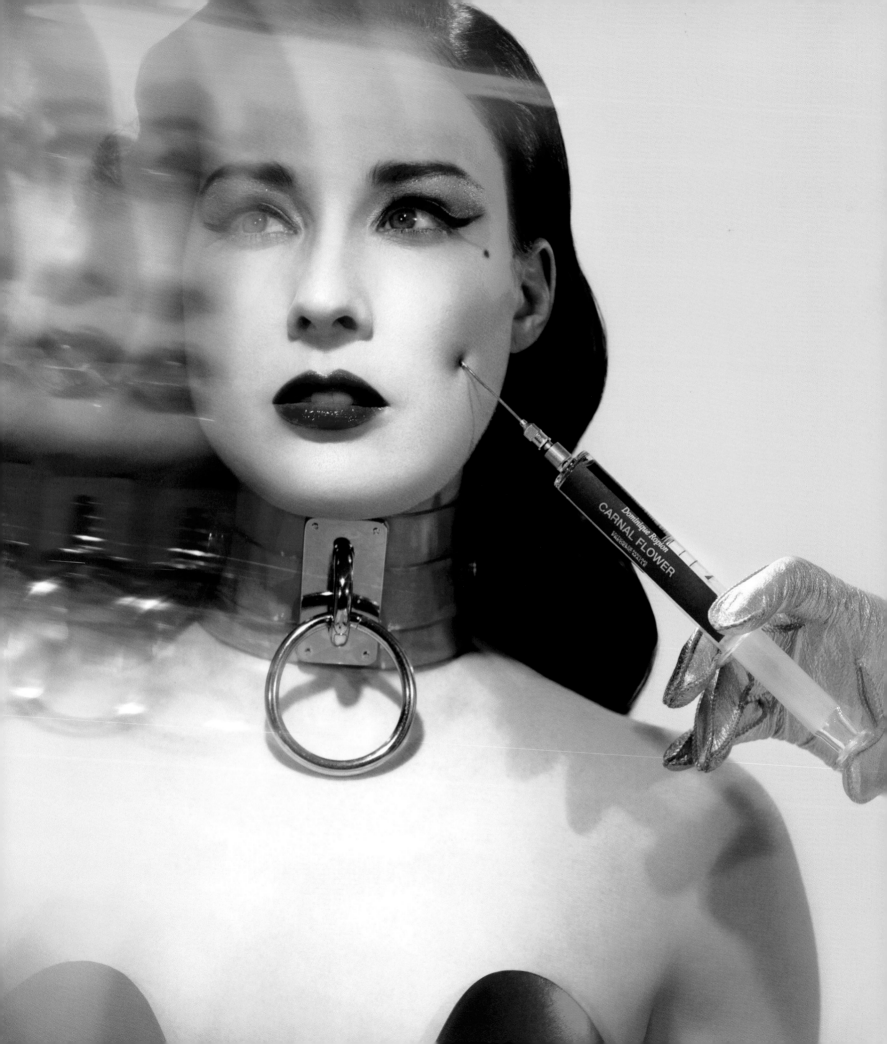

CHAPTER 19

Body of Work

With the spotlight of fame comes the scrutiny of strangers, and none more high and mighty than those "experts" from the wide field of cosmetic procedures—specifically those with publicists.

Publicity-craving doctors have accused me of having had liposuction and a nose job, which couldn't be further from the truth. My bust has had a boost and my beauty mark is a tattoo—cosmetic enhancements I have freely and widely shared since undergoing them many, many years ago. I have nothing to hide.

Yet these tweaks to nature continue to merit headlines, and are usually laced with the tawdry tone of "secrets revealed."

The fact remains that even though I work out several days a week, eat healthfully, and inherited my mother's genes, all of that apparently is not as engrossing among the gadflies who prefer to focus on a two-decade-old procedure and other creative speculation on what I have had "done." Look closely at snapshots of me at a party or on the street, and it's plain as day that my nose is not straight.

My teeth are, and that's because in 2005 I finally decided to get braces. I was never crazy about a crooked incisor that was particularly noticeable from my right side. Always trying to flaunt my best angle (from the left) was becoming tedious. So for some eighteen months I wore clear Invisalign braces. My photographer friend Ali Mahdavi begged me not to do it. He loved the imperfection of my smile. Once they were off, though, he never seemed to notice the improvement. But I did.

From smile to profile, there are those who maintain that any work somehow detracts from the authenticity of my retro-inspired look along with my credibility as a burlesque artist. These naysayers will carry on about how the famous beauties of the good old days rose to glory untouched by doctoring, as if going under the knife was a modern phenomenon.

Blade Runners

The reality is that Hollywood and cosmetic medicine have been intimately entwined ever since director D. W. Griffith and cameraman G. W. "Billy" Bitzer innovated the film close-up. Inside those early illusion factories of the old movie studio system, what a good makeup artist, costume designer, or lighting tech couldn't improve, the outside help of plastic surgery could "repair."

Who would think someone as glorious as Greta Garbo would have to go into the repair shop? In 1925, when Garbo arrived in Hollywood, MGM producer Irving Thalberg commanded that she shed thirty pounds and fix her teeth. She lost the weight and had her choppers straightened and capped. She also plucked her eyebrows pencil thin and applied plenty of eye pencil and mascara to achieve what would become her trademark look.

Such alterations weren't always a triumph. During these early days of the science, these pioneering "advances" in beauty were sometimes more like experiments with career-damaging results.

Exhibit A is Mary Pickford. As her film career began to fade to black in the 1930s, the forty-something actress submitted to a face-lift that left her skin so stretched beyond what nature intended that she no longer resembled the starlet the media once lovingly called "America's sweetheart." It was a look the filmmakers of *Sunset Boulevard* sought for their Norma Desmond, and a role Pickford vehemently refused. Instead, it garnered an Oscar nod for Gloria Swanson, herself no stranger to dabbling in the latest procedures.

Early face-lifts also left Carmen Miranda and Lucille Ball in a perpetual state of astonishment (a look replaced these days by the Spock-like expression of Botox abusers). The year 1958 even saw the cinematic release of *Le miroir à deux faces* (the original *The Mirror Has Two Faces*), a French drama that recounts how plastic surgery transforms a disfigured woman into a *femme du monde*.

By the time Gary Cooper had work done in the late 1950s, the fifty-six-year-old hunk managed to have a nip and tuck without the public finding out (well, at least not until decades later). That's right, tough guy Gary Cooper. Other alpha guys in this club include John Wayne and Frank Sinatra.

Real to Reel

As unnatural as it might seem to change our appearance by way of makeup, surgery, tattoos, undergarments, and clothes, the desire to do so is as primordial as sex. It's simply human nature.

So is it any surprise that in the quest of fulfilling this desire, generations of men and women have submitted themselves like guinea pigs to the newest experiments?

The earliest documented plastic surgery practices date way back to 600 BC. A rather popular, barbaric convention in India to mark sinners by hacking off their noses prompted a few resourceful and empathetic observers to explore the science of nasal reconstruction. Practices spread to other parts of the face and body, and from the East through the Arab world and into Europe through the centuries.

Despite the many miles traveled, the calendar years, and the medical breakthroughs, it wasn't until the twentieth century's rampant carnage from both world wars that technical innovations really changed the face of the entire cosmetic surgery field.

The battle for the box office contributed to the mass-market appeal and accessibility of one procedure or another, since each new wave in Tinseltown trends shined the (surgical) spotlight on yet another physical feature.

Matinee idols and starlets underwent the latest tricks in rhinoplasty during the 1930s and 1940s. Dean Martin was among those who had his nose narrowed and straightened. Marilyn Monroe's doctor

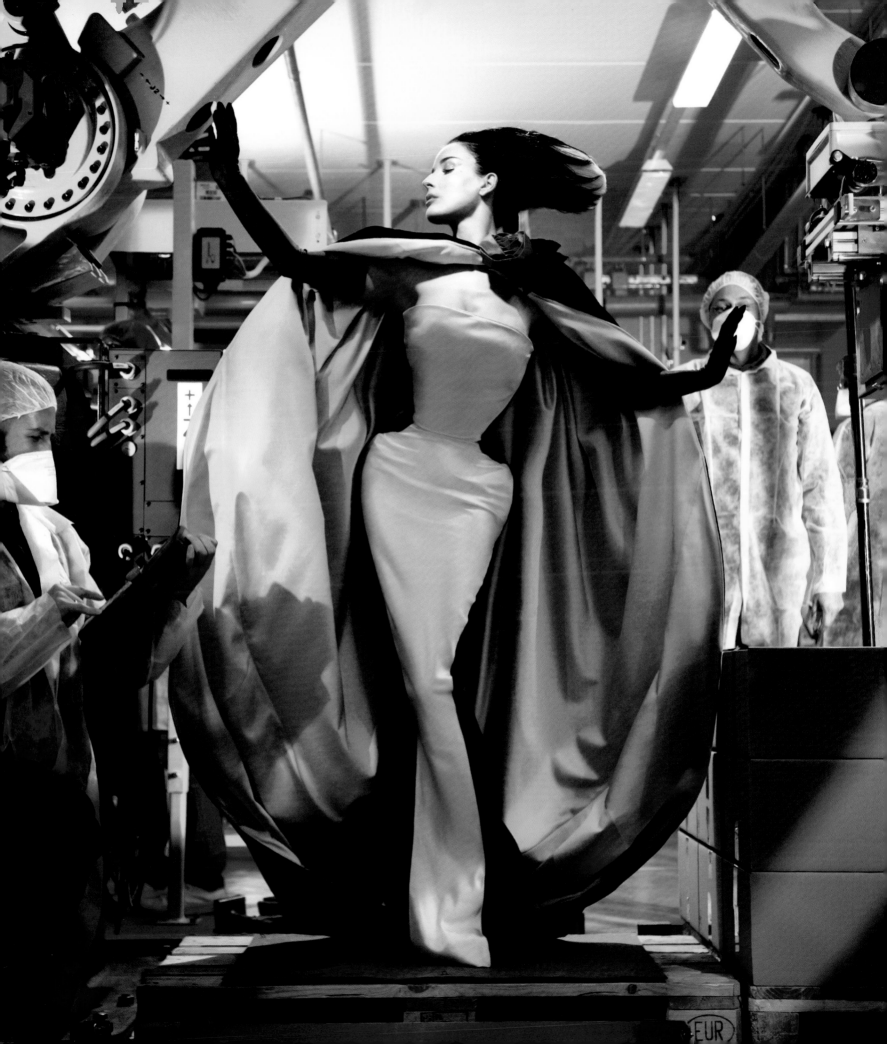

reshaped the soft cartilage in the tip of her nose so it would appear overall slimmer and shift focus to the eyes. In 1950, before she became a major film star, she underwent a chin implant, which in those pre-silicone days was made of carved bovine cartilage.

When the newly invented television came on during the next decade, the small screen only magnified wrinkles, scars, and less-than-"perfect" features. It was all too up close and personal for the comfort level of many actors, who made a quick dash to the surgeon.

Midcentury fans were turning their sights on more than just a flawless face, too. Those torpedo-like ta-tas of the 1950s and braless 1960s prompted many fearless actresses to turn to the newest procedures in breast augmentation. The first boob jobs actually date back to the turn of the century, with implants consisting of natural materials such as paraffin and even ivory! It wasn't until the introduction of silicone implants and injections in the mid-1960s that this cosmetic enhancement caught on.

Into the 1970s, as both story arcs and body parts grew ever more revealing, Hollywood looked to France's newest VIP (as in very important procedure!), liposuction.

Le Hollywood Lift

There were those who opted for nonsurgical alternatives. In a stroke of behind-the-scenes magic, the only snip-snip the popular "Hollywood Lift" required was of silk thread and rubber bands, along with paper tabs and a dab of glue. The facial skin would be pulled tautly back and secured in place, with the works hidden behind locks of hair. It worked like a marvel—as long as the setup didn't snap apart midscene.

Marlene Dietrich was a master of such disguises. From her late thirties onward, she was a habitual practitioner of the Hollywood lift and something like it involving bandaging back the years with surgical tape hidden under a wig or across her hairline. She also pioneered the use of surgical tape to lift and shape the breasts.

For the 1944 film *Kismet*, she and her hairdresser, the nearly equally legendary Sydney Guilaroff, went one step further and wrapped strands of the actress's hair around a hairpin, yanked the hairpin out to the side until it pulled the facial skin smooth, then stuck the hair-wrapped pin along the scalp so tightly it would apparently draw blood. But, hey, it took a decade off the forty-three-year-old's looks.

Dietrich's most inspired innovation came in her fifties, when she would wear a threadlike gold chain under her chin and affix it behind the ears. With the golden hair of her wig helping to camouflage any glimpse of the chain to cameras, the elaborate effect was a lifted chin and smooth neck. Shirley MacLaine, who learned this trick from Guilaroff, confessed years later that while it worked, it did so at a price. "Of course, those of us who tried the gold chain," MacLaine recalled, "all had terrible headaches by lunch!"

I can go on ad nauseum with vintage tales of the knife-styles of the rich and famous, but hopefully my point is made. Cosmetic procedures have been around forever, and certainly plastic surgery is one beauty trick tapped by those under the magnifying spotlight since the earliest days of show business.

When you get right down to it, if anything is contemporary about the whole phenomenon, it's the disclosure of the many early

"On principle, *j'adore* plastic surgery!"

An artist of lighting and lens, Ali Mahdavi is intimate with the illusion of photography. He also holds equally stark opinions on the topic of cosmetic augmentation, as he shares here.

Plastic surgery is a very powerful, magical thing. A great surgeon is a sculptor who works with the human body. Unfortunately, it is an art too often undertaken by doctors and patients who lack taste. Clients have unrealistic desires. They seek the conventional and they become a stereotype, a caricature.

Yet it can be so magical if you have some feature about yourself that you've hated all your life. Maybe you lack a chin. Or maybe you have something removed that has been the source of insecurity.

For me, it was about augmentation. I have a bump on my nose. I wanted it bigger. Yes, bigger! I went to see a plastic surgeon. The doctor used cartilage from behind my ear.

A good plastic surgeon enhances in such a way that an observer cannot tell something has been done; you just have more sparkle.

Dita had a crooked tooth. I liked it the way it was before she had it fixed by braces. I found it cute and sexy. But if she touches her nose, I won't speak to her. Ever. I swear!

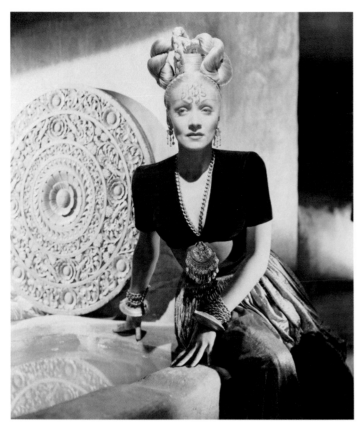

By way of surgical tape, Marlene Dietrich was the master of the "Hollywood Lift."

modifications, whether they transpired at the hands of a doctor or a hairdresser. At least at the start, these beauty secrets were closely guarded instead of plastered voluntarily all over the tabloids.

Since procedures of aesthetic enhancements have been around for eons and are now fodder for weekly rags, why oh why do they continue to reign as some taboo is beyond me. The only sin is an enhancement that is badly done or aesthetically misjudged.

Beauty by a Nose

I am all about championing what makes you feel best about yourself. What I have done and what I will do are my choice. I don't have any interest in the world thinking I'm naturally perfect, which is why I am forthright about it all.

There is beauty in natural imperfections, too, and I know and admire many fabulous individuals who have ignored the advice of critics and friends to have something "fixed." Westernized standards of beauty, especially those heralded in America, can

be oppressive. The upturned button nose and supersized full lips are fragments of a composite beauty. Yet, popular features as they might appear in the world, sometimes those bitty noses and puffed pouts are the result of science.

Going under the knife to fit in can also make for a legion of clones.

Thankfully, there are many others who believe that it's exactly the feature that doesn't meet the so-called standards of classic beauty that defines them.

Imagine the Spanish actress Rossy de Palma or British model Erin O'Connor had they submitted to the mockery and "advice" about their noses. Rhinoplasty might rate second in the top five cosmetic surgical procedures. But these two beauties have made careers on their unorthodox looks, thanks in no small way to their wonderfully large schnozes.

In their coterie of über-cool appeal is Suzanne von Aichinger (see page 338 on her in this chapter). To Jean Paul Gaultier and John Galliano, who both considered Suzanne their muse for years (as they did de Palma), an integral aspect of her towering beauty is that sniffer of hers.

Would she have scaled such heights had she had her nose fixed? Like de Palma's and O'Connor's, Suzanne's appearance—including her "imperfect" features—makes her extraordinary.

With a profile as bold as her personality, the divine Diana Vreeland observed in one of her famous memos in August 1967: "The little nose was considered cute because it reminded one of piglets and kittens. . . . Please say in this piece, 'Think twice before you alter your nose' . . . as noses are inclined after alteration . . . to drop and all the lines of sensuality and expression will never come back properly. . . ."

As Sir Francis Bacon so aptly put it: "There is no excellent beauty that hath not some strangeness in the proportion."

The Muse: Suzanne von Aichinger

Suzanne von Aichinger personifies sangfroid and elegance. Born in Germany and bred in French Canada, before she'd grown out of her teens, she was in New York City striking a pose in vintage Charles James for the legendary illustrator Antonio Lopez and Halston. Then it was off to Paris and onto the runways for Yves Saint Laurent, Thierry Mugler, and Claude Montana, before becoming muse to Christian Lacroix and muse-consultant-stylist to John Galliano, Jean Paul Gaultier, and Alexandre Vauthier.

Suzanne is the third-born in a family of two boys and two girls, yet every inch the individual. She stands out at five foot nine and a half—without heels. With her razor-sharp features and refined eye for wardrobe, her stature as a style icon far out-towers her standing on the tallest of heels. As Loulou de la Falaise has observed of Suzanne, she is "the modern archetype of the Parisian woman."

A Paris resident for years now, Suzanne consults, performs as a singer, and, when I'm in town, gets up to all kinds of trouble with yours truly, on the set with our collaborator Ali Mahdavi and off set. Here, Suzanne shares her insight.

By the time I was ten, I was taller than most boys. That did make me feel different. But there's a dichotomy between wanting to fit in and wanting to embrace differences. I was aware of my height, but I never slouched. I have a bump on my nose. But I never considered changing it. Even as a child, I loved a beautiful distinguished profile. I even love cats with big noses.

I find noses can be very chic and very sexy. Two of my heroes growing up were Alice Cooper and Keith Moon, and these weren't guys with cutesy noses. I also found Donald Sutherland devastatingly handsome with his prosthetic nose in *Casanova* by Fellini. When I was backstage with Violetta Sanchez and Betty Lago—two beauties with famous profiles—I could not stop staring at them. They were so exquisite. To me, their noses are the maximum of chic. Antonio would often draw me in profile. I quickly understood that my nose, my profile, was an asset. He once said: "You are not a strange beauty. You are a classical beauty."

All the designers I've worked with adore my nose. If I hadn't a sense of security concerning my looks, I might have made a huge mistake and had a nose job. I dislike nose jobs. But I also understand and do not judge if someone doesn't feel comfortable or wants to do a little something about it. My differences were not so much physical. My differences were interior, in the way I viewed the world.

My great love is music. I daydream in music. As a girl, I liked everything from Thelonious Monk to Leonard Cohen. But I was obsessed with Alice Cooper (only with his original band!). I couldn't think of a more ideal person in the world than a man named Alice. It was a revelation to a ten-year-old girl! He wore makeup and corsets and high-heeled boots. He was glamorous, yet virile and masculine. I loved the ambiguity. There was darkness in the songs, yet they ended in a kind of joy. He is so flamboyant and became part of my DNA.

As a teenager, I learned to make my own clothes and tailor vintage pieces to fit. I was always the best-dressed seventeen-year-old, wearing 1920s chemises and 1940s suits . . . and kimonos. I was super glamorous on $2! It's so rewarding finding a little treasure. Of course, I love modern fashion. I see many things I desire. But I have a weakness for vintage stores. After all, it is where designers go for their research.

When I arrived in New York, I had a womanly figure and didn't look like a child. Although I did have braces! When I met Halston, I was very nervous. But he chose me to be in a show he was staging honoring Charles James at the Brooklyn Museum [in 1982]. It was a time when Christie Brinkley and more commercial beauties were "It," so someone like me was unusual. But I wasn't being hired to jump around in a swimsuit.

I love going out with clean, fresh skin. I also love over-the-top makeup. I'm wearing bright blue shadow now. I don't do it every day. But when I do, I like to stick my fingers in the turquoise, cobalts, and reds and really go to town, like a Warhol, a bit messy like that. It's all or nothing.

Differences are beautiful and intriguing and mysterious and fascinating. What I do not tolerate is cruelty. I have deep admiration for the courage required to be different. I'm not talking about the fake eccentrics, who seem to be a dime a dozen these days. The person who is living the dream of who they truly are, this is the eccentric, or simply, the person who is truly courageous.

Everything comes from within. Style is an exterior manifestation of what's happening inside. I said to Dita that my whole career is due to my nose. But it's not just about the nose or my height. What really turns on the photographers, illustrators, and designers is what's in your head, your demeanor, the relationship between your body and clothing and the way you move in their work. That is what they are looking for. A muse is a woman who is using her intelligence, culture, and intuition. If you're not using your head and your heart, you're not going to inspire anyone.

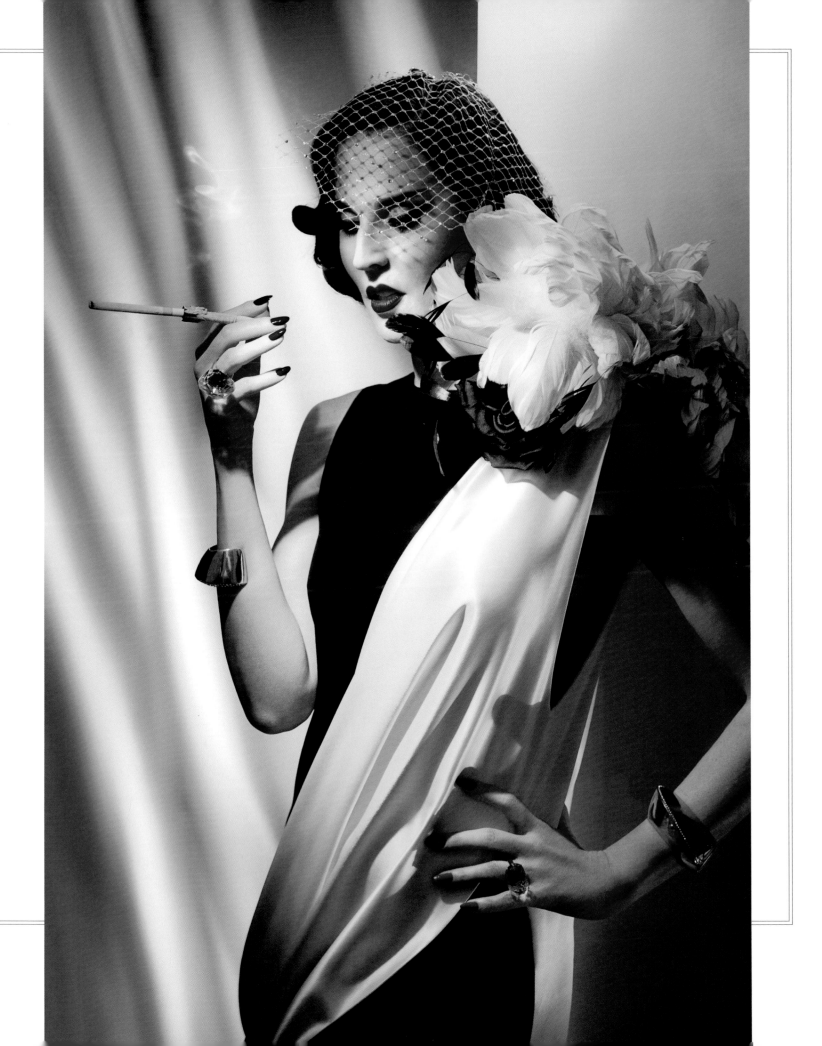

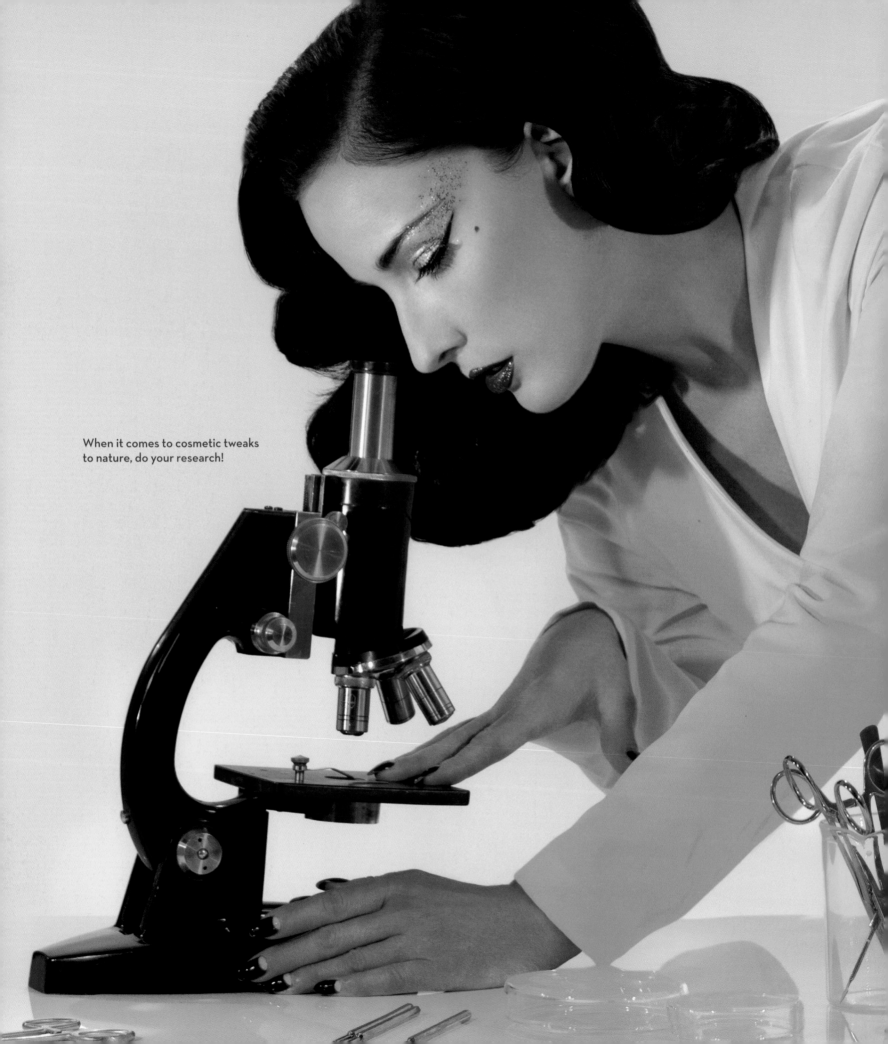

When it comes to cosmetic tweaks to nature, do your research!

It Cuts Both Ways

From Botox to a bum lift, the results lie in the hands of the practitioner. Talent is as much about aptitude as experience, and a doctor with gads of both is a doctor worth considering.

I meet women all the time who tell me, and quite unabashedly, "Your boobs look so great. How come mine don't look like that?" The evolution of techniques is continuous, and, at the time I underwent my procedure, I opted for saline implants over the muscle. Yet I never cease to be amazed by the response too frequently shared by some of these women, most of whom have gone for implants under the muscle: "Oh, I didn't know there were other ways. . . ." I can't believe my ears. Yes, there is always more than one option!

The choice I made might not be right for another body. A doctor, too, can make all the difference when it comes to skill and aesthetics. By the time you read this there will no doubt be advancements unimaginable even a year ago, so explaining the pros and cons of my procedure versus others is a moot point. To wit, after a decade of waiting, in February 2013, plastic surgeons celebrated the FDA approval of the implant dubbed the "Gummy Bear," a stable, shaped breast implant for general cosmetic use. No sooner had the news broken than articles were already circulating about stem cells possibly becoming the future of breast augmentation.

What's more, no single option is right for everyone. It depends on existing breast volume, and influences such as lifestyle and expectations. What I do urge you to do is *research*!

Step one when it came to my augmentation was to interview as many surgeons as possible. I'd lost significant weight in my late teens and early twenties thanks to too much fun in the rave scene. I straightened out and regained a healthy weight level. But no amount of exercise was going to boost my breasts—or my confidence level. So I decided, at age twenty-one, to bump up my cup size.

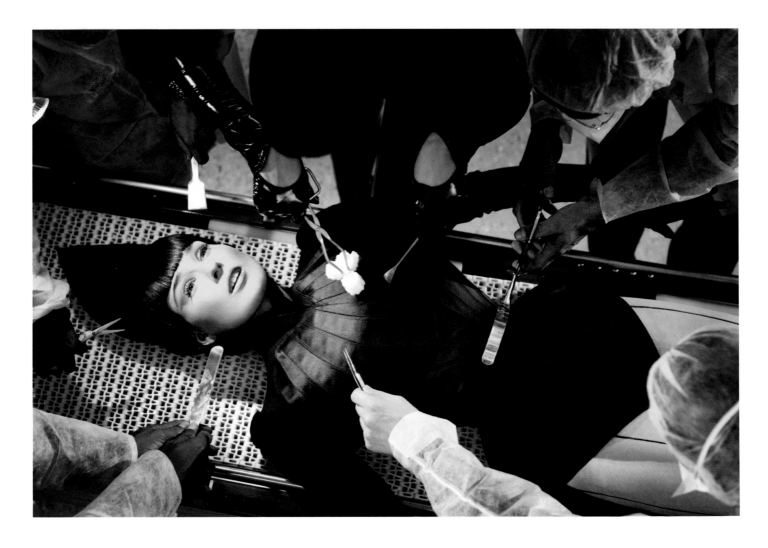

The Art of Modification

As artistic medium, plastic surgery has served the French artist ORLAN, a self-avowed pioneer who consciously brings it into the dialogue of art, as well as the late, beyond great British designer Alexander McQueen, who sent models down the runway resembling casualties of extreme physical reconstruction.

There's that divinely twisted moment in Terry Gilliam's 1985 masterpiece *Brazil* where Katherine Helmond's Mrs. Lowry is stretched like pizza dough by her doctor.

Beyond them all is the reigning queen of modification manipulated to the max, Miss Amanda Lepore. Amanda is a beauty icon—transgender or otherwise, because, really, she's amazing no matter what she was born with and had snipped along the way. One very late night in a club, she shared that she was only in L.A. for a pit stop en route to Argentina, where she would have some additional work done. After all, she quipped: "A woman's work is never done!"

She's a parody of the prepossessing femme fatale, yet simultaneously manages to be a genuine Venus. Amanda is about the visual effect like a great performance artist—or is it a great woman who knows that life is a performance?

I visited no fewer than six doctors, maybe more. And, boy, did I make them work for the gig. I asked dozens of questions. I also expected the doctors to do the same of me (not everyone did). I learned everything I could about saline versus silicone, about wear and tear . . . all and any factors that *will* eventually affect implants of any kind.

I studied the staff—receptionist, nurses, even the lady in billing—paying special attention to what work, if any, they'd had done. Did I like it? Did it make me want to dash for the door? Was their office welcoming? (Check out our chat with Dr. Walter Dishell on the next page for more invaluable inside tips.)

I was working in a strip club at the time, so I also examined the different work on display there and took referrals from my fellow dancers, who were generous enough to allow me hands-on appraisals.

Among other signs that I'd found the right doctor was something he said: "Don't tell me what you want your breasts to look like, because they're going to look the same as they do now, just bigger. The question is, when I'm in there, do you want me to go on the side of bigger or smaller?" My reply: "Smaller."

Before I had my breasts done, some friends urged against it. I do believe in having a confidante or two you can trust. It should be someone who is not benefiting from the experience financially, surgically, or otherwise. If these pals start urging a cease and desist for any more peels or plumping up, *listen*. They are not saying it out of jealousy. They are telling you for your own good. That is, after all, what friends are for.

Under no circumstances should you ever feel the pressure of getting something "done" to please a lover or society. Do it for yourself, if at all.

Any surgery should not be indulged in lightly. Given the many waxy, yanked-back faces increasingly becoming the norm because of peels, needles, lasers, and other nonsurgical quick fixes, *any* work should be thoughtfully considered.

For me, breast augmentation was the right choice. For what I do for a living, for my sense of confidence and the image I want to convey—whether these breasts are covered by a cashmere sweater or tipped with tasseled pasties—this bit of revamping was right for me.

As crucial as selecting the doctor is postoperative care. Some women like to dash right out into the world and show off the new goods. I was very careful to stay home for a full month to heal.

Never let a knife, needle, or anything go on or in your body without doing significant homework.

> "I'm not against plastic surgery, I'm just against discussing it."
>
> —*Madonna*

The father of a long-time friend, Dr. Dishell has been practicing plastic surgery for some four decades, starting out in head and neck reconstructive surgery on those afflicted with cancer and other maladies and segueing into cosmetic surgery. In an only-in-L.A. twist for the Michigan-born doctor, Dr. D. also served as the medical consultant for the TV hits M.A.S.H. *and* Medical Center.

Dr. Dishell: I have patients who come to me and say: "No matter what I do with my makeup, my hair, or dress, when I look in the mirror, I still see this nose." There's an immediate gratification to nasal surgery. The bandages come off and even when they are still swollen, the patients can see the difference. It can bring on a major change in their self-esteem and therefore a major change in their life.

Dita: People talk about my nose on the Internet, behind the cloak of anonymity. Could it be a little straighter? Maybe. But I've learned to love my nose. I think more people need to get out of the American mind-set that a small perfect nose is a pretty nose. I love a strong profile on a man or woman.

Dr. D: A lot of it is about concepts of beauty. The field has shifted to a more natural look. A lot of people come to me and say, "I want it to be smaller, but I want it to be natural. I don't want to lose my ethnicity." I agree with that concept. What concerns me is when they come in here with thirty pictures of celebrity noses and lips and say, "I want to look like this."

DVT: It's okay to admire the way other people look. But it doesn't mean you have to go out and look like them.

Dr. D: What is beauty? Is Dita a classic beauty? I don't know. After all, what is "classic" about beauty? What I love about Dita is she makes no excuses and no apologies: "Yes, I've had my boobs done. Yes, I've done this; no, I won't do that." She doesn't compromise her vision.

Rose: What should be someone's targets when it comes to any surgical modifications?

Dr. D: I have three objectives I share with my patients. First, what you ideally want is when someone meets you for the first time and cannot tell you've done anything. Secondly, those who do know you and haven't seen you in a while ask whether you changed your hair or makeup or lost weight. Finally, those who know you the best say, "Wow, you look good." It's not about looking different. It's about looking good. Ultimately, you want others to look at the whole package, not focus in on one feature—especially if it's the feature that underwent the procedure.

DVT: There's a way to do it and not look crazy. In that great old Hollywood tradition, in a way, I feel one face-lift in a lifetime is better than years of too much fillers and Botox—as long as the latest, greatest technologies are tapped.

Dr. D: A little bit of Botox is okay as long as you don't end up looking frozen. The practice has evolved to a more minimalist philosophy. It should be about a doctor considering what looks right. Start with less the first time, then review the process in a couple of weeks and add more if necessary. I'd rather do that than create a look that is overfilled and puffy. Before doing any permanent filler, do a temporary filler or even saline. You might not like a wrinkle, but you may like your face less without it!

DVT: Do you think women end up looking all puffed up because they want to get the most for their money in one office visit?

Dr. D: A lot of women become wrinkle obsessed the way someone is weight obsessed to the extent of, say, anorexia. They're obsessing over a tiny wrinkle that might show up in one area while they're on top of their lovers. I'm thinking, you should be more concerned with making love, because your partner likely isn't noticing any wrinkle! Much of the time, it's all about trying to please the mind more than the body. There's no symmetry in nature. There's no symmetry in surgery. What is it Voltaire said? "The perfect is the enemy of the good." When people keep striving for perfection, that's when they get into trouble.

RA: With regard to finding a doctor, what do you advise?

Dr. D: The Internet has become a disaster for cosmetic surgery, for any medical issue, because of all the questionable information out there online. I prefer referrals. My practice is all word of mouth. It's best to go with a doctor who specializes in the area being treated. I have a five-point checklist to use when interviewing a doctor:

1. What are the doctor's real credentials and by what board?

2. How many procedures specific to the type you're undergoing does the doctor do in a year?

3. How many of those specific procedures has the doctor performed over his or her career?

4. How often does the doctor have to do a procedure a second time (what's known as the revision rate)?

5. Who referred the doctor? In other words, is the referral getting complimentary work, or does he or she have any other relationship that could prove nonobjective?

RA: Certainly, that's one time where the Internet could be helpful, then? Learning the terminology, contacting boards, studying the various techniques and options?

Dr. D: As long as you consider the source. Is the doctor being an advocate or just trying to sell you a load of the latest procedures that you probably don't need? I believe in second opinions, too. Visit doctors in different ends of town, where the communities are a bit more diverse. It also makes me nervous when doctors significantly undercharge. Where are they cutting the costs? When a patient says she can get something done for half the cost somewhere else, I simply respond with, "See you next year when you need it fixed."

RA: So what's your take on medispas?

Dr. D: To me, a lot of the medispas are dangerous because there's no actual physician supervision. They are not regulated or licensed the same way as a doctor's office. In most states, you have to be a physician, a physician's assistant, or a registered nurse to administer any treatment. But a lot of these places are letting someone who attended school for three weeks work the lasers. They're using diluted Botox. You still get the effect; it just won't last as long. Every patient should be checked out by a doctor before undergoing any service. Get a referral from a physician you trust. Choosing someone out of the back of a tabloid is no way to do it.

DVT: Aside from any treatments to rejuvenate looks, what are your top tips to stave off signs of aging?

Dr. D: Avoid the sun. Keep a proper diet and appropriate weight. Because if you get too thin, it can age you. Exfoliate. Use mild soap. Moisturize! Really, there are no great secrets. Just use common sense.

"When people keep striving for perfection, that's when they get into trouble."

Fire and Ice

Between hope in a jar and the edge of a scalpel thrives a fountain of youth swarming with surgery-free options to freeze or melt away time. Botox, lasers, filler, peels, Ultrasonics . . . the list of new evolutions is endless. Ongoing advances make these procedures less of everything—less expensive, less painful, less disruptive, and less noticeable—which means this well of beauty opportunities isn't going dry anytime soon.

No wonder 83 percent of procedures conducted in the offices of cosmetic plastic surgeons in 2012 were minimally or non-invasive, according to the American Society for Aesthetic Plastic Surgery. Of the $11 billion spent on total plastic surgery procedures that year, some ten million of those were nonsurgical, ringing in at $4.2 million. Not surprisingly, a quarter of those pennies are going to botulinum toxin type A—as in, Botox—the most potent of neurotoxins and a formidable kapow to wrinkles, not to mention migraines.

I admit I have looked in the mirror and wondered, *Oh my God, what's that?* But I think wrinkles *can* be beautiful. They're a fact of life. If an individual wants to eliminate them with Botox, why not? It's a miracle of science. I know women and men who consider it the best invention ever.

Will I manage a wrinkle or two this way? Again, why not?

Rounding out the top five procedures are fillers, chemical peels, laser hair removal, and microdermabrasion. But as anyone who's popped her head inside a plastic surgeon's office or at Spago's at lunchtime can attest, the menu of offerings, from brush-on liquids that will grow lashes longer to dermal fillers plumping up faces like that of a blow-up doll, is deep and varied.

I love the futuristic sound of some of these applications, too, with their light-flashing laser wands ready to blast away bumps and tighten skin, or the advent of stem cell injection therapy to fill deep wrinkles. Lasers target underlying connective tissue, building collagen and thickening skin. Or there's the medical magic of thermal ultrasound energy penetrating the upper layers of skin, heating the connective tissue lining

facial muscles into contraction and voilà! Rejuvenation without a single bandage.

There are so many lasers on the market promising so many results that it's nearly impossible to know which one is the best, says Dr. Dishell. "That segment of medicine has become technology driven rather than practitioner driven," he notes. "What's happened is that any yahoo can buy a laser and have a 'laser center.' You don't have to have any knowledge of medicine."

So play it safe and undergo Botox or any treatment under a certified doctor's supervision.

As for the pain—and there is always pain, dear ones, where playing the Gods of Beauty is concerned—I've heard it all from the women I have pressed about the work they have had done: from a hot, intense pang that's over as soon as the needle or wand pulls away to a misery worse than getting eyelids tattooed (another form of aesthetic enhancement altogether).

I'm not saying one procedure is right or wrong, healthy or not healthy. I don't have the answers to all of that. It's up to each individual to make her own decision. It's also up to individuals to do their homework. Most of these treatments are temporary, requiring another boost months later. But the side effects can sometimes last longer.

Any and all of these procedures are simply additional tools of beauty that we have at our fingertips. Don't be a glutton. Don't cut corners. And, above all else, use them wisely.

Personally, I'm so far an armchair voyeur when it comes to this stuff, literally consuming articles on the latest technologies and their dreamy results like they were bonbons. My library of beauty books even contains a volume on the subject . . . published in 1929.

As a rule, for now, I can still primarily rely on the good old trifecta—exercise, eating, and DNA—to keep me fit for the spotlight.

Are there features about myself I would like to change? It's an interview question I am frequently asked. "What's your least favorite part about yourself?" reporters from around the world want to know. My response is that I'm not telling. Sure, I have insecurities and wish some parts of me looked "better." But I dislike it more when others focus on what they hate about their bodies instead of celebrating their best selves.

I choose not to dwell on it.

The day I do? Then I'll make the change. As I have said about all the tools in the beauty box, they are there for the using . . .

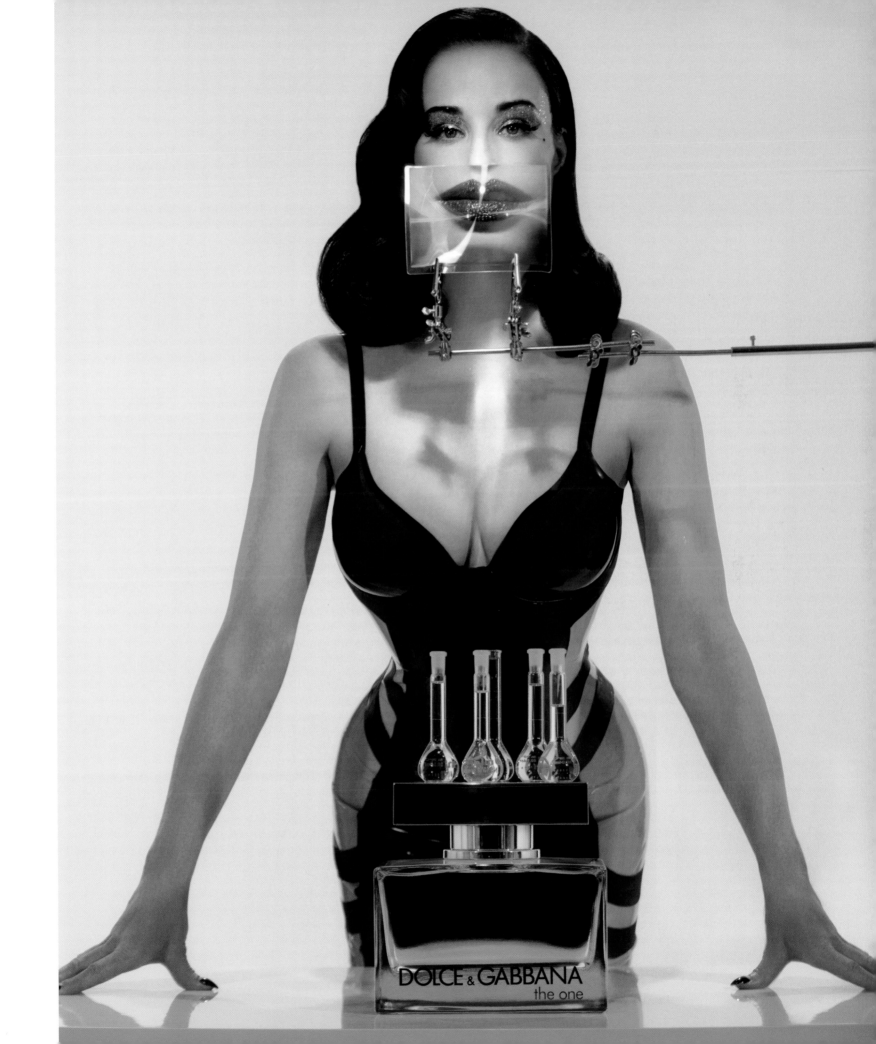

DOLCE & GABBANA
the one

Preservation Society

"If your ceiling is falling down, don't you call someone in?" quipped Carmen Dell'Orefice in About Face, *the marvelous 2012 HBO documentary by Timothy Greenfield-Sanders, that delves into issues of beauty, aging, and an industry that has a love-hate relationship with those two facts of life.*

Among the many superstar models featured in the film, Carmen wasn't talking about her New York apartment. Now in her eighties, she is possibly more extraordinary than she was at age fifteen, when she became one of the youngest women ever to appear on a Vogue cover.

Whether it's an art deco theater, a couture-quality costume, or my bare bum, I'm an advocate of any preservation efforts that keep them fit for public consumption. Which is why in these matters, it's often wise to mind those more experienced among us who continue to make their beauty mark. While exercise, plenty of sleep, and sex constitute some of Carmen's secrets to aging, the silver fox, still working hard as a model, has always been honestly forthcoming about the boosts she's gleaned from the aesthetic sciences. Here she shares her thoughts with us on the subject.

Let's tell it like it is . . . the articles got it wrong. Despite reports that I was thirty-one when I started a tweak here or there, it all started when I was about thirteen. My mother took me to an orthodontist to repair a bite. It was a matter of health, and I was making money as a model and could afford my own braces.

About a year or so later, I made a very spectacular half-gainer dive on a three-meter springboard. Well, it was nearly spectacular: I hit my nose on the board. At the time, I never even thought about having a doctor look at it. On the *Vogue* cover, *that's* the broken nose. I was training for the Olympics, and then modeling happened.

My nose hadn't really properly healed, so when I was about eighteen, I finally went to see Dr. John Marquis Converse. He pioneered many modern surgical techniques, and was a renowned expert who founded the Institute of Reconstructive Plastic Surgery at the New York University School of Medicine and wrote several books on the field.

So having any "work" done is not just about cutting and lifting. It's about fixing what we desire to fix, whether it's out of enhance-

ment or health. It's all right to want to improve yourself at any age. But do so with good guidance—and from loving parents, if you're lucky, as well as good doctors. Do proper homework and proper research. You pay your money and take your chances, true. But don't even consider beginning the process without doing some due diligence on the doctors you engage. Does he have the background? What is his work like?

There are no bargains with your body.

It's also not about looking like each other. How boring.

We all start with a handful of genes. It's true some of us can look in the mirror and admit to winning the lottery. But get real. The windfall *is* that you are alive! What you do on the outside is meaningless unless your brain connects with your heart, your empathy for the world. Marketing has ruined people to the extent that they have become so undeveloped, they think if they are a little more this or that they will be, what? More successful? More validated? *More loved?* We are the choices we make.

I was lucky as a young girl that when the time came around when a female starts thinking of herself as a female, I could watch my mother, who was in the theater, on Broadway, and knew how to put on her makeup. She counted among her friends Gypsy Rose Lee. She and my father, who was a symphony violinist, never lived together, but they gave me a healthy, diversified view on life and the body. My mother had me young, when she was twenty-one. She taught me that with makeup you enhance what you have.

Years of sun damage that came from competitive swimming motivated me to do something more when I was about thirty. Research led me to Dr. Norman Orentreich, a medical innovator and trailblazer. He is among the first to refine dermabrasion, as well as many dermatologic procedures and modern hair transplantation. The man is a genius. He also created Clinique for Estée Lauder back in 1968.

Dr. Orentreich did my surgical, medical dermabrasion, removing *all* the layers of my skin. They don't even do that procedure anymore. I can never even go to bed without sunblock. Not even daylight from a parted curtain can hit my face without sunblock.

He was also part of a study underwritten by the FDA on the first medical-grade silicone injections. As very few doctors were

licensed to do this study, I was lucky to be in it, to be a part of medical history. I was about thirty-seven. Think of a grain of sand in an oyster shell. That is the process of one droplet of silicone in my face. It stimulates the collagen of my body to stimulate a wrinkle out. This is not a one-day fix. It's a cumulative process, and a way of sustaining your normal self. Unfortunately, as securing medical-grade silicone became a challenge, too many other doctors started using it mixed with other things, terrible things. So the FDA banned it outright.

In the beginning, I went to Dr. Orentreich four to six times a year. Now I go twice yearly for Botox. I've tried Botox in my neck, but I don't think it helps that much, so I don't do injections there. I do my hands now.

I'm for anything that will help me look sharper, brighter. In early 2013, I had both knees replaced. I was good about my physical therapy, and I was able to drop my cane within a month. Good thing, too, as I was headed to London to shoot with Karl Lagerfeld. I get up every morning grateful I can stand up and not be in a wheelchair. Then I go to the mirror and say "hello" to the stranger I see there. When I apply eyeliner, it's like trying to do a straight line on an English muffin. As long as I can photograph a certain way and can stand up on my own and work, I am grateful.

We keep re-creating ourselves as humans, hopefully expanding knowledge and enjoying the trip. What's good for me might not be for another person, and vice versa. I would love to have breasts the same as Dita's. They are physically perfect. I can't even call them tits. You know, as soon as breasts fill with milk, they are no longer the same. No one tells the truth about this. A child is forever. But tits are not.

Nor is life. As I said, it's all about the choices we make. I happen to like vegetables, and I've always had the right food. I was well into my thirties before I took a drink of alcohol. I didn't even drink coffee. Movement was always a necessity, too. I was always an athlete, and moving makes me feel good, the same way sex does. It's all movement, but sex is better. It's a song and dance you do together.

Living is not for sissies. Dying is not for sissies. Hey, kids, make a plan and live the whole arc.

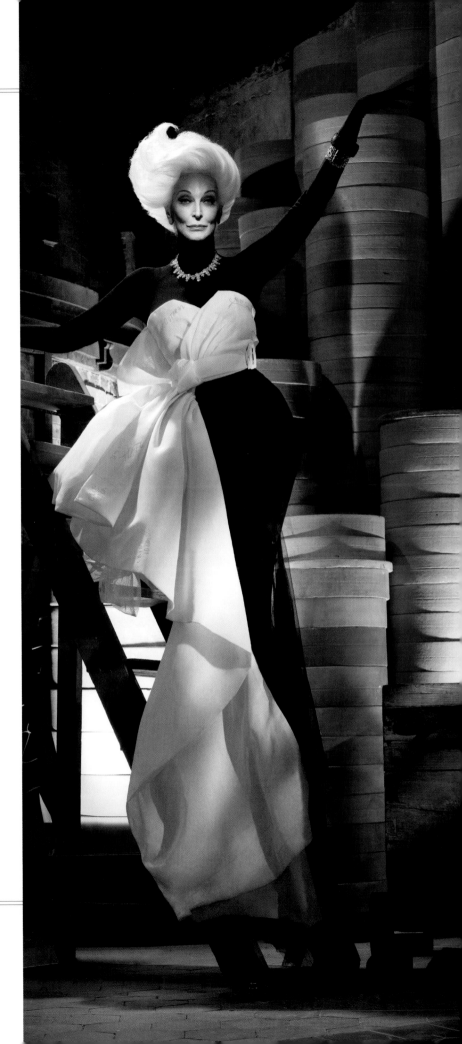

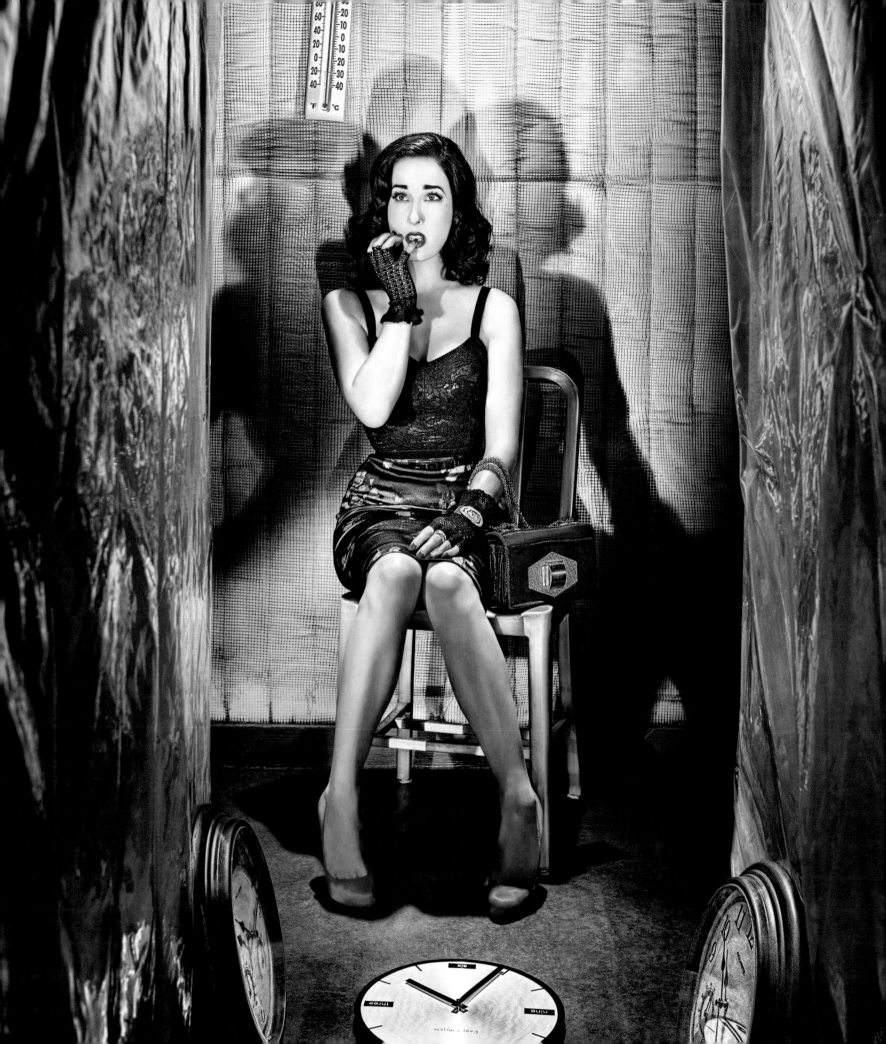

The Mirror Has Two Faces

I've always said that cosmetic surgery, cosmetic procedures of any kind, is a dramatic form of makeup.

I've also always said, never say never.

So while one can never have too many stilettos or admirers, it's all too true that too many aesthetic enhancements of any kind, temporary or permanent, can backfire.

This is no time to check out of reality. Going into a doctor's office or a medispa and expecting to walk out looking like an A-list Oscar winner is the stuff of fantasy. You might very likely end up resembling a D-list wannabe, too. Too much work of any kind can actually cancel out any aim to look younger, instead giving rise to the look of a surreal parody of a person. Nothing funny about that.

There are many pros and there are many cons about getting within blinking distance of a knife, needle, or laser. But the biggest cons of all are those unscrupulous "specialists" in the business who prey on an insecure public to make a fast buck.

The quest for beauty is a wild-goose chase, and the beauty machine that drives it is a Herculean entity employing thousands of well-meaning brainiacs striving to conjure youth from their labs, be it cellulite creams or antiaging serums. Still, even they will allow that there are no hard-and-fast miracles that can just be slathered on. Science can slow down the aging process. But it cannot stop it completely. Even the best face-lift in the world will require a follow-up within a decade or less.

Look, if a pill existed that could erase wrinkles and cellulite, keep these tits and this skin from sagging, and maintain an all-around perky and taut body and face, I would take it.

But that pill doesn't exist.

Not yet.

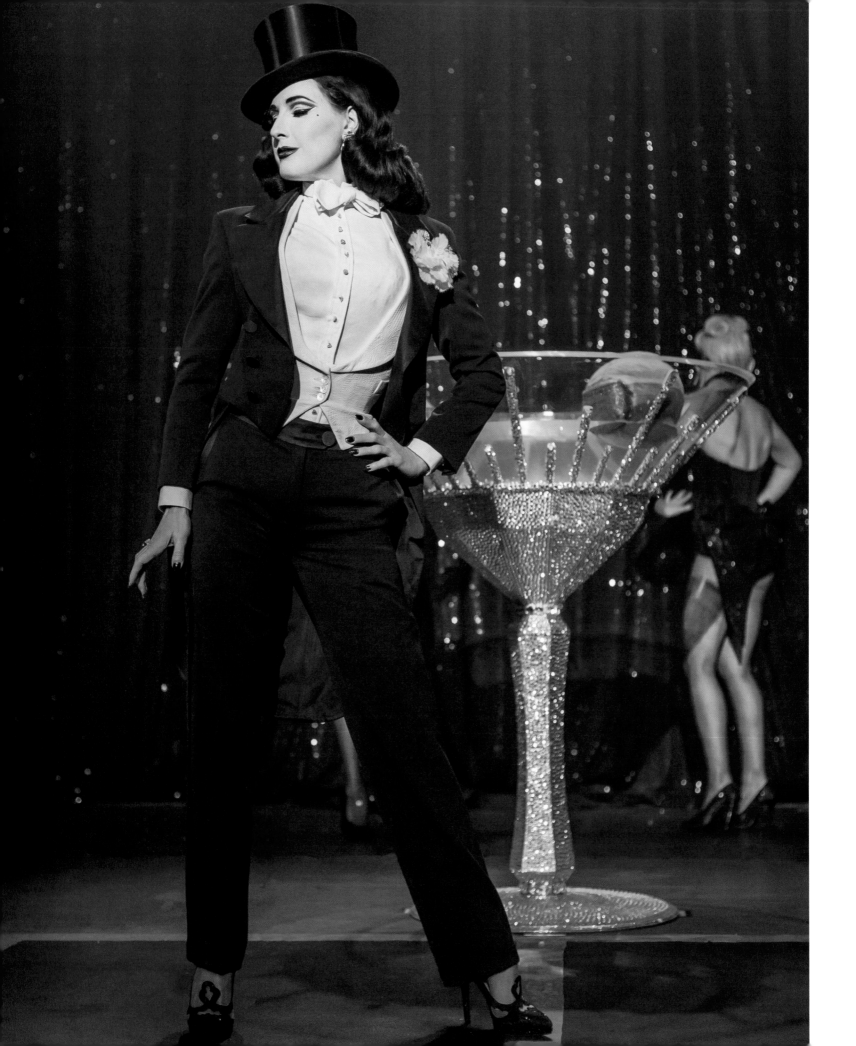

While "all the world's a stage," as Bill Shakespeare famously penned, not all the steps to beauty outlined in this book are right for the stage.

Nor is stage makeup right for life off it. "We all came into the world naked. The rest is all drag," as my darling RuPaul so eloquently observed. But standing under the bright kliegs involves laying it on thick—much thicker, bolder, frostier, and sparklier than anyone should consider doing in real life.

There are as many reasons as there are crystals encrusted on my stage corsets as to why a single performance might go down in a blaze of glory. In the case of a show some years ago at the Henry Fonda Theater in Hollywood, it all came down to the hair spray.

It was one of those nights just brimming with high spirits and bubbly. Backstage, I had styled my hair into a particularly great coif, or at least my friend and fellow burlesque performer Catherine D'Lish and I declared it so in the zeal of all the Cristal and giggles we were basking in. "Your hair looks fantastic!" my dear friend observed, and I responded by pressing down on that metallic blue can of Bed Head until the dressing room choked with mist. We were having a great hair spray moment.

Showtime. The set onstage resembled a boudoir, albeit one awash in Swarovski sparklers. Everything was just as it is every time I do the act—except this time the candelabras were lit. So be it. I was on fire with every step and swivel of my dance.

Suddenly, so was my hair.

Not that I realized at that moment, so caught up as I was in entertaining the sold-out house. But my reverie was interrupted at the sight of two other performers onstage along with my then manager and my then beloved, all coming toward me with absolutely terrified looks on their faces. On the video of the evening, the four of them are storming at me, fixed on putting my smokestack out. You can even spot a little flame among the tail of smoke.

I patted it out myself. The applause from 1,300 pairs of hands came crashing through the old theater, which now reeked of burned hair. For weeks, I was having my ends trimmed in an effort to finally rid myself of the smell. But what can I say? I love my hair spray. Talk about getting burned by too much of a good thing.

Those of you who have visited me after my shows have witnessed the truly epic amount of hair spray and makeup I wear— that all my fellow performers must wear—under the powerful spotlights onstage. I'm not only referring to the conspicuous hand of lipstick, eye shadow, and lashes applied for maximum impact so even the audience viewing from the top rows of a theater get an eyeful. From coiffed head to manicured toe, few spots not already under twinkling underpinnings or seamed stockings go without some beauty mark. My "foundations" for stage are not only a corset. They include the specially formulated skin tone base I fastidiously brush all over my body (more on that later in this chapter).

From the turn of the first hot roller to the final sweep of shimmering powder, the time I spend on beauty is all of ninety minutes before the curtain rises. Another ninety minutes are spent before the beauty ritual ruminating over any last-minute details about the night's production and attending to the all-too-crucial physical stretching (as outlined in chapter 2). Stretching also provides an invaluable opportunity for silent reflection.

As it does at home, practice makes for a more perfectly efficient expression of hair and makeup, and my process has grown more refined over my two-plus decades performing. Yet unlike my daily routine, being onstage involves more of everything— time as well as the many beauty products and tools spread out on the folding table that often serves as my ad hoc vanity in the theater dressing room.

But consider this: the shows I create take time. If there is a high priority for a new number and I only have six months, it consumes me for those six months. Most acts take much longer.

My most lavish production to date, "The Opium Den," took four years from daydream through development to take to the stage. A concept undergoes continued reshaping as each element, from choreography to cost, takes form. The elaborate sets need to be thoughtfully planned and constructed to withstand the punishment of touring. So, too, the costumes, which are painstakingly custom-made to look beautiful as well as sustain being stripped off and flung across the stage, show after show. Those for "The Opium Den" turned out to be among the most laborious undertakings for my talented collaborator, costume designer and fellow burlesque artist Catherine D'Lish. Even the array of hand props by another master craftsman and confidant Michael Schmidt took great consideration and ingenuity to realize.

Any getup doesn't end with the costume. There is the makeup . . . and the hair! For the "Opium Den" act, my look involves an extensive fall and elaborate decoration. So while the other performers entertain the audience during the "Strip Strip Hooray!" shows, I'm in my dressing room, racing to transform myself for this grand finale.

Whether it's a stage prop or eye shadow, every creative aspect of producing a show—including solving any of the endless challenges—is covered in my fingerprints. Knowing this gives me great pride and empowerment as the curtains rise: I'm not merely a gal taking off her clothes in front of an audience; I'm not stepping into a role someone developed for me. My part in all of this is more than the marquee (as wonderful as it is seeing your name in lights!). I preside over the costumes, the lighting, the music . . . even contributing the language to the publicity releases. I'm creative director and CEO. As the underwriter, I'm also the producer.

Certainly, I'm not alone in executing all of the thousand tasks required in putting on a show. My team is incredible, and as my career transitions I've learned to delegate. As much as I'd

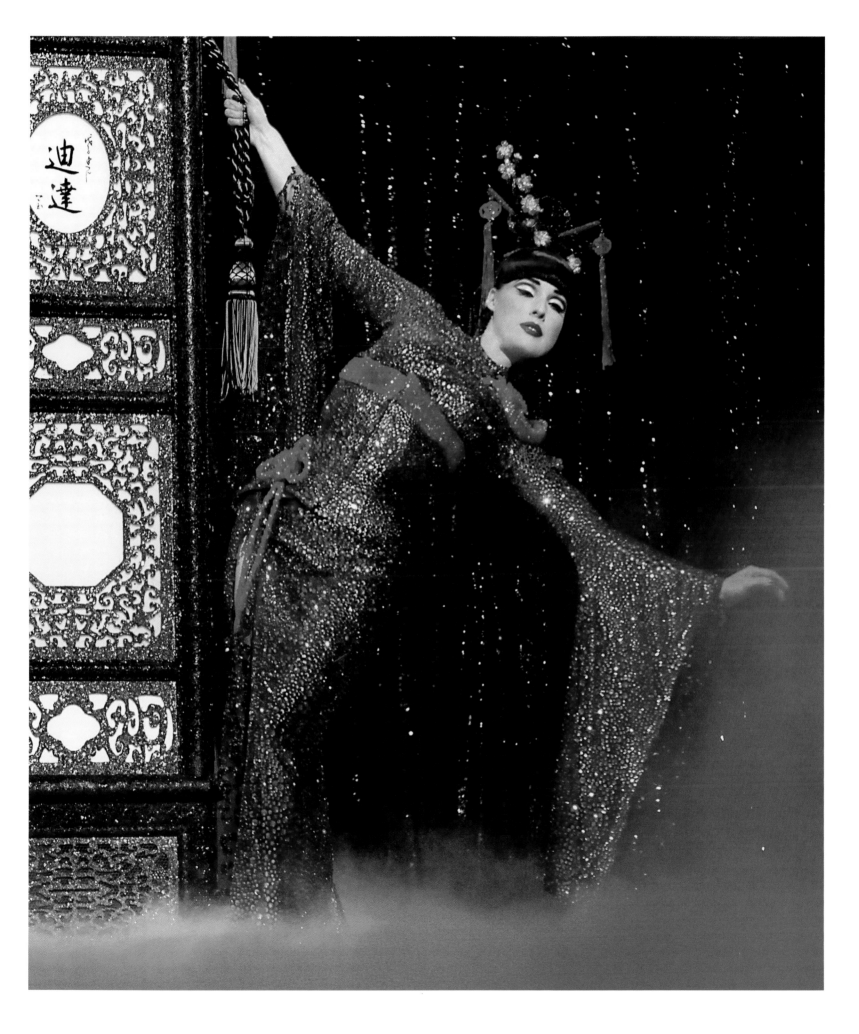

like to be personally applying the crystals on my satin shoes, as new opportunities arise, so do new obligations, and there are not enough hours in the day to do it all!

But backstage, there's no glam squad swarming about. It's only me at my lit-up vanity table doing my hair and makeup. Being so hands-on is what drives me in life. It's about the process as much as the spotlight. *Doing it* is my ultimate beauty mark.

Putting On an Act

I really love showing up before a show with nothing on. But I don't mean leaving the house with that kind of *nothing* on!

I wouldn't dream of going between home and theater looking undone. Before and after my moment under the spotlights, I like to make an entrance into the theater and an exit at the end of the night. My idea of doing the minimum is all in the beauty choices. Hair is street-ready, even if it's in a neat bun or under a turban; the extent of my makeup is a sweep of powder and red lipstick. In little more than dark sunglasses, high heels, and a trench coat, I can stealthily slip in via the theater back door, under the radar of the ticket holders outside and my castmates inside.

On some evenings, I leave home for the theater with a full hair set and a camera-ready face of makeup because the performance begins there on the red carpet for the phalanx of paparazzi. Or there might be a preshow cocktail party with sponsors or a host. I'd rather wait and wow 'em from the stage as the curtain rises, clad in all the razzle-dazzle of my costumes. But these events before a performance are all part of showbiz.

Red carpet or not, once at the theater and having greeted cast and crew, my sights are set on that meditative moment of solitude in my dressing room, when I'm seated before the mirror. My face framed by the ball-shaped vanity lights, I can get into the zone and create the vamped-up Dita Von Teese all those in the audience have paid their hard-earned money to see.

If there is a post-show soiree, I buff off the heavy blush and glitter lipstick, and swab away some of the heavier eye shading and bottom eyeliner. Other times, I might cleanse away everything from under the eyes, down to my chin line. I then apply a new swath of foundation and powder and, on my lips, a fresh swipe of matte red. When I'm lucky

enough to have a shower backstage, I scrub clean any makeup from my body before slipping into my party dress.

Since a shower backstage is a rarity, at the least I dare not leave the theater without a hat or a veil over my eyes to lessen the harsh impact of all that makeup. I avoid photographs, too. I'm not denying anyone out of meanness or insecurity. Photos are forever. I'd rather not be remembered with the magnified veneer of stage makeup offstage.

The Art of Being a Showgirl

Think sex symbol or showgirl, what pops to mind is the glamour, the makeup, the hair. I recall a performance I did at a popular Hollywood club many years ago. The setting was tailor-made for burlesque. The other dancers? Not so much. Their stage look lacked mystery, allure. Mind you, the gals were accomplished dancers; a few were certainly more technically skilled than I would ever become. But they had put zero effort into their look: their hair was pulled back into ponytails like it was a sunrise exercise class. Never mind the makeup. Between the lack of tease in their strip and glam in their style, their interpretation of the art form was more fauxlesque than burlesque.

These skilled performers had completely missed the point of the showgirl. Without the beauty, the fantasy, the glamour, all you have is a dancer. The very art of performance involves knowing how to apply makeup and style hair. It's about *conjuring* a beautiful fantasy. *That* is the magic of show business.

This do-it-yourself artistry—this spirit!—is sadly lost on many of today's stars. But historically, the song-and-dance girls from the movies and the great prima ballerinas of stage all knew the craft of beauty. They knew the rules and mores of their domains, be it ballet or burlesque. I can only imagine that, like me, their confidence and power came in part from the process of creating their own identity.

How fortunate for us that DIY artistry remains a mandatory skill among the disciplined entertainers of Cirque du Soleil and the Crazy Horse Paris. These troupes epitomize the high standards of performance. I came to know firsthand the strict rules of the beauty regime at the Crazy Horse Paris. No glitter. No gloss. No leaving the theater with stage makeup. Each one of the carefully selected dancers there is a specimen of human perfection. Yet, for stage, even the slightest skin flaw is concealed by makeup. Imagine my glee when I went to the toilet backstage and found the

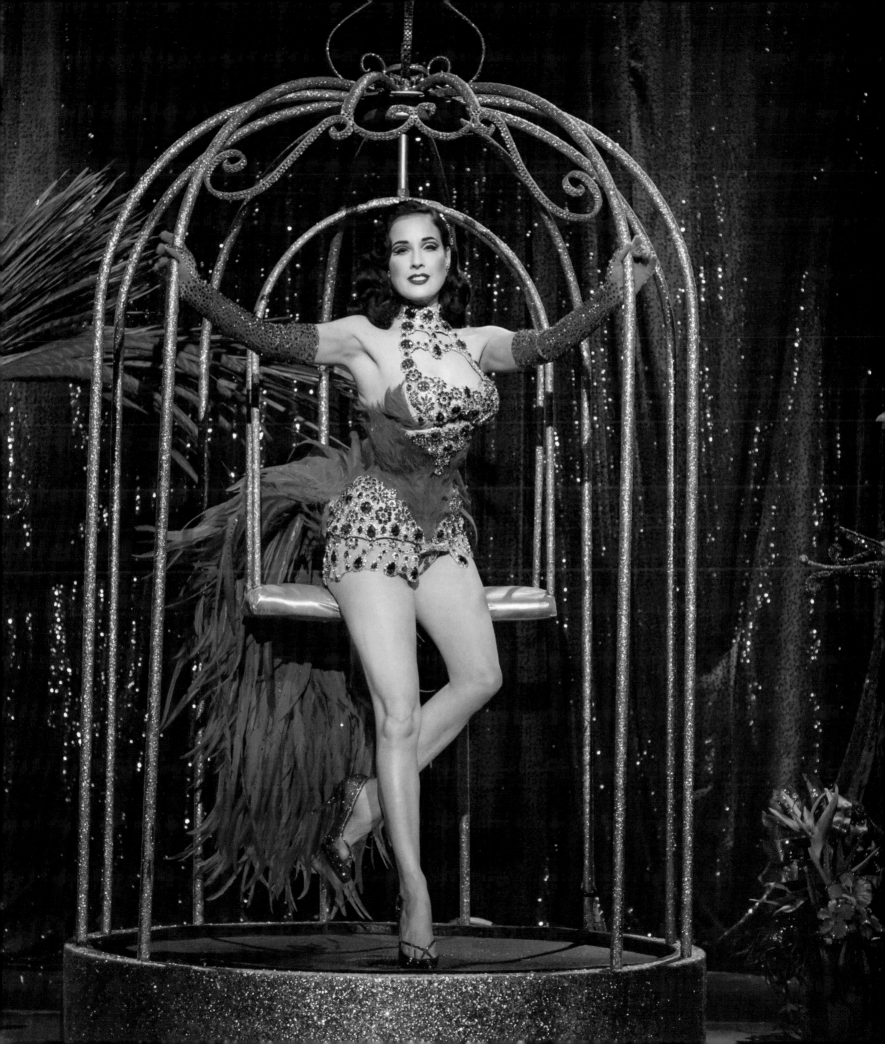

Poudre
Cordiale

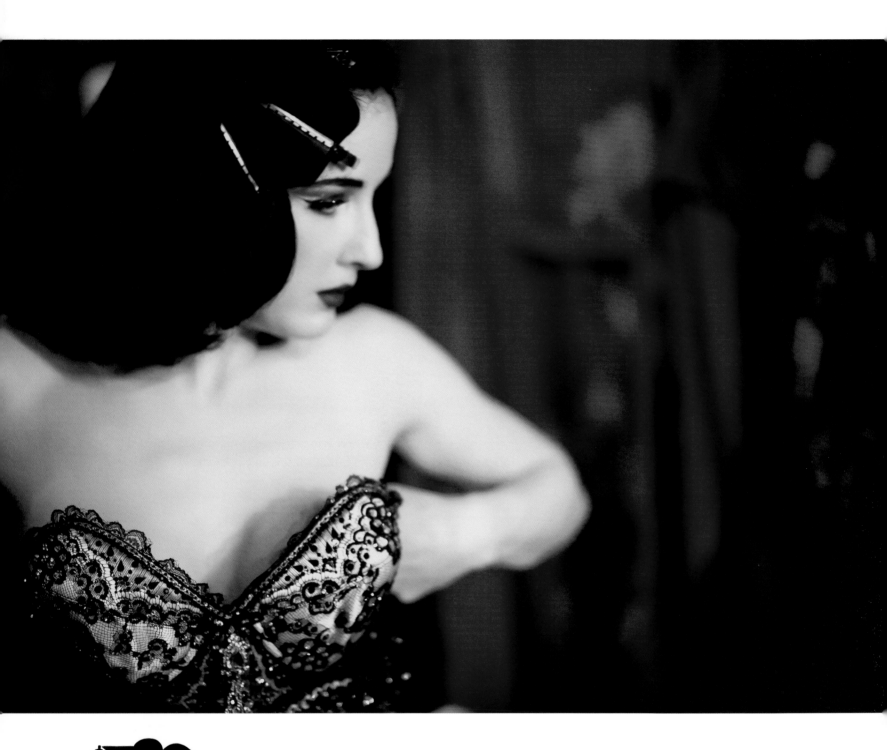

seat smudged with foundation! Now *that* is dedicaton.

 I've heard endless advice over the years. But one bon mot I take to heart is the insight one exemplary performer told her rising-star daughter: "Give the people what they want," Judy Garland instructed little Liza Minnelli. "Then go get a hamburger."

Now *that* is how you become a legend. Create the fantasy they want. This is the raison d'être of a showgirl. Even in life, there are eccentrically glamorous creatures, from their makeup to their moves, whose only stage is the theater of life. They might nibble on a veggie burger at home. But for the world to enjoy, they serve a heaping helping of caviar on a jeweled silver spoon!

 For you, too, dear reader, it might not be about the glare

of the stage spotlights. Maybe it's about shining under the colored lights of a rented hall during prom or the flickering candles of a wedding. Every one of us entertains the fantasy of being a star. The difference between those who make their mark and those who don't is sometimes a matter of lipstick, hair spray, and vamping it way up.

"Do" It Again

Clean hair is the best hair to start with, and even on show day I always start with a freshly washed head. If I had to set it for a TV appearance earlier in the day, I always make the time to wash it again before heading to the theater, using a drop of shampoo followed by conditioner, or I skip the shampoo altogether to maintain color.

From there, I tap the full range of tools in my box to realize the hairdos described in chapter 18. My prized Mason Pearson brush, a rat-tail comb, and a pile of hairpins are indispensable. Rollers and hot sticks are heated to the maximum.

There's something about that new bounce of rolled hair. When I have a crammed schedule of meetings, appearances, and photo shoots, it's not uncommon for me to set my hair in rollers three, four, even five times throughout the day. By the second or third set, a hairstyle vastly improves (as long as there's not too much product buildup).

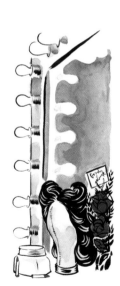

Any switches and other hairpieces that are part of my look for a particular act are displayed along with any corresponding jeweled combs or accessories. From head to toe, I rely on the brilliance of that most wonderful invention, Swarovski crystals, to make me sparkle.

As with makeup, hair is all about "more is more." More curl, more hairpieces, more hair spray, more twinkle. While I might prefer my hair to move for some acts, it's still about pumping up the volume and the sparkle for stage.

Make-Believe

The appropriate beauty look is all about context, as I noted throughout this book, and the setting is a crucial part of that consideration.

Between arriving at the venue and the rise of the stage curtain, there is never enough time to restart the beauty process. So I build on the look I arrived in.

I have a separate kit just for showtime. It's partly to keep my tools and colors organized. It's also to avoid all that glittery makeup mucking up the matte products I mostly use in my daily look. The matte group lives in its own case. There are plenty of the same essentials residing in both kits, including black eyeliner, brow powder, lip pencils in varying reds, pinks, and plums. But theater makeup stays in the theater kit.

I adore the overemphasized eyes and lips that Maria Callas, Margot Fonteyn, and Moira Shearer laid on before a performance, and which I always admired in black-and-white images growing up. They still haunt my memories as I prep for a show. Since the aim here is to exaggerate, my show kit is filled with everything, from frosted creams and matte shadows to highlighting sticks and sparkling enhancements.

Set Off

As in my daily life, I start with hair in hot rollers before a smudge of makeup is applied.

Likewise, backstage, I follow rolling my hair with the same steps to making-up as I do offstage daily: first concealer, then a liquid or cream foundation, then powder. Refer to chapter 8 for the full steps.

If a spot or other redness appeared in rehearsal, I zero in on it with a touch of the same concealer I use under my eyes or with a brush dipped in MAC Studio Fix. The fine, pointed bristles work better than fingers in blocking out a spot. That step is followed by a heavy-handed application of MAC Studio Fix Powder Plus Foundation (I use shade C2, but given that every individual has different coloring, MAC has thirty-nine others to choose from).

For blush, I choose a more vibrant shade than I would otherwise in daily life: dark rose, coral, magenta, and even red. A face cannot wash out onstage. Cheeks *must* be emphasized.

Shadow Dancer

Start with a base of foundation powder over eyelids to better catch and hold any color makeup. Across the eyelid from lash line to brow, drag a matte bright white eye shadow base, leaving the crease bare.

To give the impression of a larger eye, I take a flat and slanted brow brush dipped in black shadow and draw a line just above the natural crease of the lid and lightly blend it. The effect is further emphasized with additional shades of gray, dark brown, or navy blue, blending upward but avoiding the brow bone, which remains highlighted in white.

Layering continues in the chosen palette of eye shadows, repeating between the shading colors and white, using a flat, semi-wide brush for the lid and a small dome brush on the crease. This gives eyes a deep-set drama in the fashion of Garbo, who employed this trick throughout her life. Barbra Streisand also put it to great effect off- and on-screen, most notably in the 1968 must-see *Funny Girl*.

Then comes another sweep of the matte white shadow at the brow bone, taking care not to brush over the dark crease line. Take the brush with the dark shadow residue (do *not* add more shadow) for another sweep over the "crease," taking care to blend a bit more.

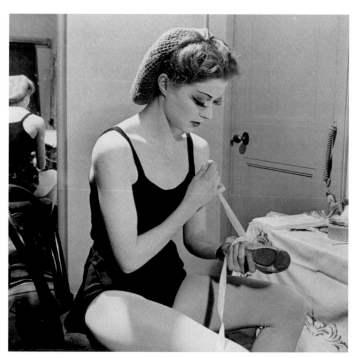

Backstage before a 1949 performance of *Cinderella*, Moira Shearer, with that wonderfully exaggerated makeup.

On the occasion that my eyelid calls for the boosted dazzle of a heightened frost or a glitter, I really go for it. See page 366 in this chapter for "All That Glitters."

For a bit of shading and depth, I may sparingly dab eye shadow under the eye at the lash line. I use the smallest dome brush, dab it in green or blue or grey or brown and run it lightly and evenly under the eye.

Draw the Line

Since impact is the name of the stage game, I line my eyes with the blackest of black: a pot of MAC Fluidline Blacktrack. I also use MAC Liquidlast Liner when considerable water is involved in an act, such as "The Birdcage" with its shower finale, or just along the outside corner of my eyes when they are sensitive to external elements. My eyes can tear up with the onslaught of stage lights, the smoke from dry ice and cigarettes in a venue, never mind allergies. The reason Liquidlast isn't my de facto liner, however, is because it is nearly impossible to correct once on skin and slow to dry.

In contrast to solely using a pencil, applying liquid or cream with a brush offers a sense of control, precision, and finish I love. Thicken the line with each drag of the liner. While the audience won't be within arm's reach, it's still important to execute every beauty step as flawlessly as possible.

Because I layer on the liner, to hasten drying, I use a hand fan. Or try a hair dryer on the coolest, lowest setting.

The vanity mirror serves as one point of view, but nothing beats a tabletop mirror with both magnified and nonmagnified sides. A hand mirror is also nonnegotiable in order to review work from all angles. Other essentials include tissues to wipe a brush clean before re-dipping it in the black pot and continuing the process. A brush becomes sullied with frosty white shadow, and the liner tends to dry, making the brush stiff. When using a potted gel such as MAC Blacktrack, flip the pot, open mouth down, to keep it from drying out during application.

The final step in making up the eyes is "opening" them up with a soft pencil. I like a shade in paper white, ivory, or pale yellow. A creamy formulation and a dull tip are advisable to avoid tugging on delicate skin. Backstage, I keep my eye pencils near the warm vanity mirror lights to soften them, making them glide on easier.

To give the illusion of larger, brighter eyes, tightline the inside rims of the eyes with white, yellow, black, or blue (see chapter 9).

I may also use the white liner under the wing of the cat eye to further emphasize the graphic line. It's a classic ballet makeup trick. I combine this accent with a black pencil line on top and bottom for added drama. Whatever the act or mood calls for!

Beware of gunking up lashes. A pet peeve of mine is when lashes, fake or natural, are clumpy with eye powder or glitter residue.

Lash Out

Lashes curled and a coat of mascara carefully and lavishly pulled through, it's time for that mandatory of showgirl effects: false eyelashes.

A case of fifty falsies is always part of my dressing-room hodgepodge. Yet I still take care to remove each one from the plastic holder with a pair of tweezers as if it were my only pair. See page 171 in chapter 9 for application steps.

For a show, it's not unusual for me to lay down one strip and follow up with half a second strip, starting in the middle of the eye and ending at the end of the cat eye tail. I personally don't do bottom lashes onstage, but I understand and support doing so. Instead, I sweep mascara on the bottom lashes.

Remember: dirty lashes are unacceptable. It's all right to wear a pair more than once—as long as they are cleaned of any eye shadow or adhesive residue each time. A glossy black lash is the desired aim.

High Brow

For my stage brows, I use black powder and pencil to emphasize a broader-than-natural brow. I take my time applying it with an angled brush, extending the length by drawing out the tail.

This can be a tricky practice, as the aim is not to draw in brows as if they were inky cutouts. Yet they should be accentuated enough for an effective stage face. Set with an extra-hold hair spray using a brow brush or wand. A sealant is advisable, too, if the act takes me to water (or if you, dear reader, tend to perspire during a performance).

Smack Down

With a sharpened dark red lip pencil, begin the first of several applications of lip color during the backstage beauty ritual, culminating with one last swipe before leaving the dressing room. Don't forget to blot and check your teeth for any lipstick markings.

Continue to build on the outline with a slightly darker red pencil, just beyond the lip line, not unlike those of the maximum outlined puckers of Lucille Ball or Carmen Miranda.

Color in the entire lip with a generous swath of one or more different shades of lipstick for depth. A layer of glitter can add pizzazz (see page 366), but any gloss or other shiny formulation should be one of the many transfer-proof kinds on the market. Anything conventional will catch hair, which can drag a tacky mark across skin. With lips materialized, I now have a sense of scale. I might return to another feature on my face for a bit more here (say, the eyes?) or there (more cheek? brow highlighter?).

"Do not go on the stage without false eyelashes or I will personally come to your apartment and slap you. I know they are difficult at first. But a seasoned pair of lashes (at least three wearings) will conform to your eye and they will be easier to apply the more you wear them."

—International burlesque star Dirty Martini

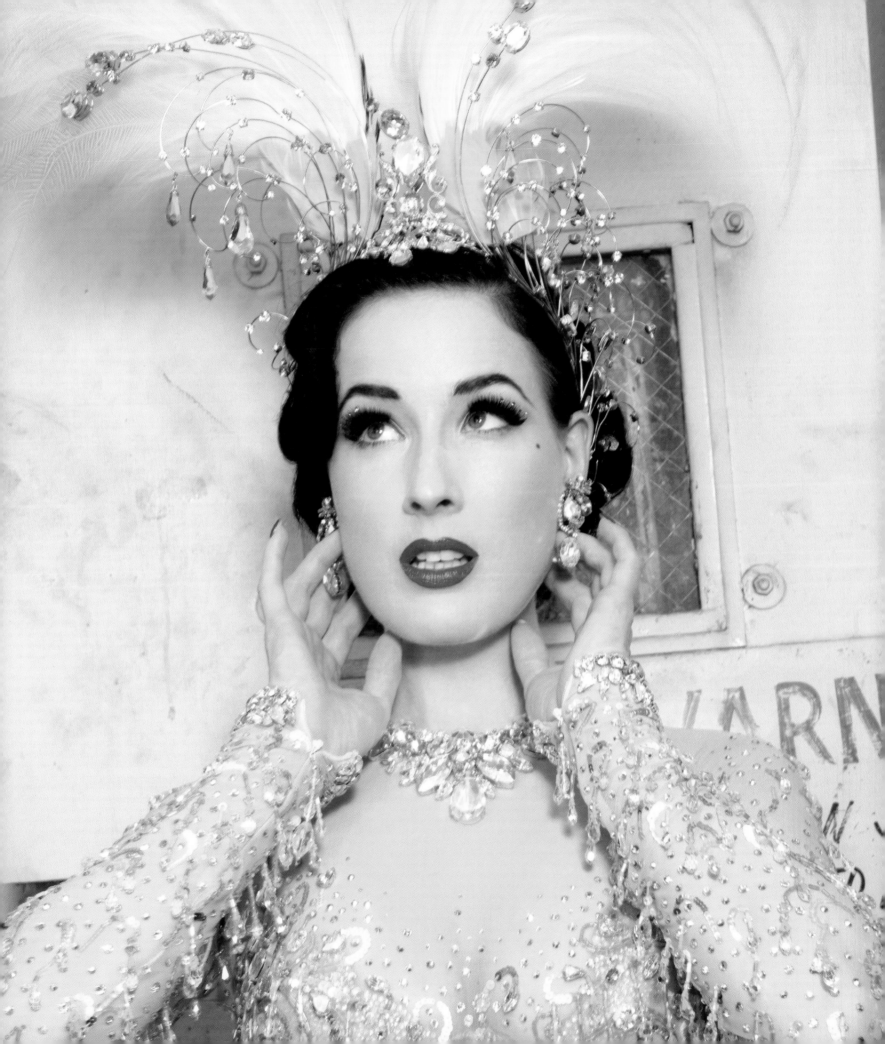

That Sparkle in Your Eye: Making Jeweled Lashes

A spectacular way to bat an eye is to trim false eyelashes in crystals.

Find the smallest size crystal possible. I like a 7-millimeter size from Swarovski Elements in crystal (clear), jet, sapphire, emerald, or a kaleidoscopic color named Aurore Boreale. Dare to be as creative as the available palette.

Have two sets of falsies on hand. They will come together as a single set, once customized to extend the lash line for a dramatic effect. Falsies also need to be dense enough to handle the weight of the crystals, so the overlap fortifies the lash, particularly practical when crystals are applied both at the lash line and the tips of individual hairs.

Snip one set in half and use the outer half of each one to extend the intact lashes of the other set. Glue together with lash glue.

With a toothpick tipped with beeswax, grab an element from the crystal top. Dab the base of the lash with either Duo Surgical Adhesive or Duo Eyelash Adhesive Waterproof, nontoxic formulations made in the United States and available in latex and nonlatex options. It's a brand highly recommended by makeup artists such as Gregory Arlt.

With patience and care, position crystals along the top lash line. For that added zing, tip the lashes with crystals. Stick the tiniest of crystals back-to-back, thereby rendering the silver backs invisible. Imagine the sparkle whether eyes are closed or open!

This is not a project to take on hours before show time. Do it a day or more before to allow plenty of time to air bedazzled lashes out before application.

All That Glitters: Peepers and Pout

Always consider the setting: for a party or on the red carpet or inside an intimate nightclub, glittering eye shadow *and* lipstick together can be too harsh up close and personal. The pairing can also be unflattering in photographs. But onstage, in a venue filled with thousands of guests, an overstated eye or lip can be dazzling.

For eyes: For more than a dusting of frost or glitter, for a look that appears like a lid is plastered in rhinestones, there are two options.

Either option should start with prepping the lid with foundation and powder, eye color, and liner. Follow with a generous layer of loose powder *under* the eye with a small, flat concealer brush; once any and all sparkle is applied, use a clean, dry fan brush to sweep away the excess.

As a final step, drag a creamy eye shadow over the lid to "grab" the glitter. I like a white cream for a white glitter lid and a color to match a colored glitter shade.

Or skim on a layer of glitter glue. Among my preferences are LASplash Splash Proof Sealer/Base, which comes in a lip gloss–like container, complete with wand, or the squeeze bottle formulation of Manic Panic Glam Glue.

After applying the sticky base (by way of cream eye shadow or glue fix), dip a brush sticky with the creamy eye shadow or glitter glue into the pot of glitter. Fold a tissue and hold it under the eye. Bend your head forward and, looking down into the mirror, gently press the glittery flat edge of the brush tip onto the lid, repeating this step with a light-handed touch, layer after layer. Be careful not to rub or dab so as to avoid a chunky result. Any excess sparkle can fall to the floor or on the tissue.

Sweep away excess sparkles and powder from your cheeks with a clean, dry fan brush. Scotch tape also works if no brush is handy. Take a strip and press it onto the skin to lift sparkle residue, using fresh strips to complete cleanup. Don't be overzealous or you risk picking up too much makeup base.

Even with these precautionary steps, for a flawless effect, a concealer touch-up is inevitable. In a perfect world, I prefer to do my eyes first and then apply a clean foundation base. But showbiz is not perfect.

Just don't forget to touch up afterward. If needed, apply a clean stroke of eyeliner and mascara, and you're ready to twinkle those peepers.

For lips: Start with lips already lined and colored in with a semi-matte formulation, but one not too dry. Go with red, or go wild with burgundy, magenta, coral, or a mix of reds or pinks.

Once the lip brush is coated with lipstick, dip it into a pot of glitter, either a color matching the lipstick or not: try red glitter, fuchsia, orange; consider a clear, nude, or gold glitter. My personal preference? Red on red, of course. Experiment, too, with glitter of varying sizes, from tiny flakes to ultrafine particles.

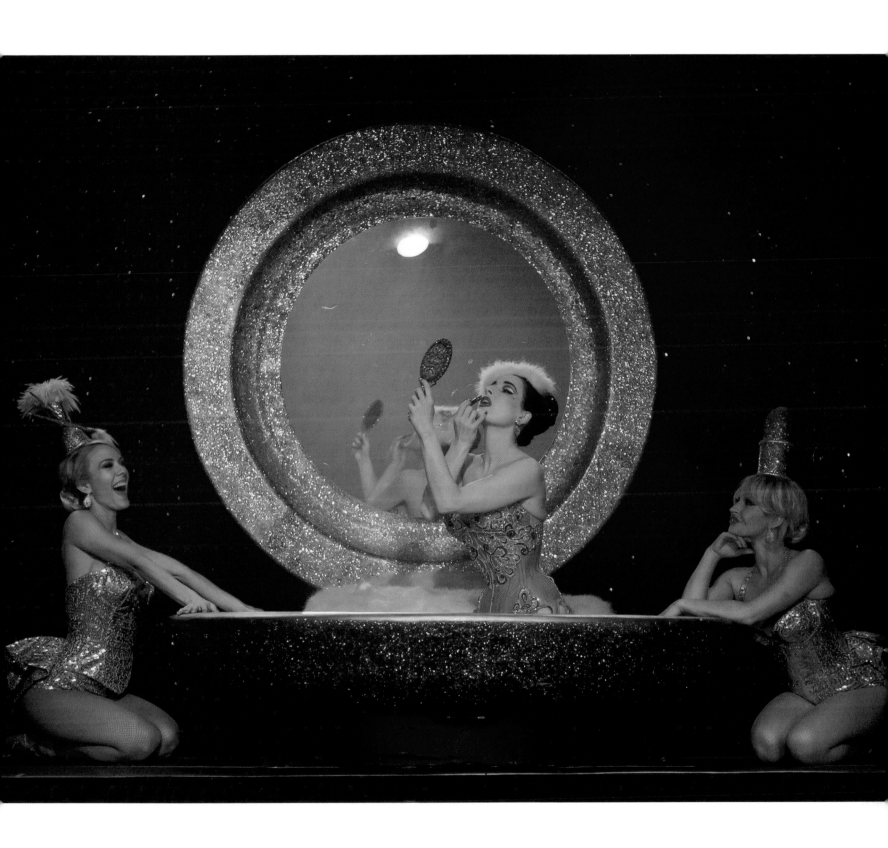

For depth, apply a lighter shade of glitter in the center of the bottom lip. The effect is a heightened version of a dab of lighter gloss or gold on a colored lip, but one perfect for stage.

Just as with the eyes, press the glitter gently on the lips, repeating layers until the desired effect is achieved. Don't rub in the glitter or smack your lips, or it loses its gleam.

Before walking away from the mirror, check your teeth!

By the way, glittering features are not a stage requisite. When I'm channeling Dietrich onstage, complete with top hat and tux, this is no time for glitter. Other times, I'll only use a hint.

Finishing Touches

Throughout the makeup process, I repeatedly swirl a dome brush in face powder and sweep it around my face, in the crevices around my nose, across my chin and temples.

Sometimes it takes a flat sponge in powder foundation for an opaque, flawless finish.

I don't do highlights for dinner or every day. But under the spotlights, they are part of the stage beauty arsenal. Try a shimmering powder with a touch of sparkle to play up features. Take a powder two shades lighter than your natural face tone, and brush it along high facial planes such as the temples and cheeks. It makes for a dazzling finish.

Last, but so very important to my identity, is the beauty mark. Here, I make a more generous point than real life, emphasizing it with waterproof MAC Liquidlast. A waterproof formulation is paramount to avoid the comet that can occur in heated theaters or during water-filled acts. I frequently top it with a velvet adhesive beauty mark or a jet-black Swarovski crystal for added razzle-dazzle.

It's All an Illusion

Imagine being arrested, not once but four times in a single day!

One day in 1933, burlesque star Sally Rand was repeatedly picked up by Chicago's finest, each time for indecent exposure. There were other arrests, too, in the days before and following that banner day, all leading up to one of her most notorious appearances, the 1933 World's Fair in the great Windy City. With each detainment, a judge dismissed the charges because of a lack of evidence that Rand was naked. It was the kind of civil disobe-dience a publicist couldn't buy, and for the queen of fan dancing and her conspirator, the king of cosmetics, Max Factor, the resulting pandemonium only aroused interest in their exhibition at the fair. Seeing Rand under carefully applied body makeup, visitors pondered: was she or wasn't she?

In little more than a thick coat of pale body paint and a set of large ostrich fans, she absolutely was! It's a fact confirmed by Gypsy Rose Lee in her own memoirs. Rand was an artist onstage as well as backstage, and, aside from the World's Fair, she always did her own makeup. Interest swelled in the exhibition, as did Rand's weekly paycheck to $3,000, from $125, as crowds clamored to see her with their own eyes. Even the World's Fair, in the midst of the national Depression, was saved from financial ruin. Rand was hawking an illusion, and spectators were buying it up. As she liked to tease, "The Rand is quicker than the eye."

I'm always asked if I feel weird being naked onstage. My reply is not that far off from something Gypsy Rose Lee once quipped: "I wasn't naked. I was completely covered by a blue spotlight." Like Rand and Lee, up there onstage, none of my exposed skin is left bare. Whatever is not concealed by crystals or other bits of costume is covered in makeup and lighting!

Backstage, I combine a mixture of Revlon ColorStay Foundation, MAC Face and Body, and Dermablend Leg & Body Cover, all in the palest shades. The latter is one of those products used by makeup professionals for full coverage of tattoos, veins, and bruises; I like that it's also water-resistant, especially for those performances involving water. To lighten it up a bit further, I stir in a squirt of white MAC Face and Body Foundation, as well as MAC's iridescent skin booster Strobe Cream.

I sit on the floor in my dressing room, atop a towel in front of a full-length mirror, hair in rollers, full face of makeup, blending this concoction on a plate. My hands are my best tools when it comes to applying body makeup, and no cranny is left without a good slathering. Should my G-string so much as creep up a nanometer during an act, no one in the audience is the wiser.

A wet towel to clean my hands is always nearby, as is an assistant to coat any hard-to-reach spots on my back and to serve as a second set of eyes to survey my work.

This foundation step is followed by a good powdering. On another plate, I mingle Coty Airspun Loose Face Powder and MAC Iridescent Loose Powder in Silver Dusk. I may even add a loose powder with sparkling pink or blue tints for effect. I apply it with a grand ten-inch puff custom-made for me by my accommodating friends at Ricky's beauty emporium in New York City.

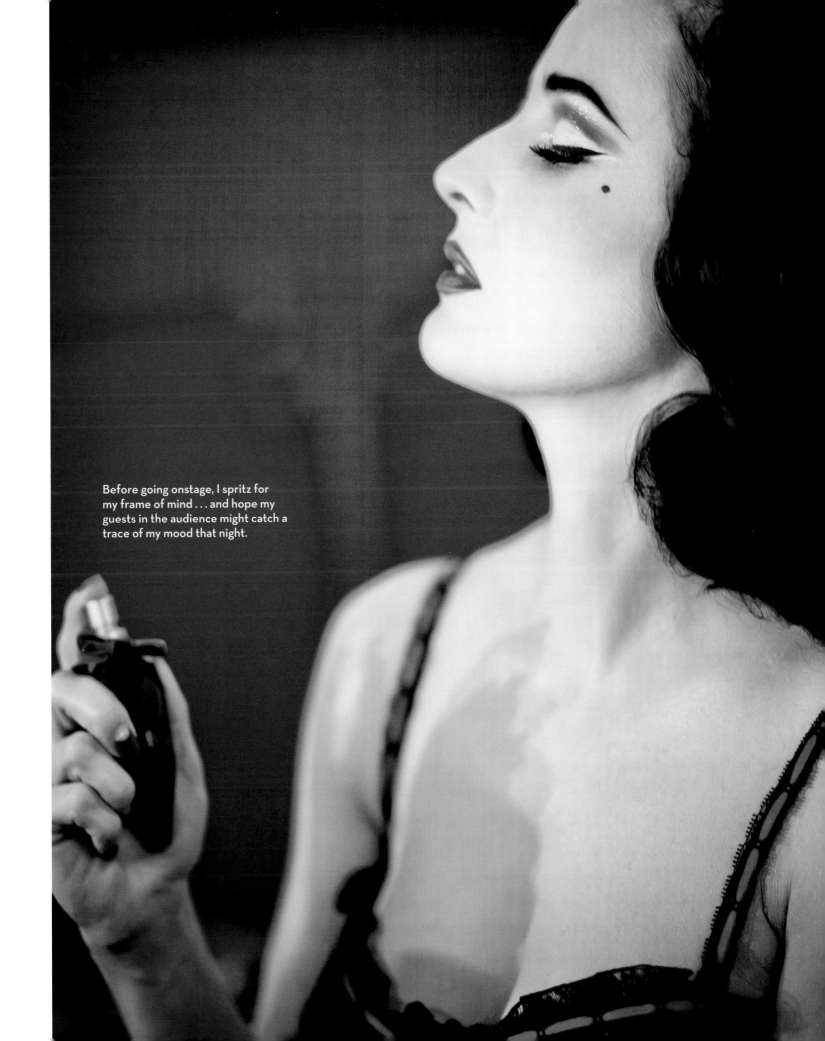

Before going onstage, I spritz for my frame of mind . . . and hope my guests in the audience might catch a trace of my mood that night.

The Light Fantastic with Jason Fox

What's my remedy for reducing cellulite? No overhead lighting! (All right, that, and maintaining healthy habits.) Lighting is everything. Just as candlelight can transform a mere supper into a seduction, so the deft use of stage lighting can metamorphose an act into legend. Or at least something the audience won't soon forget!

Good lighting not only conceals nature's thoughtlessness such as cellulite, but it also erases man-made marks like those caused by the work of my talented Mr. Pearl, the world's master corsetiere. Unlacing a corset onstage is a precarious business: it cuts fingers, burns and cuts the skin on my back. I admit that some nights after a show, I cannot wait to go home, slip into a bath, and recover. Yes, darlings, these are the perils of burlesque. (By the way, standing corseted for a prolonged length of time, as I do when I pose for a photographer, is more of a challenge than dancing for seven minutes corseted during my act!)

Lights can minimize colors and details, which is why what can look extreme up close can seem downright normal to those in the audience. Stage lights distort true colors. The pink cells over spotlights not only bathe the stage in a rosy glow, but they also cancel out any red marks on skin (which is good), while altering the true colors of makeup (not so good). Reason enough to pile on the blush.

Because lighting is exaggerated onstage, wherever in the world I find myself backstage, the bulbs around my vanity mirror must be bright. Among my beauty fantasies (and how many there are!), I imagine a glamorous hat with built-in Hollywood vanity lighting. That would be one chic chapeau, no? If such a wonder did exist, it wouldn't do anyhow. Even when I don my top hat onstage, ultimately, it, like everything else, comes off!

Early on in my burlesque career, a seasoned showbiz vet gave me a bit of salty advice: "F**k the lighting guy. He can make or break a show." Okay, so I've never had to do this, nor do I recommend it. But I and you should get the point. Lighting is a burlesque dancer's best beauty virtue, and irrefutably a star player in my shows. In a theater or on TV, a priority is introducing myself to the lighting director and making extra nice. It's why, at times, I often go to great lengths to tour with my own stage lights—and my own lighting pro, the talented Mr. Jason Fox.

Jason lives in Los Angeles, but has hit the road with "Strip Strip Hooray" when duty calls. Here, he reveals some insight into his stage magic.

Everything begins and ends with the talent. But it's not like lighting a rock band. In burlesque, every stage trick is designed to complement the performers, to enhance with that extra pow. So there is a lot of play with color, intensity, and texture, which is conveyed with light and shadow.

Shadow creates drama. So designing shadow is as critical to what I do as anything. In the case of the "Opium Den" act, shadow and strobe lights help create mystery. I also use more colors in this act, including deep blues and reds, colors that convey decadence. There are even emerald greens, which have to be carefully used. Anyone is going to look jaundiced with greens or yellows, so those colors are limited to atmospheric effect. Much of the same tenets that go into stage lighting are like those for interior design.

Dita's skin is so alabaster that it's going to pick up any color I hit her with, so I tend to use pinks, blues, or lavenders. The spotlights that follow the performers are best in these colors, and usually involve up to six shades—including three shades of pink, from light rose to magenta. Sometimes I'll kick in an amber.

Ambers and light lavenders and purples complement nicely on darker skin tones, so, during the tour, I apply those on performers such as Perle Noir.

As the clothes come off, the saturation of colors intensify. The dancers are bathed in color. This is one trick that certainly helps camouflage some of the less-than-flawless lines that naturally appear on even the fittest figures.

Lighting a theater is like a game of *Tetris*. Any lighting maps I receive in advance of arriving to a theater might not ac-

tually reflect what is there. There is also a production's needs and staging. Where the curtain hangs might cut down on 50 percent of the lighting required for an act. So communication is critical between the production crew and house manager and myself. I'm lighting this show for the audience who paid money to be there and expect a memorable experience.

Much of it is simply common sense: use makeup that flatters your skin tone, hair color, and enhances the character of the costume and performance. Flattering as they are, having lavender lights at home might not be realistic. But a dimmer for every possible light is the simplest way to change the mood in a room. While compact fluorescent lights might be friendly to the environment, they are not so much for the look of a room.

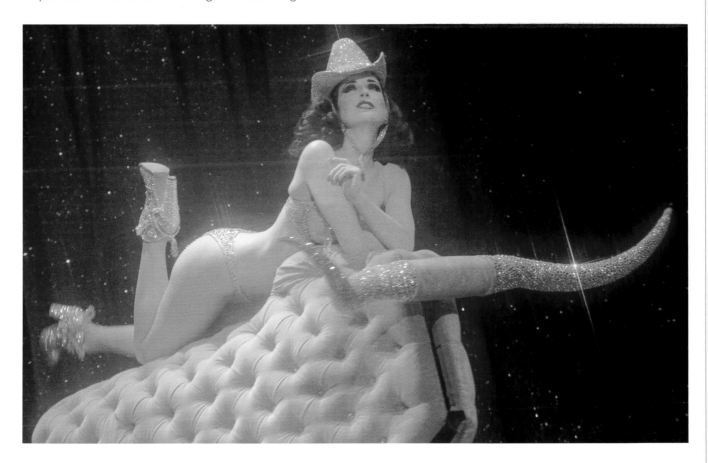

Applying body makeup is a craft, one not all professional makeup artists have mastered. When I walked the runway for Jean Paul Gaultier's Fall 2010 couture presentation, it was in little else than nude-colored gloves and stockings with a nude corset by Mr. Pearl according to Gaultier's design, paired with Gaultier's utterly sublime black crystal overpinning suggesting the human spine, pelvic girdle, and front ribs. My bum was entirely exposed.

Backstage before the fashion show, I was attended to by one of the legion of makeup artists, applying a thin layer of body makeup with the daintiest of brushes. A good twenty minutes into the process, I realized this was not working. I offered encouraging hints: "Don't be shy. Lay it on thicker. It's all right to use the whole bottle." But the poor makeup artist was sending me out of my mind.

"This is not how we do it in showbiz!" I wanted to declare. I was, after all, about to walk out on a runway flanked by some of the most critical pundits in the fashion universe. "No one should be able to see my bare skin," I urged him. "It must be spackled on."

For me, there is no reality in the nudity. *It's got to look otherworldly*. A thick, not-of-this-world layer of body makeup under the blinding lights of a catwalk or stage can appear like flawless skin.

In cases where the foundation shade is different from the skin tone, it better be expertly applied. As such, it was with a combination of patience and luck that I covered my arms, chest, and legs in a milkier-than-usual foundation for one red carpet outing some years back. I was headed to the 2002 film premiere of *The Rules of Attraction* dressed in a silky charmeuse gown the

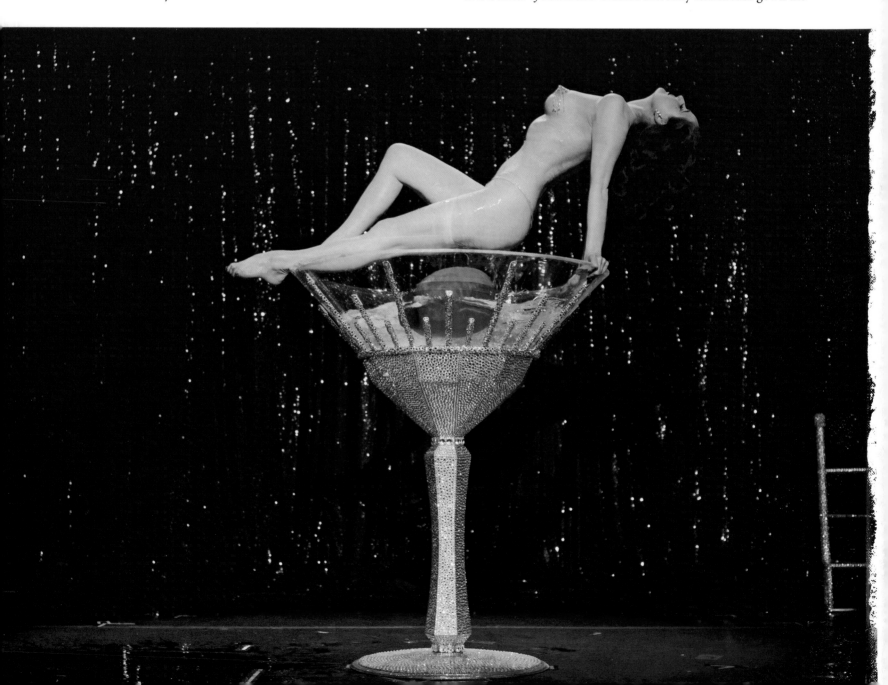

color of electric sapphire and, for a stark effect, I wanted skin that resembled that of a porcelain doll. I pulled it off, and it looks amazing in photographs. Inevitably, though, white smudges ended up all over my ex-husband's black coat.

Not that he minded. As the world knows, he's familiar with the perils of makeup!

Cleaning Up

Just as important as setting out all the makeup I will need for my show face (and body) is having everything at hand for tidying up. Being able to wipe away a smudge or clean fingers swiftly and stress-free can make an enormous difference in a performer's preparation and mood.

Essentials include a dry, clean brush to dust away colored eye or cheek powders or a pair of tweezers to pluck away a flake of mascara. Have premoistened cotton swabs and cleansing towelettes, along with a damp washcloth for hands. I also like a hand sanitizer to keep nasties at bay.

Post-show, when I'm in my dressing room, I count on MAC's industrial-strength, mineral-oil-free Cleanse Off Oil to dissolve everything away. Coconut oil is another fabulous natural option.

But it's the steamy shower I long for! Sometimes there's a shower at the theater; sometimes I must wait until I'm at the hotel or home. In the shower I slip on loofah gloves and scrub off all the body makeup, until there's a pool of milky pink aftermath at my toes. Liberation! It's a real mess and I usually have to wash a second time to fully rinse off.

One of my most memorable showers ever is also one of the most astonishing moments in my showbiz life. After one late-night show at the Crazy Horse Paris, I was sharing the showers with *les filles,* as the troupe of nubile dancers are called. Thirteen in all, each gloved in a pair of loofah mits and, with showers raining down and steam rising, they began to scrub one another's backs. We were all in a lather of soap and giggles and chatter. Everyone was on a high of post-performance triumph. It was like a teen boy's dream scene out of a 1980s movie!

Once a tour wraps, I head for a traditional Korean spa for a professional scrubbing. As I described on page 86, the attendants there really work every crevice, leaving a gal feeling sparkling clean.

Ladies and Gents . . .

Three hours after arriving at the stage door, I'm ready to step out in front of a paying audience.

But there's one more step: a wipe-down of my costume with glass cleaner wipes to make that Swarovski shine. Bet you didn't expect that to be in my show kit!

Remember, darlings: whether your stage is in a theater or in everyday life, it's all about smoke, mirrors, and desire. It might take a lot of work, grit, and pain to get there. But in the end, it's all about making it *look* easy and leaving your audience wanting more. So much more . . .

I'm often asked what it feels like to see my name in lights. Well, let me let you in on something: it *is* a lot to live up to. Yet it's no grand leap from my private self to my stage personality. This is who I am—onstage or off. In this wildly unpredictable life we all live, filled with highs and lows and everything in between, this is how a girl named Heather Sweet decided to make a mark in this world as Dita Von Teese.

This is my beauty mark.

Just onstage, it's with a heck of a lot more sparkle, hair spray, and makeup!

"You don't have to be born beautiful to be wildly attractive."

— Diana Vreeland

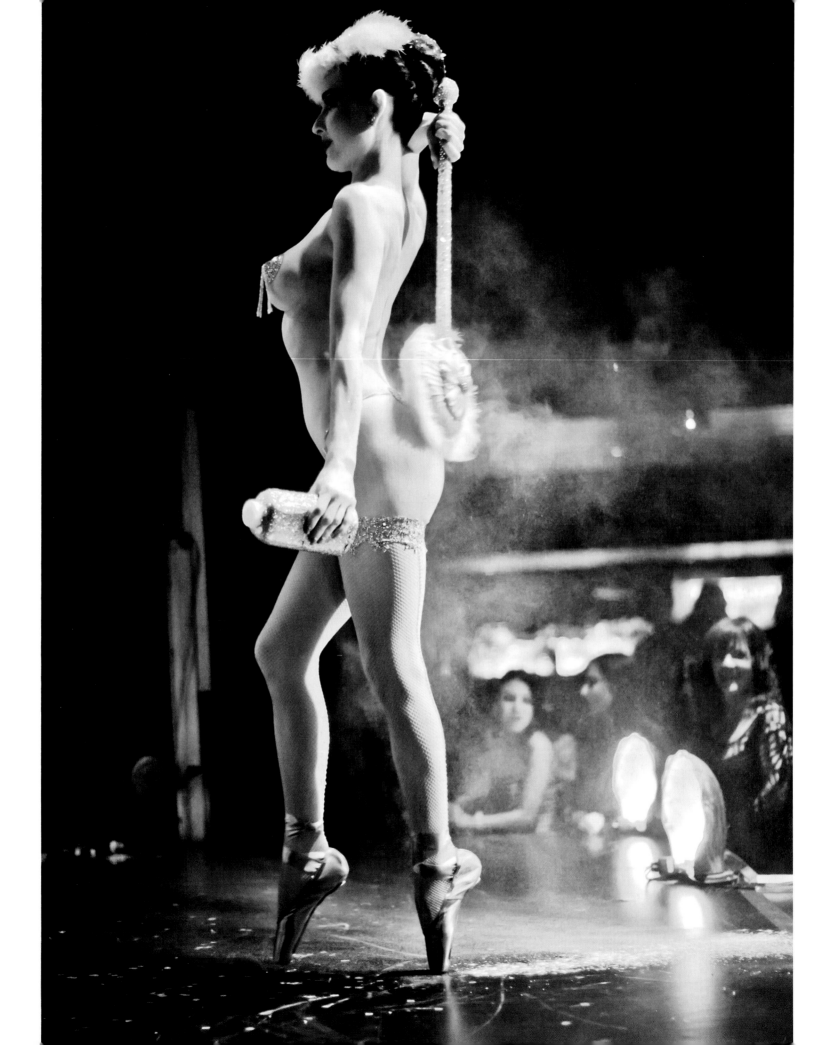

Bibliography

Allen, Robert C. *Horrible Prettiness: Burlesque and American Culture*, ed. Alan Trachtenberg. Chapel Hill: University of North Carolina Press, 1991.

Anonymous. *Authentic 1940s Hairstyles*. Long Beach, CA: Streamline Press, 1999.

Ashenburg, Katherine. *The Dirt on Clean: An Unsanitized History*. New York: North Point Press, 2007.

Berry, Sarah. *Screen Style: Fashion and Femininity In 1930s Hollywood*. Commerce and Mass Culture Series, vol. 2. Minneapolis: University of Minnesota Press, 2000.

Burr, Chandler. *The Perfect Scent*. New York: Henry Holt and Company, 2007.

Cosio, Robyn, and Cynthia Robins. *The Eyebrow*. New York: HarperCollins Publishers, 2000.

de Castelbajac, Kate. *The Face of the Century: 100 Years of Makeup and Style*, ed. Nan Richardson and Catherine Chermayeff. New York: Rizzoli, 1995.

de Feydeau, Elisabeth, trans. Jane Lizop. *A Scented Palace: The Secret History of Marie-Antoinette's Perfumer*. London: I. B. Tauris, 2006.

Etcoff, Nancy. *Survival of the Prettiest: The Science of Beauty*. 2nd ed. London: Abacus Books, 2000.

Guilaroff, Sydney, introduction to *Crowning Glory: Reflections of Hollywood's Favorite Confidant* by Angela Lansbury. Los Angeles: General Publishing Group, Inc., 1996.

Hunt, Terry. *Design for Glamour*. New York: Prentice-Hall, Inc., 1941.

Kordel, Lelord. *Eat Your Troubles Away*. 8th ed. New York: Belmont Books, 1966.

Meredith, Bronwen. *The Vogue Body and Beauty Book*. New York: Harper & Row Publishers, 1977.

Morris, Alfred. *Creative Hairstyling*. London: The Morris School of Hairdressing and Beauty Culture Ltd., 1948.

Pallingston, Jessica. *Lipstick*. New York: St. Martin's Press, 1998.

Peiss, Kathy. *Hope in a Jar: The Making of America's Beauty Culture*. Philadelphia: University of Pennsylvania Press, 2011.

Ragas Cohen, Meg, and Karen Kozlowski. *Read My Lips: A Cultural History of Lipstick*. San Francisco: Chronicle Books, 1998.

Rennells, Lauren. *Vintage Hairstyling: Retro Styles with Step-by-Step Techniques*. 2nd ed. Denver: HRST Books, 2009.

Riordan, Teresa. *Inventing Beauty*. New York: Broadway Books, 2004.

Siman, Ken. *The Beauty Trip*. New York: Pocket Books, 1995.

Spencer, Kit. *Stage & Screen Hairstyles*. New York: Watson-Guptill Publications, 2009.

Stover, Laren. *The Bombshell Manual of Style*. New York: Hyperion, 2001.

Thornton McLeod, Edyth. *Lady, Be Lovely*. New York: Wilcox and Follett Company, 1955.

Turudich, Daniela. *1940s Hairstyles*. Long Beach, CA: Streamline Press, 2001.

Vreeland, Diana. *D.V.*, ed. George Plimpton and Christopher Hemphill. New York: Da Capo Press, 1997.

Westmore, Perc, Wally Westmore, Bud Westmore, Frank Westmore, and Mont Westmore. *A Complete 1950s Guide to Vintage Makeup, Hairstyling, and Beauty Techniques*. 2nd ed. Bramcost Publications, 2009.

Zack Hanle, Dorothea. *The Hairdo Handbook: A Complete Guide to Hair Beauty*. Garden City, NY: Doubleday and Company, Inc., 1964.

Acknowledgments

And so we acknowledge . . .

A life in eccentric glamour is made all the more possible thanks to those who have enthusiastically come to the stage, set, and life as collaborators in art and beauty.

Much affection and gratitude to those visionary photographers who generously and enthusiastically provided their work for this passion project: Ellen Von Unwerth, Ruven Afanador, Mariano Vivanco, Alessia Laudoni, Alix Malka, Amedeo M. Turello, Analisa Ravella, Angie Coqueran, Anton Östlund, Arno Burgi, Brakhax2, Bryan Kasm, Candy Kennedy, Catherine D. Louis, Charbel Abouzeidan, Christophe Mourthé, Cici Olsson, Cliff Watts, Dana Maion, Danielle Bedics, Don Flood, Dulermo+Labica, Elizabeth Stewart and Michael Ellins, Erik Madigan Heck, Esther Haase, Georges Antoni, Gitte Meldegaard, Gynome B. Dos Santos, Jennifer Mitchell, Jenny Lexander, Julio Piatti and Tomas de Ruiter, K Shimomura, Kaylin Idora, Kris DeWitte, Lionel Deluy, Lionel Guyou, Magnus Ragnvid, Marcelo Cantu, Mario Sierra, Markus and Indrani, Mathu Andersen, Max Cardelli, Michael Thompson, Mike Ruiz, Morten Qvale, Naj Jamaii, Nick Fallowfield-Cooper, Paola Kudacki, Penny Lane, Peter W. Czernich, Peter Lindbergh, Pierre Toussaint, Richard Bernardin, Romain Court, Satoshi Saikusa, Scott Harrison, Scott Nathan, Sean McCall, Sheryl Nields, Simon Lekias, Star Foreman, Steve Earle, Studio Harcourt Paris, Takaki Kumada, The Bearz (a.k.a. Markus Klinko), and Ylva Erevall.

We also thank the following who facilitated the process of securing photographs and quotes with convivial patience and persistence: Arnaud Adida (A.galerie); Billy Vong (Trunk Archive); Jessica Miranda-Veiga, Lauren Kelly and Justin Skinner-Work (Jed Root); Dan Terry (August); Emile Legendre (Elie Saab); Jerome and Anne (Studio EVU); Maryna Sierra; Maud Rabin and Sylvie Cabrera (Remy-Cointreau); Pauline Roest Jonkman (Studio Harcourt Paris); Theresa Dellegrazie (Corbis, then August); Matthias Wolf (DPA); Cindi Berger and Danica Smith (PMK-BNC); Jelka Music (Jean Paul Gaultier); Anne Muhlethaler and Alvina Patel (Christian Louboutin); and Joelle Hawkes (RuCo). Special acknowledgment goes to Sarah Lynch and her associates at Getty Images; Michael Woloszynowicz of Vibrant Shot; Amy Dresser; the unflappable lifesaver Henry "George Bone" Jaremko; and, heaped with a very special kiss, Adam Rajcevich.

Beauty is in the eye and spirit of the beholder, and we are beholden to the following as allies in life's celebration and need for eccentric beauty, and whose contributions inadvertently made this beauty book more beautiful: Simon Doonan (for so poetically articulating the phrase "eccentric

glamour"); Catherine D'Lish; Mr. Pearl; Christian Louboutin; Jean Paul Gaultier; Alexis Mabille; Elie Saab; Michael Schmidt; the MAC Cosmetics family, including James Gager and Holly Bernesser; Debi Mazar; Jared Leto; Marilyn Manson; RuPaul; Elisabeth and Kilian Hennessey; Lloyd Simmons and YSL Beauty; Kathy Jeung; Laura Duncan; Kiss Lashes; Tigi Bed Head; MD Solarsciences; Eminence Skincare; Dr. Hauschka; Ricky's Beauty Emporium; Barbara Hermann; and Julie Newmar. We cherish the generous insight and friendship of John Demsey of Estée Lauder. Sincere appreciation to Melissa Dishell, Steffi Barrios, and Team DMG past and present, as well as Victoria Ball, Jasmine Vega, and Albert Murcia. We're also so grateful for the care and attention from Marcel Pariseau (True Public Relations); Barbara Karrol and Pamula Solar (Provident Financial); attorney Phil Daniels; our lovely book assistants Emily Chang, Brandee Nicole-Able, and Cherokee Neas; book designer Kris Tobiassen and her team at Matchbook Digital; and from HarperCollins, Lynn Grady, Michael Barrs, Andy Dodds, Tanya Leet, Susan Kosko, Andrea Molitor, Paula Szafranski, and the on-it, indispensable Kara Zauberman.

We are indebted to our tireless support system, Cali Crawford and Andy Griffith, for keeping us sane, fed, and on track. To Nina, who cooed through photo shoots and five years later is giving Aleister a workout, know that even in the thick of it, you always had mommy's eye—and have already made an indelible beauty mark on life.

As for those who very wittingly helped ensure this book showed that beauty—eccentric beauty—is more than skin deep, we revere the time you gave in your taxed schedules to share your boldly candid wisdom: Gregory Arlt, Danilo Dixon, Mari Winsor, Dr. Ronald W. Cotliar, Kimberly Snyder, Carmen Dell'Orefice, Dr. Walter Dishell, Douglas Little, Suzanne von Aichinger, Catherine Baba, Betony Vernon, Sutan Amrull, Angelique Noire, John Blaine—and, of course, Bonnie "Mom Von Teese" Lindsay. You each deserve your own book.

In this project and in career, we are particularly lucky to count these conspirators for their manifest artistry, creative powers, and endless magnanimity: lensmen Ali Mahdavi and Albert Sanchez, stylist Pedro Zalba, and illustrator Adele Mildred. More is beautifully more in this book. And we cannot thank you enough.

Finally, deep gratitude to HarperCollins . . . and the indefatigable, ever simpatico, truly wonderful Cassie Jones, who, through books one, two, and now three, has been there from the start. Thank you.

Photography Credits

Albert Sanchez and Pedro Zalba ii, v, vi, viii, 7, 15, 16, 88, 93, 95, 102, 109 (r), 112, 113, 116, 156, 207, 251, 256, 260, 263, 282, 365, last page
Ali Mahdavi 24–25, 36, 39, 40, 104–105, 108, 115, 120, 133, 142, 158, 165, 198–199, 200, 220–221, 223, 240–241, 280, 332, 335, 339, 340–341, 342, 347, 349
Alix Malka 314
Amedeo M. Turello 203
Analisa Ravella 238
Angie Coqueran 44
Archive Photos/Getty Images 214
Arno Burgi 6
Bob Thomas/Popperfoto/Getty Images 237, 302
Brakhax 2 217, 350
Bryan Kasm 169, 294
Candy Kennedy 180–181
Catherine D. Louis 219
Charbel Abouzeidan 295
Cici Olsson 299
Clarence Sinclair Bull/John Kobal Foundation/Getty Images 34
Cliff Watts 184, 190, 235
Dana Maion 111
Danielle Bedics 53–68, 144, 155, 171–175, 186–187, 196, 206, 224–225, 306–308, 313, 315, 318, 320–323, 325, 326–327
Danilo Dixon Archives 271
Dave Benett/Getty Images 194
Dita Von Teese Archives 5, 8, 14, 212, 278, 328, 370
Don Flood 70
Douglas Friedman xii
Dulermo+Labica 363

Michael Ellins and Elizabeth Stewart 47
Ellen Von Unwerth 45, 84, 85, 134, 213,
Erik Madigan Heck 230
Frank Worth, Courtesy of Emage International/Getty Images 294
General Photographic Agency/Getty Images 147
Georges Antoni 248, 268, 285, 317, 319
Gitte Meldegaard 146, 236
Gregory Arlt Archives 140
Hulton Archive/Getty Images 87
Jennifer Mitchell 355
Jenny Lexander 23, 183
John Blaine 310
John Kobal Foundation/Getty Images 35
John Bryson/The LIFE Images Collection/Getty Images 311
Julio Piatti and Tomas de Ruiter 92
K Shimomura 137, 210
Kaylin Idora 352, 357, 358–359, 360, 367, 369, 372, 374
Keystone-France/Gamma-Keystone via Getty Images 22
KM Archive/Getty Images 43
Kris DeWitte 305
Laszlo Willinger/John Kobal Foundation/Getty Images 337
Lionel Deluy 32–33, 83, 276
Lionel Guyou 31, 168
Lorenzo Santini/WireImage 300
Luca Teuchmann/WireImage via Getty Images 2
Marcelo Cantu 209
Mariano Vivanco 9, 42, 119,
Marilyn Manson 129

Index

Note: Page references in *italics* indicate photograph captions.

nails, 233–46. *See also* nail polish
 acrylic, 242
 buffing, 242
 filing, 242
 hangnails, 244
 keeping healthy, 244
 length and shape, 242
 manicures for, 234–42
 polish for, 234–37, 238, 239
 press-on, 237
 silk wrap for, 242
nail strengtheners, 244
Naturtint, 282
Nessler, Charles, 298
Niemoeller, A.F., 89
night creams, 29
nipple hairs, 72
nipples, coloring, 76
no-crease clips, 296
Noire, Angelique, 150
non-acetone removers, 239
Noonan, Tommy, 82
nose jobs. *See* rhinoplasty
nutrition
 healthy eating habits, 41–45
 for healthy hair, 264, 266
 professional tips, 48
nylon hosiery, 253–54

O

oats, 41
Obliphica collection, 264
O'Connor, Erin, 337
oily hair, 262–64
On Sex, Health, and ESP (West), 50
"The Opium Den," 354
Orentreich, Norma, 348–49
orgasms, 50
ORLAN, 343
Overbury, Thomas, 21–22
oxymelanin, 278

P

paddle brush, 267
Page, Bettie, 34, 278
Palma, Rossy de, 337
panades, 301
Pan-Cake, 147

Pantene products, 271
Patchett, Jean, 136
Pavés, Ken, 288
pedicures, 255–56
Pelleray, L., 303
Penn, Irving, 136
Peretti, Elsa, 100
perfume, 114. *see also* fragrance
perfume bottles
 removing stuck stopper, 107
 storing, 118
 vintage, 103
perlèche, 227
pheomelanin, 278
physical fitness, 38–40, 46–52
 arm exercises, 61
 bum exercises, 65–67
 the cooldown, 69
 core exercises, 57–60
 different types of, 69
 leg exercises, 62–64
 releasing tension points, 68
 stretching exercises, 53–56
Piaggi, Anna, 10, 194
Pickford, Mary, 334
piercing above the lip, 205
Piguet, Robert, 121
Pilates, 46, 51
Pilates, Joseph, 51
pin curls, 300
pinkeye, 168
Playboy, 250
podiatrists, 256
Poiret, Paul, 121
poultry, 43
powder. *See* foundation and powder
The Powder and the Glory, 132
Powolny, Frank, 250
Presley, Elvis, 129
Presley, Priscilla, 129
primers, 145
Princess Jean-Louis "Baba" de
 Faucigny-Lucinge, 234
probiotics, 41
pubic hair, 256–57
pubic wig, 257

Q

Quelques Fleurs perfume, 99–100

R

radial brush, 269
Raja, 208
Rand, Sally, 368
rats, for hair, 302
rat-tail brush and comb, 269
rebounder, 46
recipes
 Glowing Green Smoothie, 44
 My Sweet-Tooth Elixir, 46
Red Door salons, 46
red hair, 218, 280
Renay, Liz, 204
retinol, 29, 72, 244
rhinoplasty, 334–36, 337, 338
Rio, Dolores del, 34, *35*
Rochas, Marcel, 103–6
Rogaine, 184
rollers, 298
rosacea, 27
rouge. *See* blush
Rubinstein, Chaya, 132
Rubinstein, Helena, 132, 168
RuPaul, 43, 215, 353
Russell, Jane, 76, *87*

S

sake baths, 182
Sanchez, Violetta, 338
Sargent, John Singer, 72
scars, 145, 148
Scavullo, Francesco, 140
scents. *See* fragrance
Scent & Subversion (Herman), 121
Schiaparelli, Elsa, 106
Schmidt, Michael, 354
seamed stockings, 254
Secrets in Lace, 254
serums
 for hair, 272
 for hands, 243
 for skin, 28
sex, 50
shampoo, 118, 262, 264, 266
shaving, 90
Shearer, Moira, *362*
Sheldrake, Christopher, 114
Shere, Joe, 71

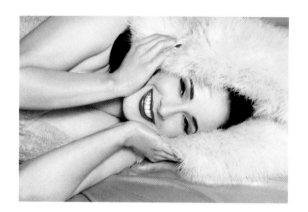